Smithsonian
Trees of
North America

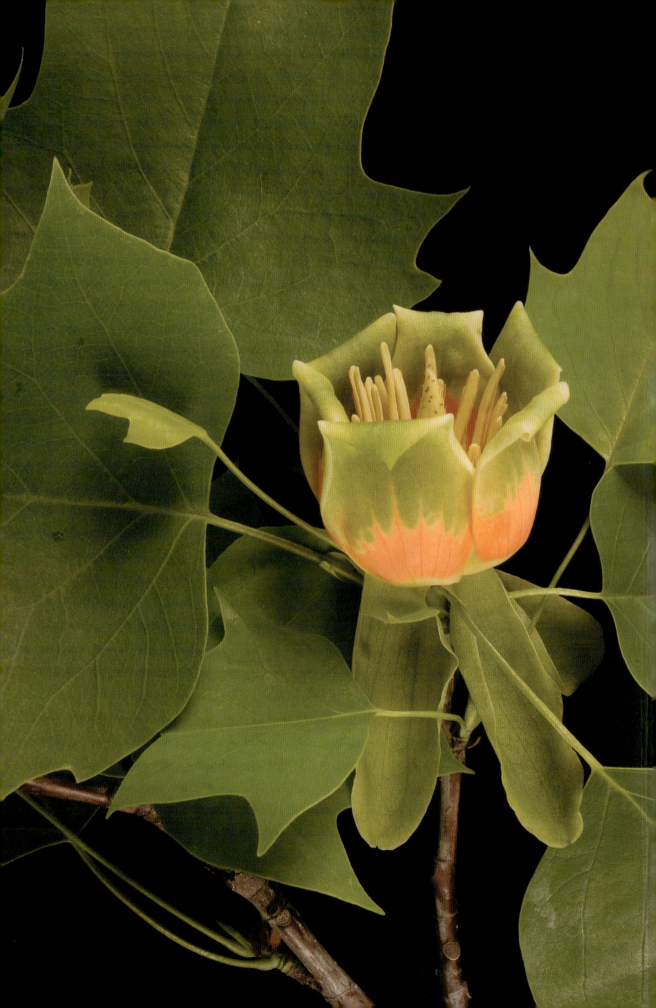

Smithsonian Trees of North America

W. John Kress

Yale UNIVERSITY PRESS
New Haven & London

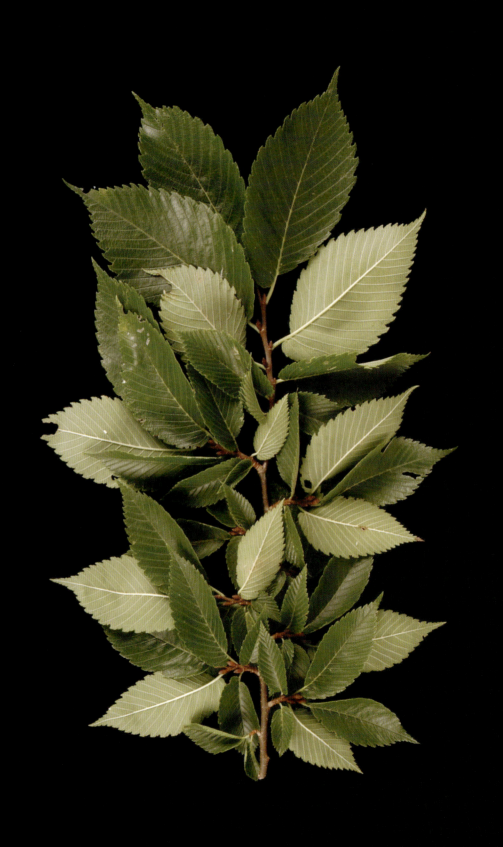

Welcome

Lonnie G. Bunch III
Secretary of the Smithsonian Institution

Since its founding in 1846, the Smithsonian Institution's mission has included the discovery, documentation, and description of biodiversity from around the world. That scientific focus began when the U.S. Naval Exploring Expedition of 1838–1842 amassed hundreds of thousands of natural history specimens and artifacts, forming the basis of our original collections and ushering in the development of science in the United States. The plant species brought back from that voyage of discovery eventually led to the founding of the United States National Herbarium as part of the National Museum of Natural History.

Following a long line of world-renowned botanists at the Institution, Dr. W. John Kress applies his extensive knowledge of plants to *Smithsonian Trees of North America*, an authoritative treatment of the natural history of trees. The more than five million plant specimens maintained and curated at the Smithsonian, along with the living collections at the National Arboretum, the United States Botanic Garden in Washington, DC, and many other botanical institutes across the country, are a vast source of information about the biology of trees. Dr. Kress has deftly synthesized and presented this collected information in an accessible volume that will help people everywhere understand, appreciate, value, and conserve the planet's trees that are so critical to our shared future.

The detailed scientific research in this volume is accentuated by Dr. Kress's undisguised passion for Nature, a direct result of his important work for over thirty years as a Curator of Botany at the Smithsonian. Traveling around the globe, particularly to tropical environments, he has enriched our understanding of trees and other plants through investigations of evolution, ecology, taxonomy, and conservation. Applying modern technologies in digital sequence information and image recognition, Dr. Kress's work has expanded our ability to recognize and identify species that had previously been scarcely known by scientists and non-specialists.

Dr. Kress's scholarship, along with that of his scientific colleagues at the National Museum of Natural History and other research units at the Institution, have built upon and added greatly to the Smithsonian's extensive history of the discovery and documentation of biodiversity. These ongoing efforts have culminated in *Smithsonian Trees of North America*, an impressive example of how my colleagues apply their knowledge and acumen to benefit the world.

OPPOSITE American elm (*Ulmus americana*)

Foreword

Margaret D. Lowman

When I began my exploration of the treetops as a canopy biologist, I started from scratch assembling my gear of jerry-rigged slingshots, fishing line, lead weights, nylon cord, rock climbing ropes, and homemade harnesses to ascend into a new botanical world. Whereas my humble arbornaut's toolkit gave scientists the ability to study the treetops, John Kress has brought trees within close reach of every reader with his magnificent book, *Smithsonian Trees of North America*. It will inspire people from many walks of life, including armchair ecologists, artists, gardeners, conservation advocates, hikers, and even entire families, to respect and appreciate the woody green giants with whom we share our planet. *Smithsonian Trees of North America* is written not only to educate readers about the diversity of trees that clothe our landscapes but also to invoke an understanding of their critical importance in keeping us alive. It is hard to imagine that, until the 1980s, botanists and foresters never studied the tops of trees in a comprehensive fashion. Similarly, it is amazing to recognize that no author has written such a superb and comprehensive volume on North American trees appropriate for a broad audience until this volume. Both the text and the illustrations are sure to capture any reader's sense of awe about these forests.

Like me, John had his humble scientific beginnings exploring nature as a child. Growing up among the bluffs overlooking the Mississippi River in southern Illinois and then moving to Long Island as a teenager, he was passionate about climbing trees, collecting wildflowers, and studying plants—not a conventional pathway for a male of his generation. John's childhood passion for nature led him to complete a biology major and a doctorate in botany. Whereas some botanists focus on one ecosystem or one group of plants, John became global in both his research expertise as well as his service to conservation. He went on to become one of the world's foremost botanists, traveling, studying, and sharing his knowledge of many trees, as well as some understory plants including heliconias and bananas. John and I crossed paths as pioneers in tropical botany because—in our generation—most of the world's rain forests had been relatively unexplored and unstudied as compared to their temperate counterparts. John became executive director of the Association for Tropical Biology and Conservation, and I served as his treasurer; we were fortunate to witness an exciting era unfold, watching the next generation of students enthusiastically embrace both research and conservation of tropical biodiversity, from tiny orchid bees to great kapok trees. John played a major leadership role in recruiting diverse students into our world of tropical botany. And now, as a senior scientist, he has returned to his childhood roots (no pun intended) to write about the temperate trees where he grew up!

Trees are the pillars of a healthy planet. During John's and my lifetime, almost fifty percent of primary forests (that is, big trees) have been cut, burned, cleared, and otherwise destroyed by human activities. As an arbornaut, I have become a voice for the trees, because trees cannot speak for themselves. As a gifted author, photographer and botanist, John Kress has brought the trees to your living room and your hikes into the forest. Anyone who reads this book will quickly appreciate, learn, and ultimately seek to conserve these amazing condominiums in the sky. With their enormous woody structure, trees house an estimated fifty percent of terrestrial biodiversity. They also provide us with medicines, foods, timber, shade, climate change amelioration, soil conservation, oxygen, energy production, and a spiritual heritage for over two billion people on earth who

practice religions that seek sanctuary in forests. Kress not only introduces us to over 300 trees but organizes each one so that readers are immersed in wonderful tree-biographies. Each description includes notes on identification, and sections about its use/value, ecology, vulnerability to climate change, and current conservation status. And as John's photographs reinforce, tree leaves and silhouettes are nature's finest works of art, with forests constituting one of the world's most special art galleries.

Every parent and student needs to read this book. It is a game-changer for trees, which are the stewards of our planetary health. John's words, photographs, and take-home messages serve as testimonial to these tallest of botanical gems. He has truly provided a voice for the trees through his ability to share a passion, knowledge, and urgency about protecting big trees as important neighbors and denizens on this planet. How many people ever knew that we have over 73,000 species of trees and an estimated three trillion stems? And that they are a simple yet effective solution to climate change? And that they sequester the carbon dioxide that humans pollute, and transform it into oxygen for us to breathe? And that fifty percent of our medicines had their origin in a chemical based on leaves?

As part of the forest ecosystem, trees offer sanctuary to many canopy residents, store carbon in their vast woody trunks, and produce energy in their amazingly efficient factories located in the canopy (called leaves). Despite their limitations of being rooted in one place with no ability to run from enemies, trees have strategically evolved to defend themselves through defensive thorns or toxic chemicals. I believe that everyone who reads this book will meet new friends and gain an entirely unique admiration for trees. Maybe you will become a citizen scientist in your local community, planting new stands or saving a few existing big trees from chain saws or encroaching cement? As you read these pages, you will embrace John's love for trees! You will also meet many new friends, all of which are tall, green, and extraordinary in their ability to keep our planet healthy.

Preface

Wherever you live, wherever you tramp or travel, the trees of our country are wondrously companionable, if you have a speaking acquaintance with them. When you have learned their names, they say them back to you, as you encounter them—and very much more, for they speak of your own past experience among them, and of our nation's forest life.
—Donald Culross Peattie, *A Natural History of Trees of Eastern and Central North America*

The last two years that I spent writing this book were the warmest on record for the world. Moreover, the temperatures of the past decade have been the highest the planet has experienced for thousands, if not millions, of years. Earth has entered a period quite different from what it experienced since modern human civilization began to take shape ten to twelve thousand years ago. Temperatures are changing, rainfall and drought patterns are changing, the integrity of many habitats is changing, and the distributions of species are changing. Although change is an inherent aspect of Earth, many of the current changes are a result of the activities of humans. Burning of fossil fuels, pollution, habitat destruction, overpopulation, and biodiversity exploitation are the root causes of most of these changes.

Various opinions have been expressed as to why human activities have become so destructive to our environments. One thing that is indisputable is that humans have somehow altered their relationship to Nature. The lack of respect and disregard for the natural world by a significant segment of our society has never been greater. This book is an attempt to help regain that relationship and respect.

The statement quoted above, about reacquainting ourselves with Nature, in this case trees, simply by knowing their names, was written more than fifty years ago but could not be truer and more relevant today. Donald Peattie was a forester who wrote wonderful and insightful books on the trees of America and Canada. The depth of his observations about trees and the beauty of expression in his descriptions of trees are unsurpassed. In reading Peattie's prose while watching what is happening to our planet today, I realized that at least one more attempt was needed to bring our citizens closer to Nature through a better understanding and appreciation of trees. That realization was the genesis of this volume.

Peattie and others, including my friend Dan Janzen, one of the greatest ecologists of all time, could not be more succinct in stating that the first step in respecting and getting to know a tree is to learn its name. Janzen wrote, "Imagine what it would do to any and all aspects of human interactions with wild plants if you could walk up to any plant anywhere and know in a few seconds its scientific name."[1] Knowing the name of a tree, whether it is the common name or the scientific name, is step number one in interacting with it. The name will open up an entirely new sphere of information about Nature, starting with just this one tree. Providing names for the common trees of North America was one reason for writing this book.

The second reason for this book was to instill in readers a sense of the value of trees in our everyday lives as humans and to demonstrate how trees function as part of their own forest communities, ecosystems, and the planet. Yes, trees have great economic and cultural value for us, but their role in maintaining a global environmental equilibrium is immense. As more and more carbon dioxide is pumped into the atmosphere by burning fossil fuels, the need for trees to sequester carbon dioxide from the air through photosynthesis is tremendous. In order to succeed, we need to prevent forest degradation, avoid deforestation, and promote reforestation on every continent.

Trees are not simple, inactive creatures. In order to survive as individuals and species, they must grow and they must multiply. Their structure and reproductive systems, which have evolved over the last 400 million years, are therefore complex and diverse. The third objective of this book was to give readers a basic understanding of the morphology and ecology of trees, thereby providing the means to appreciate the diversity of the dozens of species of trees that we could observe every day if we took the time.

The complexity of their structures also allows trees to inhabit a wide range of environments across the continent and globally. The multiplicity of biomes found in North America alone is often not fully appreciated. From northern boreal forests to slopes and plains of the Pacific, Atlantic, and Gulf coasts, from mountaintops to river flood plains, from mixed deciduous to evergreen coniferous forests, trees have adapted to differences in climate, elevation, water regimes, soil composition, disturbance, and diseases. No matter the characteristics of the habitat, a tree has evolved and adapted to live there.

But limits do exist. We are finding out that unique and extraordinary environmental conditions imposed by humans are affecting habitats in ways that make it more and more difficult for trees to cope with rapid changes in their environments. The vulnerability of trees and biodiversity to climate change and a host of wide-ranging impacts make it clear that some level of intervention is needed in order to conserve trees and prevent further degradation of habitats. This book is therefore a call for action in preserving our trees, conserving their habitats, and appreciating the forests.

Trees have not evolved in isolation from the insects, birds, mammals, and other species in their communities nor in isolation from other trees. All trees originated from a common ancestor that first appeared on land millions and millions of years ago. Through the process of evolution via natural selection, they diversified and spread across the continents. It is possible to trace the ancestral and contemporary patterns of relationships among trees with the help of modern genetic and genomic tools. A "natural classification," which can be constructed from these evolutionary pathways, is a concrete avenue for appreciating that all trees are directly related to each other and related to the rest of life. A central message of this book is that the names and the evolutionary classification of trees highlight their place in Nature and their position on the tree of life.

This book on trees of North America is intended for readers with some but not a lot of knowledge about botany and trees, some experience in identifying trees, and a great interest in learning more about trees. It is meant to help readers *identify trees* by giving them a name, by emphasizing their broad value, by placing them in their natural habitats, and by recognizing their evolution and place in Nature. It is more important than ever that readers are able to *identify with trees* in this global era of rapid environmental change.

white oak (*Quercus alba*)

The Essence of Trees

CHAPTER ONE
What Is a Tree?

Definition

I would bet a lot of money that everyone on Earth knows what a tree is. Definitions might differ, but no one would look at a tree and say, "What is that?" Readers may not know the species name, they may not know the common name, they may not know if it is native or exotic, they may not know how it functions, but they know it is a tree. Just to check, I asked two children ages six and nine to draw a picture of a tree (see figure 1.1). Yep, each one knew what a tree looked like, knew its various parts, and knew that other species interacted with the tree. And each child will probably value a tree in a very different way as she grows up.

Nonetheless, a quick review of the definition of a tree may be helpful for some readers. One of the simplest definitions is found in a popular book that covers the same geographic region as this volume. The author considers a tree to be a woody plant that is at least 4.5 meters tall. A more technical definition is included in one of the most comprehensive checklists of trees of the United States published by the United States government. It states, "Trees are woody plants having one erect perennial stem or trunk at least 3 inches (7.5 centimeters) in diameter at breast height (4½ feet or 1.3 meters), a more or less definitely formed crown of foliage, and a height of at least 13 feet (4 meters)." The author of the latter work prefaces his definition by admitting, "There is no uniform definition of a tree." And he qualifies his own definition by noting, "Large willows with several trunks from the same root system are accepted here as trees. Also, shrubby species that rarely or in certain localities become small trees are included." Finally, the most technical definition of a tree that has been used to assemble a recent and updated checklist of the trees of the United States and to assess their conservation status recognizes a tree as "a woody plant with usually a single stem growing to a height of at least two meters, or if multi-stemmed, then at least one vertical stem five centimeters in diameter at breast height." If you are going to follow these definitions, you had better get yourself a measuring tape.[1]

Other tree specialists provide vaguer, more general definitions, such as, "Everyone knows what a tree is: a large woody thing that provides shade." Eventually, the author of this definition relented and provided a bit more precise description similar to the government definition: "A 'tree' is defined as having a single stem more than 6 m (20 ft) tall which branches at some distance above ground, whereas a shrub has multiple stems from the ground and is less than 6 m."[2]

David Sibley, who has authored one of the most comprehensive and usable guides to the trees of North America, notes that "one could quibble endlessly over the definition of a tree," but he provides a very practical definition: "A tree is a perennial plant with a single woody stem at least a few inches thick (at about four feet from the ground), branching into a well-formed crown of foliage, and reaching a height of at least 12 or 15 or 20 feet." He also notes that "if you can walk under it, it is a tree; if you have to walk around it, it's a shrub."[3]

Finally, perhaps at the other extreme, some authors provide no definition at all. Two of the bibles for horticulturalists on trees and shrubs are *Dirr's Encyclopedia of Trees and Shrubs* and Dirr and Warren's volume *The Tree Book*.[4] Neither of these tomes provides any definition whatsoever of a tree or a shrub. These authors and their readers, like the two young artists mentioned at the start, just know what trees and shrubs are!

For this guide to the common trees of North America, no absolute definition of a tree was used to decide which species to include. In fact, any strict definition might have excluded some of the species listed here because trees can change in size and shape between habitats, over large geographical regions, and over time. Nature varies in time and space. Let it suffice that the range of definitions of a tree cited above should provide the reader with some guide as to what type of plants this book is about: Trees!

Evolution and Taxonomic Distribution

The first plants to colonize the land in the early history of life on Earth were small herbs that hugged the surface of the soil. Soon, about 30 million years

later, a vascular system was developed that allowed these early plants to transport water inside the stem so plants could grow taller. This feature evolved about 400 million years ago, at which point trees appeared and came to dominate the landscape. In the Carboniferous, 360–290 million years ago, swamps full of trees (eventually to become coal beds millions of years later) were common across the globe, but many of these trees looked nothing like the trees in our forests in North America today (see figure 1.2). These trees were not related to the conifers and flowering plants but were early relatives of lycophytes, the horsetails (e.g., *Calamites*), the clubmosses (e.g., *Lepidodendron*), and the earliest seed-bearing plants ("seed ferns" and *Cordaites*). Although these trees were up to 120 feet in height, their relatives today, the lycopodiums, are among the smallest evergreen vascular plants found on the forest floor.

Before long, about 290 million years ago, these trees that reproduced by spores gave way to primitive gymnosperms producing seeds, such as the ginkgos, and finally, around 200–150 million years ago, the pines and their modern gymnosperm relatives evolved and spread across the globe. The appearance of flowering trees in forests began in the Cretaceous about 150 million years ago but did not dominate until after the dinosaurs went extinct at the end of the Cretaceous, 65 million years ago. At that point, flowering plants in general, including herbs, lianas, shrubs, and trees, underwent a massive and explosive diversification that resulted in the plants that dominate most of our forests today.[5] During colder periods in the history of Earth, conifers dominated in polar regions, while flowering trees became the most common species in temperate and tropical zones (see figure 1.3). Now, as Earth heats up in the twenty-first century due to human-induced climate change, the conifers are migrating even farther toward the poles and up the mountainsides, as angiosperm trees opportunistically expand their ranges.

Although estimates are still in flux, botanists believe that 403,000 species of land plants (including ferns and mosses) inhabit the planet today. Of that number, 370,000 species are seed plants (gymnosperms and angiosperms), which include all of the trees on Earth.[6] It has been calculated that about 40 percent of seed plants, or 150,000 species, are trees, shrubs, and woody vines.[7] The latest estimate suggests that trees account for 73,000 species of that total, although numbers as high as 100,000 and as low as 58,497 have been cited for the number of tree species.[8] Regardless of how many there are, trees are geographically distributed on every continent except Antarctica.

The tree as a life form (compared to a shrub, liana, or herb) occurs throughout most of the major

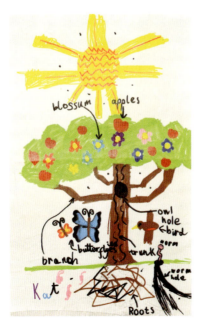
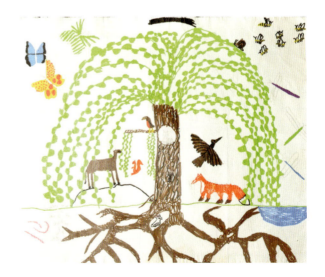

Figure 1.1. Concept of a tree. Two colorful sketches of trees by Katherine Hawksby (age six) (left) and Helena Hawksby (age nine) (right) including their own textual interpretations.

CHAPTER ONE: WHAT IS A TREE? • 3

lineages of land plants. The earliest land plants, such as the mosses, ferns, and lycophytes, are not trees in today's world, but some of the lycophytes and horsetails were trees hundreds of millions of years ago (see above), and some ferns that are currently found in tropical biomes are treelike as well (but they do not have typical wood). Within the seed plants, the gymnosperms are all woody and mostly trees, although some species can be lianas (Gnetales) and others short and shrubby in stature (Cycadales and Cupressales). In the angiosperms, trees are common except in the monocots, which are mostly herbaceous, although a few tropical groups contain treelike, or arborescent, species (e.g., the palms, pandans, and yuccas, which have a very special type of wood different from most trees). In total, fifty-two of the sixty-four taxonomic orders of flowering plants (for a list of these orders, see chapter six), or about 81 percent, include species that are trees. Twenty-six of these fifty-two orders have species that are common trees in North America. Only two rather obscure orders, which are not found in North America (Trochodendrales and Picramniales), are composed entirely of trees. Nine orders contain only woody trees and shrubs with no herbaceous species; four of these orders—the oaks (Fagales), the bladdernuts (Crossosomatales), the silktassel trees (Garryales), and the laurels (Laurales)—are found in North America and include common trees covered in this book. In summary, the vast majority of taxonomic orders as well as many large families of seed plants include trees but also shrubs, lianas, and herbs. All of these life forms appear to have evolved numerous times throughout the history of land plants.

Abundance

Not all species of trees are uniformly distributed around the world in terms of their abundance and geography. Most species of trees are relatively rare and occur in very limited geographic areas. The

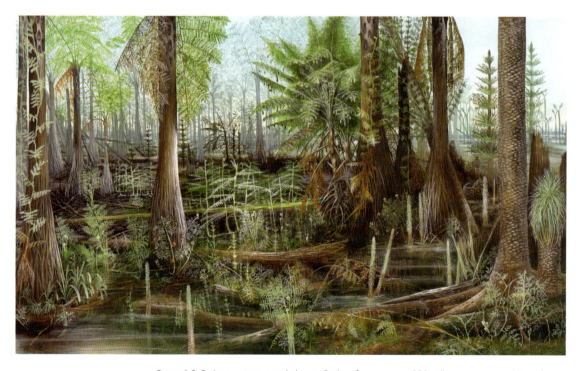

Figure 1.2. Early trees in ancient habitats. Carboniferous swamp 300 million years ago with tree-fern ancestors of marattialean ferns (*Psaronius*), treelike relatives of horsetails (such as *Calamites*), and giant quillworts (such as *Sigillaria*). Also present are the extinct seed ferns; their closest (but distant) living relatives are the cycads. (Artist's rendition.)

number of common species is much fewer than the number of rare ones, which is a general property of all species abundance distributions. But even if species of trees are rare, trees themselves as a life form are found in all fourteen of the major habitat biomes of the world. If one takes all species of trees into consideration, then the highest tree densities are found in boreal and tundra habitats, while the lowest densities occur in deserts (see figure 1.4). Intermediate levels of abundance characterize tropical, temperate, and Mediterranean forests. The latest calculations indicate that, altogether, the number of individual trees on Earth exceeds three trillion stems.[9] In the context of the total land areas of each biome type (e.g., there are more square miles of tropical forest than boreal forest), about 1.3 trillion individual trees inhabit tropical forests, 740 billion trees are found in boreal zones, and 660 billion stems are in temperate forests. The remaining 340 billion trees are scattered across deserts, mangroves, grasslands, and other habitat types.

If the global number of trees is three trillion and there are 73,000 species of trees in total, then on the average, the number of individual trees per species would be about 42,000. However, some species are rare, containing many fewer than 42,000 individuals (in North America, think about Franklinia [*Franklinia alatamaha*] from the Southeast, which is extinct in the wild), while other species are much more abundant and have many more than 42,000 stems (e.g., red maple [*Acer rubrum*], balsam fir [*Abies balsamea*], and tuliptree [*Liriodendron tulipifera*]). One can define common species of trees as those that make up a large percentage of the individual stems in a given habitat (e.g., 50 percent or 98 percent of the stems). These common species are called "dominant" or, in some cases, "hyperdominant" species, as they represent the majority of individual trees in a forest. (Note that the use of the word *dominant* is not to be confused with the silviculture term "dominant," which means the tallest tree in the canopy.) For example, it was estimated, based on a recent survey of many small tree

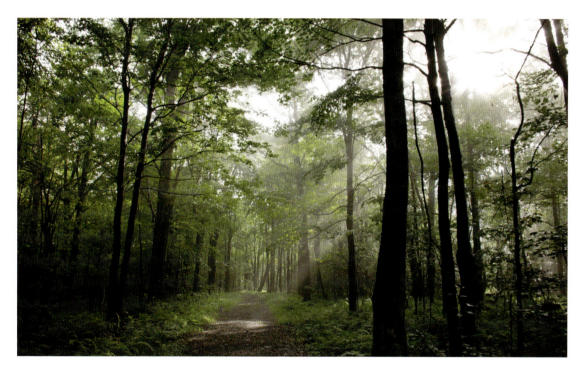

Figure 1.3. Contemporary trees in today's landscapes. Eastern deciduous forest with oaks, maples, ashes, hickories, and other broad-leaved trees.

study plots in the Amazon Basin of South America, that roughly 16,000 species of trees are present in the mixture of forest types in this region. Of those species, only 227 species, or 1.4 percent of the total, accounted for 50 percent of the individual trees present. These 227 species are the dominants, or common trees, of the forests.[10] It is astounding to think that the other 98.6 percent of the tree species in the Amazon are mostly rare. Many have not yet been discovered or described by botanists. Of course, tropical rain forests remain one of the least explored terrestrial habitats on the planet.

It is important to remember that the staggering number of individual trees found on the planet is not static. The number has changed over the last 400 million years since trees first evolved, and it is changing today. It is changing all the time. And the most critical factors affecting the current decline in number of trees are the direct and indirect effects of humans on the planet. This decline is being caused by forest degradation and destruction, tree exploitation, climate change, pollution, the introduction of invasive species, and the spread of diseases by humans. As approximately eight billion people are alive today, the ratio of trees to people is about 375 trees to every one person. Since there are so many more trees than people, one would expect that the trees would be winning. Unfortunately, that is not the case. It is estimated that over fifteen billion individual trees are lost each year due to human activities alone.[11] The number of trees on the planet ten to twelve thousand years ago, before the accelerated growth of human populations, was likely twice the number of trees existing today. Since the initiation of agriculture and the advent of civilization, humans have had a tremendous impact on tree growth and mortality, and we will continue to do so into the foreseeable future.

Our ability to monitor the extent and health of forests worldwide and the trees contained within them continues to improve as global monitoring networks expand and technologies improve. Tools, such as remote sensing and high-resolution satellite imagery, will eventually allow the mapping of every individual tree across the planet and the ability to track their changes over time.[12]

In North America (north of Mexico), the total number of tree species, both native and introduced, is much less than in the Amazon Basin. Although calculating an exact number of tree species for North America (including the United States and

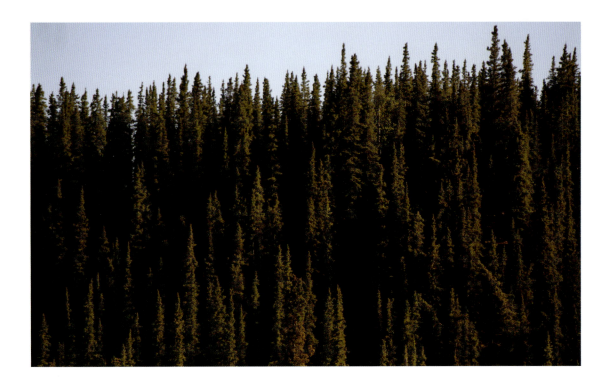

Canada) is difficult, data from the United States Department of Agriculture (PLANTS) and the Global Biodiversity Information Facility (GBIF) suggest that approximately 1,750 tree species are present.[13] Other estimates put this number at 1,432 species.[14] These estimates include many species that are known only from a limited number of cultivated and introduced trees. Accepted counts of native (and in some cases naturalized) tree species range from 748 to 1,114, with 881 species of native trees being the most recent and precise number.[15] How many of these trees are dominant or common in North America? Using data on tree abundance from the same government sources, it is possible to determine which trees are dominant and which trees are rare in North America, just as was done for the Amazon as described above. If we evaluate the commonness of a tree species at the 50 percent criterion and regardless of its status as native, introduced, naturalized, or invasive, then thirty-six species make up the most common species across North America, which equals 4 to 5 percent of the total species. If we use a criterion of 98 percent of individual trees across the continent as the definition of common, then 326 species are included. The other 425–550 species recorded for North America (depending on whose estimate of total species one accepts) make up the remaining 2 percent of the trees and are the "rare" species. The 326 species of most common trees of North America (north of Mexico) are distributed in 119 genera, forty-nine families, and twenty-six orders. These common trees, which include 280 native and 46 non-native species, are described and illustrated in this book.

Native, Introduced, and Exotic Species

The common species of trees native to North America, along with the common cultivated, naturalized, and invasive species (see figure 1.5), are included in this book. A *native* species is simply defined as one that is wild and grows naturally in the undisturbed forest vegetation of North America before the arrival of Europeans. An *introduced* species is one that was brought to North America by humans either intentionally to cultivate for some purpose or unintentionally as a weed. It is important to recognize that *cultivated* species may be native or non-native. Both types of cultivated trees may persist after cultivation

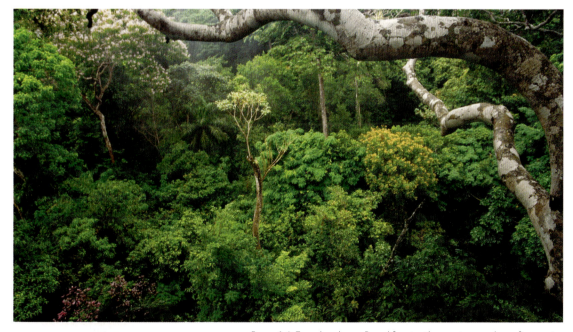

Figure 1.4. Tree abundance. Boreal forest with many trees and very few species (opposite page); tropical forest with many trees and numerous species (above).

or even escape into new habitats. A good example of a native tree that has also been widely cultivated is the black locust (*Robinia pseudoacacia*), which is native to the Appalachian and Ozark Mountains in the South and Midwest but has been planted extensively throughout the United States and is now naturalized as a "native" species. A familiar example of a non-native species that has become widely naturalized is the tree of heaven (*Ailanthus altissima*). Such *escaped* or *naturalized* tree species become common and established as though native, reproducing naturally and spreading to new habitats. If naturalized species become too aggressive and invade new habitats, ecologically displacing native species, they are often called *invasive* species (such as the tree of heaven).

Unfortunately, the terminology used for describing the origin and distribution of species is also commonly applied to the people of the planet as well, often in culturally loaded ways. Suffice it to say that no matter if we characterize a tree as native, exotic, naturalized, or invasive, as the natural world becomes more homogeneous and humans continue to accelerate the transport of species to new locations, there may not be such a thing as a native tree. Almost 15 percent of the common trees of North America included in this book did not evolve on this continent and were introduced to North America from some other part of the globe. And most are here to stay.

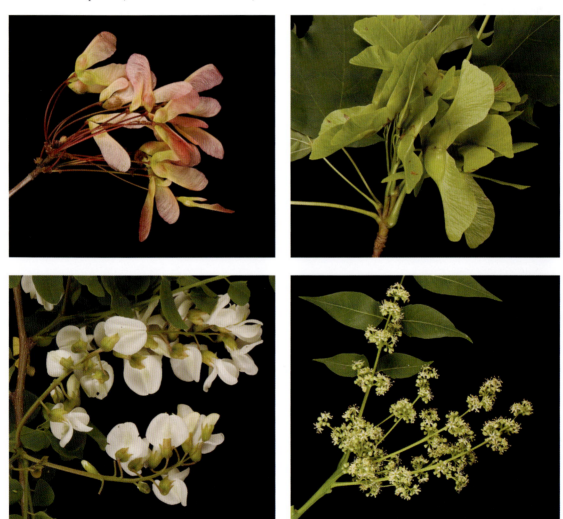

Figure 1.5. Native and exotic trees. Native red maple (*Acer rubrum*) (top left), introduced and cultivated Norway maple (*Acer platanoides*) (top right), native and cultivated black locust (*Robinia pseudoacacia*) (bottom left), and introduced and naturalized tree of heaven (*Ailanthus altissima*) (bottom right).

CHAPTER TWO
Value of Trees

Aesthetic and Cultural Value

Almost every book about trees that I have read includes at least one and often numerous quotations from philosophers, religious leaders, important teachers, poets, even politicians on the value of our arborescent neighbors. One of my favorite literary masterpieces about trees is by Gerard Manley Hopkins:

> *Binsey Poplars*
> *felled 1879*
>
> *My aspens dear, whose airy cages quelled,*
> * Quelled or quenched in leaves the leaping sun,*
> * All felled, felled, are all felled;*
> * Of a fresh and following folded rank*
> * Not spared, not one*
> * That dandled a sandalled*
> * Shadow that swam or sank*
> *On meadow & river & wind-wandering*
> *weed-winding bank.*
>
> * O if we but knew what we do*
> * When we delve or hew—*
> * Hack and rack the growing green!*
> * Since country is so tender*
> * To touch, her being só slender,*
> * That, like this sleek and seeing ball*
> * But a prick will make no eye at all,*
> * Where we, even where we mean*
> * To mend her we end her,*
> * When we hew or delve:*
> *After-comers cannot guess the beauty been.*
> *Ten or twelve, only ten or twelve*
> * Strokes of havoc unselve*
> * The sweet especial scene,*
> * Rural scene, a rural scene,*
> * Sweet especial rural scene.*
>
> —Gerard Manley Hopkins [1]

Equally moving in its own way is the song "Hickory Wind" performed by The Byrds on their album *Sweetheart of the Rodeo* from 1968 and written by Gram Parsons and Bob Buchanan. It is an ode not only to hickories, but to oaks and pines as well.

The cultural value of trees extends to all aspects of our lives. One of my colleagues, Dr. Nalini Nadkarni, has spent her life climbing trees for a living in the tropical cloud forests of Costa Rica and in the temperate rain forests of Washington State in order to learn more about how they function. She believes that trees play especially important roles not only in providing goods, shelter, and protection for people but also by improving health and healing, enhancing play and imagination, enriching spirituality and religious belief, and awakening mindfulness.[2] These activities of trees are sometimes difficult to quantify but provide untold value nonetheless.

The aesthetic value of trees, both in forests and in urban settings, is great. Since Yellowstone, the United States' first national park, was established in 1872, fifty-nine such parks are now found across our country, and numerous similar natural areas have been created around the world. As we find a growing segment of our population inhabiting urban areas, these forest parks reconnect us with Nature, and the trees remind us of our historical past connections to the open land and the woodlands. In our cities, naked concrete environments can be quickly altered by planting trees along streets, in parks, and in gardens to make links to more natural settings (see figure 2.1). Plantings of trees in cities in some cases are clearly pro forma and fail to establish the necessary aesthetic connections to Nature, but successful designs and the selection of appropriate trees will make a huge difference in the quality of life for city dwellers. The authors of one of the most important horticultural books on trees remind us that trees "can expand your sense of 'home' beyond the walls of your house. A garden invites you out, educates you, entertains you, and certainly can exercise you. A garden is a place of relaxation, peace, and beauty, where nature is brought to you rather than you traveling in search of nature."[3]

Ecological, Ecosystem, and Planetary Value

In addition to the aesthetic and cultural value to human populations, perhaps the greatest value of trees may be in natural communities, in broader landscape-scale ecosystems, and across our planet. Trees provide the foundation for all ecosystems where they occur and play key ecological roles in the functioning of forest communities. They influence water- and nutrient-cycling regimes, help determine the spatial and temporal distribution and abundance of species and individuals (both plants and animals) in the forest, facilitate recovery of communities after major disturbances, such as fire and storms, and control carbon stocks for energy recycling.[4] Enabling each of these ecological functions, as well as many more not listed here, was an invaluable service provided by trees before humans had a significant impact on ecosystems, and these functions may be even more critical now, considering the growth of human populations over the last thousand years.

With the onset and advance of the geologic era often referred to as the Anthropocene, the increase of carbon dioxide in the atmosphere and rising global temperatures have accentuated the value of trees in mitigating the effects of climate change. It is now commonly accepted that trees have the proven capacity to capture a significant percentage of carbon dioxide safely and naturally from the atmosphere and lock it up in ecosystems for years to come.[5] Because of rampant deforestation over the past centuries and skyrocketing fossil-fuel combustion, however, the planet currently does not have enough trees to alter this carbon balance in a substantial way. To succeed, an accelerated and long-term effort to plant trees and reforest the planet is needed. Recent studies suggest that increasing the number of trees on the planet by about a trillion individuals over time could remove more than two-thirds of the carbon that humans have added to the atmosphere since the industrial revolution.[6] The value of trees in addressing the biggest global challenge of this century, therefore, is immense.

Scientists have also pointed out that this reforestation effort is not just a simple exercise of planting a trillion pines or a trillion eucalyptus trees in a uniform fashion across the globe. In fact, plantations of monoculture trees would not do the job and may even hinder the process. What is needed is a concerted effort to regenerate natural forests and allow previously disturbed and degraded forests and lands to recover their natural ability to sequester carbon (see figure 2.2). This regeneration must take place across the Temperate Zone, the subtropics, and the tropical regions of the planet. It must be global. Natural forests can be up to forty times better than plantations in solving the carbon dioxide problem we

Figure 2.1. Aesthetic value. Trees are integral to contemplative garden settings, public parks, and arboreta at all times of the year. The Arnold Arboretum of Harvard University at different times of the year.

have created. And these natural forests will also serve to enhance and conserve other species, improve water quality, reduce erosion, and improve the well-being of local human populations.[7]

And trees can contribute to a resilient and rich environment in more than just forested habitats: Trees in cities provide some of the same ecological functions as trees in natural forest ecosystems—absorbing excess nutrients that accumulate from runoff, reducing heat buildup in heavy concrete areas, controlling erosion along urban waterways, moderating water and air pollution, providing habitat for wildlife, and also converting carbon dioxide in the atmosphere to stored biomass.[8] Trees can make cities and the planet more livable. They are invaluable.

Economic Value

Finally, it is impossible to miss the economic importance of trees, and especially of the wood that trees provide, in our everyday lives (see figure 2.3). According to the GlobalTree Assessment, the most common uses for trees (in order of the number of tree species employed) are construction, medicines, horticulture, fuel, human food, and household goods.[9] One can confirm this list in a brief walk through a local supermarket or shopping mall, where you will see products made of solid wood (building supplies, firewood, baseball bats, ladders, and crutches), wood pulp and paper (grocery bags, candy wrappers, diapers, books, magazines, newspapers, and milk cartons), and tree compounds (cosmetics, ice cream thickeners, medicines, shampoo, toothpaste, and vitamins). And do not forget maple syrup, wine corks, chopsticks, spices, and perfumes.[10] The list is really endless. Plastics and synthetics are now replacing some tree products for many of these objects, but these replacement substances are unfortunately not renewable and, in many cases, make up the bulk of our landfills. Wood is easily biodegradable, and trees can be replanted for an ever-replenishing source of material.

Yet trees and the products they provide to us are not unlimited. The finite nature of trees and forests became very clear to North Americans in the decades after colonization.[11] From Europeans' first encounters with the great forests of North America in the seventeenth and eighteenth centuries, the monetary value of trees rang true. Landing in an unfamiliar setting, the early settlers at first faced the dense coniferous and hardwood forests of New England. The colonists were threatened and intimidated by the unknowns that awaited within the forests' interior. Despite such fears, these pioneers pushed for new land to grow crops and quickly began to clear the trees. Since European lands were largely deforested and nations such as Britain and France were striving to be the

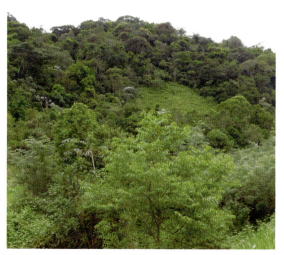

Figure 2.2. Ecological value. Regenerating forests, especially in the tropics (left), are much more effective at removing carbon from the atmosphere than forest plantations and monocultures (right).

dominant naval power, the trees of North America became a huge commodity for the growing population. For example, the construction of a single naval ship in the early 1800s required nearly six thousand trees; eastern white pine (*Pinus strobus*) was perfectly suited for the ships' tall masts (see figure 2.4). In New England alone, where 98 percent of the forests were standing before the first Europeans arrived on the continent, 75 percent of the trees were removed for shipbuilding, charcoal production, and agricultural land by the middle of the nineteenth century. The value of trees was clearly recognized, and this natural resource was overexploited and quickly depleted. Henry David Thoreau could not have been more insightful when he wrote in his 1864 book *The Maine Woods*:

> *Strange that so few ever come to the woods to see how the pine tree lives and grows and spires, lifting its evergreen arms to the light,—to see its perfect success; but most are content to behold it in the shape of many broad boards brought to market, and deem that its true success!*[12]

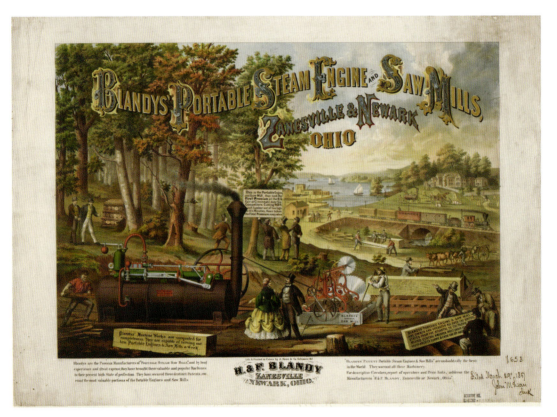

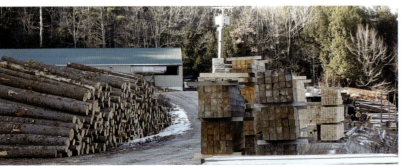

Figure 2.3. Economic value. An advertisement for a portable sawmill in Ohio in the 1860s (above) and a local sawmill and lumber yard in New Hampshire today (left).

Two recent novels, *Barkskins* by Annie Proulx and *The Overstory* by Richard Powers, document the history of North American trees at the hands of such early American entrepreneurs.[13] Yet despite all of the exploitation of forests and trees in the nineteenth century, today over 70 percent of the land in New England is once again forested.[14]

To this day in many cases, trees continue to be reduced to a monetary equivalence. Our privately owned property, state parks, and national forests are under ever-increasing threats to be converted into clear-cut, deforested lands by some sectors of the timber industry and the government. However, in the United States many believe that foresters and the practice of good forestry have served to conserve our forest resources compared to their trajectory prior to the establishment of the United States Forest Service and forestry as a profession in North America in the early 1900s. Some ecologists will disagree with this statement, arguing that sustainable, good-practice forestry remains more myth than reality and that foresters often have ignored good science in forest management. Nonetheless, in most of the world today, development and conversion to agriculture

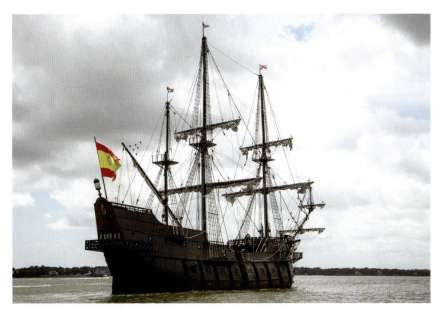

Figure 2.4. Economic value. Each nineteenth-century wooden naval sailing ship (modern replica shown here) required thousands of trees to build and equip.

Figure 2.5. Environmental value. Street trees in urban environments are highly valued for removing pollutants from the air and increasing public well-being. Magnolias along Commonwealth Avenue in Boston, MA (bottom left). Live oaks lining a street in Tallahassee, FL (bottom right).

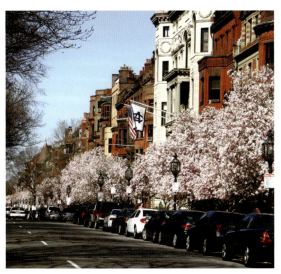
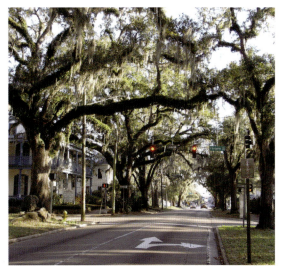

are the biggest threat to trees.[15] The realization that forests and the supply of trees are not infinite has also resulted in the consciousness that a sustainable plan for maintaining populations of trees requires new policies and incentives to preserve, regrow, manage, and protect our forests, not only in North America but around the world.[16]

The monetary worth of trees is not restricted to the trees in our natural forests and rural plantations. Even in cities, where the aesthetic and cultural value of trees is exceedingly important to ensure a high quality of life, the dollar value of trees is on every politician's mind.[17] In the largest cities of North America, such as Chicago, New York, and Los Angeles, assessors have calculated an exact dollar amount for each urban tree based on how much carbon monoxide, sulfur dioxide, nitrogen dioxide, ozone, and particulate matter it removes from the air and how much carbon it sequesters (see figure 2.5). Moreover, the monetary value of trees' reduction of air-conditioning costs and enhancement of storm-water removal, as well as the benefits associated with higher property values, reduced levels of human stress, and improved human health, is now routinely estimated. The collective worth of an urban tree was calculated a decade ago at $47.63 per tree, $90 per tree, $209 per tree, and even as high as $402 per tree, depending on the location. This monetary value, which also includes the cost of tree removal, has been used to justify why city planners need to allocate funds for the planting and maintenance of trees in urban environments. You can even calculate the monetary value as well as other ecological benefits of your own trees using the on-line tool *MyTree* produced through a partnership between the United States Department of Agriculture and Davey Tree Expert Company with the support of others.[18]

Yes, trees are invaluable.

CHAPTER THREE
Structure and Reproduction

Understanding how trees are built and how they function provides a foundation for appreciating their value and identifying them correctly. Entire books are written on how trees work, and the reader is referred to the works cited and further readings for sources of more in-depth information about tree morphology and function.[1] To increase comprehension of the lives of trees, basic background information is offered here on the structure, reproduction, and ecology of trees, including terminology. The details will also assist in making accurate identifications of the common trees of North America.[2]

Structure and Morphology

Trees, like all plants (and all organisms!), basically do two things: they grow and they multiply. If they do not succeed in either one of these activities, then the individual tree will eventually die or the species will go extinct. *Vegetative structures* that make up a tree, including the roots, wood, trunk, bark, twigs, and leaves, have evolved over time to promote and sustain growth. They are tasked with supporting and protecting the tree, as well as optimizing photosynthesis and allowing the tree to compete effectively with other trees and organisms in the surrounding forest. *Reproductive structures*, such as cones, flowers, fruits, and seeds, are in charge of multiplication. Their role is not only to propagate the tree by producing offspring but also to promote adaptation to changing environmental conditions over time by increasing genetic variation in the offspring and future generations. Growth and reproduction are the drivers of innovation and evolution in trees.

Vegetative Structures

Roots hold the tree to the ground and prevent it from toppling over. Equally if not more importantly, they

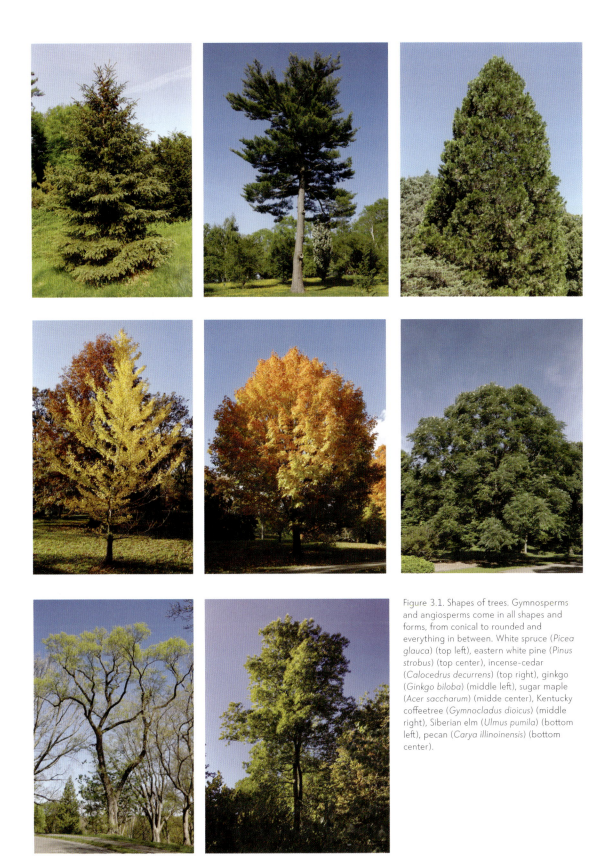

Figure 3.1. Shapes of trees. Gymnosperms and angiosperms come in all shapes and forms, from conical to rounded and everything in between. White spruce (*Picea glauca*) (top left), eastern white pine (*Pinus strobus*) (top center), incense-cedar (*Calocedrus decurrens*) (top right), ginkgo (*Ginkgo biloba*) (middle left), sugar maple (*Acer saccharum*) (midde center), Kentucky coffeetree (*Gymnocladus dioicus*) (middle right), Siberian elm (*Ulmus pumila*) (bottom left), pecan (*Carya illinoinensis*) (bottom center).

provide the tree with soil nutrients and water, which are essential for growth. To perform both of these functions, the branching network of underground roots of most trees covers a wide area at least as big as the tree's crown, though usually shallower and much wider. It is common for the root networks of adjacent trees in a forest to overlap and commingle within the soils beneath the trees. The roots in general do not function alone in absorbing water and nutrients but rely on a mutualistic relationship with soil fungi, called mycorrhizae, which increase the capacity and efficiency of water and nutrient uptake by the tree. Perhaps 90 percent or more of trees have such interactions with soil fungi, allowing for the effective establishment of a tree from seedling stage to mature form, often in less than optimal habitats. Roots and their fungal-enhanced networks are the structures of the tree that link it to the neighboring forest.[3] Most roots are not easy to recognize as belonging to a particular species of tree except in their genetic DNA signature and hence are not useful in tree identification.

Douglas-fir
(*Pseudotsuga menziesii*)

redwood
(*Sequoia sempervirens*)

western redcedar
(*Thuja plicata*)

American sycamore
(*Platanus occidentalis*)

sugar maple
(*Acer saccharum*)

yellow birch
(*Betula alleghaniensis*)

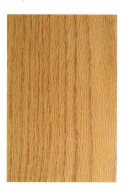
red oak
(*Quercus rubra*)

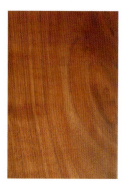
black walnut
(*Juglans nigra*)

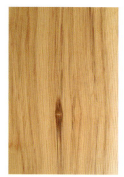
bitternut hickory
(*Carya cordiformis*)

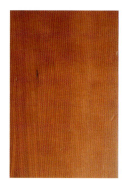
black cherry
(*Prunus serotina*)

Figure 3.2. Wood. Each of these ten commercially important common trees differs in its texture, grain, color, and density.

The roots secure the water and nutrients that flow from the soil up through the trunk and into the branches, which, taken together, form the crown of a tree. It is in this crown, in the thick covering of green leaves that are clustered usually at the ends of twigs, where photosynthesis takes place. As discussed earlier, a tree may be defined as having a single, often stout trunk supporting the crown. Shrubs more often are smaller, with multiple, slenderer stems. However, some trees can form branches near the ground and appear to have multiple trunks as well. It is the relationship and proportion of the trunk(s) to the crown that give species of trees their characteristic shape and form (see figure 3.1). Trees that grow faster at the top than on the side branches, including many conifers, such as fir and spruce, often have a conical shape. Other trees that have relatively equal rates of growth along the sides and at the top, as oaks and maples do, tend to be more rounded in appearance. However, the shape of any single individual tree is highly dependent on its age (younger trees are often narrower and older trees broader) and on immediate environmental conditions (trees growing in shade are usually narrower and more asymmetrical, while trees growing in open sunlight are fuller and broader). The form of any tree is dependent on both its genetic heritage and its immediate environment. The age and lifespan of a tree are also affected by genes and habitat. Some species of trees are known for their ability to attain great age, but harsh environmental conditions and weather events can greatly affect the longevity of an individual tree.

Wood and bark form the core body of a tree (see figure 3.2). The wood serves as a conduit for water and nutrients to travel upward from the roots to the leaves for photosynthesis and for sugars to travel downward for growth and maintenance. This transport takes place in the sapwood, which is the outermost layer of the trunk and generally is lighter in color. During the growing season of a tree, a lighter and faster-growing layer of the wood is followed by a slower-growing, denser, and hence darker layer of growth. Together, these lighter and darker layers make up annual growth rings, which can be counted in a cross section of the trunk to determine the age of a tree. One of the characteristics of trees in tropical zones, where seasons are less pronounced and where growth is continuous, is that the growth rings typical of temperate trees are absent.

Bark is the true protector of the woody transport system of the tree. Bark can take many different forms

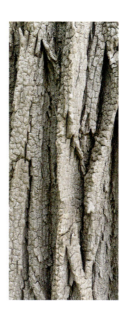

Figure 3.3. Bark (left to right): **smooth** American beech (*Fagus grandifolia*); **shaggy** shagbark hickory (*Carya ovata*); **ridged** black locust (*Robina pseudoacacia*); **striated** striped maple (*Acer pensylvanicum*).

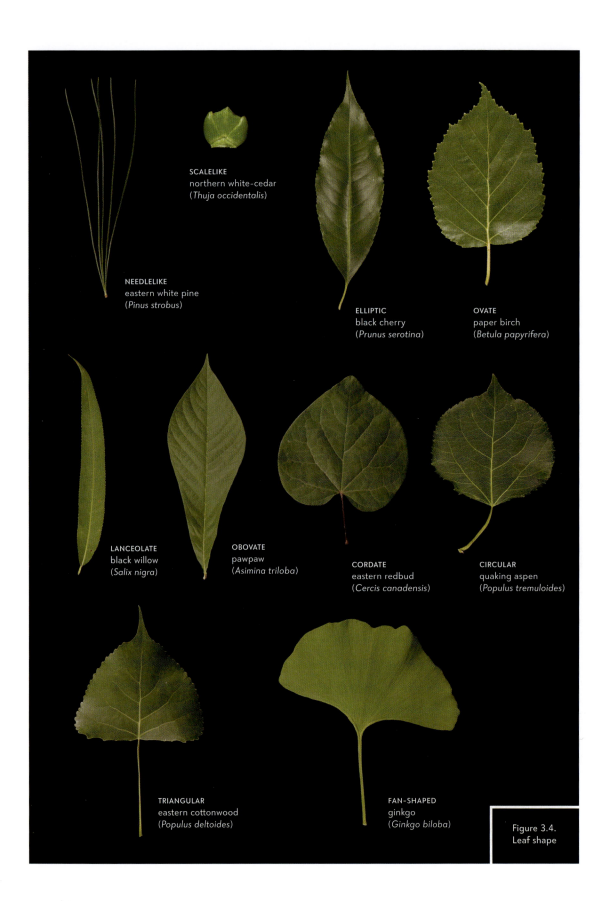

Figure 3.4. Leaf shape

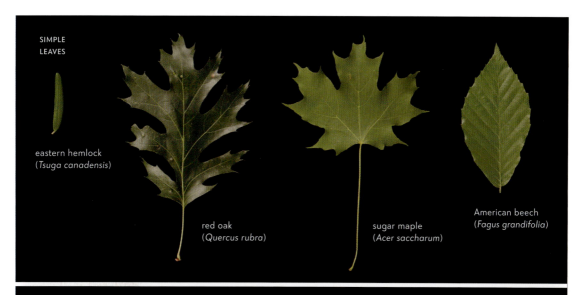
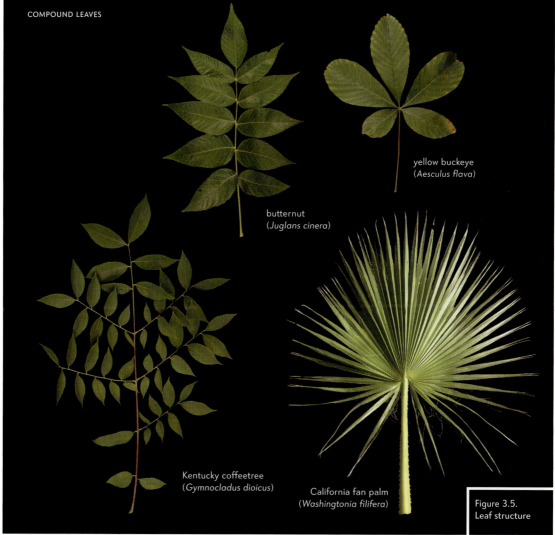

Figure 3.5. Leaf structure

in texture and color, such as smooth, flaky, gnarly, corky, papery, and fibrous, and these characteristics are often distinctive for a species (see figure 3.3). For example, the smooth gray bark of American beech (*Fagus grandifolia*) is readily distinguished from the darker, shaggy and curling, layered bark of shagbark hickory (*Carya ovata*). Yet the bark can readily vary in its basic characteristics depending on the age of the tree and the habitat where the tree is growing. Whatever form the bark takes in a particular species, it protects the tree from fire, from insect pests, and from gnawing mammals while at the same time sealing the trunk against loss of water and sap as these vital fluids move up and down the tree. This function is fundamental and indispensable to the growth of the tree.

When spring arrives in North America, the real action in a tree that has been dormant for most of winter is at the tips of the branches. It is there that the twigs, which have been establishing and protecting leaf buds and flower buds that were initiated the previous summer, spring into action and utilize the fluids that the roots and wood have been sending upward. When the weather conditions are right, these buds, which are enveloped in protective leaflike scales, "burst," and the leaves and flowers begin to expand and develop. The color and texture of the twigs, the shape and features of the scars left by the previous year's leaves (called leaf scars), and the orientation, size, and shape of the buds and their scales can be diagnostic for many species of trees.[4] Various sharp-pointed growths on twigs, such as thorns (modified

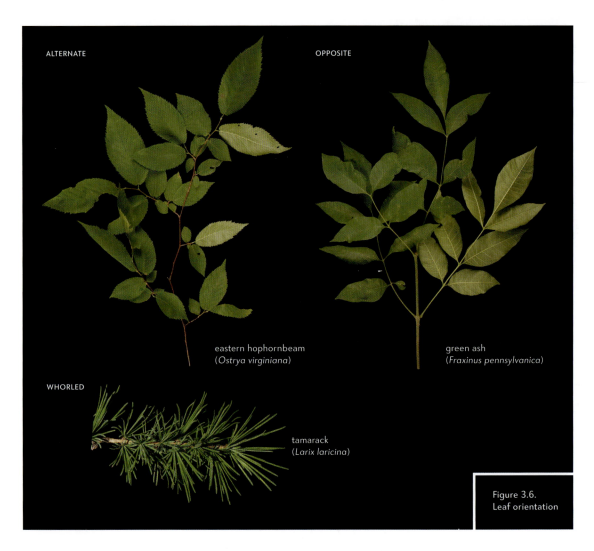

Figure 3.6. Leaf orientation

lateral twigs), spines (modified leaves), and prickles (outgrowths of the bark), have evolved to defend the buds from attackers, but they also provide important identifying features on the twigs.

If twigs and buds are where growth starts in spring, then the leaves are where it is all happening in summer and early fall. Although it may be hard to believe, the basis of almost all life on planet Earth comes from three simple things: air, water, and sunlight. A process called photosynthesis, which takes place in the green leaves of trees and other plants, takes carbon dioxide from the air and, using energy from the sun, combines it with water molecules (plus some nutrients absorbed by the roots) to form sugars. These sugars are then transported around the tree as a source of energy for the tree and are also eventually consumed by other members of the biological community, whether they are insect herbivores chewing on the leaves, pollinating birds gathering nectar from flowers, mammals hoarding acorns, or fungi exchanging nutrients with the roots. The leaves with their green chlorophyll-rich cells are where the energy that drives our living world is harnessed, mobilized, and dispersed.

The leaves of the trees of North America are remarkably diverse in their orientation, structure, shape, ornamentation, and color. And if one includes all trees of the world, including those in tropical regions, the variation in size and shape of leaves is tremendous. This variation makes leaves indispensable, although not foolproof, for species identification. Strangely enough, though, these traits, which are so important for field identification of trees, do not prove especially useful for the classification of plants. Carl Linnaeus, a Swedish botanist who proposed one of the earliest classifications of plants in 1753, realized that the characteristics of flowers were much better and more reliable than vegetative features for correctly ordering plants in a usable classification. He also used a two-word Latin botanical name for each species consisting of the genus name followed by a specific epithet, together called the binomial. These binomials are universal names for species and persist in use to this day.

Each leaf is composed of two parts: the blade, which is generally a flattened photosynthetic tissue, and the stalk-like petiole, which attaches the blade to the twig. Leaves can be scalelike or needlelike, as in most conifers, or flattened and broad, as in flowering trees (see figure 3.4). The most basic structure of a leaf with a petiole and a blade can be easily transformed through the process of evolution into a much more complicated organ as the blade becomes modified in shape, size, texture, and color. A simple leaf with an undivided blade becomes a compound leaf when the blade is deeply divided to the midrib, forming multiple parallel leaflets, called a pinnately compound leaf (see figure 3.5). These leaflets can divide again, forming a bipinnately compound leaf, or a third time, resulting in a tripinnately compound leaf. Most of the common trees of North America have simple leaves, but some possess highly divided compound leaves. Look closely at the compound leaves of the Kentucky coffeetree (*Gymnocladus dioicus*) or devil's walking stick (*Aralia spinosa*) to see if you can determine what is a branch, what is a leaf, and what is a leaflet (see description and photographs of this species on page 730). The limited number of palm trees in North America all have compound leaves, or "palm fronds," that can be pinnately arranged, as in the date palm (*Phoenix canariensis*), or palmately arranged if all the leaflets connect to a central point on the midrib, as in the cabbage palm (*Sabal palmetto*).

Leaves, whether they are simple or compound, are arranged along the stem in a specific way depending on the particular species (see figure 3.6). They can be opposite each other at a node on the twig, or they can be arranged in an alternate pattern along the twig. If there are more than two leaves in a cluster at a node, then the leaves are whorled. If the leaves remain on the tree for more than a year, then the tree is evergreen; if they fall from the tree at the end of the growing season, then the tree is deciduous. The shapes of leaves can range from undivided round or ovate in form to slightly or highly lobed (see above). The margins of the leaves or leaflets can be smooth or toothed to varying degrees. And the tips and bases of leaves take on all kinds of shapes and orientations. All of these features allow for numerous combinations that enable accurate identifications of trees based on their leaves alone. The highly successful smartphone app called *Leafsnap* (described in chapter five) based

its automatic identification of 220 species of North American trees simply on the shapes of the leaves.

It should not be forgotten that all of the modifications that facilitate our ability to identify leaves are ultimately focused on enhancing and protecting the photosynthetic capacity of the green energy machines situated at the tips of the branches. Whether it be highly lobed simple blades or finely dissected pinnately compound leaves or double-toothed margins of blades or a fine covering of hairs on the undersides of the blades, these modifications evolved to maximize the ability of leaves to photosynthesize and provide energy to the tree for growth and reproduction.

Reproductive Structures

The common trees of North America include both gymnosperms and angiosperms. These two major groups of trees sexually reproduce, genetically multiply, and vegetatively replicate in different ways. The gymnosperms evolved earlier than the angiosperms and in North America are primarily represented by conifers, which produce their male and female gametes in cones. The cones for each sex are usually quite different (see figure 3.7). The pollen-bearing cones are small, inconspicuous, and ephemeral, while the ovule-bearing cones are larger and often woody (as in pines), though sometimes fleshy (as in junipers), and persist on the trees for much longer periods, sometimes for years. In most conifers, both male and female cones are produced on the same individual trees, a condition called monoecy. If they are produced on different individuals, the condition is called dioecy (which is also found in some flowering trees). The cones are made up of a central axis and numerous scales up and down the axis, each of which contains either ovules or sacs of pollen. The seeds are produced by the ovules after fertilization and are protected by the woody scales while they develop. The variation in shape, color, size, and persistence of the female cones all provide identifying characteristics for species of gymnosperms.

The evolution of the flower, which originated 150 million years ago, was an important innovation

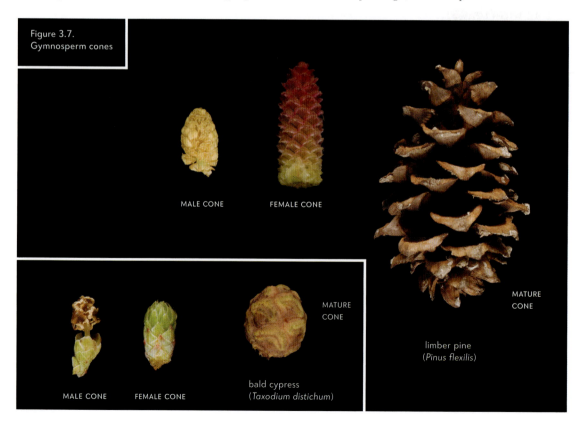

Figure 3.7. Gymnosperm cones

22 • THE ESSENCE OF TREES

in plants and resulted in a great diversification of species across Earth starting around 65 million years ago. Unlike the gymnosperms, which possess in their cones an exposed ovule in the axil of a scale, flowering plants have their ovules enclosed and protected inside a structure called an ovary, which eventually becomes the fruit. A standard flower is composed of an outer whorl of modified leaves called sepals, inside of which is a whorl of petals, which in turn enclose the stamens, which produce the pollen, and finally at the very center of the flower is the pistil, which includes the ovaries and ovules. The process of evolution has highly modified each of the four parts of the basic flower over time to produce the great variety of colors and forms found in flowering plants today (see figure 3.8).

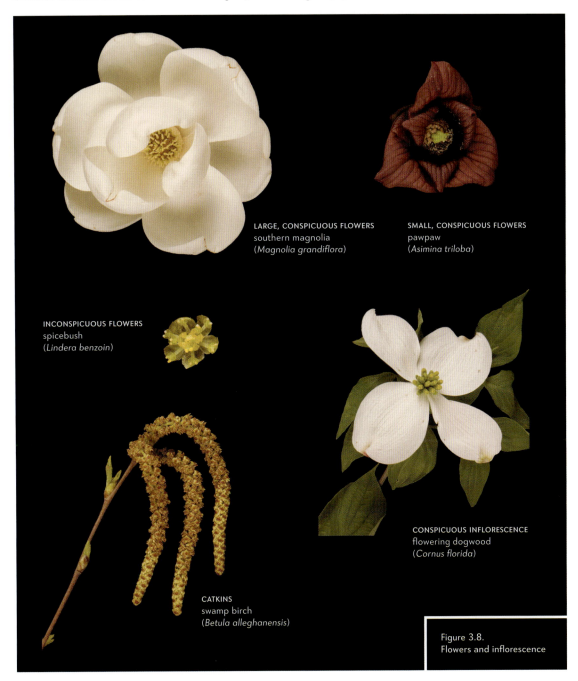

LARGE, CONSPICUOUS FLOWERS
southern magnolia
(*Magnolia grandiflora*)

SMALL, CONSPICUOUS FLOWERS
pawpaw
(*Asimina triloba*)

INCONSPICUOUS FLOWERS
spicebush
(*Lindera benzoin*)

CATKINS
swamp birch
(*Betula alleghanensis*)

CONSPICUOUS INFLORESCENCE
flowering dogwood
(*Cornus florida*)

Figure 3.8.
Flowers and inflorescence

CHAPTER THREE: STRUCTURE AND REPRODUCTION • 23

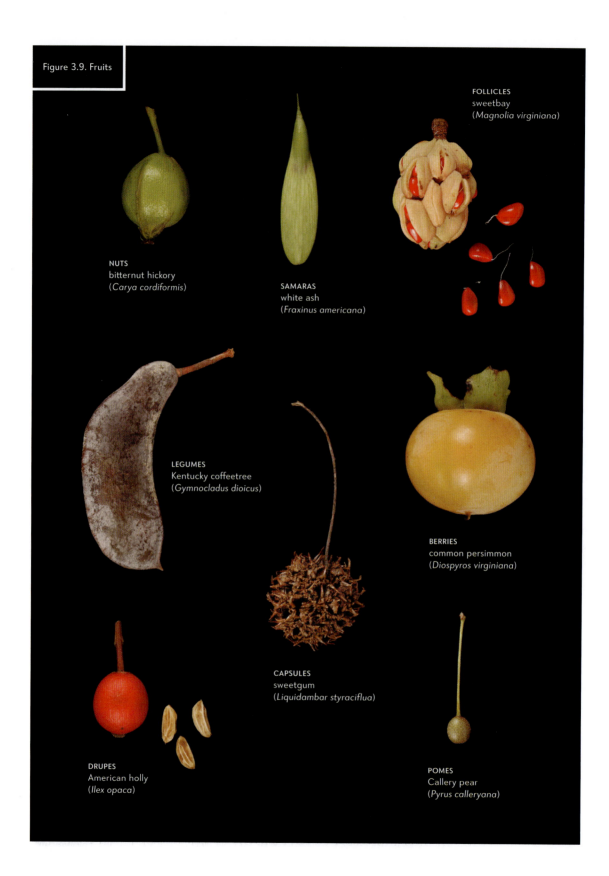

Figure 3.9. Fruits

Flowers can be bisexual, meaning both female and male organs are together in the same flower ("perfect" flowers), or unisexual, with male and female parts in separate flowers on the same plant (monoecy) or on separate plants (dioecy). The petals and sepals are often very elaborate, conspicuous, and colorful and therefore instrumental in the attraction of animal pollinators (as on magnolias, apples, and catalpas), or they can be small, inconspicuous, numerous, and wind pollinated (as on birches, poplars, and oaks), or they can fall somewhere between conspicuous and inconspicuous (as on maples and spice bush). For efficient pollen dispersal and transfer by pollinators, the flowers can be arranged as single individuals scattered throughout the crown of a tree (e.g., tuliptrees) or in large aggregates or clusters, called an inflorescence (e.g., sumacs and horse chestnuts). The number of stamens, which produce the pollen, in a flower varies greatly from just a few in animal-pollinated flowers to sometimes many in wind-pollinated species. The same is true of the pistil, which can be made up of one to several carpels. The number of carpels and their arrangement within the pistil determine the type of fruit that is produced by the flower following pollination. As summarized here, there are many forms of flowers in the angiosperms; each has significantly different properties and morphologies, and each has varying levels of success transferring pollen and producing fruit. The number and quality of seeds produced as a result of flower form and effective pollination is the name of the evolutionary game for trees.

If the diversity of flowers is not enough to complicate the identification of trees, then the variation in fruits among the angiosperms may be overwhelming (see figure 3.9). Numerous botanical terms have been given to types of fruits, such as nuts, achenes, samaras, pods, follicles, legumes, capsules, berries, drupes, and pomes, to name a few. To understand the diversity of fruits in a simpler way, think of flowering plants producing either dry or fleshy fruits. If the fruits are dry, then they can be indehiscent and never break apart (e.g., nuts and capsules), or they can be dehiscent and split apart in various fashions (e.g., legumes and follicles). If they are fleshy, then the ovary and other parts of the flower become succulent at maturity and contain either numerous seeds (then it is a berry or a pome) or only a single seed (then it is a drupe). Although botanists have tried to categorize the types of fruit that are found in angiosperms precisely, many intermediates exist, and some defy being categorized. Nonetheless, the many traits of fruits, whether they be the dry samaras of maples or the fleshy berries of persimmons, are usually diagnostic for identifying species of trees. More importantly, they are essential for the successful multiplication and dispersal of the propagules of trees by wind, water, or animals to new and distant habitats.

Reproduction

Flower Pollination and Fruit Dispersal

The myriad vegetative structures that make up a tree are oriented and optimized to enhance the growth, development, and asexual reproduction of that tree. These growth features are mirrored by a diversity and complexity of floral and fruit characteristics that are aimed solely at sexually producing offspring and multiplying the tree. Growth depends primarily on external factors, such as sunlight, water, air, soil, and fungi. Sexual reproduction also depends on external factors, including flower pollinators and fruit dispersers (see figures 3.10 - 3.11). In trees, especially trees found in temperate and boreal regions, external non-living or abiotic factors, such as wind and water, play a central role as vectors in the transport of pollen both within flowers and between flowers and as dispersal agents of the fruits. Pines, oaks, birches, hickories, and their close relatives are all dependent on wind in spring to carry the pollen from cone to cone or from flower to flower among trees. These trees tend to have small, numerous, highly exposed cones and flowers, often clustered in dangling inflorescences or aments at the ends of branches; these wind-pollinated structures function in the early spring before the leaves appear. In fall and winter, pines, maples, elms, willows, alders, birches, ashes, and some of their relatives rely on the wind and gravity to disperse their dry and usually winged seeds away from the parent tree. This dispersal can

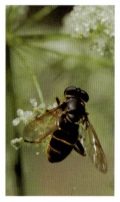
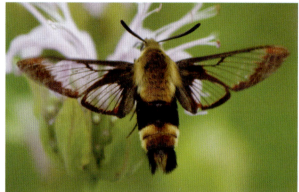
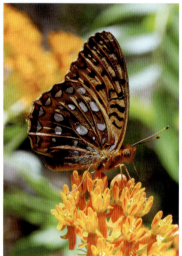
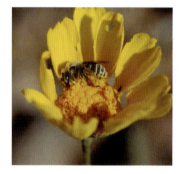

Figure 3.10. Flower pollinators of trees. Wind is a significant pollen vector of many species of common trees. The major animal pollinators include beetles, flies, moths, butterflies, bees, and hummingbirds.

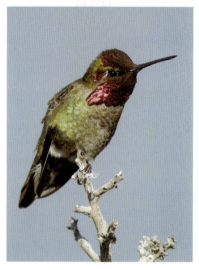

occur either while the leaves are still on the trees or, more commonly, after the leaves have fallen. The dependence on wind to disperse pollen and fruits is found in many trees in the gymnosperms and the angiosperms and has evolved numerous times.

Yet many trees, both in temperate forests and more commonly tropical forests, have come to rely not on wind, but on various types of animals as vectors for carrying pollen and dispersing fruits. To get the animals to do their bidding, trees must first attract the animals to the flowers or fruits, then reward them for their services. It is this need to attract and reward that is most responsible for the great variation in flower and fruit structures described earlier. Insects are the most common pollen vector in both the Temperate Zone and the tropics. The major types of insects that are known to pollinate trees are beetles (which pollinate pawpaws and magnolias), flies (they pollinate dogwoods), moths (they pollinate yuccas), butterflies (they pollinate California buckeye), and bees (which pollinate many trees, including cabbage palms, sumacs, lindens, cherries, and haws). Other insects have also been demonstrated to be pollinators of trees and herbs as well. Flower visitors are attracted to the plants by various color patterns on the petals and floral parts. In addition, the strong or even not-so-strong odors and fragrances produced by some flowers are similarly important attractants for insect visitors. Once at the flowers, the insects are rewarded with either nectar or pollen or, in some cases, the fragrance itself, as payment for visiting and pollinating the flowers. Though not common in Temperate Zone trees, some flowers in the tropics can actually trick the insects into visiting the flowers and provide no reward whatsoever.

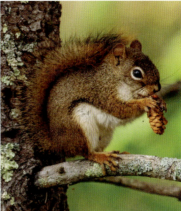
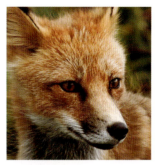

Figure 3.11. Fruit and seed dispersers of trees. The many animals that eat and disperse fruits and seeds of common trees include birds, squirrels, foxes, and raccoons. Wind, water, and gravity also disperse some propagules.

Other animals that are known to pollinate trees include birds (such as hummingbirds, honeycreepers, and honeyeaters), bats, and non-flying mammals (such as marsupials, lemurs, and primates). Yet all of these larger animals, except for some birds, are not present as pollinators of North American trees. Just as in the insects, each type of large animal has specific floral cues and rewards that have evolved to attract and compensate them for their service to the plants. Hummingbirds specialize on brightly colored, usually red, tubular flowers that have little or no fragrance and plentiful nectar. In North America, they are known to visit and pollinate a number of cultivated ornamental trees as well as several native species, such as the trumpet creeper (*Campsis radicans*). In the deserts of the southwestern United States, white-winged doves are highly dependent specialist pollinators of the saguaro cactus, which has large tubular flowers producing copious nectar. If trees were pollinated by bats or non-flying mammals in North America, they would have large, dull-colored flowers that open in the night, produce a rather unpleasant odor, and be rich with pollen and nectar. All of these features are found in tropical trees pollinated by these animals; there are no known bat-pollinated trees in the Temperate Zone.

All of the fleshy fruits and even some of the dry fruits produced by trees in North America are eaten and dispersed by animals. Birds and rodents are the prime dispersal agents of most of the brightly colored, especially red, fruits produced by members of the rose family, the dogwoods, and viburnums. Some of the fruits that are not brightly colored themselves (e.g., the magnolias) will have a red fleshy aril surrounding the seeds that serves as an attractant and reward for their bird dispersers. Other fleshy fruits are dispersed by raccoons, foxes, and even bears. Rodents and squirrels are perhaps the most important fruit dispersers, but they also consume the hard nuts produced by walnuts, hickories, and oaks. In some cases, for species of trees that grow in aquatic habitats, such as water tupelo (*Nyssa aquatica*) and overcup oak (*Quercus lyrata*), their propagules may be dispersed by water and flooding. These important and critical interactions between the trees and the animals that pollinate their flowers and disperse their fruits and seeds are the glue that holds together these forest communities.

Vegetative Reproduction

North American trees sexually reproduce via flowers, fruits, cones, and seeds. In turn, they vegetatively reproduce by the multiplication of sprouts from seedlings, trunks, branches, and roots. These vegetative offspring differ from the offspring resulting from sexual reproduction in that they are for the most part genetically identical to the parent plant. Such sprouts are produced as a response to stressful conditions experienced by the young tree (seedling and sapling sprouts), as a response to injury or damage to the parent tree (trunk sprouts), and as an attempt to expand the spatial footprint of the individual tree into new territory (root sprouts and branch layering).[5]

When stressful and harsh conditions occur due to desiccation, grazing by insects and animals, and unusual breaks in the canopy, seedlings and saplings of most species of temperate trees, especially flowering plants, will readily produce sprouts that greatly enhance their survival capabilities at this early life stage. The formation of trunk sprouts in adult trees (sometimes called "collar sprouts" because they originate from the collar of the trunk just above where it intersects with the roots) is usually a reaction to severe damage to the parent tree and is common in many species of temperate angiosperms. The sprouts form from suppressed buds at the base of the trunk that lie dormant for many years until the injury occurs. Trunk sprouts are rarely found in conifers.

Root sprouts (or root "suckers") promote the colonization of an individual tree into a wider ecological space; the sprouts extend the tree laterally rather than vertically. They also form from suppressed buds found on underground roots and sprout as part of the normal growth habit of up to a quarter of temperate species of trees. Trees such as sassafras (*Sassafras albidum*), quaking aspen (*Populus tremuloides*), staghorn sumac (*Rhus typhina*), and slippery elm (*Ulmus rubra*) are some species that produce root sprouts.

It is not infrequent in many species of trees growing in exposed, sunny habitats with somewhat harsh environmental conditions for the lowermost branches that come into contact with moist soils to produce adventitious roots at their nodes (sometimes called "branch layering"). When the opportunity arises, these branches can then separate from the parent tree and become freestanding. Both conifers, such as tamarack (*Larix laricina*), northern white-cedar (*Thuja occidentalis*), and eastern hemlock (*Tsuga canadensis*), and flowering trees, including red maple (*Acer rubrum*), red mulberry (*Morus rubra*), and American beech (*Fagus grandifolia*), can vegetatively reproduce via their lateral branches.

Vegetative reproduction in trees by sprouting in seedlings, from the trunk and the roots, and through adventitious roots on low-hanging branches is a

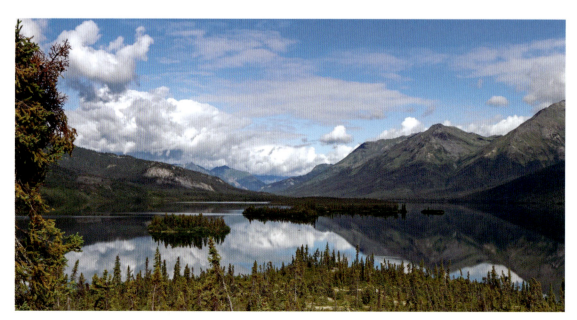

Figure 4.1. Forest habitats. Boreal forest.

means to survive stressful but temporary environmental conditions, to prolong the life of an individual that has experienced major injury or damage, and to expand the size of the individual tree into new territory. At the same time, all of these responses will increase the capacity of the tree to sexually reproduce and evolutionarily prosper.

CHAPTER FOUR
Ecology and Conservation

Habitats

The common trees of North America (here focusing north of Mexico) include both native species that have evolved locally and non-native or "exotic" species that have been introduced from other regions. Besides those that are common because of cultivation (which are few in this book but include the ginkgo), most of the common trees favor one or more particular habitat types, which are variously distributed across the continent. These habitats can be categorized in a general sense into three types: climax or primary habitats, which show little impact by humans; disturbed or secondary habitats, which have been affected to varying degrees by humans; and successional habitats, which are in transition from secondary to climax stages. Of course, humans are not the only cause of forest disturbance. Fire, weather events, and landslides also have significant influence on the growth of trees and forests. In fact, the occurrence of undisturbed or "primary" forest habitats may be a myth; they may not exist at all. Some level of disturbance may be the normal state of affairs for forests, which may always be in transition or succession.

Ecologists have been attempting to characterize and categorize forest and habitat types, or "biomes," for centuries. Although biologists and conservationists often identify different sets of global terrestrial biomes, fourteen are often considered standard. These biomes are classified as follows, with nine of them (marked by an asterisk) being habitats in which the common trees of North America (north of Mexico) are found:

1. Tropical and subtropical moist broadleaf humid forests
2. Tropical and subtropical dry or semi-humid broadleaf forests
3. Tropical and subtropical coniferous semi-humid forests

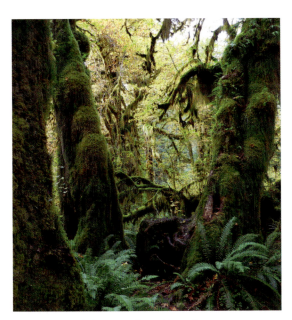

Figure 4.2. Forest habitats. Pacific Northwest forest.

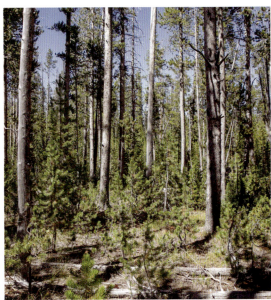

Figure 4.3. Forest habitats. Rocky Mountain forest.

4. Temperate broadleaf and mixed humid forests *
5. Temperate coniferous humid to semi-humid forests*
6. Boreal humid forests *
7. Mediterranean forests, woodlands, and scrub or sclerophyll semi-humid to semi-arid forests (with winter rainfall)*
8. Tropical and subtropical semiarid grass-lands, savannas, and shrublands
9. Temperate semiarid grasslands, savannas, and shrublands *
10. Flooded grasslands and savannas (fresh or brackish water inundated)*
11. Montane grasslands and shrublands: alpine (above the tree line) or montane (below the tree line)*
12. Tundra (arctic)*
13. Deserts and xeric shrublands*
14. Mangrove (salt water inundated)

It is impressive that so many of the global terrestrial biomes are found on just one continent; only the tropical habitats are not fully represented. In North America, the three states and regions with the highest numbers of tree species are Texas, California, and the southeastern United States, and each of these regions includes multiple habitat biomes.[1] A slightly different and more dissected classification of North American biomes is provided in the *National Wildlife Federation Field Guide to Trees of North America*, which refers to regions and habitats specifically in North America, rather than the entire world.[2] Short summaries of thirteen of these forest types are provided below.

Boreal Forests (see figure 4.1). These forests, almost completely dominated by conifers, cover more land than any other forest type in North America, have the least diversity of tree species, and are the most northerly biome of the continent where trees can grow. North of this zone stretches the treeless tundra. Spruce, especially white spruce (*Picea glauca*) and black spruce (*Picea mariana*), and tamarack (*Larix laricina*) are the dominant tree species, although some angiosperms, such as paper birch (*Betula papyrifera*) and quaking aspen (*Populus tremuloides*), invade after fires. Farther south, other confers, such as balsam fir (*Abies balsamea*), red spruce (*Picea rubens*), and northern white-cedar (*Thuja occidentalis*), are present, especially in peat bogs and wet swampy zones. The low overall species diversity is in part due to the very short growing seasons.

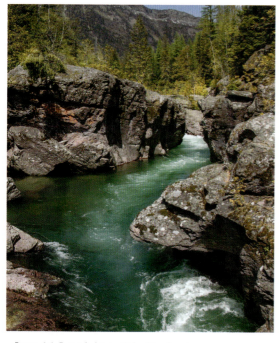

Figure 4.4. Forest habitats. Columbian forest.

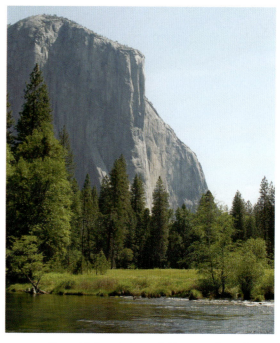

Figure 4.5. Forest habitats. California coniferous forest.

Pacific Northwest Forests (see figure 4.2). Similar to the boreal forests, this forest type is dominated by evergreen conifers, such as Douglas-fir (*Pseudotsuga menziesii*), western redcedar (*Thuja plicata*), and western hemlock (*Tsuga heterophylla*). Extending from northern California along the coast through Oregon and Washington to British Columbia and Alaska, these forests are generally wet, and fog predominates for a good part of the year, allowing for abundant growth of epiphytes. It is in this fog belt that Sitka spruce (*Picea sitchensis*) and, toward the southern end, redwood (*Sequoia sempervirens*) attain their great heights in the coastal temperate rain forests. During the summer dry season, though, fires can affect large swathes of these forests, allowing some angiosperms, such as red alder (*Alnus rubra*), white alder (*Alnus rhombifolia*), and bigleaf maple (*Acer macrophyllum*), to invade.

Rocky Mountain Forests (see figure 4.3). The coniferous forests of the Rocky Mountains are scattered from Arizona and New Mexico northward into British Columbia wherever the appropriate montane elevations are present. They form a band of forest vegetation between the lower dry zones and the upper subalpine growth. Ponderosa (*Pinus ponderosa*), limber (*Pinus flexilis*), and lodgepole (*Pinus contorta*) pines are common depending on the level of aridity. Douglas-fir (*Pseudotsuga menziesii*), white fir (*Abies concolor*), Engelmann spruce (*Picea engelmannii*), and blue spruce (*Picea pungens*) are also present. Where fire has taken its toll on the conifers, quaking aspen (*Populus tremuloides*) and paper birch (*Betula papyrifera*) quickly become dominant. Some of the pine forests can be extremely dense but give way to grasslands, willows, and cottonwoods in low-lying wet areas.

Columbian Forests (see figure 4.4). A distinctive forest type that is found in the Rocky Mountains is a result of the Pacific storms that drop moisture on the Pacific Northwest forests but also the western slopes of these inland mountains. In the Columbian forests, which are located from Montana north into Canada, western hemlock (*Tsuga heterophylla*) and western redcedar (*Thuja plicata*) dominate the moist zones, while grand fir (*Abies grandis*), western larch (*Larix occidentalis*), white spruce (*Picea glauca*), Douglas-fir (*Pseudotsuga menziesii*), lodgepole pine (*Pinus contorta*), and ponderosa pine (*Pinus ponderosa*) are common in the drier habitats less affected by the rains from the Pacific. Angiosperm species, such as

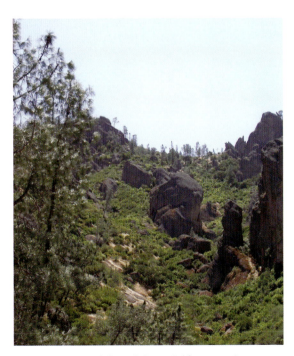

Figure 4.6. Forest habitats. California mixed evergreen woodland/forest.

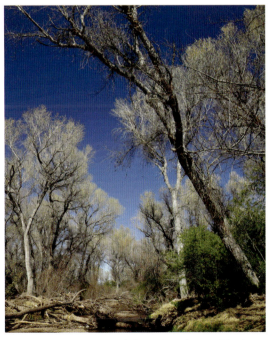

Figure 4.7. Forest habitats. Great Basin and Southwest forest/woodland.

Rocky Mountain maple (*Acer glabrum*), paper birch (*Betula papyrifera*), balsam popular (*Populus balsamifera*), and speckled alder (*Alnus incana*) are also found following fire.

California Coniferous Forests (see figure 4.5). The conifer forests of western North America encompass a unique set of species found primarily in California sandwiched between the woodlands at lower elevations and the stunted forests of the subalpine zone. Here species such as incense-cedar (*Calocedrus decurrens*), sugar pine (*Pinus lambertiana*), Jeffrey pine (*Pinus jeffreyi*), and California red fir (*Abies magnifica*) form somewhat of an elevational gradient up the mountainsides. Scattered just below the tree line at high elevations above these evergreen forests are the *subalpine forests*, where conifers continue to dominate. The trees in this zone, including subalpine fir (*Abies lasiocarpa*), Engelmann spruce, (*Picea engelmannii*), mountain hemlock (*Tsuga mertensiana*), and whitebark pine (*Pinus albicaulis*), grow in scattered dense clumps amid meadows and grasslands, enduring the harsh conditions of aridity, wind, and cold.

California Mixed Evergreen Woodlands and Forests (see figure 4.6). Throughout most of the coastal ranges of California is found a distinctive type of forest characterized by a mixture of conifers and evergreen angiosperm trees. This mixture of species is not found anywhere else in North America, although it is also characteristic of the Mediterranean region of Europe. Summers are hot and dry; only a small amount of rain occurs during the winter months. Dominant conifers include incense-cedar (*Calocedrus decurrens*), Douglas-fir (*Pseudotsuga menziesii*), and ponderosa pine (*Pinus ponderosa*), and Pacific madrone (*Arbutus menziesii*), California bay (*Umbellularia californica*), and live oaks (red oak species of *Quercus*) provide the broadleaf evergreen component. These forests are also dotted with *oak woodlands* made up primarily of both evergreen and deciduous species and areas of *chaparral* that are fire adapted and burn intensively on an annual basis.

Great Basin and Southwest Forests and Woodlands (see figure 4.7). Across the vast deserts of the southwestern United States are distributed a number of mountain ranges that provide enough moisture to support woodlands of sparsely distributed trees.

Figure 4.8. Forest habitats. Laurentian mixed forest. Summer, autumn, and winter.

Here a number of species of pinyons combine with several types of junipers to form a short woodland forest with low diversity and low tree abundance. Moving up the mountain slopes, these species give way to other mixtures of conifers and oaks, including white fir (*Abies concolor*), limber pine (*Pinus flexilis*), ponderosa pine (*Pinus ponderosa*), lodgepole pine (*Pinus contorta*), and Gambel oak (*Quercus gambelii*). Near the border with Mexico, junipers associate with other oaks to form different assemblages of species in low woodlands with little rainfall.

Laurentian Mixed Forests (see figure 4.8). The forests that stretch from the Atlantic coast to west of the Great Lakes and straddle the border between Canada and the United States are a "grand mosaic" of habitats possessing various mixtures of species of trees. The exact composition of any one forest is dependent on moisture, soils, elevation, and slope. Following fire, red pine (*Pinus resinosa*), eastern white pine (*Pinus strobus*), and jack pine (*Pinus banksiana*) invade if the soils are sandy, while balsam fir (*Abies balsamea*), red spruce (*Picea rubens*), white spruce (*Picea glauca*), and eastern hemlock (*Tsuga canadensis*) are prominent in more mesic areas. Among the common broadleaf angiosperm trees that eventually take over the conifer-dominated forests are northern red oak (*Quercus rubra*), paper birch (*Betula papyrifera*) and yellow birch (*Betula alleghaniensis*), sugar maple (*Acer saccharum*) and red maple (*Acer rubrum*), and American beech (*Fagus grandifolia*). Scattered throughout this mosaic are conifer bogs with tamarack (*Larix laricina*), northern white-cedar (*Thuja occidentalis*), and black spruce (*Picea mariana*). The Laurentian mixed forests serve as a transition between the coniferous boreal forests to the north and the eastern deciduous forests to the south.

Eastern Deciduous Forests (see figure 4.9). The large expanse of deciduous forest that lies south of the mixed conifer and deciduous Laurentian domain is heterogeneous in composition but somewhat uniform in structure. Here are found numerous species of trees, some of which are distributed throughout, such as white ash (*Fraxinus americana*) and green ash (*Fraxinus pennsylvanica*), white oak (*Quercus alba*), black oak (*Quercus velutina*), and northern red oak (*Quercus rubra*), bitternut hickory (*Carya cordiformis*), shagbark hickory (*Carya ovata*), red maple (*Acer rubrum*), silver maple (*Acer saccharinum*),

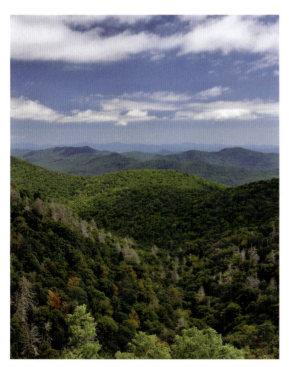

Figure 4.9. Forest habitats. Eastern deciduous forest.

Figure 4.10. Forest habitats. Southern oak-hickory-pine forest.

CHAPTER FOUR: ECOLOGY AND CONSERVATION • 33

eastern hophornbeam (*Ostrya virginiana*), American hornbeam (*Carpinus caroliniana*), and slippery elm (*Ulmus rubra*). Other suites of trees become dominant to the north, south, east, and west. The rivers that flow east from the Great Plains also provide riparian habitats where species such as eastern cottonwood (*Populus deltoides*), black willow (*Salix nigra*), black walnut (*Juglans nigra*), American sycamore (*Platanus occidentalis*), and several types of ash (*Fraxinus* species) increase in abundance. Farther to the east in the southern Appalachian Mountains, cove forests, which are protected from harsh weather conditions, have a rich diversity of trees, including white ash (*Fraxinus americana*), tuliptree (*Liriodendron tulipifera*), American basswood (*Tilia americana*), mountain silverbell (*Halesia tetraptera*), yellow buckeye (*Aesculus flava*), and sweet birch (*Betula lenta*). The eastern deciduous forests constitute the second most extensive forest type in North America.

Southern Oak-Hickory-Pine Forests (see figure 4.10). A variant of the eastern deciduous forests extends in a band from New Jersey to Oklahoma and differs primarily in the species of pines that make up the dominant conifer in the tree communities. Loblolly pine (*Pinus taeda*) and shortleaf pine (*Pinus echinata*) prevail, with a complement of southern red oak (*Quercus falcata*), hickories (*Carya* species), sweetgum (*Liquidambar styraciflua*), sourwood (*Oxydendrum arboreum*), and tuliptree (*Liriodendron tulipifera*). Toward the northeastern end of this forest type is found another set of pines and broadleaf trees: pitch pine (*Pinus rigida*), blackjack oak (*Quercus marilandica*), and turkey oak (*Quercus laevis*) are the common trees in the fire-prone and fire-adapted pine barrens.

Southeastern Coastal Plains Forests (see figure 4.11). Between the oak-hickory-pine forests and the Atlantic Ocean and Gulf of Mexico sits a broad coastal

Figure 4.11. Forest habitats. Southeastern coastal plains forest.

Figure 4.12. Forest habitats. Southern flood-plain forest.

Figure 4.13. Forest habitats. Savanna.

plain that is inhabited by mainly pine-dominant forests. Longleaf pine (*Pinus palustris*) predominates in one large stretch of forest from Texas to Virginia. These forests are fire dependent and require some type of burning either through naturally occurring processes or, more often, human-caused activities. Along with the pine-dominated canopy, a number of angiosperm trees are found in these forests, including southern red oak (*Quercus falcata*), post oak (*Quercus stellata*), turkey oak (*Quercus laevis*), bluejack oak (*Quercus incana*), sand live oak (*Quercus geminata*), and the common persimmon (*Diospyros virginiana*). Another type of coastal plain forest is found farther to the south and is dominated by slash pine (*Pinus elliottii*). Within these slash pine forests are pockets of standing water that harbor stands of baldcypress (*Taxodium distichum*), pond pine (*Pinus serotina*), sweetbay (*Magnolia virginiana*), loblolly bay (*Gordonia lasianthus*), black tupelo (*Nyssa sylvatica*), and water tupelo (*Nyssa aquatica*). There are even small areas of hardwood forest with oaks (*Quercus* species), hickories (*Carya* species), southern magnolia (*Magnolia grandiflora*), American beech (*Fagus grandifolia*), and eastern hophornbeam (*Ostrya virginiana*). Directly bordering the oceans and bays are forests of generally evergreen, salt-tolerant species, such as redbay (*Persea borbonia*), sand live oak (*Quercus geminata*), eastern redcedar (*Juniperus virginiana*), and cabbage palm (*Sabal palmetto*). The coastal plain forests are a diverse amalgam of water-dominated habitats and evergreen species of trees.

Southern Flood-Plain Forests (see figure 4.12). Unlike the coastal plain forests, which have nutrient-poor sandy soils and evergreen fire-dependent trees, the flood-plain forests associated with the major rivers in North America are rich in nutrients, seldom experience fires, and are composed of broadleaf deciduous tree species. Water tupelo (*Nyssa aquatica*), sweetgum (*Liquidambar styraciflua*), American sycamore (*Platanus occidentalis*), American hornbeam (*Carpinus caroliniana*), and baldcypress (*Taxodium distichum*) dominate, with additional species of elms (*Ulmus* species), ashes (*Fraxinus* species), and hickories (*Carya* species). These forests have experienced extensive influence by the activities of humans for hundreds, if not thousands, of years and may not much resemble the earliest forests found in these regions of rivers and estuaries where extensive farmlands exist today.

Savannas (see figure 4.13). Most habitats dominated by grasslands harbor very few and scattered trees. The savannas of eastern Africa are perhaps one of the best-known savannas. In North America, our grasslands are distributed from the Everglades of Florida and cypress savannas of the Southeast, where baldcypress (*Taxodium distichum*) is the most common tree; to the northern edge of the Great Plains, where grasslands harbor bigtooth aspen (*Populus grandidentata*), balsam popular (*Populus balsamifera*), boxelder (*Acer negundo*), green ash (*Fraxinus pennsylvanica*), burr oak (*Quercus macrocarpa*), and several willows (*Salix* species); to the savannas of central and western Texas, in which junipers (*Juniperus* species), live oaks (*Quercus* species), and honey mesquite (*Prosopis glandulosa*) dot the landscape. None of these grass-dominated habitats would be characterized as forest, yet some common trees do persist.

Environments

The thirteen biomes and habitats of North America provide a guide as to where the many species of common trees are found. Each of these habitats is characterized by certain combinations of environmental conditions for which each species of tree has evolved and adapted. In some cases, entire lineages appear to be adapted to certain types of environments. An example is the conifers, which are found most often in cooler climates. In other cases, lineages with many species have diversified over evolutionary time to be adapted to a large variety of environmental conditions. The oaks and the maples, for example, have species in cold and warm climates, wet and dry soils, or undisturbed as well as highly disturbed places. Some of the primary environmental factors that affect species distributions include climate, elevation, topography, water availability, soil composition, disturbance, and pests and diseases.[3]

Climate. The features of climate that have the greatest impact on trees are the amount of moisture in the air, the range of daily and nightly temperatures, and seasonality. All three factors are interdependent. Environments may be dry and arid or wet and humid or in between. Temperatures will fluctuate during the day and night, but the range of these fluctuations is usually quite stable and predictable and varies from arctic, alpine, and boreal to montane and temperate to subtropical and tropical. And both moisture and temperature can be more or less invariable, with little seasonal change, or vary across the year in seasonable climates, such as hot and dry in summer versus cool and moist in winter, or vice versa.

Elevation. It has long been known that climatic variation from the poles to the equator is replicated from the base of mountains to the peaks. In Alexander von Humboldt's classic 1807 work *Essay on the Geography of Plants,* he described how changes in elevation up the slopes of Mount Chimborazo in Ecuador mimicked changes in climate and vegetation as one traveled south to north across latitudes.[4] This holds true for the slopes of the Rockies of North America and for the Andes of South America.

Topography. Flat coastal plain or flood-plain habitats pose different challenges to tree growth than mountain slopes. Within the mountains, north-facing slopes can be cooler and wetter than south-facing slopes, even over short distances. Montane valleys harbor quite different vegetation than exposed ridges because of the contrasting climates between these topologies. Within the flatter plains, slight dips in the terrain can create much wetter environments containing swamps or standing water. All of these topographical alternatives require adjustments in strategies if trees are to survive and grow.

Water Availability. The ability of soils to absorb and retain water has a direct impact on the type of vegetation and trees that can grow in a given location. Those soils that retain the least water will support only xeric forests whose trees are adapted to very dry conditions. If soils rarely dry out, then a different set of trees that are adapted to mesic conditions will be present. The wettest habitats with standing water harbor trees with shallow root systems or other adaptations for soils that never dry out. The daily and seasonal availability of water is a critical environmental factor affecting the distribution of trees.

Soil Composition. Similar to the impact of water availability on tree growth is the composition of the soils. The pH of the soils and the degree of acidic versus basic properties, often associated with the history of the soils and geology of the location, have a significant impact on the vegetation growing there. In addition, some trees are better than others at tolerating the presence of heavy metals in soils. Often it is possible to determine the specific composition of soils based on the types of trees that are present.

Disturbance. It is a given fact that habitats are always in flux and that they are always changing. These changes can happen on a daily or seasonal basis, or they can be gradual, occurring over long periods of time. If change is predictable over time, trees can adapt to these changes. However, change can also be rapid, unexpected, and sometimes severe. Species of trees have evolved different levels of tolerance for natural disturbances in their habitats. Variation in tolerance for shade, drought, fire, and windthrow among species of trees will determine the range of environments that can be inhabited. The tolerance of trees may be changing as human disturbance of natural habitats increases in severity. Pollution of the air causing acidic fog and rain can harm tree growth and mortality. The introduction of some non-native plants, especially invasive vines such as the kudzu vine, English ivy, oriental bittersweet, and Japanese honeysuckle can also influence the survival and growth of trees.

Pests and Diseases. A major result of human-caused disturbance is the introduction of invasive insects from outside of North America. The gypsy moth, Asian longhorned beetle, emerald ash borer, and wooly adelgids are insects that have attacked many of our native tree species. In addition, introduced non-native fungi and other pathogens have decimated populations of some of the most common tree

species, such as the American chestnut (*Castanea dentata*), American elm (*Ulmus americana*), butternut (*Juglans cinerea*), eastern white pine (*Pinus strobus*), and others. It should be remembered that all trees are subject to disease and predation from native pests and herbivores, but most of these species of trees and pests have evolved together and these native pests do not kill or even substantially harm the trees. It is the unexpected blights from outside North America that do the most damage.

Threats and Conservation

Environmental Threats. Multiple factors are affecting natural and secondary environments in North America and will therefore have significant impacts on the conservation of trees. These factors are all human effects. They can be categorized into six major influences on the environment: first, the degradation and destruction of natural habitats through residential development, industrialization, poor forestry practices, agricultural expansion, mining, and road building (broadly categorized as land-use change); second, the exploitation of species through commercial collecting in the wild of medicinal plants, timber trees, ornamentals, and the like; third, pollution of the air, land, and sea with substances other than greenhouse gases, including industrial chemicals, plastics, and pesticides; fourth, urbanization, through expansion of major cities and the further isolation of humans from Nature; fifth, invasive species encroaching on and outcompeting native species; and sixth, the spread of plant and animal diseases and pests between formerly isolated continents and land masses. All of these elements are having an impact on local communities, populations, and species of trees.

Vulnerability to Climate Change and Global Warming. Perhaps the least predictable but possibly most devasting environmental factor affecting tree species is the rise in global temperatures associated with the increase of carbon dioxide in the atmosphere. There is little doubt that the geographic ranges of species will shift as temperatures rise and trees migrate through fruit dispersal to track equitable climates. If temperatures rise too quickly for trees to adapt and migrate, then populations will decline. Equally threatening are the events associated with rises in atmospheric and surface temperatures, such as the amplified invasion and spread of exotic and native species of pathogens, the decline of native pollinators and fruit dispersers, and changes in patterns of precipitation, storms, and fires. Taken together, global warming will potentially have massive effects on the native trees of North America.

In order to evaluate the vulnerability of these trees to climate change, the United States Forest Service recently developed a global-warming assessment of over 300 species.[5] Each species was categorized according to risk factors relating to its exposure to climate change, its sensitivity to climate change, and its capacity to adapt to climate change. Eight species of common trees included in this book have the highest risk category. For example, among these eight species, chinkapin (*Castanea pumila*) has a high exposure to climate change because of the environments where it grows and a moderate ability to adapt to a changing climate. A second species in the same genus, the American chestnut (*Castanea dentata*), has a somewhat lower exposure but an even poorer capacity to adapt. Both species are categorized as high risk.

In addition to those eight species in the highest risk category, sixty-six common species of trees are significantly vulnerable but may persist and adapt. Fifteen species may have a high risk in the future, but not at present. Because of their status as a widely cultivated ornamental, naturalized, or invasive species, the risk of sixty-eight species is low. The overall vulnerability to climate change of about a third of the native common species of trees that have been assessed is currently low, but over one-fifth of the species have not yet had a thorough evaluation. Based on the available data provided in the United States Forest Service framework, a climate-change assessment for each common tree included in this guide is provided under the individual species descriptions. The assessment categories listed below are ordered from unknown to lowest risk to highest vulnerability:

Vulnerability is currently unknown. Immediate assessment is recommended.

Vulnerability is considered low because of wide geographic distribution as an ornamental and/or naturalization and/or invasive.

Vulnerability is currently considered to be low.

Vulnerability, though currently considered to be low, may increase in the future. Ongoing monitoring is recommended.

Vulnerability is significant but has reasonable probability of persistence in the future. Ongoing monitoring is recommended.

Vulnerability is significant but may have the capacity to adapt to changing conditions in the future. Ongoing monitoring is recommended.

Vulnerability is high, may have little capacity to adapt to changing conditions, and has a low potential to persist in the future. Ongoing monitoring is required.

Conservation Assessment. Even though 11–16 percent of tree species in North America are threatened with extinction, most of the common trees included in this volume are not thought to be currently under global threat due to their abundance.[6] However, because of the many factors that can have adverse effects on the future of trees, such assessments can change rapidly. For example, the emerald ash borer, an invasive beetle imported from Asia and first discovered near Detroit in 2002, has now spread to thirty-six states, primarily west of the Rocky Mountains. This pest has had a major detrimental impact on populations of ash (*Fraxinus* spp.) across North America and has recently been detected in Oregon.[7] The conservation status of ash trees has been significantly and rapidly altered as a result.

It should also be recognized that even though a species of tree may not be threatened globally, local environmental conditions may have a substantial impact on the conservation status in a particular region. Increased levels of fires, drought, grazing pressure, and urban expansion may all have a local effect on the well-being of a tree despite an overall national or global assessment of "Least Concern."

The two most widely used threat assessment protocols for North American trees are those of the IUCN Red List and NatureServe Explorer.[8] The tree extinction risks provided here follow the IUCN main categories of conservation assessment:[9]

Endangered (EN)—at very high risk of extinction in the wild

Vulnerable (VU)—at high risk of unnatural (human-caused) extinction without further human intervention

Near Threatened (NT)—close to being at high risk of extinction in the near future

Least Concern (LC)—unlikely to become extinct in the near future

Data Deficient (DD)—insufficient data to assess status

Not Evaluated (NE)—yet to be assessed for status

In this book, a conservation assessment of each of the 326 species of trees is provided at the end of each species description.

Trees in the Age of Humans. Why and how did these changes to our tree environments come about? This topic is immense and much debated today. The impact of humans on planet Earth is now recognized as being substantial enough that scientists have suggested a new geologic era to mark the influence of people on the globe. The era is called the Anthropocene, meaning Earth in the Age of Humans.[10] Much has been written on the subject, and the following causal factors have been suggested and researched: There are too many people on the planet and not enough resources to support human populations; humans in general are very poor at using natural resources sustainably; human societies in general have developed in ways that do not promote the equal use and distribution of these resources across populations, societies, and cultures of their own spe-

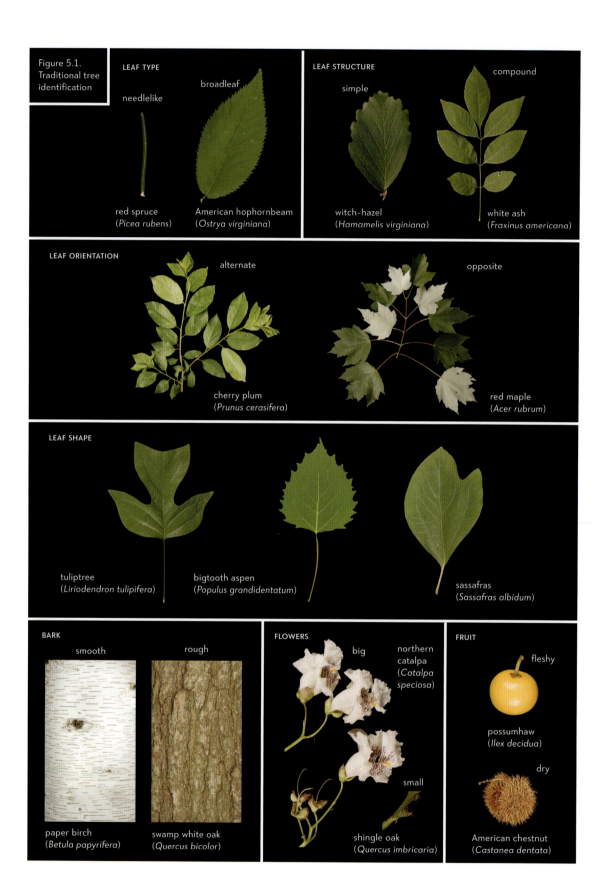

Figure 5.1. Traditional tree identification

40 • THE ESSENCE OF TREES

cies; humans lack respect for the natural world; and, as a species, humans still do not understand their place in relationship to Nature. Not everyone agrees on the severity of each factor.

Forgoing an extended debate about the causes and factors that have led to the Anthropocene, it can be said that humans have clearly had a major effect on Earth and the biodiversity found on the planet, including the trees. A 1,500-page report produced in mid-2019 by the United Nations Intergovernmental Science-Policy Platform on Biodiversity and Ecosystem Services identified four core messages about the threats to habitats, species, and Nature: First, Nature and its vital contributions to people are deteriorating worldwide; second, direct and indirect drivers of change have accelerated during the past fifty years; third, goals for conserving and sustaining Nature cannot be met by current trajectories, and transformative changes are needed across economic, social, political, and technological arenas; and fourth, Nature can be conserved, restored, and sustained only through urgent and concerted efforts.[11] Their main conclusion was that as many as one million plant and animal species are now at risk of extinction. Conservation of biodiversity, primarily through a major change in human lifestyles and priorities, is imperative.

CHAPTER FIVE
Names and Identification

Names

To know a tree's name is the beginning of acquaintance—not an end in itself. There is all the rest of one's life in which to follow it up. Tree friendships are very precious things.
—Julia Ellen Rogers, *The Tree Book: A Popular Guide to a Knowledge of the Trees of North America and to Their Uses and Cultivation*

As so poetically stated in the quotation above, the name of a tree is fundamental to getting to know something about it and to beginning to learn how to appreciate it. On the way to work every day, you might pass by a tree planted along the street and pay it no attention because you know nothing about it. But once you know that its name is ginkgo, and maybe even that it has the scientific name *Ginkgo biloba*, suddenly you have opened a gateway to an infinite amount of information about this tree. With just a little bit of effort, you will now know that it is not native to North America, that it comes from China and has been cultivated for thousands of years, that all of its leaves suddenly turn bright yellow and fall from the tree on a single day in autumn, and that the fruits have an absolutely putrid smell but, every year when they fall, are collected, cooked, and eaten by Asians. So what is the next tree whose name you are going to learn?

Names are important to non-specialists in getting to know trees, and they are essential to scientists in all fields of biology. The species, which is the basic unit of study by naturalists, is also the basic unit of naming. Scientific names for life on Earth start with a two-part name (in Latin) for a species, called a binomial. This binomial includes a species epithet tagged to a genus name. For example, the scientific name of red oak is *Quercus rubra*. The "Quercus" part denotes the genus of all oaks, and the "rubra" part describes

the species with red leaves. There is also gray oak (or *Quercus griesea*), black oak (*Quercus velutina*), shingle oak (*Quercus imbricaria*), and so on. Species are grouped into a genus, which is grouped with other genera into a family, which is grouped with other families into an order. Each of these categories has a scientific name that is uniform, stable, and standardized throughout the scientific world. In this guide, the scientific names are standardized according to the Flora of North America database, the United States Department of Agriculture PLANTS database, and the Forest Service *Checklist of United States Trees*.[1]

Common names usually describe a species, such as red oak or black oak or shingle oak. However, common names are not always uniform: their spelling may vary, they may not always refer to the same species, or they may change from one language or geographic area to another. This non-uniformity can lead to confusion in many instances. It is best and often standard practice to refer to both the scientific name and the common name of a tree.

The science of taxonomy and classification not only aims to provide uniform and stable names for accurate communication but also seeks to order species into underlying patterns of relationships so the evolution of the tremendous diversity of life on Earth can be understood more fully. In this book, the trees are grouped according to their broad evolutionary relationships—namely, how they are similar through descent (see the next section, "Evolutionary Relationships of Trees: A Natural Classification"), and not just by their physical traits, such as opposite versus alternate leaves or simple versus compound leaves. These evolutionary relationships are reflected in the sequence of the major groups of trees presented here, the taxonomic orders within those major groups, and the taxonomic families within the orders. For simplicity, genera and species are arranged alphabetically within these larger categories.

Identification

In order to get an accurate name of a tree, be it a Latin binomial or a local common name, one first needs to identify the tree. It is not uncommon for someone with authority to tell you the name. "That is a ginkgo." "That one is *Quercus rubra*." If there is no one around to tell you the name, then you can use various diagnostic features of the tree to come up with your own identification. Regional tree-identification guides probably provide the best sources of information on the features of trees that can help you determine the name.

Traditional Methods for Tree Identification. Everything that has been discussed in these first chapters can be useful and even essential if you are going to identify a tree correctly. Observing the ecology of a species helps you begin to narrow down the list of possibilities. A tree's location, the type of habitat where it is growing, the characteristics of its environment, its pollinators and dispersers, even the diseases of a tree can help with proper identification. Of course, the morphological features are the most helpful, both the vegetative structures (tree shape, bark, wood, leaves) and the reproductive structures (flowers, fruits, and seeds), and play the most critical role in identification (see figure 5.1).

Without repeating all the information provided in the early parts of this section, it is helpful to focus on the following seven core traits of tree morphology in order to determine the name:[2]

1. *Type of leaves*: broadleaf, needlelike, or scalelike
2. *Structure of the leaves*: simple or compound
3. *Orientation of the leaves*: alternate or opposite along the branch
4. *Characteristics of the leaves*: simple shape, color, margins, and upper and lower surfaces
5. *Bark*: surface features and color
6. *Flowers*: general size, shape, number, color, and position
7. *Fruit*: type (dry or fleshy), shape, number, and color

Leaves (traits nos. 1–4) are usually the first traits to be noted and the most important for a quick and rapid identification of a tree. They are also traits that are most reliably present on a tree, at least in the late spring, summer, and autumn. Bark (no. 5) can be diagnostic at any time of the year, but only for a limited number of species, and it usually takes a lot

of work to get to know bark well enough for identification. For much of the year, flowers (no. 6) and fruits (no. 7) are not present on a tree or are present for only a short period of time (this is especially true for flowers) and therefore are not always helpful in identification.

A few final thoughts about morphological traits may be helpful and should be remembered when trying to identify trees. First, almost all characteristics of a tree are under genetic control and passed along from one generation to the next. This genetic control determines that all individuals within a species possess the same or very similar features. That being said, the local environment where an individual tree is growing can also have a noticeable effect on various features. This interplay between genes and the environment is always at work. Second, some features of trees change with age; the size and shape of the traits of seedlings and saplings may look different from those of mature individuals. Third, variation in form and function is a rule of Nature and is always present within and between individuals, within and between populations, and within and between species. Always expect some variation to be present in each trait of a tree. This variation, though sometimes difficult for the identifier, is a prerequisite for evolution and natural selection. Finally, no single character or trait alone will identify all trees. This situation is unfortunate, but it is true.

Figure 5.2. Tree identification by DNA sequence technology using DNA barcodes. Botanists use tissue samples and vouchered herbarium specimens (as represented on the left) to generate unique DNA barcode sequences as represented by the color-coded patterns (on the right).

CHAPTER FIVE: NAMES AND IDENTIFICATION • 43

New Technologies for Tree Identification. Before we end this section on names and identification, some mention must be made about new technologies that are being developed for identifying species of plants and trees. The first innovation is image-recognition technology, and the second is DNA technology. The ability to recognize faces in human populations is equally applicable to other species. One example of such a technology that was available to the public is *Leafsnap*, a free mobile app for smart phones. *Leafsnap* used visual-recognition software to help identify species of trees by photographs of their leaves.[3] First released in 2011, the app encompassed a large number of species of trees of northeastern North America and parts of eastern Canada, and it was a direct precursor to the development of this guide. Unfortunately, like many apps, *Leafsnap* is no longer available.

A number of other applications are now available for the identification of trees, plants, birds, and other organisms using smartphones. One of the most popular Nature apps is *iNaturalist*,[4] which allows one to identify any living species, including plants, fungi, and animals. This tool, a joint project of the California Academy of Sciences and the National Geographic Society, initially did not employ image-recognition software for identification; rather, it used crowd-sourcing by the large community of scientists and naturalists who use the app. Just take a photo of the species in question with a smartphone, upload it via the internet with *iNaturalist*, and very rapidly suggested identifications become available to the user. The species, location, date, and time can then be verified and shared with the community of over a million users as well as a host of scientific databases. *iNaturalist* has now added *Seek* to its suite of tools for identification. Employing computer vision technology, this mobile phone app provides on-screen identification across the tree of life, including plants. The primary goal of the developers of *iNaturalist* has always been to "connect people to nature," and these new tools continually enhance that capability.

Connecting people to Nature is not only important to people, but also critical to conserving Nature. If we are going to gather the necessary information vital to preserving biodiversity, both as habitats and species, the scientific community cannot do it alone. Laypersons not professionally trained as scientists but

Figure 6.1. Darwin's Tree of Life. The first representation of evolutionary relationships among hypothetical species was proposed by Charles Darwin in his 1837 notebook (left). He then developed the schematic further in his 1859 book *On the Origin of Species* (right). Here he shows how lines of descent (from the bottom toward the top) differentiate in a bifurcating manner over hundreds of generations—the source of new species.

vitally interested in how Nature works have become a core component to the successful monitoring of the changes that we are now seeing across the natural environments of the planet. Dr. Margaret Lowman, a scientist who has spent her career exploring the trees of the world, especially their canopies, realized early on that all the tree biologists in the world could not gather the necessary data to understand tree growth and reproduction. Only by enlisting the help of enthusiastic non-specialists, a.k.a. citizen scientists, could she complete her own scientific work. She invented and devised means to get her citizen scientists up into the trees through climbing methods and canopy walkways in an efficient and engaging manner.[5] Modern tools for easily identifying trees were critical for her success.

A second innovation that has all but revolutionized the identification of species of plants, animals, and fungi is DNA barcoding. DNA barcodes are standardized short sequences of DNA that can be isolated easily and are unique enough to identify all species on the planet.[6] It took a while to determine the standardized DNA sequences that worked for plants, but a number of regions were finally pinpointed. The primary use of DNA barcodes is to identify species no matter which part of a plant is available. Leaves, wood, bark, flowers, fruits, seeds, and seedlings can all be identified from the DNA signature. This is why DNA barcoding is becoming a universal means of identifying species.

As a biodiversity-discovery tool, DNA barcoding can flag species that are potentially new to science, and it also serves as a means to identify regulated species, invasive species, and endangered species, as well as to test the identity and purity of commercial herbal medicines and dietary supplements.[7] DNA barcodes are now also being used to address ecological, evolutionary, and conservation issues. The DNA-sequencing technology required to make DNA barcodes as useful as *iNaturalist*, which is conveniently carried on a mobile phone, is still years away. However, hand-held DNA-sequencing devices are at early stages of development, and it may not be too long before the non-specialist can carry a "barcoder" in his or her pocket to identify a tree in the forest or park or on a city street.

CHAPTER SIX
Evolutionary Relationships of Trees: A Natural Classification

The theory of evolution requires only three things to work: variation of traits among individuals, inheritance of those traits, and differential survival of individuals possessing those traits. Yet the products of evolution can be quite complicated to interpret, especially if traced over long periods of time. Nonetheless, understanding how evolution works has greatly helped taxonomists to develop a logically organized and "natural" system of plant classification. In *On the Origin of Species*, Darwin proposed that evolutionary relationships should be incorporated into classifications, and in his book, he provided one of the first branching diagrams to represent the tree of life (see figure 6.1).[1]

The metaphor of a branching tree that shows the diversification of life from a single beginning (that is, the trunk) to the diversity of species (the twigs) has been used over and over for 150 years. Such branching diagrams indicate the close and distant relationships of groups of plants, whether these groups are species, genera, families, or orders. The closer the branches are on the tree, the closer is their evolutionary history. These branching trees also indicate how one group of plants originated from another group by sharing a common ancestor (a branching point) in a series of advances from those with the most primitive features to those with the most advanced traits. In general, these "trees" have been built from morphological features that characterize each plant group. Such branching diagrams can then be translated directly into a hierarchical classification.[2]

Today plant taxonomists use a great variety of characters to devise and organize their classifications. Morphological features such as roots, stems, buds, leaves, and flower parts; anatomical traits; and embryological and pollen characters, as well

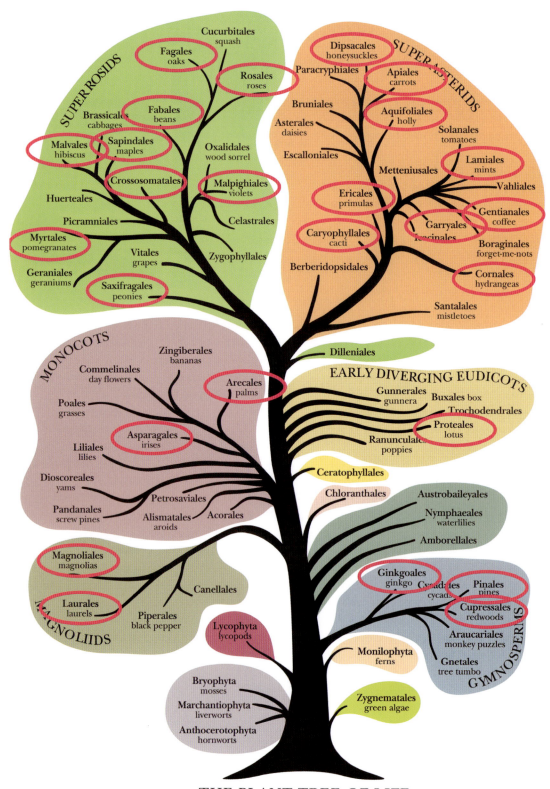

THE PLANT TREE OF LIFE

46 • THE ESSENCE OF TREES

as chemistry and chromosome number have all been considered in developing a classification of modern-day plants. If fossils of a particular plant group are known, they too are often used to provide estimates of the timing of various branching events on the evolutionary tree. Of all the evidence now available for constructing evolutionary trees and classifications, DNA has played the most important role over the last decades.[3]

The application of DNA sequence data to our understanding of the evolutionary relationships of plant groups has greatly enhanced our capability as taxonomists to devise natural, phylogenetic classifications. Fundamentally, DNA data are no different from other types of characters for interpreting evolutionary patterns. The basic advantage is that a larger amount of such sequence data is now available, and, in most cases, it is easier to interpret than morphology, anatomy, and plant structure. For example, each DNA character, called a base pair or nucleotide, can be one of only four possible discrete kinds. On the other hand, for each hair or leaf or flower type, plants may have numerous different kinds, which often make plant characters more difficult for botanists to interpret than DNA characters. Over the last decade, taxonomists have come to rely almost entirely on sequence data for constructing meaningful phylogenetic trees and classifications. In many cases, these classifications match previous work; in some cases, they have proven radically different.

Once all of the sources of character information have been gathered, the taxonomist then analyzes the data by a method consistent with evolutionary theory and groups species according to characters that have uniquely evolved from their common ancestor. The result is a *phylogeny*, which is an evolutionary chronicle of how species descended from a common ancestor and how they are related today. The branching tree of life that represents these relationships is called a *cladogram*. Groups of plants that have evolved from a single common ancestor are called *monophyletic*. Non-monophyletic groups are not acceptable as valid in a classification and therefore are rejected as not being "natural." By pairing the

Figure 6.2. Plant Tree of Life (opposite page). The evolutionary relationships among the major groups of plants are represented in a treelike model. The plant orders circled in magenta include species that are common trees in North America.

most closely related species in a bifurcating series of branches, a modern evolutionary classification can be built from the cladogram. In order to make the information easier for specialists and non-specialists to interpret, these cladograms can also be portrayed in the form of a real-looking but imaginary tree or *plant tree of life*. As new information on plant evolution is made available, the plant tree of life is constantly being refined and updated. The plant tree of life used in this book reflects the most current consensus view of plant evolution and phylogeny (see figure 6.2). The figure was created through the Tree of Life Initiative at the Royal Botanic Gardens, Kew, in southwest London.[4]

The plant tree of life can also be translated into a descriptive evolutionary classification that reflects the branching patterns of the cladogram exactly. Therefore, one could, if desired, reconstruct the evolutionary tree from the classification and vice versa. An ever-changing but ever-improving classification is a tribute to the many botanists who have shared their combined knowledge of the evolution of the rich diversity of plants in the world today and, in this case, the common trees of North America.

Current Classification of the Major Groups of Plants

To assist the reader in navigating around this plant tree of life, the major groups or lineages of plants, how they are phylogenetically related to each other, and some of their defining characters are presented below.

Plant Lineages Without Trees (not included in this book)

Fungi. Although fungi have traditionally been considered plants and within the field of botany, scientists now agree that these organisms are not plants at all. They lack the ability to photosynthesize and possess a distinctive type of cell wall, suggesting that fungi are evolutionarily most closely related to animals.

Algae. The term *algae* refer to several groups of unrelated photosynthetic plants that are primarily aquatic. These groups include the red algae, the brown algae, the diatoms, the dinoflagellates, and the green algae. Each group is distinguished by the type of pigment used in the process of photosynthesis and by a characteristic life cycle. The green algae and land plants share a common ancestor that dates back one billion years.

Mosses. Mosses have traditionally been associated with liverworts and hornworts in a group called "bryophytes," which sits at the base of the plant tree of life. It is now agreed that these three types of plants are not monophyletic and hence not a natural group. Mosses are probably the group most closely related to all other land plants, with which they share a specialized reproductive structure.

Monilophytes. The ferns and some of their traditional allies (such as horsetails) are now grouped together in a single lineage called the monilophytes. The club mosses (lycophytes) have been excluded from this group on the basis of DNA sequence data and because they have a different leaf structure than the ferns. The monilophytes and the club mosses are the first branches on the plant tree of life whose members possess water-conducting cells, or vascular tissue, in the stems. Some monilophytes and lycophytes were arborescent in the past, but few show such a growth habit today.

Plant Lineages With Trees (all included in this book)

Gymnosperms. The evolution of seeds (made up of the young embryo, some nutritive tissue, and an outer protective covering) was an important step in the proliferation of plants on land. Both gymnosperms and angiosperms produce seeds, but the seeds of gymnosperms are "naked"—that is, the ovules that result in seeds are not enclosed within a fruit wall even though the mature seeds are contained in structures called cones. The groups of gymnosperms living today include the conifers, the ginkgos, and the cycads, all of which have a well-developed vascular system and are trees. Botanists do not completely agree on the evolutionary relationships of the various groups of gymnosperms, nor on which of the groups is most closely related to the flowering plants. Perhaps some missing links between the gymnosperms and the angiosperms became extinct long ago. Seventy-four species of gymnosperms are common trees in North America.

Angiosperms. The evolution of the flowering plants, which resulted in an explosive diversification of plant species, began over 150 million years ago and continues to this day. The innovation that stimulated this rich diversity was a flower that combined a closed chamber to protect the ovules and seeds (called a carpel), a much-reduced group of cells to facilitate fertilization, and a unique nutritive tissue to provide for the developing embryo (called the endosperm). The evolution of the flower and the simultaneous adaptation of many different animals for pollinating them led to the origin of the perhaps 350,000 species of angiosperms that are estimated to live on Earth currently. The common trees of North America include 252 species of angiosperms.

Most botanists now accept the basic patterns of relationships among the major divisions of flowering plants as worked out by an assemblage of scientists working together called the Angiosperm Phylogeny Group. These major groupings are generally referred to by the names *Magnoliids*, *Monocots*, *Early Diverging Eudicots*, and *Core Eudicots*, which include the *Rosids* and *Asterids*.

The term *Magnoliids* is applied to one of the earliest diverging lineages of flowering plants. The group includes many trees. Some of them, such as the magnolias, have very large attractive blossoms, while others, like the laurels, have smaller, less conspicuous flowers. Twelve species of Magnoliids are common trees in North America. Together with several other lineages that do not make up a monophyletic group, the Magnoliids are sometimes called the *basal angiosperms*. No single character is shared by all of these disparate basal lineages; they are grouped together at the base of the phylogenetic tree simply by being excluded from the rest of the flowering plants.

For hundreds of years, many botanists recognized two major groups within the angiosperms: monocot-

yledons ("monocots") and dicotyledons ("dicots"). We now know that the "monocots" are a monophyletic group allied with the basal angiosperms, but the "dicots" are not monophyletic.

The *Monocots* make up a large monophyletic group containing nearly 85,000 species and accounting for one-quarter of all flowering plants. They are distinguished from other angiosperms by possessing a single seedling leaf (called a cotyledon), a diffusely scattered vascular system, and floral parts in whorls of three (although this feature is also present in several other basal angiosperms), as well as several specialized cellular characteristics. Monocots probably originated between 125 and 140 million years ago. Most are herbaceous, but several lineages, including the palms, screw pines, and yuccas, can be treelike in form but do not have wood like most typical trees. Only eight species of Monocots are common trees in North America, each with very distinctive treelike features: Canary Island date palm (*Phoenix canariensis*), cabbage palm (*Sabal palmetto*), queen palm (*Syagrus romanzoffiana*) California fan palm (*Washingtonia filifera*), Mexican fan palm (*Washingtonia robusta*) Joshua tree (*Yucca brevifolia*), soaptree yucca (*Yucca elata*), and Mohave yucca (*Yucca schidigera*).

All of the remaining flowering plants are contained within a monophyletic group called the *Eudicots*, which are identified primarily by DNA sequence data but also defined by the presence of pollen grains with three distinctive grooves. It is easiest to consider the Eudicots as made up of several entities informally called the "Early Diverging Eudicots," the "Rosids," and the "Asterids." Similar to the basal angiosperms, the *Early Diverging Eudicots* are composed of several different and unrelated lineages that do not form a monophyletic group. These lineages include the poppies, the proteas, and the plane trees, which can be arborescent in stature. The number of species contained in each of these plant groups is generally quite small; families rarely contain more than 1,000 species. Only two species of the Early Diverging Eudicots are common trees in North America (American sycamore [*Platanus occidentalis*] and California sycamore [*Platanus racemosa*]).

The *Core Eudicots*, which make up the main component of what was formerly called the "dicots," are split into two major lineages: here called the *Rosids* and the *Asterids*. Together, these two groups comprise the bulk of the flowering plants and include the majority of the common tree species of North America.

The *Rosids* contain a very large number of species, perhaps one-third of the angiosperms, and are very diverse in form and geographic distribution. The Rosids include many plants that were formerly not thought to be related to each other, and the complexities of relationships within the group are now being studied intensely. DNA sequence data are the prime evidence for combining these very different types of plants into a single large group, including the eucalypts, crepe myrtles, fuschias, poinsettias, willows, carambolas, beans, roses, figs, oaks, mustards, mallos, and oranges. The Rosids contribute 186 species to the common trees of North America.

The *Asterids* are also diverse and speciose, containing nearly 80,000 species. Unlike the Rosids, however, this group is characterized by a number of specialized features, such as fused petals, unique chemical compounds (iridoids, alkaloids, etc.), and a distinctive ovule structure, as well as DNA sequence data. Botanists are in general agreement about the evolutionary relationships among the major subgroups within the Asterids—for example, uniting the blueberries with the persimmons and camellias and grouping the ashes with the catalpas. Forty-four species in the Asterids are common trees in North America.

This short synopsis of the major evolutionary groups of land plants serves as an entryway into the overall relationships of the common tree species of North America. A hierarchical classification of the common trees includes 326 species in 119 genera grouped into 49 plant families (see page 752). This sampling of common species of trees, which is by no means exhaustive for the plant world, represents a cross section of the overall plant diversity distributed across the planet.

The Diversity of Trees

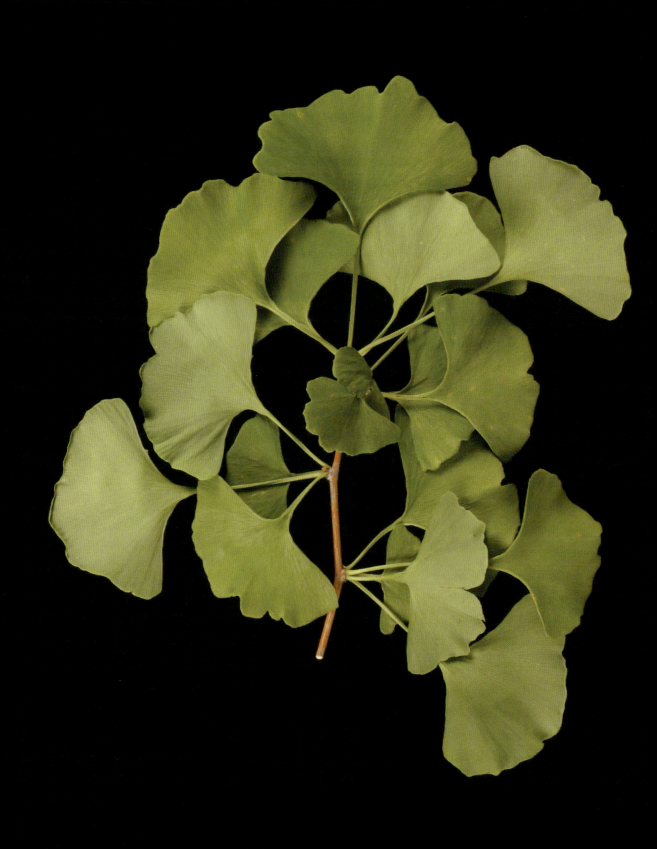

Gymnosperms: Trees with Cones

Gymnosperm is a term that comprises a number of different groups of plants that are related by the possession of seeds, but do not form a single branch on the tree of life. The evolution of seeds (made up of the young embryo, some nutritive tissue, and an outer protective covering) was an important step in the proliferation of plants on land. In gymnosperms the seeds are "naked"—that is, they are not enclosed within a fruit. The living gymnospermous groups include the conifers, ginkgos, "Gnetophytes," and cycads, all of which have a well-developed vascular system like the ferns and flowering plants.

ORDER GINKGOALES

This order of gymnosperms is well represented in the fossil record with leaves of many different forms, but it contains only a single living species, *Ginkgo biloba*. The ginkgos, which are commonly cultivated as ornamentals around the world, are rare in their native habitats in China. The fan-shaped leaves have distinctive branching veins and turn a bright yellow in autumn before they fall from the branches. Ginkgos have changed very little since they evolved hundreds of millions of years ago. One genus in one family includes a species of tree that is common in North America.

Family Ginkgoaceae

Gymnosperms in general have separate male and female reproductive structures, and in the ginkgo, these male and female structures are borne on separate trees. The pollen is produced in small male cones resembling catkins, called strobili, which hang down and release the pollen to be dispersed by the wind. The female gametes are borne in pairs of reduced down fleshy ovules.

OPPOSITE Ginkgo (*Ginkgo biloba*)

GENUS GINKGO

The ginkgo has existed, unchanged, for millions of years on planet Earth. This long history and the plant's unique fan-shaped leaf make it perhaps the most widely recognized of all shade and ornamental trees.

—Michael A. Dirr on *Ginkgo biloba* in *Dirr's Encyclopedia of Trees and Shrubs*

The first representatives of the ginkgos appear in the fossil record in the Permian, and fossils nearly identical to the leaves of *Ginkgo biloba* extend back nearly 200 million years. The extinct relatives of the modern ginkgo were widespread and diverse. Today all species but *Ginkgo biloba* are extinct. This single introduced species in the genus *Ginkgo* is a common tree in North America.

Ginkgo
Ginkgo biloba L.
GINKGO TREE, MAIDENHAIR TREE

Ginkgo is native to China and was brought to the northeastern United States, where it is widely planted as an ornamental tree in urban environments. Trees can grow up to 98 ft (30 m) tall and produce attractive fan-shaped leaves. The species is one of the best-known examples of a living fossil.

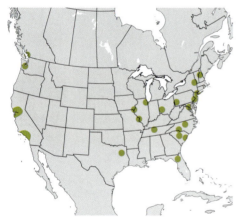

DESCRIPTION. A very long-lived deciduous tree, growing up to 98 ft (30 m) in height by 49 ft (15 m) in width. Main trunk often produces sucker shoots at the base, resulting in several vertical trunks in mature trees. Leaves are distinctive, alternate, and clustered on spur shoots along main branches, green, fan-shaped, up to 3 in (7.5 cm) long with petiole 3 in (7.5 cm) long, often with vertical slit in apex and venation radiating from the center of leaf base, turning bright yellow rapidly in autumn, with all leaves falling simultaneously from branches. Bark is brownish gray, furrowed, and ridged. Trees are dioecious with male and female reproductive organs on separate plants. Male strobili, or "catkins," are pendulous, produce copious bright yellow pollen in early spring; female strobili are much reduced and held close to the branches. Fleshy fruits are produced in early fall only on female trees, tan to orange in color and foul-smelling.

USES AND VALUE. Wood not commercially important. Popular ornamental often planted as specimen tree or urban street tree. Seeds are edible and used in Chinese cooking, although fleshy "fruits" are foul-smelling when mature. Important source for traditional Chinese medicine.

ECOLOGY. Introduced as ornamental tree and very adaptable to various soils and habitats. Known only in cultivation outside of its native China, where it is rare in nature if not extinct. Shade intolerant. Prefers moist, well-drained sites, and is drought tolerant. Largely pest free. Seed production begins when specimens are twenty years old.

CLIMATE CHANGE. Vulnerability is considered low because of wide geographic distribution as an ornamental.

CONSERVATION STATUS. Least concern.

leaf above

leaf below

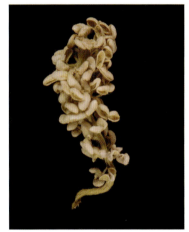
male strobili

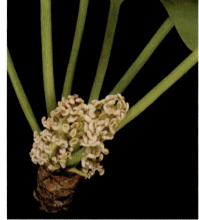
male strobili on branchlet

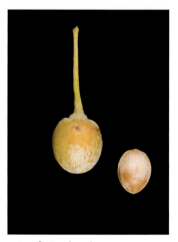
mature fruit and seed

bark

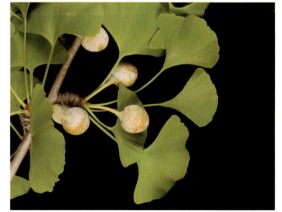
female cones on branch

FAMILY GINKGOACEAE • 55

ORDER PINALES

Eleven genera and approximately 230 species in the Pinales are alive today. They are all woody trees and are characterized by a number of distinguishing cellular features and an interesting relationship with specialized fungi in the roots. The leaves are needlelike and usually in groups of two to five. This order, which was formerly much larger and contained more shapes and forms, includes the Pinaceae (the only family now in the order Pinales). Three to five other families are placed in a second order, Cupressales. Seven genera in the Pinales include species of trees that are common in North America.

Family Pinaceae

The Pinaceae, or pine family, contains eleven genera and 230 species. Two types of cones are produced in the Pinaceae: male cones, which contain the tiny pollen grains, and female cones, which produce the seeds. Both types of cones are borne on the same trees. The seeds of pines are primary components of the diets of many species of birds, squirrels, and other rodents in natural forests, and these trees play a key role in ecosystem functioning. The Pinaceae, including pines, spruces, firs, hemlocks, and larches, is almost entirely limited in geographic distribution to the Northern Hemisphere. Seven genera and fifty-three species, including several nonnative and cultivated species, are common in North America.

GENUS ABIES

Balsamic fragrance breathes from them, squirrels bound in their branches, grouse devour their seeds, porcupines commit lamentable depredations on their bark; the black-tailed and mule deers are highly dependent on them for food and you may practically count on seeing some of these beautiful creatures, sooner or later, in any good growth of White Fir.

—Donald Culross Peattie on *Abies concolor* in *A Natural History of North American Trees*

The genus *Abies*, known as the firs, includes about fifty species. They are evergreen trees found in mountainous regions throughout North America, Central America, Asia, Europe, and Africa. The large trees have needlelike leaves and cones that are held erect on branches. Firs are unique in having their leaves attached to the twigs by small "suction cups" that are visible when a leaf is removed. These leaves are flattened and always have two white lines underneath formed by waxy stomates, or pores. Most species are not favored for construction, but they are popular as cultivated ornamentals and Christmas trees. Some firs serve as food plants for the larvae of certain butterflies, and the sacred fir (*Abies religiosa*) is the host for overwintering monarch butterflies (*Danaus plexippus*) in Mexico. Seven species of *Abies* are common trees in North America.

Pacific Silver Fir

Abies amabilis Douglas ex Forbes
RED FIR, CASCADE FIR

Pacific silver fir is a charismatic tree named after its new foliage, which is light gray or silvery. In old-growth stands, this species provides habitat for the federally threatened northern spotted owl and is commercially grown as a popular Christmas tree.

DESCRIPTION. A conifer growing to 98–230 ft (30–70 m) tall. Bark rough, light gray, and flaky with horizontal scales; in saplings smooth with resin-filled blisters. Crown is symmetrical with branches growing ninety degrees from stem. Shoots are pubescent with spirally arranged needlelike leaves. Needles are glossy, green, notched at the tip, with silvery undersides marked with two bands of stomata, curved on cone-bearing branches. Tress are monoecious producing male and female cones on the same plant. Male pollen cones are red to reddish yellow; female seed cones are erect, pubescent, violet brown before maturity, becoming brown with age, 0.35–0.59 in (9–15 mm) long. Seeds are winged, tan, and 0.39–0.47 in (10–12 mm) long.

USES AND VALUE. Wood commercially important. Marketed with western hemlock and used for construction framing, plywood, sheathing, subflooring, and pulp. Species name *amabilis* means "lovely," and spire-like crown and lustrous foliage make it a popular ornamental with fragrant boughs. Bark has resin-filled blisters often made into gum. Native Americans used resin as antiseptic and healing agent for wide range of conditions, including sore throat, coughs, and colds; bark and needles used to make tea.

ECOLOGY. Prefers well-drained moist soils and maritime climates with average precipitation at 38–262 in (97–665 cm). Grows on variety of soil types and depths, although adequate moisture is imperative. Lives up to 400–500 years. Susceptible to fire and windthrow due to thin bark and shallow roots. Prone to insect and fungal attack; mature trees often exhibit considerable stem rot. Low seed-germination capacity may result in insufficient genetic diversity to allow adaptation to new environments.

CLIMATE CHANGE. Vulnerability is currently considered to be low.

CONSERVATION STATUS. Least concern.

branchlet above

branch above

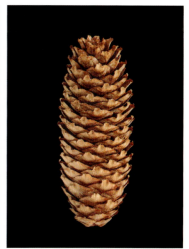
mature cone

Balsam Fir

Abies balsamea (L.) Mill.

Balsam fir grows in the glaciated moist soils and forests of eastern Canada and the northeastern United States, where it is commercially important.

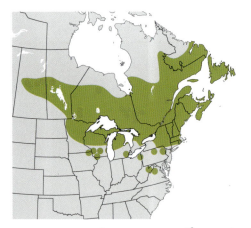

DESCRIPTION. An evergreen conifer growing 39–79 ft (12–24 m) tall. Bark is grayish, smooth, and dotted with resin blisters on older specimens. Twigs are yellow green, maturing to gray. Branches extend from the trunk at right angles, making it a popular specimen for Christmas trees. Leaves are 1–1.5 in (2.5–3.8 cm) long, flat, and rounded at the tip. Trees are monoecious producing male and female cones on the same plant, cones open in late May and early June before vegetative buds. Male pollen cones are 0.12 in (3 mm) long at maturity, yellowish red to purple, and placed 16 ft (5 m) below crown; female seed cones are about 0.98 in (25 mm) long at maturity, purplish, and found at top 5 ft (1.5 m) of the crown; mature cones are 2–4 in (5–10 cm) long and round, with irregularly notched scales with pointed tips. Seeds are 0.08–0.12 in (2–3 mm) long, brown, bear wings twice as long as the body, and released in late summer or early fall.

USES AND VALUE. Wood commercially important. Marketed with spruce and pine; used for light framing construction, for pulp and very popular Christmas tree. Bark resins are made into gum. Native Americans use the resin as an antiseptic and healing agent for a wide range of ailments, including sore throat, coughs, and colds. They also use the needles to make tea. Mice, voles, and birds eat the seeds; birds and squirrels browse the buds; and bears girdle the stems. Moose rely on the twigs for food in winter, and deer often "yard up" in fir stands for warmth and cover.

ECOLOGY. Grows best in the eastern extent of its range, where the climate is cool and moist, on a variety of glaciated soils. Soil moisture is most important factor for persistence. Susceptible to windthrow and fire because of shallow roots and thin bark with resin blisters. Prone to insect and fungal attack, especially spruce budworm, which prefers fir over spruce and periodically decimates stands. Stem rot infects mature trees. Prolific seed producer every two to four years and regenerates in abundance despite low germination capacity (~22 percent). Very shade tolerant when young but requires more light as it matures. A cold-weather species intolerant of hot and dry conditions.

CLIMATE CHANGE. Vulnerability is currently considered to be low.

CONSERVATION STATUS. Least concern.

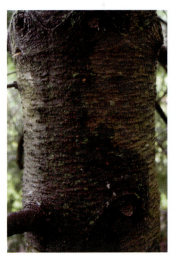

bark

leaf above (left), leaf below (right)

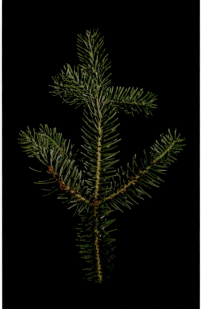
branch above

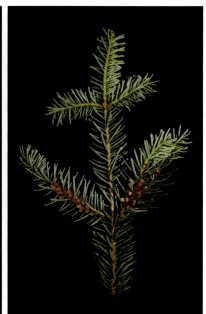
branch below

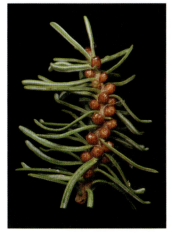
branchlet above

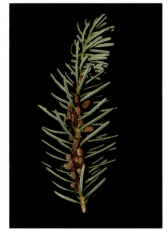
male cones

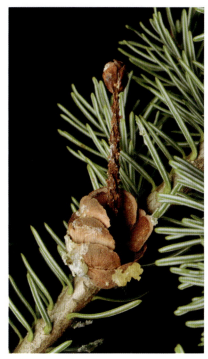
mature cone on branch

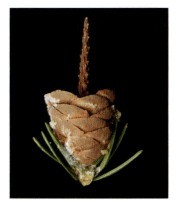
mature cone

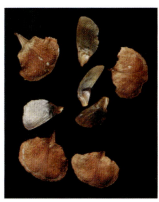
seeds

FAMILY PINACEAE • 59

White Fir

Abies concolor (Gord. & Glend.) Lindl. ex Hildebr.

White fir is native to the mountains of western North America, where it is a tall conifer with flattened needles arranged spirally on the shoot and pale brown cones. It is popular Christmas tree.

DESCRIPTION. A long-lived, evergreen, coniferous tree, reaching 197 ft (60 m) in height. Grows in a variety of habitats in its native North America. Twigs are yellowish green and sometimes pubescent, becoming gray and smooth at maturity. Bark is gray and smooth with resin blisters when young, becoming ashy gray and furrowed with age. Flattened needles are 2–3 in (5–7.5 cm) long, often curve upward, bluish or grayish green in color, slightly white waxy in appearance. Trees are monoecious with male and female cones produced on the same plant in late spring. Male pollen cones are yellowish to reddish and catkin-like; female seed cones are yellow brown maturing to purple and finally brown, up to 5.9 in (15 cm) long, and cylindrical.

USES AND VALUE. Wood commercially important. Marketed with western hemlock; used for construction framing, plywood, and pulp. A popular Christmas tree in west, highly desirable as an ornamental. Pitch used as antiseptic poultice; infusion of the foliage used in baths to treat rheumatism. Bark produces light tan-colored dye. Seeds are consumed by pocket gopher and numerous other rodents; seedlings are frequently browsed by deer and other mammals. Provides shelter and concealment for many birds and mammals.

ECOLOGY. Grows in mountain forests. Shade tolerant as a seedling and persists in the understory for 15–20 years before requiring more light. Despite shallow and wide-spreading root system, very tolerant of dry conditions as well as thin, moisture-deficient soils. Susceptible to fire due to thin bark; shallow roots predispose to windthrow. Frequently attacked by dwarf mistletoe beetles and bark beetles, leading to significant deformity and mortality. Prolific seeder on a five-year cycle; germination about 30 percent. Genetic variability is high.

CLIMATE CHANGE. Vulnerability is currently considered to be low.

CONSERVATION STATUS. Least concern.

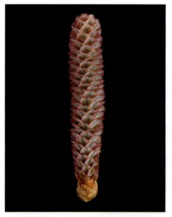

female cone

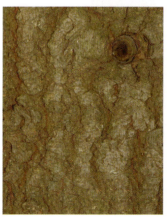

bark

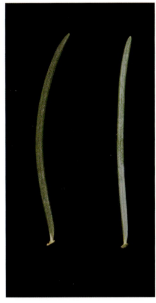

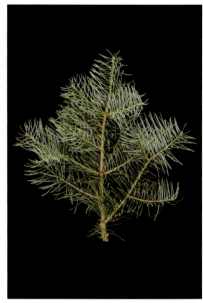

leaf above (left), leaf below (right) | branch above | branch below

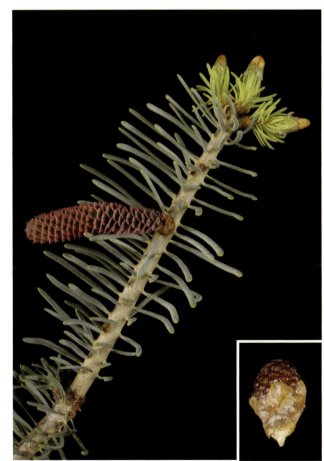
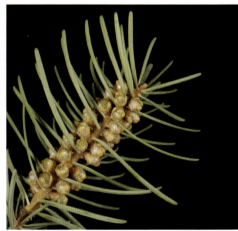
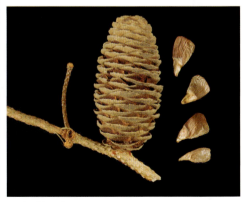

female cones on branchlet, male cone (inset)

male cones on branchlet

seeds with mature cone

FAMILY PINACEAE • 61

Grand Fir

Abies grandis (Douglas ex D. Don) Lindl.
GIANT FIR, LOWLAND WHITE FIR

Grand fir is native to lowland forests of the Pacific Northwest. The deep green foliage and conical form make it a popular Christmas tree.

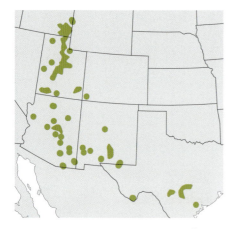

DESCRIPTION. An evergreen coniferous tree growing up to 200 ft (61 m) tall with a wide crown. Twigs are often opposite, light brown, and pubescent. Bark is gray, thin to thick, and maturing to brown. Leaves are 1.2–2.4 in (3–6 cm) long, pungent, needlelike, flattened, and glossy dark green above with two stomatal bands below. Trees are monoecious producing male and female cones on the same plant. Male pollen cones open spring to early summer and are ovoid or cylindrical and hang singly below seed cones; female seed cones are 2.4–4.7 in (6–12 cm) long, with a rounded apex and densely pubescent scales, ripen in fall, releasing tan winged seeds 0.24–0.31 in (6–8 mm) across.

USES AND VALUE. Wood commercially important. Marketed with western hemlock and used for construction framing, plywood, and pulp. Popular Christmas tree in Pacific Northwest. Resin from bark is used as ointment and poultice; aromatic needles are used to deter moths.

ECOLOGY. Grows in moist valleys and on mountain slopes; one of least shade tolerant of true firs. With deep spreading root system prefers moist, alluvial soils but can survive on wide range of soils. Seedlings are reasonably drought resistant. More resistant to fire and windthrow than other firs because of thicker bark and deeper roots. Moderate seeder with reasonable crops every two to three years. Dwarf mistletoe and stem rot are common pathogens. Considerable genetic variability allows occupation of widest range of sites among the true firs.

CLIMATE CHANGE. Vulnerability is currently considered to be low.

CONSERVATION STATUS. Least concern.

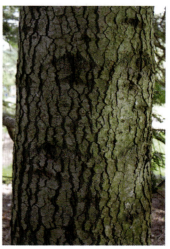

bark

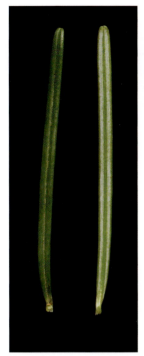 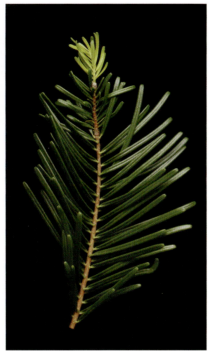

leaf above (left), leaf below (right) branchlet above branchlet below

branch above branch below

FAMILY PINACEAE • 63

Subalpine Fir
Abies lasiocarpa (Hook.) Nutt.
ROCKY MOUNTAIN FIR, WESTERN BALSAM FIR

Subalpine fir grows in the mountains of western North America. The scientific name means "hairy-fruited" and refers to the pubescent cones.

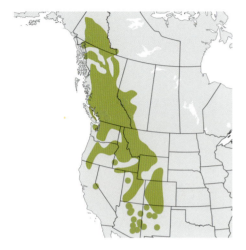

DESCRIPTION. An evergreen coniferous tree growing up to 164 ft (50 m) tall with very narrow spired crown. Twigs are stout and green gray to light brown, with sparse brown pubescence and uniformly branched. Bark is smooth, gray, and blistered on young trees becoming rough and fissured in more mature individuals. Leaves are 0.6–1.2 in (1.5–3 cm) long, blue green, and glaucous above with three to six stomatal bands below leaf. Trees are monoecious producing male and female cones on the same plant. Male pollen cones are purple green and mature in spring; female seed cones are purple blue to gray purple and 2.4–4.7 in (6–12 cm) long, with a rounded apex and highly pubescent bracts. Seeds are 0.24 in (6 mm) long and brown, with a light brown wing.

USES AND VALUE. Wood commercially important. Marketed with spruce and pine, and used for construction framing, plywood, and pulp. Cones are ground into fine powder and mixed with oil or fat to make candy. Resin from trunk is used for chewing gum. Needles and twigs repel moths and serve as incense.

ECOLOGY. Grows in middle to upper elevations of mountains on moist acidic, gravelly or sandy soils, forming extensive stands between lower-elevation forests and alpine tundra; does not survive in warmer, drier climates. Good seed producer with crops every three years; germination is moderate (30 percent). Very shade tolerant. Shallow root system and thin bark make it susceptible to windthrow and fire.

CLIMATE CHANGE. Vulnerability is currently considered to be low.

CONSERVATION STATUS. Least concern.

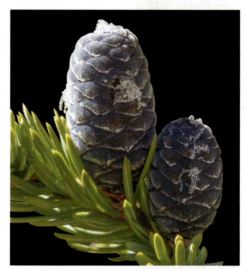
mature cones

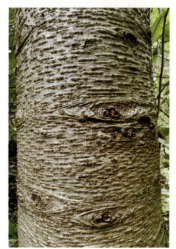
bark

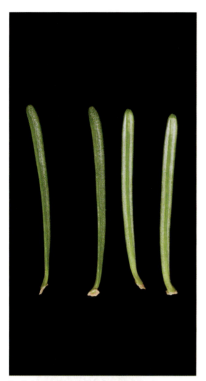 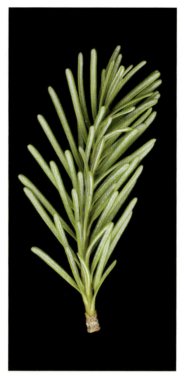 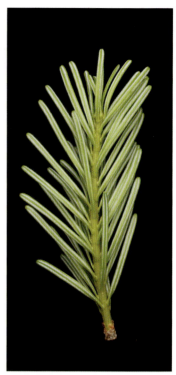

leaf above (left), leaf below (right) branchlet above branchlet below

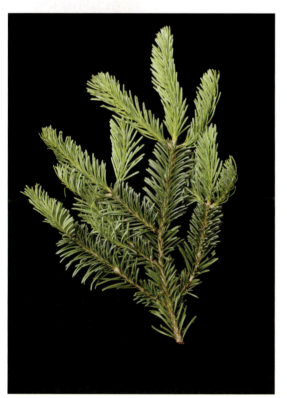 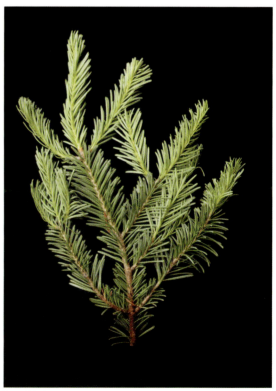

branch above branch below

FAMILY PINACEAE • 65

California Red Fir
Abies magnifica A. Murray
GOLDEN FIR, SHASTA RED FIR

California red fir is a tall, massive evergreen conifer with needlelike leaves which release a camphor odor when crushed. These trees dominate mixed conifer forests, where they provide rich habitat for many animal species that are found in this ecosystem. Two varieties are recognized.

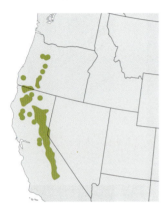

DESCRIPTION. A narrowly conical to nearly columnar conifer that grows 66–197 ft (20–60 m) in height. Branches are short and stout; twigs are reddish, pubescent, and arranged opposite or in whorls. Bark is gray and smooth with resinous blisters in saplings and becomes fissured and reddish brown with age. Leaves are needlelike, densely spirally arranged, dark green (although new growth may appear silver), release a camphor odor when crushed, underside of leaf contains two bands of four to five rows of stomata. Trees are monoecious producing male and female cones on the same plant. Male pollen cones are violet to red and open in early spring; mature female seed cones are 3.5–8.3 in (9–21 cm) long and yellow green to brown when mature with pubescent scales. Seeds are reddish brown, winged, and approximately 0.59 in (15 mm) long.

TAXONOMIC NOTES. Variety *magnifica* (California red fir) is a more southerly form and has no visible bracts on the cones; var. *shastensis* (Shasta red fir) grows in the northern part of the range and has distinctive protruding bracts on the cones. Also known to hybridize with noble fir (*Abies procera*).

USES AND VALUE. Wood commercially important. Marketed with western hemlock and used for construction framing, plywood, and pulp. No food or medicinal uses known. Valued in watershed management because of common occurrence in high-elevation forests. Seeds are important source of nutrients for small rodents, pocket gophers, and squirrels, but effects of these predators on regeneration significant. Spring browsing of succulent shoots by deer may also have impact on survival.

ECOLOGY. Often a community dominant in montane mixed conifer forests and prefers slightly acidic, well-drained soils, but adaptable to varied soil conditions. Intermediate in shade tolerance; requires direct sunlight to survive after the seedling stage. Prolific seeder, with good crops every two to three years; germination rate is relatively low (25 percent). Relatively windfirm but susceptible to fire damage, even though bark is quite thick on older trees. Suffers considerable damage and mortality from red fir dwarf mistletoe.

CLIMATE CHANGE. Vulnerability, though currently considered to be low, may increase in the future. Ongoing monitoring is recommended.

CONSERVATION STATUS. Least concern.

bark

leaf above (left), leaf below (right)

leaf above

leaf below

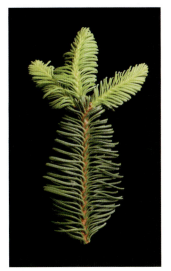
branchlet above

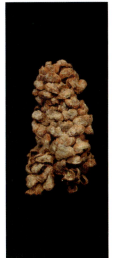
male cone

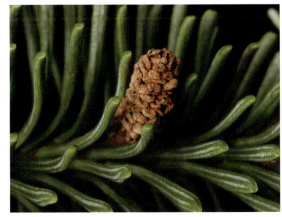
male cone on branch

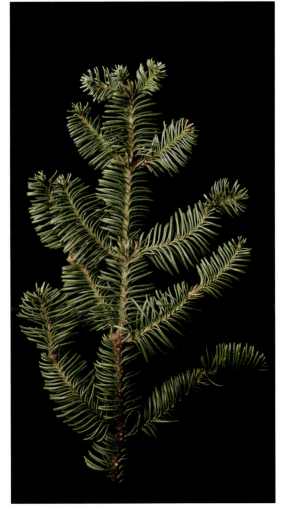
branch

FAMILY PINACEAE • 67

Noble Fir
Abies procera Rehder
RED FIR

Noble fir, a shade-intolerant evergreen tree, is one of the largest of the true firs producing very high-quality lumber. Leaves are needlelike with the smell of turpentine and cones have distinctive pubescent bracts that are reflexed over scales.

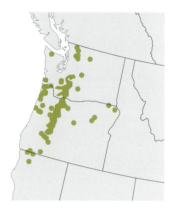

DESCRIPTION. A large, narrowly conical conifer, growing to 262 ft (80 m) in height. Trees are self-pruning, resulting in pillar-like trunks in older adults. Branches grow from trunk at ninety degrees, with finely pubescent new growth. Bark is light grayish when young and becomes rough, reddish brown, and furrowed with age. Leaves grow densely and are needlelike, spirally arranged, densely clustered, and four-sided in cross section, 0.4–1.2 in (1–3 cm long); release a turpentine odor when crushed. Trees are monoecious producing male and female cones on the same plant. Female seed cones, which open in early summer, vary in color from green to red or purple becoming brown at maturity, with pubescent bracts are reflexed over scales, 4–5.9 in (10–15 cm) long. Seeds are approximately 0.47 in (12 mm) long, reddish brown, and winged.

USES AND VALUE. Wood commercially important. Marketed with western hemlock and produces best lumber of all species in genus; used for construction framing, plywood, pulp, ladders and airplane construction. Popular Christmas tree and ornamental. No reported food or medicinal uses.

ECOLOGY. Grows in cool maritime climates at high-altitudes from 984–4,921 ft (300–1,500 m) above sea level. Persists in a variety of habitats and prefers slopes and loam soils derived from volcanic material. Relatively shade-intolerant and recruits will not survive under a closed canopy. Trees may live to be four hundred years old. The wide, relatively deep root system mitigates windthrow, but thin bark increases susceptible to fire. Not prolific seeder.

CLIMATE CHANGE. Vulnerability is currently considered to be low.

CONSERVATION STATUS. Least concern.

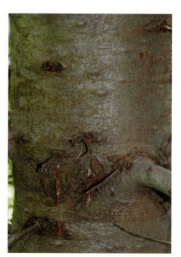

bark

leaf above (left), leaf below (right)

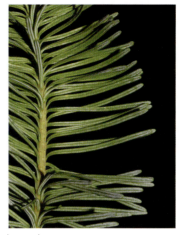
leaves above

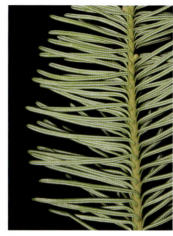
leaves below

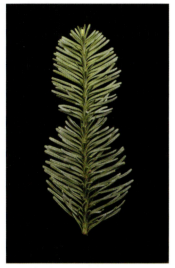
branchlet above

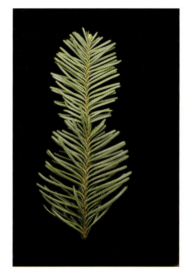
branchlet below

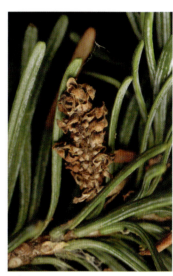
male cone

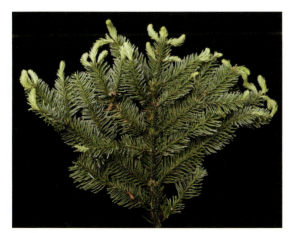
branch above

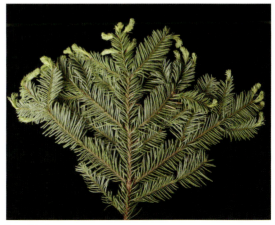
branch below

FAMILY PINACEAE • 69

GENUS CEDRUS

A fully developed specimen provides cause for reflection and inspiration.

—Michael A. Dirr on *Cedrus libani* in Dirr's Encyclopedia of Trees and Shrubs

True cedars, with one to four species, are found in North Africa, the Near East, Cyprus, and the Himalayas, generally at higher elevations. The generic name *Cedrus* is derived from the ancient Greek name for these trees: *kedros*. The name *cedar* is also used for several other plants not in the genus *Cedrus* (e.g., species of *Thuja*). Cedars are tall, majestic trees with spicy resinous wood, thick ridged bark, and more or less horizontal branches. The woody branches themselves are bare of leaves but produce short lateral shoots with the needlelike leaves. The cones are held erect on the shoots, and the seeds have resin bubbles that contain a bad-tasting gum that may be a defense against predators. All true cedars are popular ornamental trees widely cultivated primarily in regions with temperate climates. One introduced species of *Cedrus* is a common tree in North America.

Deodar Cedar
Cedrus deodara (Roxb. ex D. Don) G. Don
HIMALAYAN CEDAR

Deodar cedar is native to the western Himalayas and is grown in North America as an ornamental tree, often planted in parks. A tall conifer, the long, slender needles are characteristically arranged singly on long shoots or in clusters on short shoots. It is the national tree of Pakistan.

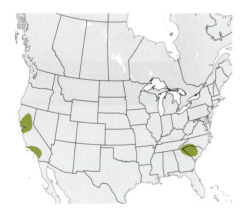

DESCRIPTION. A long-lived evergreen tree growing to 197 ft (60 m) in height. Bark is gray brown to dark gray becoming furrowed into scaly ridges over time. Needles are sharply pointed, dark green to blue green, 1–2 in (2.5–5 cm) long and arranged singly or in whorls of fifteen to twenty on short shoots.

Trees are monoecious producing both male and female cones on the same plant. Male pollen cones are 2–3 in (5–7.5 cm) long and appear on the lower branches in late summer; female seed cones are produced on the upper branches, ovoid or oblong-ovoid in shape, up to 4 in (10 cm) long, and green to purplish in color when young, becoming reddish brown at maturity.

USES AND VALUE. Wood commercially important. Used for construction, boats, and furniture. Often planted as ornamental. Relative wind-firmness makes this tree useful for shelterbelt plantings. Employed medicinally for wide range of ailments, including snake bite. No known food uses. "Deodara" is the local name for this tree in its native northern India.

ECOLOGY. Grows on a variety of soils and is drought resistant. Shade intolerant.

CLIMATE CHANGE. Vulnerability is considered low because of wide geographic distribution as an ornamental.

CONSERVATION STATUS. Least concern.

leaf above

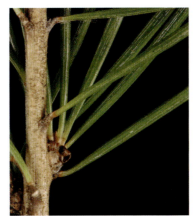
leaves below

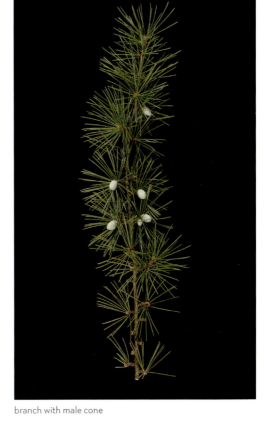
branch with male cone

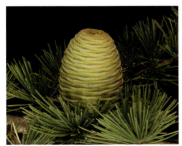
male cones on branchlet

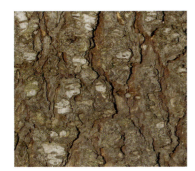
female cone on branchlet

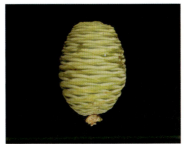
female cone

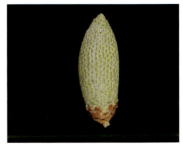
immature male cone

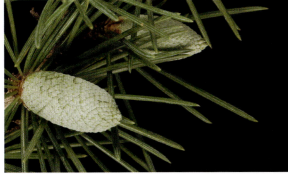
bark

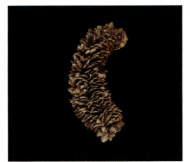
mature male cone

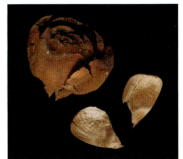
seeds with mature cone

FAMILY PINACEAE • 71

GENUS LARIX

And there is no more delicate charm in the North Woods than the moment when the soft, pale-green needles first begin to clothe the military sternness of the Larch. So fine is that foliage, and so oddly clustered in sparse tufts, that Tamarack has the distinction among our trees of giving the least shade. The northern sunlight reaches right to the bottom of a Tamarack grove.

—Donald Culross Peattie on *Larix laricina* in A Natural History of Trees of Eastern and Central North America

Although most conifers are evergreen, species of *Larix* are deciduous and lose their needles in autumn after their display of bright yellow fall color. *Taxodium* (bald cypress) is the only other conifer native to North America that is also deciduous. Larches are found naturally in the cooler temperate regions of the Northern Hemisphere around the world. The trees are long-lived and often invade recently disturbed and cleared areas, sometimes in very wet habitats. Taxonomists accept ten or eleven species of *Larix*. The wood of most of the species is tough, durable, and in general disease free, making it valuable for construction and boat building. Two native species of *Larix* are common trees in North America.

Tamarack
Larix laricina (Du Roi) K. Koch
AMERICAN LARCH, EASTERN LARCH

Tamarack is native to cold wet sites and high elevation zones in northern North America. One of the few deciduous confers, the needles turn bright yellow in autumn before falling from the tree.

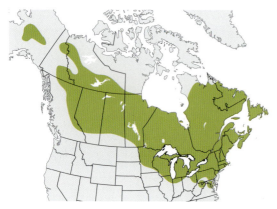

DESCRIPTION. A tall tree, 66 ft (20 m), with a straight trunk and pyramidal shape. One of two deciduous conifers in North America (along with bald cypress). Branches are whorled; twigs are reddish or pinkish brown. Bark is reddish brown and scaly on mature specimens. Leaves are deciduous, bluish green, three-sided, keeled on the bottom, 0.4–0.8 in (1–2 cm) long, and arranged on short shoots, twelve to thirty in a cluster. Trees are monoecious producing male and female cones on the same plant. Male pollen cones are small, yellow, and roundish; female seed cones are produced on short, curved, pendulous stalks, with smooth scales longer than the bracts, when young red, pink, or yellowish green in color, 0.20–0.39 in (5–10 mm) long, becoming oval-shaped, tan, 0.4–0.8 in (1–2 cm) long at maturity in late summer; seeds 0.12 in (3 mm) long with 0.27 in (7 mm) wings.

USES AND VALUE. Wood commercially important. Used primarily for pulpwood, poles, posts, rough lumber, boxes, and crates, dogsled runners, fish traps, and boat ribs. Native Americans chewed resin to cure indigestion; other parts used to treat wide range of ailments. Tea formerly made from roots or needles. Porcupines eat bark, snowshoe hares eat seedlings, and squirrels and other rodents eat seeds. American osprey frequently nest in upper branches.

ECOLOGY. Grows in cold wet soils, including swamps and bogs, in riparian areas, lake borders, and occasionally upland. Tolerates wide range of soils growing best on moist organic soils and peatlands. Shade intolerant. Produces seed every year, with good crops every two to six years; germination often low due to predation by rodents. Thin bark and shallow rooting result in susceptibility to both fire damage and windthrow. Host to variety of insect and fungal diseases, but few cause substantial damage. Larch sawfly can cause losses in commercial logging.

CLIMATE CHANGE. Vulnerability is currently considered to be low.

CONSERVATION STATUS. Least concern.

leaf above (left), leaf below (right)

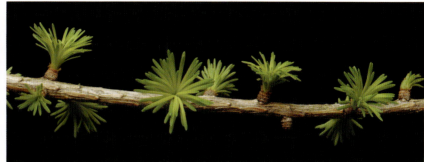
branchlet above

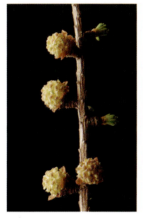
male cones

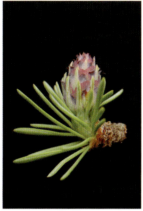
female cone

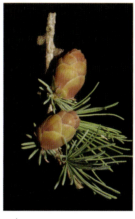
mature unopen cones

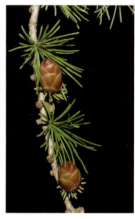
mature unopen cones on branchlet

bark

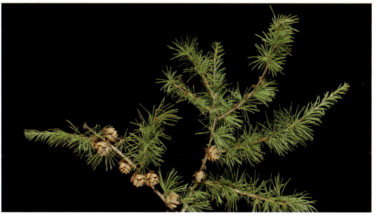
branch above

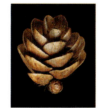
mature open cone

autumn leaves

FAMILY PINACEAE • 73

Western Larch
Larix occidentalis Nutt.
MOUNTAIN LARCH

Western larch is a large deciduous tree native to the mountain valleys and lower slopes of the Pacific Northwest, extending into Canada. The wood is commercially important with many uses, including construction, railroad ties, and flooring.

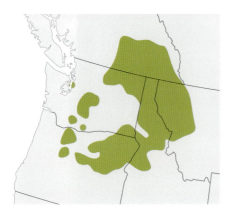

DESCRIPTION. A large deciduous coniferous tree growing 98–197 ft (30–60 m) tall with characteristic short lateral shoots and a narrow conical crown. Bark is reddish brown and scaly with deep furrows between flat, flaky, cinnamon-colored plates, lenticels inconspicuous. Needles are slender, light green, soft, spirally arranged in bunches of fifteen to thirty along dwarf twigs, 1–2 in (2.5–5.0 cm) long, turning bright yellow in autumn before they fall. Trees are monoecious producing male and female cones on the same plant. Male pollen cones are 0.4 in (1 cm) long; female seed cones are borne on curved stalks, papery, 1–1.4 in (2.5–3.5 cm) long, 0.5–0.6 in (1.3–1.6 cm) wide, with long subtending bracts, at maturity 0.8–1.2 in (2–3 cm) long, red turning brown at maturity. Seeds are released when scales open flat four to six months after pollination.

USES AND VALUE. Wood commercially important. Used for construction lumber, veneer, plywood, pulp, glue lam, railroad ties, mine timbers, and flooring. Water-soluble gum, called arabinogalactan, is employed in lithography, pharmaceutical products, food, paint, and ink. Gum, leaves, and shoots are used to treat wide range of ailments, including some forms of cancer. Important tree for wildlife; broken crowns provide nesting holes for birds.

ECOLOGY. Grows on mountain slopes and in valleys. Shade intolerant. Produces seed annually, with good crops every five to seven years. Trees are deep-rooted and windfirm. Thin bark when young causes susceptibility to ground fires; thick bark in older trees results in fire resistance. Dwarf mistletoe causes significant damage as needle blight.

CLIMATE CHANGE. Vulnerability is currently considered to be low.

CONSERVATION STATUS. Least concern.

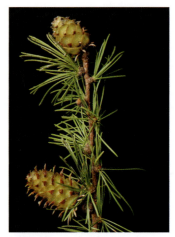
female cones on branch

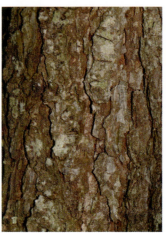
bark

74 • THE DIVERSITY OF TREES

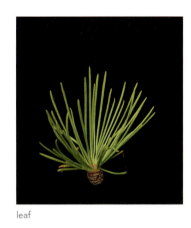
leaf

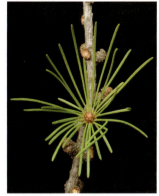
leaf

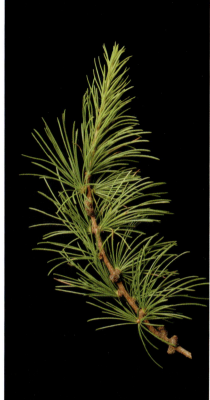
branchlet

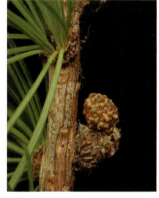
male cones

male cones on branch

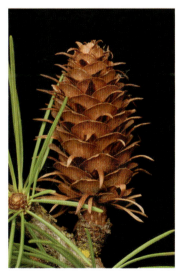
mature cone

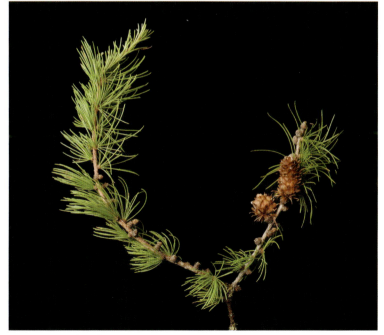
mature cones on branch

FAMILY PINACEAE • 75

GENUS PICEA

And when the late mountain light begins to leave the summer sky, there is something spirit-like about the enveloping hosts of the Engelmanns Spruce. Always a dark tree, the Spruce's outlines are now inky, and its night silence makes the sounds of an owl, or an old moose splashing somewhere across the lake, mysterious and magnified in portent.

—Donald Culross Peattie on *Picea engelmannii* in *A Natural History of North American Trees*

The genus *Picea*, the spruces, is made up of about thirty-five species distributed in northern temperate and boreal forests around the world. Trees are evergreen and can be distinguished from other conifers by the four-sided needlelike leaves that are attached to the twigs by small pegs. After a few years' time, these pegs remain on the twigs when the leaves fall off, making the branches rough. The spruces' cones distinctively hang downward when mature. The wood is used for timber, for paper, and as soundboards for musical instruments; the young shoots are a source of vitamin C. Six native species and one introduced species of *Picea* are common trees in North America.

Norway Spruce
Picea abies (L.) H. Karst.

Norway spruce is native to Europe but widely cultivated in North America for timber and as a Christmas tree. Every Christmas, the people of Oslo donate a Norway spruce to Washington, DC, New York, Edinburgh, and London in gratitude for aid given during World War II.

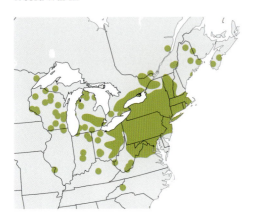

DESCRIPTION. A short-lived, evergreen tree that grows to 59–66 ft (18–20 m) in height. Bark is red brown becoming gray brown and scaly with age. Needles are light to dark green, up to 1 in (2.5 cm) long, four-angled, stiff, and sharp-pointed, with the points facing toward the branch tips. Trees are monoecious producing both male and female cones on the same plant in mid-spring. Male pollen cones are yellow brown to red or purplish and produced in the axils of the branches; female seed cones are found at the tips of branches and are reddish pink maturing to brown, 4–5.9 in (10–15 cm) long, and cylindrical, with stiff diamond-shaped scales.

USES AND VALUE. Wood commercially important. Grown in plantations and used for pulpwood, construction lumber, and musical instruments. Commonly cultivated as Christmas tree and ornamental in gardens and landscapes. Tea is made from new shoots, which are rich in vitamin C; shoot tips also used in making spruce beer. Buds, resin, and needles are antibiotic and antiseptic.

ECOLOGY. Grows in moist soils but is found in variety of sites. Shade intolerant. Non-native to North America and has few serious pests.

CLIMATE CHANGE. Vulnerability is considered low because of its wide geographic distribution as an ornamental.

CONSERVATION STATUS. Least concern.

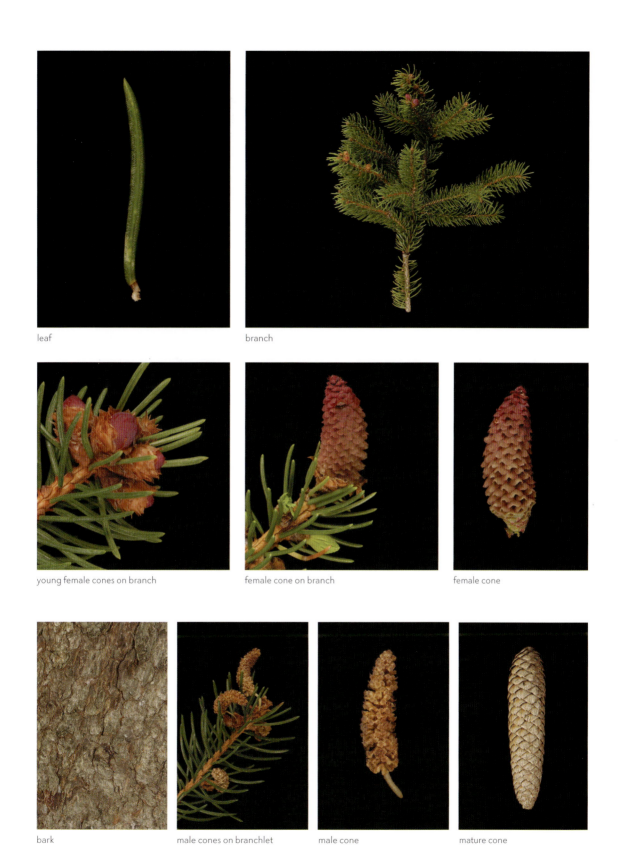

FAMILY PINACEAE • 77

Engelmann Spruce
Picea engelmannii Parry ex Engelm.
COLUMBIAN SPRUCE, MOUNTAIN SPRUCE

Engelmann spruce is a large evergreen tree with a straight trunk native to the montane and subalpine forests of western North America.

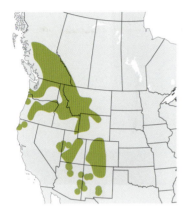

DESCRIPTION. An evergreen coniferous tree growing to 197 ft (60 m) tall with a single straight trunk up to 7 ft (2 m) in diameter. Twigs are buff brown to orange brown and densely pubescent. Bark is brownish red to reddish or purple, thin, and loosely scaly. Leaves are needlelike, four-angled, blue green above, blue white with two stomatal bands below, 0.6–1.2 in (1.5–3 cm) long, borne singly. Trees are monoecious producing male and female cones on the same plant. Male pollen cones are purplish brown, 0.4–0.6 in (1–1.5 cm) long; female seed cones are violet to deep purple, maturing to buff brown, 1.2–2.4 in (3–6 cm) broad, ellipsoid, and pendent. Seeds 0.08–0.12 in (2–3 mm) long with a pale brown wing 0.20–0.31 in (5–8 mm) long.

USES AND VALUE. Wood commercially important. Wood used for construction lumber, plywood sheathing, and pulp. Sometimes serves as substitute for Sitka spruce in the construction of pianos, musical instruments, and airplane parts. Tea is made from new shoots, which are rich in vitamin C. Young cones, inner bark, and seeds are edible. Various parts are used to treat variety of diseases, including cancer and eczema.

ECOLOGY. Grows in montane forests in cold high-altitude environments on deep, well-drained, loamy sands and silts from volcanic or sedimentary origins. Shade tolerant. Produces good seed crops every three to six years; seed germination rates are usually high. Thin bark, even in mature trees, results in susceptibility to damage from fire. Bark beetles cause substantial damage to some populations.

CLIMATE CHANGE. Vulnerability is currently considered to be low.

CONSERVATION STATUS. Least concern.

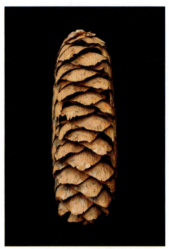

mature cone

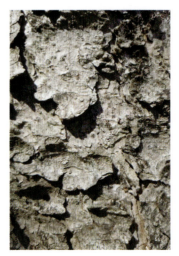

bark

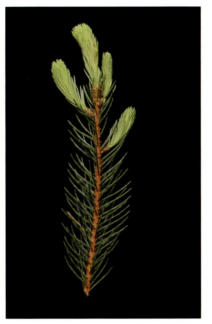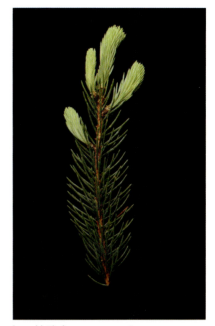

leaf above (left), leaf below (right)　　　　　　branchlet above　　　branchlet below

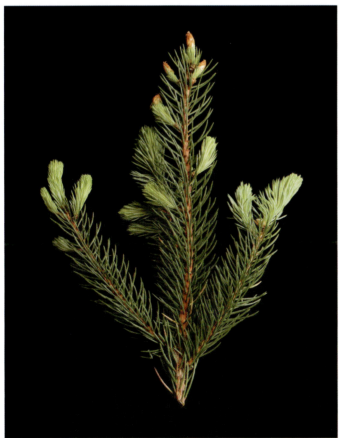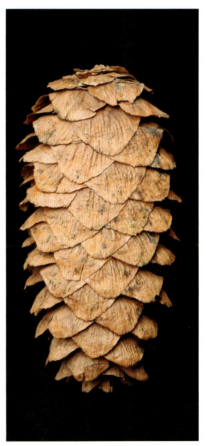

branch　　　　　　　　　　　　　　　　　　　　mature cone

FAMILY PINACEAE • 79

White Spruce

Picea glauca (Moench) Voss

Often used as a Christmas tree, white spruce is a North American native tree that also provides shelter and food to wildlife. The green to bluish-green evergreen needles are straight, rigid, four-angled, and crowded on the upper side of the twigs.

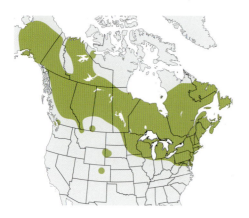

DESCRIPTION. A spire-shaped coniferous tree growing to 115 ft (35 m) tall with horizontal branches. Twigs are shiny, purplish, or orange when young, becoming yellowish brown. Bark is grayish brown and scaly, the exposed inner layer may be pink or silvery. Leaves are evergreen needles crowded on the upper side of the branches, green to bluish green, straight, rigid, and four-sided with lines of white dots on all sides, 0.59–0.87 in (15–22 mm) long, omit a somewhat foul odor when crushed. Trees are monoecious with male and female cones produced on the same plant at ends of previous year's twigs. Male pollen cones are tiny, borne in erect catkins, first appear red, then turn yellow, 0.39–0.79 in (10–20 mm) long, and grow in the lower half of the tree; female seed cones are oblong to cylindrical, nearly stalkless, pendent, 1.2–2.4 in (3–6 cm) long, with broad red or yellowish-green scales that become brown and flexible when mature. Seeds, which are released during fall and winter, are 0.08–0.16 in (2–4 mm) long with narrow wings 0.16–0.31 in (4–8 mm) long.

USES AND VALUE. Wood commercially important. Marketed with other spruce, pines and firs, and used for construction, pulp, millwork, and crates. Native Americans used parts of tree to treat wide range of diseases, especially chest complaints. Young cones, inner bark, and seeds are edible as gum, tea, or condiments.

ECOLOGY. Native to northern United States and commonly grows in boreal forests both at low and middle elevations. Intermediate in shade tolerance. Good seed crops produced every two to six years. Shallow-rooted, making it susceptible to windthrow; also sensitive to fire and flooding.

CLIMATE CHANGE. Vulnerability is significant but has a reasonable probability of persistence in the future. Ongoing monitoring is recommended.

CONSERVATION STATUS. Least concern.

bark

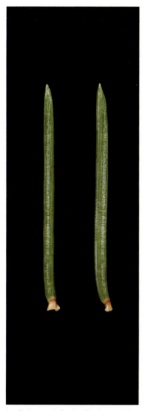

leaf above (left), leaf below (right) branch

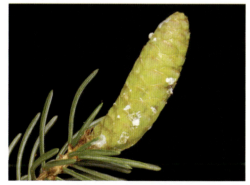

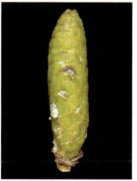
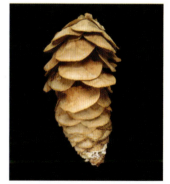

female cone on branch female cone mature cone

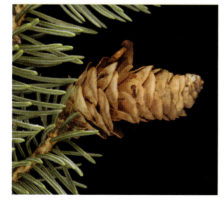
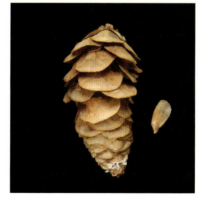
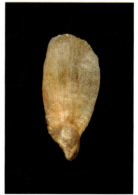

mature cone on branch mature cone and seed seed

FAMILY PINACEAE • 81

Black Spruce
Picea mariana (Mill.) Britton, Sterns & Poggenburg

Black spruce is a North American native evergreen conifer found in cold swamps and bogs at somewhat higher elevations in northern United States, the Appalachian Mountains, and the Rocky Mountains. With limited commercial use as pulp wood, it provides valuable food and shelter for birds and small mammals. The cones persist on the tree for years.

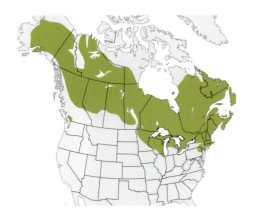

DESCRIPTION. A coniferous tree growing to 75 ft (23 m) tall in its typical habitat, with short, pendulous, and upcurving branches, presenting a spire-like profile. Twigs are orange brown or yellowish brown. Bark is reddish or grayish brown and becomes darker and scalier with age. Leaves are straight needles with blunt ends, arranged densely along the twig, with side needles at right angles and upper needles pointing forward, grayish green with lines of white dots on the underside, 0.31–0.59 in (8–15 mm) long. Trees are monoecious producing male and female cones on the same plant. Male pollen cones are borne in the lower half of the tree, tiny and rounded, catkin-like, erect, red, 0.39–0.79 in (10–20 mm) long; female seed cones are placed in the upper part of the crown, attached by short curved stalks, oval with blunt ends, 0.8–1.2 in (2–3 cm) long, and reddish purple when young becoming purplish brown when mature, cone scales are tight-fitting, finely toothed, and woody; seed cones generally mature in early fall, but may remain on the tree for thirty years. Seeds are tiny, dark, oblong, 0.08 in (2 mm) long, with pale wings, 0.08–0.16 in (2–4 mm) long.

USES AND VALUE. Wood not commercially important. Used for pulp and construction lumber. Sometimes harvested for Christmas trees. Gum used to make healing salve. Native Americans use the roots as fibers to stitch together canoes and in basketry. Young cones, inner bark, and seeds are edible and used for tea, condiments, and gum. Medicinal uses are numerous, including for relief of mouth sores and toothaches. Spruce grouse is highly dependent on black spruce for cover, food, and nesting. Many birds eat the seeds.

ECOLOGY. Grows in cool bogs in the southern part of its range and on upland slopes in the north. Prefers moist alluvial well-drained soils. Shade tolerant. Irregularly produces good annual seed crops; seed germination around 60 percent. Thin bark makes tree susceptible to fire damage; windthrow common due to moist soils and shallow roots. Attacked by numerous insect and fungal pathogens; spruce budworm, one of the worst pests, can decimate trees.

CLIMATE CHANGE. Vulnerability is significant but has a reasonable probability of persistence in the future. Ongoing monitoring is recommended.

CONSERVATION STATUS. Least concern.

bark

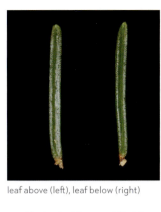
leaf above (left), leaf below (right)

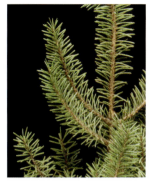
branch

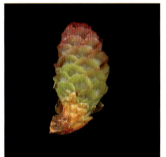
female cone

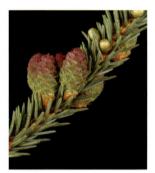
female cones on branchlet

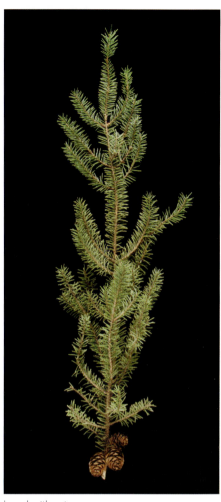
branch with mature cones

male cone

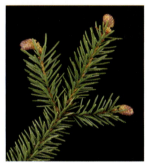
male cones on branchlet

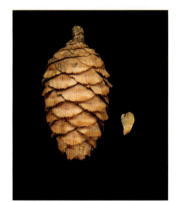
mature cone and seed

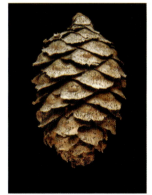
mature cone

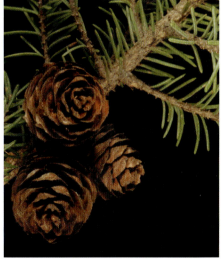
mature cones on branch

FAMILY PINACEAE • 83

Blue Spruce
Picea pungens Engelm.
COLORADO BLUE SPRUCE

Blue spruce is an evergreen tree native to western North America characterized by long, needlelike leaves with very sharp tips. The gray green and glaucous blue coloration of the needles is caused by surface waxes that intensify with the age of the tree.

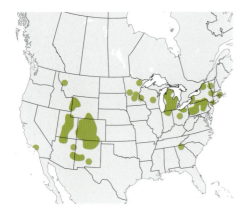

DESCRIPTION. A long-lived, slow-growing, evergreen tree, reaching nearly 98 ft (30 m) in height. Bark is gray brown to red brown and scaly, becoming shallowly fissured with age. Needlelike leaves are four-angled, stiff, sharply pointed, gray green to blue green, and 1–1.3 in (2.5–3.2 cm) long. Trees are monoecious producing both male and female cones on the same plant in late spring. Male pollen cones are reddish purple becoming yellow brown; female seed cones are larger, cylindrical, 2–4 in (5–10 cm) long, and greenish to purple maturing to light brown, with wavy cone scales tipped with "claws," some remaining unopen on trees for many years.

USES AND VALUE. Wood not commercially important. Very popular as ornamental with many cultivated varieties; often used as Christmas tree. Flowers, inner bark, and seeds are edible. Tea made from young shoots is high in vitamin C. No medicinal uses are known.

ECOLOGY. Grows most commonly along streambanks, in moist canyon bottoms, and in mid-montane forests in its native North America. Intermediate in shade tolerance. Produces good seed crops every two to three years. Sensitive to fire and susceptible to windthrow. Attacked by a variety of insects and fungi, but none causes severe damage.

CLIMATE CHANGE. Vulnerability is significant but may have the capacity to adapt to changing conditions in the future. Ongoing monitoring is recommended.

CONSERVATION STATUS. Least concern.

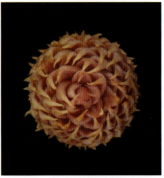
male cone

bark

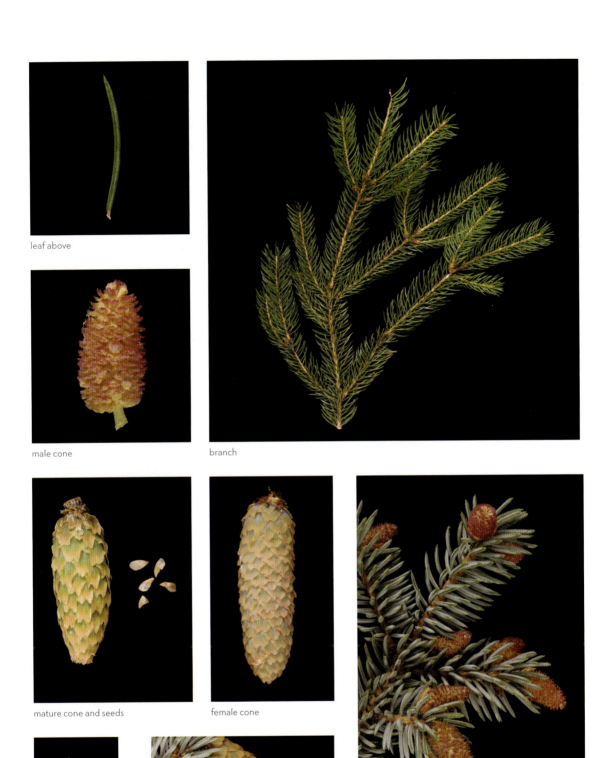

FAMILY PINACEAE • 85

Red Spruce
Picea rubens Sarg.
EASTERN SPRUCE, YELLOW SPRUCE

Red spruce, native to northeastern North America and the Appalachians, is one of the most common lumber trees in the region. The wood is often used to make sounding boards in musical instruments and is commonly used as a Christmas tree. The buds, tender foliage, and seeds provide food for birds and mammals.

DESCRIPTION. A coniferous tree growing to 79 ft (24 m) tall, that may live for several hundred years. Branches slope downward. Twigs are shiny and yellow or reddish brown. Bark is reddish-brown developing large scales with age. Leaves are needlelike, evergreen, and persist for years, curved with have blunt tips, spirally arranged and closely aligned with the twigs, 0.39–0.63 in (10–16 mm) long. Trees are monoecious producing male and female cones on the same plant. Male pollen cones are catkin-like, erect, borne along or at the ends of the previous year's twig, 0.39–0.79 in (10–20 mm) long; female seed cones are borne in the upper portion of the tree, oval, greenish purple at the time of pollination, later dark brown, with stiff scales ending in blunt tips, 1.2–2 in (3–5 cm) long, pendent at maturity in late summer or early fall. Seeds are shed during the following year, dark brown, 0.08 in (2 mm) long with wings 0.12–0.20 in (3–5 mm) wide.

USES AND VALUE. Wood very commercially important. Wood used for pulp, construction lumber, and for sounding boards in musical instruments. Young cones, inner bark, and seeds are edible and made into tea and gum, which is rich in vitamin C. Medicinal uses include treatment of colds and measles. Mice and voles feed on red spruce seeds; squirrels eat the terminal buds.

ECOLOGY. Grows in cool moist bogs and on well-drained upland sites, especially on sandy loam with good moisture. Shade tolerant. Produces good seed crops at three- to eight-year intervals, germination is around 60 percent. Very susceptible to windthrow and thin bark results in severe damage by fire. Attacked by spruce budworm, which can decimate trees.

CLIMATE CHANGE. Vulnerability, though currently considered to be low, may increase in the future. Ongoing monitoring is recommended.

CONSERVATION STATUS. Least concern.

seed

bark

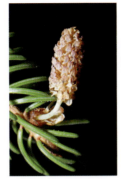

leaf above (left), leaf below (right) male cone on branchlet

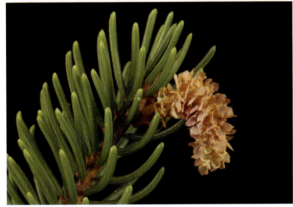
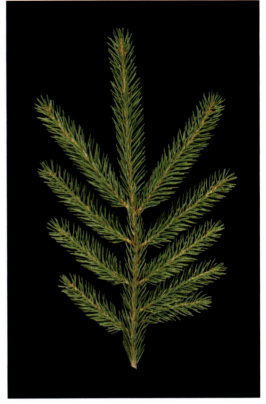

male cone on branchlet branch

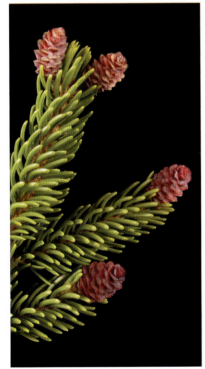
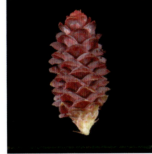
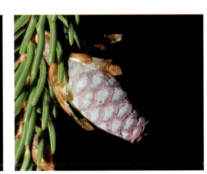

female cone female cone

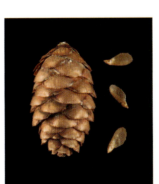
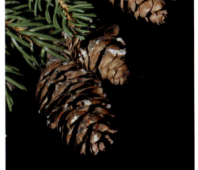

female cone on branchlet mature cone and seeds mature cones on branch

FAMILY PINACEAE • 87

Sitka Spruce
Picea sitchensis (Bong.) Carrière
COAST SPRUCE

Sitka spruce, a large conifer native to the lowland Pacific coastal forests of North America, grows in maritime climates, occurring from the shoreline to the timberline in the northern part of its range, but primarily near the shoreline farther south.

DESCRIPTION. An evergreen coniferous tree growing to a height of 197 ft (60 m) and diameter of 10 ft (3 m) with a single, straight and buttressed trunk, short open crown, and a wide-spreading shallow root system. Twigs are stout, pinkish brown, glabrous, and rough. Bark is gray, smooth, thin, and dark purplish brown, with scaly plates. Leaves are needlelike, flattened-triangular in cross section, blue green to light yellow green, and 0.6–1 in (1.5–2.5 cm) long, upper surface is darker green with narrow stomatal bands, while the lower surface is glaucous with conspicuous stomatal bands. Trees are monoecious producing male and female cones on the same plant. Female seed cones are pendent, oblong, borne at the top of the tree, green to purple, maturing to a buff brown, and 2–3.5 in (5–9 cm) long.

USES AND VALUE. Wood very commercially important. Used for construction lumber, plywood, and pulp, with numerous specialty uses, including sounding boards for musical instruments, airplane components, wind turbines, and custom-made boats. Immature cones, inner bark, and seeds are edible. Young shoots made into a tea rich in vitamin C.

Native Americans use many parts of the tree to treat wide variety of diseases and aliments. Inner bark is laxative.

ECOLOGY. Grows in hyper-maritime and maritime climates, including temperate rain forests, and occurs from shoreline to timberline in northern range but only near the shoreline farther south. Prefers deep, moist, well-drained soils with high calcium, magnesium, and phosphorus content. Salt and shade tolerant. Produces good seed crops every three to five years. Highly susceptible to windthrow and moderately damaged by fire. White pine weevil is serious pest that attacks the terminal shoots of young trees.

CLIMATE CHANGE. Vulnerability is currently considered to be low.

CONSERVATION STATUS. Least concern.

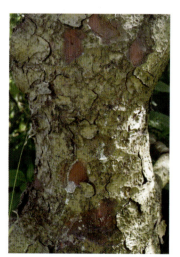

bark

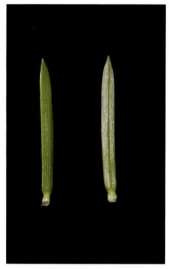
leaf above (left), leaf below (right)

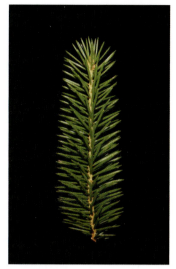
branchlet above

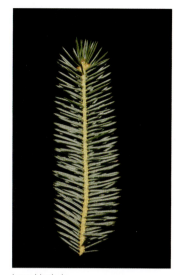
branchlet below

branch above

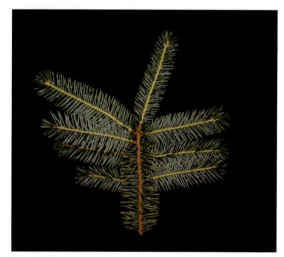
branch below

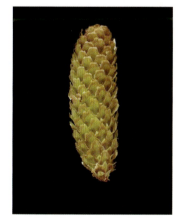
female cone

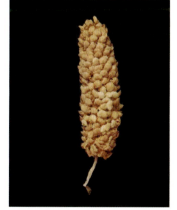
male cone

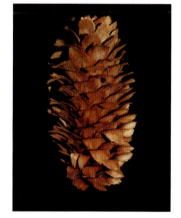
mature cone

FAMILY PINACEAE • 89

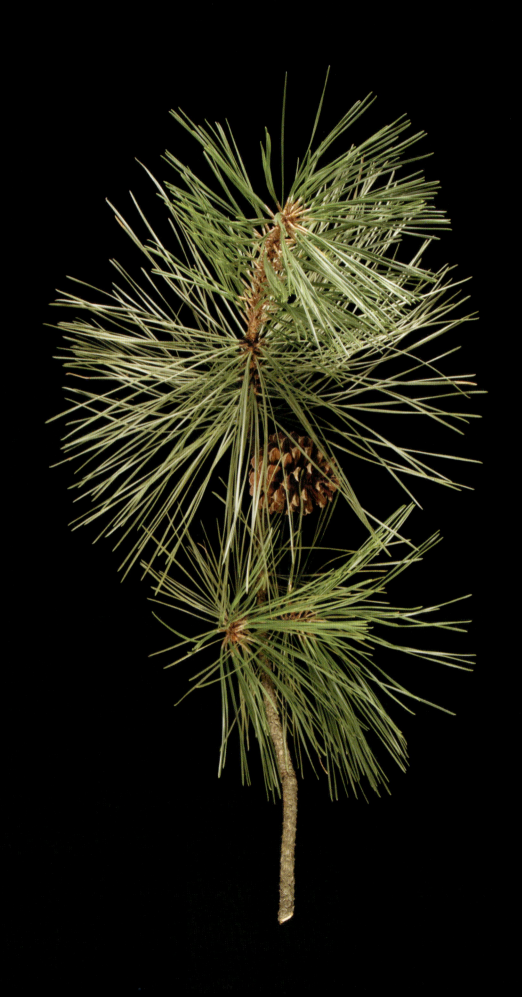

GENUS PINUS

This intransigent Pine has no business future, nor will it—slow-growing, stingy of shade, without one concession to grace—ever find a role in horticulture. Its place is high on a mountain ridge, where it looks down on the soaring buzzards, where the wildcat lives, and the rattler suns its coils.

—Donald Culross Peattie on *Pinus pungens* in *A Natural History of Trees of Eastern and Central North America*

About 125 species of *Pinus* are currently recognized. The name *pine* derives from the Latin *pinus*, which means "resin." Pines are for the most part found in the Northern Hemisphere and may occur in a wide variety of habits at elevations ranging from wet tropical forests to cold Temperate Zones to arid regions. They are medium-sized to tall evergreen trees that can live one thousand years or more. The trunk appears to have whorls of branches at each node, but upon closer inspection these branches are clustered into tight spirals around the stems. The leaves are needlelike and produced in small groups on the twigs, called fascicles. The number of needles in a fascicle is an important character in the classification of pines. Pines are monoecious and produce both male and female cones on the same tree. The seeds are dispersed by the wind in some species and by birds in others. Many species of *Pinus* are commercially important for lumber and often grown in plantations. Trees of some species are cultivated as ornamentals and seeds, or "pine nuts," may be used in baking and cooking. Four introduced species and twenty-seven native species of *Pinus* are common trees in North America.

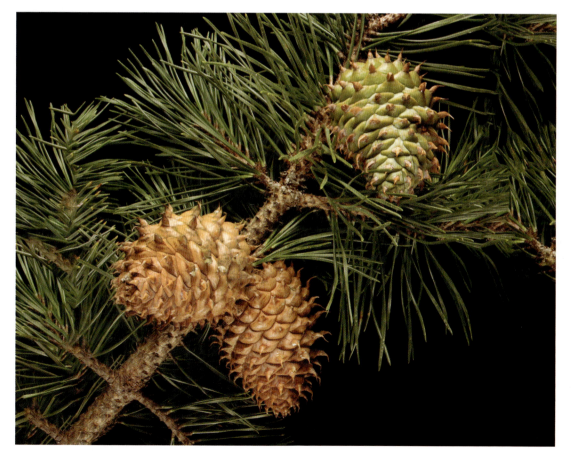

OPPOSITE Pitch pine (*Pinus rigida*). **ABOVE** Table mountain pine (*Pinus pungens*).

Whitebark Pine

Pinus albicaulis Engelm.

Whitebark pine, an endangered, alpine member of the pine family, has a spreading or columnar shape depending on light availability. It has coevolved with Clark's nutcracker and relies on the bird for seed dispersal and germination.

DESCRIPTION. An evergreen conifer growing to 16–66 ft (5–20 m) tall with an irregular canopy that can be spreading to columnar. Trunk is fast-tapering with long willowlike branches that withstand heavy snow loads and strong winds. Twigs are stout, reddish, and pubescent. Bark is white to gray and smooth in saplings, separating and fissured in older trees. Curved needlelike leaves are arranged in groups of five, yellow green, and 1.6–3.1 in (4–8 cm) long, white below due to stomatal rows, and distal margins minutely serrate. Trees are monoecious producing male and female cones on the same plant. Male pollen cones are red and 0.39–0.59 in (10–15 mm) long; female seed cones are dull gray, cross-keeled, indehiscent, and 1.6–3.1 in (4–8 cm) long. Seeds are 0.27–0.43 in (7–11 mm) long, wingless, and edible.

USES AND VALUE. Wood not commercially important. Cultivated as ornamental due to high aesthetic value and serve in watershed protection. Seeds are edible and ground into powder as flavor for soups and other foods. No medicinal uses are known. Clark's nutcrackers, which bury and cache the seeds, are responsible for natural regeneration. Blue grouse roost and nest in the branches. Seeds are source of food for grizzly bears and other wildlife.

ECOLOGY. Adapted to cold moist climates at 4,265–12,139 ft (1,300–3,700 m) of elevation in alpine areas near the timberline. Prefers rocky, well-drained, nutrient poor, and acidic soils. Shade intolerant. Produces large seed crops at irregular intervals with low germination rates (8–14 percent). Significant damage caused by white pine blister rust (*Cronartium ribicola*) and mountain pine beetle (*Dendroctonus ponderosae*). Individual trees are long-lived (1,200 years old), resistant to windthrow due to the deep spreading root system, susceptible to damage from fire, and drought resistant.

CLIMATE CHANGE. Vulnerability is currently considered to be low.

CONSERVATION STATUS. Endangered.

leaves

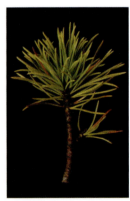

branch

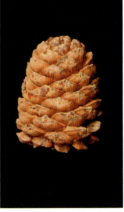

mature cone

bark

Sand Pine

Pinus clausa (Chapm. ex Engelm.) Vasey ex Sarg.

Sand pine is an evergreen conifer that grows on xeric sandy soils in scrub habitats in Alabama and Florida. Cones are semiserotinous and may not depend on fire for dispersal.

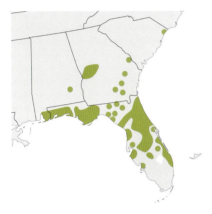

DESCRIPTION. A small monoecious evergreen conifer that grows up to 66 ft (20 m) tall. Branches are divided. Twigs are slender and violet to ruddy colored. Bark is gray and fibrous, brittle, and lacks resin pockets. Leaves are needlelike, two per fascicle, and 2.4–3.5 in (6–9 cm) long; stomata are present on all surfaces. Trees are monoecious producing male and female cones on the same plant. Male pollen cones are yellow, 0.39 in (10 mm) long; female seed cones are sessile or short-stalked, reddish, and 1.2–3.1 in (3–8 cm) long; mature within two years and may be serotinous or non-serotinous. Seeds are dark brown, 0.16 in (4 mm) long with a wing up to 0.67 in (17 mm) long.

USES AND VALUE. Wood commercially important. Used for pulpwood and construction lumber. Cultivated as Christmas tree. Important for wildlife, providing cover, nesting sites, and food for many threatened or endangered species of animals.

ECOLOGY. Grows on sandy coastal sites and small islands as a community dominant in Florida scrub habitat. Prefers xeric sandy soils at low elevations (20–200 ft or 6–61 m) on well-drained, acidic, marine soils. Moderately shade intolerant, especially when young. Produces good seed crops every four to six years. Semiserotinous cones are not dependent on fire for reproduction. Susceptible to damage by fire but resistant to wind, salt, and drought. Pests include Ips bark beetle, which causes significant loss in growth and mortality.

CLIMATE CHANGE. Vulnerability, though currently considered to be low, may increase in the future. Ongoing monitoring is recommended.

CONSERVATION STATUS. Least concern.

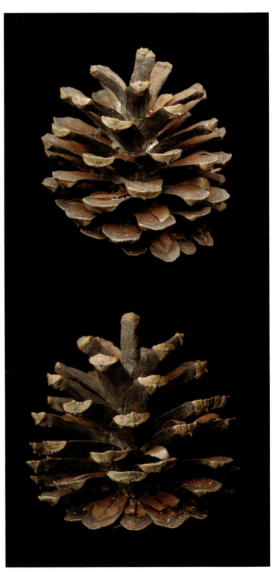

mature cones

Bristlecone Pine
Pinus aristata Engelm.
COLORADO BRISTLECONE PINE, FOXTAIL PINE

Bristlecone pine is a small conifer that grows as a tree or large shrub on nutrient-poor acidic soils in montane and subalpine communities. Individuals can live to be one thousand years or more old.

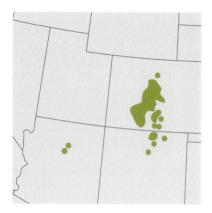

DESCRIPTION. A small tree growing up to 39 ft (12 m) in height with a diameter of 3 ft (1 m), typically single-stemmed but may have multiple stems. Habit varies with elevation, most often growing as a tree in subalpine elevations and becoming stunted near tree line. Trunk is typically twisted and irregular. Bark is gray to reddish with shallow irregular fissures. Leaves are needlelike, arranged five per fascicle, becoming denser near branch terminus, 1–2 in (2.5–5 cm) long, resinous and sticky to the touch, the surface below narrowly grooved, white due to stomata. Trees are monoecious producing male and female cones on the same plant. Male pollen cones are bluish or red in color and 0.39 in (10 mm) long; female seed cones are armed with sharp scales, mature in two years, and 2.4–4.3 in (6–11 cm) long. Winged seeds are 0.20–0.24 in (5–6 mm) long with wings 0.39–0.71 in (10–18 mm) long.

USES AND VALUE. Wood not commercially important. Trees have high aesthetic value by naturalists and recreationalists. Their long lives and old age provide scientists with important information on past climates.

ECOLOGY. Grows on nutrient-poor acidic soils in upper montane and subalpine habitats, typically between 7,546 and 11,975 ft (2,300–3,650 m) above sea level. Wood dense and resinous, so resistance to decay is high. Individuals can be long-lived to over one thousand years old. Mountain pine beetle (*Dendroctonus ponderosae*) and white pine blister rust (*Cronartium ribicola*) may cause severe damage.

CLIMATE CHANGE. Vulnerability, though currently considered to be low, may increase in the future. Ongoing monitoring is recommended.

CONSERVATION STATUS. Least concern.

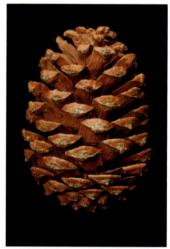

mature cone

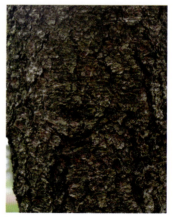

bark

leaves

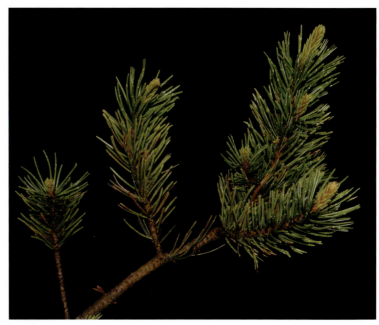
branch

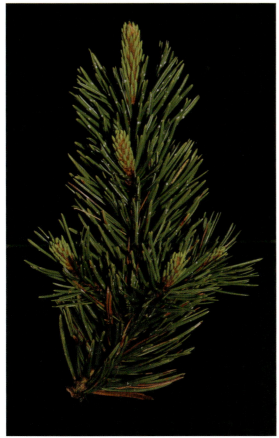
branchlet

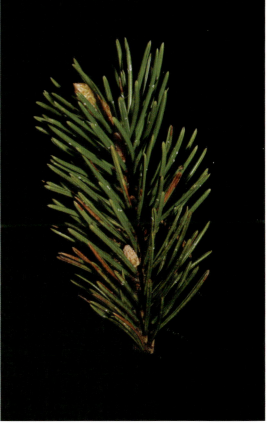
male cones on branchlet

Knobcone Pine
Pinus attenuata Lemmon

Knobcone pine is one of North America's most widely occurring western pines with closed cones. Typically found in transition habitats between chaparral, woodland, and high-elevation forests, this species prefers mild climates and shallow rocky soils. The distinctive seed cones may remain closed for many years until heated by fire.

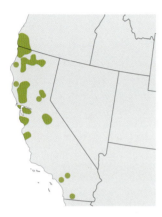

DESCRIPTION. A fast-growing conifer that reaches 20–39 ft (6–12 m) in height, often multistemmed, with a straight bole and conical crown. Bark is violet brown to dark brown with shallow fissures, becoming nearly smooth on the upper trunk. Leaves are needle-like, borne three per fascicle on slender and reddish twigs, straight to slightly curved and yellow green, with stomata on both upper and lower surfaces. Trees are monoecious producing male and female cones on the same plant. Male pollen cones are 0.39–0.59 in (10–15 mm) long and orange; female seed cones are distinctive in being asymmetric, arched, and indehiscent, produced in whorls of four or five, may stay closed for up to twenty years and open in response to fire. Seeds are black and 0.24–0.27 in (6–7 mm) long with a single wing up to 0.79 in (20 mm) long.

USES AND VALUE. Wood not commercially important. No food or medicinal uses are known.

ECOLOGY. North America's most widely occurring western closed-cone pine and occupies transitional habitats between chaparral, woodland, and high-elevation forest. Populations historically maintained by fire. Prefers mild Mediterranean climates and commonly grows on serpentine substrate or volcanic soils that are shallow and rocky. Individuals often do not live beyond sixty years. Drought resistant. Relatively free of diseases due in large part to the dry conditions of environments. Serotinous cones require fire to open and disperse the seeds.

CLIMATE CHANGE. Vulnerability is currently considered to be low.

CONSERVATION STATUS. Least concern.

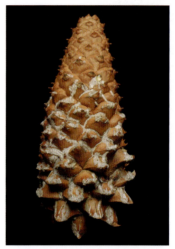

mature cone

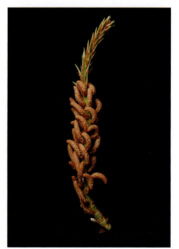

male cones on branchlet

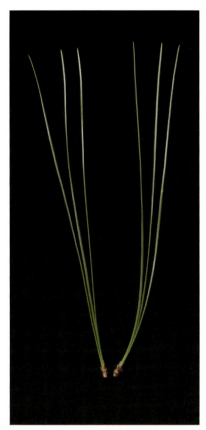

leaves above (left), leaves below (right)

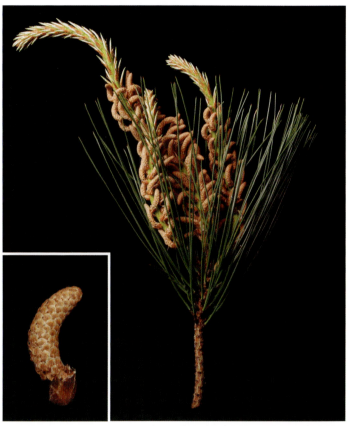

branch with male cones, male cone (inset)

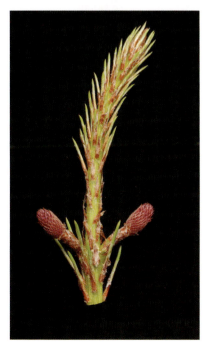

female cones on branchlet

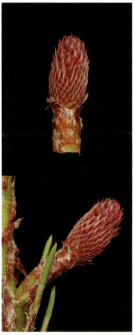

female cones

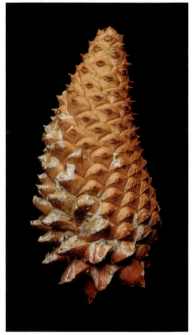

mature cone

FAMILY PINACEAE • 97

Jack Pine
Pinus banksiana Lamb.
HUDSON BAY PINE, SCRUB PINE

Jack pine is a small conifer native to the far northern forests of Canada and the United States, occurring frequently in sandy soils and rocky outcrops. Kirtland's warbler relies on this species to provide essential habitat for survival.

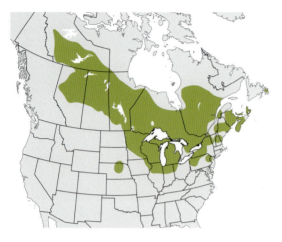

DESCRIPTION. A small coniferous tree growing to 66 ft (20 m) tall with a conical crown and ascending arched branches. Trunks in mature specimens may be branched until 20–30 ft (6–9 m) above the ground. Twigs are thin and yellowish green when young, turning grayish brown, ridged, and grooved. Bark is reddish brown in young trees, becoming dark brown and platy in older trees. Leaves are needlelike, evergreen, in bundles of two with persistent bundle sheath, straight or slightly twisted, and stiff, with sharp points and tiny toothed edges, 0.8–1.6 in (2–4 cm) long. Trees are monoecious producing male and female cones on the same plant. Male pollen cones yellow, clustered; female seed cones also clustered in two or three at nodes, stalkless, yellowish-brown, oblong to conical in shape, asymmetrical, usually curve inward and point forward; cone scales are thick at the tips, keeled, and sometimes with tiny prickles; may persist on tree in an indehiscent state for many years at which time fire or strong sunlight cause the cones to open. Seeds dark brown, ridged, 0.12 in (3 mm) long with wings 0.39 in (10 mm) long.

USES AND VALUE. Wood commercially important. Used for pulp, construction lumber, poles, and pilings. Young cones, inner bark, and seeds are edible; used for tea and condiments. Turpentine obtained from resin has wide range of medicinal properties, including treating kidney and bladder complaints. Kirtland's warbler relies on large populations (eighty acres or more) of jack pine as habitat; active management of these forests has allowed populations of bird to recover.

ECOLOGY. Grows on a wide range of soils, including poor, dry, sandy, well-drained soils, where other conifers will not persist. Pioneer species, often establishing and persisting on burned-over sites and habitats with thin soil over bedrock or permafrost. Shade intolerant. Prolific seeder, producing good crops every three to four years with germination rates of 60–75 percent. Susceptible to fire and to some extent dependent on fire for reproduction because of serotinous cones. Root system deep and spreading, resulting in resistance to windthrow. Damaging herbivores include white-tailed deer, snowshoe hares, elk, and voles, all of which browse on young seedlings. Porcupine feed on larger trees. A host of insects and fungi, including the mountain pine beetle (*Dendroctonus ponderosae*), are pests.

CLIMATE CHANGE. Vulnerability is significant but has a reasonable probability of persistence in the future. Ongoing monitoring is recommended.

CONSERVATION STATUS. Least concern.

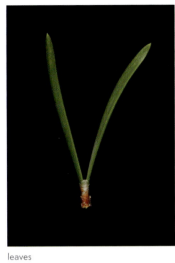
leaves

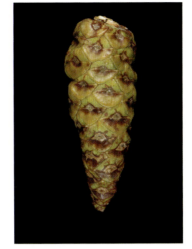
mature unopen cone

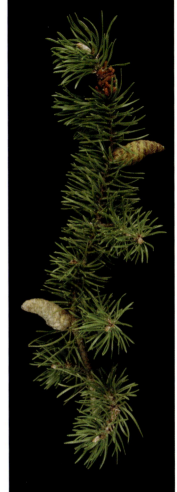
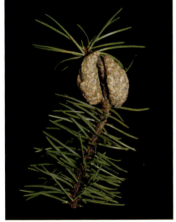
mature cones on branchlet

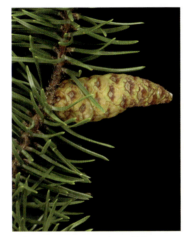
mature unopen cone on branchlet

branch with male and female cones

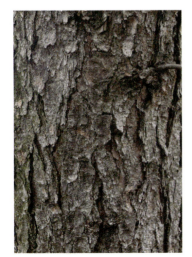
bark

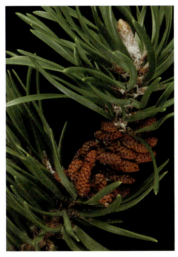
male cones on branchlet

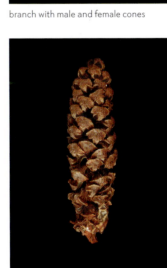
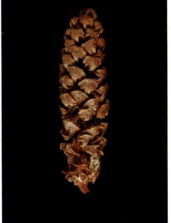
male cone

FAMILY PINACEAE • 99

Lodgepole Pine
Pinus contorta Douglas ex Loudon
SHORE PINE

Lodgepole pine is a species of large conifer native to the Rocky Mountains and Pacific coastal forests of western North America that grows in a variety of elevations, soil conditions, and moisture gradients. Four varieties are recognized.

DESCRIPTION. An evergreen coniferous tree growing up to 164 ft (50 m) tall with a straight or contorted trunk. Twigs are slender, rough, and orange to red brown. Bark is brown to gray or red brown and furrowed. Leaves are needlelike, twisted, two per fascicle, 0.8–3.1 in (2–8 cm) long, all surfaces have stomatal lines, margins finely serrulate, with blunt apex. Trees are monoecious producing male and female cones on the same plant. Male pollen cones are cylindrical, 0.20–0.59 in (5–15 mm) long; female seed cones are reddish purple ripening to orange brown, 1.2–2.4 in (3–6 cm) long. Seeds black, 0.20 in (5 mm) long. Some varieties require fire to release seeds from their cone.

TAXONOMIC NOTES. Variety *contorta* distinguished by relatively shorter leaves (about 0.8–2.8 in or 2–7 cm long) and furrowed bark, coastal form, known as "shore pine," grows to 30 ft (9 m) in height and 1.6 ft (0.5 m) in diameter with short bole, irregular crown, and misshapen branches, found in peat bogs and dry sanding soils along the coast; var. *latifolia* has asymmetric seed cones with upper branches horizontally spreading, inland form (lodgepole pine) grows to 79 ft (24 m) in height and 3 ft (1 m) in diameter with a clear cylindrical stem and short narrow crown, found on moist, well-drained, sandy or gravelly loam at elevations from 1,499 to 11,483 ft (457–3,500 m); var. *murrayana* with symmetric seed cones, not serotinous, and do not persist; var. *bolanderi* lacks resin canals.

USES AND VALUE. Coastal form (shore pine) not commercially important; inland form (lodgepole pine) very commercially important. Used for construction lumber, plywood, pulpwood, utility poles, fence posts, and railroad ties. Inner bark, sap, and seeds are edible and used for condiments and gum. Native Americans use various parts of tree to treat wide range of ailments. Provides critical cover for grazing livestock on many western lands. Aesthetically valued by outdoor naturalists.

ECOLOGY. Grows in a variety of elevations, soil conditions, and moisture gradients. Found on slopes and basins, but also common on rocky terrain on steep slopes. Grows best in deep soils. Shade intolerant. Produces good seed crops every two to three years. Preferred host for mountain pine beetle (*Dendroctonus ponderosae*), which has decimated stands in western North America. Highly susceptible to fire damage due to thin bark and windthrow due to shallow root system to.

CLIMATE CHANGE. Vulnerability is currently considered to be low.

CONSERVATION STATUS. Least concern.

bark

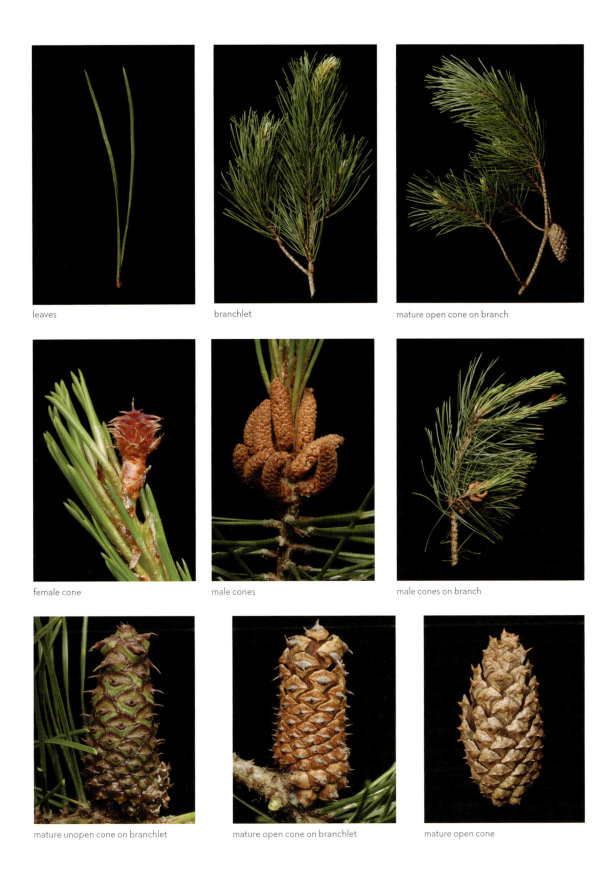

FAMILY PINACEAE • 101

Shortleaf Pine
Pinus echinata Mill.
YELLOW PINE

Shortleaf pine is a coniferous evergreen tree native to the eastern United States. The irregularly shaped crowns provide protection for many animals and habitat for the endangered red-cockaded woodpecker. The wood is a commercially important source of lumber.

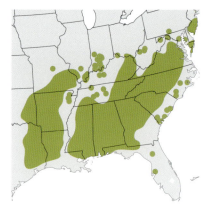

DESCRIPTION. A medium-lived, evergreen, coniferous tree usually found in upland dry forests that grows to 98 ft (30 m) in height. Bark is black and scaly when the tree is young, becoming fissured in reddish-brown plates when older. Leaves are needlelike, clustered in groups of two or three, flexible, dark yellowish green, and 2.8–5.1 in (7–13 cm) long. Trees are monoecious producing both male and female cones in mid-spring. Male pollen cones are clustered, pale purple, and 0.59–0.79 in (15–20 mm) long; female seed cones are reddish brown, egg-shaped, and 1.6–2.4 in (4–6 cm) long. Seeds are brown with wings 0.18 in (4.5 mm) long.

USES AND VALUE. One of the four most commercially important southern yellow pines. Used for construction lumber, plywood, and pulpwood. Medicinal applications are minor. In natural communities provides cover, nesting sites, and food for birds and rodents. Old-growth stands are critical habitat for the federally endangered red-cockaded woodpecker.

ECOLOGY. Grows in a broad range of dry to moist habitats. Shade intolerant. Produces good crops of seed every three to six years, with germination rate of 70 percent. Windfirm due to a deep taproot; generally resistant to fire, will produce stem sprouts if damaged. Most resistant to windthrow, ice damage, and extreme temperature changes among the southern yellow pines. Attacked by southern pine beetle (*Dendroctonus frontalis*) and little leaf disease, but in general is relatively pest free.

CLIMATE CHANGE. Vulnerability is currently considered to be low.

CONSERVATION STATUS. Least concern.

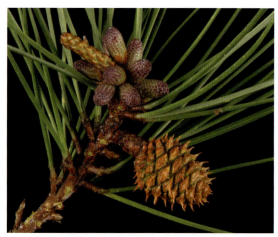

male and female cones on branchlet

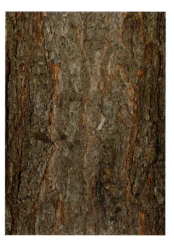

bark

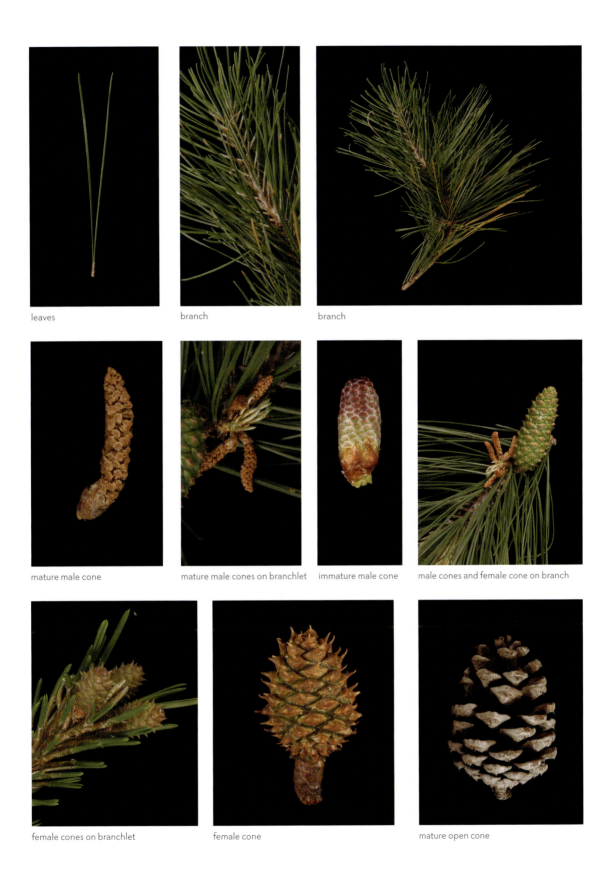

FAMILY PINACEAE • 103

Pinyon
Pinus edulis Engelm.
NUT PINE, TWO-NEEDLE PINYON

Pinyon is a long-lived, drought-tolerant, shrublike tree that lives in semiarid regions of the southwestern United States, where it co-habits woodland communities with juniper and other pine species. The wingless seeds remain in the cone and are dispersed by several species of bird.

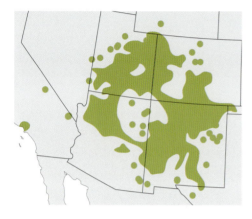

DESCRIPTION. A slow-growing, erect, conical large shrub or tree that reaches 69 ft (21 m) in height. Crowns are flat-topped in older individuals. Roots include both lateral root system and a taproot, which grows more than 20 ft (6 m) into the terrain. Twigs are reddish or tan, maturing to a gray color. Bark is reddish brown and shallowly furrowed into scaly ridges. Leaves are needlelike, grouped two per fascicle, upcurved, two-sided, with both surfaces covered with stomatal bands, 0.8–1.6 in (2–4 cm long) long. Trees are monoecious producing male and female cones on the same plant. Male pollen cones are yellowish to red brown and 0.27 in (7 mm) long; female seed cones are symmetric, yellow to reddish brown, and resinous, 1.4–2 in (3.5–5 cm long), mature in two years. Seeds are brown, 0.39–0.59 in (10–15 mm) long, ten to twenty per cone, wingless and remain attached by scaly tissue.

USES AND VALUE. Wood not commercially important. Fuelwood preferred by local communities because of high energy content and pleasing aroma. Seeds are highly valued and marketable. Inner bark, seed, and cones are edible and used for condiments, gum, tea, and food. Some medicinal uses reported.

ECOLOGY. Grows in warm semiarid regions of the southwestern United States typically 4,593–8,858 ft (1,400–2,700 m) in elevation with other pines and junipers ("pinyon-juniper woodland"). Often found on foothills above desert shrublands or grasslands, below ponderosa pine forest. Drought- and cold-tolerant, adapted to intense sun exposure, wind, and high evapotranspiration rates. Persists on a wide range of soils. Long-lived, often five hundred to one thousand years old. Shade intolerant. Produces good seed crops every five to seven years; dispersal by four species of birds: Steller's jay, western scrub-jay, pinyon jay, and Clark's nutcracker. Young trees susceptible to fire. Windfirm due to large taproot and spreading root system required to survive on dry slopes. Attacked by various insect and fungal pests, including mountain pine beetle (*Dendroctonus ponderosae*).

CLIMATE CHANGE. Vulnerability is currently considered to be low.

CONSERVATION STATUS. Least concern.

bark

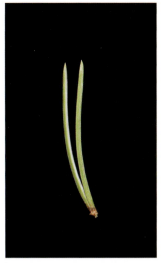
leaves

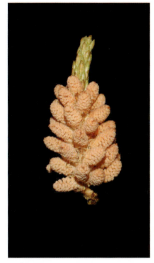
male cones

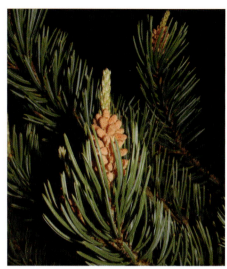
male cones on branchlet

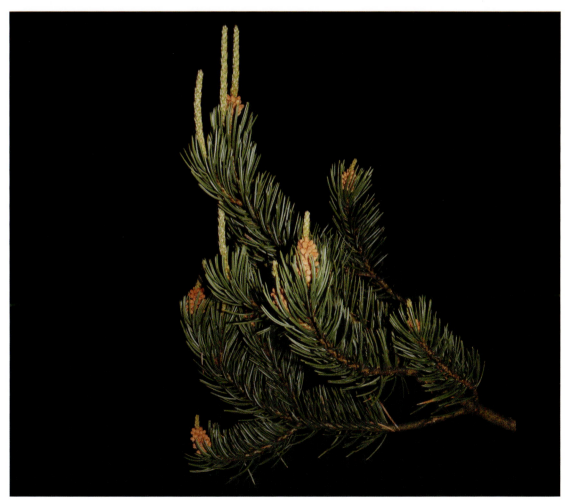
male cones on branch

FAMILY PINACEAE • 105

Slash Pine
Pinus elliottii Engelm.

Slash pine is a tall erect conifer found in warm humid climates in the southern United States often with conspecifics or in mixed hardwood forests with oak and juniper species. Commercially important and used for timber and production of turpentine. Two varieties are recognized.

DESCRIPTION. An evergreen conifer growing to 98 ft (30 m) in height with a straight erect trunk and long needles. Both lateral roots and taproot systems present. Twigs are orange when new, maturing to dark brown, rough, and scaly. Bark is characterized by thick irregular plates, orange to violet brown, papery in texture. Leaves are arranged two to three per fascicle, slightly twisted, straight, all surfaces with stomatal lines, leaf margins finely serrate, 5.9–7.9 in (15–20 cm) long. Trees are monoecious producing male and female cones on the same plant. Male pollen cones are purple, 1.2–1.6 in (3–4 cm) long; female seed cones are produced alone or in pairs on 1.2 in (3 cm) stalks, symmetric, 3.5–7.1 in (9–18 cm) long, mature in two years, scales are cross-keeled with a small prickle. Seeds are tan to dark brown, 0.24–0.27 in (6–7 mm) long, with a wing up to 0.79 in (20 mm) long.

TAXONOMIC NOTES: Variety *elliottii* is more northerly form and usually has three needles per cluster; var. *densa* is somewhat shorter in stature and has longer needles in clusters of two, smaller cones, and a longer taproot.

USES AND VALUE. One of the four most commercially important southern yellow pines. Wood is used for construction lumber, plywood, veneer, heavy timbers, railroad ties, and pulpwood. Historically, source of naval stores and tapped for resin which was converted into tar, turpentine, and rosin; today these are by-products of pulping. No known edible parts. Seeds are eaten by a variety of birds and small rodents; canopies provide cover and nesting sites for wildlife.

ECOLOGY. Grows in warm humid climates at elevations less than 492 ft (150 m), typically in mesic areas with moderate soil moisture. Shares these habitats with species of oak (*Quercus* spp.), southern redcedar (*Juniperus virginiana*), and pond cypress (*Taxodium ascendens*). Life span can exceed two hundred years. Tolerates variety of soils. Shade-intolerant, fast-growing, and aggressive invader of disturbed sites (especially after fire). Produces good seed crops every three to five years. Resistant to windthrow because of deep taproot; low susceptibility to fire. Most serious disease is fusiform rust; relatively resistant to attack by southern pine beetle (*Dendroctonus frontalis*).

CLIMATE CHANGE. Vulnerability is currently considered to be low.

CONSERVATION STATUS. Least concern.

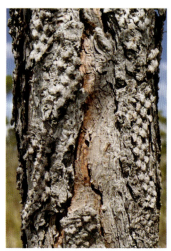

bark

leaves above (left), leaves below (right)

mature cone

branch

FAMILY PINACEAE • 107

Limber Pine
Pinus flexilis E. James

Limber pine, an evergreen conifer, is native to the mountains of the western United States and Canada. Although not especially important commercially, birds and mammals are dependent on this species for food and nesting sites.

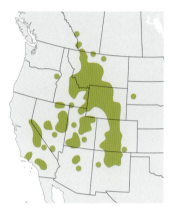

DESCRIPTION. A long-lived, evergreen, coniferous tree that grows to 39–50 ft (12–15 m) in height in dry and rocky soils in montane forests. Trunk is fast tapering with plumelike branches that reach to the ground. Bark is gray and smooth when young, becoming brown to black and furrowed, with scaly plates and ridges. Leaves are needlelike, rigid, dark green, 1.2–3.5 in (3–9 cm) long, and clustered in groups of five. Trees are monoecious with both male and female cones produced on a single tree in summer. Male pollen cones are in clusters, reddish, and 0.59 in (15 mm) long; female seed cones are ovoid, reddish purple becoming light brown at maturity, 2.8–5.9 in (7–15 cm) long. Seeds brown, 0.39–0.59 in (10–15 mm) long, sometimes with short wing.

USES AND VALUE. Wood not commercially important. Used for rough construction, mine timbers, railroad ties, and poles. Sometimes harvested as Christmas tree. Inner bark and seeds are edible and used for condiments. Medicinal uses are minor. Serves as nesting site for mountain bluebirds, northern flickers, and squirrels. Clark's nutcracker is most important seed consumer and disperser.

ECOLOGY. Pioneer species following disturbance in upper montane habitats. Shade intolerant. Good seed crops produced every two to four years. With deep taproot trees are windfirm. Susceptible to fire due to thin bark. Attacked by a wide variety of insects and fungi, including mountain pine beetle (*Dendroctonus ponderosae*).

CLIMATE CHANGE. Vulnerability is currently considered to be low.

CONSERVATION STATUS. Least concern.

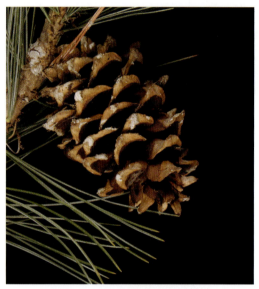

mature cone on branchlet

bark

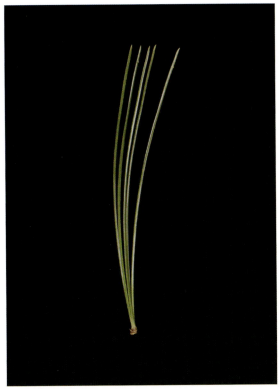
leaves

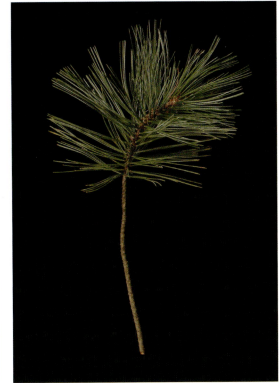
branch

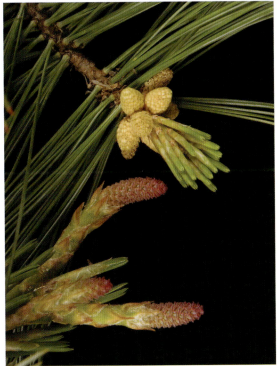
male and female cones on branchlet

male cone

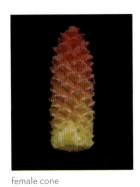
female cone

mature cone

FAMILY PINACEAE • 109

Spruce Pine
Pinus glabra Walter
CEDAR PINE

Spruce pine is a southern species of evergreen conifer typically found in mixed hardwood forests. This flood-tolerant pine prefers wet habitat and acidic sandy soils with high organic content. The timber is of little economic value, but its seeds are used by wildlife.

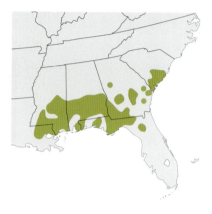

DESCRIPTION. A medium-lived conifer that grows 89–98 ft (27–30 m) in height. Trunk is straight or twisted, depending on light availability as sapling. Branches are arranged in whorls with slender reddish twigs. Bark is smooth and gray in young trees becoming fissured into papery, scaly plates at maturity resembling bark of oaks. Leaves are needlelike, two per fascicle deep green, straight and slightly twisted, has stomata on all surfaces, margins minutely serrate, 1.6–3.1 in (4–8 cm long). Trees are monoecious producing male and female cones on the same plant. Male pollen cones are purple to brown, 0.39–0.59 in (10–15 mm) long; female seed cones are red brown and unarmed, mature in two years. Seeds are mottled and deltoid-obovoid, 0.24 in (6 mm) long, with a wing 0.47 in (12 mm) long.

USES AND VALUE. Wood not commercially important. Used for pulp when harvested with other species. Limited use as a Christmas tree. Various parts are medicinal. In mixed hardwood stands with other trees, provides cover and food for wildlife, especially as winter roosting site for wild turkeys.

ECOLOGY. A member of mixed hardwood forests growing with other pine species, southern magnolia (*Magnolia grandiflora*), American beech (*Fagus grandiflora*), and species of oak (*Quercus* spp.); uncommonly found in pure stands of conspecifics. Fast growing, often outcompeting other neighboring species to become dominant in canopy. Prefers wet areas on acidic sandy soils with high organic content, persists in poorly drained areas, and withstands long-term flooding. Shade tolerant. Sensitive to cold, requiring warm moist environment to thrive. Sustains wind damage because of relatively weak wood.

CLIMATE CHANGE. Vulnerability is significant but may have the capacity to adapt to changing conditions in the future. Ongoing monitoring is recommended.

CONSERVATION STATUS. Least concern.

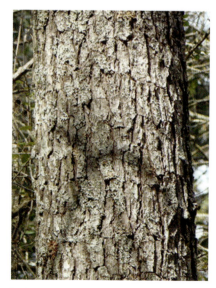

bark

leaves above (left), leaves below (right)

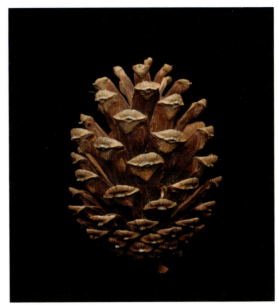
mature cone

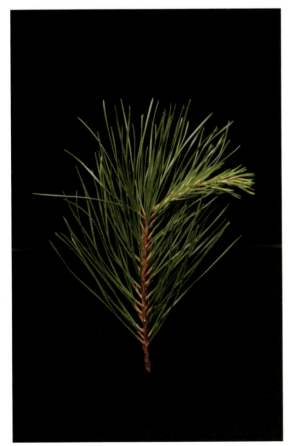
branch above

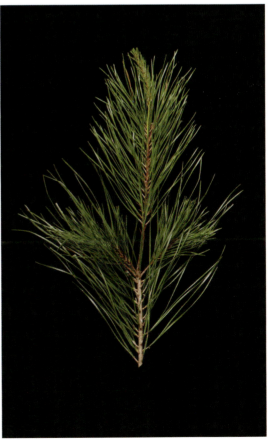
branch below

FAMILY PINACEAE • 111

Aleppo Pine
Pinus halepensis Mill.

Aleppo pine, which is native to the Mediterranean region, has naturalized in California after its introduction there as an ornamental. This single-trunked conifer has needles sparsely arranged on the ridged twigs and characteristic bark scored vertically into plates.

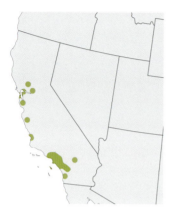

DESCRIPTION. A single-trunked conifer growing 49–82 ft (15–25 m) tall with a rounded or flattened crown. Branches and twigs are gray green and smooth, with shallow ridges. Bark in young trees is smooth and gray, maturing into violet-brown, vertically scored, scaly plates. Leaves are needlelike, sparse on the twigs, arranged in fascicles of two or three, twisted with finely serrate margins, stomata on all surfaces, 2–4.7 in (5–12 cm long). Trees are monoecious producing male and female cones on the same plant. Female seed cones are produced singly or in whorls of two to three on thick scaly stalks, long, symmetrical, and red to purple brown, 2.4–4.7 in (6–12 cm) long, mature in three years and persist after maturation. Seeds are 0.20–0.24 in (5–6 mm) long with wing up to 1 in (2.5 cm) long.

USES AND VALUE. Wood not commercially important. Planted primarily as ornamental. In native Mediterranean region commercially important for lumber production.

ECOLOGY. Naturalized in California after its introduction as an ornamental. Shade intolerant, drought resistant, and windfirm.

CLIMATE CHANGE. Vulnerability considered to be low because of wide geographic distribution as an ornamental and/or invasive.

CONSERVATION STATUS. Least concern.

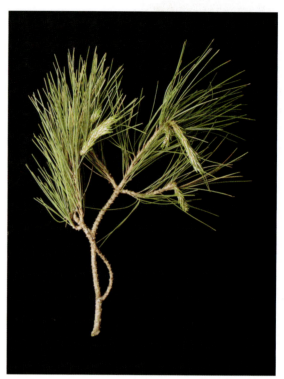
branch

bark

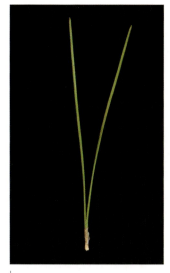
leaves

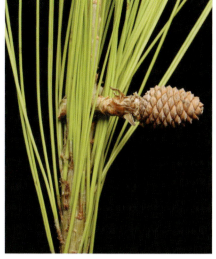
female cone on branchlet

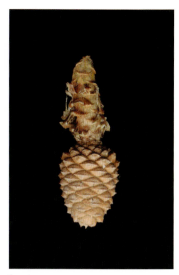
female cone

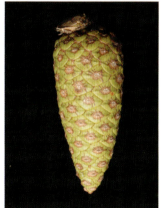
mature unopen cone

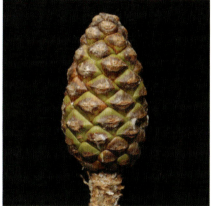
mature unopen cone

mature unopen cone

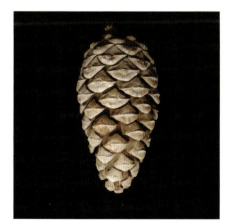
mature unopen cone

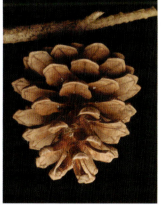
mature open cone

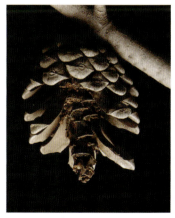
mature cone after opening and shedding seeds

FAMILY PINACEAE • 113

Jeffrey Pine
Pinus jeffreyi Balif.
BLACK PINE

Jeffrey pine is a long-lived, slow-growing conifer found in dry habitats on serpentine soils in western North America. Many of its features are highly variable by habitat, changing its growth form, trunk shape, and needle width as conditions vary.

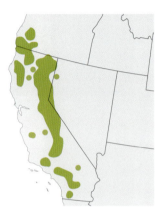

DESCRIPTION. A large, slow-growing, long-lived conifer. Conical in shape when young, over time branching into more rounded crowns with habitat conditions often affecting tree morphology. Trunks are straight except in high wind conditions. Twigs are thick, purple and roughen with age. Bark is deeply furrowed into large plates, yellow or cinnamon, smells like lemon and vanilla. Leaves are needlelike, grouped three per fascicle, twisted, gray to yellow green, thickness varies with habitat (tending to be thicker as light availability and elevation increases), stomata present on all surfaces, 4.7–8.7 in (12–22 cm) long. Trees are monoecious producing male and female cones on the same plant. Male pollen cones are generally yellow, 0.79–1.38 in (20–35 mm) long; female seed cones are terminal, asymmetric at the base, reddish brown, and nearly sessile, 5.9–11.8 in (15–30 cm) long, scales not keeled with a slightly reflexed prickle, mature in two years. Seeds are gray brown, mottled, 0.4 in (1 cm) long, with wing 1 in (2.5 cm) long.

USES AND VALUE. Wood commercially important. Similar to ponderosa pine and used for veneer, plywood, sheathing, subflooring, construction lumber, interior trim, and cabinets. Various parts used medicinally. Seeds are an important food source for a variety of rodents, including squirrels, chipmunks, mice, and voles.

ECOLOGY. Grows on very dry sites in serpentine soils with wide edaphic and elevational ranges. Often occurs on shallow, rocky, infertile soils and can persist in dry pumice or bare granitic substrates. In mixed conifer forests is community dominant where fire occurs; in the absence of fire, replaced by more shade-tolerant species. Elevation ranges from 492 to 9,514 ft (150–2,900 m) and is common above habitats dominated by ponderosa pine. Although shade intolerant, will persist in understory for considerable time. Good seed crops produced every two to eight years; seeds dispersed by wind and several species of birds, especially Clark's nutcracker. Very sensitive to fire, especially early in growing season; windfirm due to deep taproot. Serious biotic pests include dwarf mistletoe and various rusts.

CLIMATE CHANGE. Vulnerability is currently considered to be low.

CONSERVATION STATUS. Least concern.

bark

leaves above (left), leaves below (right)

branch

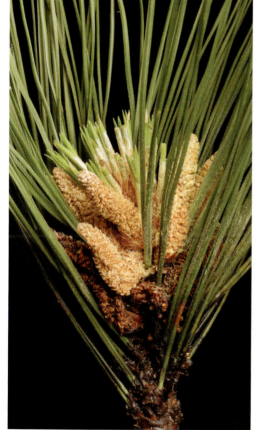
male cones on branch

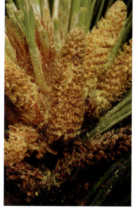
male cones

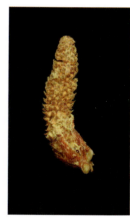
male cone

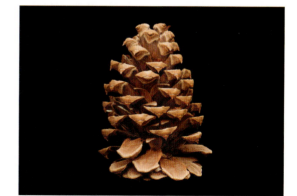
mature open cone

FAMILY PINACEAE • 115

Sugar Pine

Pinus lambertiana Douglas

Sugar pine is the tallest member of the genus and has the longest cones of any conifer. The sweet resinous sap gives the tree its common name. Trees grow in mixed conifer forests, chaparral, and timberland habitats in California and Oregon.

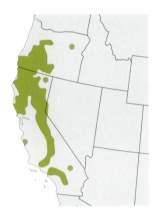

DESCRIPTION. The tallest species in its genus grows up to 249 ft (76 m) in height with conical crown. Branches are produced in uneven whorls; lower branches held at right angles to the trunk and become ascending toward the top. Twigs are gray green to ruddy, turning gray with age. Sap is sweet. Bark is cinnamon colored to gray brown and deeply furrowed into long plates. Leaves are needlelike, sharp, straight, and slightly twisted, arranged five to a fascicle, top side is white with stomatal lines, margins minutely serrate, 3 in (7.5 cm) long. Trees are monoecious producing male and female cones on the same plant. Male pollen cones are yellow, 0.59 in (15 mm) long; female seed cones are produced in clusters at the tips of branches on stalks 2.4–5.9 in (6–15 cm) long, shiny yellow brown, 9.8–11.8 in (25–30 cm) long, mature in two years, and are the longest cones of any conifer. Seeds are brown, 0.4–0.8 in (1–2 cm) long, with a wing 0.8–1.2 in (2–3 cm) long.

USES AND VALUE. Wood commercially important. Highly valued for clear, dimensionally stable, soft, and even-grained properties and used for construction lumber, interior finish work, and musical instruments. Seeds, which are edible, have a sweet, nutty, slightly resinous taste and made into butter. Various parts are used medicinally.

ECOLOGY. Grows in mixed conifer forests with firs (*Abies* spp.) and other pine species (*Pinus* spp.). Persists in a variety of climates. In southern California, found in chaparral and timberland habitats in moist soils on steep slopes from sea level to 9,843 ft (3,000 m) in elevation. Relatively long-lived, often attaining ages of four to five hundred years. Intermediate in shade tolerance. Not a prolific seeder with mature trees producing good crops irregularly every two to seven years; germination ranges from 40 to 70 percent. Windfirm but susceptible to fire, especially when young. Damaging pests include white pine blister rust (*Cronartium ribicola*) and mountain pine beetle (*Dendroctonus ponderosae*).

CLIMATE CHANGE. Vulnerability is currently considered to be low.

CONSERVATION STATUS. Least concern.

bark

leaves

branch

branchlet

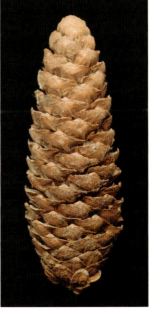
mature cone

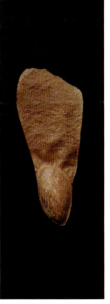
seed

FAMILY PINACEAE • 117

Singleleaf Pinyon
Pinus monophylla Torr. & Frém.

A widely distributed species, singleleaf pinyon is among North America's most xeric pines and is often a community dominant in pinyon-juniper habitat occurring on dry rocky slopes and ridges. It is the only pine that produces one needle per fascicle, and hence its common name. Three geographic varieties are recognized.

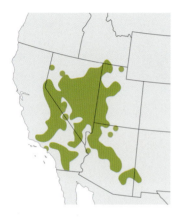

DESCRIPTION. A usually single-trunked conifer with many upswept branches and a rounded or flattened crown growing 20–39 ft (6–12 m) in height. Twigs are thick and orange brown when young, aging to gray. Bark is ruddy in color with deep irregular furrows and often scaly in mature trees. Leaves are needlelike, curved, short, gray green, and producing one needle per fascicle (the only pine with this feature), stomata on all surfaces, margins entire, 0.8–2.4 in (2–6 cm) long. Trees are monoecious producing male and female cones on the same plant. Male pollen cones are yellow and 0.39 in (10 mm) long; female seed cones are symmetric, nearly sessile, 1.6–2.4 in (4–6 cm) long, and mature in two years. Seeds are edible, brown, wingless, 5.9–7.9 in (15–20 cm) long, and do not detach from cones.

TAXONOMIC NOTES. Variety *californiarum* is found in the southwestern part of the range; var. *fallax* is found in the southeast; and var. *monophylla* occurs in the remaining areas; each variety varies in number of resin canals, seed length, and number of stomatal lines.

USES AND VALUE. Wood not commercially important. Used for fuelwood, fence posts, Christmas trees, and pinyon nuts. Seeds are edible with an agreeable almondlike taste, exceptionally low in protein, and high in starch. Used by Native Americans for antiseptic purposes. Provides cover and food for birds and rodents.

ECOLOGY. Considered North America's most xeric pine. Grows as the dominant species in pinyon-juniper habitats with junipers and other pines. Found most typically on dry rocky slopes and ridges, less often in drainages or low-lying areas. Prefers well-drained soils with low levels of organic matter. Exceptionally hardy and can withstand drought, extreme cold, heat, and poor soils. Trees are long-lived, sometimes living for one thousand years. Shade intolerant usually in open areas where light is not a limiting factor. Good seed crops produced every three to seven years; rodents and birds are primary dispersal agents consuming majority of seeds produced. Host to dwarf mistletoe and attacked by various insects and fungi.

CLIMATE CHANGE. Vulnerability is currently considered to be low.

CONSERVATION STATUS. Least concern.

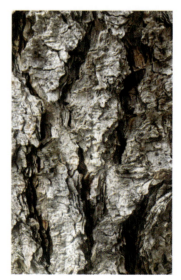

bark

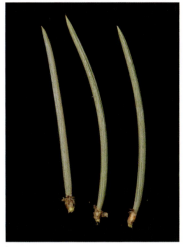 leaves
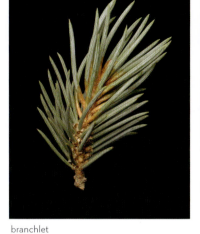 branchlet
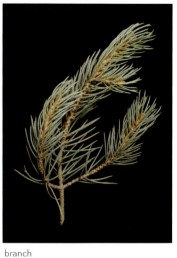 branch

 male cone
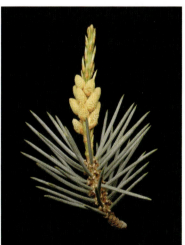 male cones on branch
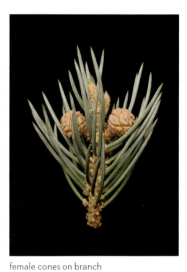 female cones on branch

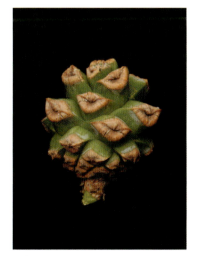 mature unopen green cone
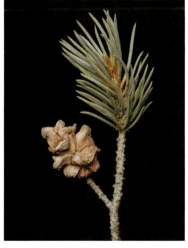 mature open cone on branch
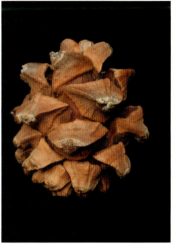 mature open cone

FAMILY PINACEAE • 119

Western White Pine
Pinus monticola Douglas ex D. Don
MOUNTAIN WHITE PINE

Western white pine is a large conifer native to mountain forests of western Canada and the west coast of the United States. Commonly used in interior carpentry it is near threatened because of its susceptibility to white pine blister rust.

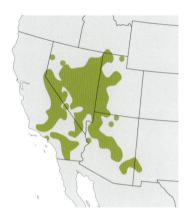

DESCRIPTION. An evergreen coniferous tree growing up to 164 ft (50 m) tall with a straight trunk and a narrowly conic crown. Twigs are slender and pale red brown, with rusty pubescence. Bark is gray and thin, smooth, furrowed into scaly plates in large trees. Leaves are needlelike, blue green, slightly twisted, and in fascicle of five, underside with conspicuous stomatal lines, margins finely serrulate, apex narrowly acute, 1.6–4 in (4–10 cm) long. Trees are monoecious producing male and female cones on the same plant. Male pollen cones are small and yellow; female seed cones are larger, 2–2.8 in (5–7 cm) long, greenish pink ripening to red brown. Seeds triangular, paired, black, 0.16–0.27 in (4–7 mm) long. Wings are slender and 0.6–0.9 in (1.5–2.2 cm) long.

USES AND VALUE. Wood commercially important. Light in weight with low resin content and used for interior finish carpentry, molding trim, doors, interior paneling, veneer, plywood, light construction, and wooden matches. Resin is used for gum. Seeds have oil-rich, resinous taste. Resin and turpentine are antiseptic and used for treating wounds, in baths, and as ointments to treat respiratory ailments and rheumatism.

ECOLOGY. Grows in mountain forests and wetlands with intermediate tolerance for shade. Seedlings may persist in shade for some years but ultimately requires sunlight to survive and grow. Although large seed crops are rare, modest crops are produced every two to three years. Deep taproot makes it extremely windfirm; thin bark results in high susceptibility to fire. Pine beetles (*Dendroctonus* spp.) and white pine blister rust (*Cronartium ribicola*) cause considerable damage and may lead to population decline.

CLIMATE CHANGE. Vulnerability is currently considered to be low.

CONSERVATION STATUS. Near threatened.

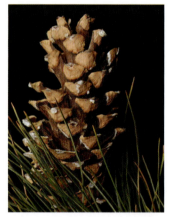

mature cone on branch

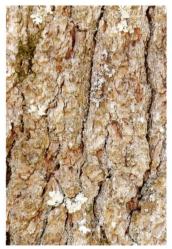

bark

leaves

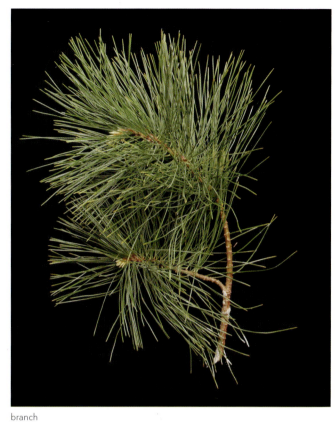

branch

mature cone

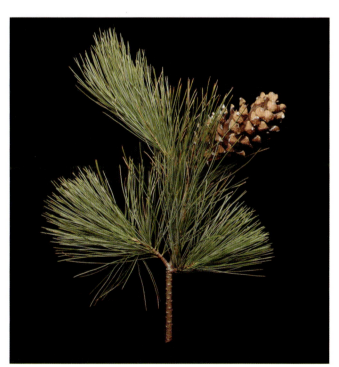

mature cone on branch

FAMILY PINACEAE • 121

Austrian Pine
Pinus nigra Arnold
EUROPEAN BLACK PINE

Introduced from Europe, Austrian pine is a naturalized species commonly cultivated as a landscape and ornamental tree. It is highly tolerant to pollution and occurs on a variety of soils within temperate climates in North America.

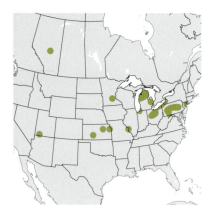

DESCRIPTION. An introduced erect single-trunked conifer that grows up to 164 ft (50 m) tall, with conical crown that flattens with age. Twigs are thick and bumpy with swollen protuberances resulting from shed fascicles. New shoots are yellow green and darken to red brown with age. Bark is deeply fissured into scaly ridges, dark gray or pink in older trees. Leaves are needlelike, arranged in fascicles of two, margins finely serrulate, stomata arranged in lines on both sides of needle, 3.1–6.3 in (8–16 cm) long. Trees are monoecious producing male and female cones on the same plant. Male pollen cones are clustered at base of new shoots, yellow, 0.59–0.98 in (15–25 mm) long, open in spring; female seed cones are borne singly or in whorls of two to five on short peduncle, scales are cross-keeled, unarmed or with a deciduous prickle. Seeds are flat and 0.24–0.31 in (6–8 mm) long, with a wing 0.59–0.98 in (15–25 mm) long.

USES AND VALUE. Wood not commercially important. Widely used as an ornamental in North America and Europe. Planted as windbreaks in the Midwest plains. Leaves of seedlings provide browse for white-tailed deer, voles, and rabbits.

ECOLOGY. Introduced from Europe as an ornamental in the mid-1700s and now naturalized. Extremely tolerant of pollution. Prefers a temperate climate and grows on a variety of soil types, including limestone soils and podzolic soils. Shade intolerant. Produces large seed crops every two to five years.

CLIMATE CHANGE. Vulnerability is considered low because of wide geographic distribution as an ornamental and/or invasive.

CONSERVATION STATUS. Least concern.

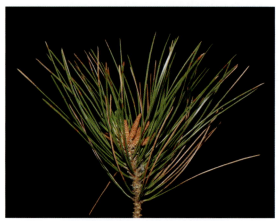
male cones on branch

bark

122 • THE DIVERSITY OF TREES

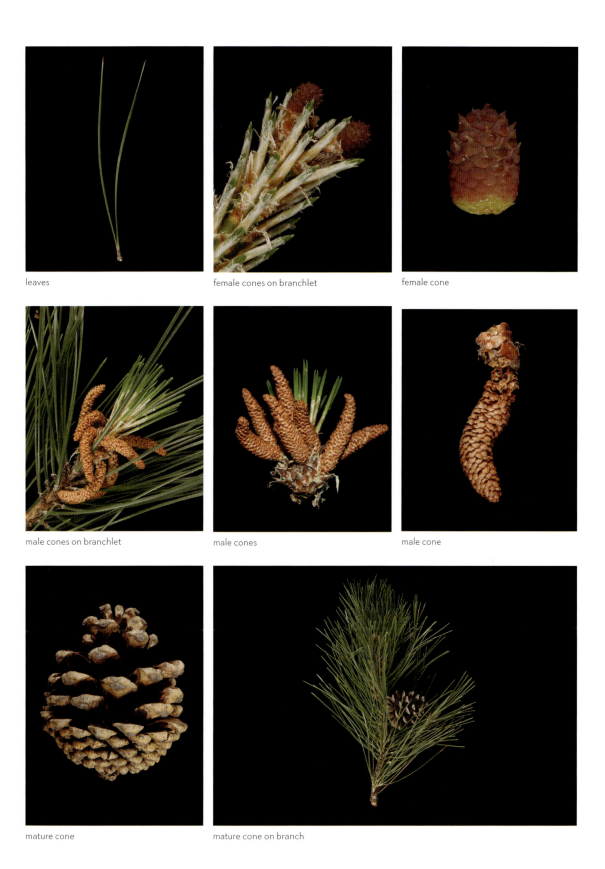

leaves

female cones on branchlet

female cone

male cones on branchlet

male cones

male cone

mature cone

mature cone on branch

FAMILY PINACEAE

Longleaf Pine
Pinus palustris Mill.

Longleaf pine is an endangered species native to the southern United States that provides habitat for multiple threatened species of animals. As one of the most distinctive and important species of southern yellow pines it is very tolerant of frequent burning and replaced by other species in the absence of fire.

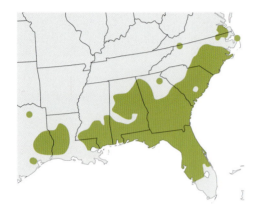

DESCRIPTION. An evergreen coniferous tree growing to 98 ft (30 m) in height with a long clear bole and short open crown. Very long-lived and well-adapted to fire due to the tight arrangement of needles protecting vegetative buds. Bark is reddish-brown bark, rough and scaly. Leaves are needlelike, clustered in bundles of three, flexible, 9.8–18.1 in (25–46 cm) long and persist for two seasons; bud scales are very large and white, looking like candles at the tips of the branches. Trees are monoecious with both male and female cones appear on the same plant in early spring. Male pollen cones are dark, purplish blue, grouped in large clusters at the base of terminal buds, 1–1.5 in (2.5–3.8 cm) long; female seed cones are purplish, produced in pairs or clusters, when mature fall from tree in the second year after formation, 5.9–9.8 in (15–25 cm) long with tiny prickles on the scales.

USES AND VALUE. Wood very commercially important. Used primarily for construction lumber and plywood; also an important source of naval stores. Seeds are edible. Resin and turpentine are antiseptic and used for treating wounds, in baths, and as ointments to treat respiratory ailments and rheumatism. Mature stands are preferred habitats for the endangered red-cockaded woodpecker, while the understory vegetation is important refuge for other wildlife. Seeds are consumed by numerous species of rodents and birds.

ECOLOGY. Commonly found in the southeastern coastal plain and Gulf coast of the United States and on rocky ridges in the Piedmont. Not only provides habitat for many threatened animals, but is endangered itself. Grows in warm wet climates, prefers sandy, infertile, well-drained soils and is typically found from sea level to 656 ft (200 m) in elevation. Commonly associated with conspecifics in longleaf pine forests and mixed hardwood. Adapted to frequent low-intensity fire and without frequent burning may be replaced by other species. May live for hundreds of years. Shade intolerant. Produces good seed crops every five to seven years, with seed viability from 50 to 75 percent. Very deep taproot makes this species resistant to windthrow. Young stems persist for two or more years in a "grass stage" with no apparent trunk during which time the taproot develops. Relatively pest free, including resistance to the southern pine beetle (*Dendroctonus frontalis*). Foraging hogs and cattle as well as fire can damage young plants in the "grass stage."

CLIMATE CHANGE. Vulnerability is currently considered to be low.

CONSERVATION STATUS. Endangered.

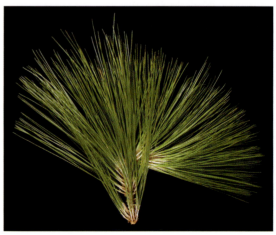

branchlet

leaves

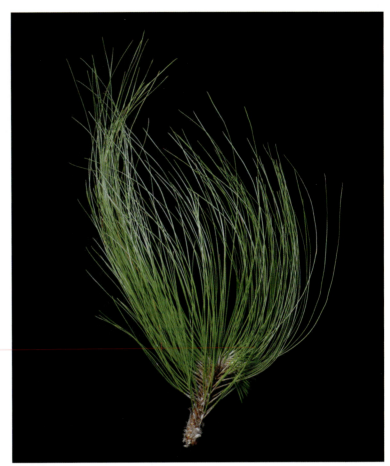
branchlet

bark

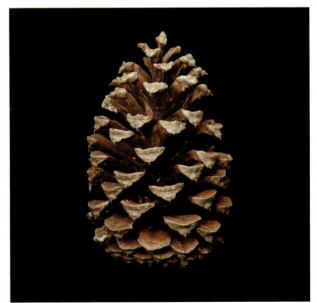
mature cone

Italian Stone Pine
Pinus pinea L.
STONE PINE, UMBRELLA PINE

Native to Europe, Italian stone pine has been cultivated as a source of edible seeds, called pignoli nuts, for thousands of years. In North America, this tree is grown as an ornamental in California and Arizona.

DESCRIPTION. An introduced conifer from the Mediterranean region that grows to 39–82 ft (12–25 m) tall with a distinctively broad, flattened crown. Branches protrude thirty to sixty degrees from the trunk in an upswept manner. Bark is plated, deeply fissured, and reddish to orange with darker plate margins. Leaves are needlelike, arranged in fascicles of two, gray when young turning to deep green, margins minutely serrate, stomatal lines on all sides, 4–7.1 in (10–18 cm) long. Trees are monoecious producing male and female cones on the same plant. Female seed cones are produced on short stalks, green maturing to brown after one year, 3.1–4.7 in (8–12 cm) long. Seeds are edible, light brown, covered in a black powdery substance, 0.59–0.79 in (15–20 mm) long, with vestigial wings 0.12–0.31 in (3–8 mm) long.

USES AND VALUE. Wood not commercially important. Planted primarily as an ornamental. In its native Mediterranean region, the seeds called pignoli nuts are considered a delicacy. The first pine known to be cultivated.

ECOLOGY. Prefers Mediterranean climates and sandy, moist, well-drained soils. Sensitive to disturbance. Short-lived, rarely beyond 150 years. Shade intolerant. Drought resistant and windfirm.

CLIMATE CHANGE. Vulnerability is considered low because of its wide geographic distribution as an ornamental.

CONSERVATION STATUS. Least concern.

bark

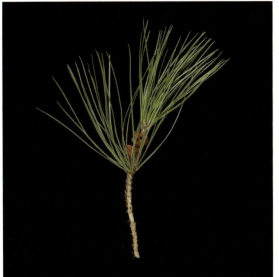
branch above

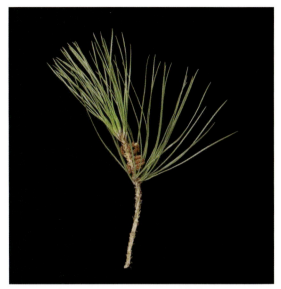
branch below

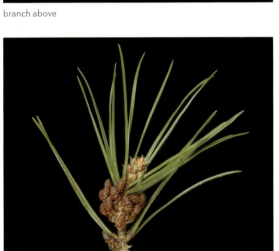
male cones on branch

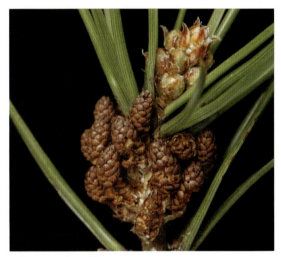
male cones on branchlet

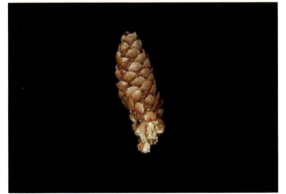
male cone

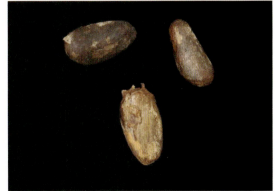
seeds

FAMILY PINACEAE • 127

Ponderosa Pine
Pinus ponderosa Douglas ex P. Lawson & C. Lawson
WESTERN YELLOW PINE

Ponderosa pine is a long-lived, large coniferous tree native to moist mountain ridges from British Columbia to Mexico and from western Texas to the west coast. One of the most commercially important western pine trees in North America.

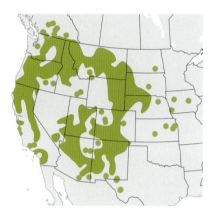

DESCRIPTION. An evergreen coniferous tree growing up to 98–164 ft (30–50 m) tall with a straight trunk and a broadly conical crown. Twigs are stout and orange to black. Bark is very dark on younger trees but ages into cinnamon-colored plates with deep furrows. Leaves are needlelike, tough, in fascicles of three, yellow green, stomatal lines on both sides, margins toothed, terminate in sharp point, produce a turpentine odor, 4.7–11 in (12–28 cm) long. Trees are monoecious producing male and female cones on the same plant. Male pollen cones are cylindrical, red, 0.20–0.59 in (5–15 mm) long; female seed cones are yellow ripening to orange brown, 3–5.1 in (7.5–13 cm) long. Seeds are triangular, paired, black, 0.20 in (5 mm) long with wings 0.6–1 in (1.5–2.5 cm) long.

USES AND VALUE. One of the most commercially important western pine trees. Used for veneer, plywood, construction lumber, post and poles, interior trim, and cabinetry. Important as wildlife habitat and for aesthetic value to outdoor naturalists. Inner bark, seed, and resin are edible. Gum and turpentine are antiseptic and used for treating wounds, in baths, and as ointments to treat respiratory ailments and rheumatism.

ECOLOGY. Occurs primarily in Rocky Mountains and montane areas of the Pacific; also found in southwestern United States on rocky hills and at low elevations in mountains. Prefers deep, sandy, gravelly or clay loams. Tolerates alkaline soils. Shade intolerant. Good seed crops produced every three to five years. Highly resistant to drought; relatively windfirm due to moderate taproot. Mature trees with thick bark are especially resistant to fire. Mountain pine beetle (*Dendroctonus ponderosae*) is most severe pest. Rabbits, hares, and pocket gophers cause damage to small seedlings.

CLIMATE CHANGE. Vulnerability is currently considered to be low.

CONSERVATION STATUS. Least concern.

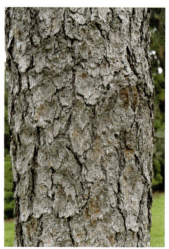

bark

leaves

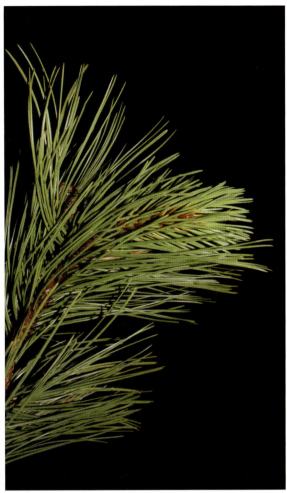
branch

branchlet

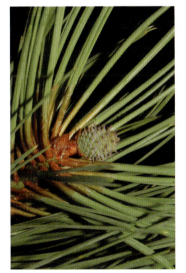
female cone on branchlet

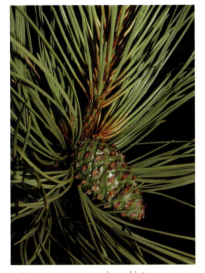
mature unopen cone on branchlet

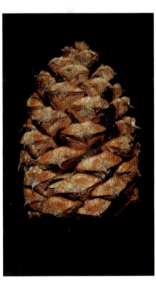
mature open cone

FAMILY PINACEAE • 129

Table Mountain Pine
Pinus pungens Lamb.
HICKORY PINE

Table mountain pine is native to the Appalachian Mountains in the eastern United States. A small conifer, trees grow as single, scattered individuals on rocky slopes. This pine gained its reputation in the 1908 novel *The Trail of the Lonesome Pine* by John Fox, Jr.

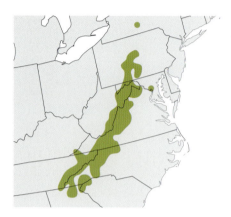

DESCRIPTION. A long-lived, evergreen, coniferous tree growing to 39 ft (12 m) tall with horizontal branches that droop towards the ground. Bark is thick and reddish brown with irregular scaly plates. Leaves are needlelike, clustered in groups of two or three, twisted, dark yellowish green, 1.2–2.8 in (3–7 cm) long. Trees are monoecious, producing both male and female cones on the same individual in mid-spring. Male pollen cones are produced at base of new twigs, yellow, ellipsoid, 0.59 in (15 mm) long; female seed cones are clustered in groups of three to five, purplish brown, asymmetric and ovoid, 2–3.5 in (5–9 cm) long, with spiny brown scales. Seeds are pale brown, 0.24 in (6 mm) long with wings 0.31–0.47 in (8–12 mm) long.

USES AND VALUE. Wood not commercially important. Sometime used as pulpwood and locally for fuel. Important for watershed protection. No food uses known. Gum and turpentine are antiseptic and used for treating wounds.

ECOLOGY. Grows in mountainous habitats with dry sandy or shaley soils on dry rocky slopes and ridges. Shade intolerant. Produces good seed crops annually. Both windfirm and resistant to drought because of deep taproot. Infected by various types of root-rot and stem-rot fungi; southern pine beetle (*Dendroctonus frontalis*) can be extremely damaging.

CLIMATE CHANGE. Vulnerability is significant but has a reasonable probability of persistence in the future. Ongoing monitoring is recommended.

CONSERVATION STATUS. Least concern.

seed

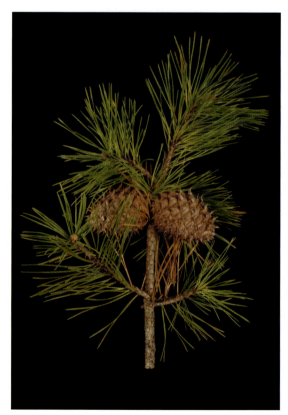

branch with mature unopen cones

130 • THE DIVERSITY OF TREES

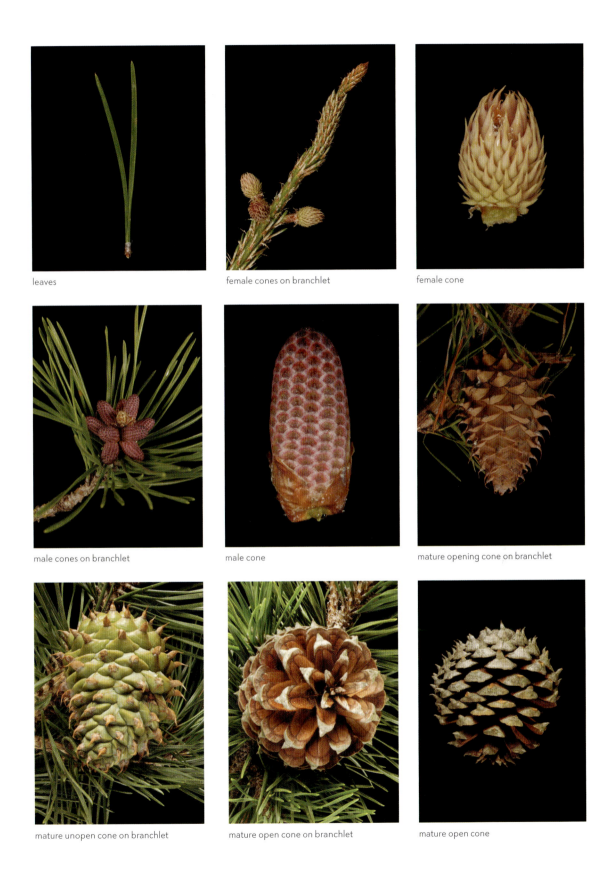

FAMILY PINACEAE • 131

Red Pine

Pinus resinosa Aiton

Red pine, which is native to central and northeastern North America, is characterized by tall straight trunks. The bark is thick and gray at the base becoming thin, flaky, and bright red towards the crown, hence its common name. It is the state tree of Minnesota.

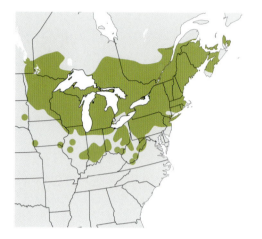

DESCRIPTION. A medium-lived, evergreen, coniferous tree that grows to 82 ft (25 m) in height and has large spreading branches. Bark is gray to brown at base of trunk often turning red towards apex, scaly with shallow fissures and reddish-brown scales. Leaves are needlelike, clustered in groups of two, flexible, 4.7–6.7 in (12–17 cm) long. Trees are monoecious producing both male and female cones on the same plant in summer. Male pollen cones are grouped at the tips of branches, red, rounded, 0.47–0.71 in (12–18 mm) long; female seed cones are reddish-brown, ovoid, 1.6–2.4 in (4–6 cm) long, with keeled scales.

USES AND VALUE. Wood commercially important. One of most widely planted trees in North America and used for posts, poles, railroad ties, log cabins, construction lumber, finish lumber, and pulp. Important for watershed protection, often planted around reservoirs to reduce wind erosion on sand dunes. Cultivated as ornamental because of colorful bark. Admired for aesthetic value by outdoor naturalists. No food uses are known. Gum and turpentine are antiseptic and used for treating wounds. Provides important habitat for wildlife.

ECOLOGY. Grows in sandy soils of secondary forest in northern climates. Intermediate in shade tolerance. Good seed crops produced every three to seven years with viability typically high (80–90 percent). Relatively windfirm but susceptible to damage by fire because of thin bark. Red pine scale, an invasive pest, can completely defoliate trees.

CLIMATE CHANGE. Vulnerability is significant but with a reasonable probability of persistence in the future. Ongoing monitoring is recommended.

CONSERVATION STATUS. Least concern.

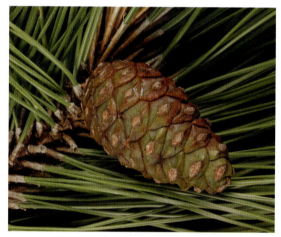

mature unopen cone on branchlet

bark

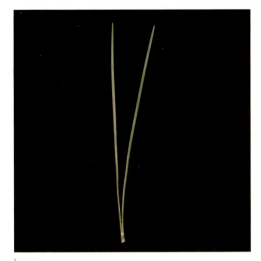
leaves

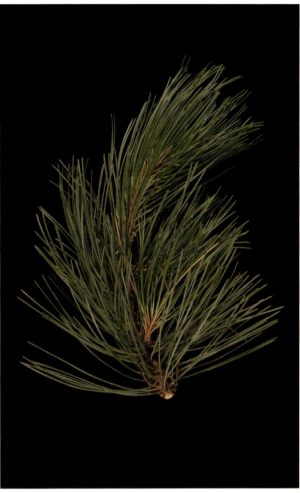
branch

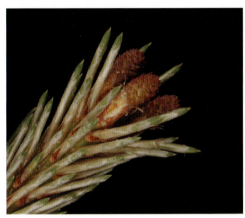
young female cone on branchlet

young female cone

mature unopen cone

mature open cone

FAMILY PINACEAE • 133

Pitch Pine
Pinus rigida Mill.

Pitch pine, a tall evergreen coniferous tree native to the northeastern United States, has very thick, grayish-brown bark that is resistant to fire. It is the dominant tree in the pine barrens of New Jersey. The decay-resistant wood was formerly used to build sailing ships.

DESCRIPTION. A medium-lived, evergreen, coniferous tree that grows to 49–98 ft (15–30 m) in height, exhibits significant variation in form depending on habitat. Twigs are stout, orange brown. Bark is reddish brown, scaly becoming furrowed with age. Leaves are needlelike, twisted and stiff, clustered in groups of three (tufts of needles often found growing on trunk), green to yellow green, margins finely serrate, apex sharply pointed, 2.8–5.5 in (7–14 cm) long with basal sheath 0.35–0.47 in (9–12 mm) long. Trees are monoecious producing both male and female cones on the same plant in spring. Male pollen cones are clustered, yellow, cylindrical, 0.4–0.8 in (1–2 cm) long; female seed cones are yellow to red becoming light brown when mature, ovoid, 1.6–3.1 in (4–8 cm) long with flat scales bearing a small spine. Seeds are light to dark brown, three-angled, 0.16–0.24 in (4–6 mm) long with wings up to 0.8 in (2 cm) long.

USES AND VALUE. Wood earlier commercially important but less so today. Used for pulp, mine timbers, posts, fencing, and rough construction. With high resin content and resistance to decay at one time highly favored for ship building. No food uses are known. Gum and turpentine are antiseptic and used for treating wounds. Cones open slowly after fire and provide important source of food for birds and small rodents in winter. Larval host for pine-devil (*Citheronia sepulcralis*) moth.

ECOLOGY. Grows in sandy soils on low and high rocky slopes. Extremely hardy, fire adapted, drought resistant, and windfirm due to the well-developed taproot. Shade intolerant. Good seed crops are produced every three or more years. Relatively immune to fungal pests; susceptible to insect attacks, such as loopers, which cause significant defoliation.

CLIMATE CHANGE. Vulnerability is significant but with a reasonable probability of persistence in the future. Ongoing monitoring is recommended.

CONSERVATION STATUS. Least concern.

bark

leaves above (left), leaves below (right)

branch

male cones on branchlet

male cone

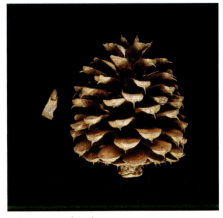
mature cone and seed

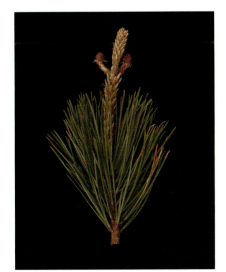
female cone on branchlet

female cone

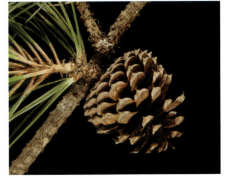
mature cone on branchlet

FAMILY PINACEAE • 135

Gray Pine
Pinus sabiniana Douglas ex Douglas
CALIFORNIA FOOTHILL PINE

Gray pine is a conifer with an often crooked or bent trunk endemic to the Mediterranean climates of California. The characteristic bark is black with plates that peel off to reveal the reddish-brown underbark. The giant female seed cones are distinctive.

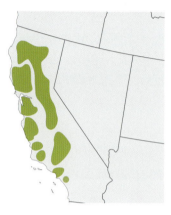

DESCRIPTION. A coniferous evergreen that grows 39–69 ft (12–21 m) tall and characterized by sparse crown and sometimes bent or forked trunk. Branches are ascending and often stout when producing cones. Twigs are light brown and become rough and gray with age. Bark is nearly black and deeply furrowed into blocky or scaly plates that break away to reveal a ruddy red underbark. Leaves are needlelike, drooping, twisted, pale gray green, arranged sparsely in fascicles of three, margins finely serrate, all surfaces covered in stomata, 5.9–12.1 in (15–32 cm) long. Trees are monoecious producing male and female cones on the same plant. Male pollen cones are yellow, 0.39–0.59 in (10–15 mm) long; female seed cones are large, symmetric, resinous, 5.9–9.8 in (15–25 cm) long, produced on stalks up to 2 in (5 cm) long, require two years to mature; cone scales are sharply keeled with a curved prickle up to 0.8 in (2 cm) long. Seeds are dark brown, large, up to 0.79 in (20 mm) long with a 0.39 in (10 mm) wing.

USES AND VALUE. Wood not commercially important. Used locally for fuelwood. Inner bark, seeds, and immature cones are all edible. Seeds high in protein and fat, important food for Native Americans. Gum and turpentine are antiseptic and used for treating wounds.

ECOLOGY. Grows on exposed rocky slopes 98–5,906 ft (30–1,800 m) in elevation. Prefers Mediterranean climates in oak woodlands, where it often associates with blue oak (*Quercus douglasii*); on serpentine soils may dominate habitats. Very shade intolerant. Consistently produces large seed crops every two to three years. Cones open slowly and often remain closed until winter. Heavy seeds with poorly developed wings are not adapted for dispersal by wind; birds and rodents play the critical role in seed dispersal. Fire resistance is low because of the thin bark and high resin content. Attached by *Ips spinifer*, an aggressive bark beetle that may prove lethal.

CLIMATE CHANGE. Vulnerability is currently considered to be low.

CONSERVATION STATUS. Least concern.

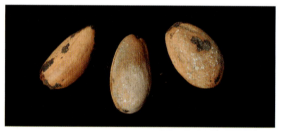
seeds

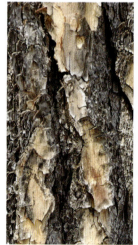
bark

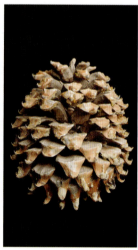
mature cone

Pond Pine
Pinus serotina Michx.
MARSH PINE

Pond pine earns its scientific name from its "serotinous" cones, which explode open in the presence of fire. In the southeastern United States, where it is native, this fire-adapted pine is often outcompeted by faster-growing pines on drier soils, but it is a community dominant in habitats with saturated soils.

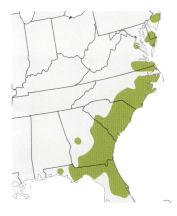

DESCRIPTION. A small conifer that grows up to 82 ft (25 m) in height and has an irregular crown that becomes even more so with age. Twigs are tufted at the tips and yellow or orange, aging to brown. Trunk sprouts new foliage from adventitious buds (unlike most other pines). Bark is reddish brown and furrowed into flat, rectangular plates. Leaves are needlelike, arranged three per fascicle, twisted, with stomata on all surfaces, margins minutely serrate, 5.9–7.9 in (15–20 cm) long. Trees are monoecious producing male and female cones on the same plant. Male pollen cones are cylindrical, yellow, 1.18 in (30 mm) long; female seed cones are produced in whorls, either sessile or on peduncles up to 0.4 in (1 cm) long, round, symmetric, reddish to pale brown, 2–3.1 in (5–8 cm) long, scales cross-keeled and sometimes armed with a prickle; cones mature after two years, can burst open at maturity, but most are serotinous and depend on fire to dehisce. Seeds are tan or mottled darker, 0.20–0.24 in (5–6 mm) long with a wing up to 0.79 in (20 mm) long.

USES AND VALUE. Wood not commercially important. Used for pulpwood and low-grade construction lumber. No food uses are known. Gum and turpentine are antiseptic and used for treating wounds. Provides important shelter for wildlife in wetland habitats, including the endangered red-cockaded woodpecker.

ECOLOGY. Grows in a variety of habitats in the southeastern United States. Prefers swamps and ponds occurring on saturated peaty or sandy soils and is a dominant in low-lying wet areas. Highly adapted to regular fire with serotinous cones. Thrives in soils with pH lower than 4.5, high in organic matter, and low in nutrient availability. Shade intolerant. Produces seed regularly with serotinous cones persisting on trees for years.

CLIMATE CHANGE. Vulnerability is currently considered to be low.

CONSERVATION STATUS. Least concern.

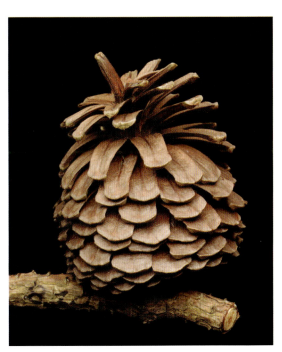

mature cone

Southwestern White Pine
Pinus strobiformis Engelm.
MEXICAN WHITE PINE

Southwestern white pine is a conifer that grows in moist cool habitats in pine forests, mixed conifer woodlands, and spruce-fir forests. Of low commercial importance, this species provides lumber, Christmas trees, and ornamental plantings.

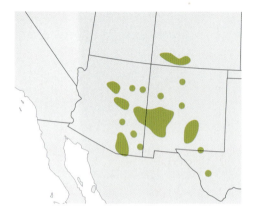

DESCRIPTION. A tall conifer that grows up to 98 ft (30 m) in height with an erect trunk and conical, somewhat irregular crown. Twigs are pale and reddish, turning ashy brown with age. Bark is pale gray and smooth in young trees becoming ashy brown, furrowing into rough plates with age. Leaves are needlelike, arranged in fascicles of five, dark green, curved and slightly twisted with two to four resin canals, ventral surface covered in stomatal rows, margins sharp, smooth or finely serrate, 1.6–4 in (4–10 cm) long. Trees are monoecious producing male and female cones on the same plant. Male pollen cones are yellow to brown, 0.24–0.39 in (6–10 mm) long; female seed cones are light brown and produced on stalks up to 2.4 in (6 cm) long, symmetric or lance-cylindrical in shape, scales are cross-keeled with reflexed tip, mature in two years and burst open when mature. Seeds are reddish brown, 0.39–0.51 in (10–13 mm) long with an inconspicuous wing.

USES AND VALUE. Wood not commercially important. Used for doors, window frames, and cabinetry, primarily in Mexico. Cultivated as an ornamental and as a Christmas tree. Inner bark and seeds are edible; important food for Native Americans. Gum and turpentine are antiseptic and used for treating wounds.

ECOLOGY. Grows in moist cool habitat in the southwestern United states and is found in low densities in pine, mixed conifer woodlands, and spruce-fir forests. Prefers loamy soils on ridges and slopes of montane areas between 5,906 and 9,843 ft (1,800–3,000 m) in elevation. Seeds are primarily dispersed by birds.

CLIMATE CHANGE. Vulnerability is significant but may have capacity to adapt to changing conditions in the future. Ongoing monitoring is recommended.

CONSERVATION STATUS. Least concern.

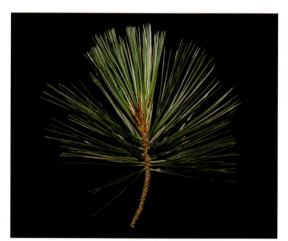
branchlet

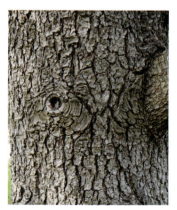
bark

138 • THE DIVERSITY OF TREES

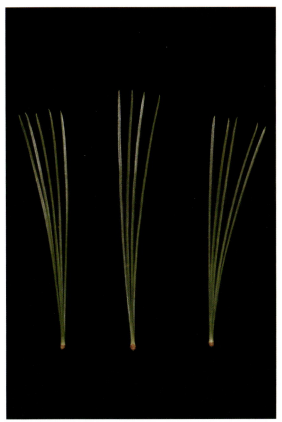
leaves

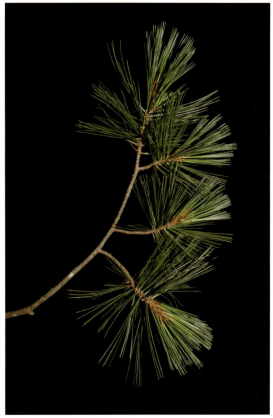
branch

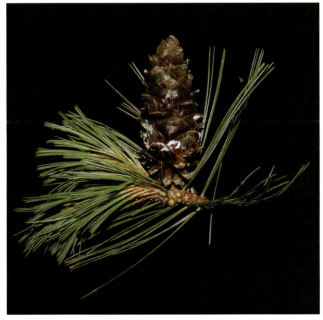
mature cone on branchlet

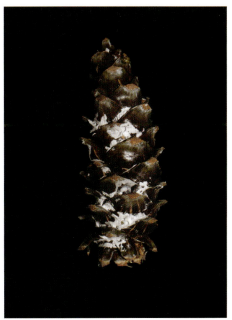
mature cone

FAMILY PINACEAE • 139

Eastern White Pine
Pinus strobus L.
SOFT PINE

Eastern white pine, which is native to eastern North America, produces flexible bluish-green needles bundled in fascicles of five. The tall straight trunks were an important source of masts for sailing ships in colonial times.

DESCRIPTION. A medium-lived, evergreen, coniferous tree that grows to 98 ft (30 m) in height with a tall clear trunk and plumelike branches forming an irregular crown. Root system is large and spreading with a limited taproot. Twigs are greenish to orange brown. Bark is smooth, grayish green on young trees, becoming reddish brown with pronounced rounded long ridges and dark furrows with age. Leaves are needlelike, clustered in fascicles of five, flexible, bluish green, with a deciduous basal sheath, 2.4–5.5 in (6–14 cm) long. Trees are monoecious producing male and female cones on the same plant in late spring. Male pollen cones are stalked, yellow, clustered near the tips of the branches, 0.31–0.59 in (8–15 mm) long; female seed cones are positioned at the tips of branches, pink, cylindrical, 4–5.9 in (10–15 cm) long with thin rounded purple scales.

USES AND VALUE. One of most commercially important trees in Northeast. Used for construction lumber, interior finish work, cabinetry, boats, and artistic carving. Demand for the tall straight trunks, which served as a critical source for masts in wooden sailing ships, nearly led to its demise through overharvesting in the eighteenth century. Inner bark and seeds are edible and used for condiments, gum, tea, and other drinks. Gum and turpentine are antiseptic and used for treating wounds.

ECOLOGY. Able to survive in a wide variety of soils and habitats; prefers acidic sandy soils in cool forests. Intermediate in shade tolerance. Prolific seeder, producing good crops every three to five years with high seed germination (80–90 percent). Because of thin bark, sensitive to fire damage, particularly when young; moderately resistant to windthrow. Pests include white pine weevil, which attacks and destroys the terminal bud, and white pine blister rust, which causes significant damage and mortality.

CLIMATE CHANGE. Vulnerability is currently considered to be low.

CONSERVATION STATUS. Least concern.

bark

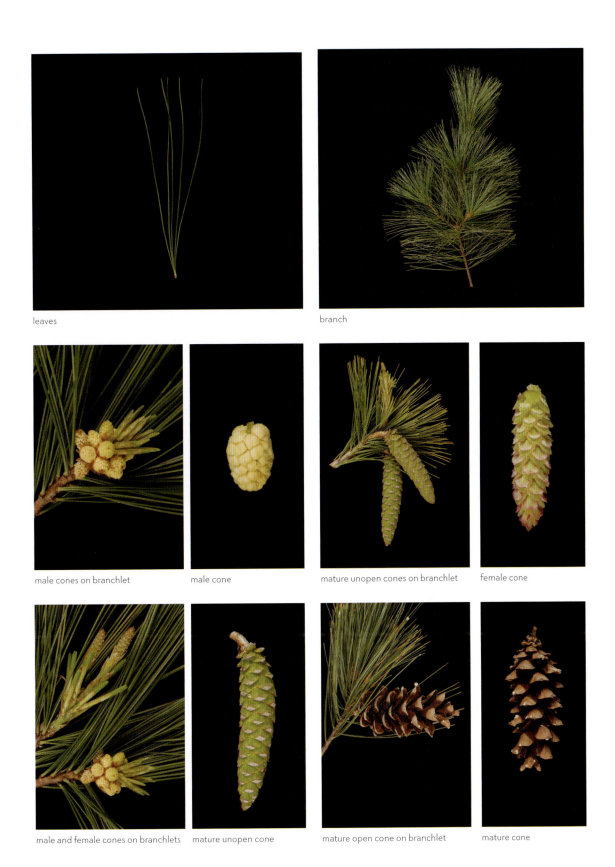

FAMILY PINACEAE

Scots Pine
Pinus sylvestris L.
SCOTCH PINE

Scots pine is native to Europe and Asia, and now naturalized in cool regions of North America. The distinctive, short, bluish-green needles and orange-red bark make this species attractive as an ornamental as well as for habitat restoration.

DESCRIPTION. A medium-lived, evergreen, coniferous tree growing between 45 and 75 ft (15–25 m) in height. Twigs are orange brown, becoming grayish and rough with age. Bark is grayish brown to orange red brown, scaly, and fissured. Leaves are needlelike, clustered in groups of two, bluish to grayish green, stiff, thick, and twisted, 1.2–4 in (3–10 cm) long. Trees are monoecious producing male and female cones on the same plant in mid-spring. Male pollen cones are yellow, ovoid, clustered along the twigs, and up to 0.39 in (10 mm) long; female seed cones are yellow green to reddish, becoming gray to yellowish brown when mature, ovoid, 1.2–3.1 in (3–8 cm) long with scales four-sided at the apex. Seeds are grayish- to reddish-brown, 0.12–0.24 in (3–6 mm) long with 0.8 in (2 cm) long wings.

USES AND VALUE. Wood not commercially important. Used for pulpwood, poles, fence posts, and rough construction lumber. A nonnative species planted widely in reforestation projects for windbreaks and watershed protection. Inner bark is edible. Gum and turpentine are antiseptic and used for treating wounds.

ECOLOGY. Grows well on well-drained upland soils, where it is often cultivated. Shade intolerant. Produces good seed crops every three to six years. Susceptible to fire damage due to thin bark, especially at younger ages. Damaged by ice, snow, and wind as a result of heavy branch load.

CLIMATE CHANGE. Vulnerability is considered low because of wide geographic distribution as introduced restoration tree.

CONSERVATION STATUS. Least concern.

branch

bark

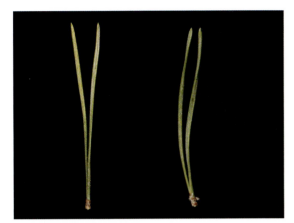
leaves above (left), leaves below (right)

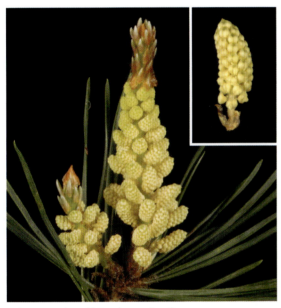
male cones on branchlet, male cone (inset)

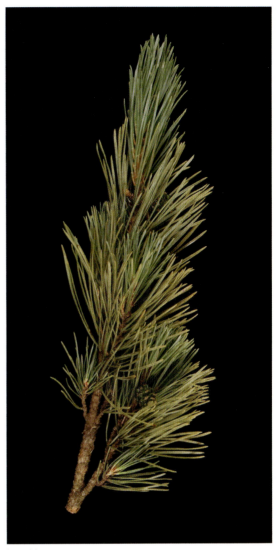
branchlet

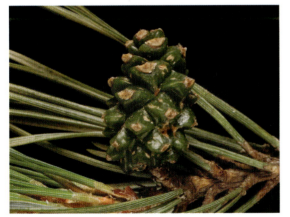
mature unopen cone on branchlet

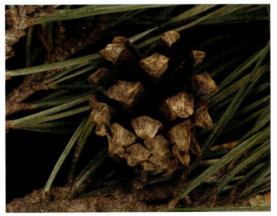
mature open cone on branchlet

FAMILY PINACEAE • 143

Loblolly Pine
Pinus taeda L.

Loblolly pine, native to the southeastern United States, is the largest of the pines in this region and the most commercially important. The word *loblolly* means "low, wet place" or "mud puddle" and refers to habitats where the trees commonly grow.

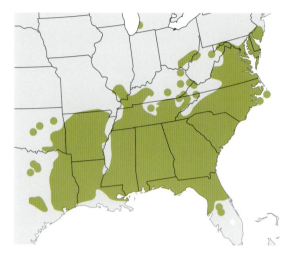

DESCRIPTION. A medium-lived, evergreen, coniferous tree growing up to 100 ft (30 m) in height with self-pruning lower branches. Trunk is long and clear with open crown. Root system is laterally spreading with a small taproot. Twigs are yellowish brown, turning darker brown with age. Bark is reddish brown, shallowly fissured with long flat plates in older trees. Leaves are needlelike, grouped in clusters of three, yellowish green, sharp-pointed, stiff and twisted with persistent basal sheaths, 4.7–9.1 in (12–23 cm) long. Trees are monoecious producing male and female cones on the same plant in mid-spring. Male pollen cones are in large clusters at branch tips, slender yellow, about 2 in (5 cm) long; female seed cones are lateral near the ends of twigs, solitary or in groups of two or three, yellow, ovoid to cylindrical, and 2.8–5.9 in (7–15 cm) long with flattened and wrinkled scales bearing small spines. Seeds are dark brown and 0.24 in (6 mm) long with 0.63–0.79 in (16–20 mm) long wings.

USES AND VALUE. Most commercially important southern yellow pine. Used for construction lumber, plywood, veneer, subflooring, sheathing, and pulp. No food uses are known. Gum and turpentine are antiseptic and used for treating wounds. Provide important habitats for wildlife and food for many animals. Old-growth stands are especially important habitats for endangered red-cockaded woodpecker and provide nesting sites for osprey and bald eagles.

ECOLOGY. Grows in habitats ranging from sandy mountain slopes to secondary-growth forests to moist lowlands and swamp borders. Intolerant of drought but resistant to flooding. Moderately shade tolerant when young becoming intolerant at maturity. Some seeds produced annually with good seed crops every three to six years. Wind, snow, and ice can significantly damage trees. Most important pest is southern pine beetle (*Dendroctonus frontalis*).

CLIMATE CHANGE. Vulnerability is currently considered to be low.

CONSERVATION STATUS. Least concern.

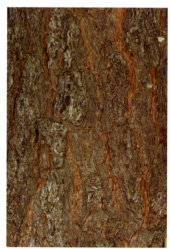

bark

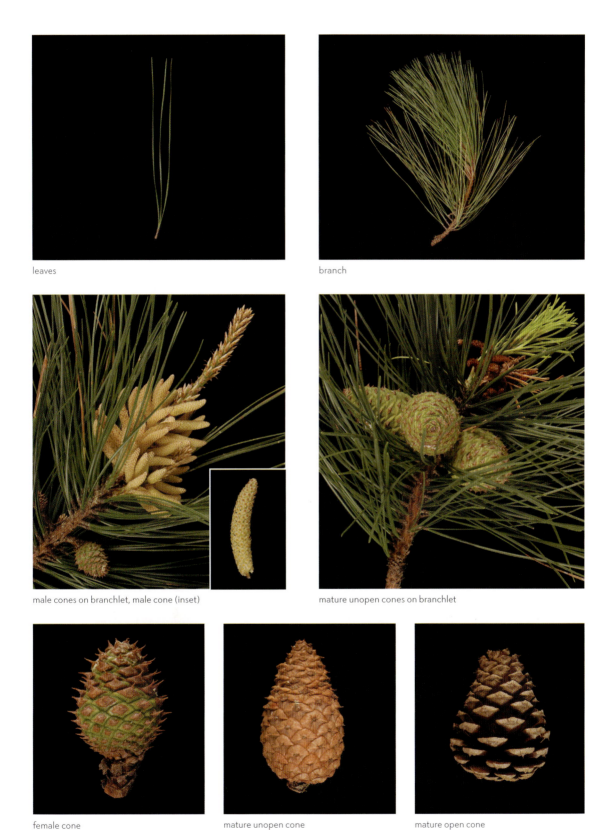

FAMILY PINACEAE • 145

Virginia Pine
Pinus virginiana Mill.

JERSEY PINE

Virginia pine is a medium-sized conifer native to the eastern United States, where it inhabits dry and often highly disturbed habitats. For this reason, it is often used for restoration of abandoned farms and mining sites.

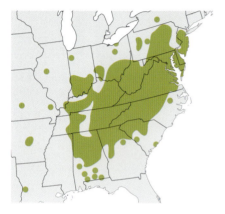

DESCRIPTION. A long-lived, evergreen, coniferous tree growing to 59 ft (18 m) in height with horizontal branches and a flat-topped crown. Twigs are green and purple turning grayish brown. Bark is smooth when young, becoming brown and thinly scaly in older trees. Leaves are needlelike, clustered in groups of two, stiff and twisted, yellowish green, 1.4–3.1 in (3.5–8 cm) long with the basal sheath about 0.24 in (6 mm) long. Trees are monoecious producing both male and female cones on the same plant in mid-spring. Male pollen cones are clustered at the tips of branches, orange to brownish; female seed cones are pale green, ovoid, 1.6–2.4 in (4–6 cm) long, scales rose-colored with spiny apex. Seeds are 0.24 in (6 mm) long with 0.31–0.47 in (8–12 mm) long wings.

USES AND VALUE. Wood commercially important. Used primarily for pulp and construction lumber. Because of its characteristics as a pioneer species, used to restore mine sites and other areas which were highly disturbed by human activities. Seeds are edible. Gum and turpentine are antiseptic and used for treating wounds.

ECOLOGY. As a pioneer tree inhabits dry uplands, old fields, and lower montane zones on sandy or shaley soil. Often grows with oaks in old fields and on slopes. Shade intolerant. Seeds produced annually, with good crops every three years. Susceptible to windthrow due to shallow root system. Easily damaged by fire, especially when immature. Attacked by a variety of pests, including southern pine beetle (*Dendroctonus frontalis*) and heart rot.

CLIMATE CHANGE. Vulnerability is currently considered to be low.

CONSERVATION STATUS. Least concern.

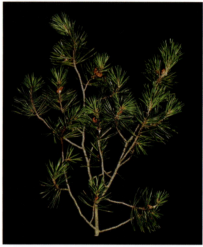

branch

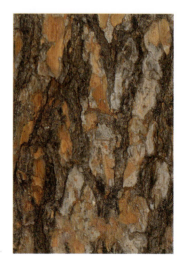

bark

leaves

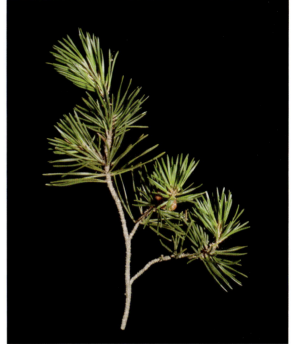
branch

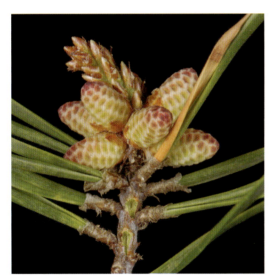
male cones on branchlet

male cone

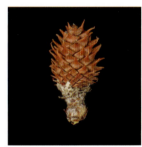
female cone

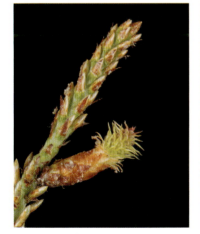
female cone on branchlet

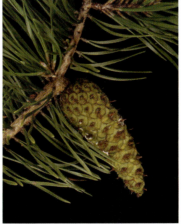
mature unopen cone on branchlet

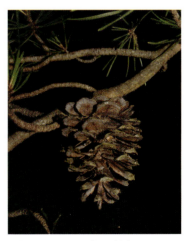
mature open cone on branchlet

FAMILY PINACEAE • 147

GENUS PSEUDOTSUGA

Though the general habit of the tree is not what gardeners call weeping, these long pendants have a sort of sorrowful grace. When the summer winds blow lightly through the forest they stir this shawl-like fringe in an idle, ferny way; when winter rains come driving through the forest, level and endless from the storm-bound Pacific, then these long pennants lie out waving upon the gale in a way that gives the whole tree a wild and streaming look.

—Donald Culross Peattie on *Pseudotsuga taxifolia* (now *P. menziesii*) in *A Natural History of North American Trees*

Pseudotsuga means "false hemlock" because the leaves resemble those of the true hemlock, *Tsuga*. Only four species are included in the genus *Pseudotsuga*, although twenty-two species have been described in the past. *Pseudotsuga* is one of the many genera containing species found in either western North America or eastern Asia, indicating a long evolutionary history dating back to the time when North America and Asia were joined as a single continent. Two native species of *Pseudotsuga* are common trees in North America.

Bigcone Douglas-Fir
Pseudotsuga macrocarpa (Vasey) Mayr.

Bigcone Douglas-fir, a near-threatened conifer endemic to California, is found in middle-elevation habitats with gray pine (*Pinus sabiniana*) and bigleaf maple (*Acer macrophyllum*). Historically it was used for fuel and lumber; today serves to protect watersheds and for environmental restoration.

DESCRIPTION. A near threatened conifer that grows to 80 ft (25 m) in height with an erect pyramidal crown. Branches are long, slender, pendulous, and covered with sparse pubescence when young. Bark is dark brown when young and lightens to grayish brown with age, deeply furrowed into thin plates separating into corky layers with closely appressed scales. Leaves are needlelike, two-ranked, blue gree, 0.8–1.2 in (2–3 cm) long, with a callus apex. Trees are monoecious producing both male and female cones on same plant. Female seed cones are produced on short stalks and can persist for up to a year after shedding seeds, large, up to 1.6–2.8 in (4–7 cm) long, with flattened and thick scales, each with an exserted bract. Seeds are dark brown to black and glossy, 0.5 in (1.3 cm) long with wings approximately same length as the seed.

USES AND VALUE. Wood not commercially important. Formerly provided fuel and lumber and now extensively used for watershed protection and environmental restoration. Provides appropriate habitats for large mammals, including black-tailed deer and black bear, as well as seeds as food for rodents and birds.

ECOLOGY. Prefers Mediterranean climates with gray pine (*Pinus sabiniana*) and bigleaf maple (*Acer macrophyllum*) from 2,001 to 8,858 ft (610–2,700 m) in elevation. At low elevations occurs primarily in moist soils; at middle elevations grows on slopes and ridges; and at highest elevations occurs on variety of terrain. A climax species, shade tolerant when young and intolerant with age. Small quantities of seed are produced most years. Well adapted to fires due to thick bark and ability to sprout new growth from adventitious buds. Resistant to drought. Saplings are heavily browsed by deer and other mammals.

CLIMATE CHANGE. Vulnerability is significant but may have the capacity to adapt to changing conditions in the future. Ongoing monitoring is recommended.

CONSERVATION STATUS. Near threatened.

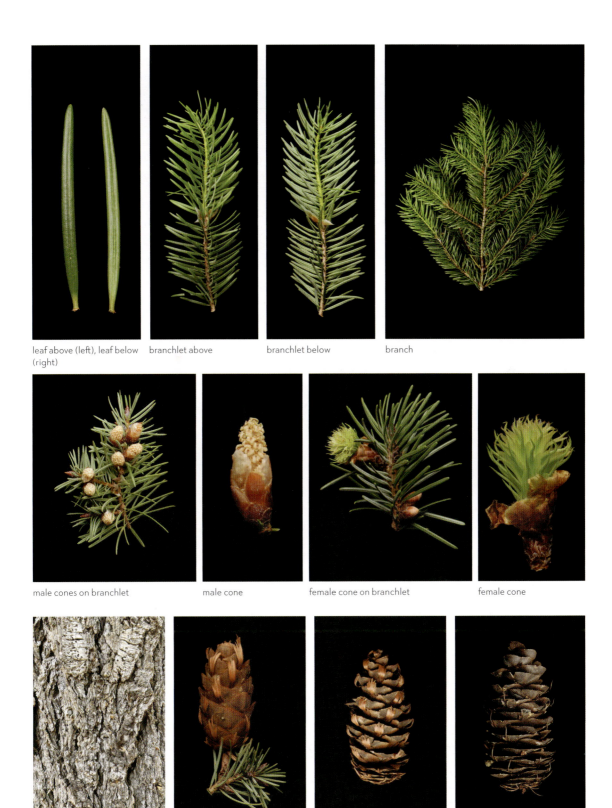

FAMILY PINACEAE • 149

Douglas-Fir
Pseudotsuga menziesii (Mirb.) Franco

Douglas-fir, native to the Pacific Northwest and British Columbia, has been introduced throughout North America. It is the second tallest tree in North America. This conifer was first described on Vancouver Island almost two hundred years ago by botanist Archibald Menzies, for whom it is named. Two varieties are recognized.

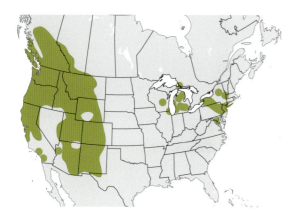

DESCRIPTION. An evergreen tree growing 230 ft (70 m) tall or taller with a pyramidal shape, lower branches drooping and upper branches ascending. Bark is thick, dark brown, and ridged. Leaves are needlelike, flat, yellowish green, grooved above with two bands of white stomata beneath, with pointed apex, 0.8–1.2 in (2–3 cm) long. Trees are monoecious producing both male and female cones on same plant. Male pollen cones are yellow to deep red, produced in leaf axils; female seed cones are oval, pendulous, deep green to red depending on age, 2–4 in (5–10 cm) long with three-pronged bracts that turn brown when the seeds are mature. Pollination occurs in mid-spring with seed dispersal in fall and winter.

TAXONOMIC NOTES. Variety *menziesii* grows on Pacific coast, 328–361 ft (100–110 m) in height, 13–16 ft (4–5 m) in diameter, with longer yellow-green needles, and larger cones (10 cm [4 in]) with flat three-pronged bracts; var. *glauca* in the Rocky Mountains grows to 131 ft (40 m) in height and 3 ft (1 m) in diameter with shorter blue-green needles, and smaller cones (7.5 cm [3 in]) with reflexed three-pronged bracts.

USES AND VALUE. One of the most commercially important trees in the Pacific Northwest. Used for veneer, plywood, timbers, and construction lumber with clearer grades utilized for interior trim. Cultivated as Christmas tree. Inner bark is edible. Native Americans use extract from bark as antiseptic.

ECOLOGY. Grows in coastal forests and on mountainous slopes. Young trees shade tolerant, but demand for light increases with maturity, becoming somewhat intermediate in tolerance. Heavy seed crops are produced every five to seven years. Relatively resistant to fire because of thick bark at maturity. Generally windfirm. Attached by host of pests, especially dwarf mistletoe and laminated root rot.

CLIMATE CHANGE. Vulnerability is currently considered to be low.

CONSERVATION STATUS. Least concern.

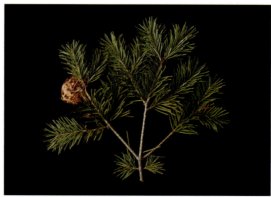
branch above (var. *glauca*)

bark

leaf above (left), leaf below (right)

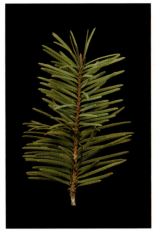
branchlet above (var. *glauca*)

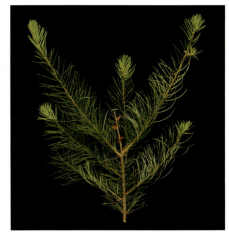
branch above (var. *menziesii*)

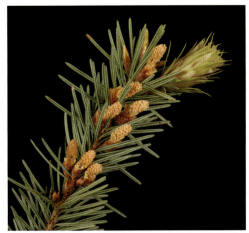
male and female cones on branchlet (var. *menziesii*)

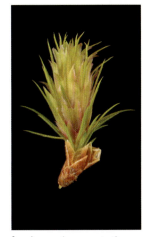
female cone (var. *menziesii*)

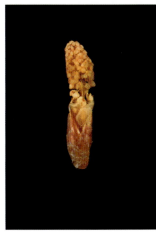
male cone (var. *menziesii*)

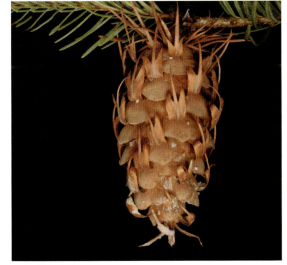
mature cone on branchlet (var. *glauca*)

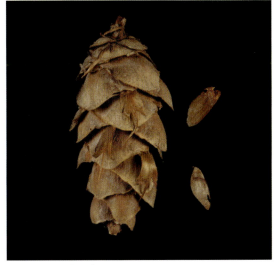
mature cone and seeds (var. *menziesii*)

FAMILY PINACEAE • 151

GENUS TSUGA

But though the Hemlock's top may rejoice in the boldest sun and brave any storm, the tree unfailingly has its roots down in deep cool, perpetually moist earth. And no more light and heat than a glancing sunbeam ever penetrates through the somber shade of its boughs to the forest floor.

—Donald Culross Peattie on *Tsuga canadensis* in *A Natural History of Trees of Eastern and Central North America*

The Latin name *Tsuga* is adapted from the Japanese common name for the tree. Taxonomists recognize eight to ten species, all of which are distributed in either North America or eastern Asia. The trees are medium-sized to large and evergreen, with horizontally held, flattened branches that gracefully bend toward the ground. The needlelike leaves are attached to the twigs by swollen protuberances called pulvini. Each needle has two characteristic white stripes below. Hemlocks prefer moist, cool, Temperate Zone habitats with significant rainfall. Their drooping branches are often seen covered with snow in winter. Commonly called "hemlock," this conifer is not the plant known as "poison hemlock," which is a species of flowering plant in the daisy family. Species of *Tsuga* are not toxic; in fact, they are often grown as ornamental trees around homes, in gardens, and in parks. Three native species of *Tsuga* are common trees in North America.

Eastern Hemlock

Tsuga canadensis (L.) Carrière
CANADIAN HEMLOCK

Eastern hemlock is a large coniferous tree native to and widespread in eastern North America that inhabits swamp margins, valleys, ravines, rocky ridges, and moist mountain slopes. Stands of mature trees provide essential shelter for white-tailed deer in winter.

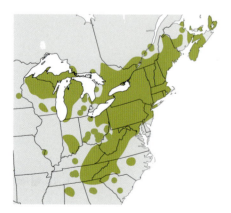

DESCRIPTION. A long-lived, evergreen, coniferous tree that grows up to 75 ft (25 m) or more in height. Trunk in older trees is branch free for 50 percent of its height but does not self-prune. Root system is shallow and spreading. Twigs are yellowish brown to grayish brown and pubescent when young, becoming glabrous with age. Bark is gray brown to red brown, flaky and scaly, developing wide ridges and furrows with age. Leaves are needlelike, arranged spirally on the twigs but appear two-ranked, flat with rounded blunt tips, dark green above with two whitish bands below, 0.24–0.59 in (6–15 mm) long. Trees are monoecious producing both male and female cones on same plant in mid-spring. Male pollen cones are found in axils of leaves, light yellow, subglobose, and about 0.4 in (1 cm) long; female seed cones are produced at ends of new shoots, pale green becoming brown when mature, ovoid, and 0.6–1 in (1.5–2.5 cm) long.

USES AND VALUE. Wood moderately commercially important. Used for pulpwood, framing construction, pallets, boxes, truck beds, and plywood. Tannin from bark was formerly important in leather industry. Popular ornamental because of attractive foliage and crown. Inner bark is edible. Native Americans and herbalists use tannin as astringent and antiseptic. Important tree for wildlife, especially white-tailed deer, which eat young shoots in winter and gather around the trees for protection. Larval host for the Columbia silkmoth.

ECOLOGY. Prefers moist mountain ridges, slopes and valleys. Shade tolerant. Produces abundant seed crops every two to three years. With seed germination typically high. Young trees susceptible to fire, whereas older trees are more protected by thicker bark. Generally drought intolerant. Attacked by wide variety of insects and fungi; most consequential is hemlock woolly adelgid, an invasive insect from Asia that is decimating stands and causing major population declines in the many parts of geographic distribution.

CLIMATE CHANGE. Vulnerability is currently considered to be low.

CONSERVATION STATUS. Near threatened.

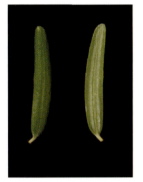
leaf above (left) and below (right)

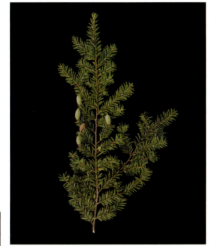
branch above

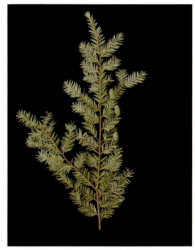
branch below

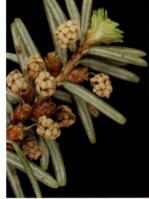
male cones on branchlet

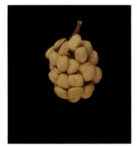
male cone

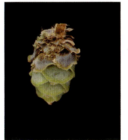
female cone

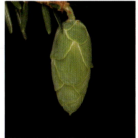
immature cone on branchlet

bark

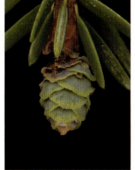
female cone on branchlet

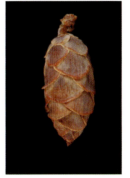
mature cone

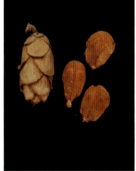
mature cone and seeds

Western Hemlock
Tsuga heterophylla (Raf.) Sarg.
PACIFIC HEMLOCK

Western hemlock is a common long-lived large coniferous tree native to moist low-elevation sites along the west coast of North America from Alaska to northern California. It is one of the four most important commercial tree species in the Pacific Northwest.

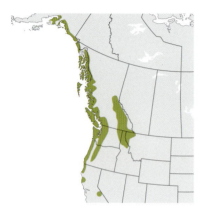

DESCRIPTION. An evergreen conifer that grows up to 164–200 ft (50–66 m) tall and has a broadly conic crown. Bark is brown, thin, and furrowed; on pendulous branchlets and shoots very pale buff brown or white and pubescent. Leaves are needlelike, arranged spirally on the shoots and twisted at the base, strongly flattened in cross section, dark green above, with two stomatal bands on the underside, margin finely serrate, apex bluntly acute, 0.20–0.90 in (5–23 mm) long. Trees are monoecious producing both male and female cones on same plant. Male pollen cones are small, yellow, and clustered around the base of the needles; female seed cones are terminal on lateral shoots, small, purple to golden brown, slender, cylindrical with fifteen to twenty-five scales, 0.55–1.18 in (14–30 mm) long, 0.27–0.31 in (7–8 mm) broad, mature six months after fertilization. Seeds are brown, 0.08–0.12 in (2–3 mm) long with a thin, light brown wing 0.27–0.35 in (7–9 mm) long.

USES AND VALUE. One of the four commercially important tree species in the Pacific Northwest. Used for framing construction, plywood, boxes, crates, pilings, poles, and pulp; best grades used for interior applications. Inner bark is edible. Native Americans use tannin as astringent and antiseptic. Roosevelt elk and black-tailed deer browse western hemlock in southern portion of range; used as food source by black bears, snowshoe hares, deer mice, and other mammals throughout range. Provides important habitat for many birds and small mammals.

ECOLOGY. Thrives in cold moist areas of the Pacific coast and northern Rocky Mountains, where it occurs on moist alluvial soils in riparian areas and low-lying wooded slopes. Considered the climax species of the Pacific Northwest forests. Very shade tolerant. Produces large seed crops every three to four years with high seed germination. Thin bark and shallow roots make it very susceptible to fire and windthrow. Numerous pests include dwarf mistletoe and root rot.

CLIMATE CHANGE. Vulnerability is currently considered to be low.

CONSERVATION STATUS. Least concern.

bark

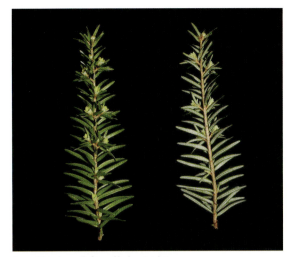

branchlet above (left) and below (right)

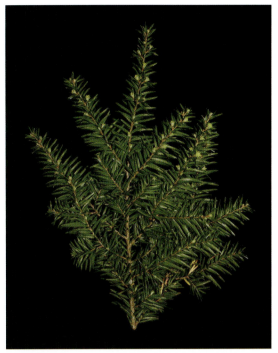

branch above

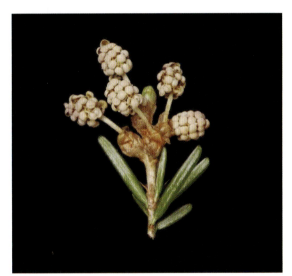

male cones

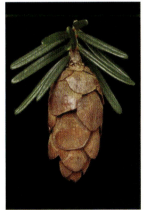

mature cone on branchlet

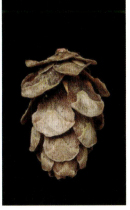

mature cone

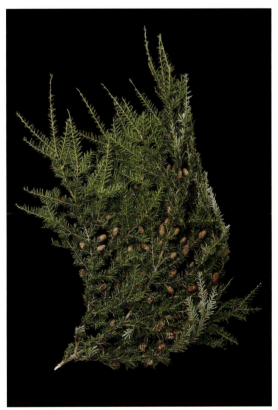

branch with cones

FAMILY PINACEAE • 155

Mountain Hemlock
Tsuga mertensiana (Bong.) Carrière

Mountain hemlock is an evergreen conifer native to wooded subalpine slopes throughout northwestern North America. Trees can attain ages of over eight hundred years.

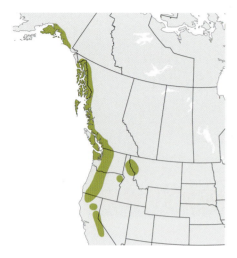

DESCRIPTION. An evergreen conifer that grows 30–98 ft (9–30 m) tall with a narrowly conical crown. Shoots are orange brown with a dense pubescence. Bark is gray, thin, square-cracked or furrowed. Leaves are needlelike, soft, blunt-tipped, pale and glaucous blue green above with two broad bands of bluish-white stomata below, 0.27–0.98 in (7–25 mm) long, 0.04–0.06 in (1–1.5 mm) wide. Trees are monoecious producing both male and female cones on same plant from June to July. Male pollen cones are small, yellow; female seed cones are small, pendent, sessile, terminal, purple to reddish brown, woody, cylindrical, 1–3 in (2.5–7.6 cm) long with numerous thin imbricate scales.

USES AND VALUE. Wood commercially important. Used for boxing, crates, pallets, framing construction, plywood, and pulp. Trees are important for watershed protection and valued by outdoor naturalists. Inner bark is edible. Native Americans use tannin as astringent and antiseptic. Provides food and protection to wildlife, especially deer and other mammals.

ECOLOGY. Grows in cold, snowy, subalpine or boreal habitats, where it may live to be eight hundred years in age or older. Occurs on a variety of soils but prefers moist soils rich in organic matter. Shade tolerant. Produces good seed crops annually; germination is usually high. Susceptible to damage from both fire and wind because of thin bark and shallow roots. Most significant pest is laminated root rot, which can result in mortality.

CLIMATE CHANGE. Vulnerability is currently considered to be low.

CONSERVATION STATUS. Least concern.

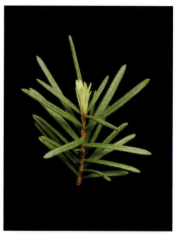

branchlet

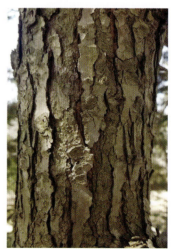

bark

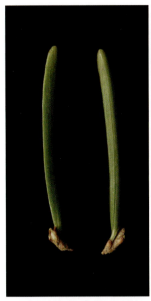

leaf above (left), leaf below (right) branchlet

branchlet

branch

mature cone

FAMILY PINACEAE • 157

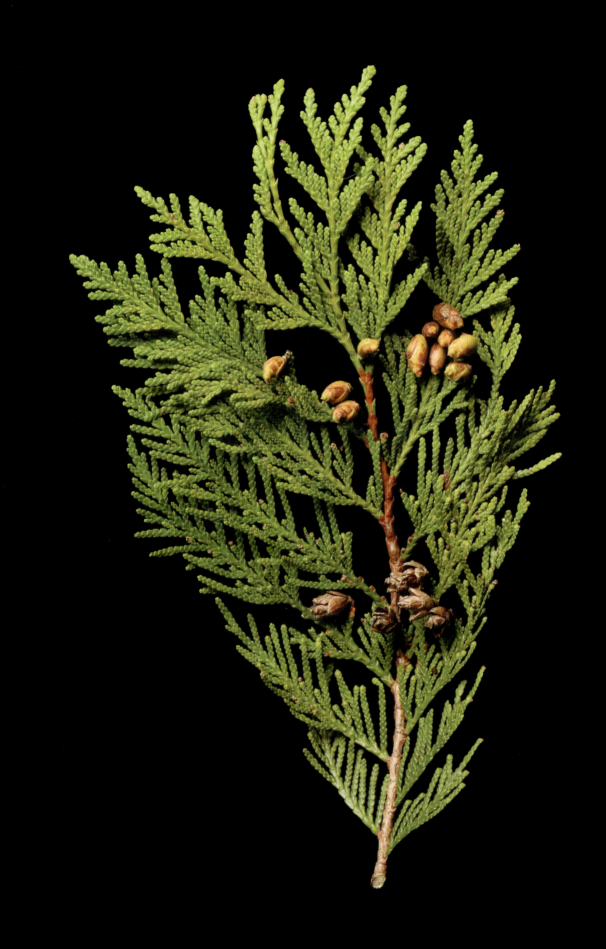

ORDER CUPRESSALES

A number of plant families formerly included in the order Pinales are now segregated into their own order, Cupressales, based on chemical features and several unique genetic anomalies as well as DNA sequence evidence. The Cupressales may contain from three to five families, up to fifty-seven genera, and 380 species. In North America, the two important families are the Cupressaceae and Taxaceae.

Family Cupressaceae

The Cupressaceae, or cypress family, has from twenty-seven to thirty genera, including the junipers, redwoods, and bald cypress, and contain about 130–140 species in all. The family is found around the world on all continents but Antarctica, from Scandinavia in the north to the tip of Chile in the south. One species of juniper in the Himalayas, *Juniperus indica*, is reported to occur at the highest elevation of all trees. Almost all members of the Cupressaceae are evergreen trees, but a few, including *Taxodium* from North America, shed their leaves in winter. Individual species can have both male and female cones on the same trees (monoecious) or on separate individual trees (dioecious). The cones that produce the seeds can be either typical conifer woody structures or fleshy and look like berries. Eight genera and twenty-one species are considered common in North America.

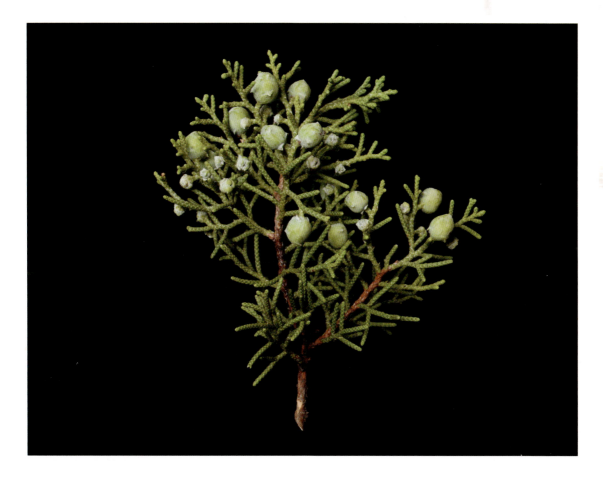

OPPOSITE Western redcedar (*Thuja plicata*). **ABOVE** California cedar (*Juniperus californica*).

GENUS CALOCEDRUS

Judged by ordinary mortal standards, Incense Cedar is a splendid species, with its flat sprays of foliage which reflect the clear Sierra sunlight, its colorful trunks, its limber boughs full of grace.

—Donald Culross Peattie on *Calocedrus decurrens* in *A Natural History of North American Trees*

This genus is a relative of *Thuja* and native to eastern Asia and western North America. The generic name means "beautiful cedar." Of the four species of *Thuja*, one is from North America and three are from China and Vietnam. The one native species of *Calocedrus* is a common tree in North America.

Incense-Cedar

Calocedrus decurrens (Torr.) Florin.

Incense-cedar is found in mixed conifer forests in the western United States. The tree is commonly used as a landscape plant because of its shape and the distinctive incense-like aroma released when the needles are crushed.

DESCRIPTION. A large evergreen tree growing 49–148 ft (15–45 m) tall with tapering trunk and columnar crown. Slow growing and long-lived with individuals aged four hundred to one thousand years old. Bark is thick, cinnamon colored, and deeply furrowed, often fibrous and shredded in mature trees. Leaves are scalelike, arranged in whorls of four, and release an incense-like scent when crushed. Trees are monoecious producing both male and female cones on same plant, reproduce every three to six years in spring. Male pollen cones are 0.12 in (3 mm) long; female seed cones are up to 1.2 in (3 cm) long with a distinctive "duckbill" appearance when mature. Seeds are four per cone, winged.

USES AND VALUE. Wood commercially important. Used for production of pencils because of softness and ease of cutting without splintering, for siding, outdoor furniture, and fence posts because of resistance to rot. Grown widely as ornamental.

ECOLOGY. Grows in mixed coniferous forests at low to middle elevations on a wide variety of soils. Shade tolerant, long-lived and slow-growing. Good seed crops are produced every three to six years; regeneration is abundant in moist organic litter. Not drought resistant; because of its thin bark when young, easily damaged by fire. Stem rot, root-rot fungi, and mistletoe cause significant damage to mature trees.

CLIMATE CHANGE. Vulnerability is currently considered to be low.

CONSERVATION STATUS. Least concern.

male cones

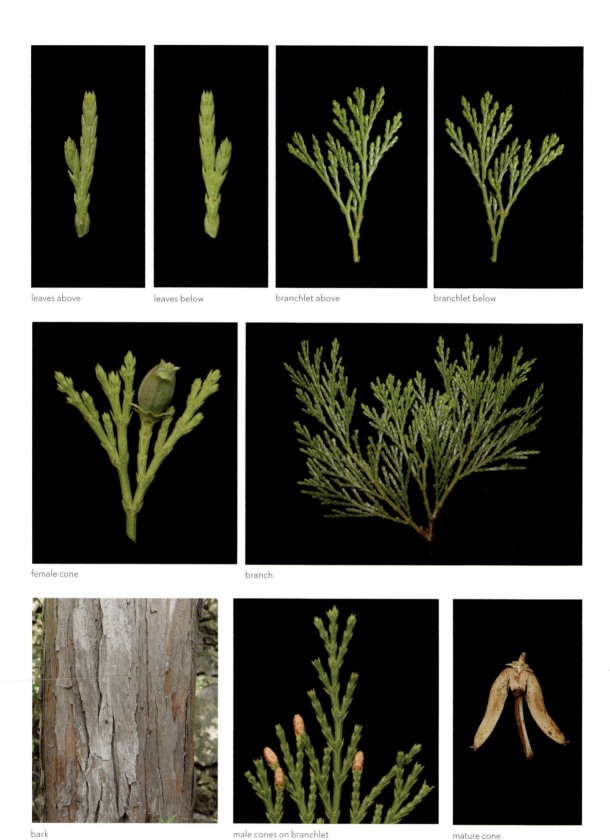

GENUS CHAMAECYPARIS

If sighted at all, the Cedar swamps are seen by most people from a flying train, or a car on an elevated superhighway designed to get you to Atlantic City or Philadelphia without seeing anything but the car ahead of you. And, speeding by, the traveler tosses them the idle thought that someone—Uncle Sam, or the Rockefellers—ought to drain those swamps and turn them into good farms.

—Donald Culross Peattie on *Chamaecyparis thyoides* in *A Natural History of Trees of Eastern and Central North America*

The six or seven species in the genus *Chamaecyparis* are native to eastern Asia and western North America. The name is derived from the Greek *khamai*, meaning "ground," and *kuparissos* for "cypress trees." The leaves can take two distinct forms (similar to junipers): on young seedlings during their first year of growth, the leaves are needlelike, while on adult trees, the leaves are transformed into smaller scalelike structures. Several of the species are cultivated as important ornaments, and the scented wood has applications in construction. Two native species of *Chamaecyparis* are common trees in North America.

Port-Orford-Cedar

Chamaecyparis lawsoniana (A. Murray) Parl.
OREGON CEDAR

Port-Orford-cedar is a tall evergreen tree valued as an ornamental and timber species growing in coastal areas of northern California and Oregon. This charismatic conifer is classified as near threatened due to its susceptibility to the *Phytophthora* fungus.

DESCRIPTION. An evergreen tree growing to 197 ft (60 m) in height. Trees are long-lived and may attain six hundred years of age. Mature trees have enlarged branchless buttressed trunks and lack a taproot. Bark is fibrous and shredded. Leaves are small, scalelike with white markings on the underside, arranged tightly into branchlets; foliage is aromatic and with faint odor of parsley. Trees are monoecious producing male and female cones on same plant, opening in late spring. Male pollen cones are distinctively red, 0.12–0.16 in (3–4 mm) long; female seed cones are small, dark red brown, somewhat rounded, with thick wrinkled scales. Seeds are marginally winged, 0.12–0.16 in (3–4 mm) long, and highly variable in size.

USES AND VALUE. Wood commercially important. Highly prized, especially in Japan, where used in wooden ware and to repair houses and temples. In North America, used for arrow shafts, boats, boxes, musical instruments, and decking. A popular ornamental tree. Powder from the resin is a strong diuretic. No food uses are known.

ECOLOGY. Grows in high-moisture soils in coastal areas; inland populations sparse. Shade tolerant, especially when young, and grows well in both direct sunlight and full shade. Produce large seed crops every four to five years, with abundant regeneration on both burned and unburned sites. Susceptible to windthrow due to lack of taproot; damaged by fire when young due to thin bark. Very susceptible to root fungus (*Phytophthora lateralis*), which is responsible for near threatened status.

CLIMATE CHANGE. Vulnerability is currently considered to be low.

CONSERVATION STATUS. Near threatened.

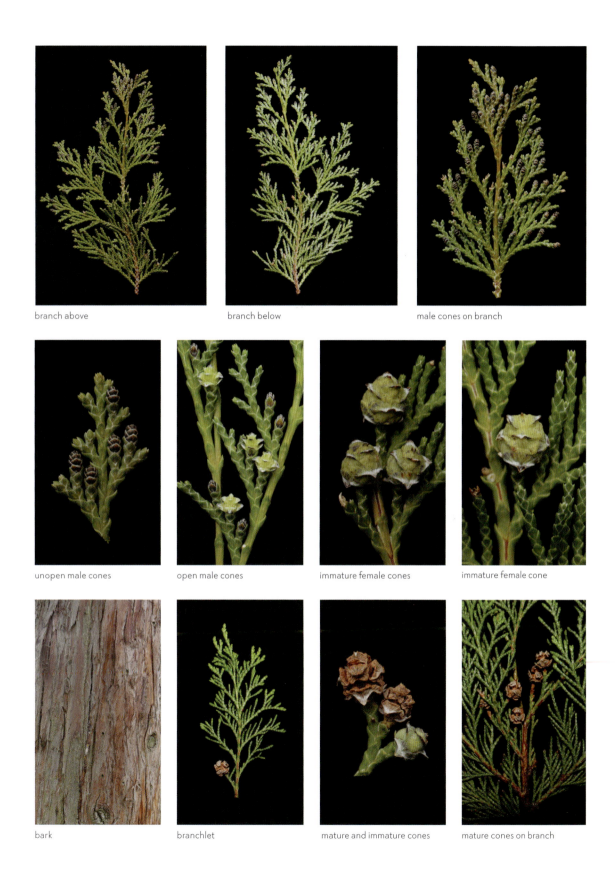

FAMILY CUPRESSACEAE

Atlantic White-Cedar

Chamaecyparis thyoides (L.) Britton, Sterns & Poggenb.
SOUTHERN WHITE-CEDAR

Atlantic white-cedar is a long-lived evergreen tree native to the Atlantic and Gulf coasts of North America, where it grows in bogs and swamps. The decay-resistant wood was much prized as a building material.

DESCRIPTION. A native long-lived, evergreen, coniferous tree columnar in form growing to 66–92 ft (20–28 m) tall and about 20 ft (6 m) wide. Bark is light brown. Leaves are flattened and dense, small and scaly, bluish green in color with white margins, 0.06–0.12 in (1.5–3 mm) long. Trees are monoecious producing male and female cones on same plant in spring. Male seed cones are reddish yellow, tiny; female seed cones are 0.25 in (6.4 mm) in diameter at maturity, with four or five bluish-purple, glaucous scales, each of which contains five to fifteen small, winged seeds.

USES AND VALUE. Wood commercially important. Highly resistant to decay and used for fence posts, telephone poles, boats, siding, outdoor furniture, and shingles. Leaves emit a strong scent upon steaming that is used to treat headaches and backaches. No parts are edible. Branches serve as nesting sites for birds. Larval host for Hessel's hairstreak (*Callophrys hesseli*) butterfly.

ECOLOGY. Grows in swamps and bogs on the coastal plains of the Atlantic Ocean and Gulf of Mexico. Produce good seed crops most years with germination up to 90 percent. Winged seeds are distributed widely by the wind. No serious insect pests and highly resistant to stem-rot fungi. Susceptible to windthrow due to shallow roots; thin bark is easily damaged by fire.

CLIMATE CHANGE. Vulnerability, though currently considered to be low, may increase in the future. Ongoing monitoring is recommended.

CONSERVATION STATUS. Least concern.

mature cone

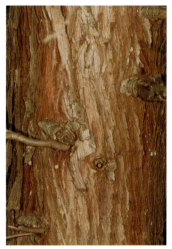

bark

branchlet

branch

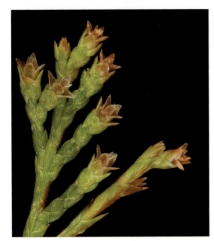
male cones on branchlet

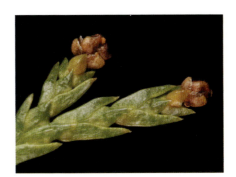
male cones on branchlet

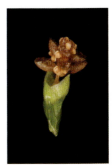
male cone

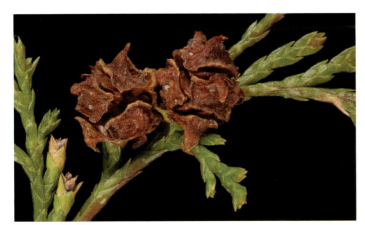
mature cones on branchlet

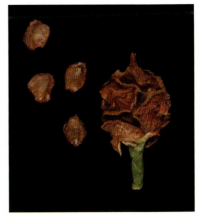
mature cone and seeds

FAMILY CUPRESSACEAE • 165

GENUS JUNIPERUS

On the very edge of the opened book of the Grand Canyon—page upon page of red stone tablets receding away into the purple shadows of a billion years of time gone by—perches Utah Juniper. Now erect of stem, with crown symmetrically intact, now aslant over the awesome chasm, with storm-torn, broken head, and the stem contorted as by the whirl of winds themselves or lightening-riven and stripped to the white bones of half its bark—this indomitable tree dares the south rim of the Canyon for miles.

—Donald Culross Peattie on *Juniperus osteosperma* in A Natural History of North American Trees

Species in the genus *Juniperus* are distributed in the Northern Hemisphere from Africa to Asia to North America and the Arctic. Taxonomists estimate that between fifty and seventy species exist today and inhabit some of the highest-altitude forests in the world. Junipers can be tall trees or sprawling shrubs and thrive in a variety of environments: from dry, rocky, well-drained soils to woodland forests to open secondary growth. Some species are invasive and quickly smother local vegetation, leading to significant changes in the flora of particular habitats. Some species may have two types of leaves (similar to *Chamaecyparis*): young plants bear needlelike leaves, while more mature plants produce scalelike leaves. Some species have both male and female cones on the same plant (monoecious), while others have the sexes on separate plants (dioecious). The female cones, which look like berries, are composed of fleshy scales that fuse together when mature. People use species in the genus as flavorings, herbal cures, and ornamentals. Eleven native species of *Juniperus* are common trees in North America.

Ashe Juniper
Juniperus ashei J. Buchholz

Ashe juniper is a drought-tolerant, multistemmed, evergreen small tree or shrub native to Texas that is well known for its ability to form dense thickets. Overgrazing and fire suppression of grasslands has resulted in the invasion and overabundance of this species of juniper on shallow limestone soils.

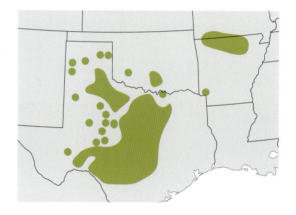

DESCRIPTION. An evergreen shrub or small tree typically smaller than 30 ft (9 m) in height with large taproot in addition to lateral roots in the upper surface of soil. Bark is shaggy and aromatic. Leaves are scalelike in adults and often prickly in young growth and seedlings. Trees are dioecious producing male and female cones on different plants. Female cones are soft, berrylike, green when immature, turning blue to violet at maturity.

USES AND VALUE. Wood not commercially important. Used for fence posts, fuelwood, erosion control, and shade for livestock and wildlife. No known medicinal uses. Pollen can cause highly allergic reaction in humans known as "cedar fever."

Fruits are edible, raw or cooked. Fruits attractive and palatable to many species of bird. Foliage generally not preferred by large grazers.

ECOLOGY. Grows in shallow limestone soils on Edwards Plateau. Invades grasslands as a result of fire suppression and overgrazing; unchecked growth creates dense evergreen thickets that reduces biodiversity of native species. Shade intolerant. Seedlings susceptible to fire; dense cedar brakes can prevent crown fires. Resistant to drought and windthrow due to deep roots.

CLIMATE CHANGE. Vulnerability is significant but has a reasonable probability of persistence in the future. Ongoing monitoring is recommended.

CONSERVATION STATUS. Least concern.

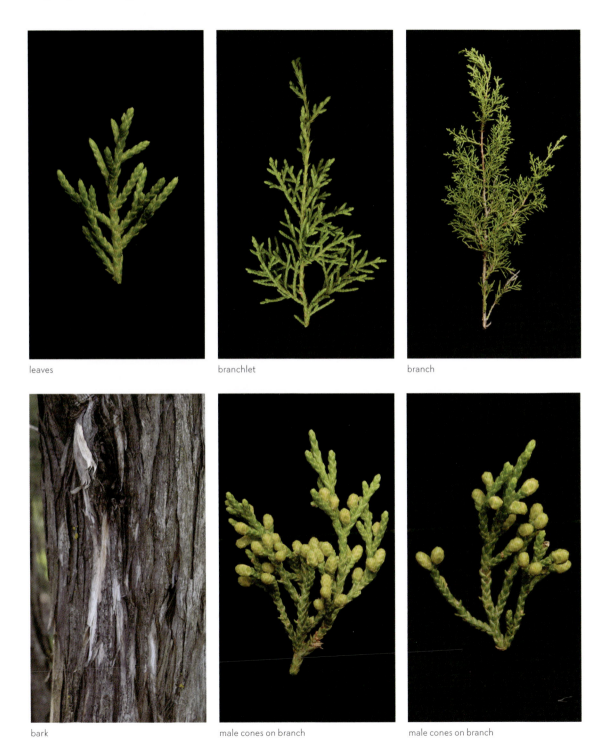

leaves

branchlet

branch

bark

male cones on branch

male cones on branch

California Juniper
Juniperus californica Carrière

California juniper is a short, drought-tolerant, shrublike tree with berrylike cones that are eaten by wildlife. It is found at moderate altitudes and prefers sloping well-drained soils in Arizona, California, and Nevada.

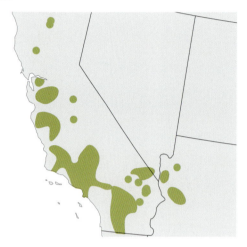

DESCRIPTION. A small multistemmed tree typically less than 33 ft (10 m) tall. Stems are stout and irregular. Bark is grayish, thin, with a shredded appearance; on twigs bark is brown to ashy and not exfoliating or flaky. Leaves are needlelike when young becoming scalelike at maturity, closely appressed and often arranged in opposite pairs or in whorls of three, 0.04–0.20 in (1–5 mm) long. Trees are primarily dioecious producing male and female cones on separate plants, but infrequently monoecious. Young female seed cones open in spring, are soft and berrylike, waxy, blue brown becoming reddish brown, woody and fibrous at maturity, 0.27–0.51 in (7–13 mm) long.

USES AND VALUE. Wood not commercially important. Used for fence posts and fuelwood. Popular as ornamental, especially as bonsai. Berries are edible. Infusion of twigs or bark reported to be cure for hangovers and other ailments. Provides shade and cover for wildlife.

ECOLOGY. Grows at moderate altitudes on slopes with coarse, well-drained soils; range extends into desert habitats, where it occurs with pinyon pine (*Pinus edulis*), oaks (*Quercus* sp.) and Joshua tree (*Yucca brevifolia*). Shade intolerant and drought resistant.

CLIMATE CHANGE. Vulnerability is significant but has a reasonable probability of persistence in the future. Ongoing monitoring is recommended.

CONSERVATION STATUS. Least concern.

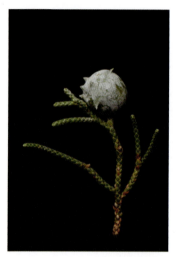
mature cone

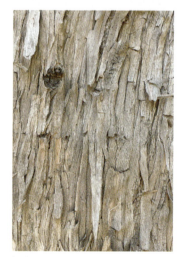
bark

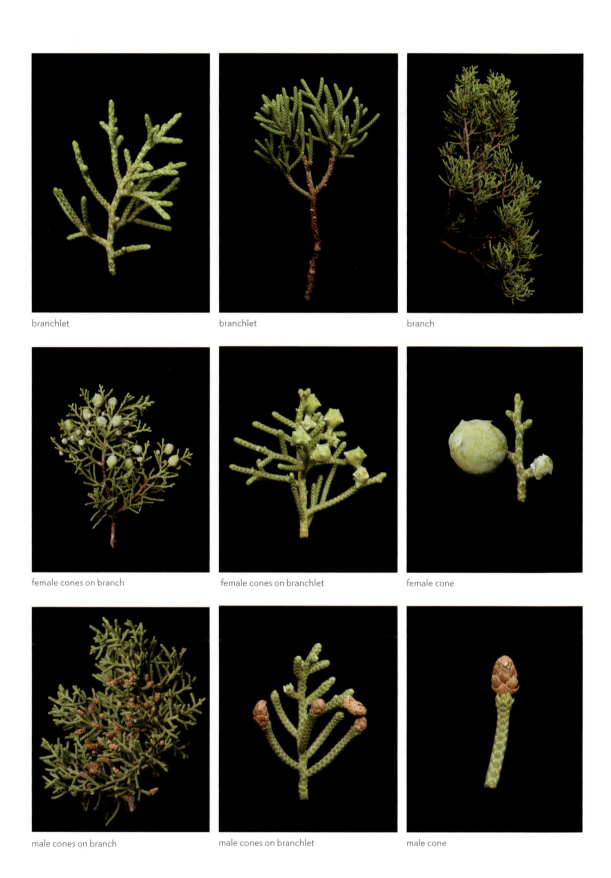

FAMILY CUPRESSACEAE • 169

Common Juniper
Juniperus communis L.

Distributed throughout North America this native species is an evergreen shrub or small tree with scaly bark. The young seed cones are reddish when young, ripen to a bluish-black color when mature, and used as a medicinal and to flavor gin.

DESCRIPTION. An evergreen shrub or tree, generally trunkless with many long branches at ground level, usually growing no taller than 10 ft (3 m), but occasionally up to 30 ft (10 m). Bark is reddish brown, thin, and scaly. Leaves are needlelike, arranged in whorls of three, blue green, often waxy, awl-shaped, jointed at the base, with spiny tips, 0.47–0.79 in (12–20 mm) long. Trees are monoecious producing male and female cones on same plant or dioecious producing male and female cones on separate plants. Male pollen cones are solitary at the end of short shoots, catkin-like, 0.3 in (0.8 cm) long; female seed cones are green when young, somewhat catkin-like on very short stalks, composed of three to eight scales that fuse over one to three years until mature, dark blue with a waxy coating at maturity, less than 0.39 in (10 mm) wide, with one or more seeds.

USES AND VALUE. Wood not commercially important. Used for fuel. Often cultivated as ornamental. A wide range of medicinal uses and is included in some commercial preparations. Fruit, seeds, and leaves are edible; "berries" have long been used to flavor gin.

ECOLOGY. Grows in habitats ranging from old fields to coastal zones and mountains on a wide range of soils, including shallow, rocky, and low-moisture sites. Somewhat shade tolerant; drought resistant.

CLIMATE CHANGE. Vulnerability is currently unknown. Immediate assessment is recommended.

CONSERVATION STATUS. Least concern.

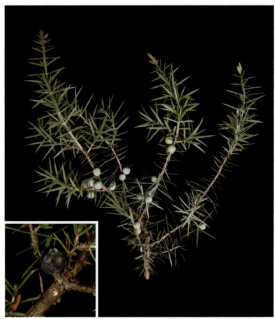

mature cone on branch (inset), mature cones on branch (above)

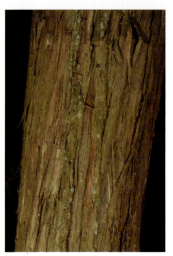

bark

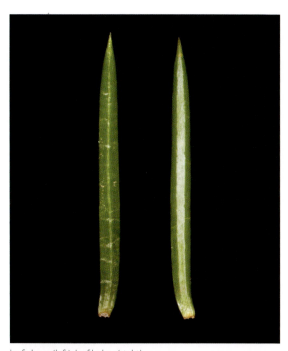
leaf above (left), leaf below (right)

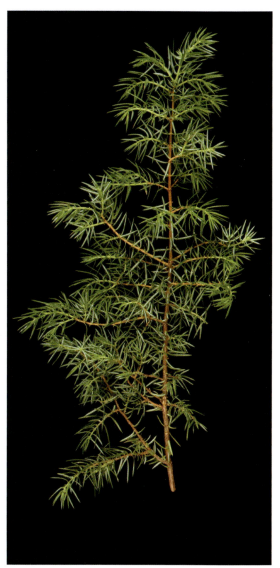
branch

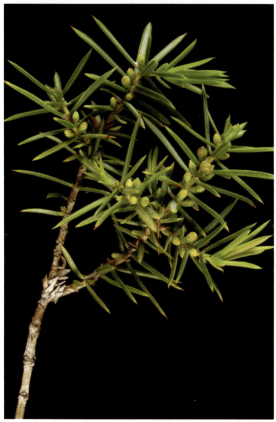
female cones on branch

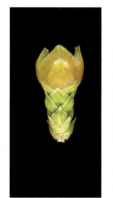
female cone

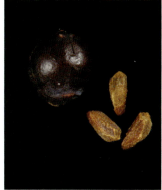
mature cone and seeds

Alligator Juniper
Juniperus deppeana Steud.

Alligator juniper, found at moderate altitudes in arid areas in the southwestern United States, is easily distinguished from its relatives by its hard bark scored in quadrangular plates or strips. Fruits are orange brown when mature and a source of food for wildlife.

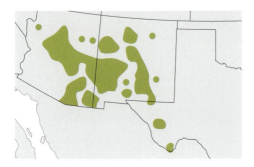

DESCRIPTION. A single-stemmed tree with a rounded crown that grows to 33–66 ft (10–20 m) tall. Long-lived up to five hundred years old. Bark is distinctively reticulated and scored with deep checkered furrows that resemble alligator skin, very hard and thereby allowing tree to grow taller than other junipers in arid habitats. Leaves are arranged in opposite pairs or whorls of three, scalelike, 0.04–0.10 in (1–2.5 mm) long. Trees are typically dioecious producing male and female cones on separate plants in early spring. Female seed cones are 0.20–0.59 in (5–15 mm) in diameter and green when young, becoming orange brown at maturity in the second year, 0.5 in (1.3 cm) in diameter, produce one to six seeds.

USES AND VALUE. Wood not commercially important. Used for fence posts and fuel. Fruits are edible with a dry mealy consistency and sweet taste. No medicinal uses are known. Like many junipers, the berrylike cones provide forage for birds and small mammals.

ECOLOGY. Grows at moderate altitudes (2,461–2,297 ft or 750–2,700 m) on dry soils in arid habitats in the southwestern United States. Common in pinyon-juniper woodlands. Shade intolerant and drought resistant.

CLIMATE CHANGE. Vulnerability is currently considered to be low.

CONSERVATION STATUS. Least concern.

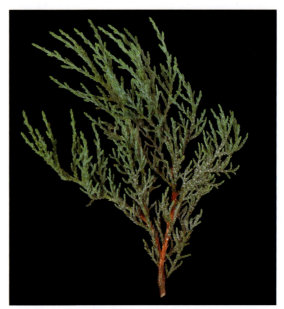
branch

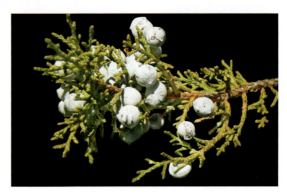
mature cones

bark

Oneseed Juniper

Juniperus monosperma (Engelm.) Sarg.

Oneseed juniper is a small shrublike tree that prefers dry, arid climates and persists on a variety of soils in the southwestern United States. Distinguished from close relatives by the lack of conspicuous scale glands.

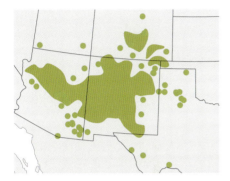

DESCRIPTION. A long-lived evergreen tree typically growing to 10–39 ft (3–12 m) in height with multitrunked shrubby habit and curved branches projecting from the base. Branchlets are erect and four- to six-sided. Bark is thin and shredded. Leaves are scalelike, keeled, rarely overlap, 0.04–0.12 in (1–3 mm) long, scale glands not conspicuously visible. Trees are dioecious producing male and female cones on separate plants in spring. Female seed cones are fleshy and berrylike, become dark blue to nearly black when mature, contain one or, rarely, two seeds.

USES AND VALUE. Wood not commercially important. Used for fencing and as fuel. Fruits are edible; resin made into a gum considered to be delicacy. Native Americans used various parts for medicinal purposes.

ECOLOGY. Commonly grows in desert grasslands and pinyon-juniper shrublands. Prefers dry rocky flats and slopes with parent rock of basalt, limestone, or sandstone. Drought tolerant; can cease growth when water availability is low. Shade intolerant.

CLIMATE CHANGE. Vulnerability is currently considered to be low.

CONSERVATION STATUS. Least concern.

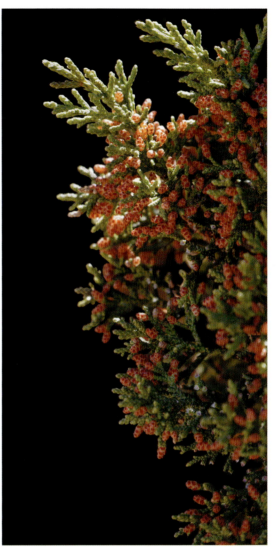

male cones

bark

Western Juniper
Juniperus occidentalis Hook.

Western juniper is a long-lived evergreen tree typically found on mountain slopes or high plateaus with shallow rocky soils. A yellow exudate produced by glands on the leaves turns dark brown with age and is a distinguishing feature of this juniper. Two subspecies are recognized.

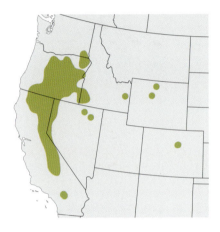

DESCRIPTION. An evergreen tree typically 16–59 ft (5–18 m) in height with dark brown trunks. Long-lived from one thousand to six thousand years in age. Bark is shredded, furrowed, reddish on twigs, exfoliates into flakes. Leaves are arranged alternately or in whorls of three, scalelike; leaf glands are distinctive producing a yellow exudate that turns dark brown or black with age. Trees are monoecious producing male and females cones on the same plant or dioecious producing male and female cones on separate plants in spring. Female seed cones are berrylike, blue green when young after two years becoming dark blue or bluish black when mature, each cone contains two or three seeds, 0.27–0.39 in (7–10 mm) long.

TAXONOMIC NOTES. Subspecies *occidentalis* is found from Washington to northern California with leaves in whorls of three; ssp. *australis* is found from the Sierra Nevada in California to western Nevada with alternating leaves.

USES AND VALUE. Wood not commercially important. Used for fencing and fuel. Fruits are sweet and nutritious, either raw or cooked. Native Americans use various parts for wide range of medicinal purposes.

ECOLOGY. Grows on mountain slopes or high plateaus preferring shallow stony soils with little organic content. Shade intolerant, drought resistant, and windfirm.

CLIMATE CHANGE. Vulnerability is currently considered to be low.

CONSERVATION STATUS. Least concern.

bark

branchlet above

branchlet below

mature cone on branchlet

branch

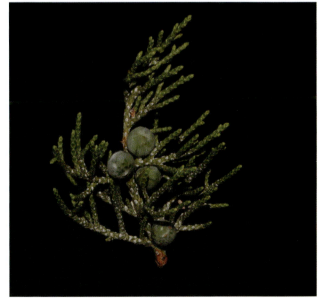
mature cones on branchlet

FAMILY CUPRESSACEAE • 175

Utah Juniper
Juniperus osteosperma (Torr.) Little
DESERT JUNIPER

Utah juniper is a slow-growing, drought-tolerant, evergreen tree and a member of pinyon-juniper woodlands of the Great Basin. It is not commercially important but provides an important source of cover and forage for wildlife.

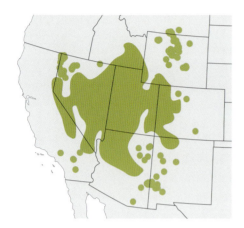

DESCRIPTION. A long-lived, slow-growing evergreen tree living 350–700 years in age with single or multiple stems and a rounded crown that reaches 20–39 ft (6–12 m) in height. Produces both a taproot and lateral roots, which can constitute up to two-thirds of an individual's biomass. Bark is grayish and exfoliates into strips. Leaves are scalelike, not overlapping, light yellow green, margins minutely denticulate, keeled, 0.12–0.20 in (3–5 mm) long, abaxial glands present but inconspicuous. Trees are monoecious producing male and female cones on same plant in spring. Female seed cones are berrylike, bluish brown, require one to two years to mature, 0.31–0.35 in (8–9 mm) in diameter with straight peduncles.

USES AND VALUE. Wood not commercially important. Used for fencing and fuel. Fruits are edible. Native Americans use various parts for wide range of medicinal purposes.

ECOLOGY. A common tree in the Great Basin, where it is a community dominant in pinyon-juniper woodlands. Grows extremely slowly and is one of the most drought-resistant junipers in North America. Prefers dry rocky slopes at 4,265–8,530 ft (1,300–2,600 m) in elevation. Shade intolerant and drought resistant. Host of juniper tip midge (*Oligotrophus betheli*) which makes small violet clustered galls.

CLIMATE CHANGE. Vulnerability is currently considered to be low.

CONSERVATION STATUS. Least concern.

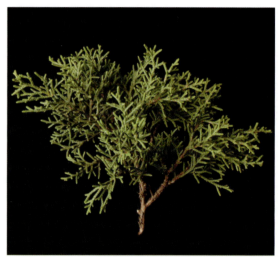
branch

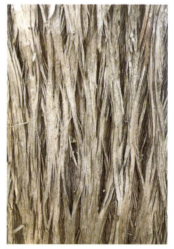
bark

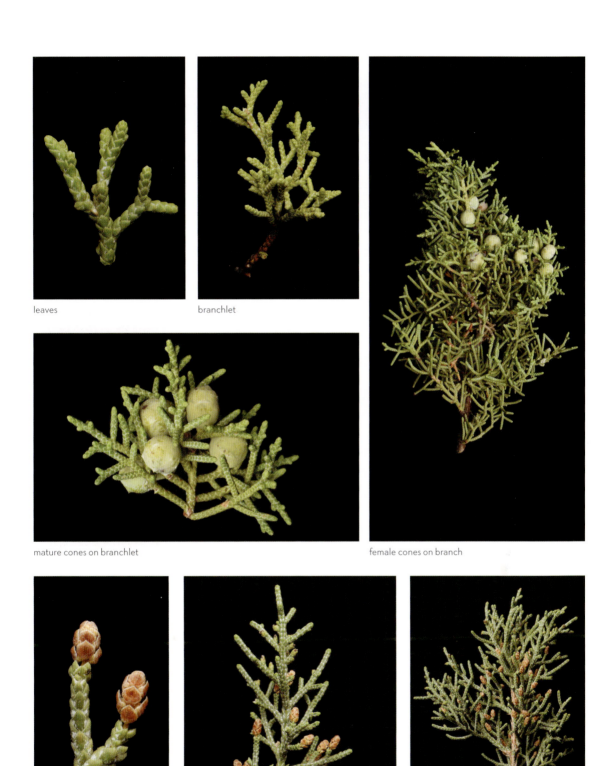

leaves
branchlet
mature cones on branchlet
female cones on branch
male cones
male cones on branchlet
male cones on branch

FAMILY CUPRESSACEAE • 177

Pinchot Juniper
Juniperus pinchotii Sudw.

Pinchot juniper is a shrubby evergreen tree that grows in shallow rocky soils in New Mexico, Oklahoma, and Texas. In some areas, ranching and fire suppression have altered habitats allowing this juniper to form dense thickets, which can be a nuisance to ranchers and farmers.

DESCRIPTION. A 3–26 ft (1–8 m) tall shrubby tree with an extensive lateral root system. Branchlets are stiff and about 0.04 in (1 mm) in diameter. Bark is light grayish brown, and exfoliates into strips, revealing fresh ruddy bark. Leaves are scalelike but may also be needlelike, fragrant, often with glands producing white exudate; glands on whip-leaves are raised and oval. Trees are typically dioecious producing male and female cones on separate plants, occasionally monoecious. Male pollen cones are 0.12–0.16 in (3–4 mm) long, open and release pollen in fall; female seed cones are berrylike, coppery brown with rosy wax and take one year to mature, 0.20–0.31 in (5–8 mm) in diameter.

USES AND VALUE. Wood not commercially important. Provides food and habitat for birds and mammals. Foliage is palatable as browse. Can be invasive in some regions and considered a nuisance by ranchers and farmers.

ECOLOGY. Prefers shallow, rocky, limestone soils in woodlands, canyons, and foothills. Commonly occurs with mesquite (*Prosopis glandulosa*) and oaks (*Quercus* spp.). Ranching and fire suppression by local inhabitants have created environmental conditions favorable for this juniper to form dense thickets. Somewhat shade tolerant and drought resistant.

CLIMATE CHANGE. Vulnerability is significant but has a reasonable probability of persistence in the future. Ongoing monitoring is recommended.

CONSERVATION STATUS. Least concern.

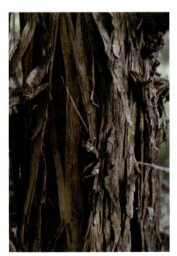

bark

leaves

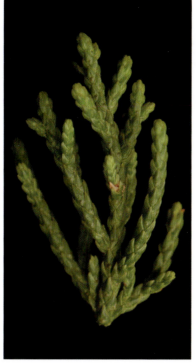
leaves on branchlet

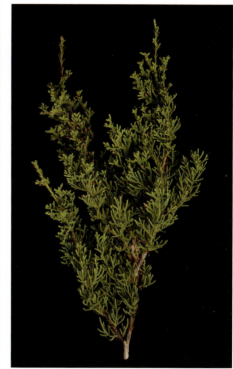
branch

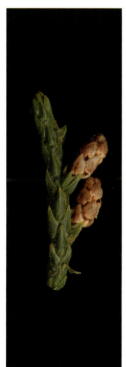

male cones

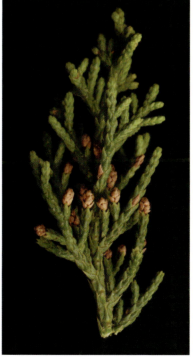
male cones on branchlet

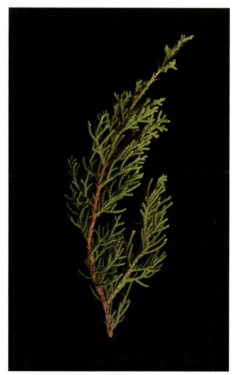
branchlet

FAMILY CUPRESSACEAE • 179

Rocky Mountain Juniper

Juniperus scopulorum Sarg.

Rocky Mountain juniper is a widespread shrubby coniferous tree that is highly variable in form across its range. In shaded areas, branchlets are flaccid and displayed as "weeping sprays," while in more open habitats branchlets are held erect. Commonly cultivated as a landscape ornamental and frequently used in bonsai.

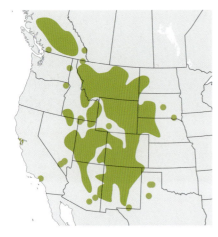

DESCRIPTION. A widespread conical evergreen shrubby tree that is typically shorter than 33 ft (10 m) in height and highly variable in form within its range. Branchlets may be erect or flaccid and three- to four-sided in cross section. When growing in shade, the foliage is less erect and grows in "weeping sprays." Bark is gray and thin with shredded appearance; outer exfoliating strips reveal new reddish copper bark inside. Leaves are arranged in pairs, scalelike, light green or bluish green, 0.04–0.12 in (1–3 mm) long. Trees are mostly dioecious producing male and female cones on separate plants, but occasionally monoecious with cones opening in spring. Male pollen cones are solitary and terminal on branchlets, 0.08–0.16 in (2–4 mm) long; female seed cones are blue, fleshy, berrylike, 0.16–0.31 in (4–8 mm) in diameter and contain one to three seeds.

USES AND VALUE. Wood somewhat commercially important. Used for fence posts and fuel; lumber suited for building specialty items, such as cedar chests and custom furniture, on a small scale. Native Americans use various parts to treat venereal disease and wide range of ailments. Fruits are edible and used as substitute for coffee. Trunks used as "rubbing posts" by mammals.

ECOLOGY. Commonly found in pinyon-juniper woodlands, co-occurring with other species of juniper. Grow on steep, dry, clay, rocky, or sandy slopes and prefer calcareous and alkaline soils as well as moist drainage areas. Regularly lives to 250–300 years of age and has been recorded to live three thousand years. Shade tolerant when young but requires full sun at maturity. Drought resistant and windfirm. Some individuals, especially smaller stunted trees, are prolific seeders, but germination rates are low (25 percent).

CLIMATE CHANGE. Vulnerability is currently considered to be low.

CONSERVATION STATUS. Least concern.

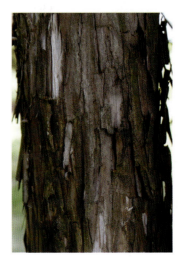

bark

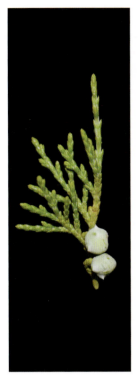
mature cones

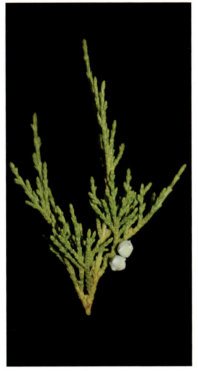
mature cones on branchlet

branch

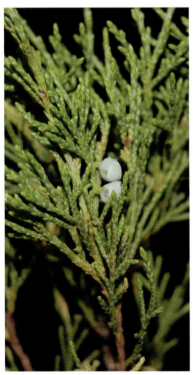
mature cones on branch

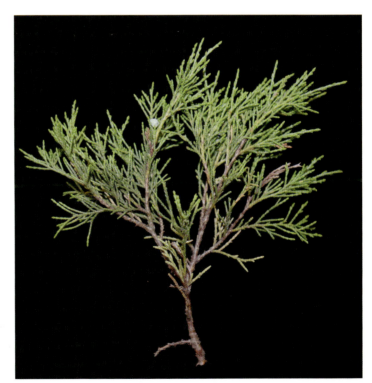
branchlet

FAMILY CUPRESSACEAE • 181

Eastern Redcedar
Juniperus virginiana L.
EASTERN JUNIPER

Eastern redcedar is an evergreen, dense, slow-growing tree native to eastern North America with reddish-brown bark that peels off the trunk in thin strips. The aromatic wood, which is repellent to moths, is used to make "cedar closets" and "cedar chests" to prevent damage to clothes.

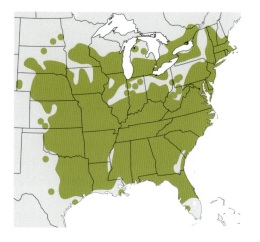

DESCRIPTION. A medium- to long-lived evergreen tree native to North America that grows to 98 ft (30 m) tall and 15–30 ft (4.57–9.14 m) wide, with dense pyramidal form when young becoming more open at maturity. Bark is exfoliating, gray brown. Leaves are small needles or tiny scales less than 0.25 in (0.65 cm) long, green. Trees are dioecious producing male and female cones on separate plants in late spring. Male pollen cones are yellowish brown; female seed cones are berrylike, bluish green at maturity, about 0.25 in (0.64 cm) long, with one to three seeds.

USES AND VALUE. Wood commercially important. Highly valued for beauty, workability, and durability, and used for fence posts, closet linings, cedar chests, outdoor furniture, and other specialty items. Important for shelterbelt plantings to mitigate wind erosion of soils. Used as Christmas tree and cultivated ornamental. Essential oil extracted from the wood used in soaps, insecticides, insect repellants, and perfume. Native Americans use various parts for wide range of aliments and chew the berries to treat mouth sores.

Fruits are edible, either cooked or raw. Important for wildlife, providing shade, shelter, and food for wide variety of birds and deer. Birds are responsible for seed dispersal after eating the fruit. Larval host for eastern pine elfin and olive hairstreak butterflies.

ECOLOGY. Grows in a wide range of environments, including woodlands, coastal dunes, and open fields, preferring full sun and moist soils but will also tolerate dry conditions on rocky, sandy, and limestone soils. Sometimes weedy or even invasive in all or parts of its North American range. Good seed crops produced every two or three years. Shade intolerant. Susceptible to fire damage due to the thin bark and shallow root system. Alternative host for cedar apple rust and is removed from habitats near apple orchards.

CLIMATE CHANGE. Vulnerability is currently considered to be low.

CONSERVATION STATUS. Least concern.

bark

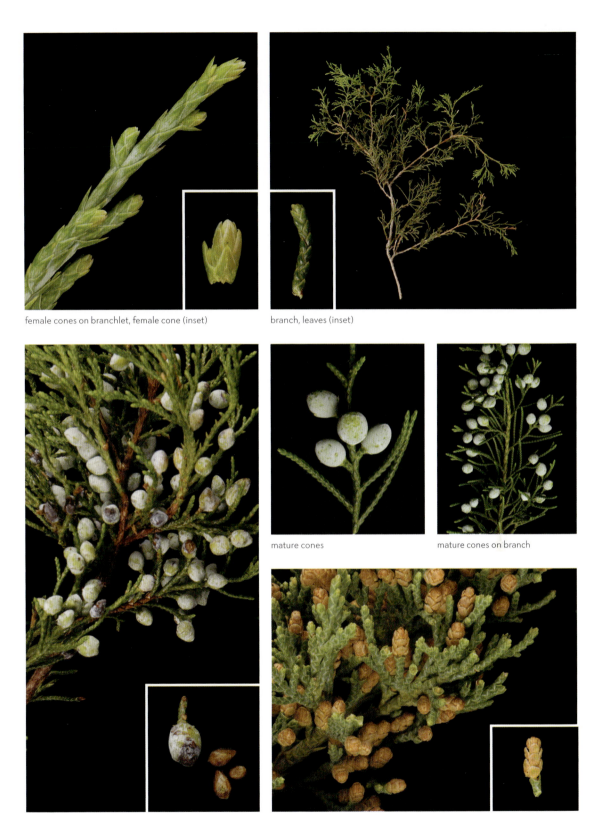

female cones on branchlet, female cone (inset)　　branch, leaves (inset)

mature cones　　mature cones on branch

mature cones on branchlet, mature cone and seeds (inset)　　male cones on branch, male cone (inset)

FAMILY CUPRESSACEAE • 183

GENUS SEQUOIA

And they are mighty past telling. Their enormously swelled bases are buttressed with great lynx-like claws, as if the trees gripped the earth to keep their balance. The ruddy shafts rise up, unlike almost all other trees, with scarcely any discernable taper, the sides parallel as those of columns for a hundred feet or two hundred, till they disappear in the high canopy of branches.

—Donald Culross Peattie on *Sequoia sempervirens* in A Natural History of North American Trees

Although the genus *Sequoia* has a significant fossil record back to the late Cretaceous, only one species is alive today. It inhabits the coastal forests of northern California and southern Oregon. These giant trees are related to two other colossal conifers: *Sequoiadendron*, also found in North America, and *Metasequoia*, native to China. The origin and rationale behind applying the botanical name *Sequoia* to these plants, which was first applied by an Austrian taxonomist, may be linked to the name Sequoyah of a Cherokee scholar.

Redwood
Sequoia sempervirens (Lamb. Ex D. Don) Endl.
CALIFORNIA REDWOOD, COAST REDWOOD

Redwoods are long-lived evergreen conifers endemic to the coast of northern California and Oregon and considered the tallest trees on Earth, typically growing over 300 ft (100 m) tall and occasionally taller. These giant trees are federally listed as an endangered species and provide critical habitat for numerous animals, including the federally threatened northern spotted owl.

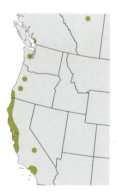

DESCRIPTION. A towering evergreen tree well known for its impressive size, growing up to 197–328 ft (60–100 m) tall with a conical crown and fluted buttressed trunks. Branches are angled downward and slender twigs end in a scaly bud. Bark is ruddy, fibrous, and deeply furrowed into scaled ridges. Leaves are needlelike, with stomata on all surfaces, 0.04–1.18 in (1–30 mm) long. Trees are monoecious producing male and female cones on separate branches of the same tree. Male pollen cones are produced on terminal or axillary stalks and 0.08–0.20 in (2–5 mm) long; female seed cones mature in one season, are reddish in color, 0.47–1.38 in (12–35 mm) long with flat pointed scales. Seeds are flattened, produced two to five per scale, 0.12–0.24 in (3–6 mm) long with two wings.

USES AND VALUE. Wood commercially important. Extremely resistant to decay and commonly selected for outdoor and ground-contact in construction lumber, veneer, plywood, beams, posts, decking, exterior furniture, and trim. Burls are excellent for carving. No food uses are known. Native Americans use a poultice of leaves to treat earaches. Provides habitat for many organisms, including the federally threatened northern spotted owl.

ECOLOGY. Endemic to a long corridor along the coast of northern California and Oregon and a key element in the climax forest habitats throughout its native range. Grows in foggy coniferous forests with deep moist soils and high precipitation, most commonly between 328 and 2,297 ft (100–700 m) above sea level. Long-lived attaining ages of over 2,000 years. Very shade tolerant. Prolific annual seed production with low germination rates (10 percent or less). Fire is biggest threat to redwoods; even light ground fires can be fatal to young trees due to thin bark. Despite absence of a taproot, very windfirm. Insect and fungal pests are few and limited in effects.

CLIMATE CHANGE. Vulnerability is currently considered to be low.

CONSERVATION STATUS. Endangered.

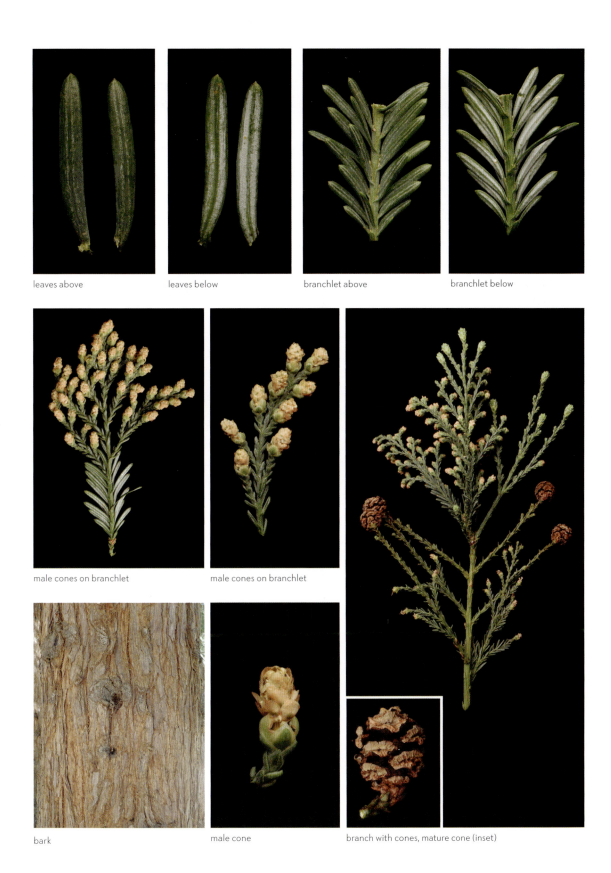

leaves above leaves below branchlet above branchlet below

male cones on branchlet male cones on branchlet

bark male cone branch with cones, mature cone (inset)

FAMILY CUPRESSACEAE • 185

GENUS SEQUOIADENDRON

Yet the trees conceal their true immensity by the very perfection of proportion. For each part—breadth at base, spread of boughs, thickness of trunks, shape of crown—is in calm Doric harmony with the rest.

—Donald Culross Peattie on *Sequoia gigantea* (now *Sequoiadendron*) in *A Natural History of North American Trees*

Similar to its close relative *Sequoia*, only a single species of this genus lives today, although a fossil species has also been described. *Sequoiadendron giganteum* is known only from the western slopes of the Sierra Nevada Mountains of California. Individual trees are among the most massive plants in the world.

Giant Sequoia
Sequoiadendron giganteum (Lindl.) J. Buchholz
BIGTREE

Individuals of giant sequoia are long-live and the most massive trees in the world with enlarged and buttressed trunks. Native to California, trees grow in isolated groves along the western foothills of the Sierra Nevada and are planted ornamentally all over the world.

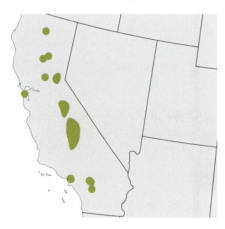

DESCRIPTION. Among the most massive trees on Earth, growing 249–276 ft (76–84 m) tall with columnar and buttressed trunks, thick heavy limbs, and narrow pyramidal crowns. Long-lived to over 3,000 years. Twigs are reddish brown with scaly bark; branchlets are terete. Bark is fibrous, deeply furrowed. Leaves are evergreen, scalelike, sessile, bluish green, arranged spirally on the shoots, 0.12–0.24 in (3–6 mm) long. Trees are monoecious producing male and female cones on the same plant from April to May. Male pollen cones are egg-shaped; female seed cones are yellowish when young, egg-shaped, oval, and woody at maturity, 1.6–2.8 in (4–7 cm) long. Seeds are dark brown, 0.16–0.20 in (4–5 mm) long, 0.04 in (1 mm) wide with a yellow-brown wing on each side.

USES AND VALUE. Wood not commercially important. Trees were historically clear-cut, despite brittle wood; little economic value today besides matchsticks and fence posts. Iconic status of these large and ancient trees makes them extremely valuable to naturalists. Cultivated as ornamental. No food or medicinal uses are known.

ECOLOGY. Restricted to a limited strip of coniferous forest on granitic soils in the Sierra Nevada of California from 3,000–8,900 ft in elevation. Shade intolerant. Large quantities seed produced annually with low viability (25 percent). Fire causes most severe damage in young trees with thin bark although mature trees may also be affected. Insects and fungal pathogens are few.

CLIMATE CHANGE. Vulnerability is significant but may have the capacity to adapt to changing conditions in the future. Ongoing monitoring is recommended.

CONSERVATION STATUS. Endangered.

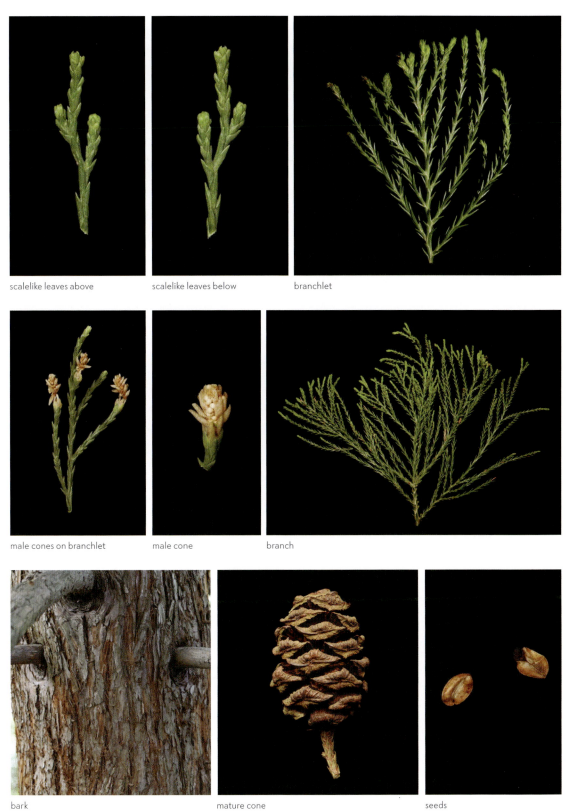

GENUS TAXODIUM

The "knees" that rise up at intervals from the main roots and are distinguished from stumps by their smooth, conical shapes, are still a physiological puzzle. Many people believe that they gather air for the submerged root system. Others declare that they strengthen it. The cypresses keep their secrets from the prying investigator, and the solemn cormorants that build in the treetops will never tell.

—Julia Ellen Rogers on *Taxodium distichum* in *The Tree Book: A Popular Guide to a Knowledge of the Trees of North America and to Their Uses and Cultivation*

Taxodium is a genus of at least two and maybe three species. The generic name contains both the Latin word *taxus* (meaning "yew") and the Greek word *eidos* (meaning "similar to"), indicating a relationship to other conifers. Trees in this genus prefer swamps and river bottoms and are related to trees in two genera found in similar habitats in Asia. Species of *Taxodium* occur in the southern part of North America, primarily the southern United States and Central America. They are large trees with needlelike leaves. Their flood-tolerant nature is made possible in part by the unique "cypress roots," or pneumatophores, which are woody protrusions that project from the base of the tree above the water level to help the trees "breathe." The wood of all *Taxodium* species resists both rot and termite damage and is therefore used in construction. One native species of *Taxodium* is a common tree in North America.

Baldcypress
Taxodium distichum (L.) Rich.

Baldcypress is considered a symbol of southern North American swamps and is called the "wood eternal" because of its resistance to decay. One of the few conifers that loses its needles in the winter months, trees also produce distinctive "cypress knees," which anchor the plant to the substrate and protrude above the water line. Three varieties are recognized.

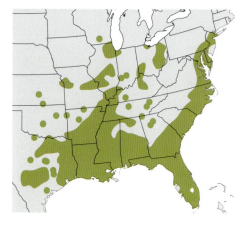

DESCRIPTION. A long-lived, deciduous, coniferous tree, growing to a height of 98 ft (30 m) or more. Characteristic woody growths produced at the base of the trunk, called "knees," help anchor the tree in the soft, muddy soils where it grows. Trunk tapers rapidly and crown is open and narrowly pyramidal. Terminal twigs on a branch are brown and remain attached, lateral twigs are deciduous and resemble feathery leaves. Bark is reddish-brown to gray, marked with fibrous ridges, and shreds off the trunk over time. Leaves are needlelike, appear two-ranked, green to yellowish green, 0.4–0.8 in (1–2 cm) long. Trees are monoecious producing male and female cones on the same plant in mid-spring. Male pollen cones are globose, produced in drooping panicles to about 5.1 in (13 cm) long; female seed cones are ovoid to globose, covered with peltate scales, clustered at the ends of branches, 0.7–1.0 in (2–3 cm) long.

TAXONOMIC NOTES. Variety *disticum* with leaves needlelike, alternate, 10–17 mm long; var. *imbricarium* with leafy shoots yarn-like, leaves appressed to twigs, 3–10 mm long; var. *mucronatum* with leaves needlelike, alternate, less than 10 mm long.

USES AND VALUE. Wood moderately commercially important. Highly resistant to decay and excellent for interior trim, exterior construction, docks, boats, and veneer. Sometimes planted as ornamental and shade tree. No food uses are known. Resin in the cones used as analgesic for treating wounds. Branches provide nesting sites for birds and inundated roots create spawning zones for catfish.

ECOLOGY. Grows in standing waterways in coastal and flood plains of the southern United States. Intermediate in shade tolerance. Produces seed annually, with good crops every three to five years. Extremely windfirm owing to extensive root system and deep taproot. Fire not a threat in wetland habitats where trees grow. Insect and fungal pests few.

CLIMATE CHANGE. Vulnerability is currently considered to be low.

CONSERVATION STATUS. Least concern.

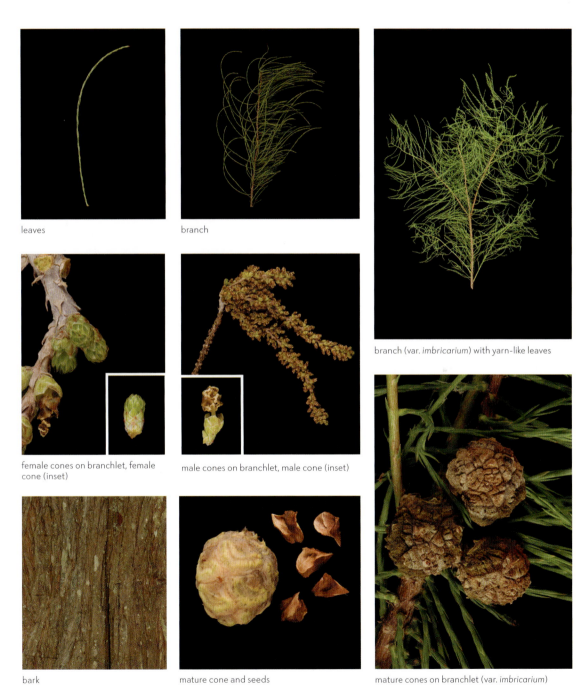

leaves

branch

female cones on branchlet, female cone (inset)

male cones on branchlet, male cone (inset)

branch (var. *imbricarium*) with yarn-like leaves

bark

mature cone and seeds

mature cones on branchlet (var. *imbricarium*)

FAMILY CUPRESSACEAE • 189

GENUS THUJA

Young limbs lift upwards joyfully; old ones spread downward and outward with majestic benevolence. And over all glitters the lacy foliage in flat sprays that are forked and forked again, drooping parted, like the mane of a horse, from the axis of the branchlet in a gesture of strong grace.

—Donald Culross Peattie on *Thuja plicata* in *A Natural History of North American Trees*

This genus is commonly called "arborvitae" or "cedar." The five species of *Thuja* are found in North America and Asia. These evergreen trees, similar to several other genera of conifers, produce dimorphic leaves that are needlelike when the shoots are young but become scale leaves as the plants mature. The leaves and wood are aromatic and have been used medicinally and in construction and woodworking, especially for making cedar chests and musical instruments. Two native species of *Thuja* are common trees in North America.

Northern White-Cedar

Thuja occidentalis L.
ARBORVITAE

Northern white-cedar is native to the eastern United States, extending from the Northeast through the Appalachian Mountains and part of the Midwest. This swamp-dwelling tree has rot resistant wood that makes it especially suited for certain types of building and construction.

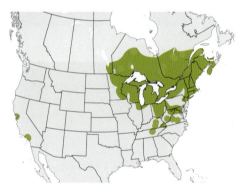

DESCRIPTION. A coniferous tree growing to 49 ft (15 m) tall, with a dense crown that is conical or columnar and branches that turn upward toward their tips. Twigs are flat and totally covered by the scalelike leaves. Bark is shiny reddish brown on young trees, turning grayish brown with fibrous strips at maturity. Leaves are aromatic with obvious resin glands and pointed tips, green above and yellowish beneath, 0.04–0.08 in (1–2 mm) long. Trees are monoecious producing male and female cones on the same plant at the ends of separate twigs, opening in mid-spring. Male pollen cones are tiny, oval-shaped with three to six pairs of scales; female seed cones are oblong, purplish, with four pairs of scales, at maturity seed cones are borne on a short curved stalk, pale brown, oval or oblong, upright, 0.4 in (1 cm) long, with leathery scales, persist for months. Seeds are winged, 0.12 in (3 mm) long, dispersed in late summer.

USES AND VALUE. Wood moderately commercially important. Very resistant to rot and used for fence posts, shingles, pilings, outdoor furniture, and pulp. Widely planted as an ornamental. Pith of young shoots, which has a sweet, pleasant flavor, added to soups and tea. Medicinal value is great: Native Americans use wood and needles for treatment of fevers, coughs, and headaches; in current-day herbalism used as antiviral agent. Protects wildlife, especially deer, which use it in harsh winters for shelter and browse.

ECOLOGY. Grows in swampy areas, lake margins, and open rocky hillsides on moist, well-drained, alkaline soils. Moderately tolerant of shade. Produces some seed annually, with good crops every three to five years. Although commonly found in wet areas, susceptible to flooding where drainage is poor. Larger trees prone to windthrow and fire is especially harmful because of thin bark. Insect and fungal pests are minor.

CLIMATE CHANGE. Vulnerability is currently considered to be low.

CONSERVATION STATUS. Least concern.

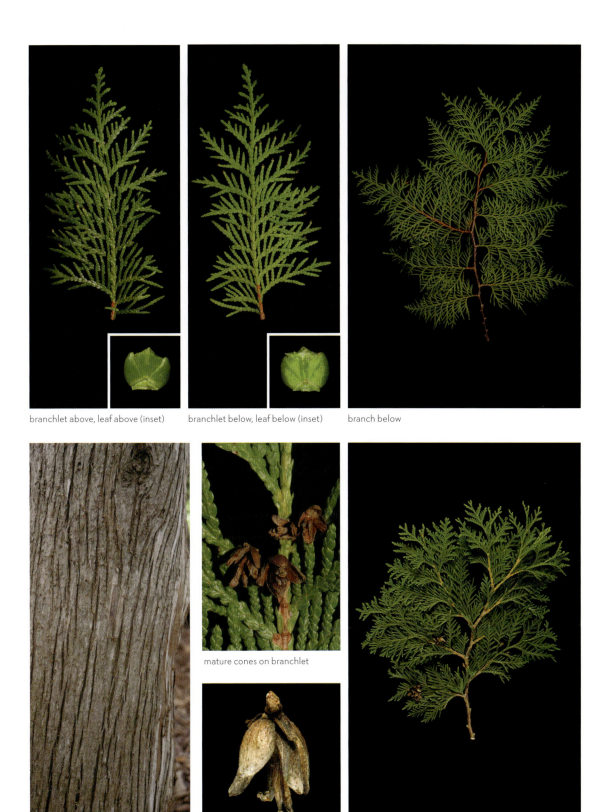

FAMILY CUPRESSACEAE • 191

Western Redcedar

Thuja plicata Donn ex D. Don
CANOE-CEDAR

Western redcedar is a large evergreen tree native to low-elevation, moist, mixed coniferous forests of the Pacific Northwest and northern Rocky Mountains. The wood is one of the most commercially valuable in the Pacific Northwest with many uses.

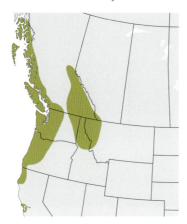

DESCRIPTION. An evergreen tree growing 164–230 ft (50–70 m) tall, with a buttressed base and conical crown. Twigs are brown, flattened, and sheathed when young becoming smooth, flexible, slightly zigzag, lustrous, and red brown to dark gray with aging. Bark is reddish brown to grayish brown, fibrous, and fissured, peeling easily. Leaves are opposite in alternating pairs on either side of twigs, scalelike, sharply pointed, glossy green above and white-striped below, 0.12–0.24 in (3–6 mm) long, with a spicy fragrance when crushed. Trees are monoecious producing male and female cones on the same plant. Male pollen cones are produced in a cup formed by two leaf pairs at the tips of lateral branchlets, 0.12 in (3 mm) long; female seed cones are typically erect on branches, ellipsoid, 0.39–0.47 in (10–12 mm) long when dry and fully opened. Eight to fourteen seeds are produced per cone, 0.16–0.29 in (4–7.5 mm) long, including wings.

USES AND VALUE. One of the most commercially important trees in the Pacific Northwest. Used for shingles, exterior lumber, siding, decking, fencing, boats, and musical instruments. Oil in the leaves used in preparation of perfumes, insecticides, medicinal treatments, veterinary soaps, shoe polishes, and deodorants. Planted as ornamental, often as dense hedge. Inner bark and resin are edible. Native Americans use the leaves, buds, and small branches to treat a wide range of illnesses, including colds, stomachaches, and toothaches. Bark used in weaving. Provides important habitat for many species of wildlife. Seedlings are browsed and a major source of food for animals during Rocky Mountain winters. Black bears strip the bark to feed on sapwood.

ECOLOGY. Grows in maritime climates in coastal and montane forests on shallow soils over calcareous material and tolerating both acidic and alkaline substrates. Very tolerant shade. Produces some seed annually, with large crops every three years; germination is usually high (70 percent). Because of thin bark, extremely susceptible to fire damage; shallow root system increases vulnerability to windthrow. Few insect or fungi pests. Young seedlings are favorite food of deer and elk.

CLIMATE CHANGE. Vulnerability is currently considered to be low.

CONSERVATION STATUS. Least concern.

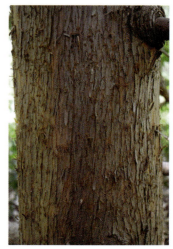

bark

branchlet above

branchlet below

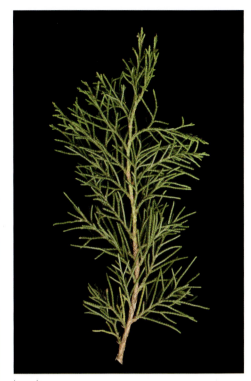
branch

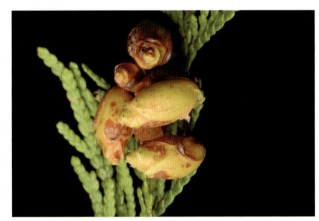
female cone on branchlet

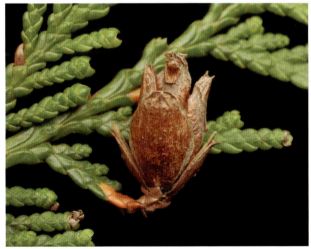
mature cone

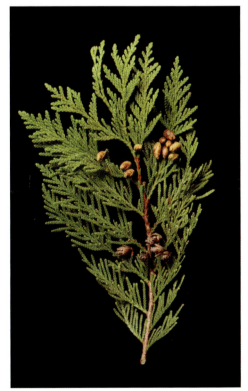
female cone and mature cone on branch

FAMILY CUPRESSACEAE • 193

GENUS XANTHOCYPARIS (FORMERLY CALLITROPSIS)

The Alaska Cedar can be one of the most beautiful yet most sorrowful of western conifers. Its long, lithe leader shoot bows its head—sometimes bent nearly double in a young tree—and its dull dark bluish-green foliage is evergreen for two years, then turns a rusty brown. The dead foliage is not shed, however, for another year, leaving the whole tree more or less tinged with the hue that, for vegetable life, is the color of mourning.

—Donald Culross Peattie on *Chamaecyparis nooktkatensis* (now *Xanthocyparis*)
in *A Natural History of North American Trees*

Taxonomists have now determined that the correct name for this genus, which was commonly referred to as *Callitropsis*, is *Xanthocyparis*. Although the argument is complicated and the name may change in the future (some botanists segregate one of the species into the genus *Cupressus*), the botanical community now generally accepts *Xanthocyparis*. Only two species are currently recognized in this genus, one from North America *(X. nootkatensis)* and one from Vietnam *(X. vietnamensis)*. The single native species of *Xanthocyparis* is a common tree in North America.

Alaska-Cedar
Xanthocyparis nootkatensis (D. Don) Farjon & D. K. Harder
YELLOW-CEDAR

Alaska-cedar is a species of large evergreen tree native to the moist boggy forests of British Columbia and Alaska, rocky ridges of the Olympic Mountains, and the western slopes of the Cascade Mountains. The wood is highly valued for a variety of construction uses and products

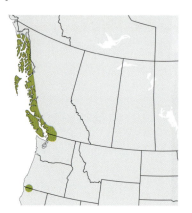

DESCRIPTION. An evergreen coniferous tree growing to 131 ft (40 m) tall, becoming shorter at higher elevations. Juvenile twigs are flattened. Branchlet sprays are pinnate, flat, and drooping. Bark is grayish brown, exfoliating into long, narrow, vertical strips, 0.4–0.8 in (1–2 cm) thick. Leaves are scalelike, bluish green, with rounded to acute apex, 0.06–0.10 in (1.5–2.5 mm) long. Trees are monoecious producing male and female cones on the same plant. Male pollen cones are grayish brown, 0.08–0.20 in (2–5 mm) long; female seed cones are green, 0.31–0.47 in (8–12 mm) broad, mature in one to two years at which time they become a reddish-brown resinous structure with four to six scales. Seeds are four to six per cone, 0.08–0.20 in (2–5 mm) wide.

USES AND VALUE. Wood commercially important. Highly prized and used for boat building, carving, and making musical instruments, as well as siding, decking, outdoor furniture, boxes, and chests. Bark is used medicinally for treatment of arthritis and rheumatism through poultices and in sweat baths. No food uses are known.

ECOLOGY. Grows in wet, cool, maritime, subalpine, and boreal climates from shoreline to tree line. Prefers deep well-drained soils rich in nutrients, although it may persist in rocky soils of alpine environments. Shade tolerant and slow growing. Good seed crops are produced every four years, but germination rates and seedling survival are low. Few insect and fungal pests. Production of naturally occurring chemicals nootkatin, chamic acid, and chaminic acid in the heartwood protects against stem and root rot.

CLIMATE CHANGE. Vulnerability is currently considered to be low.

CONSERVATION STATUS. Least concern.

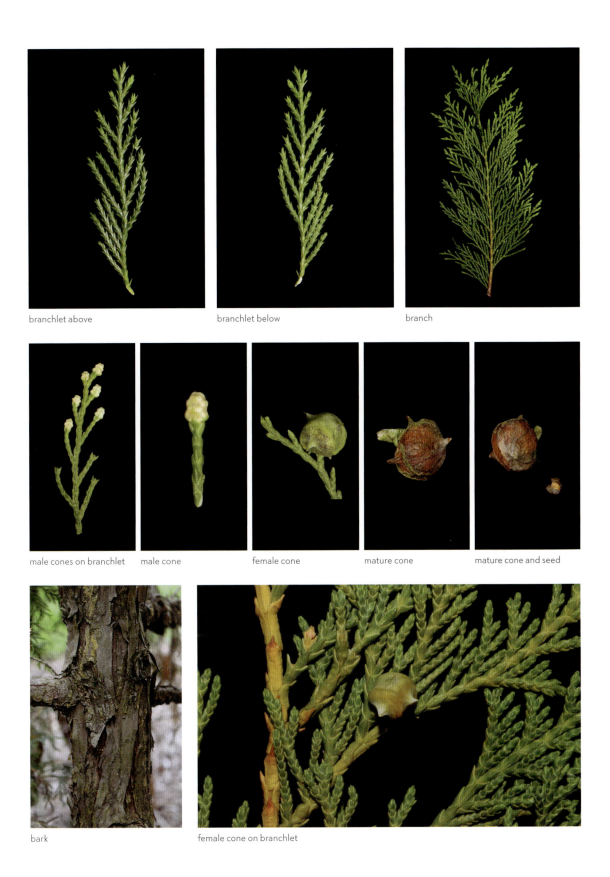

Family Taxaceae

The Taxaceae, or yew family, is made up of five genera and twenty to twenty-five species, although the taxonomy is not completely stable. The plants are small trees and shrubs with evergreen scalelike leaves. Generally, members of the yew family are not aromatic like other conifers. The male and female cones are produced on separate individual trees (dioecious). The female cones, similar to a few other gymnosperms, have evolved a very specialized structure and contain only a single seed that is surrounded by a fleshy, brightly colored, sweet, and juicy aril that is attractive to birds. Note that the seeds are highly poisonous to humans. Only two genera and two species are common in North America.

GENUS TAXUS

Species of *Taxus* are relatively slow-growing, long-lived, small trees and shrubs. They are native in both warm and cool climates around the world on almost every continent. Taxonomists disagree if there is one widely distributed species or nine separate species. The female cones, similar to all member of the family, resemble a red berry at maturity and birds are the primary dispersal agents of the seeds. All species of yew contain highly toxic alkaloids that are found in all parts of the plants except the red arils, which are sweet and edible. The wood of some species of *Taxus* is used for making bows, and the trees are widely cultivated for landscaping and in gardens. One native species of *Taxus* is a common tree in North America.

Pacific Yew
Taxus brevifolia Nutt.
WESTERN YEW

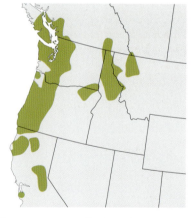

Pacific yew is a species of long-lived conifer native to the mountain ravines and slopes throughout northwestern North America and Alaska. This understory tree grows in cool, moist, and shaded habitats sometimes forming dense thickets of conspecifics.

DESCRIPTION. A slow-growing evergreen tree that reaches 33–49 ft (10–15 m) tall as an understory tree and develops an open conical crown. Twigs are round, slender, and remain green for many years. Bark is thin, reddish brown, and scaly; inner bark reddish purple. Leaves are needlelike, single, spirally arranged, dark yellow green above and paler beneath, 0.4–1.2 in (1–3 cm) long. Tree are dioecious producing male and female cones on separate plants in June to July. Male pollen cones are stalked and budlike, pale yellow; female seed cones are greenish, composed of a few scales, and produced on underside of branches, at maturity berrylike with red, fleshy, ovoid aril, 0.4 in (1 cm) in diameter.

USES AND VALUE. Wood not commercially

important. Used for canoe paddles, tool handles, and carvings. Bark contains taxol, which is employed as treatment for breast cancer. Very sweet and gelatinous berrylike cones are edible though seeds are poisonous.

ECOLOGY. Grows in cool, moist, and shaded habitats in mesothermal climates often in low-lying and montane coastal zones on deep, well-drained, and acidic soils. Can form dense thickets of conspecifics. Very shade tolerant. Produces some seed every year, with large crops irregular. Attacked by various insects and fungi, but none is damaging. Fire is biggest threat.

CLIMATE CHANGE. Vulnerability is currently considered to be low.

CONSERVATION STATUS. Near threatened.

leaf above (left), leaf below (right)

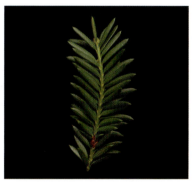
branchlet above

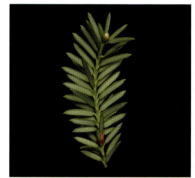
branchlet below

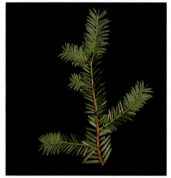
branchlet above

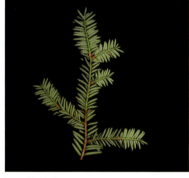
branchlet below

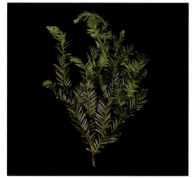
branch above

bark

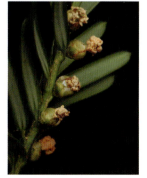
male cones on branchlet

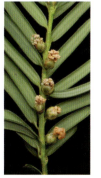
male cones on branchlet

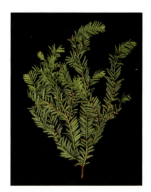
branch below

FAMILY TAXACEAE • 197

GENUS TORREYA

The genus *Torreya* includes six (maybe seven) species, four of which are native to eastern Asia with the remaining two native to North America. The trees are small to medium-sized, usually less than 82 ft (25 m) in height and often much smaller. The female cones are highly modified from the standard "pine cone" structure. When mature, they contain a single large seed that is surrounded by fleshy green to purple scales when ripe. The generic name commemorates the contributions of the American botanist John Torrey to our knowledge of the plants of North America. One native species of *Torreya* is a common tree in North America.

California Torreya
Torreya californica Torr.
CALIFORNIA-NUTMEG

California torreya is a medium-sized evergreen tree endemic to California. The distribution is divided into two populations: one near the California coast, the other in the Cascade-Sierra Nevada foothills. The needlelike leaves and nutmeglike cones produce a pungent and aromatic, somewhat disagreeable odor when crushed.

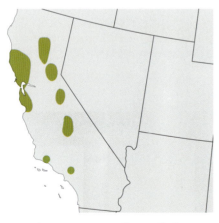

DESCRIPTION. An evergreen coniferous that grows 16–98 ft (5–30 m) tall with a pyramidal crown that becomes irregular with age. Branches are whorled, slightly drooping, and reddish brown. Leaves are needlelike, arranged spirally, twisted at the base, and flattened, dark glossy green above, lower surface with two grooved bands of stomata, 1.2–3.1 in (3–8 cm) long, release a pungent somewhat disagreeable odor when crushed. Trees are dioecious producing male and female cones on separate plants. Male pollen cones are white, clustered in rows underneath shoots, 0.20–0.27 in (5–7 mm) long; female seed cones are produced singly or in whorls of two to five along branchlet, maturing in eighteen months, 1.0–1.5 in (2–4 mm) long, covered by a fleshy, green (sometimes purplish) aril, containing a single indehiscent seed.

USES AND VALUE. Wood not commercially important. Native Americans use wood for making bows, roots for weaving, needles for tattooing, and large seeds as an important food.

ECOLOGY. Endemic to California; the range is divided into separate populations: one near the California coast and the other in the Cascade-Sierra Nevada foothills. Grow in a variety of habitats, including riparian areas, canyons, and lowland flats, and thrives in moist soils. Shade tolerant.

CLIMATE CHANGE. Vulnerability, though currently considered to be low, may increase in the future. Ongoing monitoring is recommended.

CONSERVATION STATUS. Vulnerable.

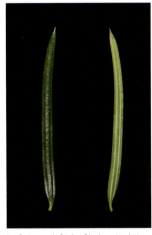 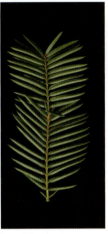

leaf above (left), leaf below (right) branchlet above branchlet below branch

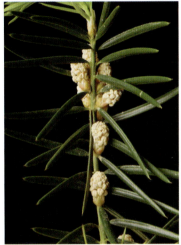 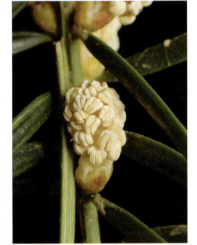 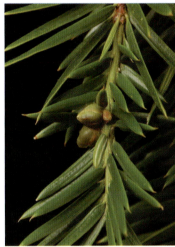

male cones on branchlet male cone female cones on branchlet

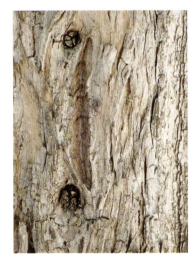 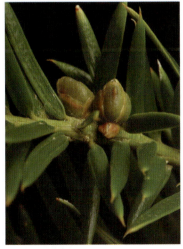 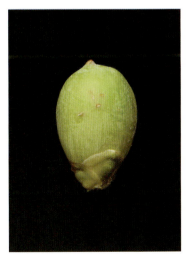

bark female cones mature cone

FAMILY TAXACEAE • 199

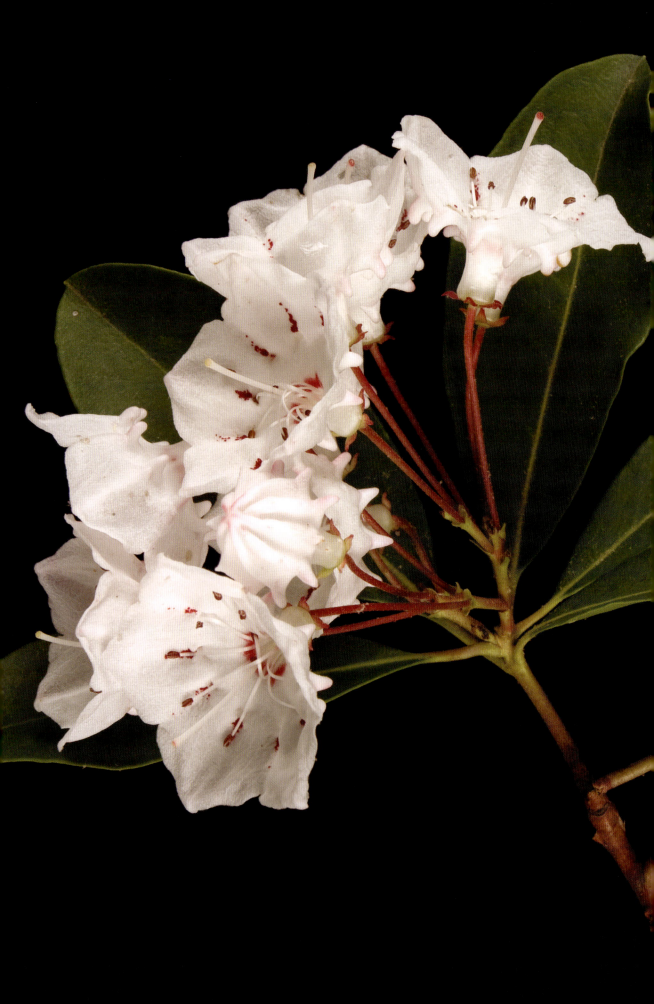

Angiosperms: Trees with Flowers

The angiosperms, or flowering plants, probably originated 150 million years ago, followed by an explosive diversification of species about 85 million years later that continues to this day. The innovation that stimulated this rich diversity was the evolution of the flower, which combined a closed chamber to protect the seeds (called a carpel), a much-reduced group of cells to facilitate fertilization, and a unique nutritive tissue to provide for the developing embryo (called the endosperm). The evolution of the flower and the coincident adaptation of many different animals for pollinating them led to the origin of the 400,000 species of angiosperms that are estimated to live on Earth today.

One of the most important contributions of DNA sequence data over the last several decades has been our increased understanding of the evolutionary relationships within the flowering plants. For hundreds of years, many botanists recognized two major groups: monocotyledons ("monocots") and dicotyledons ("dicots"). As will always be true in the field of plant taxonomy, new data will change and refine our ideas about classification. The monocots are still thought to have descended from a common ancestor at the base of the flowering plant tree of life, but the dicots are no longer seen as a coherent, monophyletic lineage. The major groupings within the flowering plants are now generally referred to by the informal names *Magnoliids, Monocots, Early Diverging Eudicots, Rosids,* and *Asterids.* (The latter two groups are sometimes collectively called *Core Eudicots.*) Very few common trees of North America are found in the Magnoliids, Monocots, and Early Diverging Eudicots. The great majority are members of the Rosids and Asterids.

OPPOSITE Mountain laurel (*Kalmia latifolia*)

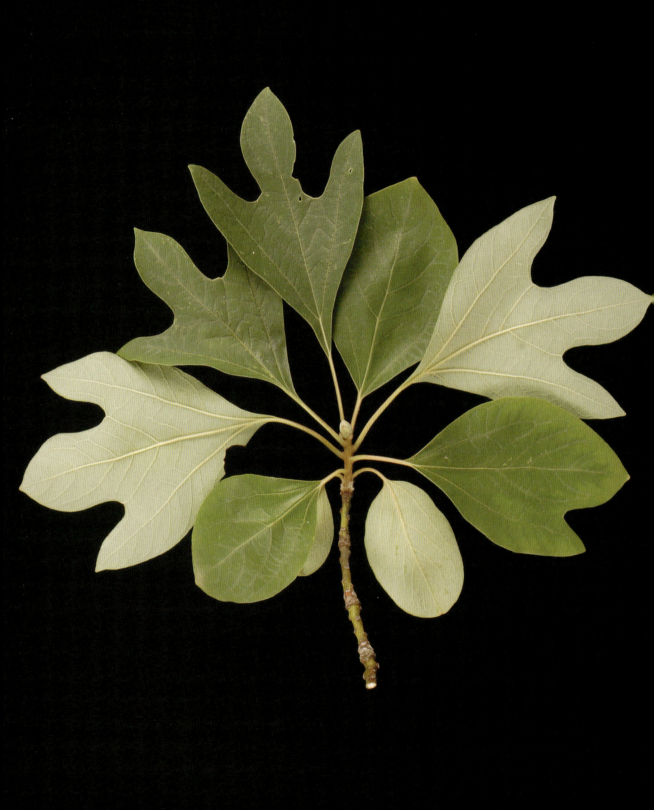

Magnoliids: Trees Related to Magnolias and Avocados

The term *basal angiosperms* is another informal name that applies to the earliest diverging lineages of flowering plants that are not a single unified group. No single character is shared by all of these disparate lineages; they are simply grouped together at the base of the evolutionary tree by being excluded from the rest of the flowering plants. The Magnoliids is one group within the basal angiosperms and is made up of four taxonomic orders, including peppercorns, nutmegs, laurels, magnolias, and tulip trees. These plants share unique chemical compounds and various cellular structures as well as similar DNA patterns. The Magnoliids contain about 7,600 species and are distributed around the globe. The fossil record goes back to the Cretaceous over 100 million years ago. The two orders, the Laurales and the Magnoliales, have eight genera and twelve species that are common trees in North America.

ORDER LAURALES

This order includes seven families, the largest of which includes the laurels and avocados. Most of the features that distinguish the members of the Laurales are found in specialized floral structures, including the ovary position and inner stamens that do not produce pollen. This order is most closely related through evolution to the Magnoliales in the Magnoliids. The Lauraceae is the only family of the order Laurales in North America and includes five species of common trees.

Family Lauraceae

Members of the Lauraceae are found primarily in the tropics, especially the Americas, Southeast Asia, and Australasia, where they are often large canopy trees. However, several genera are also found in the Temperate Zone, including species of *Camphora, Lindera, Persea, Umbellularia,* and *Sassafras,* all of which are common trees in North America. This family comprises over fifty genera and 2,300 species.

OPPOSITE Sassafras (*Sassafras albidum*)

GENUS CINNAMOMUM

Cinnamomum is a genus of evergreen trees and shrubs with aromatic oils in their leaves and bark. The genus contains about 350 species, distributed in tropical and subtropical regions of Asia, Africa, and Australia. No species are native to North America, but one, *Cinnamomum camphora*, is commonly cultivated and naturalized in the southeastern United States. The presence of these aromatic oils makes several species important economically, especially camphor and many types of cinnamon. The leaves are leathery and, because of a thick layer of wax, often shiny in appearance. The small green, yellow, or white flowers contain both male and female sex organs. The single-seeded fruit is like a small smooth peach and sits inside a cuplike structure. One introduced species of *Cinnamomum* is a common tree in North America.

Camphor-Tree
Cinnamomum camphora (L.) J. Presl
CAMPHOR LAUREL

Introduced from Asia for agricultural cultivation, camphor-tree is now considered weedy and even invasive in moist, disturbed areas of the southeastern United States. Used for its essential oils, leaves, and timber. The bark, twigs, and leaves of this tree release a camphor scent when peeled or crushed.

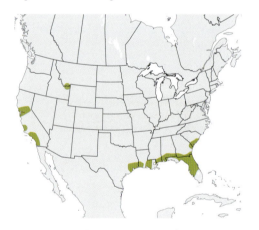

DESCRIPTION. An evergreen tree that grows up to 20 ft (6 m) tall, occasionally to 100 ft (30 m). Introduced from Asia, it is a multitrunked, densely foliated plant that produces a camphor scent from the bark, twigs, and leaves. Twigs age from green to brown. Leaf buds are sharp, pointed, up to 0.6 in (1.5 cm) in length. Bark is pale gray to reddish, scaly or irregularly furrowed. Leaves are simple, alternate, oval to elliptic, glossy green, with margins entire to undulate in some individuals. Trees are monoecious with separate male and female flowers produced on the same plant, blooming in spring. Flowers are in panicles, inconspicuous, perfect, pale green to yellow, up to 2.8 in (7 cm) long. Fruits are fleshy drupes, dark blue, 0.4–0.6 in (1–1.5 cm) in diameter and produced on persistent floral tubes; toxic when eaten in high quantities.

USES AND VALUE. Wood not commercially important in North America; in Asia wood is used for furniture, cabinets, and interior finish work. Often planted as an ornamental in warmer climates. Young shoots and leaves are poisonous in large doses but can be cooked and eaten. Dried leaves used as a spice in cooking. A long history of medicinal use in China and Southeast Asia for a wide variety of treatments; in Western cultures used primarily to make essential oils for external application. Seeds are consumed and dispersed by birds, whch allows this introduced species to invade new habitats.

ECOLOGY. Weedy; prefers moist, disturbed areas of the coastal regions of the southeastern United States. Grows in moist pastures, woodlands, and riparian zones on a variety of moist well-drained soils. Intermediate in shade tolerance. Relatively free of insect and fungal pests. Flowers are pollinated by flies.

CLIMATE CHANGE. Vulnerability is considered low because of wide geographic distribution as an ornamental and invasive.

CONSERVATION STATUS. Least concern.

leaf above

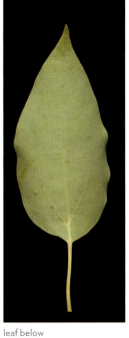
leaf below

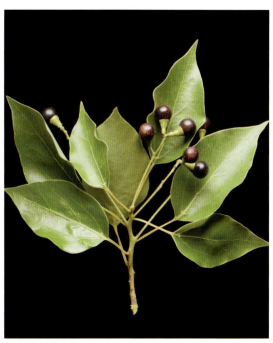
branchlet with infructescence

fruit and seed

bark

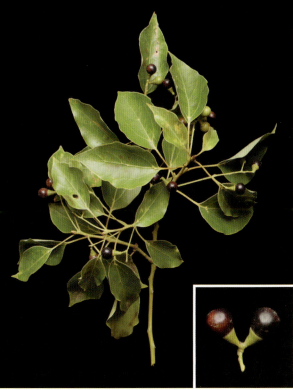
branch with fruits, fruits (inset)

FAMILY LAURACEAE • 205

GENUS LINDERA

Imagine an early April day in the North after a particularly difficult winter, the branches of spicebush studded with small greenish yellow flower—a harbinger that all will be well in the world.

—Michael A. Dirr on *Lindera benzoin* in *Dirr's Encyclopedia of Trees and Shrubs*

Lindera is a genus that includes eighty to one hundred species of shrubs and small trees that are native primarily to eastern Asia, but three species occur in eastern North America. The Latin name *Lindera* commemorates the Swedish botanist Johan Linder, who lived in the seventeenth century. Trees of *Lindera* are dioecious; male and female flowers occur on separate trees. The flowers are white to green to yellow in color, with six tepals in a star-shaped arrangement. Pollinators include bees and other small insects. The fruits are dispersed mainly by birds. Many species reproduce vegetatively, and a single individual plant may cover a large area in the understory of the forest. The species of *Lindera* in North America may have been more common when the climate was more tropical than today. One native species is a common tree.

Spicebush

Lindera benzoin (L.) Blume

The small yellow flowers of the common spicebush light up the understory of hardwood forests and are a welcome sign that spring is on its way. The spicy lemony odor of the leaves is a characteristic of bay leaf, sassafras, and many other members of the same family.

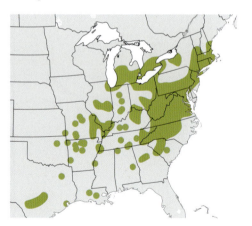

DESCRIPTION. A deciduous shrub growing to 16 ft (5 m) tall with many branches, often forming thickets by root sprouting. Bark is dark brown. Twigs are greenish to brown with many light lenticels. Leaves are simple, alternate, oblong or obovate, green above and paler below, 2.4–5.9 in (6–15 cm) long, 1–2.4 in (2.5–6 cm) wide, margins entire, apex acute, produce a spicy odor when crushed. Trees are dioecious with male and female flowers produced on separate plants, blooming in early spring before leaves. Male flowers are yellow with nine stamens producing pollen and no ovaries; female flowers have twelve to eighteen infertile stamens and a functional ovary that produces fruits. Fruits are shiny red berries, 0.24–0.39 in (6–10 mm) long and contain single seed.

USES AND VALUE. Wood not commercially important. Planted as an ornamental. Young leaves, twigs, and fruit contain highly aromatic essential oils used for tea or to make condiments. Dried and powdered fruit is substitute for allspice. Medicinally used for treatment of colds, dysentery, and intestinal parasites. Leaves, shoots, flowers, and fruits provide food for a wide range of animals, including white-tailed deer, ground birds, and songbirds. Host for spicebush swallowtail *(Papilio troilus)* and other swallowtail butterfly species.

ECOLOGY. Grows in understories of woodlands, wetland margins, and riparian areas, sometimes forming dense thickets. Prefers a variety of rich fertile soils. It is considered intermediate in shade tolerance.

CLIMATE CHANGE. Vulnerability is currently unknown. Immediate assessment is recommended.

CONSERVATION STATUS. Least concern.

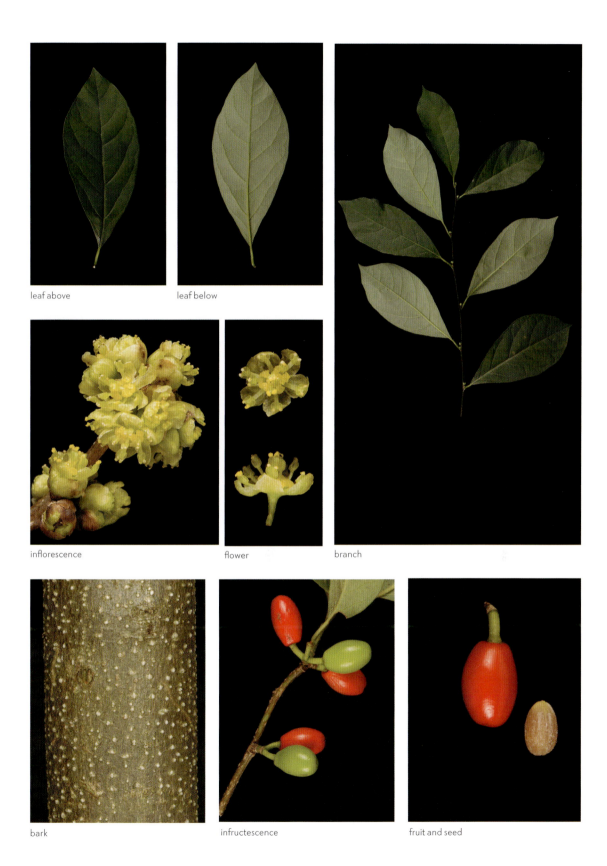

FAMILY LAURACEAE • 207

GENUS PERSEA

Persea is a genus of about 150 species of evergreen tropical and subtropical trees. The avocado, *Persea americana*, is commonly cultivated for its large edible fruit and is probably the best-known species in the genus. The distribution of *Persea* is very broad. Most species are found in tropical America and southeastern Asia, but a single species is restricted to the northwestern coast of Africa. The fruits of *Persea* can be an important food source for animals in tropical forests, including large birds. Three species are native to North America, and one (the avocado) is introduced and naturalized. The one introduced species is considered a common tree.

Redbay

Persea borbonia (L.) Spreng.

Redbay is a small evergreen tree that can be shrubby and low-growing. The glossy leaves are aromatic when crushed. Although still abundant, this tree is being infected by fungal laurel wilt that is carried by the introduced Asian redbay ambrosia beetle (*Xyleborus glabratus*).

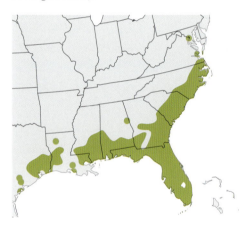

DESCRIPTION. A charismatic evergreen tree that grows up to 49 ft (15 m) tall, though typically shrubby and low-growing. Branches droop as they age. Twigs are green when new with sparse brown pubescence. Buds are short and rounded with rusty pubescence. Bark is ridged and reddish brown. Leaves are simple, alternate, glossy, leathery, green above and below, emit a spiced aroma when crushed, elliptic to oblong, margins entire, 2.8–5.9 in (7–15 cm) long. Flowers are in cymes, produced in April or May, perfect, inconspicuous, green. Fruits are small, dark blue drupes that ripen in late summer.

USES AND VALUE. Wood not commercially important. Planted as an ornamental. Dried leaves used as a condiment. Native Americans used it for wide variety medicinal purposes, especially as emetic. Deer and bears eat the fruits and leaves, while small mammals, ground birds, and songbirds eat the fruit.

ECOLOGY. Grows on the coastal margins of the southeastern United States in forested wetlands, mixed hardwood swamps, and Mississippi bogs. Prefers moist peaty soils that are rich in organic matter. Shade intolerant. Attacked by the invasive redbay ambrosia beetle (*Xyleborus glabratus*) introduced from Asia, which carries a fungus that causes laurel wilt, a devastating disease.

CLIMATE CHANGE. Vulnerability, though currently considered to be low, may increase in the future. Ongoing monitoring is recommended.

CONSERVATION STATUS. Endangered.

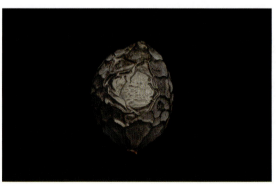

fruit

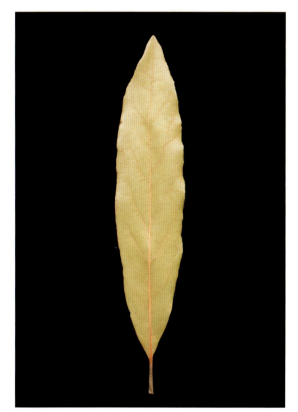
leaf above

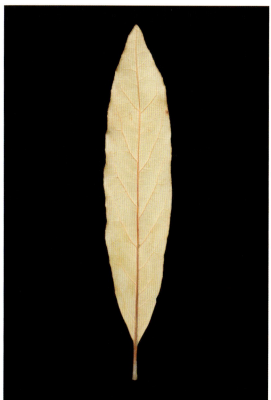
leaf below

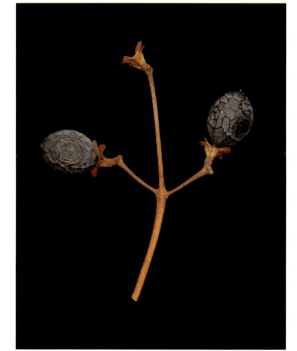
infructescence

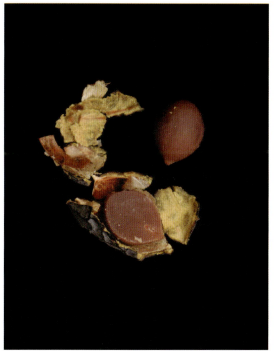
fruit and seeds

FAMILY LAURACEAE • 209

GENUS SASSAFRAS

Against the Indian summer sky, a tree lifts up its hands and testifies to glory, the glory of a blue October day. Yellow or orange, or blood-orange, or sometimes softest salmon pink, or blotched with bright vermilion, the leaves of the Sassafras prove that not all autumnal splendor is confined to northern forests.... The deep blue fruits on thick bright red stalks complete a color effect in fall which few trees anywhere surpass.

—Donald Culross Peattie on *Sassafras albidum* in *A Natural History of Trees of Eastern and Central North America*

Sassafras is a genus of three extant species of deciduous trees native to eastern North America and eastern Asia. These trees are distinguished by the frequency of variously lobed leaves and characteristics of their floral biology. Species of *Sassafras* are unusual in having three distinct leaf patterns on the same plant: unlobed oval, bilobed, and trilobed (rarely five-lobed). The tiny yellow flowers usually have six tepals. Some species are dioecious, with male and female flowers on separate trees, while other species have male and female flowers on the same tree. The fruit is a small, usually blue-black drupe, like a smooth peach. All species in the genus are characterized by distinctive aromatic properties and are frequently used by humans. The aromatic roots, stems, leaves, bark, flowers, and fruits are used for culinary and medicinal purposes in regions where the trees are either native or cultivated. One native species of *Sassafras* is a common tree in North America.

Sassafras

Sassafras albidum (Nutt.) Nees

Sassafras is a medium-sized deciduous tree native to eastern North America with shoots that become reddish brown and furrowed with age. These shoots were once used to flavor root beer, but most commercial root beers have replaced the extract of sassafras with that found in the bark of sweet birch *(Betula lenta)*.

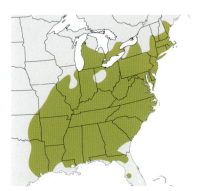

DESCRIPTION. A deciduous shrub to medium-sized tree that grows 49 ft (15 m) or, occasionally, 100 ft (30 m) tall. Twigs are green and pubescent when young, becoming smooth and reddish brown with age. Foliage and twigs produce a spicy aroma when broken or bruised. Bark is reddish brown with deep furrows and flat ridges. Leaves are simple, alternate, oval to ovate, usually possess one or two broad lobes resembling a mitten (or sometimes unlobed), dark green above, paler below, margins smooth, 3.1–5.9 in (8–15 cm) long. Trees are dioecious with distinctive male and female flowers produced on separate trees, blooming in late spring. Flowers of both sexes are yellow green, lack petals, 0.31 in (8 mm) long, and are arranged in dense clusters 2–4 in (5–10 cm) long. Fruits are blue drupes on a red stalk, ovoid, 0.4 in (1 cm) long.

USES AND VALUE. Wood not commercially important. Sometimes used for boats, fences, and furniture. Trees planted to restore depleted soils. Traditionally used as medicine. Bark of roots steeped to make a fragrant tea; oil extracted as a fragrance and insecticide. Native North Americans used bark for a wide variety of medicinal purposes, including gastrointestinal disorders and colds. Leaves are edible and used in salads or as condiment. Bark, twigs, and leaves are an important food source for wildlife, including deer.

ECOLOGY. A pioneer tree that grows in woodlands and secondary growth along fencerows and on roadsides in the eastern United States. Good seed crops

produced every one or two years with 35 percent viability. Shade intolerant. Highly susceptible to fire at all ages. Attacked by host of damaging foliage diseases, including *Mycosphaerella sassafras*, which causes leaf spot. Many insects, such as Japanese beetle (*Popillia japonica*), also cause infestations. Birds and rainwater are the primary dispersal agents of seeds.

CLIMATE CHANGE. Vulnerability is currently considered to be low.

CONSERVATION STATUS. Least concern.

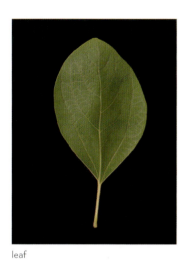
leaf

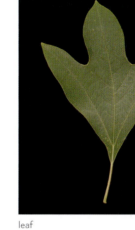
leaf

leaf

male inflorescence

male flowers

branch with leaves dark green above and leaves pale green below

bark

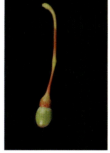
fruit

branchlet with infructescence

FAMILY LAURACEAE • 211

GENUS UMBELLULARIA

Oregon's Myrtle becomes California Laurel as soon as you cross the state boundary. Now it assumes many other forms, as it adapts itself variously to growth upon sea bluffs forever swept by salt-laden winds, or in the profound shade of mighty Redwoods and Douglas trees, in the sun-scorched chaparral, on the open hills or in the depths of canyons.

—Donald Culross Peattie on *Umbellularia californica* in A Natural History of North American Trees

The genus *Umbellularia* includes only a single species, *Umbellularia californica*, which is a large hardwood common tree native to coastal forests of California and Oregon. The numerous names of this species, including California bay laurel, Oregon myrtle, pepperwood, spicebush, cinnamon bush, peppernut tree, mountain laurel, and balm of heaven, all refer to the aromatic leaves, which are similar in fragrance to the leaves of bay laurel, native to the Mediterranean region. The small yellow to green flowers contain both male and female sexual organs (unlike many members of the family Lauraceae) and are produced in flat-topped clusters called umbels (hence the scientific name *Umbellularia* or "little umbel"). The fruits resemble a tiny avocado (to which this genus is related), possessing leathery skin, oily pulp, and a single hard pit.

California Bay
Umbellularia californica (Hook. & Arn.) Nutt.
CALIFORNIA LAUREL

California bay is a branching evergreen shrub or tree which can vary in shape and form depending on water availability, becoming shrublike in drier habitats. The leaves release a peppery menthol aroma when crushed and if inhaled may cause sneezing and headaches. Two varieties are recognized.

DESCRIPTION. A much-branched evergreen shrub or tree that grows 10–148 ft (3–45 m) tall becoming shrublike in drier habitats. Crown is densely foliated and broadly conical to pyramidal in shape. Bark is green to reddish brown, smooth on young trees, and shreds with age. Leaves are simple, alternate, oblong, glossy green, leathery, 1–4.3 in (2.5–11 cm) long and release a peppery menthol aroma when crushed which may cause sneezing and headaches if inhaled. Flowers are perfect, inconspicuous, yellow or green, and borne in clusters of six to ten. Fruits are brown-violet drupes, 0.4–1 in (1–2.5 cm) in diameter and attached to thick yellow stalks. Seeds are white with a thin light brown seed coat.

TAXONOMIC NOTES. Variety *californica* has leaf blades that are glabrous abaxially or with appressed pubescence; var. *fresnensis* has leaf blades that are tomentose abaxially.

USES AND VALUE. Wood commercially important and prized for turned wooden ware, furniture, cabinets, and interior finish work. Burls provide wood carvings that are marketed as "myrtlewood." Planted as an ornamental. Fruits and seeds are edible. Seeds roasted for coffee; leaves use as a substitute for bay leaf. Native Americans used as an analgesic; also for treating symptoms of digestive system. Important for wildlife providing both food and cover. Silver-gray squirrels, dusky-footed woodrats, California mice, and Steller's jays all feed on the seeds. Deer and goats browse the young shoots in spring and summer.

ECOLOGY. Grows in cool, humid, maritime climate of Californian and Oregonian coastal forests and also inhabits hillsides and canyons at elevations below 5,249 ft (1,600 m). Prefers loam, sandy-loam, or clay soils with a pH of 5.7–7.4. Good seed crops produced annually after trees have attained an age of thirty years or more. Dispersal agents include water, wind, and animals. Shade tolerant. Susceptible to windthrow and ice damage in coastal areas due to evergreen foliage, which holds snow and ice. Attacked by more than forty species of fungi and insects, but none causes particular damage.

CLIMATE CHANGE. Vulnerability is currently considered to be low.

CONSERVATION STATUS. Least concern.

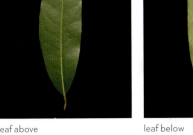

leaf above

leaf below

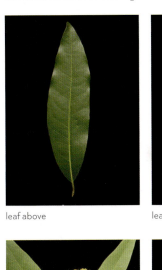

branch with inflorescence

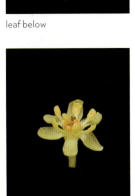

flower

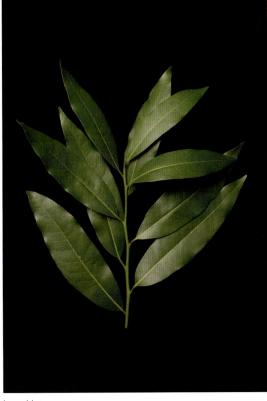

branchlet

bark

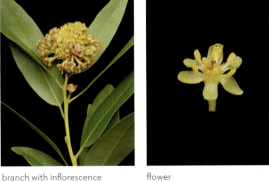

branch with infructescence

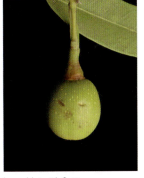

branchlet with fruit

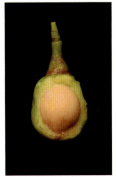

seed inside fruit

FAMILY LAURACEAE • 213

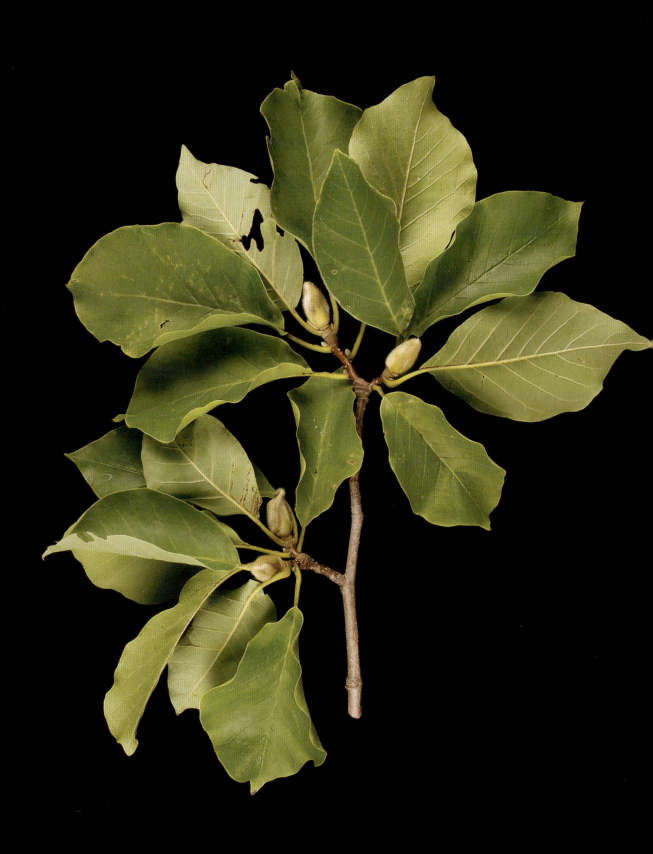

ORDER MAGNOLIALES

The six families in this order, including the magnolias, custard apples, and nutmegs, have traditionally been recognized by taxonomists as closely related plants. DNA data also strongly support this close relationship. Numerous vegetative and cellular features, as well as the presence of a fleshy structure surrounding the seeds called an aril, are found in all the members of the Magnoliales, also suggesting their descent from a common ancestor. Three genera in two families of the order Magnoliales are common trees in North America: *Magnolia* and *Liriodendron* in the family Magnoliaceae and *Asimina* in the family Annonaceae.

Family Annonaceae

The Annonaceae, one of the six families in the order Magnoliales, is comprised of trees and shrubs that are pantropical in distribution. The largest concentration of species is in the Asian tropics, but many species are in the Americas and Africa. In total, the family contains 106 genera and 2,400 species. Only a single species in the genus Asimina is common in North America. The flowers are fragrant and usually have numerous free and spirally arranged petals, stamens, and carpels. Like other basal angiosperms, the flowers show various adaptations for pollination by beetles, including closed flowers, fruity odors, special food tissues to reward the insects, and fleshy petals.

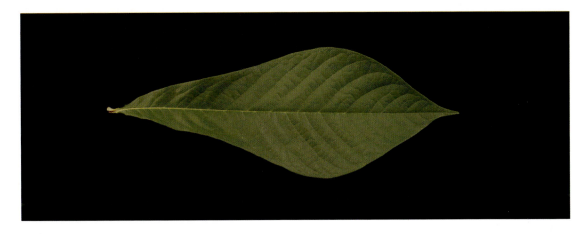

Family Magnoliaceae

The fossil record indicates that the family Magnoliaceae has a long evolutionary history of over 100 million years and that the geographic distribution was formerly much broader than it is today. Most of the species in the Magnoliaceae are found in Asia, from the Himalayas eastward to Japan and southeastward through the Malay Archipelago to Papua New Guinea. The rest of the species are native to the Americas, from temperate southeastern North America to tropical and subtropical South America, including Brazil. The family includes two genera (*Magnolia* and *Liriodendron*) and 220 species, of which only six are common trees in North America. (Species accounts for members of the family Magnoliaceae begin on page 218.)

OPPOSITE Cucumber-tree (*Magnolia acuminata*) **ABOVE** Pawpaw (*Asimina triloba*)

GENUS ASIMINA

The first reference to this curious species of an otherwise notably tropical family occurs in the chronicles of DeSoto's expedition in the Mississippi valley in 1541, for naturally an edible fruit of such size was important to a host of conquistadores always near starvation.

—Donald Culross Peattie on *Asimina triloba* in A Natural History of Trees of Eastern and Central North America

The genus *Asimina* is made up of eight species of small trees, all of which are distributed in eastern North America. The name is adapted from the Native American name *assimin*. Most flowers of the genus hang down on short stalks of the branches. They produce an odor similar to that of decomposing meat and are pollinated by insects, usually beetles or flies. Fruit production is often low in natural populations, and fruits are consumed mostly by mammals, such as foxes, opossums, squirrels, and raccoons. Pawpaw leaves and twigs are seldom consumed by rabbits or deer. One native species of *Asimina* is a common tree in North America.

Pawpaw
Asimina triloba (L.) Dunal

Pawpaw is a small tree native to eastern North America that spreads by root suckers as well as sexual reproduction. The leaves are generally unpalatable to most insects, but caterpillars of the zebra swallowtail (*Eurytides marcellus*) butterfly regularly feed on this plant.

DESCRIPTION. A generally small, deciduous tree, with some individuals growing up to 46 ft (14 m) tall. Often found in large clonal thickets, spreading extensively in the forest understory by suckers. Bark is brown with warty lenticels. Leaves are simple, alternate, obovate, green above and below, 4–11.8 in (10–30 cm) long, and 2–3 in (5–7.5 cm) wide. Flowers are perfect, blooming in early spring before leaves mature, hang down at maturity, purplish brown, with six petals, each 0.8–1 in (2–2.5 cm) wide. Fruits are berries, yellowish brown when ripe, somewhat banana-shaped, 2.8–6.3 in (7–16 cm) long. Seeds, flat, brown black.

USES AND VALUE. Wood not commercially important. Cultivated for fruit, as an ornamental, and for habitat restoration, particularly in wet soils. Fruits are edible, taste like bananas, and are avidly collected in the wild by local people.; used in pies, custards, ice cream, and other sweet deserts. Fruit employed medicinally as laxative; seeds, which contain asiminine, are emetic and narcotic. Squirrels, foxes, bears, raccoons, opossums, and other mammals consume the fruit.

ECOLOGY. Pawpaws are common in the understory of deciduous forests, on slopes, and along flood plains with rich soils. Shade tolerant. Generally free of pests.

CLIMATE CHANGE. Vulnerability is significant but has a reasonable probability of persistence in the future. Ongoing monitoring is recommended.

CONSERVATION STATUS. Least concern.

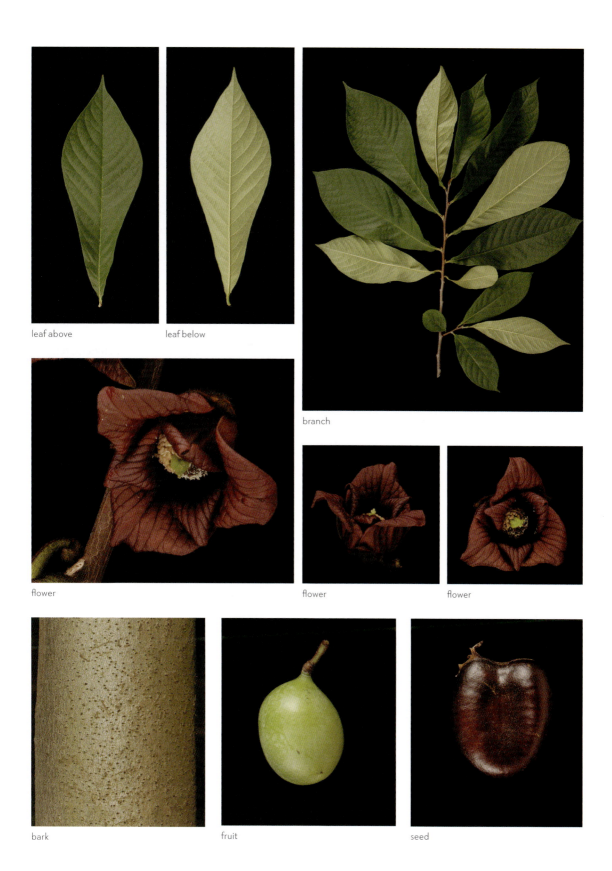

FAMILY ANNONACEAE • 217

GENUS LIRIODENDRON

But despite the splendor of its dimensions, there is nothing overwhelming about the Tuliptree, but rather something joyous in its springing straightness, in the candle-like blaze of its sunlit flowers, in the fresh green of its leaves, which, being more or less pendulous on long slender stalks, are forever turning and rustling in the slightest breeze; this gives the tree an air of liveliness lightening its grandeur.

—Donald Culross Peattie on *Liriodendron tulipifera* in *A Natural History of Trees of Eastern and Central North America*

Species in this genus are widely known by the common name "tuliptree" for their large tuliplike flowers. In fact, the scientific name *Liriodendron* means "lily tree." The names tulip poplar or yellow poplar are also often applied to this genus, although it is unrelated to the true poplars. Tuliptrees are easily recognized by their distinctive leaves, which in general have four lobes with a notch at the top. The genus *Liriodendron* includes only two species. One is native to China; the other is found in North America, where it is common in deciduous forests as well as cultivated. This pattern is an example of a disjunct East Asian-North American distribution, which suggests the long evolutionary history of these plants. Fossils have been reported from the late Cretaceous to the early Tertiary of North America and Central Asia, suggesting an earlier circumpolar northern distribution. The ancient species in Europe became extinct due to changing climate during the age of the glaciers. The one native species of *Liriodendron* is a common tree in North America.

Tuliptree
Liriodendron tulipifera L.
YELLOW POPLAR

Tuliptree is one of the tallest hardwood species native to eastern North America. The pale green to yellow flowers with a conspicuous orange band at the base attract bees, Their nectar yields a strong, dark red honey.

DESCRIPTION. One of the most distinctive hardwood deciduous trees in the Northeast growing to 197 ft (60 m) tall with an exceptionally straight trunk. Twigs are smooth, red brown with glaucous terminal buds, 0.4–0.6 in (1–1.5 cm) long and shaped like the bill of a duck. Bark is gray, smooth when young, becoming deeply furrowed and brownish gray with time. Leaves are simple, alternate, somewhat square with four main lobes and a notched or flat apex, dark green above, paler below, glabrous, margins entire, 3–5.9 in (7.5–15 cm) long and wide. Flowers are perfect with both stamens and pistil, blooming in mid- to late spring, six petals are found in two rows, greenish yellow with orange inside, about 0.2 in (0.5 cm) long. Fruits are dry, brown, cone-shaped, 3 in (7.5 cm) long, with clusters of angled samaras, each 1.2–1.6 in (3–4 cm) long.

USES AND VALUE. Wood commercially important. Used for crates, pallets, furniture frames, plywood, and pulp. Valued as a honey tree producing copious nectar. Cultivated as ornamental in parks. Roots produce a lemonlike flavoring used in spruce beer. Medicinally, raw green bark is chewed as an aphrodisiac. Quail, purple finches, rabbits, gray squirrels, and white-footed mice eat the seeds.

ECOLOGY. Common in moist eastern deciduous forests, usually found on well-drained soils. Large seed crops produced at irregular intervals; seed viability is low, 11 percent or less. Honeybees are responsible for pollination. Intolerant of shade and relatively resistant to windthrow due to deep and wide-spreading root system. Remarkably free of insect and fungal pests.

CLIMATE CHANGE. Vulnerability is currently considered to be low.

CONSERVATION STATUS. Least concern.

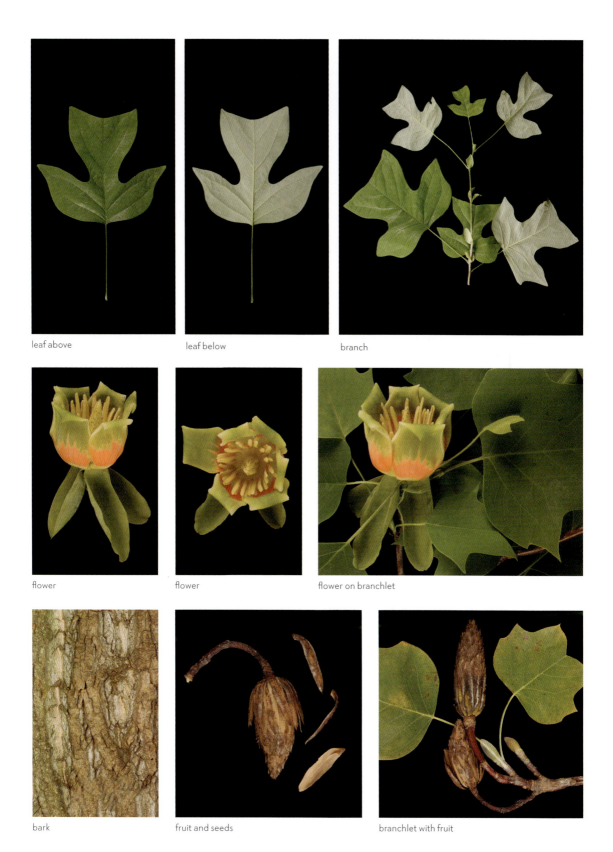

FAMILY MAGNOLIACEAE • 219

GENUS MAGNOLIA

In the coves of the southern Appalachians, cooled by the breezes set astir by ever-falling water and fresh with fern and saxifrage, this lovely tree is most at home, its flowers shining forth serenely as water lilies floating in the forest green.

—Donald Culross Peattie on *Magnolia fraseri* in *A Natural History of Trees of Eastern and Central North America*

The large conspicuous flowers of *Magnolia* are mainly pollinated by beetles. As in other flowers pollinated by beetles, those of *Magnolia* are large in size, white or pink in color, lack nectar, have an abundance of pollen, and emit a sweet fragrance. Linnaeus named the genus *Magnolia* in honor of the French botanist Pierre Magnol. Ten species of *Magnolia* are native to North America, and several more from Asia are commonly cultivated. Five native species of *Magnolia* are common trees in North America.

Cucumber-tree
Magnolia acuminata (L.) L.
CUCUMBER MAGNOLIA

One of the largest magnolias, the cucumber-tree is native to eastern North America and the only magnolia that extends its range into Canada. The Latin species name *acuminata* refers to the tapered tips of its leaves.

DESCRIPTION. A deciduous tree growing to 100 ft (30 m) tall. Trunk is straight and typically free of limbs owing to its propensity for self-pruning. Twigs are brown and glossy, with pale lenticels and a lemon smell when bruised. Bark is light grayish brown and flaky. Leaves are alternate, simple, ovate to obovate or elliptic, dark green above, pale and pubescent below, 0.6–1 in (1.5–2.5 cm) long and 2.8–4 in (7–10 cm) wide, with entire margins and an acuminate tip (hence the Latin name *Magnolia acuminata*). Flowers are perfect, blooming in late spring to early summer, green to greenish yellow, bell-shaped, 2–3.1 in (5–8 cm) long, with the six petals much longer than the sepals. Fruits are cone-shaped, cylindrical, green when immature but turning red and finally dark brown when ripe, 2–3.1 in (5–8 cm) long. Seeds are round, red, 0.6 in (1.5 cm) long.

USES AND VALUE. Wood moderately commercially important; soft, durable, straight grained, and light colored; often mixed with tuliptree (*Liriodendron tulipifera*) when sold commercially. Used for pallets, crates, barn siding, interior parts of furniture, framing, and plywood. Planted as an ornamental owing to attractive leaves, flowers, and fruit; cultivated successfully far north of natural range. Bark made into a tea that is antiperiodic, aromatic, and mildly diaphoretic and serves as laxative, stimulant, and tonic. Historically substitute for quinine in treatment of malaria. Bark is chewed by people to break dependence on tobacco; also hot infusion of bark treatment for sinus problems. Fruit used in tea as tonic and for treatment of general debility and stomach ailments. Small mammals and birds, such as grackles and blackbirds, eat fruits and seeds; twigs, leaves, and buds, browsed by deer, not palatable to humans.

ECOLOGY. Common in moist eastern deciduous forests on cool slopes and valleys, where it is native. Produces good seed crops every four to five years.

Intermediate in shade tolerance. Relatively free of insect and fungal pests. Seeds are dispersed by birds, wind, water, and gravity.

CLIMATE CHANGE. Vulnerability is high, may have little capacity to adapt to changing conditions, and has a low potential to persist in the future. Ongoing monitoring is required.

CONSERVATION STATUS. Least concern.

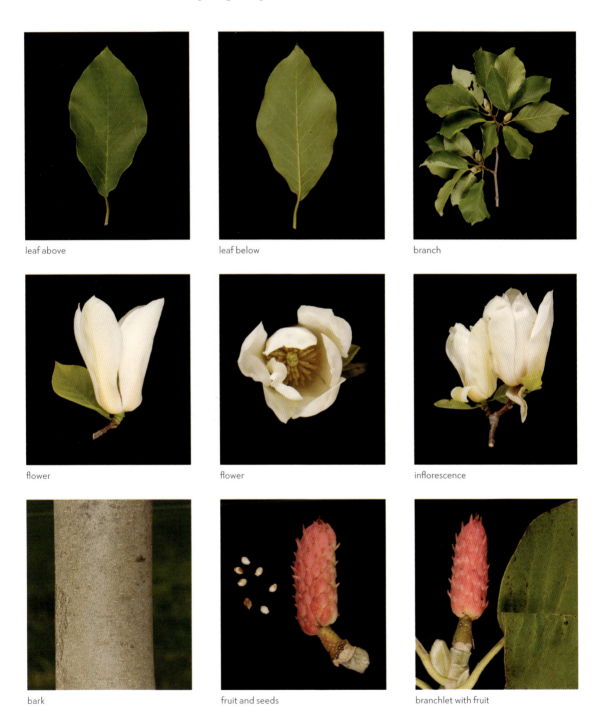

leaf above • leaf below • branch

flower • flower • inflorescence

bark • fruit and seeds • branchlet with fruit

Fraser Magnolia
Magnolia fraseri Walt.
MOUNTAIN MAGNOLIA

Fraser magnolia is a deciduous tree native to the Appalachians whose range appears to be expanding due to widespread planting and cultivation as an ornamental. The large, creamy white flowers up to ten inches in diameter make this an attractive tree for garden landscapes and parks.

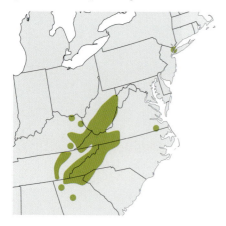

DESCRIPTION. A deciduous tree that grows 33–49 ft (10–15 m) tall with a single straight trunk or multiple trunks. Trees produce a deep taproot and well-developed lateral roots. Twigs are stout, purple to brown, with conspicuous leaf scarring and a large 0.8–1.2 in (2–3 cm) long smooth and violet terminal bud. Bark is grayish brown and splotchy with a scaly or warty texture. Leaves are simple, alternate, clustered at the branch terminus, large, up to 21 in (53 cm) long, leaf base auriculate, upper side glossy, underside dull and smooth. Flowers are perfect, blooming in May or June, showy, creamy white, each with nine tepals, releases an unpleasant odor, 6.3–9.8 in (16–25 cm) in diameter. Fruits are cone-like aggregates of fleshy follicles, scarlet, 6.9–7.9 in (17.5–20 cm) long, senescing to be woody and brown. Seeds are drupe-like, red, 0.6 in (1.5 cm) long.

USES AND VALUE. Wood of minor commercial importance. Generally marketed with yellow poplar (*Liriodendron tulipifera*). Frequently planted as ornamental. Animals use rotten stems for den trees; deer browse sprouts and saplings; small rodents feed on seeds.

ECOLOGY. Grows in moist montane well-drained soils on mesic sites. Trees are commonly multi-stemmed in bottomlands and single-stemmed on slopes and ridges. Elevation ranges from 1,640 to 5,577 ft (500–1,700 m), although most common between 1,968 and 4,265 ft (600–1,300 m). Native range in the Appalachians is likely expanding due to widespread planting and cultivation as an ornamental. Good seed crops produced every four years. Intermediate in shade tolerance. Extremely susceptible to damage from fire due to thin bark. Various trunk-rot fungi and insect pests attack the tree, but none is especially damaging. Small animals are responsible most seed dispersal.

CLIMATE CHANGE. Vulnerability is significant but has a reasonable probability of persistence in the future. Ongoing monitoring is recommended.

CONSERVATION STATUS. Least concern.

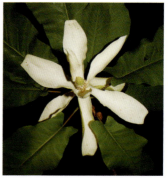
flower on branch

bark

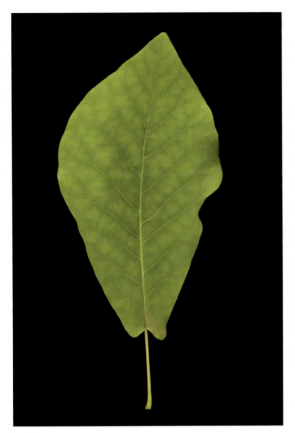
leaf above

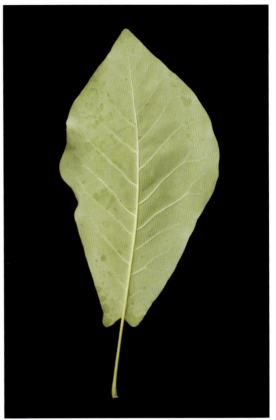
leaf below

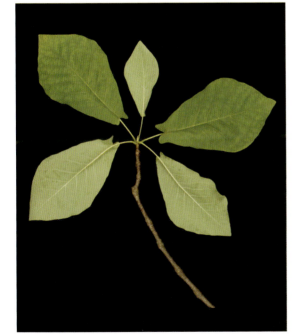
branch

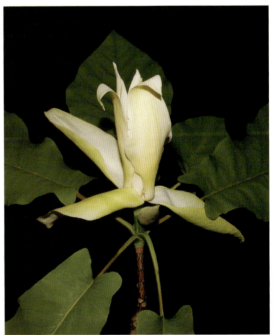
flower on branch

FAMILY MAGNOLIACEAE • 223

Southern Magnolia
Magnolia grandiflora L.

Native to the southeastern United States, southern magnolia has a striking appearance with large dark green leaves and showy lemon-scented flowers almost a foot in diameter. The state tree of both Mississippi and Louisiana.

DESCRIPTION. A long-lived evergreen tree most common in the southern United States and grows to 100 ft (30 m) in height with a straight trunk and densely packed, spreading branches, irregular pyramidal crown, and deep root system. Young twigs are covered in woolly hairs. Bark is brown to gray, smooth when young but later becoming scaly. Leaves are simple, alternate with a leathery texture, glossy green above and velvety below, 5.1–7.9 in (13–20 cm) long. Flowers are perfect, blooming in late spring and summer, white, with six (sometimes nine to twelve) tepals, 7.9–11.8 in (20–30 cm) in diameter, intense perfume-like fragrance produced especially in the evenings. Fruits are aggregated in cone-like structures, reddish brown, 2–4 in (5–10 cm) long. Seeds are flattened, red, 2–5 in (6–13 mm) long.

USES AND VALUE. Wood of moderate commercial importance; marketed with other species in genus. Used for furniture, pallets, and veneer. With large, fragrant, white flowers and shiny, dark green, evergreen leaves, very popular as ornamental around the world. Flowers are eaten and used as spice or condiment. Employed medicinally in treatment of malaria and rheumatism; alcoholic extract reported to reduce blood pressure. Seeds are important food source for squirrels, turkeys, quail, and opossums.

ECOLOGY. Grows in bottomlands and moist lowland forests in the southeastern coastal plain of North America. Shade tolerant when young requiring more light as it matures. Good seed crops normally produced every year; viability is around 50 percent. Easily damaged by fire. Several fungal pests cause leaf spot; magnolia scale insect *(Neolecanium cornuparyum)* will damage individual branches or entire trees.

CLIMATE CHANGE. Vulnerability is significant but has a reasonable probability of persistence in the future. Ongoing monitoring is recommended.

CONSERVATION STATUS. Least concern.

flower

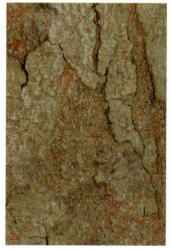

bark

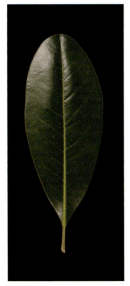
leaf above

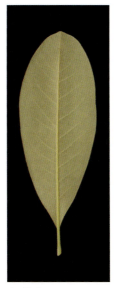
leaf below

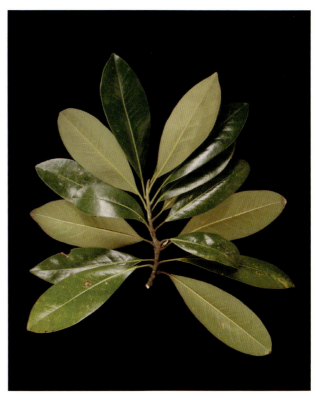
branch

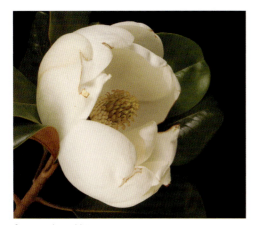
flower on branchlet

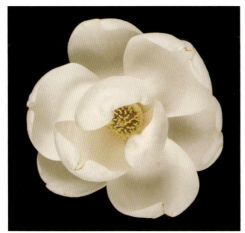
flower

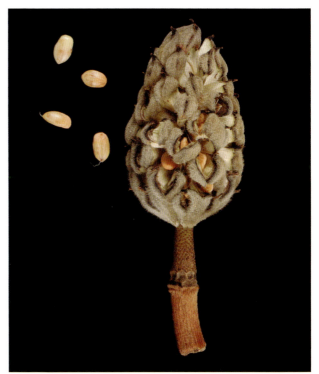
fruit and seeds

FAMILY MAGNOLIACEAE • 225

Bigleaf Magnolia
Magnolia macrophylla Michx.

Bigleaf magnolia, which is native to the southeastern United States and eastern Mexico, has the largest simple leaf (30 inches long) and single flower (ten inches in diameter) of any North American tree. The name *macrophylla* derives from the Greek words *macro* (large) and *phyllon* (leaf) referring to these big leaves.

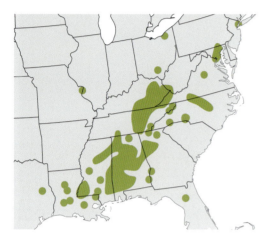

DESCRIPTION. A deciduous tree that grows to 40 ft (12 m) in height, with the lower branches spread distinctively 90 degrees from the main stem. Twigs are stout in order to support the very large leaves. Bark is grayish brown with platelike patches on older trees. Leaves are simple, alternate, obovate with entire margins and two rounded, earlike lobes at the base, shiny green above and covered with woolly hairs below, 29.5 in (75 cm) long, 13.8 in (35 cm) wide. Flowers are perfect with both stamens and pistils, white, fragrant, blooming in mid-spring, with six petals in two whorls, 5.9 in (15 cm) long and 9.8 in (25 cm) wide. Fruits are conelike, rose colored, 2–3 in (5–7.5 cm) long.

USES AND VALUE. Wood not commercially important. Occasionally planted as a specimen tree in arboreta and gardens. No parts known to be eaten. Infusion of the bark used to treat stomachaches and cramps.

ECOLOGY. Grows in moist forests along valleys and ravines in the southeastern United States. Not a prolific seed producer. Intermediate in shade tolerance. Generally free of insect and fungal pests.

CLIMATE CHANGE. Vulnerability is high, with little capacity to adapt to changing conditions and low potential to persist in the future. Ongoing monitoring is required.

CONSERVATION STATUS. Least concern.

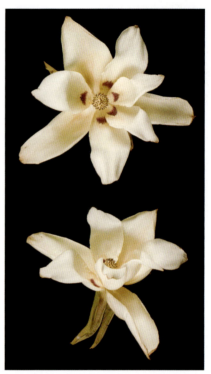

flowers

bark

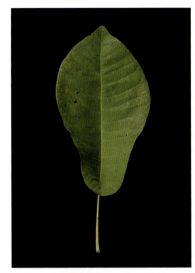
leaf above

leaf below

fruit

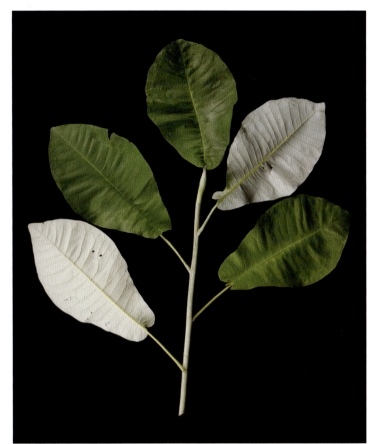
branch

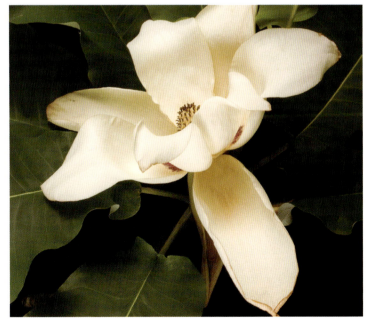
flower on branchlet

FAMILY MAGNOLIACEAE • 227

Sweetbay

Magnolia virginiana L.

Sweetbay, which is a tree native to the southeastern United States, can be either deciduous or evergreen, depending on local climate conditions. Called "beavertree" by early colonists in North America, the roots were used as bait for trapping beavers. This magnolia was the first to be scientifically described and serves as the type species of the genus *Magnolia*.

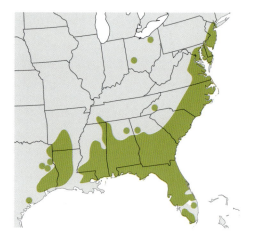

DESCRIPTION. A small deciduous tree that grows to 60 ft (20 m) in height. Twigs are pale green and lustrous. Bark is smooth and reddish brown to gray. Leaves are simple, alternative, oval to oblong, tip is blunt, and base is acute, with smooth margins, shiny dark green above and silvery below, 3.1–5.9 in (8–15 cm) long, and 1–2.8 in (2.5–7 cm) wide. Flowers are perfect, blooming in late spring, start out white but quickly change to light brown, with nine to twelve petals in several concentric whorls, fragrant, somewhat smaller than other magnolias, 2–2.8 in (5–7 cm) in diameter. Fruits are aggregated into a cone-like structure, oblong, pink to red, 3–5 cm long. Seeds are red, and 8–10 mm long.

USES AND VALUE. Wood of moderate commercial importance. Used for veneer, plywood, interior trim, and furniture frames. Leaves provide a spice for cooking. Bark chewed to break dependence on tobacco. Tea made from the bark was used to treat malaria as well as colds, respiratory infections, and gout. Scent of leaves and bark may act as mild hallucinogenic.

Leaves are high in protein and a favorite food of deer and can account for 25 percent of winter diet of cattle. Seeds are eaten by turkey, quail, many songbirds, gray squirrels, and white-footed mice.

ECOLOGY. Grows in swampy woods, along streambanks, and in "magnolia bogs in the southeastern United States. Seeds are produced in small quantities annually and dispersed by birds, wind, and sometimes water. Intermediate in shade tolerance; very resistant to fire due to thick bark. Some fungi infect the leaves, with little damage.

CLIMATE CHANGE. Vulnerability is currently considered to be low.

CONSERVATION STATUS. Least concern.

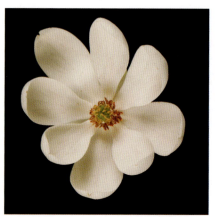

flower

bark

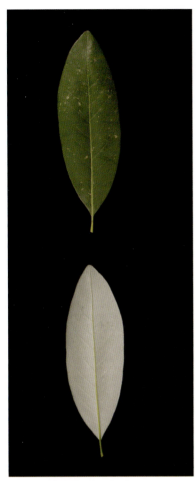
leaf above (top), leaf below (bottom)

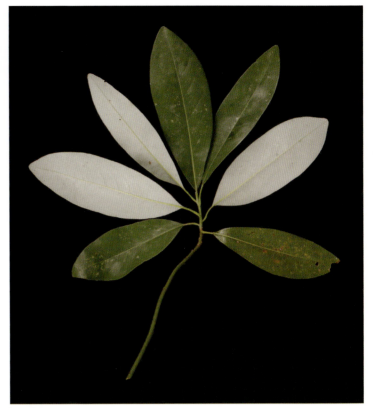
branch

flower

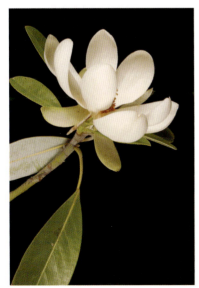
flower on branchlet

fruit

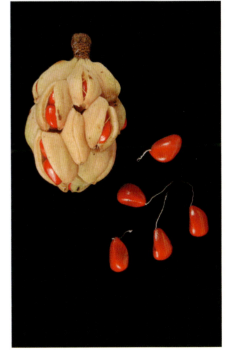
fruit and seeds

FAMILY MAGNOLIACEAE • 229

Monocots: Trees Related to Palms

The Monocots are the largest monophyletic group in the basal angiosperms, containing nearly 60,000 species, which is one-fifth of all flowering plants. They are distinguished from other angiosperms by possessing a single seedling leaf (called a cotyledon), a diffusely scattered vascular system, and floral parts in whorls of three (although this feature is also present in several other basal angiosperms), as well as several specialized cellular characteristics. Monocots probably originated between 125 and 140 million years ago. Eleven major lineages are recognized within the Monocots, including the pickerel weeds and aroids, the screw pines, the onions and orchids, the lilies, the palms, the gingers and bananas, the day-flowers, and the grasses and bromeliads. The yuccas in the order Asparagales and family Asparagaceae and the palms in the order Arecales and family Arecaceae are the only treelike Monocots found in North America.

ORDER ARECALES

This order consists of a single family, the palms, which contains 2,800 species. Palms are distinguished within the Monocots by their "woody," usually unbranched, trunks and were mistakenly allied with the tropical screw pines because of this look-alike feature. They have a unique type of leaf development and unusual pleated leaves. The palms share a number of chemical and cellular traits that indicate they are most closely related to the gingers, day-flowers, bromeliads, and grasses. Four genera in one family include species of trees that are common in North America.

Family Arecaceae

Palms are found everywhere in the tropical regions of the world: rain forests, cloud forests, dry forests and deserts, and mangrove forests. The diverse family Arecaceae contains almost 190 genera, but only four are considered common outside of the tropics in North America. Palms yield many products of value, including nuts, vegetables, oil, wax, and rattan. The earlier botanical name for palms was "Principes," and these plants have always been royally treasured as ornamental plants for the garden and on city streets. The large strap- or fanlike leaves are unmistakable and characteristic of this family.

GENUS PHOENIX

The genus *Phoenix*, which includes the date palm, is made up of fourteen species that grow in a variety of habitats from northern and southern Europe eastward across southern Asia to parts of Southeast Asia. They are generally large palms with pinnate leaves (uncommon for the other palms to which it is related). The date palm has long been cultivated for its fruits, while other species in this genus, including the one common species in North America, *Phoenix canariensis*, are cultivated as ornamentals. The leaf segments at the base of each leaf are uniquely modified into long sharp spines. Flowers are unisexual; the male and female flowers, pollinated by wind as well as insects, are produced on separate plants. The brightly colored fruits are bunched into large tight clusters; each fruit produces a single seed. The name *phoenix* comes from the Greek word for the date palm. One introduced species of the genus *Phoenix* is a common tree in North America.

Canary Island Date Palm

Phoenix canariensis Chabaud

Canary Island date palm, a large, stout, erect palm, is a popular ornamental that grows in Mediterranean or subtropical climates in North America. A drought-tolerant species, naturalized populations are likely to occur along slopes and disturbed areas.

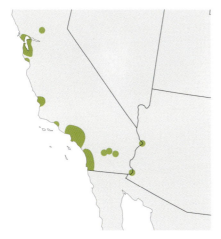

DESCRIPTION. A large erect palm growing 33–66 ft (10–20 m) in height with a stout columnar trunk leading to a large crown of up to fifty leaves. Bark is gray and leaf scars form a distinctive diamond scoring on the trunk. Leaves are pinnately compound, with up to 100 leaflets on each side of the rachis, 13–20 ft (4–6 m) long. Trees are dioecious with and male and female flowers produced in clusters on separate plants, emerging from a husklike bract, blooming throughout the year, rather than in a single season. Fruits are orange or violet drupes, 0.8 in (2 cm) long, hang in clusters and ripen in summer, with a single large seed.

USES AND VALUE. Commercial importance is limited. Planted as an ornamental. Sap is also used to make palm syrup. No food or medicinal uses are known.

ECOLOGY. Native to the Canary Islands, grows in Mediterranean or subtropical climates in North America, where it has a tendency to naturalize in low-lying, moist areas with fertile soil along slopes and disturbed areas, often at elevations below 1,608 ft (490 m). Shade and frost intolerant. Drought tolerant once established. Attacked by wide range of fungal and insect pests, many of which are fatal; weevils of the genus *Rhynchophorus* are particularly lethal.

CLIMATE CHANGE. Vulnerability is considered low because of its wide geographic distribution as an ornamental.

CONSERVATION STATUS. Least concern.

leaf section-apex

leaf section-mid

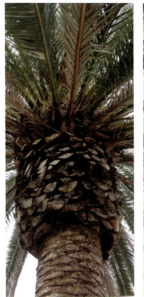
crown

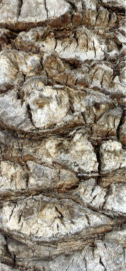
bark

GENUS SABAL

"Palmetto Scrub" is the bane of hunters, surveyors, and others who are obliged to go on foot through regions covered with the tough young growth of these trees.

—Julia Ellen Rogers on *Sabal palmetto* in *The Tree Book: A Popular Guide to a Knowledge of the Trees of North America and to Their Uses and Cultivation*

The eighteen species of *Sabal* are native to the American tropics from the southern United States through Mexico and Central America to northern South America and the Caribbean islands. The fanlike, palmately compound leaves are distinctive and in many species are produced on prostrate trunks on the ground. The genus probably originated 66 million years ago, and many fossilized leaves are found in Europe and Japan, indicating a much wider geographic distribution in the past. Only a single species, the cabbage palm (*Sabal palmetto*), is a common tree in North America.

Cabbage Palm
Sabal palmetto (*Walter*) Lodd. Ex. Schult. & Schult. F.
CABBAGE PALMETTO

Cabbage palm is an erect evergreen palm tree with leaves that are fan-shaped and palmately divided with spineless petioles This tree is salt and wind tolerant and can withstand hurricane conditions.

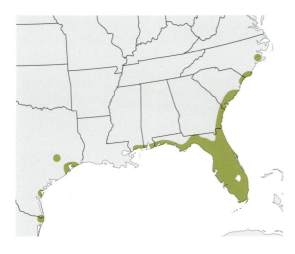

DESCRIPTION. An erect evergreen palm tree growing 33–82 ft (10–25 m) in height. Trunk is gray brown, rough, and fibrous. Leaf bases may persist on the trunk or slough off with age. Root system is a short bulbous stem with orange-colored roots that reach to 20 ft (6 m) below the soil surface. Leaves are upright and held-erect, fan-shaped and palmately divided with spineless petioles, 3–10 ft (1–3 m) long. Flowers are blooming from April to August on arching or drooping clusters, perfect, showy, and creamy white in color. Fruits are fleshy drupes produced in winter, black, with a single spherical seed.

USES AND VALUE. Wood not commercially important. Widely planted as an ornamental. Formerly used for pilings and the construction of forts, as it does not splinter when hit by cannon and rifle fire. Palm fronds are shipped worldwide for celebrations of Palm Sunday. Fruit, leaves, and terminal buds are edible; latter is canned and sold as commercial product. Nectar produces a dark, strong honey. Fruits have analgesic properties. Fruits also an important source of food for a wide variety of wildlife, including deer, bear, racoon, squirrel, bobwhite, and wild turkey.

ECOLOGY. Grows in poorly drained neutral or alkaline soils rich in calcium, adjacent to wetlands in humid subtropical and warm-temperate climates in North America. Salt and wind tolerant and able to withstand hurricane conditions. Produces abundant fruit and seed annually, with viability often less than 10 percent. Shade tolerant. Susceptible to peat fires and rising sea levels; generally pest free.

CLIMATE CHANGE. Vulnerability is currently considered to be low.

CONSERVATION STATUS. Least concern.

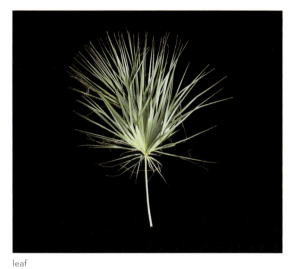
leaf

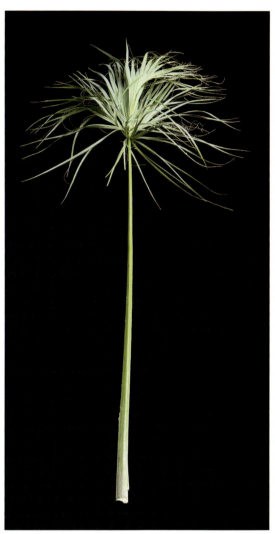
leaf with long petiole

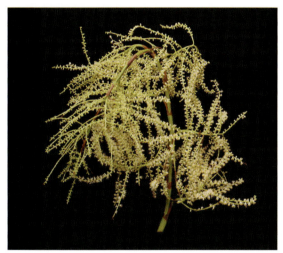
inflorescence

inflorescence

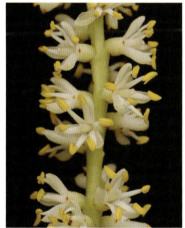
flowers

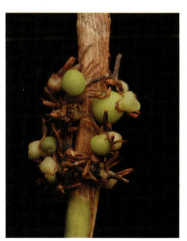
immature fruit

FAMILY ARECACEAE • 233

GENUS SYAGRUS

More than fifty species make up the genus *Syagrus*. They are native to South America; only a single species is endemic to a number of islands in the eastern arc of the Caribbean. Usually single-trunked, the trees can be tall and graceful with pinnately compound leaves without spines. The flowers are unisexual: both sexes are present on the same individual and within the same inflorescence. The single species in North America is commonly cultivated as an ornamental and was originally brought from southern subtropical South America. This genus is closely related to the coconut palm. One introduced species of *syagrus* is a common tree in North America.

Queen Palm
Syagrus romanzoffiana (Cham.) Glassman

Queen palm is an erect single-trunked palm tree introduced into subtropical North America from South America and often used for urban landscaping. In its native South America, this palm grows in rain forest and riparian areas along the coast.

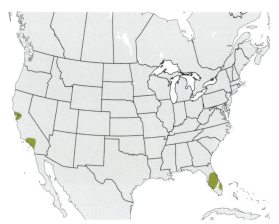

DESCRIPTION. An erect single-trunked palm tree with a crown of drooping glossy leaves. Trunk is smooth, gray, and scored into lateral rings by leaf scars. Leaves are pinnately compound, 16 ft (5 m) long each typically with 300 leaflets, each leaflet approximately 20 in (50 cm) long. Dead fronds persist for several months before abscising. Trees are monecious producing male and female flowers on the same plant. Inflorescences protrudie from a bract-like structure producing showy panicles in spring. Flowers are imperfect, white, produced in groups of three, in which two are male and one is female. Fruits are bright orange, 1 in (2.5 cm) long, and hang in large clusters, ripening in winter.

USES AND VALUE. Wood not commercially important. Cultivated as popular ornamental for urban landscaping. Fiber in leaves used for basket making and cordage. Fruits not edible. In native habitats, fruits are highly attractive to birds and bats, which disperse the seeds.

ECOLOGY. Native to South America, grows in acidic, well-drained soils of subtropical zones in North America, where it has been introduced. In natural tropical habitats in South America, grows in wet forest and riparian areas along the coast.

CLIMATE CHANGE. Vulnerability is considered low because of its wide geographic distribution as an ornamental.

CONSERVATION STATUS. Least concern.

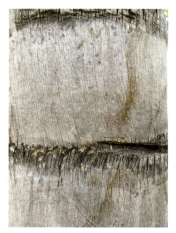

bark

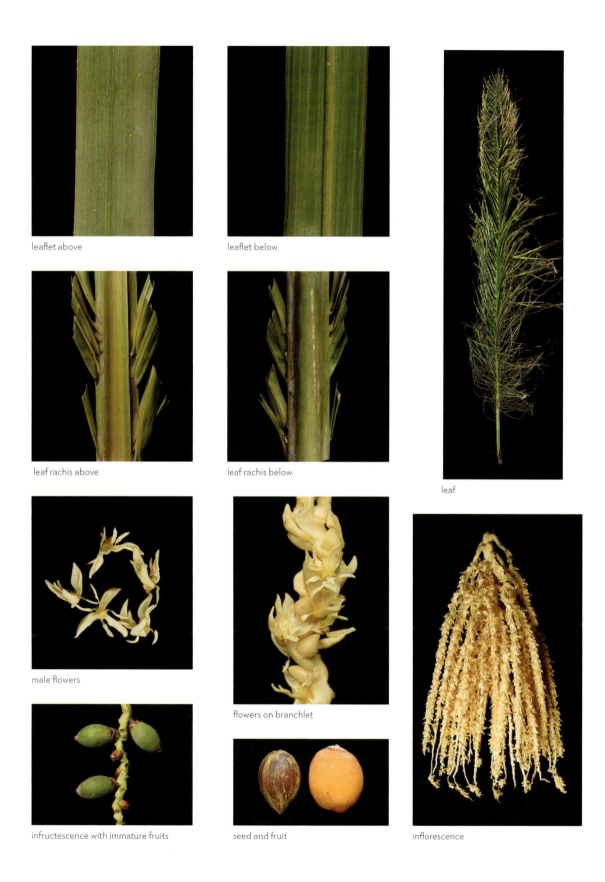

GENUS WASHINGTONIA

By moonlight these trees are especially magical—palms indeed seem meant for the moon and warm winds—and then this desertic portion of the planet, its barren features unsoftened by water, seems indeed like some lunar landscape, save for the proud difference of the Desert Palms, waving life's green banners.

—Donald Culross Peattie on *Washingtonia filifera* in *A Natural History of North American Trees*

The genus *Washingtonia* is native to the southwestern United States and northwestern Mexico, where the two species are found in desert habitats almost always near some source of water, such as an oasis. The genus was named after the first president of the United States, George Washington, and is cultivated across the globe in warmer climates as an ornamental palm. The trunks can be exceptionally tall in cultivation, with the palmately compound leaves clustered at the top. The bushy crowns are the home of many species of insects, birds, and bats in their native ranges. One native and one introduced species of *Washingtonia* are common trees in North America.

California Fan Palm

Washingtonia filifera (Linden ex Andreé) H. Wendl. Ex de Bary.
DESERT PALM, PETTICOAT PALM

California fan palm is an evergreen palm that is North America's tallest native palm. The long fibrous threads produced at the margins of the fan-shaped leaves are the sources of the scientific name "filifera" meaning "thread bearing." This palm is commonly cultivated and also has naturalized in wet areas of the Sonoran Desert.

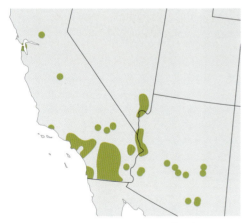

DESCRIPTION. An evergreen palm that grows to 30–49 ft (9–15 m) tall with a large columnar trunk that supports a loose, open rosette of large leaves. North America's tallest palm and typically lives for 150 years. Bark is thick, grayish, and rindlike, textured by ringed leaf scars. Leaves are fan-shaped, waxy, palmate, up to 13 ft (4 m) in length, leaf margins produce long fibrous threads that hang down. Dead leaves hang at the base of the rosette in a skirt that may persist the entire length of the trunk providing habitat for birds and invertebrates. Trees produce multiple inflorescences of branching spadices that project outward from the crown. Flowers are perfect and white. Fruit a red drupe with a single seed.

USES AND VALUE. Wood is not commercially important. Cultivated as an ornamental. Fruit, seeds, and leaves are all edible. Thin sweet pulp of fruit has tastes similar to dates. No medicinal uses are known. Provides critical habitat and food for a wide variety of animals in the oases habitats where it occurs, including tree frogs and other amphibians, rodents, songbirds (especially the hooded oriole), and the western yellow bat. A rat snake (*Elaphe rosalica*) depends upon the shag of the hanging leaves for shelter and food.

ECOLOGY. Grows naturally in desert washes, seeps, and springs where water is usually available, occurring at elevations from 328 to 3,937 ft (100–1,200 m). Widely cultivated and naturalized in wet areas of the Sonoran Desert.

CLIMATE CHANGE. Vulnerability is currently unknown. Immediate assessment is recommended.

CONSERVATION STATUS. Least concern.

leaf segment above

leaf segment below

leaf below

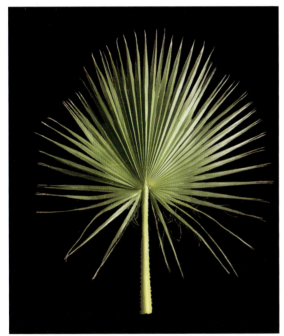
leaf above

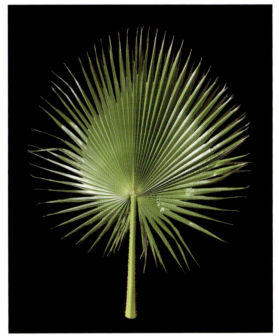
leaf below

leaf blade at petiole below

bark

bark with leaf bases

FAMILY ARECACEAE • 237

Mexican Fan Palm
Washingtonia robusta H. Wendl.

Mexican fan palm occurs naturally in Mexico in washes and riparian corridors. This palm is commonly cultivated in California and Florida, where it has become naturalized in disturbed areas.

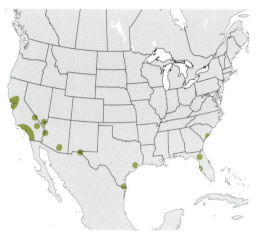

DESCRIPTION. An erect palm growing up to 100 ft (30 m) in height. Trunk is reddish gray, becoming ashy gray and ringed with leaf scars as it ages. Leaves are fan-shaped, spirally arranged, glossy green, margins of petioles are orange to tan and lined with curved, sawlike spines; dead leaves are persistent on the trunk. Inflorescences are produced on branches up to 10 ft (3 m) long and composed of small white perfect flowers, blooming from April to June. Fruits are round, fleshy, black drupes, 0.3–0.5 in (0.84–1.3 cm) in diameter.

USES AND VALUE. Wood not commercially important. Very popular as cultivated ornamental. Senesced leaves provide habitat for small mammals, birds, and invertebrates.

ECOLOGY. Grows in washes and riparian corridors where it is native in the Sonoran Desert and Baja California; has now naturalized in disturbed areas of California and Florida. Persists in a variety of acidic soil types and requires well-drained substrates. Susceptible to breakage and windthrow. Attacked by several rot fungi, including basal trunk rot caused by *Ganoderma zonatum*.

CLIMATE CHANGE. Vulnerability is considered low because of its wide geographic distribution as a naturalized ornamental.

CONSERVATION STATUS. Least concern.

entire leaf above

leaf segment below

leaf segment above

leaf below

leaf above

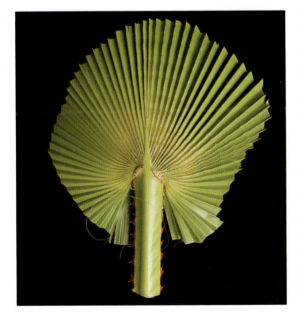
leaf blade at petiole below

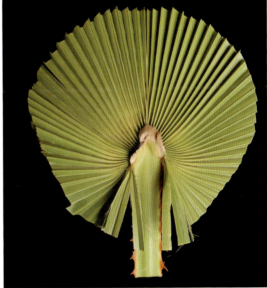
leaf blade at petiole above

FAMILY ARECACEAE • 239

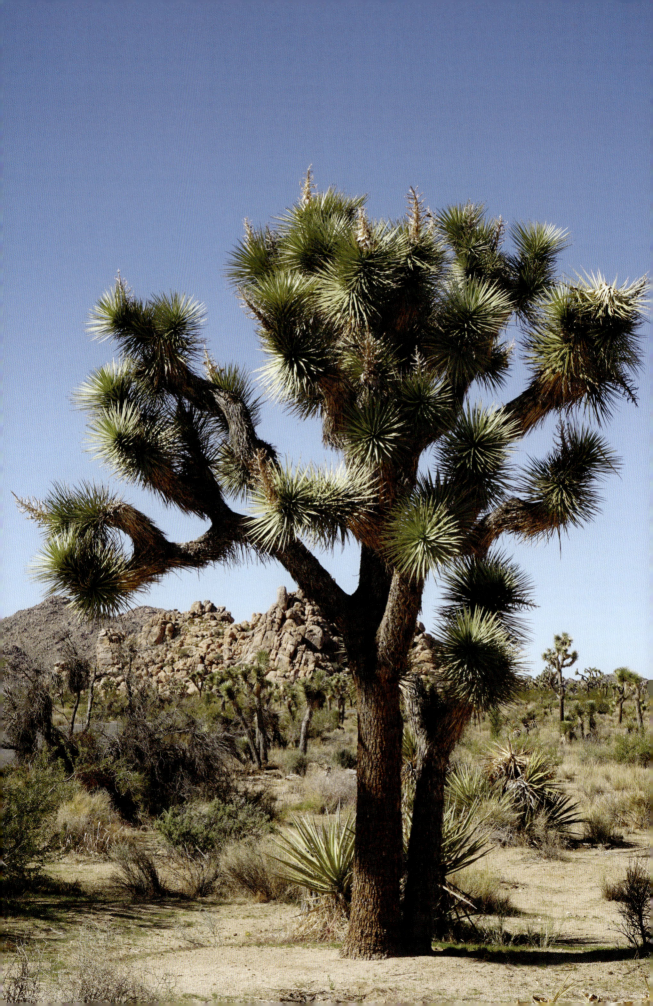

ORDER ASPARAGALES

Although this order contains many plants that formerly were thought to be related to the lilies, the Asparagales share a more recent common ancestor with the most advanced Monocots, including the day-flowers, the gingers, the bromeliads, and the grasses. Some taxonomists estimate that up to 30,000 species are contained in this order, most found in the orchid family. The Asparagales also include the onions, amaryllis, daffodils, iris, agaves and yuccas, hyacinths, asparagus, day lilies, dragon trees, Solomon's seal, and snow drops. Many of the spring-flowering ephemerals in our temperate forests are members of the Asparagales. All of them possess black seeds and a unique type of nectary in the flowers. One genus in one family includes species of trees that are common in North America.

Family Asparagaceae

Some taxonomists include the one common treelike genus of this order, *Yucca*, in the Asparagaceae, a broadly defined family with thousands of species. Others put *Yucca*, *Agave*, *Furcraea*, and several additional genera into their own family, the Agavaceae, which contains only hundreds of species. Despite DNA evidence, it is still not clear what the best taxonomy should be for these plants. Nonetheless, *Yucca*, along with *Agave* and *Furcraea*, are good sources of commercial fiber, compounds used in oral contraceptives, and horticulturally valued plants. Together they are pollinated by moths, birds, and bats.

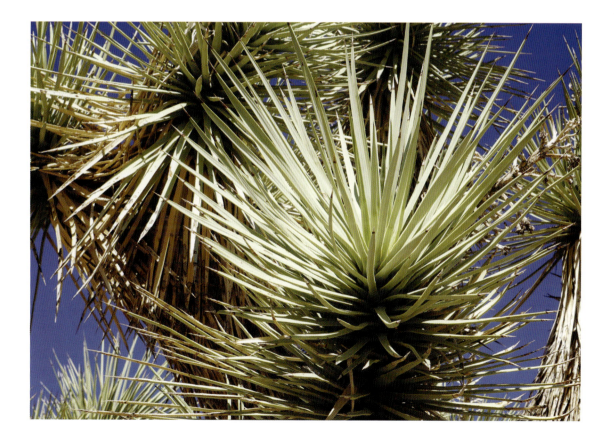

OPPOSITE, ABOVE Joshua tree (*Yucca brevifolia*)

GENUS YUCCA

There are some who love it from the moment they first behold it, silhouetted, perhaps, against some desert sunset sky, with the snows of far-off peaks still flashing their signals, and the twilight filled with the last cry of the day birds—the ash-throated flycatchers and plaintive Say's phoebes—while nighthawks sweep the skies with pointed wings and the burrowing owls begin to pipe from their holes in the sands. At such a moment the Joshuas lose their gauntness and take on a spiritual quality.

—Donald Culross Peattie on *Yucca brevifolia* in *A Natural History of North American Trees*

Species of *Yucca* are found native throughout Central America, Mexico, North America, and the Caribbean, from Guatemala to Canada. These plants always add a very distinctive element to the flora with the sword-like clusters of leaves and tall flowering spikes bearing striking white flowers. These same features make some of the species popular as ornamental garden plants. The bisexual flowers are pollinated by yucca moths, which have evolved a mutualistic plant-animal interaction with the yuccas. The female moths carefully transfer pollen from the stamens to the stigma while at the same time laying eggs within the flower. The developing larvae of the moth feed on the immature seeds, but their limited number allows the plant to produce significant numbers of seeds to reproduce. Both the moths and the plants benefit from this interaction. Of the fifty possible species, only three are common trees in North America.

Joshua Tree

Yucca brevifolia Engelm.

Joshua tree is the largest and most well-known species of the yuccas, growing in sandy or rocky soils of desert flats in the Mojave and northern Sonoran Deserts. Many desert species of animals use this tree for food, nesting material, and habitat. Two varieties are recognized.

DESCRIPTION. The largest of the yuccas growing to 3–49 ft (1–15 m) in height, highly branched with a single trunk that forms a distinctive irregular crown. Branches are stout, forking, and occasionally drooping with rosettes of leaves at the terminus. Leaves are simple, stiff, narrow, blue green, resembling daggers, yellow, margins serrulate, 5.9–13.8 in (15–35 cm) long. Inflorescence are exserted from the apex of the rosette of leaves and 11.8–19.7 in (30–50 cm) long. Flowers are blooming from April to May, perfect, creamy white, and bell-shaped, 1.6–2.8 in (4–7 cm) long. Fruits are capsules, 2.4–3.3 in (6–8.5 cm) long, produced in clusters.

TAXONOMIC NOTES. Variety *brevifolia* is 20–40 ft (5–12 m) tall, branching is not truly dichotomous, and leaves are 7.5–15 in (19–37 cm) long; var. *jaegeriana* is 10–20 ft (3–6 m) tall, displays true dichotomous branching, and leaves are less than 8.7 in (22 cm) long.

USES AND VALUE. Not commercially important. Used for fuel and fence posts. Attractive for ecotourism and cultivated as an ornamental. Fiber taken from the leaves used for making baskets and clothing. Flowers, fruit, seed, and seedpod are all edible. Mature, open flowers are rich in sugar and eaten like candy. No medicinal uses are known. Wildlife species of the desert use for food, nesting material, and habitat.

ECOLOGY. Grows in the Mojave and northern Sonoran Deserts, where it is found in desert flats at elevations from 1,312 to 6,562 ft (400–2,000 m). Pre-

fers sandy or rocky soils that are fine, loose, and well drained. Intermediate in shade tolerance.

CLIMATE CHANGE. Vulnerability is significant but may have the capacity to adapt to changing conditions in the future. Ongoing monitoring is recommended.

CONSERVATION STATUS. Vulnerable.

leaf blade above

leaf blade below

leaf above

leaf below

leaf cluster

flower

inflorescence

flower

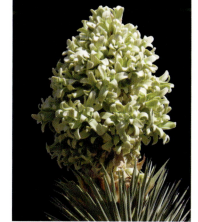
inflorescence

bark with leaf bases

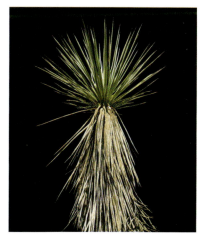
leaf crown

FAMILY ASPARAGACEAE • 243

Soaptree Yucca
Yucca elata Engelm.

Soaptree yucca is found in desert scrub communities and arid grasslands on a variety of coarse soils in the southwestern United States. It has distinctive grasslike leaves and a tall stalk of flowers. Soap can be made from the roots, hence the common name. Two varieties are recognized.

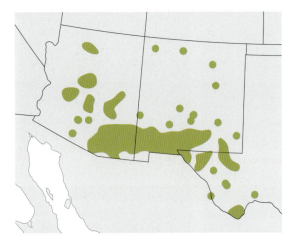

DESCRIPTION. An arborescent yucca with a distinctive trunk that grows to be 3–7 ft (1–2 m) tall but may grow as tall as 30 ft (9 m). With an underground rhizomatous stem, the unique rhizome develops downward before extending laterally to produce new shoots. Leaves are arranged in large rosettes, grasslike, simple, linear and pointed with an apical spine, 9.8–37.4 in (25–95 cm) long, margins white with curly threads, 0.8–2 in (2–5 cm) long. Inflorescence is a spreading panicle. Flowers are perfect, bell-shaped, white, 1.6–2.4 in (4–6 cm) long, produced on stout pedicles. Fruits are fleshy capsules dehiscent at maturity, producing 150 dark ovoid seeds.

TAXONOMIC NOTES. Variety *elata* has a leaf blade 11.8–37.4 in (30–95 cm) long; var. *verdiensis* has a leaf blade 9.8–17.7 in (25–45 cm) long.

USES AND VALUE. Not commercially important. Cultivated as an ornamental. Native Americans use fibers from the leaves to make clothing, matts, baskets, and sandals. Trunk and roots produce a soapy substance high in saponins used in shampoo to stimulate hair growth. Flowers, fruit, seedpod, and stem are edible. No known medicinal uses.

ECOLOGY. Grows in desert scrub communities and arid grasslands on a variety of coarse soils. In the Guadalupe Mountains, most frequently occurs on gypsum dunes and quartz sand hills. In the Davis Mountains, on moderate igneous slopes. Shade tolerant and very windfirm.

CLIMATE CHANGE. Vulnerability is currently unknown. Immediate assessment is recommended.

CONSERVATION STATUS. Least concern.

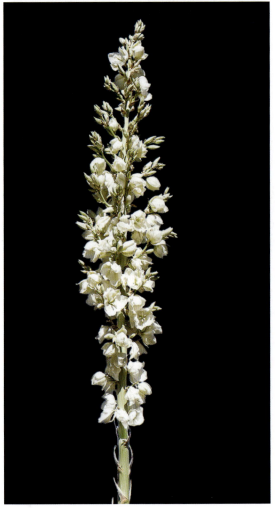

inflorescence

244 • THE DIVERSITY OF TREES

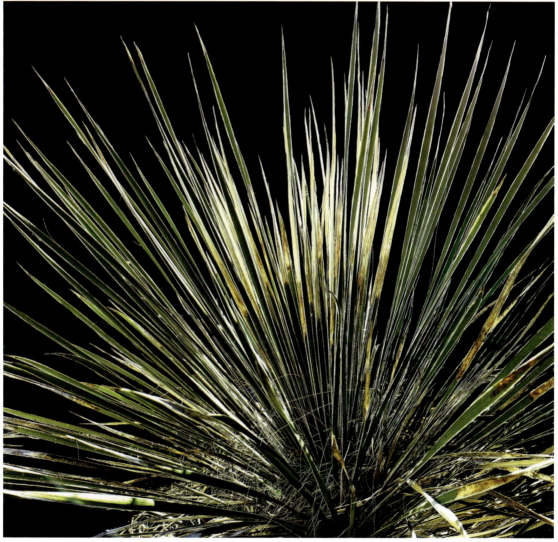

leaf crown

Mojave Yucca

Yucca schidigera Roez ex Ortgies

Mojave yucca is a long-lived, drought-tolerant small tree that prefers hot and arid habitats on gravelly, chalky soils. Similar to Joshua tree but differs in its threadlike fibers on the leaf margins.

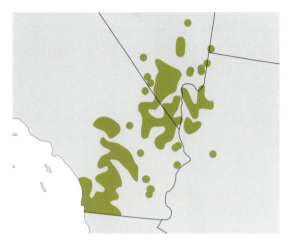

DESCRIPTION. An erect evergreen tree with variable habits that grows 3–16 ft (1–5 m) tall with single or multiple trunks and few upright branches. Morphologically similar to Joshua tree, which lacks the specialized leaf margins. Bark is rough and furrowed, often covered by senesced leaves. Leaves are simple, arranged in rosettes at the ends of each branch, 1–5 ft (30–150 cm) long, margins with threadlike fibers, terminal spines, 0.27–0.47 in (7–12 mm) long. Flowers are perfect, produced in a panicle on a 1.6–4.3 ft (0.5–1.3 m) long stalk, blooming from April to May, white, bell-shaped. Fruits are indehiscent fleshy capsules, cylindrica, 2–4.3 in (5–11 cm) long. Seeds are dull black, 0.24–0.35 in (6–9 mm) in diameter.

USES AND VALUE. Wood not commercially important. Native Americans use fiber from leaves to make rope, baskets, and matts. Extracts from vegetative parts used in animal feed and herbal medicines. Contains saponins, which are used in food-grade surfactants. Flowers, fruit, and stem are edible with young flowering stems cooked like asparagus. Medicinal uses include treatment of dandruff, headaches, bleeding, gonorrhea, and rheumatism. Evolved mutualism with yucca moth (*Tegeticula yuccasella*) upon which it relies for pollination as the moth larvae feed on the plant's fruits. Small mammals and birds use for food and nest material.

ECOLOGY. Grows as long-lived, drought-tolerant tree in the southwestern United States in the Mojave Desert. Prefers hot and arid habitat on gravelly, chalky soils at elevations up to 5,905 ft (1,800 m). Often co-occurs with Joshua tree. Shade tolerant.

CLIMATE CHANGE. Vulnerability is currently unknown. Immediate assessment is recommended.

CONSERVATION STATUS. Least concern.

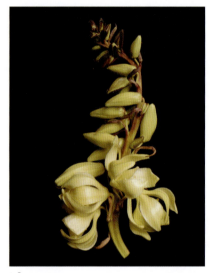

inflorescence

bark with leaf bases

leaf apex above leaf apex below leaf blade above leaf blade below leaf above leaf below

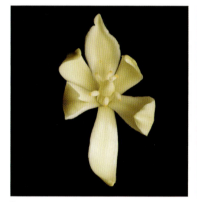 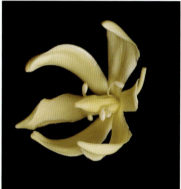 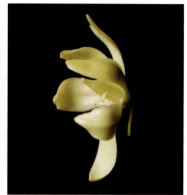

flower flower flower

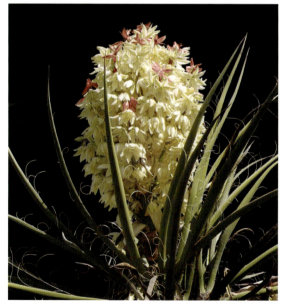

inflorescence leaf crown

FAMILY ASPARAGACEAE • 247

Early Diverging Eudicots: Trees Related to Poppies, Proteas, and Plane Trees

Similar to the basal angiosperms, the Early Diverging Eudicots are composed of several diverse lineages that do not form a monophyletic group. These lineages include the poppies, buttercups, proteas, plane trees, and lotus. The number of species contained in each of these plant groups is generally quite small, rarely more than 1,000 per family. Only the family Platanaceae in the order Proteales is found in North America.

ORDER PROTEALES

The three main components of this interesting group of plants—the proteas, the sycamore or plane trees, and the aquatic lotus flowers—were never thought to be related until DNA sequence data provided solid evidence that they had evolved together. The non-DNA features that they share are somewhat obscure, although some characters of the flowers and leaf margins as well as fossils link the plane trees and proteas. The ancestors of the Proteales were the start of a major plant radiation that gave rise to the great diversity of the "core eudicots," including the Rosids and the Asterids. One genus in one family includes species of trees that are common in North America.

Family Platanaceae

The plane tree family contains only a single genus with less than ten species, which are mostly found in the Northern Hemisphere around the globe. Flaking bark and hanging spherical "fluffy" fruits are characteristic of the sycamores. Although only a few species are still living today, members of the Platanaceae were common as fossils during the Cretaceous around 100 million years ago. Today's species of *Platanus* can be considered living fossils. Only two species are common trees in North America.

GENUS PLATANUS

In winter against a stormy sky it looks wonderfully living, amidst all the appearances of lifelessness in other deciduous trees. Yet seen as a snag in the Mississippi, with the bleaching timbers of some wreck piled on it, the white bark looks deader than any other dead tree can look, with the gleam to it of picked bones.

 —Donald Culross Peattie on *Platanus occidentalis* in *A Natural History of Trees of Eastern and Central North America*

The genus *Platanus*, which includes trees known as plane trees or sycamores, is made up of about ten species found mostly in the Northern Hemisphere in North America, Mexico, Eurasia, and Southeast Asia. They are tall, deciduous, and conspicuous trees that prefer to grow along streambanks and in wetlands. The distinctive smooth bark flakes off in large irregular patches, often resulting in a multicolored trunk. The male and female flowers are grouped in separate clusters on the same individual tree, and the fruits are borne in tightly condensed balls made up of many single-seeded nutlets with downy adornments. Wind is responsible for both pollination and seed dispersal in these trees. One of the most

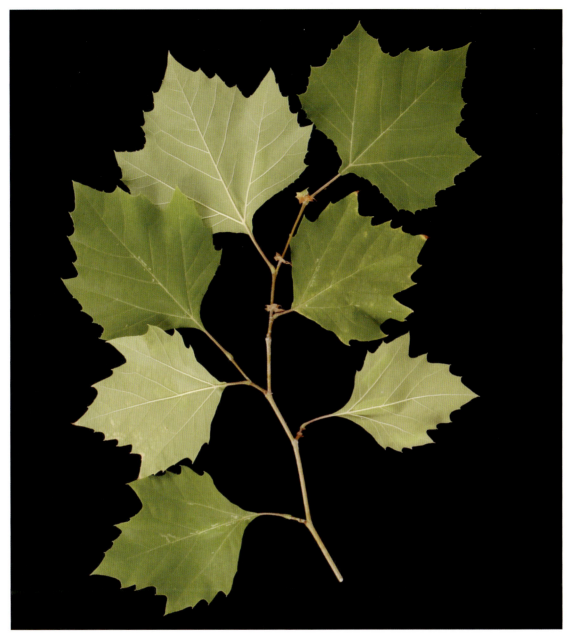

ABOVE American sycamore (*Platanus occidentalis*)

common street trees, especially in the United Kingdom, is the London plane (*Platanus* x *hispanica*), which is a hybrid of two species of *Platanus*. Two native species of *Platanus* are common trees in North America.

American Sycamore
Platanus occidentalis L.

American sycamore is an iconic tree found across North America along streambanks and in bottomlands. The exfoliating bark is most conspicuous in winter, and the spherical ball-like fruits dangling from the branches make this species easy to identify and appreciate.

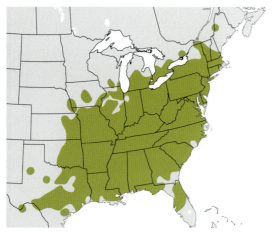

DESCRIPTION. A long-lived deciduous tree growing to 148 ft (45 m) tall and 10 ft (3 m) in diameter with an open spreading crown and large crooked branches. Twigs are brown to olive. Bark is white to gray, exfoliating to reveal multicolored, mottled inner layers. Leaves are alternate, simple, broader than long, with three to five pointed lobes and coarsely toothed margins, 4–10 in (10–25 cm) long. Trees are monoecious with separate male and female flowers on the same plant, blooming in late spring to early summer. Male flowers are tiny, yellowish green, and tightly clustered at the tips of branches; female flowers are equally small and rusty to dark red. Fruiting structures are brown spherical balls, 1 in (2.5 cm) in diameter, suspended on a stalk, and made-up of many small nutlet-like fruits (called achenes) clustered together. Seeds are winged and 0.5 in (1.25 cm) long.

USES AND VALUE. Wood commercially important. Used as plywood, veneer, interior trim, flooring, furniture, particle board, pulpwood, and turned objects. Cultivated as popular ornamental for parks and large open spaces. Sap is palatable and used to make sweet syrups. Inner bark is astringent, diuretic, emetic, and laxative; used as a tea considered effective for the treatment of dysentery, coughs, colds, lung ailments, hemorrhages, and measles. An important component of riparian habitats, offering nesting cavities for species of birds; wildlife does not eat fruits, seeds, or foliage.

ECOLOGY. Grows in open habitats along rivers and flood plains. Intermediate in shade tolerance. Seed crops are produced annually, with generally low germination rates. Trunks are windfirm due to deep, wide-spreading root system. Attacked by few insect pests, whereas fungal pathogens are common.

CLIMATE CHANGE. Vulnerability is currently considered to be low.

CONSERVATION STATUS. Least concern.

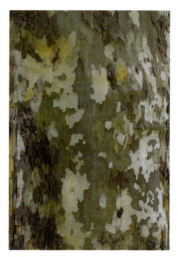

bark

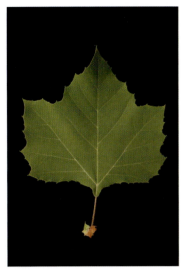
leaf above

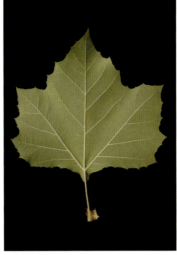
leaf below

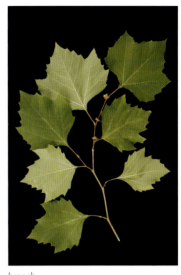
branch

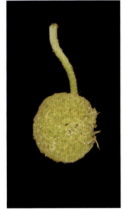
male inflorescence

branch with male inflorescence

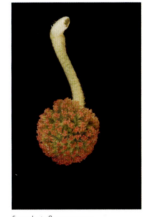
female inflorescence

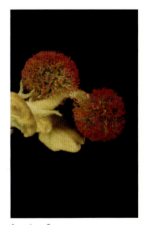
female inflorescence

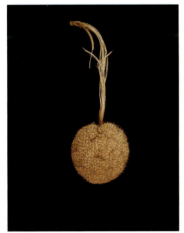
fruit

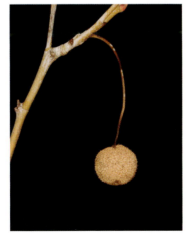
branchlet with fruit

seed

California Sycamore
Platanus racemosa Nutt.

California sycamore is a deciduous tree with an irregular, rounded crown that grows in wetland and riparian zones in canyon bottoms in California. Although the wood has little commercial value trees are commonly cultivated in open landscapes.

DESCRIPTION. A deciduous tree that grows 39–79 ft (12–24 m) tall often branched near the base with an irregular, rounded crown. Bark is tan, separating into thin scales, becoming smooth and ashy white in upper part of the trunk. Leaves are alternate, simple, palmately lobed, with three to five individual lobes, light green with underside covered in pale pubescence denser near the midrib, up to 9.8 in (25 cm) long; stipules are conspicuous, leaflike, rounded, 0.8–1.2 in (2–3 cm) long. Trees are monoecious with male and female flowers produced on the same plant, blooming in April. Male flowers are green to yellow, produced in spherical clusters of four to five; female flowers are maroon to reddish, produced in clusters of two to seven. Fruiting structures are brown to maroon spherical balls, 0.8–1.2 in (2–3 cm) in diameter, several suspended on a stalk, and made up of many small nutlet-like fruits (called achenes) clustered together.

USES AND VALUE. Wood not commercially important. Cultivated widely as an ornamental tree in landscapes and parks. An important wildlife tree, hosting small birds that feed on its fruits and various mammals that browse the twigs and bark.

ECOLOGY. Grows in wetlands and riparian habitats in canyon bottoms in California and sometimes near drier habitats including chaparral, valley grassland, mixed woodlands, and evergreen forests. Prefers sandy and clay soils.

CLIMATE CHANGE. Vulnerability is significant but may have capacity to adapt to changing conditions in the future. Ongoing monitoring is recommended.

CONSERVATION STATUS. Least concern.

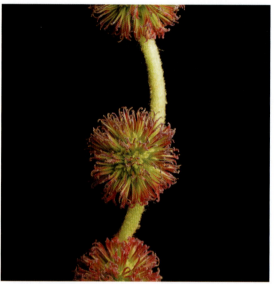

inflorescence

bark

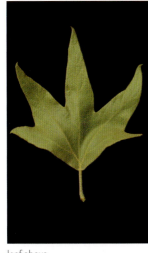
leaf above

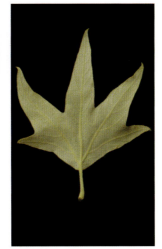
leaf below

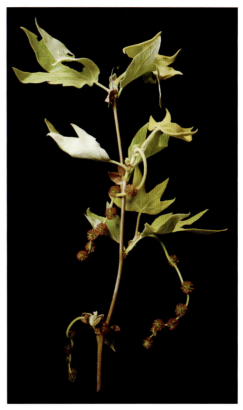
branch with flowers

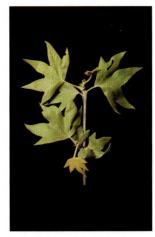
branch above

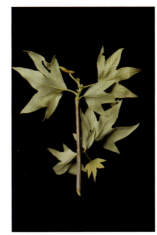
branch below

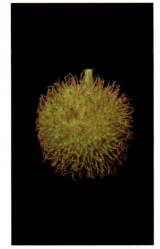
infructescence

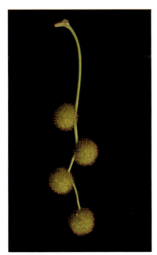
infructescence

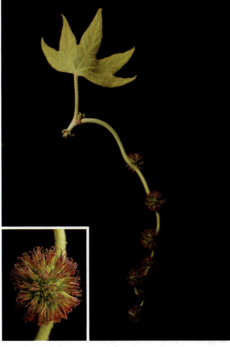
branch with inflorescence, inflorescence (inset)

FAMILY PLATANACEAE • 253

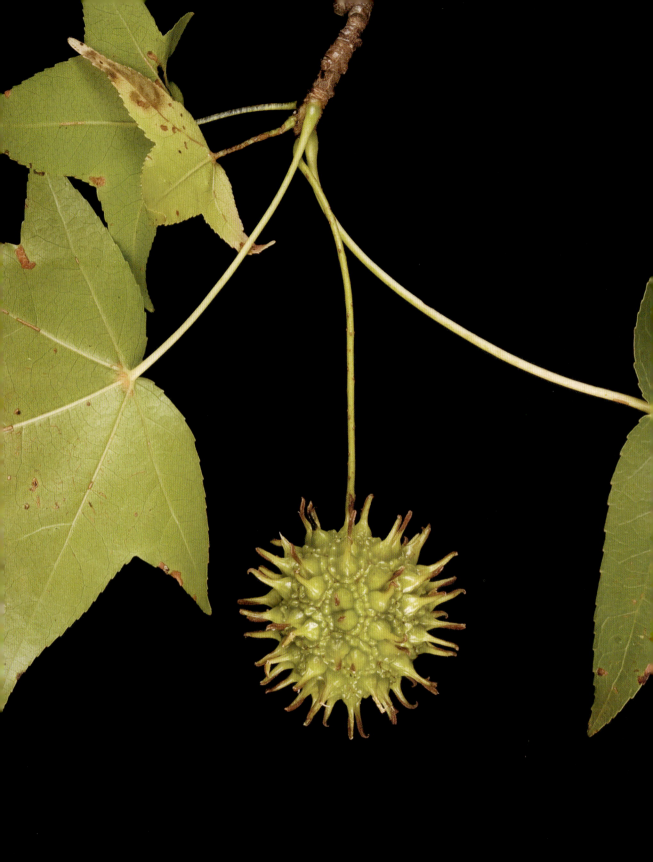

Rosids: Trees Related to Maples, Apples, and Oaks

The Core Eudicots make up the main component of what was formerly called the "dicots." They are divided into two main lineages known as the Rosids and the Asterids (sometimes called SuperRosids and SuperAsterids). The Rosids contain a very large number of species, perhaps one-third of the angiosperms, and are varied in form and geographic distribution. They originated and began to diversify about 110 million years ago. This group contains many plants that formerly were not thought to be related to each other at all, and the complexities of relationships within the group have now been intensively studied by taxonomists. DNA sequence data are the prime evidence for combining these very different types of plants into a single large group, which includes the eucalypts, crepe myrtles, fuschias, poinsettias, willows, carambolas, beans, roses, figs, oaks, mustards, mallows, and oranges. In North America, nine orders encompassing twenty-three families and 187 species of common trees are included in the Rosids.

ORDER SAXIFRAGALES

Earlier botanists never considered the twelve to fourteen families of plants now classified as members of this order to be closely related. Only critical information obtained from DNA sequence data serves to indicate the evolutionary relatedness of these plants. The Saxifragales include witch-hazels, stone crops, saxifrages, sweetgums, paeonies, gooseberries, and a number of lesser-known plant families. Members of this order share some flower features, such as the bicarpellate ovary; fruit traits, including the woody capsules; and leaf characters. Two genera in the families Hamamelidaceae and Altingiaceae include species of trees that are common in North America.

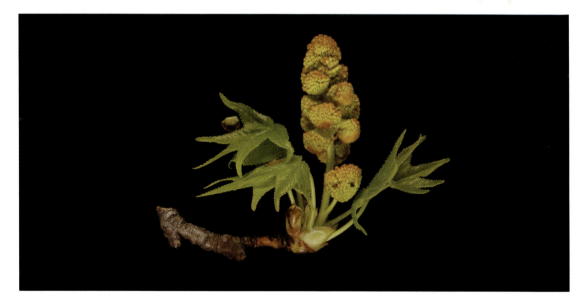

OPPOSITE AND ABOVE Sweetgum (*Liquidambar styraciflua*).

Family Hamamelidaceae

The Hamamelidaceae have a long and plentiful fossil record starting over 100 million years ago. Today they are found in the Northern Hemisphere in Asia, China, Europe, and North America. With twenty-five genera and up to 100 species, the family includes woody shrubs and small trees. The flowers are pollinated by insects, birds, and wind, depending on the genus. The fruits are woody when mature and usually have two chambers that release the very hard seeds, which are often dispersed by water. Only a single species is a common tree in North America.

GENUS HAMAMELIS

[I]t is certain that, in early days in America, Witch Hazel was used in local witchery, to find water or even mineral deposits. You took a forked branch, one whose points grew north and south so that they had the influence of the sun at its rising and setting, and you carried it with a point in each hand, the stem pointing forward. Any downward tug of the stem was caused by the flow of hidden water or the gleam of buried gold.

—Donald Culross Peattie on *Hamamelis virginiana* in *A Natural History of Trees of Eastern and Central North America*

Hamamelis is a genus of small trees and shrubs native to North America and temperate Asia. The four species found in North America characteristically have both mature fruits and newly opened flowers in autumn, after the leaves have fallen from the branches. The brightly colored flowers and handsome shape of the stems make these species attractive ornamentals for the garden, and many hybrids are available in cultivation. Although the trees have provided a popular tonic and remedy for many ailments, little scientific evidence supports the existence of any medicinal properties. One native species of *Hamamelis* is a common tree in North America.

Witch-Hazel
Hamamelis virginiana L.

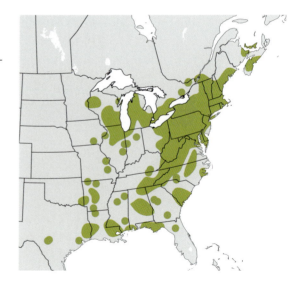

The bright yellow flowers of the American witch-hazel are welcome in the autumn months of the year. The bark and leaves of this deciduous shrub or small tree, often growing in dense clumps, are well-known ingredients in skin creams, ointments, soaps, and tonics.

DESCRIPTION. A deciduous shrub or small tree that grows to 15–25 ft (4.6–7.6 m) in height often forming dense clumps. Twigs are tan to reddish brown, glabrous to pubescent. Bark is thin, gray, and smooth. Leaves are alternate, simple, oval to obovate, green and glabrous above, slightly paler and glabrous to pubescent below, 2–5.9 in (5–15 cm) long with asymmetrical base and wavy-toothed margins. Flowers are arranged in clusters of two to four, yellow, four-petalled, and strap-like, 0.6–0.8 in (1.5–2 cm) long, blooming in fall. Fruits are capsules, obovoid in shape, pubescent, brown 0.4–0.6 in (1–1.5 cm) long.

Seeds are two per capsule, glossy black.

USES AND VALUE. Wood not commercially important. Cultivated as an ornamental. Branches preferred by water diviners. Leaves and twigs used in tea. Bark and leaves are ingredients of commercial

eye drops, skin creams, ointments, soaps, and tonics. Native Americans used leaves and bark as cold remedy and dermatological aid. Deer and beavers browse the leaves; birds and small mammals eat the fruits.

ECOLOGY. Grows in woods, bottomlands, thickets, high dunes, and ravine slopes along forest margins or in the understory on rich, well-drained, acidic soils. Not drought tolerant. Intermediate in shade tolerance.

CLIMATE CHANGE. Vulnerability is currently unknown. Immediate assessment is recommended.

CONSERVATION STATUS. Least concern.

leaf above

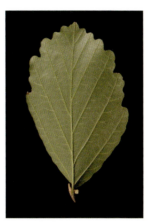
leaf below

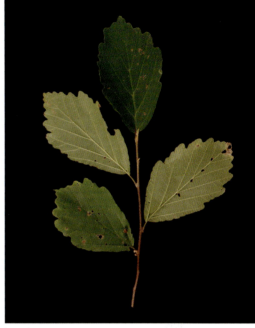
branch

flowers

bark

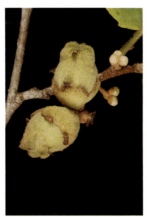
infructescence

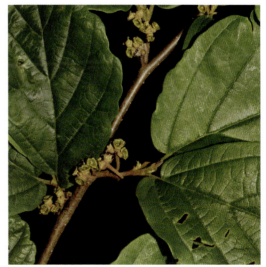
branch with young fruits

FAMILY HAMAMELIDACEAE • 257

Family Altingiaceae

Members of this family were earlier included in the Hamamelidaceae, but recent DNA and morphological data correctly segregate the genus *Liquidambar* into its own family, Altingiaceae. Distinguishing features include unisexual flowers that are found on the same plants (monoecy), the absence of petals, and woody fruits aggregated into a globose head. Members of this family are found in Asia and the Americas in both temperate and tropical habitats. One species is a common tree in North America.

GENUS LIQUIDAMBAR

But even when the leaves have turned a deep winy crimson and fallen, Sweet Gum is striking by reason of the broad corky wings on the twig. True, one might confuse them with those of some of the Elms, but the fruiting heads of woody spiny balls, hanging all winter on the slim stalks after the winged seeds have escaped, are unique among all American trees.

—Donald Culross Peattie on *Liquidambar styraciflua* in *A Natural History of Trees of Eastern and Central North America*

The fifteen species that make up the genus *Liquidambar* are all large deciduous trees with palmately shaped leaves that turn bright colors in autumn. Although most of the species are native to cooler climates in the Northern Hemisphere, at least one is tropical and several are subtropical. The name "sweetgum" comes from the hard sap or resin that is exuded from the bark and can be chewed for medicinal purposes. One native species of *Liquidambar* is a common tree in North America.

Sweetgum

Liquidambar styraciflua L.

Sweetgum is native to warm regions in eastern North America. The leaves of this deciduous tree look similar to those of maples but are alternate rather than opposite. Mature trees produce a clear brownish-yellow resin that has been used to treat wounds in both humans and animals.

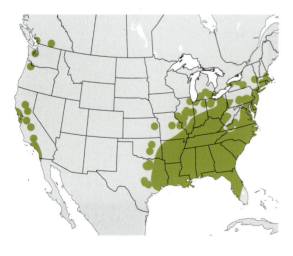

DESCRIPTION. A long-lived deciduous tree that grows up to 131 ft (40 m) in height with a shallow wide-spreading root system, a long, straight, buttressed trunk, and a small oblong or pyramidal crown. Bark is gray and rough with long rounded ridges. Leaves are simple, alternate, distinctively star-shaped with five to seven lobes, and margins serrate, shiny green above and paler below, small tufts of hairs in axils of main veins, 3.1–8.7 in (8–22 cm) wide. Trees are monoecious with separate male and female flowers produced on the same tree, blooming in the early to mid-spring. Flowers are yellow green tinged with red; male flowers are 0.4–0.6 in (1–1.5 cm) long, grouped in little balls held upright in racemes 2–4 in (5–10 cm) long; female flowers are also grouped in rounded solitary balls that hang on slender stalks. Fruits are hanging clusters of small spiny spherical capsules, green turning brown and dry when ripe. Seeds are winged and sift out slits in capsules as they dry.

USES AND VALUE. Wood commercially important.

Used for decorative plywood panels, veneer, interior trim, millwork, furniture, and pulpwood. Resin can be made into chewing gum and used medicinally for the treatment of sore throats, coughs, and asthma. Seeds are eaten by birds, chipmunks, squirrels, and other small rodents.

ECOLOGY. Grows in a wide range of habitats from upland woodlands to lowlands, swamps, flood plains, and coastal areas in the southeastern United States.

Seed production begins at twenty to thirty years of age; germination rates vary between 25 and 75 percent. Shade intolerant. In drier habitats, develops a significant taproot and is windfirm. Insect and fungal pests are few.

CLIMATE CHANGE. Vulnerability is currently considered to be low.

CONSERVATION STATUS. Least concern.

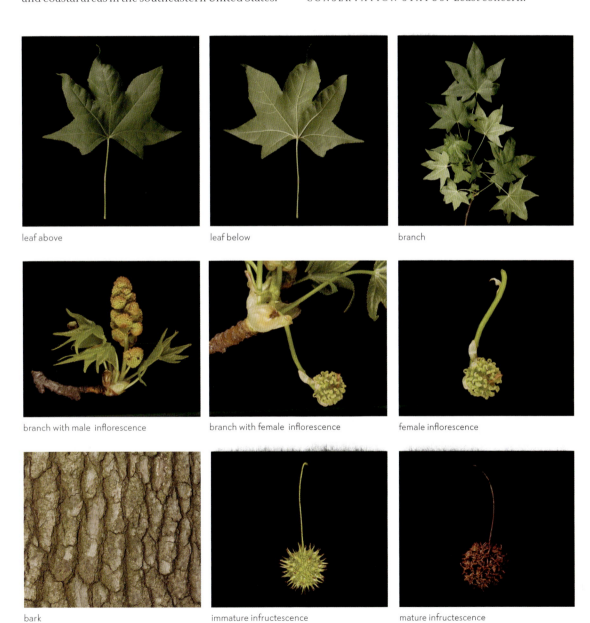

leaf above

leaf below

branch

branch with male inflorescence

branch with female inflorescence

female inflorescence

bark

immature infructescence

mature infructescence

FAMILY ALTINGIACEAE • 259

ORDER MYRTALES

This order's closest relatives in the Rosids are still unclear. The Myrtales contain over 9,000 species in total, including such well-known plants as the myrtles, the evening primroses, the loosestrifes, the melastomes, and some mangrove plants. Several characteristics of the wood structure and some flower features unite the thirteen families of the Myrtales. Many species of myrtles and melastomes are native to tropical zones. Only two of the families contain species of common trees in North America, and they are all cultivated or naturalized.

Family Lythraceae

The family Lythraceae is one group of plants where all traditional systems of classification as well as evidence from DNA sequence data agree—both on its placement in the order Myrtales and on its close relationship to the evening primrose family, the Onagraceae. Many members of the Lythraceae produce two types of flowers: one type has long styles and short stamens; the other type has short styles and long stamens. This reciprocal arrangement of floral types promotes the transfer of pollen between flowers of the two types and thus ensures cross-fertilization between plants. Only a single species of this family, which is a common street and garden tree, is common in North America.

GENUS LAGERSTROEMIA

Native to tropical Asia, many species of the genus *Lagerstroemia* are cultivated around the world in warmer climates as ornamentals and street trees for their colorful flowers. All of the fifty species are woody, deciduous or evergreen trees up to 98 ft (30 m) in height often with multiple trunks. The leaves are opposite and, in many species, turn bright colors in autumn. One species, *Lagerstroemia indica*, is common as an introduced ornamental tree in the warm southern regions of North America.

Crapemyrtle
Lagerstroemia indica L.

Crapemyrtle, native to China and Korea, is widely planted in the United States as an ornamental street tree. The attractive panicles of white to red flowers bloom throughout summer. Crapemyrtle grows best in full sun and well-drained alkaline soils.

DESCRIPTION. A deciduous tree with multiple stems and a wide-spreading, flat-topped or rounded crown that typically grows 15–25 ft (4.5–7.5 m) tall. Twigs are four-winged. Bark is grayish red, exfoliates to reveal green young bark underneath. Leaves are opposite or, in the upper branches, alternate or in whorls of three, simple, elliptic to obovate, pointed or rounded at apex, lustrous, green to reddish purple,

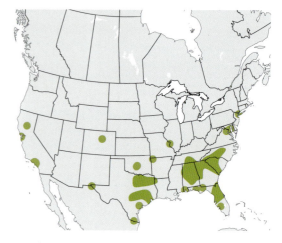

1–2.8 in (2.5–7 cm) long, 0.7–1.5 in (1.9–3.8 cm) wide. Flowers are perfect, borne in panicles 5.9–7.9 in (15–20 cm) long, 3–5 in (7.6–12.7 cm) wide, six-petaled, range in color from white to pink, purple, and red,

1–1.5 in (2.5–3.8 cm) wide, blooming throughout summer. Fruits are six-valved brown capsules, 0.5 in (1.3 cm) wide. Seeds winged, 0.5 in (1.25 cm) long, persist during winter.

USES AND VALUE. Wood not commercially important. Commonly cultivated as a landscaping tree, especially popular as a street tree in the southern United States. Used for nesting by wrens and other songbirds.

ECOLOGY. As an introduced tree, grows best in full sun or partial shade and well-drained alkaline soils, although tolerant of many soil types.

CLIMATE CHANGE. Vulnerability is considered low because of wide geographic distribution as an ornamental.

CONSERVATION STATUS. Least concern.

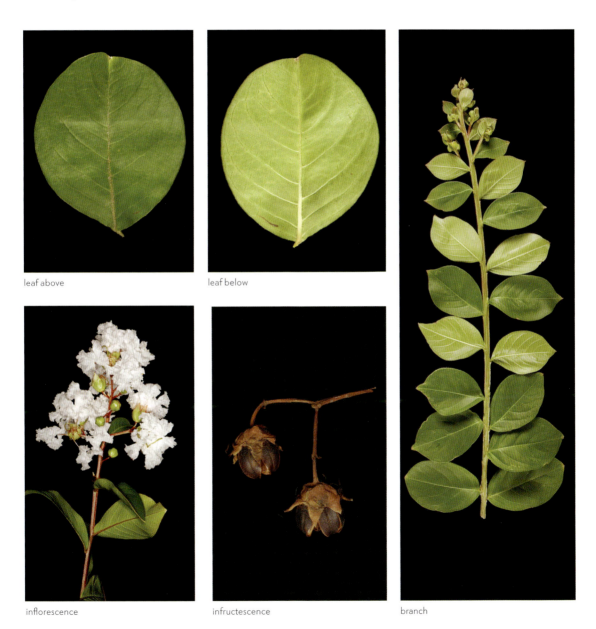

leaf above

leaf below

inflorescence

infructescence

branch

FAMILY LYTHRACEAE • 261

Family Myrtaceae

The large family Myrtaceae has 144 genera and over 4,500 species that are distributed mainly in tropical regions around the world, including the Americas, Asia, Australia, and sub-Saharan Africa. The family is a coherent evolutionary group recognized by all botanists and supported by numerous lines of evidence, including DNA. The flowers possess many conspicuous, often colorful stamens, and the bark has a tendency to flake or peel in a characteristic fashion. Many members of this family are ornamentals, and the three species in two genera that are common trees in North America are cultivated or invasive plants.

GENUS EUCALYPTUS

The trees have beautiful evergreen leaves, graceful habit, handsome bark, and, finally, curious, nut-like fruits—all characteristics that give the trees popularity among available ornamental kinds. As a forest cover and a windbreak the eucalypts have a serious work to do.

—Julia Ellen Rogers on *Eucalyptus globosus* in *The Tree Book: A Popular Guide to a Knowledge of the Trees of North America and to Their Uses and Cultivation*

The genus *Eucalyptus* contains more than 700 species. Members are conspicuous and a dominant component of the native forests of Australia. They vary widely in size, abundance, and characteristics, and many are uniquely adapted to naturally occurring fires. Various species of animal, such as the koala, are dependent on eucalypts for food and shelter. The oil glands, scythe-like leaves, and often stringy bark are all distinctive traits of the trees. The oldest fossils of *Eucalyptus*, which go back over 50 million years, are from South America, where no living species of native eucalypts are found today. Some species are important timber trees and cultivated as ornamentals outside of their native Australia. Three species of cultivated *Eucalyptus* are common trees in North America primarily on the West Coast.

Bluegum Eucalyptus
Eucalyptus globulus Labill.
TASMANIAN BLUE GUM

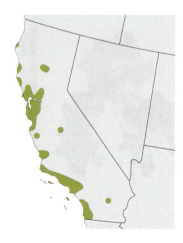

Bluegum eucalyptus is an evergreen tree introduced into the United States from Australia and Tasmania. These relatively large trees grow in dense stands, often overrun native vegetation, and are an invasive fire hazard in California.

DESCRIPTION. An evergreen tree that grows 98–180 ft (30–55 m) tall, occasionally up to 262 ft (80 m). Bark is reddish-brown and white, peels into large strips appearing shredded. Leaves are simple, alternate, narrow, sickle-shaped, blue gray with waxy texture (hence common name "bluegum"), 3.9–11.8 in (10–30 cm long). Flowers are perfect, clustered, cream colored. Fruits are woody capsules, 2.4–9.8 in (6–25 cm) in diameter.

USES AND VALUE. Wood commercially important as plantation species around the world, though not in North America. In California designated as invasive and major fire hazard with field programs underway to remove and restore native vegetation. Leaves are

traditional Aboriginal herbal remedy in Australia. Essential oil found in leaves is powerful antiseptic and used globally to relieve coughs, sore throats, colds, and other infections.

ECOLOGY. Native to Tasmania and Australia and introduced to California and Hawaii in the mid-1800s; now naturalized in both states. Grows in dense stands, crowding out native vegetation. Prefers Mediterranean climates on deep, slightly acidic soils with good drainage. Drought tolerant and shade intolerant.

CLIMATE CHANGE. Vulnerability is considered low because of its wide geographic distribution as invasive.

CONSERVATION STATUS. Least concern.

leaf above

leaf below

leaf above (left), leaf below (right)

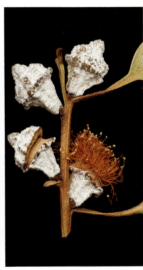
flower and fruits

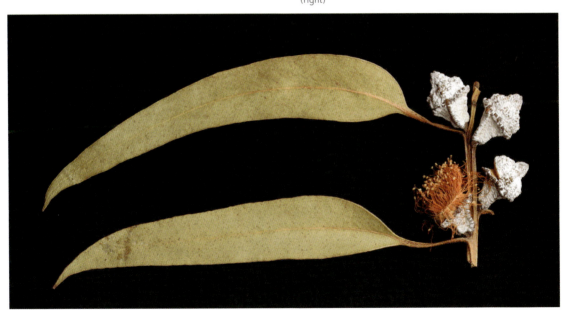
flower and fruits with leaves

FAMILY MYRTACEAE • 263

Red Ironbark Eucalyptus

Eucalyptus sideroxylon A. Cunn. Ex Woolls

Red ironbark eucalyptus is an introduced evergreen tree native to southeastern Australia. Cultivated in California, this eucalyptus has naturalized in disturbed coastal areas at lower elevations.

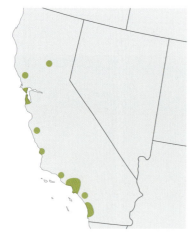

DESCRIPTION. A non-native evergreen tree that grows up to 82 ft (25 m) in height. Bark is dark reddish-brown, deeply and irregularly furrowed. Leaves are simple, alternate, on stalks, lanceolate, dull green, aromatic when crushed, 2.4–5.5 in (6–14 cm) long. Flowers are perfect, lack petals, stamens conspicuous, pink or red, outer stamens lacking anthers, each flower with a cup-shaped hypanthium, 0.16–0.24 in (4–6 mm) long, produced in fall, winter, or spring in clusters of five to seven flowers on pendulous umbels. Fruits are capsules, ovoid, 0.4 in (1 cm) long.

USES AND VALUE. Wood not important commercially. Used for firewood and sometimes for furniture, very dense and will not float. Commonly cultivated as landscape tree. Leaves source of eucalyptus oil. No known edible parts with very few medicinal uses. Fruit and flowers are attractive to wildlife.

ECOLOGY. Native to southeastern Australia; cultivated and naturalized in California in disturbed coastal areas at low elevation less than 656 ft (200 m). Grows in a variety of soil types. Intolerant of shade and drought tolerant.

CLIMATE CHANGE. Vulnerability is considered low because of its wide distribution as an ornamental and naturalization.

CONSERVATION STATUS. Least concern.

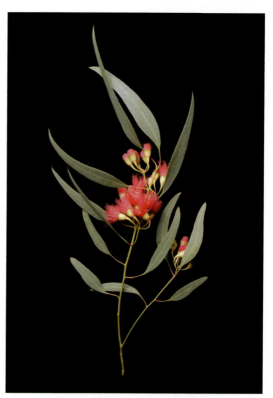

branch with flowers

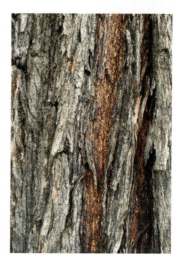

bark

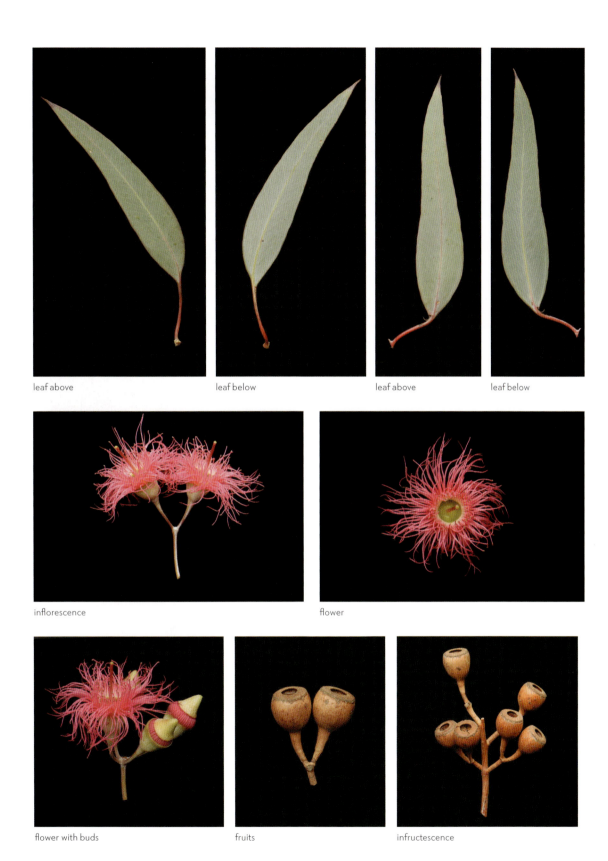

FAMILY MYRTACEAE • 265

GENUS MELALEUCA

Containing nearly 300 species, the genus *Melaleuca* is variable in its habitats and features. Most species are native to the region of Australia and found in swamps and wet boggy habitats. The flowers are clustered into long brushlike structures resembling bottle brushes and produce copious nectar for birds and mammals, which serve as their pollinators. The trees' papery, exfoliating bark makes them tolerant to fires. Some species, such as *Melaleuca quenquinervia*, have been introduced as ornamentals or to assist in draining wet marshy areas and have become invasive, often outcompeting native species. Only a single non-native species of *Melaleuca* is a common tree in North America.

Punktree
Melaleuca quinquenervia (Cav.) S.F. Blake
BOTTLE BRUSH TREE, PAPERBARK

Native to Australia, punktree grows in subtropical climates and establishes most successfully on sandy and poorly drained soils but survives and thrives in a wide variety of habitats. It is federally listed in the United States as a noxious and invasive plant.

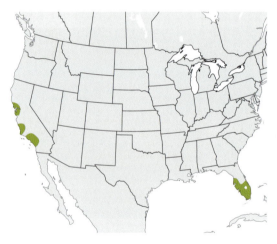

DESCRIPTION. An evergreen tree with form and habit varying depending on environment and population density. Grows as a tall shrub, 26–33 ft (8–10 m) in height, and in favorable conditions a small tree with a straight trunk and slender crown, 66–98 ft (20–30 m) tall. Branches on young trees are ascending and droop with age. Twigs continue to grow after flowering, producing either flowers or leaves alternating over time. Bark is thick, spongy, and composed of many layers, with age becomes loose, torn, and dangling. Leaves are arranged in whorled rows, dark green, leathery, 1.6–4.7 in (4–12 cm) long. Flowers are perfect, borne terminally, densely packed into spikes, 1.2–2 in (3–5 cm) long. Fruits are persistent woody capsules, 0.2 in (0.5 cm) in length, aggregated into multiple clusters at branch tips. Seeds are asymmetric, angular, 0.02–0.04 in (0.5–1 mm) long.

USES AND VALUE. Wood not commercially important. Planted as an ornamental and now considered invasive in Florida.

ECOLOGY. Grows in subtropical climates in disturbed wetland areas; does not survive regular or prolonged freezing. Prefers sandy and poorly drained soils but tolerates a wide variety of habitats. Introduced from Australia to the United States around 1900 as an ornamental and marsh-loving species. Now classified as a noxious weed in six states: Florida, South Carolina, North Carolina, Massachusetts, Oklahoma, and Texas. Especially damaging in the Everglades, where it has invaded native sawgrass habitats.

CLIMATE CHANGE. Vulnerability is considered low because of its wide geographic distribution as an invasive.

CONSERVATION STATUS. Least concern.

leaf above

leaf below

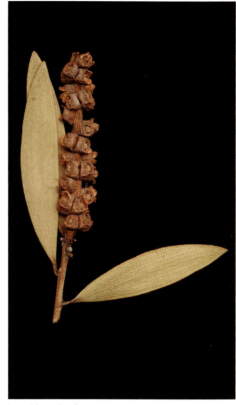
branchlet with infructescence

bark

inflorescence

FAMILY MYRTACEAE • 267

ORDER CROSSOSOMATALES

This order is composed of several disparate plant families that were previously thought to be unrelated but now, according to genetic data, are recognized to be closely allied. A specialized seed structure and fusion of various floral parts also unite the plants. The species are mostly shrubs and small trees that occur in Temperate Zone environments. A single family with one species is a native common tree in North America.

Family Staphyleaceae

This family includes only two genera and about forty-five species. Botanists have recorded very little about the taxonomy and biology of this family. Species are generally small trees found in the northern Temperate Zone in Asia, the Americas, and Europe, but several also occur in South America. One is a common species of tree in North America.

GENUS STAPHYLEA

I stumbled upon this species, growing contentedly in an alluvial plain above the Oconee River, during a hike through a local woodland. Not an unworthy plant, upright-spreading; a small side shoot was extracted and moved to the Dirr garden. Years later, root pieces were still throwing up suckers.

—Michael A. Dirr on *Staphylea trifolia* in Dirr's Encyclopedia of Trees and Shrubs

The genus *Staphylea* is composed of shrubs and small trees distributed in northern zones of the Americas, Europe, and Asia, primarily China. Of the ten species in the genus, several are cultivated as ornamentals because of their attractive flowers and inflated papery fruits. One species is a common small tree in North America.

American Bladdernut

Staphylea trifolia L.

American bladdernut, native to eastern North America, is a small tree or large shrub that produces drooping clusters of white bell-shaped flowers in spring and distinctive green to brown inflated fruits in the late summer and fall. It is listed as endangered in Florida.

DESCRIPTION. A deciduous shrub or small tree, growing to 20 ft (6 m) in height. Twigs are reddish to greenish brown and often striped. Bark is gray, becoming fissured. Leaves are opposite, pinnately compound with three leaflets, 5.9–9 in (15–23 cm) long, ovate to obovate, green above, paler and pubescent below, with the terminal leaflet long-stalked and laterals short-stalked, each 1.6–4 in (4–10 cm) long, margins serrate. Flowers are borne on drooping panicles 1.6–4 in (4–10 cm) long, perfect, white, bell-shaped with five petals, 0.31–0.39 in (8–10 mm) long, blooming in spring, Fruits are capsules, green to brown, three-celled, inflated, thin, papery, 1.2–2.5 in

(3–6.4 cm) long. Seeds one to four per capsule, brown to yellow-brown, globose.

USES AND VALUE. Wood not important commercially. Seeds are sometimes eaten raw or cooked; sometimes compared to pistachios. Sweet edible oil obtained from seeds is used for cooking.

ECOLOGY. Grows in moist hardwood forests. Intermediate in shade tolerance.

CLIMATE CHANGE. Vulnerability is currently unknown. Immediate assessment is recommended.

CONSERVATION STATUS. Least concern.

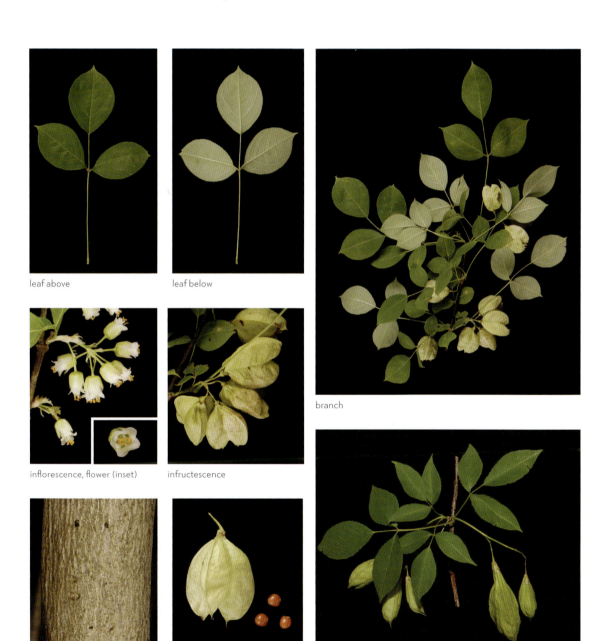

leaf above

leaf below

inflorescence, flower (inset)

infructescence

branch

bark

fruit and seeds

branchlet with fruits

FAMILY STAPHYLEACEAE • 269

ORDER SAPINDALES

Most of the members of this order are trees or shrubs whose leaves are divided into leaflets arranged along a central midrib. In addition, many of the families are characterized by the production of resins and bitter compounds in the leaves, bark, and wood. Most of the trees are native to the tropical and subtropical regions of the world. Nine families make up the Sapindales: maples, soapberries, horse chestnuts, mahogany, citruses, sumacs, poison ivies, frankincense, and myrrh. Important fruits include the lychee, rambutan, akee, mango, cashew, and orange. The nine families and 600 species in this order have always been recognized as closely related by evolution due to their compound leaves, nectar disks in the flowers, and specialized stigma. Five of the nine families containing twenty-nine species are common trees in North America.

Family Anacardiaceae

The seventy genera in this primarily tropical family are found around the world. The presence in bark and leaves of resins that cause dermatitis characteristic of poison ivy is typical in members of the family. In contrast to poison ivy, the delicious fruits and nuts of mangos, cashews, and pistachios are also in the Anacardiaceae. Three genera and eight species of common trees in this family are found in North America and include both native and introduced plants.

GENUS PISTACIA

The genus *Pistacia* is made up of ten to twenty species and distributed across Europe, Asia, Africa, and the Americas, generally in warmer regions in Mediterranean-type climates. These shrubs and small trees have either male or female flowers on a single individual plant, but not both (called dioecy). Many species are cultivated as ornamentals, and one, *Pistacia vera*, the pistachio, produces edible nuts. One introduced species is a common small tree in North America.

Chinese Pistachio
Pistacia chinensis Bunge

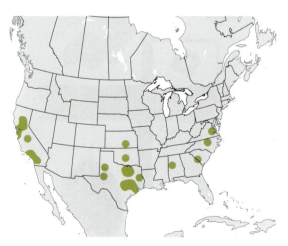

Introduced to the United States from East Asia, Chinese pistachio occurs in riparian areas and grows on a variety of soils. This tree is widely cultivated as an ornamental because of its attractive autumn foliage.

DESCRIPTION. A non-native tree introduced to North America that grows up to 43 ft (13 m) tall. Twigs are stout and grayish with large terminal buds and shield-shaped leaf scars. Bark is grayish brown with shallow, ruddy furrows becoming rectangular ridges that peel to reveal salmon-colored inner bark. Leaves are alternate, pinnately compound with narrow, ovate, glossy green leaflets, margins entire.

Trees are dioecious with male and female flowers on separate plants, blooming before the leaves in early spring. Flowers are borne in panicles, red or green;

male flowers are arranged in tight clusters, 1.6–2 in (4–5 cm) long; female flowers are arranged in looser, elongated clusters. Fruits are bright red drupes that mature to dark blue, arranged in long drooping clusters that ripen in fall.

USES AND VALUE. Wood not commercially important. Cultivated widely as an ornamental tree because of brilliant foliage in fall and tolerance to drought. Leaves and roasted seeds are edible, but not desirable.

ECOLOGY. Introduced into the United States from East Asia, grows in riparian areas on a variety of soils. Persists on poor-quality substrates. Shade intolerant.

CLIMATE CHANGE. Vulnerability is considered low because of its wide geographic distribution as an ornamental.

CONSERVATION STATUS. Least concern.

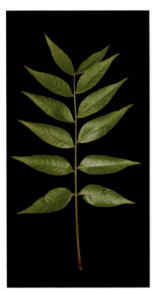
leaf above

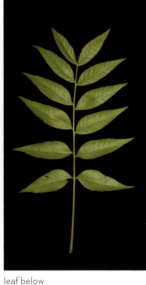
leaf below

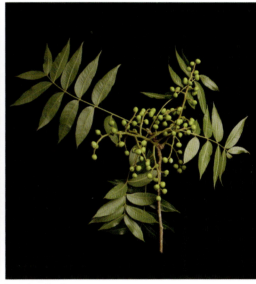
branch with infructescence

bark

fruits

infructescence

GENUS RHUS

But still in summer, unchanged, the Staghorn Sumac lifts its immense panicles of vivid flowers among the great frond-like pinnate leaves, and still in autumn the brilliant fruits, the most variously brilliant foliage, shout out their color to the dying year. Flaunting orange, vermillion, buttery yellow, or sometimes angry purple may be seen all together on a single tree.

—Donald Culross Peattie on *Rhus typhina* in *A Natural History of Trees of Eastern and Central North America*

A genus of about thirty-five species, *Rhus* is found throughout the world in both temperate and subtropical zones. Full of resins and other compounds, many species are used for spices, dyes, and medicines. The five species of *Rhus* that are common trees in North America are often encountered along roadsides and highways, where they form large clones of many individual trunks. The leaves turn deep red and purple in fall.

Winged Sumac
Rhus copallinum L.
FLAMELEAF SUMAC, SHINING SUMAC

Winged sumac is a shrub or small tree that occurs on dry soils in open woods, old fields, prairies, hillsides, thickets, and roadsides. Sometimes planted as an ornamental, it plays an important role in sustaining native fauna. Two varieties are recognized.

DESCRIPTION. A deciduous clonal shrub or small tree that grows up to 20–33 ft (6–10 m) tall. Twigs are reddish brown, finely pubescent, and slightly zigzag. Bark is brown or gray, scaly. Leaves are alternate, pinnately compound, 5.9–11.8 in (15–30 cm) long, with seven to twenty-one ovate or lanceolate leaflets, 1–3 (2.5–7.4 cm) long, shiny green above, paler and pubescent below, margins entire, rachis pubescent and winged. Trees are dioecious with male and female flowers on separate plants, blooming in late summer. Flowers are tiny, greenish-yellow, produced on terminal, pyramidal panicles, 7.9 in (20 cm) long. Fruits are hairy, red drupes 1.6–2 in (4–5 mm) long.

TAXONOMIC NOTES. Variety *copallinum* has seven to twenty-three leaflets, 3–4 in (7.5–10 cm) wide; var. *lanceolata* has five to thirteen leaflets, 0.5–1.6 in (1.4–4 cm) wide, oblong in shape.

USES AND VALUE. Wood not commercially important. Planted as ornamental. Bark and leaves contain tannin and used in tanning industry. Native North Americans added crushed winged sumac fruit to drinking water for palatability. Moderately important as browse for white-tailed deer; bark and twigs eaten by rabbits, especially in winter. Grouse, wild turkey, and songbirds consume mature berries. Thickets provide protection for variety of birds and mammals.

ECOLOGY. Grows on dry soils in open woods, old fields, prairies, hillsides, thickets, and roadsides. Occasional in oak savannas, woods, or sandy fields. Early colonizer after wildfires and often planted on dry rocky soils to encourage naturalization. Shade intolerant.

CLIMATE CHANGE. Vulnerability is currently unknown. Immediate assessment is recommended.

CONSERVATION STATUS. Least concern.

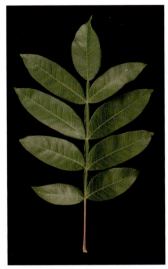
leaf above

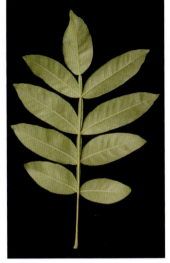
leaf below

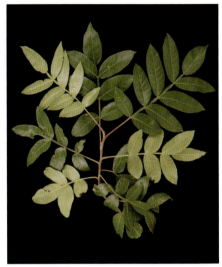
branch

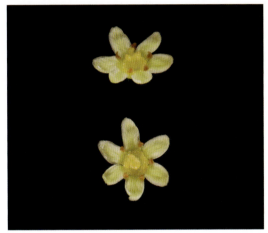
flowers

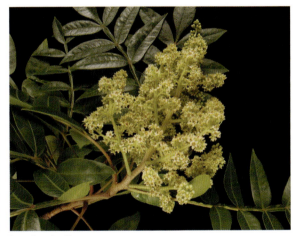
branch with inflorescence

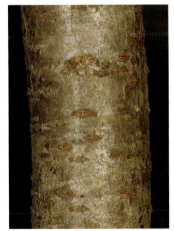
bark

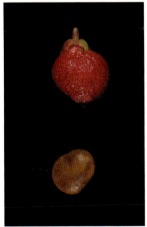
fruit (top), seed (bottom)

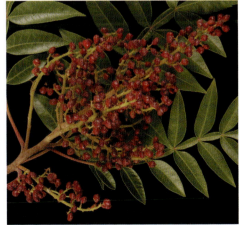
mature infructescence

FAMILY ANACARDIACEAE • 273

Smooth Sumac
Rhus glabra L.

Smooth sumac is a deciduous clonal shrub or small tree that grows on dry soils in open woodlands, old fields, and roadsides. It is the larval host plant for the red-banded hairstreak (*Calycopis cecrops*) butterfly.

CLIMATE CHANGE. Vulnerability is currently unknown. Immediate assessment is recommended.

CONSERVATION STATUS. Least concern.

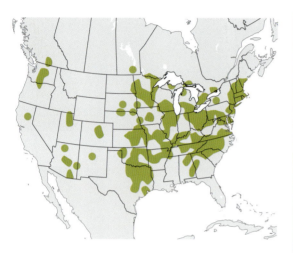

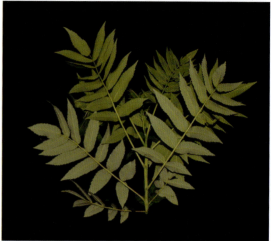

branch

DESCRIPTION. A deciduous clonal shrub or small tree that grows up to 23 ft (7 m) tall. Twigs are large and smooth, brown, glaucous, and three-sided. Bark is smooth and brown to gray. Leaves are alternate, pinnately compound, 7.9–19.7 in (20–50 cm) long, with eleven to thirty-one lanceolate leaflets, 2–4 in (5–10 cm) long, dark green above, pale or white below, margins serrate, rachis smooth. Trees are dioecious, producing male and female flowers on separate plants, blooming in mid-spring. Flowers are small, yellow green in terminal panicles, 3.9–9.8 in (10–25 cm) long. Fruits are red drupes, hairy, 0.12–0.2 in (3–5 mm) in diameter, produced in upright clusters.

USES AND VALUE. Wood not important commercially. Sometimes planted as ornamental. Fruits and inner bark used to make textile dyes. Moderately resistant to browse damage from deer. Songbirds, white-tailed deer, opossums, wild turkeys, and quail consume fruits; rabbits consume bark.

ECOLOGY. Grows on dry soils in open woodlands, old fields, and roadsides.

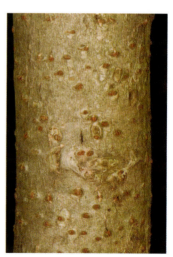

bark

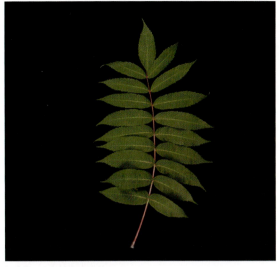
leaf above

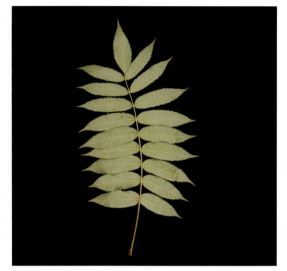
leaf below

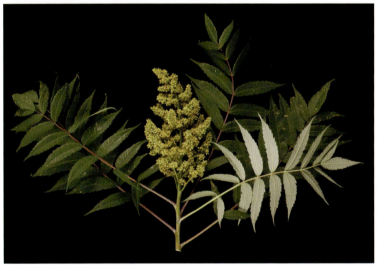
branch above with flowers

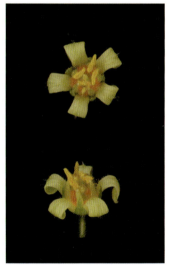
flowers

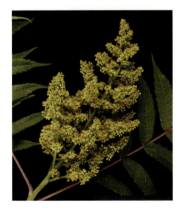
branch with inflorescence

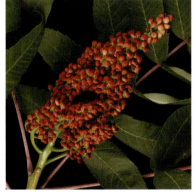
infructescence

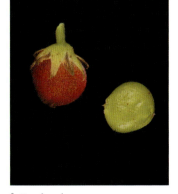
fruit and seed

FAMILY ANACARDIACEAE • 275

Lemonade Sumac

Rhus integrifolia (Nutt.) Benth. & Hook. F. ex W.H. Brewer & S. Watson

Lemonade sumac is an evergreen shrub or small tree restricted in distribution to southern California and Baja California on north-facing slopes and chaparral. Sometimes planted as an ornamental.

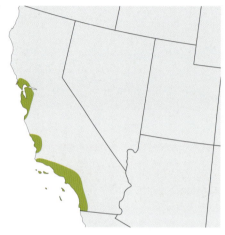

DESCRIPTION. An evergreen shrub or small tree forming thickets growing to heights of 3–26 ft (1–8 m) tall. Bark is scaly and grayish, with smooth reddish underbark evident between ridges. Leaves are simple, alternate, oblong ovate, leathery, dark yellow green above, paler with obvious veins below, margins usually entire, 1–2.4 in (2.5–6 cm) long with short petiole, 0.08–0.27 in (2–7 mm) in length. Flowers are perfect, small, green sepals with white or pink petals, produced in dense clusters, blooming in early spring. Fruits are berries, glandular, red, 0.27–0.39 in (7–10 mm) in diameter.

USES AND VALUE. Wood not commercially important. Planted as an ornamental. Used by Native Americans to make lemonade-like beverage. Birds consume fruits; leaves are resistant to deer browsing; flowers supply copious nectar to butterflies.

ECOLOGY. Restricted to southern California and Baja California on north-facing slopes and chaparral habitat, typically at elevations less than 2,953 ft (900 m) on sandy or loam, well-drained soils. Not shade tolerant.

CLIMATE CHANGE. Vulnerability is currently unknown. Immediate assessment is recommended.

CONSERVATION STATUS. Least concern.

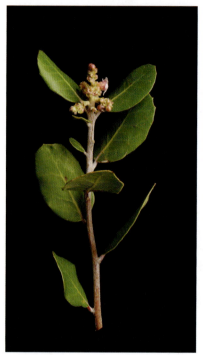

branchlet

bark

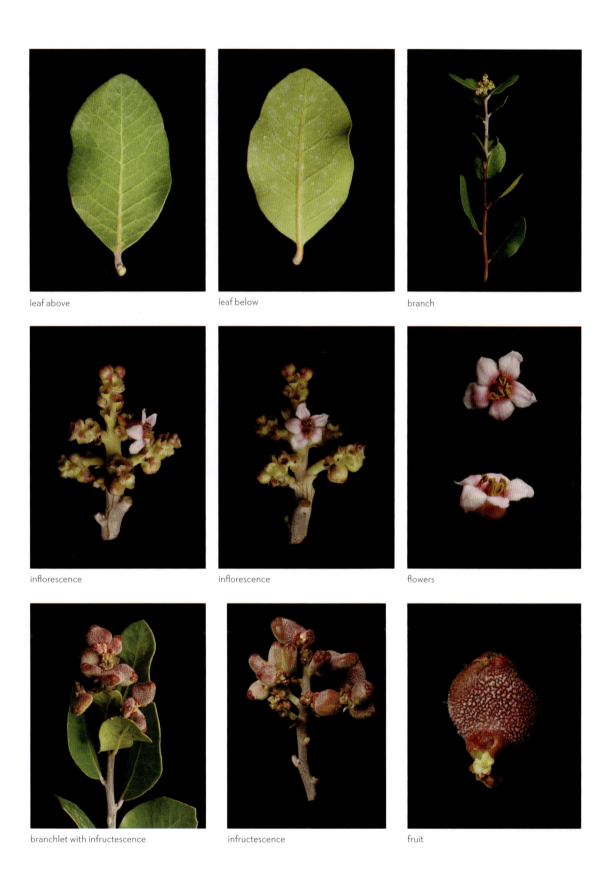

FAMILY ANACARDIACEAE • 277

Sugar Sumac

Rhus ovata S. Watson

Sugar sumac is a broadleaf evergreen shrub that grows on dry slopes of canyons and in chaparral habitats in southern California and parts of Arizona. Uses are similar to lemonade sumac with little commercial value.

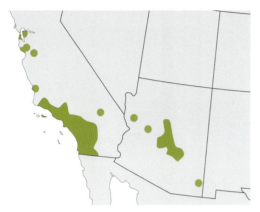

flowers

DESCRIPTION. A broadleaf evergreen shrub or small tree that grows to 10 ft (3 m) tall. Twigs are red and green, aging to gray with hairy buds hidden by petioles. Bark is grayish brown and becomes scaly and rough with age. Leaves are simple, alternate, folded at the midrib, 1.5–3.3 in (3.5–9 cm) long, with reddish petioles. Flowers are perfect, small, white to pink with red sepals, produced in dense terminal clusters, blooming in spring. Fruits are red, sticky, drupes, coated in a sugary substance, 0.24–0.31 in (6–8 mm) in diameter.

USES AND VALUE. Wood not commercially important. Native Americans used parts of tree to treat colds and coughs, and ease childbirth. Fruits used to make drink similar to lemonade. Sometimes cultivated as an ornamental. Flowers are pollinated by butterflies and fruits are dispersed by birds.

ECOLOGY. Grows on ridges and slopes of dry canyons and in chaparral habitats. Prefers dry soils.

CLIMATE CHANGE. Vulnerability is currently unknown. Immediate assessment is recommended.

CONSERVATION STATUS. Least concern.

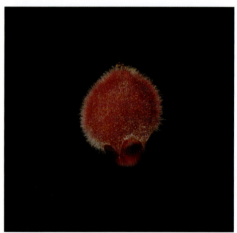
fruit

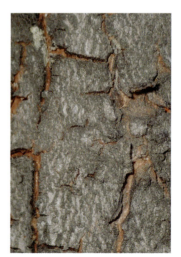
bark

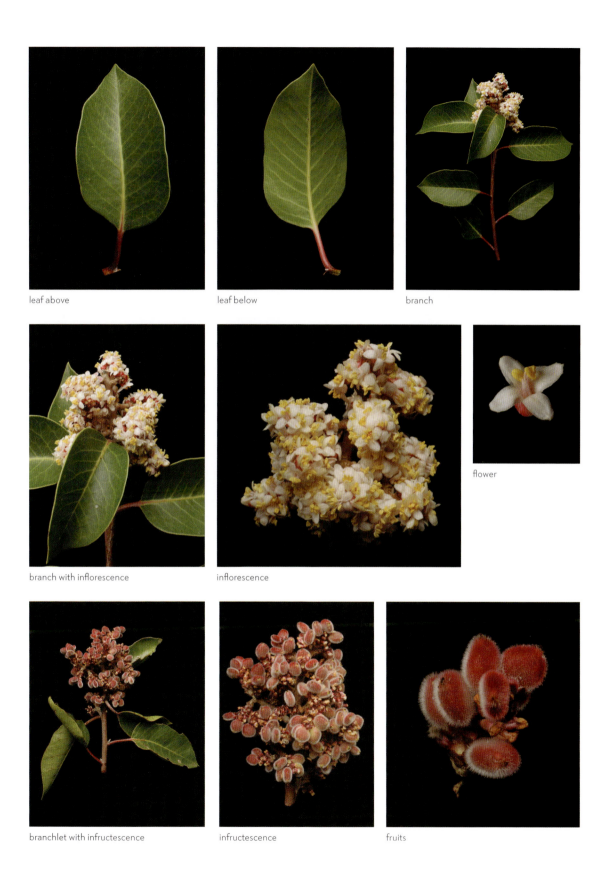

FAMILY ANACARDIACEAE • 279

Staghorn Sumac
Rhus typhina L.

Staghorn sumac is a native clonal, sometimes weedy, small tree that grows in open habitats in North America. In autumn the compound leaves turn bright yellow, red, and orange and are a conspicuous element of the landscape.

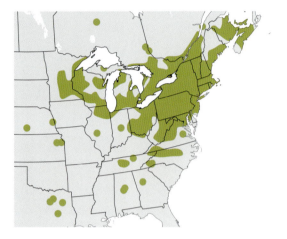

DESCRIPTION. A short-lived deciduous clonal shrub or small tree that grows up to 33 ft (10 m) tall. Twigs are large and brown, with velvety hairs. Bark is gray brown, smooth when older, and sometimes scaly. Leaves are alternate, pinnately compound, 7.9–23.6 in (20–60 cm) long, with eleven to thirty-one lanceolate leaflets, 2–4 (5–10 cm) long, smooth, dark green above, paler and pubescent below, rachis and petioles pubescent, margins serrate. Trees are monoecious producing male and female flowers on the same plant or dioecious with flowers of only a single sex produced on a plant, blooming in late spring. Flowers are tiny, yellow green, arranged in terminal upright panicles, 7.9–11.8 in (20–30 cm) long. Fruits are drupes, red, hairy, 0.08–0.2 in (2–5 mm) in diameter, clustered on erect panicles at ends of twigs, 4–7.9 in (10–20 cm) long.

USES AND VALUE. Wood not important commercially. Sometimes planted as ornamental. Leaves used medicinally. Fruits made into a drink and preserves. Tannins in fruit, bark, and leaves used for tanning leather. Flowers provide nectar for honeybees, which pollinate the flowers. Many species of ground birds, songbirds, and mammals eat seeds and fruits; white-tailed deer and moose browse leaves and twigs.

ECOLOGY. Grows on dry rocky soils in open woods, old fields, and especially roadsides, where it readily spreads through clonal growth. Shade intolerant.

CLIMATE CHANGE. Vulnerability is currently unknown. Immediate assessment is recommended.

CONSERVATION STATUS. Least concern.

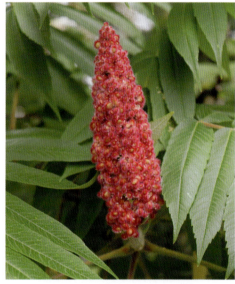

infructescence

bark

leaf above

leaf below

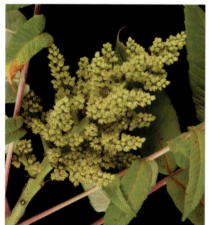
inflorescence

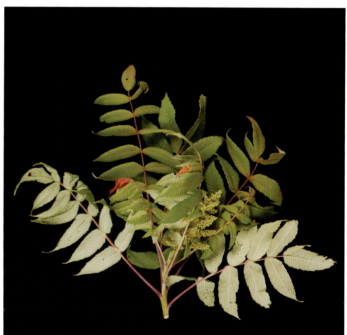
branch

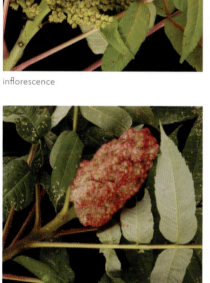
infructescence

flowers

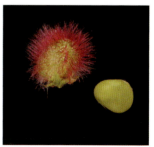
fruit and seed

FAMILY ANACARDIACEAE • 281

GENUS SCHINUS

With perhaps ten species, the genus *Schinus* is found throughout South America, primarily in the southern zones. Some species can become invasive outside of their native ranges, as is the case with the two common tree species in North America. Some taxonomic confusion remains in this genus.

Peruvian Peppertree
Schinus molle L.
PEPPERTREE

Peruvian peppertree is native to South America and has naturalized in washes, slopes, and abandoned fields in California, where it is considered an introduced pest.

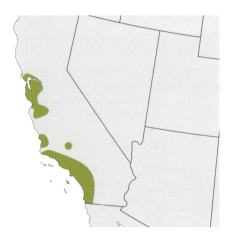

DESCRIPTION. A non-native evergreen tree or shrub that grows 16–59 ft (5–18 m) tall with a weeping canopy. Bark is light green and smooth when young becoming irregularly furrowed ruddy brown with age. Leaves are alternate, pinnately compound, and drooping, 5–15 in (12–37 cm) long, with twenty to forty, lanceolate leaflets, 1–3 in (2.5–7.5 cm) long, green, margins sparsely toothed, aromatic when crushed. Trees are dioecious producing male and female flowers on separate plants, blooming in summer. Flowers are small, white, hang in loose, drooping clusters. Fruits are round drupes, pink to red, 0.15–0.25 in (3.5–6 mm) in diameter.

USES AND VALUE. Wood not commercially important. Cultivated as ornamental. Fruits are sometimes used as peppercorns (though not closely related to true black pepper). Flowers provide nectar to insects and fruits foraged by wildlife.

ECOLOGY. Native to Peru and has naturalized in washes, slopes, and abandoned fields in California. Drought tolerant, grows on moist to dry soils. Considered a serious invasive species in many parts of the world, including California.

CLIMATE CHANGE. Vulnerability is considered low because of its wide geographic distribution as an ornamental and invasive.

CONSERVATION STATUS. Least concern.

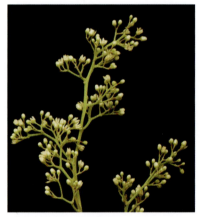

inflorescence

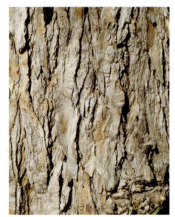

bark

282 • THE DIVERSITY OF TREES

leaf above

leaf below

branch

branch with inflorescence

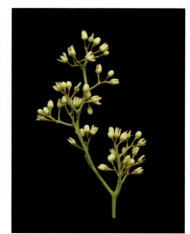
flowers

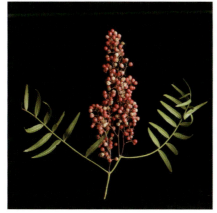
branchlet with infructescence

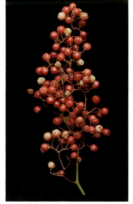
infructescence

fruits

FAMILY ANACARDIACEAE • 283

Brazilian Peppertree
Schinus terebinthifolius Raddi
CHRISTMAS BERRY

Brazilian peppertree is a non-native evergreen tree or shrub introduced from South America in the 1800s. Federally listed as a noxious plant, it grows in disturbed areas and can form dense thickets crowding out native species.

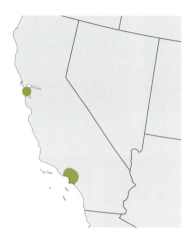

DESCRIPTION. A non-native evergreen tree or shrub that (also reported to grow as liana or epiphyte) that grows to 10–43 ft (3–13 m) tall. Trunk is often hidden by dense branches. Bark on twigs is smooth becoming scaly with age. Leaves are alternate, pinnately compound, 1.5–4 in (3–10 cm) long, with three to ten glabrous leaflets, 0.8–4 in (2–10 cm) long, leathery, green, pubescent, margins bluntly toothed. Trees are dioecious producing male and female flowers on separate plants, blooming in fall. Flowers are small, white, produced in axillary panicles, 3.5 in (8 cm) long. Fruits are drupes, glossy, red, 0.14–0.24 in (3.5–6 mm) wide, mature by December.

USES AND VALUE. Wood not commercially important. Formerly cultivated as ornamental. Fruits consumed by birds and mammals.

ECOLOGY. Native to South America, Brazilian peppertree was introduced to the United States as an ornamental in the 1800s. Now invasive in Florida. Grows in disturbed areas forming dense thickets. Common on calcareous soils. As an invasive species, sale of all parts of plant illegal in Florida and Texas.

CLIMATE CHANGE. Vulnerability is considered low because of its wide geographic distribution as an invasive.

CONSERVATION STATUS. Least concern.

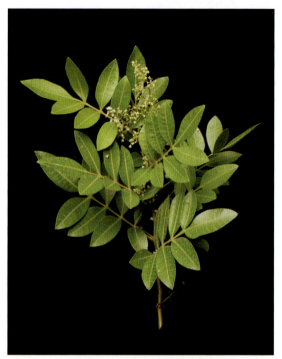
branch

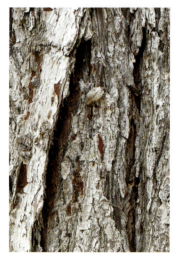
bark

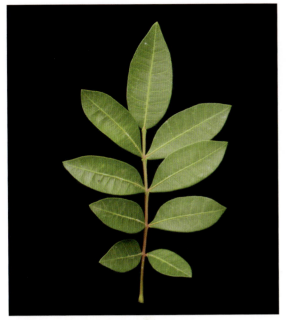
leaf above

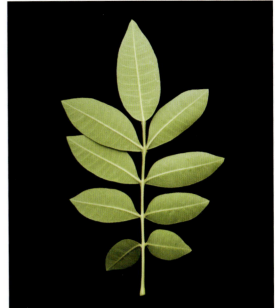
leaf below

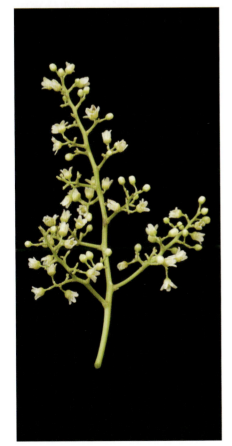
branchlet with inflorescence

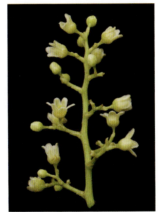
flowers

flowers

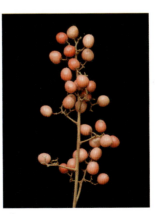
infructescence

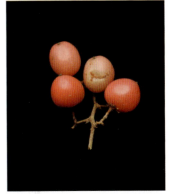
fruits

FAMILY ANACARDIACEAE • 285

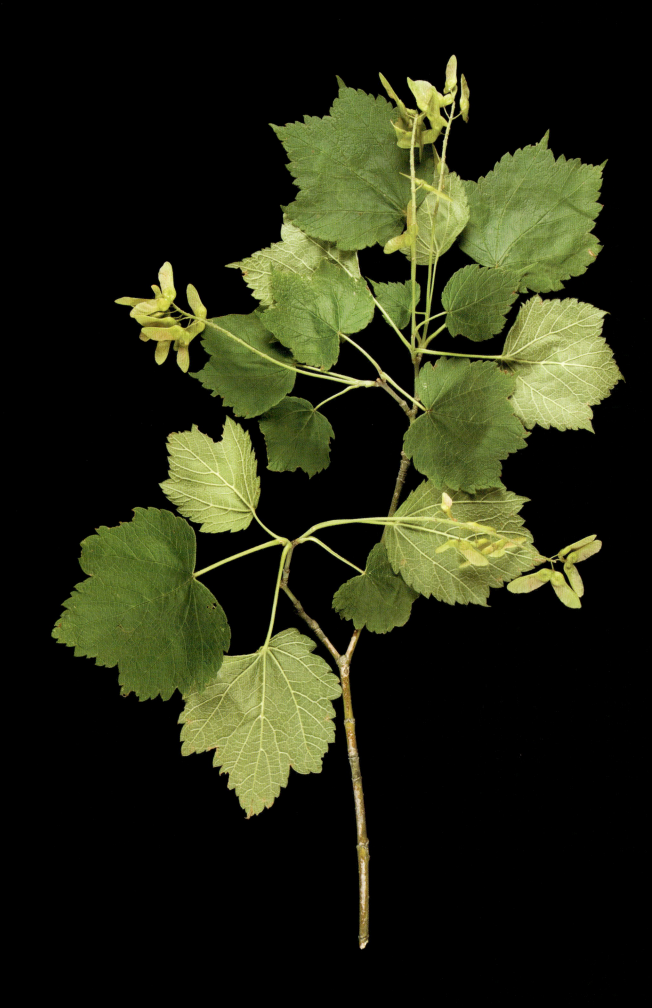

Family Sapindaceae

Nearly 150 genera and 2,200 species make up the worldwide Soapberry family (Sapindaceae). Formerly the maples and buckeyes were placed in separate families. However, evidence from DNA and chemistry now suggest that these trees should all be included in a single family, Sapindaceae. The maples include some of the most abundant, most valuable, and most beautiful trees on the continent. Each fall, their brilliant yellows, reds, and flaming oranges light up canyons, streambanks, and woodlands from coast to coast. Four of the genera—the maples, the buckeyes and horse chestnuts, the goldenrain trees, and the soapberries—contain seventeen species that are common trees in North America.

GENUS ACER

Clearest yellow, richest crimson, tumultuous scarlet, or brilliant orange—the yellow pigments shining through the over-painting of red—the foliage of the Sugar Maple at once outdoes and unifies the rest. It is like the mighty, marching melody that rides upon the crest of some symphonic weltering sea and, with its crying song, gives meaning to all the calculated dissonance of the orchestra.

—Donald Culross Peattie on *Acer saccharum* in *A Natural History of Trees of Eastern and Central North America*

The maples (genus *Acer*) contain nearly 130 species, and all but one are found in the north temperate regions of Europe, Africa, Asia, and North America. The distinctive opposite palmate leaves and winged fruits, called samaras, easily distinguish maples from most other trees. Their flowers interest botanists because they can be either male or female on the same tree (monoecious), all male on one tree and all female on other trees (dioecious), or a combination of the two conditions. (This is why you often see some trees with many fruits and other trees with none.) The wood of maples is very valuable for lumber and for crafting furniture and musical instruments; the spring sap is the essence of maple syrup; and a maple leaf appears on the national flag of Canada, a sign of cultural significance. Twelve species (ten native and two introduced) are common in North America. (See p. 742 for leaf shapes of twelve species of *Acer*.)

OPPOSITE Mountain maple (*Acer spicatum*)

Rocky Mountain Maple
Acer glabrum Torr.
MOUNTAIN MAPLE, DWARF MAPLE, SIERRA MAPLE

Rocky Mountain maple is the northernmost maple in North America; it is found growing in montane forests and on wooded hills as far north as southeastern Alaska. Six varieties are recognized.

DESCRIPTION. A deciduous shrub or small tree growing 7–33 ft (2–10 m) tall. Twigs are slender, reddish, and hairless. Bark is thin, smooth, and grayish to reddish purple. Leaves are simple, opposite, with three to five palmately ovate lobes, shiny green above and pale below, turn yellow to orange in fall, margins double-toothed, 2.8–4.7 in (7–12.5 cm) long and broad, petioles red. Trees are dioecious with male and female flowers on separate plants, blooming in spring as leaves appear. Flowers are greenish yellow and borne on drooping stalks in short, branched terminal or axillary flat-topped clusters, 1–2 in (2.5–5 cm) long. Fruits are samaras, 1.6–2 in (4–5 mm) long, with a lateral wing, 0.8–1.2 in (2–3 cm) long, with two seeds.

TAXONOMIC NOTES. Variety *glabrum* is the largest form; occurs in Rocky Mountains, Idaho, Wyoming, Colorado, Utah, and Arizona; var. *diffusum* has smaller leaves than description and white twigs, occurs in eastern portion of species' range in California, Nevada, and Utah; var. *douglasii* has three- to five-lobed leaves with shallow sinuses, twigs are red, occurs in southern Canada, Montana, Idaho, Washington, and Oregon; var. *greenei* has smallest leaves, wings of samaras overlap, occurs in southern Sierra Nevada; var. *neomexicanum* has leaves 2–4 in (5–10 cm) long with three-lobes or nearly so, occurs in southern Colorado, New Mexico, southern Utah, and southeastern Arizona; var. *torreyi* has five-lobed leaves and samaras with wings spread at 45°. Occurs in southern Oregon, northern California, and Nevada.

USES AND VALUE. Wood not commercially important. Native North Americans used parts for a variety of items, including bows and snowshoes, and made rope and matts from inner bark. Inner bark, leaves, and seeds edible; young shoots can be cooked like asparagus, while seeds can be boiled and consumed hot. Medicinally, an antiemetic. Browsed by elk, deer, cattle, and sheep.

ECOLOGY. Occurs in wooded hills and ravines along streams in mountains. Grows best in moist, well-drained, and rocky soils. Shade tolerance intermediate. Asian longhorned beetle (*Anoplophora glabripennis*) can be a serious pest.

CLIMATE CHANGE. Vulnerability, though currently considered to be low, may increase in future. Ongoing monitoring is recommended.

CONSERVATION STATUS. Least concern.

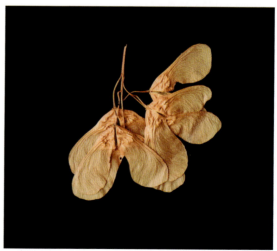

infructescence

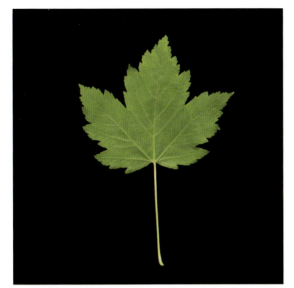
leaf above

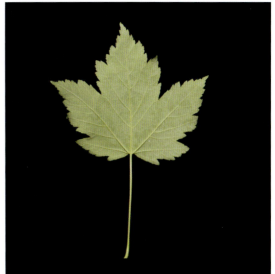
leaf below

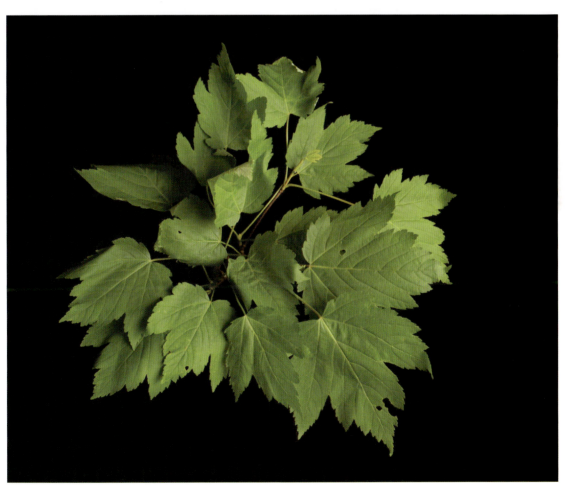
branch

FAMILY SAPINDACEAE • 289

Canyon Maple
Acer grandidentatum Nutt.
BIGTOOTH MAPLE

Canyon maple is closely related to sugar maple (*Acer saccharum*) of the East, with spectacular fall colors. Commonly found in riparian areas and woodlands. Two varieties are recognized.

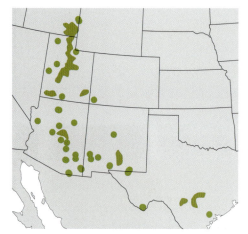

DESCRIPTION. A deciduous small tree or shrub growing 49–98 ft (15–30 m) tall. Habit may vary with moisture availability. Branches are erect and thick. Bark is dark brown to gray and may be smooth or scaly. Leaves are simple, opposite, palmately lobed (three to five lobes), 2–5 in (5–15.5 cm) long, green, pubescent on underside, turning gold or red at end of season. Trees are monoecious producing male and female flowers on the same plant or dioecious with male and female flowers on separate plants, blooming in early spring with new leaves. Flowers are pale green, lack petals, produced in umbellate to corymbose clusters. Fruits are dry indehiscent pair of samaras with two wings, 0.75–1.5 in (1.8–3.6 cm) long, ovary with long hairs.

TAXONOMIC NOTES. Variety *sinuosum* occurs in Arizona, New Mexico, and Texas; var. *grandidentatum* occurs throughout species' range.

USES AND VALUE. Wood not commercially important. Used for fuelwood and fence posts. Sometimes planted as ornamental. Sap, seeds, and inner bark edible; seeds are boiled and roasted before consumption. Sap can be boiled down to make syrup or a sweet drink. No medicinal uses known. Combines with white fir (*Abies concolor*) in riparian areas to provide high-quality fish and wildlife habitat.

ECOLOGY. Occurs on moist soils of canyons, mountains, and plateaus; also commonly found in riparian areas and woodlands. Persists on wide variety of soil depths and textures but grows best in moist well-drained soils. Heat and cold hardy. Intermediate in shade tolerance. Asian longhorned beetle (*Anoplophora glabripennis*) can be a serious pest.

CLIMATE CHANGE. Vulnerability is significant but may have capacity to adapt to changing conditions. Ongoing monitoring is recommended.

CONSERVATION STATUS. Least concern.

bark

 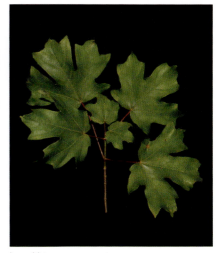

leaf above | leaf below | branchlet

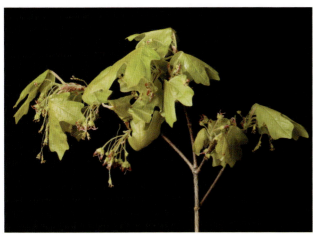 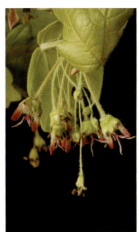 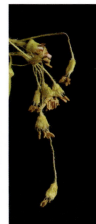

inflorescence with leaves | female flowers | male flowers

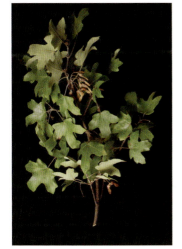 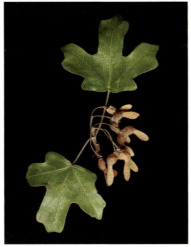 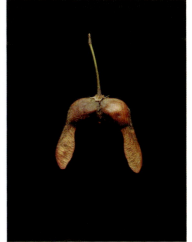

branch | infructescence with leaves | fruit

FAMILY SAPINDACEAE • 291

Bigleaf Maple
Acer macrophyllum Pursh
OREGON MAPLE

Bigleaf maple is one of the tallest maples in North America and one of the few commercially important hardwood species in the cool, moist forests of the Pacific Northwest.

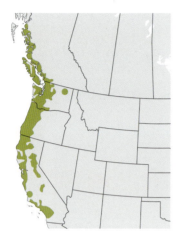

DESCRIPTION. A deciduous, moderately long-lived, medium to large tree growing 49–98 ft (15–30 m) tall. Bark is smooth and grayish brown on young stems, becoming red brown and deeply fissured; broken into scales on surface. Leaves are deciduous, simple, opposite, glabrous, dark blue green above, lighter green below, turning gold and yellow in fall, very large, 5.9–11.8 in (15–30 cm) across, with five deeply incised palmate lobes along margin, exudes milky sap from petioles. Trees are monoecious with male and female flowers on the same plant, blooming with leaves from April to May. Flowers are small, greenish yellow, inconspicuous, and fragrant, produced in pendulous racemes, 3.9–5.9 in (10–15 cm) long. Fruits are pubescent, paired, winged samaras, 1–1.5 in (2.4–3.6 cm) long. Seeds 4–12 mm long and 0.16–0.35 in (4–9 mm) thick.

USES AND VALUE. Wood commercially important. Used for making furniture, piano frames, and decorative veneer as well as for fuel and pulp. Cultivated as shade tree. Flowers, inner bark, leaves, sap, and seeds all edible; sap boiled down to make maple syrup or sweet drink. No medicinal uses known. Seeds are favorite food for small mammals and birds; deer and elk browse young shoots.

ECOLOGY. Grows among riparian hardwood forests and cool moist temperate mixed-wood forests along Pacific coast. Annual seed production good; natural regeneration frequently abundant. Shade tolerant. Attacked by trunk-rot fungi and Asian longhorned beetle (*Anoplophora glabripennis*).

CLIMATE CHANGE. Vulnerability is currently considered low.

CONSERVATION STATUS. Least concern.

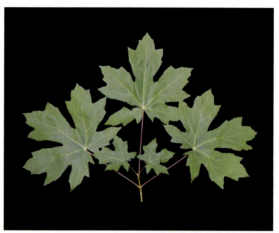
branchlet

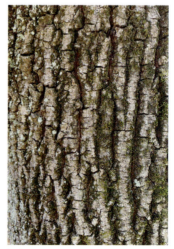
bark

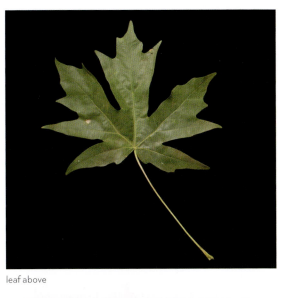
leaf above

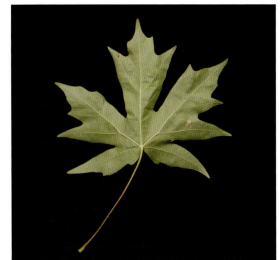
leaf below

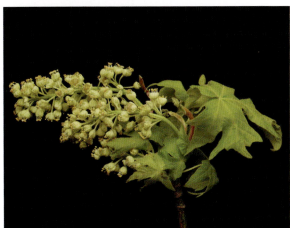
inflorescence

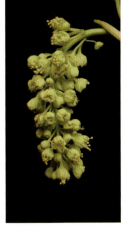
inflorescence with male flowers

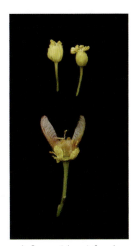
male flowers (above), female flower (below)

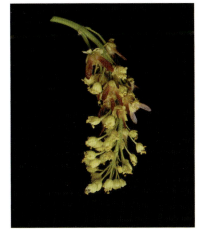
inflorescence with male and female flowers

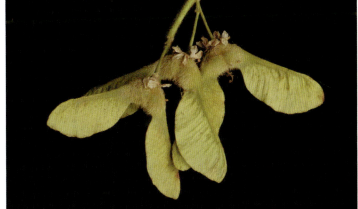
infructescence

FAMILY SAPINDACEAE • 293

Boxelder
Acer negundo L.

Boxelder is the only North American maple with compound leaves. Many types of wildlife, including dozens of moths, butterflies, and birds, rely on the leaves and fruits to survive the winter.

DESCRIPTION. A short-lived, multitrunked, medium-sized tree, growing 33–82 ft (10–25 m) tall with thick trunk (98–164 in or 30–50 cm in diameter), tendency to sucker-sprout. Bark is grayish brown and warty. Leaves are opposite and pinnately compound, 5.1–7.9 in (13–20 cm) long, 1.2–2.4 in (3–6 cm) wide, with three to five but sometimes seven leaflets, 2–4 in (5–10 cm) long, light green above and paler below, turn yellow in fall, margins coarsely serrate or lobed. Trees are dioecious producing male and female flowers on separate plants, blooming in early to late spring. Flowers are produced in racemes, yellow green, 0.2 in (0.5 cm) long. Fruits are sharply V-shaped winged samaras, 1–1.5 in (2.5–3.8 cm) long, grouped in clusters and mature in fall.

USES AND VALUE. Wood not commercially important. Once planted for shade but no longer used as ornamental due to short-lived habit and susceptibility to heart rot and ice damage. Inner bark, sap, and seeds all edible; sap contains considerable sugar and made into refreshing drink or boiled down to make syrup. Inner bark sometimes used to make emetic tea. Birds and mammals eat seeds.

ECOLOGY. Grows on wet soils, in bottomlands and disturbed sites. Starts producing seed annually after ten years of age. Intermediate in shade tolerance. Resistant to windthrow and drought, also cold hardy. Asian longhorned beetle (*Anoplophora glabripennis*) is a serious pest.

CLIMATE CHANGE. Vulnerability is currently considered low.

CONSERVATION STATUS. Least concern.

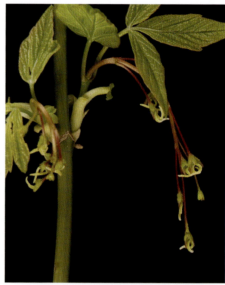

inflorescence with female flowers

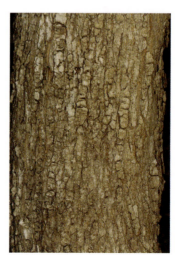

bark

leaf above

leaf below

branch

inflorescence with male flowers

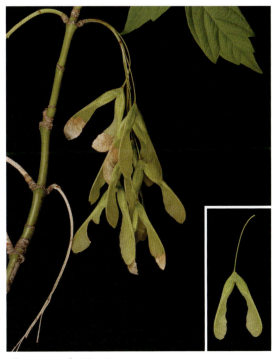
infructescence, fruit (inset)

FAMILY SAPINDACEAE • 295

Black Maple

Acer nigrum F. Michx.

BLACK SUGAR MAPLE, HARD MAPLE, ROCK MAPLE

Black maple is very similar to sugar maple (*Acer saccharum*) with very few genetic or morphological differences. Classified by some botanists as a variety of that species. Distinguished by its preference for rich woodlands and streamsides.

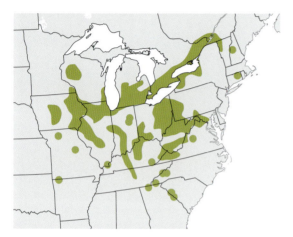

DESCRIPTION. A deciduous tree growing to 131 ft (40 m) tall with orange yellow branchlets. Twigs are brown, lustrous, and angled. Bark is very dark and furrowed in mature trees. Leaves are opposite, simple, mostly three-lobed but occasionally five-lobed, 3.9–5.9 in (10–15 cm) long and equally wide, slightly acuminate and coarsely toothed with deep sinuses on margins, stipulate, yellowish green, leathery, paler and hairless below, turning bright yellow in fall, petioles 1.6–3.1 in (4–8 cm) long. Trees are monoecious with separate male and female flowers produced on the same tree, blooming in early spring before leaves. Flowers appear perfect but are functionally male or female, both sexes produced in upper part of tree, only male flowers in lower part, pendent in corymbs on short pedicels, 1–3 in (2.5–7.6 cm) long, greenish yellow, 0.20–0.24 in (0.5–0.6 cm) wide. Fruits are double samaras with almost parallel wings, 1.2–1.6 in (3–4 cm) long, dangling. Seeds are ripe when samaras turn yellowish green in fall, 0.27–0.35 in (7–9 mm) long.

USES AND VALUE. Wood very important commercially. Used for veneer, flooring, furniture, pulpwood, fuelwood, and baseball bats. Inner bark, leaves, sap, and seeds all edible; trunks are tapped for sap to make maple syrup. Medicinally used as astringent. Cultivated as ornamental. Seeds are important food source for red, gray, and flying squirrels. Shoots heavily browsed by deer. Sapsuckers tap bole for sweet sap.

ECOLOGY. Grows in bottomlands and woods on dry calcareous soils in midwestern United States and Canada. Good seed crops produced every four years; some seed produced most other years. Very shade tolerant. Susceptible to fire damage due to thin bark; resistant to windthrow. Attacked by two species of bud miner (*Proteoteras moffatiana* and *Obrussa ochrefasciella*); otherwise relatively free from serious damage by fungi and insects.

CLIMATE CHANGE. Vulnerability is significant but has reasonable probability of persistence in the future. Ongoing monitoring is recommended.

CONSERVATION STATUS. Least concern.

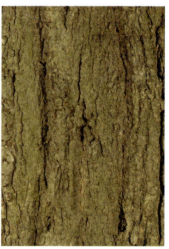

bark

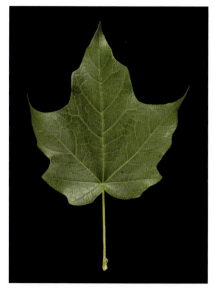
leaf above

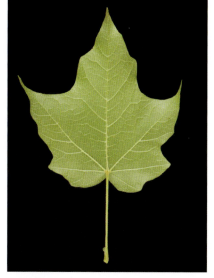
leaf below

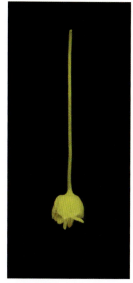
bisexual flower

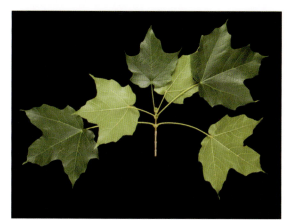
branchlet

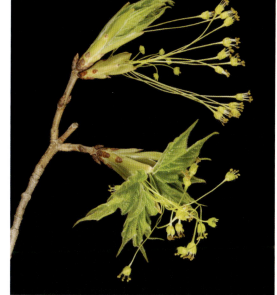
inflorescence

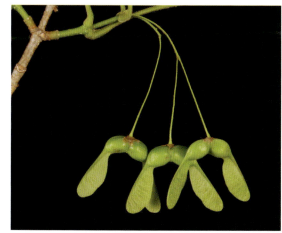
infructescence

male flower

bisexual flower

FAMILY SAPINDACEAE • 297

Striped Maple

Acer pensylvanicum L.
MOOSEWOOD

Striped maple is a small understory tree that gets its common name from the bark, which is green brown with silver stripes. Because moose eat the bark in winter, the tree is also known as "moosewood."

DESCRIPTION. A deciduous shrub to small tree, growing slowly and often living for over 100 years, up to 33 ft (10 m) tall. Bark is green with silver stripes. Leaves are opposite, simple, orb-shaped, three-lobed, green above and paler below, margins serrate, 5–7.9 in (12.75–20 cm) long. Trees are dioecious with male and female flowers produced on separate plants, blooming in late spring. Flowers are in clusters, yellow green, bell-shaped, 0.25 in (0.64 cm) long. Fruits are paired samaras, 0.75–1 in (1.9–2.5 cm) long, ripening in late summer to early fall.

USES AND VALUE. Wood not important commercially. No edible parts. Tea made from leaves and shoots is both emetic and antiemetic, depending on dosage. Important to wildlife, providing food for rabbits, porcupines, deer, moose, and woodland caribou.

ECOLOGY. Grows in understory of moist cool forests on northern slopes. Prefers moist, well-drained, acidic soils. The most shade tolerant of all maples. Despite shallow, wide-spreading root system, not susceptible to windthrow due to position in understory. Attacked by Asian longhorned beetle (*Anoplophora glabripennis*).

CLIMATE CHANGE Vulnerability is significant but may have capacity to adapt to changing conditions. Ongoing monitoring is recommended.

CONSERVATION STATUS. Least concern.

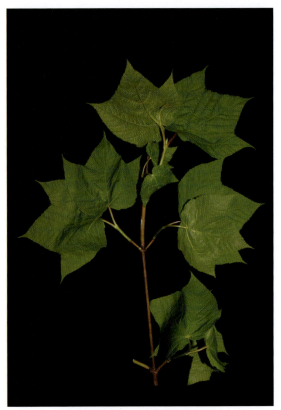

branch

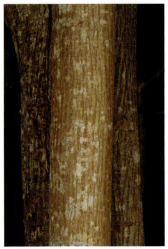

bark

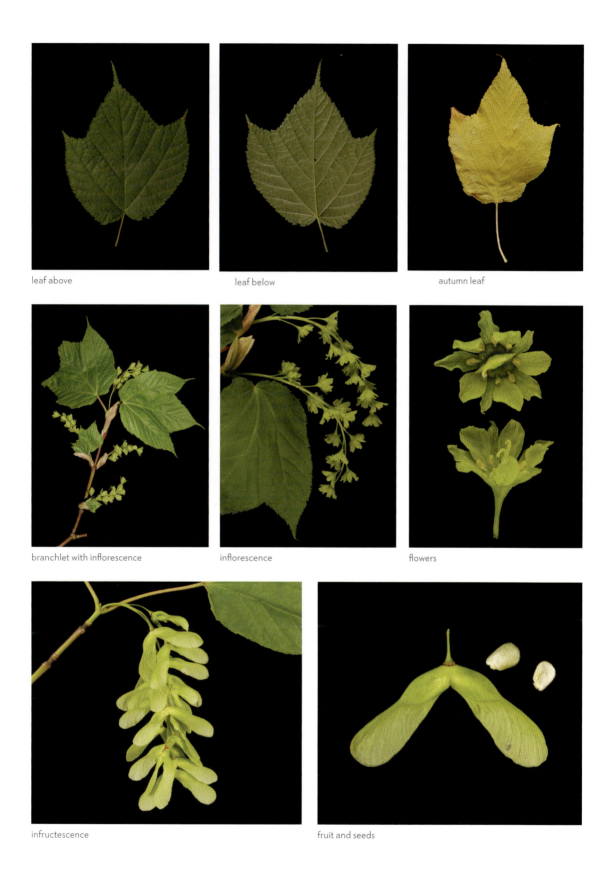

FAMILY SAPINDACEAE • 299

Norway Maple
Acer platanoides L.

Native to Europe and western Asia, Norway maple, which is appreciated for its colorful leaves in fall, was introduced as an ornamental and quickly spread across the Northeast.

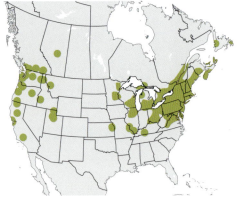

DESCRIPTION. A short-lived, fast-growing, deciduous tree that grows to 50 ft (15.2 m) in height and 30–45 ft (9.1–13.7 m) in width. Bark is grayish brown and regularly grooved on older trees. Leaves are opposite, simple, with five to seven lobes with long teeth, dark green above, paler below, petiole exudes white sap when broken, 5–8 in (12.5–20 cm) long. Trees are dioecious with male and female flowers on separate plants, blooming in early spring. Flowers are inconspicuous, yellow green. Fruits are two-winged samaras, brown, 1.5–2 in (3.8–5.2 cm) long, in clusters.

USES AND VALUE. Wood not important commercially. One of the most commonly cultivated trees along streets due to tolerance for pavement, air pollution, compacted soil, and other conditions of city living. Copious sap edible, contains sugar that can be made into a drink or boiled down to make syrup. No medicinal uses reported.

ECOLOGY. Non-native and commonly planted on streets, in yards, and in parks in urban environments. Releases chemicals that inhibit the growth of nearby native understory saplings. Outcompetes native maples and banned in some states as invasive.

CLIMATE CHANGE. Vulnerability is considered to be low because of wide distribution as an ornamental and invasive.

CONSERVATION STATUS. Least concern.

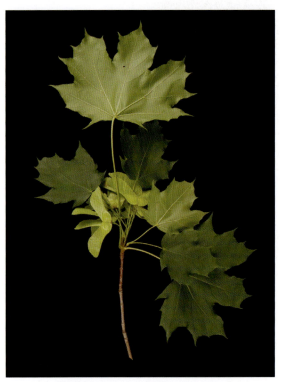

branch with infructescence

bark

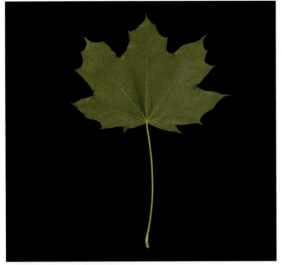
leaf above

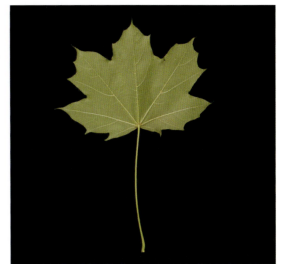
leaf below

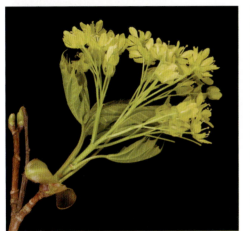
inflorescence

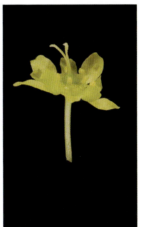
perfect flower (side)

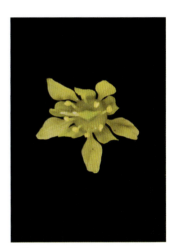
perfect flower (above)

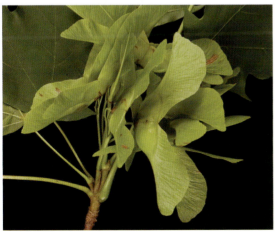
infructescence

fruit

FAMILY SAPINDACEAE • 301

Sycamore Maple
Acer pseudoplatanus L.

Sycamore maple, like Norway maple (*Acer platanoides*), is native to Europe and western Asia, and is commonly cultivated as an ornamental. It is considered an invasive species in parts of North America.

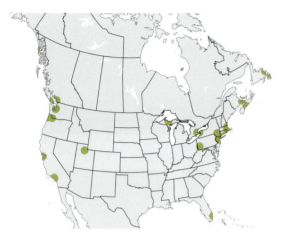

DESCRIPTION. A moderate-lived, deciduous tree with moderate growth rate, reaching 100 ft (30.5 m) in height with a short trunk and wide crown. Bark is gray and somewhat scaly, showing an orange color underneath peeled bark. Leaves are opposite, simple, five-lobed, dark green above, very pale below, margins serrate, heart-shaped base, 5–6 in (12.7–15.2 cm) long. Trees are monoecious with male and female flowers produced on the same tree, blooming in late spring. Flowers are yellow, arranged in inconspicuous 3–5 in (7.6–12.7 cm) long clusters. Fruits are winged samaras, 1.5 in (3.8 cm) long.

USES AND VALUE. Wood not important commercially. Cultivated as ornamental shade tree primarily in parks and along streets in urban environments. Considered invasive by United States Department of Agriculture. Leaves, sap, and seedpods edible; sap contains sugar and can be made into a drink or boiled down to make syrup. Bark mildly astringent.

ECOLOGY. Non-native. Prefers cooler climates, where it is successful as urban cultivated species.

CLIMATE CHANGE. Vulnerability is considered low because of wide distribution as an ornamental and invasive.

CONSERVATION STATUS. Least concern.

branch with infructescence

bark

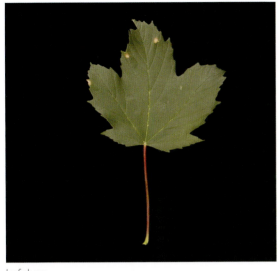
leaf above

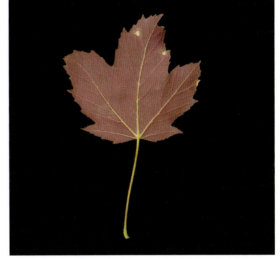
leaf below

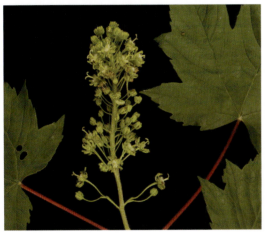
inflorescence

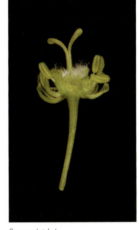
flower (side)

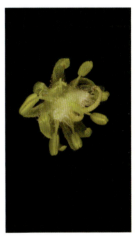
flower (above)

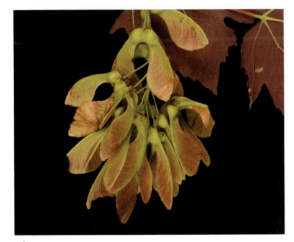
infructescence

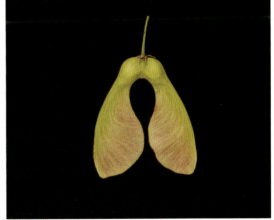
fruit

FAMILY SAPINDACEAE • 303

Red Maple
Acer rubrum L.
SOFT MAPLE

Red maple thrives in many forest and secondary habitats, including swamps, and is consequently one of the most abundant trees in the eastern deciduous forest, found as far north as Minnesota and Quebec and as far south as Texas and Florida. The red petioles, twigs, flowers, fruits, and fall foliage are characteristic.

DESCRIPTION. A long-lived (up to 200 years) deciduous tree, growing rapidly up to 80 ft (24.4 m) tall and sprouting vigorously. Twigs are red and smooth. Bark is gray and smooth when young, becoming darker with scaly plates when older. Leaves are opposite, simple, with three to five shallow lobes, margins serrate, green and glabrous above and may be glaucous and hairless or hairy below, 2–5.9 in (5–15 cm) long, and 1.4–5.9 in (3.5–15 cm) wide. Trees are polygamodioecious with some plants producing only male or female flowers, and others both male and female flowers, blooming in early spring several weeks before leaves emerge. Flowers on slender red stalks in drooping clusters. Fruits are small-winged, brownish-red samaras, 0.7 in (1.9 cm) long, ripening in spring.

USES AND VALUE. Wood commercially important. Used for veneer, plywood, grade lumber, pulpwood, and fuelwood. Widely cultivated as ornamental. Inner bark, leaves, sap, and seeds all edible; high in sugar content, sap can be made into refreshing drink or maple syrup. Leaves are poisonous to horses. Medicinally, inner bark has been used as astringent. Shoots and buds are important winter food for deer and elk; rodents and birds eat seeds.

ECOLOGY. Grows in habitats ranging from wetlands to moist forests to dry slopes. Adapted to wide climatic conditions. Shade tolerant. Produces seeds annually, good crops every two years; germination rates up to 90 percent. Susceptible to fire damage due to thin bark; prone to windthrow due to shallow root system, especially in wet soils. Numerous trunk rots cause considerable wood defects in many trees. Thin bark makes tree susceptible to scarring, providing infection sites for rot fungi. Suffers from numerous leaf diseases. Attacked by many insects, including Asian longhorned beetle (*Anoplophora glabripennis*).

CLIMATE CHANGE. Vulnerability is currently considered low.

CONSERVATION STATUS. Least concern.

bark

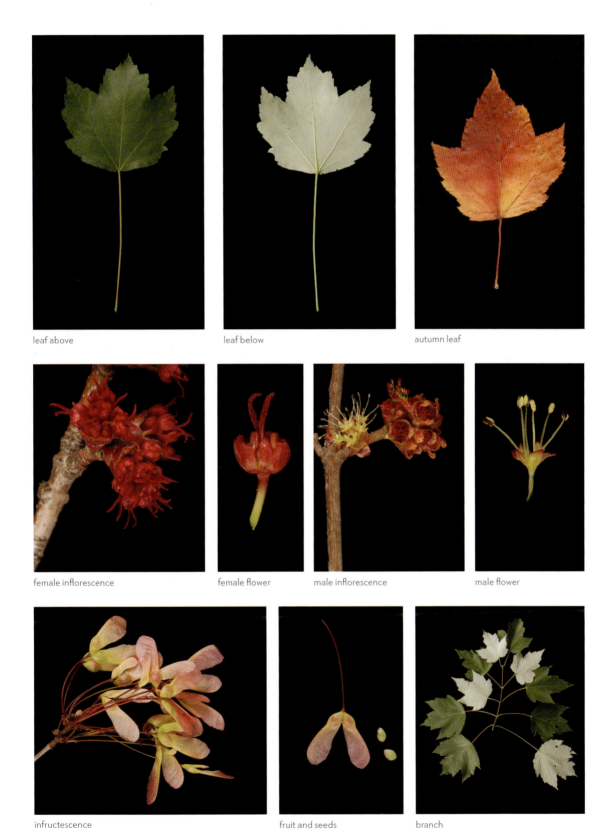

FAMILY SAPINDACEAE • 305

Silver Maple

Acer saccharinum L.

Silver maple is one of the most abundant trees in the United States. Its common name denotes the silvery undersides of its deeply lobed leaves.

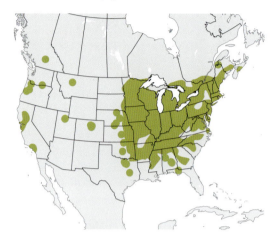

DESCRIPTION. A short-lived, deciduous tree with fast growth rate, attaining heights up to 85.3 ft (26 m) tall. Trunk is usually short, typically dividing into multiple stems, with crown vase-shaped, wide-spreading, root system shallow. Bark is light gray and smooth when young, hangs in loose strips on older trees. Leaves are simple, opposite, palmate with five deep sinuses, coarsely serrate, 2.5–5 in (6.35–12.7 cm) long. Trees are monoecious with male and female flowers produced on the same plant, blooming in early spring before leaves. Flowers are greenish red, 0.24 in (6 mm) long, hanging in clusters from stalks. Fruits are large-winged greenish-brown samaras, 1.5–2.5 in (3.8–6.4 cm) long.

USES AND VALUE. Wood commercially important. Marketed with red maple (*Acer rubrum*) and used for veneer, lumber, pallets, pulpwood, fuelwood, musical instruments, and turned products. Cultivated widely as ornamental. Inner bark, leaves, sap, and seeds all edible; high in sugar content, sap can be made into refreshing drink or syrup. Medicinally, inner bark has been used as astringent. Shoots and buds are important winter food source for deer; rodents, squirrels, and birds eat seeds; preferred food source of beavers. Provides nesting sites for wood ducks and goldeneye ducks.

ECOLOGY. Tolerates wide variety of climates and soils; grows along streambanks and bottomlands, able to withstand temporary flooding. Produces good seed crops annually; fruits dispersed widely, primarily by wind and water. Shade tolerant except on poor or very wet sites. Branches brittle, easily broken by wind, snow, and ice, creating entry points for fungal attack. Susceptible to fire damage due to thin bark; prone to windthrow due to shallow root system. Few insect pests, except Asian longhorned beetle (*Anoplophora glabripennis*) which can cause damage. Highly susceptible to trunk- and root-rot fungi.

CLIMATE CHANGE. Vulnerability is significant but has reasonable probability of persistence in the future. Ongoing monitoring is recommended.

CONSERVATION STATUS. Least concern.

bark

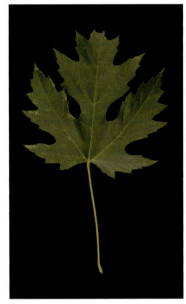
leaf above

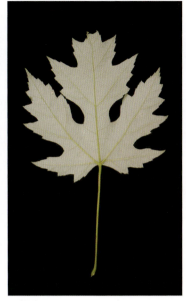
leaf below

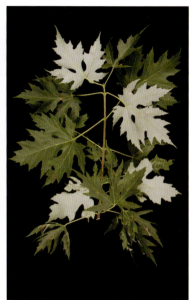
branch

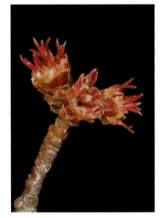
female inflorescence

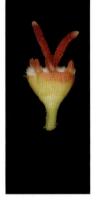
female flower

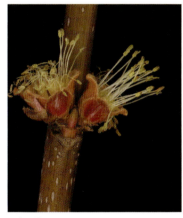
male inflorescence

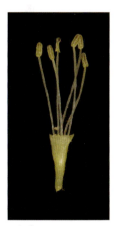
male flower

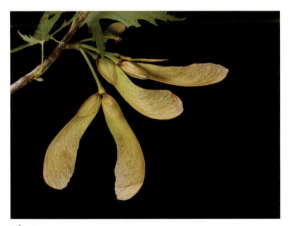
infructescence

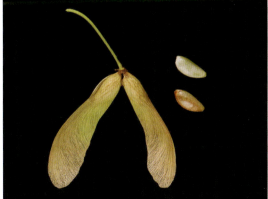
fruit and seeds

FAMILY SAPINDACEAE • 307

Sugar Maple
Acer saccharum Marsh

Sugar maple, along with black maple (*Acer nigrum*), is the source for nearly all maple syrup. The highly recognized lobed palmate leaf appears on Canada's national flag. The foliage turns spectacular shades of yellow and red orange in fall.

DESCRIPTION. A long-lived (up to 400 years) deciduous tree with slow growth rates, attaining heights up to 120 ft (36.6 m). Trunk is clear and straight with crown large and dense; root system shallow to deep depending on soil conditions. Bark is brown, gray, or black and forms large plates in older trees. Leaves are opposite, simple, palmate, two basal lobes are smaller than upper three, medium to dark green with fall color ranging from bright yellow to fluorescent orange red, blades 5 in (12.7 cm) long and 5 in (12.7 cm) wide on 3 in (7.6 cm) petioles. Trees are monoecious producing both male and female flowers in upper part of crown and only male flowers in lower part, blooming in mid-spring. Flowers are held on long pedicels, yellow, 2.5 in (6.4 cm) long. Fruits are winged yellowish-green samaras, 1–1.6 in (2.5–4 cm) long, only one of pair usually has seed.

USES AND VALUE. Wood commercially important. Used for veneer, flooring, furniture, pulpwood, fuelwood, and baseball bats. Cultivated as ornamental. Inner bark, leaves, sap, and seeds all edible. Sap high in sugar content; tree primarily used to make maple syrup. Tea from bark acts as expectorant. Seeds are important food source for red, gray, and flying squirrels. Shoots heavily browsed by deer; sapsuckers extract sweet sap from trunks.

ECOLOGY. Grows in areas with cool moist climates and thrives on wide variety of soils. Produces good seed crops every two to five years; germination rates high (often 95 percent or more). Shade tolerant. Susceptible to fire damage due to thin bark, but relatively resistant to windthrow due to adaptive root system. Similar to other maples, attacked by at least two species of bud miner (*Proteoteras moffatiana* and *Obrussa ochrefasciella*). Asian longhorned beetle (*Anoplophora glabripennis*) is a serious pest.

CLIMATE CHANGE. Vulnerability is currently considered low.

CONSERVATION STATUS. Least concern.

autumn branch

bark

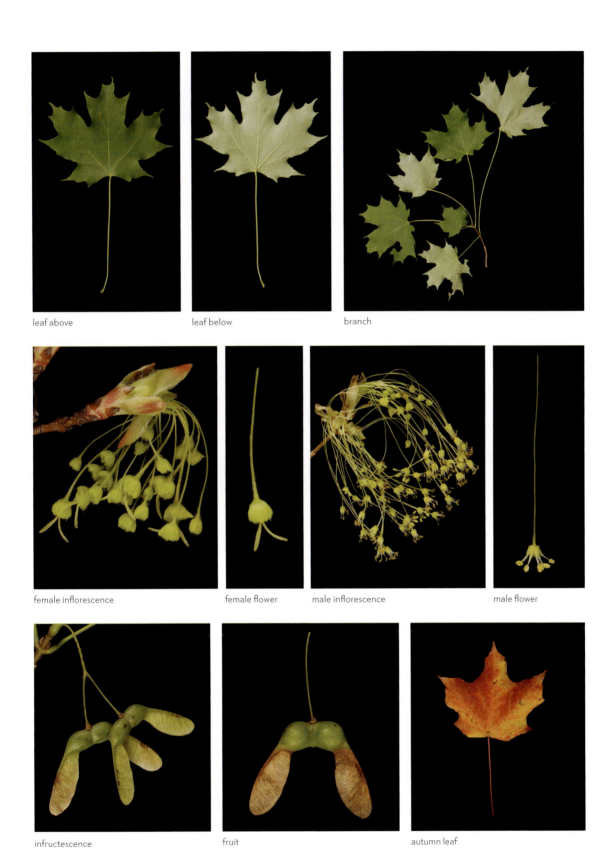

FAMILY SAPINDACEAE • 309

Mountain Maple

Acer spicatum Lam.
MOOSE MAPLE

The species name *spicatum*, which means "spiked," refers to the tall, erect, and upright flower clusters of mountain maple. These flowers are an important source of nectar for pollinating bees.

DESCRIPTION. A deciduous shrub or small tree that grows up to 33 ft (10 m) in height with an often crooked trunk. Twigs are yellow green in summer becoming pale red and pubescent in winter. Bark is gray, flakes into shallow furrows. Leaves are simple, opposite with three to five lobes, yellow green with sunken veins above, pubescent below, margins coarsely serrated, 2.5–5 in (6–12 cm) long and wide. Trees are monoecious with male and female flowers on the same plant, blooming in summer. Flowers are green to yellow and borne in erect, slender terminal clusters. Fruits are samaras, 0.6 in (1.5 cm) long, in pairs, with seed cavity indented on one side, hang in clusters, mature in late summer.

USES AND VALUE. Wood not commercially important. Sap boiled down to make syrup. Medicinally, Native North Americans used infusion of pith of branches as eye drops. Important source of nectar for pollinating bees. Provides browse for moose, woodland caribou, white-tailed deer, and beavers.

ECOLOGY. Grows in cool humid climates on hillsides and flatlands, but also found on talus slopes and in forested bogs. In northern range, occurs most often in moist rich soils in riparian areas or well-drained acidic soils. Attacked by Asian longhorned beetle (*Anoplophora glabripennis*).

CLIMATE CHANGE. Vulnerability is significant but has reasonable probability of persistence in the future. Ongoing monitoring is recommended.

CONSERVATION STATUS. Least concern.

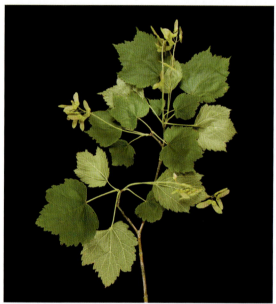
branch with fruits

bark

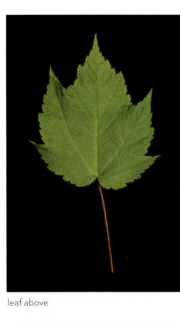
leaf above

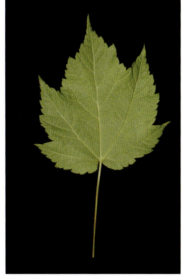
leaf below

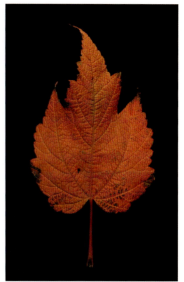
autumn leaf

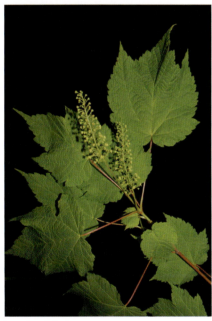
branch with flowers

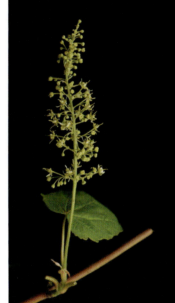
inflorescence

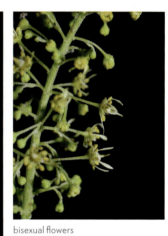
bisexual flowers

fruit

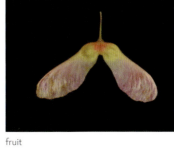
fruit

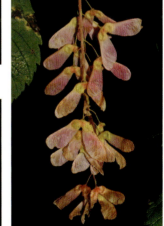
infructescence

FAMILY SAPINDACEAE • 311

GENUS AESCULUS

If the good weather keeps up, the leaves fairly rush into full foliage while, all about, the Hickories and Oaks, the Locusts and Ashes remain closed in winter's steely secrecy. Soon the flowers, borne stiffly in open clusters at the ends of the upturned clumsy twigs, make their appearance, the color of pale spring sunshine.

—Donald Culross Peattie on *Aesculus glabra* in *A Natural History of Trees of Eastern and Central North America*

The genus *Aesculus* contains fewer than twenty species, and all are found in the northern temperate regions of North America, Asia, and Europe. Similar to the leaves of their closest relatives, the maples, the leaves are opposite and highly palmately divided. Unlike the maples, the large and conspicuous individual flowers have both male and female sexual parts. Even though the trees are commonly cultivated as ornamental plants, the seeds and other parts of the plant are somewhat toxic. Three native species of *Aesculus* are common trees in North America.

California Buckeye
Aesculus californica (Spach) Nutt.

California buckeye is a small tree that grows in Mediterranean climates of California on dry slopes and along waterways below 3,937 ft (1,200 m) in elevation. It is a popular landscaping ornamental with poisonous seeds.

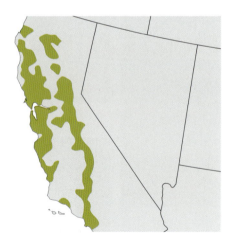

DESCRIPTION. A deciduous shrub or small tree growing up to 39 ft (12 m) tall with a broad rounded crown. Bark is gray and smooth. Leaves are opposite, palmately compound, 4–8 in (10–20 cm) long, with five to seven lanceolate leaflets, 2–7.8 in (5–17 cm) long, dark green above paler below, margins finely serrulate. Flowers are perfect, arranged in panicles, 4–7.9 in (10–20 cm) long, showy with pale rose or white petals, five to seven exserted stamens with orange anthers, blooming in early summer. Fruits are pear shaped capsules, smooth, containing one to six glossy brown seeds, 0.8–1.2 in (2–3 cm) in diameter.

USES AND VALUE. Wood not commercially important. Ecologically serve to stabilize soils where they grow. Cultivated as popular landscaping ornamental. Seeds contain saponins and are poisonous. Boiling for several days removes toxins and nuts can be processed into edible flour. Native Americans used seeds to stun fish to facilitate capture. Medicinally, saponins serve as expectorant; various parts used to treat variety of ailments. Glycosidal compounds found in bark, leaves, stems, fruits, and seeds are poisonous to most animals.

ECOLOGY. Grows in Mediterranean climates on dry slopes and along waterways below 3,937 ft (1,200 m) in elevation. Occurs frequently on well-drained sandy, sandy-loam, or gravelly-loam soils. Shade intolerant.

CLIMATE CHANGE. Vulnerability is currently considered to be low.

CONSERVATION STATUS. Least concern.

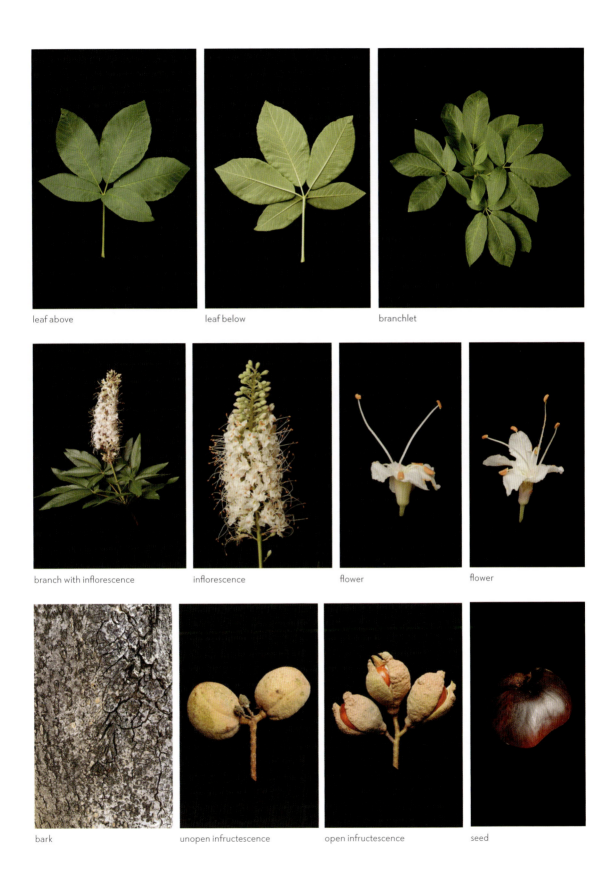

FAMILY SAPINDACEAE • 313

Yellow Buckeye
Aesculus flava Sol.

Yellow buckeye, native to the eastern United States, has distinctive palmately compound leaves with five leaflets. Fruits are round capsules that contain up to three shiny brown nuts that are poisonous to humans.

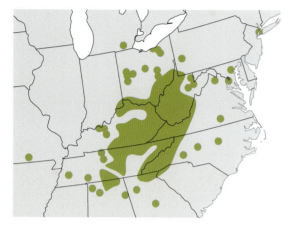

DESCRIPTION. A long-lived deciduous tree that grows up to 80 ft (24 m) tall and 40 ft (12.2 m) wide, with a straight trunk and drooping branches. Bark is grayish brown and splotchy, with large scaly patches on older trees. Leaves are opposite, dark green above, paler below, palmately compound, 10–15 in (25.4–38.1 cm) long, with five oval leaflets, 3–7 in (7.6–17.8 cm) long, margins serrate. Trees are monoecious with male and female flowers on same plant, blooming in late spring. Flowers are yellow orange, tubular, held in upright clusters 4–8 in (10.2–20.3 cm) in length. Fruits are capsules with thick and leathery husks, 2–3 in (5–7 mm) in length. Seeds are dark brown and shiny.

USES AND VALUE. Wood not commercially important. Used as pulpwood and utility-grade lumber for boxes and crates. Burls from trees are highly prized for coloration and crafted into bowls and other specialty items. Twigs and seeds contain poisonous glucoside called aesculin and therefore unsuitable source of food for wildlife. Native Americans eat seeds after boiling or roasting to eliminate toxins. No medicinal uses are known.

ECOLOGY. Grows in rich soil along river bottoms or on mountain slopes. Partially sun and shade tolerant. Relatively free of damaging insects and fungi.

CLIMATE CHANGE. Vulnerability is high, may have little capacity to adapt to changing conditions, and low potential to persist in the future. Ongoing monitoring is required.

CONSERVATION STATUS. Least concern.

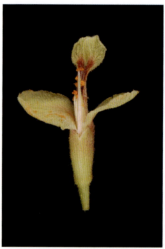
flower

bark

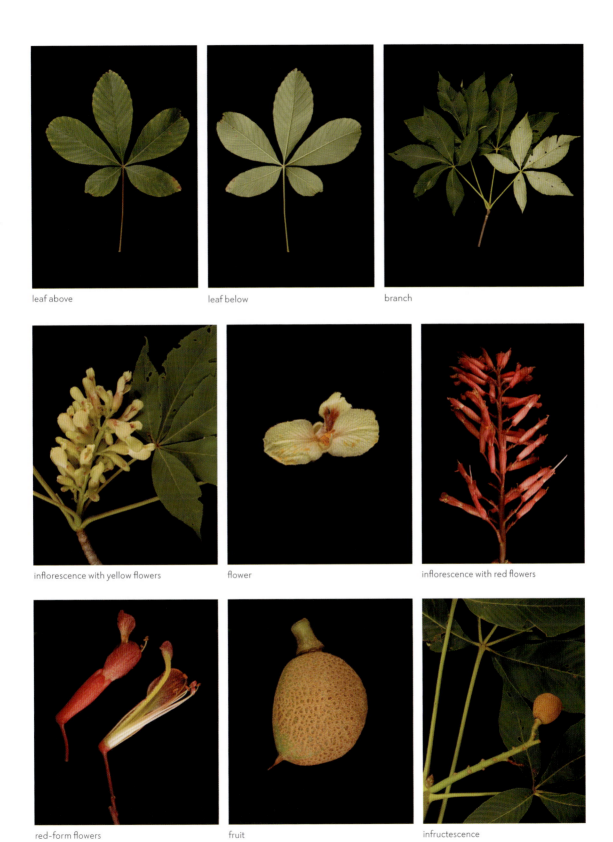

FAMILY SAPINDACEAE • 315

Ohio Buckeye
Aesculus glabra Willd.

Ohio buckeye is a medium-sized tree native to the lower Great Plains and midwestern regions of the United States. The shiny capsular fruits, which contain high quantities of tannic acid, have been used by Native Americans to tan leather.

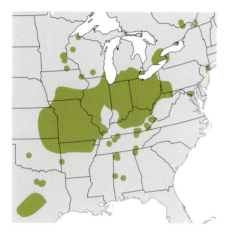

DESCRIPTION. A long-lived, deciduous tree, growing to 49 ft (15 m) tall. Twigs are reddish brown, becoming gray. Bark is yellowish brown, smooth or scaly, becoming darker and furrowed. Leaves are opposite, palmately compound, 3–7 in (7.5–17.5 cm) long, with five, rarely seven, leaflets, 2.8–5.9 in (7–15 cm) long, elliptic to obovate, glabrous, and yellowish green above, paler below, margins finely serrate. Trees are monoecious with separate male and female flowers or with perfect flowers on the same plant, blooming in mid-spring. Flowers are yellowish green, with four petals on upright panicles, 4.7–5.9 in (12–15 cm) long. Fruits are round, prickly, light brown capsules, 1.2 in (3 cm) across, usually containing one smooth brown seed.

USES AND VALUE. Wood not commercially important. Used as pulpwood and for utility-grade board for boxes and crates. Twigs and seeds contain a poisonous glucoside called aesculin and therefore unsuitable source of food for wildlife. Native Americans eat the seeds after boiling or roasting to eliminate the toxin. Minute dose of seeds used to treat spasmodic coughs, asthma, and internal ailments. Sometimes cultivated as ornamental. Flowers attract hummingbirds, which feed on the nectar.

ECOLOGY. Grows in wet-mesic woods, bottomlands, streambanks, and flood plains. Intermediate in shade tolerance. Relatively free of damaging insects and fungi.

CLIMATE CHANGE. Vulnerability is high, may have little capacity to adapt to changing conditions, and has a low potential to persist in the future. Ongoing monitoring is required.

CONSERVATION STATUS. Least concern.

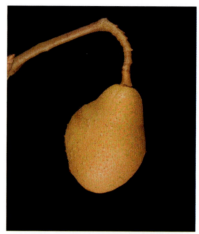

fruit

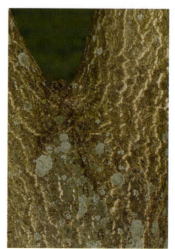

bark

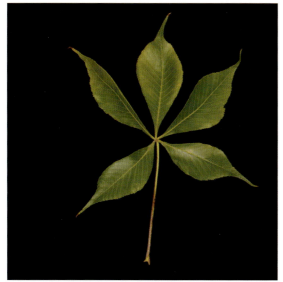
leaf above

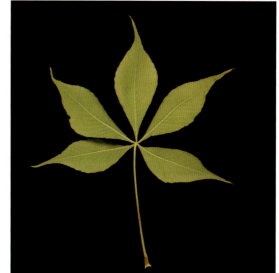
leaf below

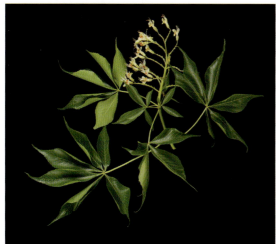
branch

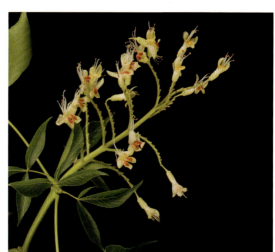
inflorescence

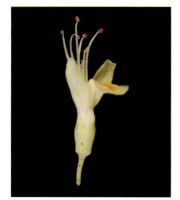
flower

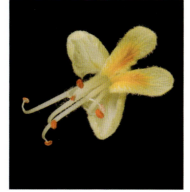
flower

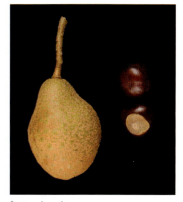
fruit and seeds

FAMILY SAPINDACEAE • 317

GENUS KOELREUTERIA

This species never receives its due, but offers amazing climatic and cultural adaptability as well as stunning flowers and handsome fruit.

—Michael A. Dirr on *Koelreuteria paniculata* in *Dirr's Encyclopedia of Trees and Shrubs*

The three species of the genus *Koelreuteria* are native to China and Korea. All are commonly planted as ornamental trees in gardens and landscapes in various parts of the world; one species is invasive outside of its native range. In addition to the large panicles of brightly colored flowers, the inflated fruits are characteristic of these trees. One introduced species is a common tree in North America.

Goldenrain Tree
Koelreuteria paniculata Laxm.

Goldenrain tree is native to eastern Asia and is cultivated in the United States for its attractive leaves, flowers, and seedpods. This small deciduous tree has a dome-shaped crown and bears tripartite, inflated capsular fruits that turn orange and pink in fall as they ripen.

DESCRIPTION. A moderate-lived, deciduous tree, growing 30–49 ft (9–15 m) tall. Twigs are reddish brown and zigzag. Bark is light gray brown with ridges and furrows. Leaves are alternate, pinnately or bipinnately compound, 5.9–13.8 in (15–35 cm) long, with seven to fifteen leaflets, 1.6–2.4 in (4–6 cm) long, glabrous and green above, paler and sometimes pubescent below, margins irregularly serrate and lobed. Flowers are perfect, yellow, 0.5 in (1.2 cm) wide, with four petals, in panicles, 9.8–15.7 in (25–40 cm) long, bloom in late spring. Fruits are papery, triangular, brown capsules, 1–2.2 in (2.5–5.5 cm) long, containing three round black seeds, 0.24–0.31 in (6–8 mm) across.

USES AND VALUE. Wood not commercially important. Cultivated as an ornamental in North America due to attractive and conspicuous flowers, leaves, and fruits. Considered an invasive in eastern United States, especially Florida.

ECOLOGY. Native to eastern Asia, thrives in urban environments.

CLIMATE CHANGE. Vulnerability is considered low because of its geographic distribution as an ornamental and invasive.

CONSERVATION STATUS. Least concern.

bark

leaf above

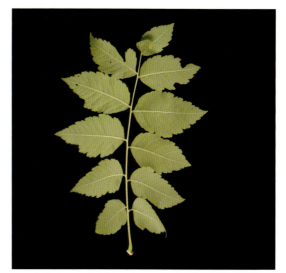
leaf below

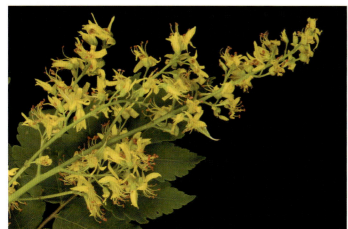
inflorescence

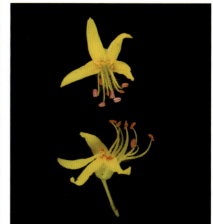
flowers

immature infructescence

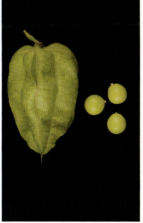
immature fruit and seeds

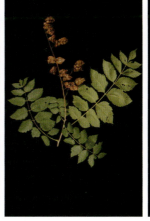
branch

mature fruit and seeds

FAMILY SAPINDACEAE • 319

GENUS SAPINDUS

The approximately ten species of *Sapindus* are small trees that are native to warm temperate and tropical regions around the world. The fruits produce soaplike compounds—hence the common name "soapberry" and Latin name *Sapindus*. Only a single native species of this genus is a common tree in North America.

Soapberry
Sapindus saponaria L.
WESTERN SOAPBERRY, WINGLEAF SOAPBERRY

Soapberry is a small to medium size deciduous tree that grows in subhumid to semiarid climates. The seeds are poisonous but sometimes used medicinally; fruits are used as soap. Two varieties are recognized.

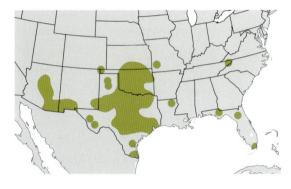

DESCRIPTION. A small to medium deciduous tree that grows 20–49 ft (6–15 m) in height. Twigs are yellowish gray to gray brown and may be pubescent. Bark is grayish to reddish brown and split by deep fissures into narrow plates. Leaves are alternate, pinnately compound, 8–18 in (20–45 cm) long, with four to ten pairs of oblong leaflets, green above, becoming yellow in fall, glossy and glabrous, with soft variable pubescence below, petiole winged. Trees are dioecious producing male and female flowers on separate plants, blooming in spring. Flowers are small, cream-colored, produced in axillary or terminal panicles, 5.1–9.8 in (13–25 cm) long. Fruits are fleshy, translucent, orange, wrinkled drupes, produced in clusters of ten to thirty, mature in fall and become shriveled and black by following spring. Seeds are one to three per drupe, dark brown, glossy with a minutely pitted surface.

TAXONOMIC NOTES. Variety *saponaria* is found in southeastern North America, from South Carolina to Mississippi; var. *drummondii* occurs in southwestern North America, from Louisiana to Arizona. Some taxonomic confusion remains concerning the status of these varieties.

USES AND VALUE. Wood not commercially important. Used as fuelwood and to make baskets. Sometimes cultivated as an ornamental. Produces poisonous saponins, thereby of low forage and browse value for livestock and wildlife. Seeds are poisonous; used medicinally by Native Americans. Fruits used to treat rheumatism, fever, and kidney diseases; also as soap and for washing laundry. Poultice of sap used in treating wounds.

ECOLOGY. Prefers subhumid to semiarid climates, where it grows on canyon sides, desert washes, and arroyos but also in foothills, uplands, wood margins, and disturbed areas. Very common in riparian woodlands. Tolerant of dry soils and often found on highly calcareous or clay soils.

CLIMATE CHANGE. Vulnerability is significant but may have capacity to adapt to changing conditions in the future. Ongoing monitoring is recommended.

CONSERVATION STATUS. Least concern.

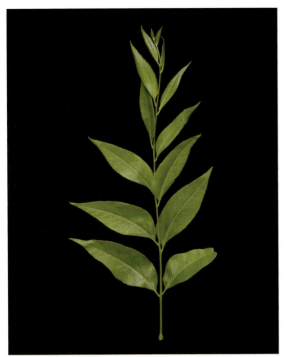
leaf above

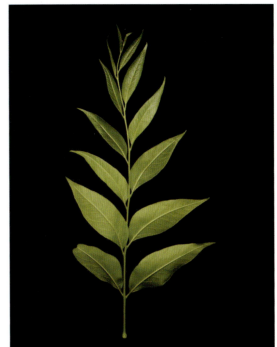
leaf below

branch

branch

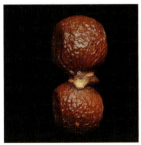
infructescence

fruit

Family Simaroubaceae

The trees and shrubs of the Simaroubaceae are mostly found in the tropics and subtropics, and a number of species are cultivated as ornamentals. The 100 species in this family lack the caustic resin found in some families of the order Sapindales (e.g., Anacardiaceae), uniting the Simaroubaceae with the families Meliaceae and Rutaceae, which also lack the resins. Only a single naturalized species is common in North America.

GENUS AILANTHUS

The vigor of ailanthus seedlings is amazing. Suckers ten feet high shoot up in one season. They appear in the most unexpected places. The tilting rafts on which the seeds are borne carry them with the wind, and lusty young trees come up in crannies of city back yards, covering unsightly objects with their graceful plumes of green.

—Julia Ellen Rogers on *Ailanthus glandulosa* (now *A. altissima*) in *The Tree Book: A Popular Guide to a Knowledge of the Trees of North America and to Their Uses and Cultivation*

Although it is ubiquitous in the urban landscape, Ailanthus *is never counted in street tree inventories because no one planted it—and consequently its contribution to making the city a more livable place goes completely unrecognized.*

—Peter Del Tredici on *Ailanthus altissima* in *Wild Urban Plants of the Northeast: A Field Guide*

The number of species that should be recognized in the genus *Ailanthus* is not clear—perhaps up to ten. All are distributed from East Asia to Australasia. The one introduced common species in North America is highly invasive and found in almost every state. It is ironic that this "nuisance species" is commonly called the "tree of heaven."

Tree of Heaven

Ailanthus altissima (P. Mill.) Swingle

Tree of heaven is a rapid-growing deciduous tree native to Asia and introduced into North America for its ornamental flowers and fruits. Trees rarely live to more than fifty years of age. Greenish yellow seeds with pink wings form large conspicuous clusters on the plant. The bark, leaves, and roots of this tree are used in traditional Chinese medicine.

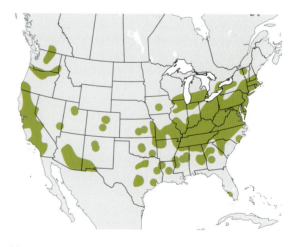

DESCRIPTION. A short-lived deciduous, very fast-growing tree, reaching up to 60 ft (18.3 m) tall and almost as wide. Bark is thin and brown. Leaves are alternate, pinnately compound, 17.7–23.6 in (45–60 cm) long, with up to twenty-five dark green leaflets, 2–6 in (5–15 cm) long, ovate to lanceolate, with broad teeth near base. Trees are usually dioecious producing male and female flowers on separate plants, blooming in mid-spring. Flowers yellowish green, growing in dense terminal clusters; male flowers, with a disagreeable fragrance, more conspicuous than female flowers. Fruits are greenish-yellow or reddish-brown samaras, 1–3 in (2.5–7.6 cm) long, produced in large clusters.

USES AND VALUE. Wood not commercially important. Originally cultivated as ornamental in urban settings because of resistance to air pollutants, arid conditions, and compacted soils common in city habitats. Used in reclamation forestry on former mine sites. Today considered noxious and invasive on National Forest System lands and in many states. Various parts used widely in traditional oriental herbal medicine. Seeds are eaten by birds, including pine grosbeak and crossbills.

ECOLOGY. Adaptable to wide variety of climatic conditions, with ability to colonize and invade new habitats. Prolific seeder; sprouts readily in harsh environments.

CLIMATE CHANGE. Vulnerability is considered low because of wide geographic distribution as an ornamental and invasive.

CONSERVATION STATUS. Least concern.

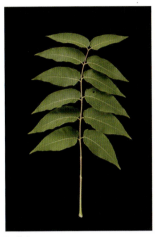
leaf above

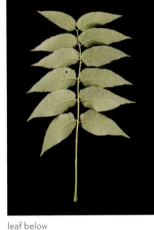
leaf below

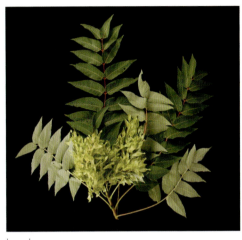
branch

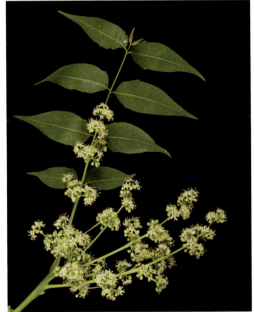
inflorescence

infructescence

fruit and seed

flowers

bark

FAMILY SIMAROUBACEAE • 323

Family Meliaceae

Members of the mahogony family, the Meliaceae, are found in most of the tropical regions of the world and grow as understory trees in rain forests, mangroves, and even deserts. The fifty-one genera and 550 species are considered to be closely related evolutionarily to each other based on evidence from DNA and non-DNA characters. The single species in the Meliaceae that is common in North America is not native, but is commonly cultivated.

GENUS MELIA

A scourge over much of the South, consuming fencerows and open spaces. On the flip side, a pretty round-headed tree with glossy dark green leaves, 1 to 2 ft. long, with 1 ½ to 2-in.-long toothed or lobed leaflets.

—Michael A. Dirr on Melia azedarach in Dirr's Encyclopedia of Trees and Shrubs

The genus *Melia* is composed of eight species native to Asia and Australia. The highly divided leaves and attractive small fruits with toxic seeds are characteristic of this genus. The single introduced species of *Melia* in North America is not native, often naturalizes around old homesites and along roadsides, and in some areas is invasive.

Chinaberry
Melia azedarach L.
INDIAN LILAC

Introduced from Asia, Chinaberry is a deciduous tree with a rounded crown and clusters of fragrant violet flowers. Widely cultivated, it is invasive in some states and is associated with soil disturbance and flooding.

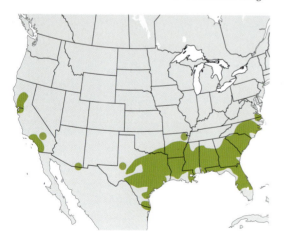

DESCRIPTION. A deciduous tree that grows 33–49 ft (10–15 m) tall with a rounded crown. Bark is purple or red and dotted with light lenticels. Leaves are alternate, bi- or tri-pinnately compound, 11.8–23.6 in (30–60 cm) long, leaflets dark green and glossy, pungent when crushed, margins serrate, 1–2 in (2–5 cm) long. Flowers perfect, clustered in a loose panicle, small, five-petalled, violet and aromatic. Fruits are drupes, various shades of yellow, 0.4–0.8 in (1–2 cm) in diameter, produced in clusters and is colored.

USES AND VALUE. Wood not commercially important. Widely cultivated, primarily in the southern United States, as an ornamental beginning in the 1830s, especially as a street tree. Roots are aggressive and may damage sidewalks and street pavement. Now considered invasive. Seeds are highly toxic to humans and other mammals. Birds consume fruits and disperse the seeds.

ECOLOGY. Grows in humid climates in subtropical to semiarid habitats in North America. Grows in areas disturbed by humans. Thrive on a variety of soil textures, pH values, and drainage levels.

CLIMATE CHANGE. Vulnerability is considered low because of wide distribution as an ornamental and invasive.

CONSERVATION STATUS. Least concern.

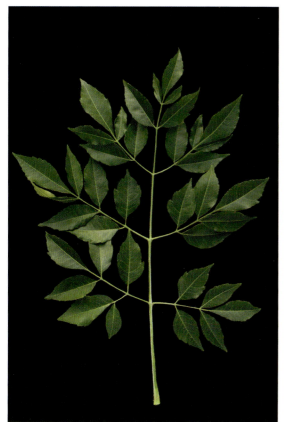
leaf above

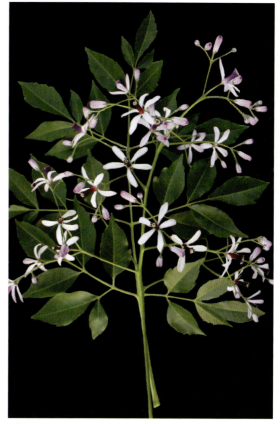
inflorescence

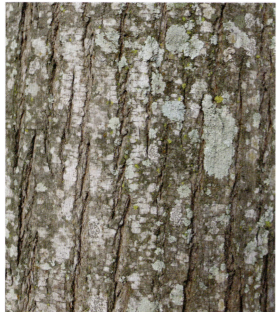
bark

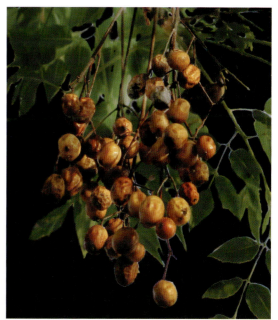
infructescence

FAMILY MELIACEAE • 325

Family Rutaceae

Although the members of the family Rutaceae make up a unified evolutionary group, the internal classification within the family is still not clear. One of the most characteristic traits of the Rutaceae is the tiny cavities present in the leaves and other tissues of the plant that contain ethereal oils and give the oranges and their relatives their special sweet oily odors. The family contains over 900 species and 155 genera that are native primarily to the tropical regions of the world, especially in the Southern Hemisphere; a few species also inhabit the Temperate Zone. The flowers of many species are intensely fragrant and attract various insects as their pollinators. The Rutaceae have evolved fleshy fruits with leathery or hard rinds, winged fruits, fruits that split open, and many other types of fruits as a means to disperse the seeds by animal (vertebrates) and non-animal (wind) vectors. Two native tree species in the Rutaceae are common in North America.

GENUS PTELEA

Its branches are short; its leaves remind one of poison ivy in their arrangement; its bark has a decidedly unpleasant odor, and so have its flowers, which are sought out by the carrionflies and pollinated by them. The fruits, which droop all winter on the tree and finally break off to sail by their wings on the wind, were once in high repute as a substitute for hops.

—Donald Culross Peattie on *Ptelea trifoliata* in *A Natural History of Trees of Eastern and Central North America*

All eleven species of the genus *Ptelea* are native to North America. The alternate three-foliate leaves and winged fruits are characteristic of these shrubs and small trees. One species is a common tree.

Common Hoptree

Ptelea trifoliata L.

Native to North America, the common hoptree is a small deciduous tree most frequently found on rocky slopes. The characteristic ridged bark is reddish to gray brown. The leaves are sometimes used as a substitute for hops in brewing beer, hence the common name.

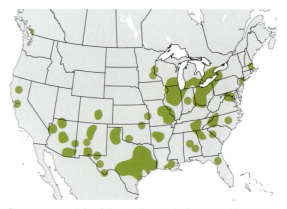

DESCRIPTION. A long-lived deciduous shrub or small tree, growing to 26 ft (8 m) tall. Twigs are brown. Bark is reddish to grayish brown with horizontal lenticels and corky ridges. Both bark and twigs have an unpleasant odor. Leaves are alternate, palmately compound, 7–11 in (17.5–28 cm) long, with three leaflets, shiny dark green above and paler below, ovate to elliptic, 2–5.9 in (5–15 cm) long, 1–3.1 in (2.5–8 cm) wide, margins entire or crenate-serrate, tips rounded, bases cuneate. Flowers are perfect or unisexual (trees then monoecious), pistillate flowers greenish white, 0.16–0.27 in (4–7 mm) long, in compound cymes, 1.6–3.1 in (4–8 cm) wide, with an unpleasant odor, blooming in late spring to early summer. Fruits are light brown waferlike samaras, 0.6–1 in (1.5–2.5 cm) wide with prominently veined wing.

USES AND VALUE. Wood not important commercially. Bitter-tasting fruits are edible. Leaves used as substitute for hops in making beer and added to yeast

to make flour rise more quickly when making bread. Bark of root is anthelmintic, antibacterial, and antiperiodic. Host of larvae of tiger swallowtail and giant swallowtail butterflies.

ECOLOGY. Grow on moist soils often in rich woodlands or on dry slopes.

CLIMATE CHANGE. Vulnerability is currently unknown. Immediate assessment is recommended.

CONSERVATION STATUS. Least concern.

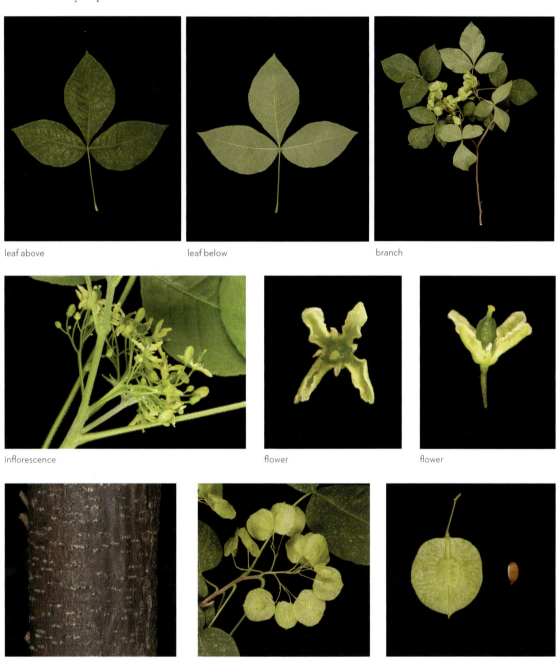

leaf above

leaf below

branch

inflorescence

flower

flower

bark

infructescence

fruit and seed

FAMILY RUTACEAE • 327

GENUS ZANTHOXYLUM

And one whiff of the lemony odor of the fruits of the Toothache-tree, or one nibble on their skins—which first completely benumbs the palate and then fiercely bites it—will inform your senses that you are making the acquaintance of something with an exotic flavor.

—Donald Culross Peattie on *Zanthoxylum americanum* in A Natural History of Trees of Eastern and Central North America

The nearly 250 species of the genus *Zanthoxylum* are distributed around the world in warm temperate and subtropical zones. The botanical name means "yellow wood" after the distinctive yellow coloration of the inner roots. Only a single species is a native common tree in North America.

Common Pricklyash
Zanthoxylum americanum Mill.
TOOTHACHE TREE

Common pricklyash is a widely occurring aromatic shrub or tree armed with spines up to a half-inch long. Related to oranges, the twigs of this tree have a strong citrus-like odor when crushed.

DESCRIPTION. An aromatic shrub or tree that grows up to 26 ft (8 m) tall. Twigs have a strong citric aroma when broken and are armed with prickles at the nodes. Bark is dark brown and spotted with prickles up to 0.51 in (13 mm) long. Leaves are alternate, pinnately compound, 11.8 in (30 cm) long, with leaflets dark green and speckled with glands above, undersides lighter in color and pubescent, 1.6–3.1 in (4–8 cm) long. Flowers are perfect or unisexual (trees then dioecious), green yellow, blooming in spring before leaves appear, 0.12 in (3 mm) in diameter.

Fruits are capsules, ripen in late summer, brown at maturity, 0.2 in (0.5 cm) in diameter, each containing a single seed that hangs from split capsule.

USES AND VALUE. Wood not commercially important. Oil extracts from bark have been used in traditional and alternative medicine. Used medicinally by many Native Americans for pain relief and variety of ailments. Fruits are eaten by birds and small mammals. Larval host for Thoas swallowtail (*Papilio thoas*), giant swallowtail (*P. cresphontes*), and spicebush swallowtail (*P. troilus*) butterflies.

ECOLOGY. Grows in riparian zones, on rocky hillsides, in thickets in prairie ravines, along roadsides, and in disturbed areas.

CLIMATE CHANGE. Vulnerability is currently unknown. Immediate assessment is recommended.

CONSERVATION STATUS. Least concern.

leaf above

leaf below

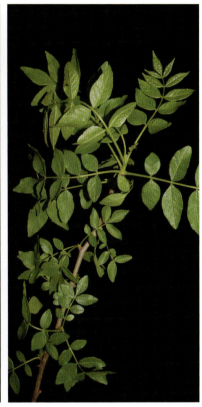
branch

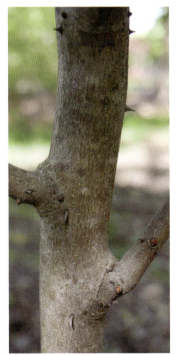
bark

immature infructescence

branch with infructescence

FAMILY RUTACEAE • 329

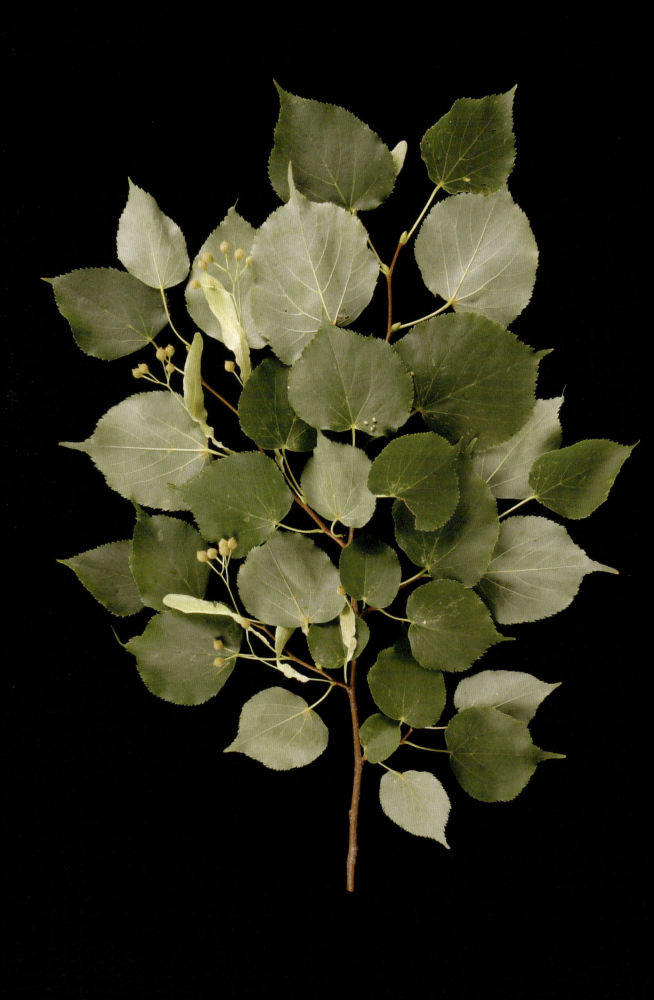

ORDER MALVALES

The nine or ten plant families and over 3,500 species in the Malvales share several unique characters in their wood structure, stamen development, and seed coat. DNA data strongly support that they are closely related. Within the order, the definition of the families has recently changed significantly: many genera are now placed into a very large mallow family, the Malvaceae. Many members of the Malvales are important tropical trees, and the large flowers of a number of them are pollinated by birds and bats. Only the family Malvaceae is represented in North America with three common species of tree.

Family Malvaceae

The family Malvaceae formerly included only those plants that were closely related to hibiscus. However, new evidence, primarily from DNA sequence data, has expanded the taxonomic boundaries of this family to include former members of the families Tiliaceae (lindens), Sterculiaceae (chocolate), and Bombacaceae (baobabs). This current classification includes 243 genera and over 4,200 species in the Malvaceae. Although some botanists contest this amalgamation of families, it is justified by what we know about the evolution of these plants and the fact that the traits of the four separate families were always somewhat indistinct. Three species in two genera are common native trees in North America.

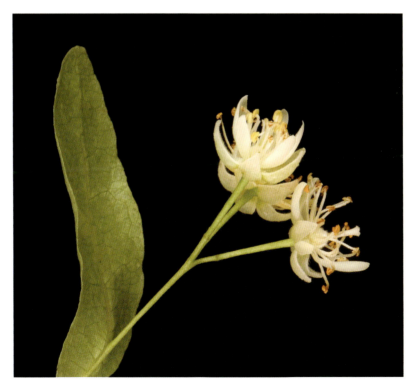

OPPOSITE American basswood (*Tilia americana*). **ABOVE** Littleleaf linden (*Tilia cordata*).

GENUS FREMONTODENDRON

The genus *Fremontodendron* is made up of three species of shrubs and small trees native to southwestern North America and northern Mexico. The conspicuous bright yellow flowers make these species popular as ornamental trees. Only one native species is a common tree in North America.

California Flannelbush
Fremontodendron californicum (Torr.) Coville

California flannelbush is a fast-growing, large shrub or small tree that grows in Mediterranean climates on dry granitic slopes of chaparral, in open woodlands, and on dry slopes and foothills. Some naturalists may not consider this species to be a true tree, but it is common and included here for completeness.

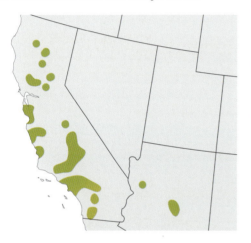

DESCRIPTION. A fast-growing, spreading, evergreen shrub or small tree that reaches up to 10 ft (3 m) tall. Twigs are covered in dense stellate hairs. Leaves are alternate, simple, three- to five-lobed, ovate, soft, leathery, dark green and pubescent above, paler and velvety below, leaf bases shallowly cordate, 0.5–2 in (1.2–5 cm) long, with petioles up to 1.2 in (3 cm) long. Flowers are perfect, borne on stalks, 0.16–0.71 in (4–18 mm) long, subtended by three sepal-like bracts, keeled, sepals yellow to red, with silky pit margins, 1.38–2.36 in (35–60 mm) wide, blooming in late spring to early summer. Fruits are spherical capsules, 0.50–1.5 (1.2–4 cm) across, ovoid, pubescent, dull brown.

USES AND VALUE. Wood not commercially important. Sometimes used for habitat restoration. Commonly cultivated as landscape plant and valued for conspicuous and attractive inflorescences and flowers. Tea made from the inner bark to relieve throat inflammation. Provides browse for livestock and wildlife.

ECOLOGY. Prefers Mediterranean climates growing on dry granitic slopes in the foothills of chaparral and in open woodlands at elevations from 656 to 7,546 ft (200–2,300 m). Highly drought tolerant and intermediate in shade tolerance.

CLIMATE CHANGE. Vulnerability is currently unknown. Immediate assessment is recommended.

CONSERVATION STATUS. Least concern.

bark

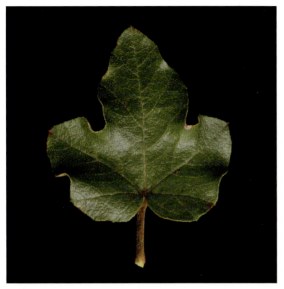
leaf above

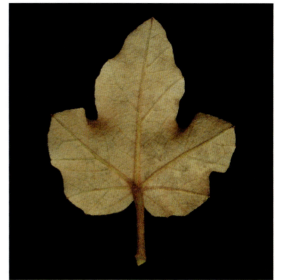
leaf below

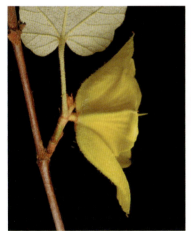
flower

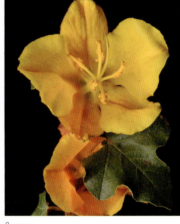
flower

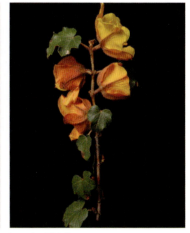
branch with inflorescence

branch

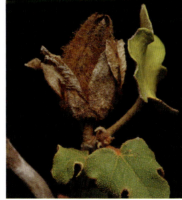
fruit

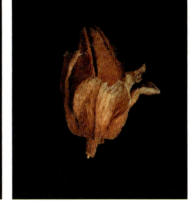
fruit

FAMILY MALVACEAE • 333

GENUS TILIA

When the shade begins to be heavy and the midges fill the woods, and when the western sky is a curtain of black nimbus slashed by the jagged scimitar of lightning, when the wood thrush seldom sings except after rain and instead the rain crow, our American cuckoo, stutters his weary, descending song—an odor steals upon the moist and heavy air, unbelievably sweet and penetrating.

—Donald Culross Peattie on *Tilia americana* in *A Natural History of Trees of Eastern and Central North America*

The thirty species in the genus *Tilia* are distributed in the northern Asia, Europe, and North America. The large dense branches, rounded heart-shaped leaves, and very fragrant flowers make these species popular as ornamentals and street trees in urban environments. Various parts of the tree supply lumber, provide fibers for making baskets, and are used in herbal medicines and perfume. Two species, one native and one introduced, are common trees in North America.

American Basswood
Tilia americana L.
LINDEN

American basswood is native to eastern North America and mature trees produce small, yellowish-white flowers subtended by a conspicuous yellow bract. The flowers produce an abundance of nectar that rewards bees as pollinators resulting in a delicious honey.

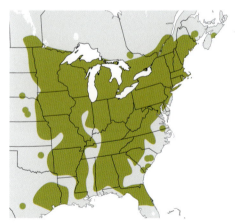

DESCRIPTION. A long-lived (up to 200 years) deciduous tree, growing 30–80 ft (10–26 m) tall with a long, clear, sometimes buttressed trunk, and a wide-spreading root system. Twigs are green to brown, zigzag, and smooth. Bark is gray brown, with scaly flat-topped ridges. Leaves are alternate, simple, ovate to obliquely cordate, green and glabrous above, paler and sparsely pubescent below, with serrate margins, 2.8–7.9 in (7–20 cm) long. Flowers are perfect, yellow white, hairy, with five petals, 0.47–0.59 in (12–15 mm) across, on drooping cymes attached to a conspicuous yellow bract, blooming in late spring. Fruits are gray to brown, nutlets, globose, hard, indehiscent, tomentose, 0.20–0.39 in (5–10 mm) across, in hanging clusters attached to persistent yellow bract.

USES AND VALUE. Wood commercially important. Used for carving, lumber, musical instruments, veneer, plywood, wood pulp, and fiber products. Cultivated as popular ornamental and shade street tree. Fibers of inner bark used for rope, baskets, mats, and fish nets. Leaves, twigs, and buds are used as food. Tea made from inner bark applied to burns to soothe and soften the skin. Leaves are taken internally to treat lung complaints, dysentery, heartburn, and weak stomach. Bark is diuretic. Flowers produce abundance of nectar taken by bees during pollination from which choice honey is made. Chipmunks, mice, squirrels, and birds eat the fruits and seeds. Rabbits and voles eat the bark. Larval host of various butterflies. Bark and trunks provide nesting cavities for many birds and small mammals.

ECOLOGY. Grows in moist to dry woods, on ravine slopes, and in dunes in the eastern United States. Good seed crops are produced annually; wind, water, and animals are the primary dispersal agents. Intermediate in shade tolerance. Attacked by many insects, including the linden borer (*Saperda vestita*), linden looper (*Erannis tiliaria*), basswood leafminer (*Baliosus nervosus*), spring cankerworm (*Paleacrita vernata*), fall cankerworm (*Alsophila pometaria*), whitemarked tussock moth (*Orgyia leucostigma*),

gypsy moth (*Lymantria dispar*), and forest tent caterpillar (*Malacosoma disstria*). Leaves host to various diseases, including anthracnose (*Gnomonia tiliae*), black mold (*Fumago vagans*), and leaf spot (*Cercospora microsora*).

CLIMATE CHANGE. Vulnerability is significant but has a reasonable probability of persistence in the future. Ongoing monitoring is recommended.

CONSERVATION STATUS. Least concern.

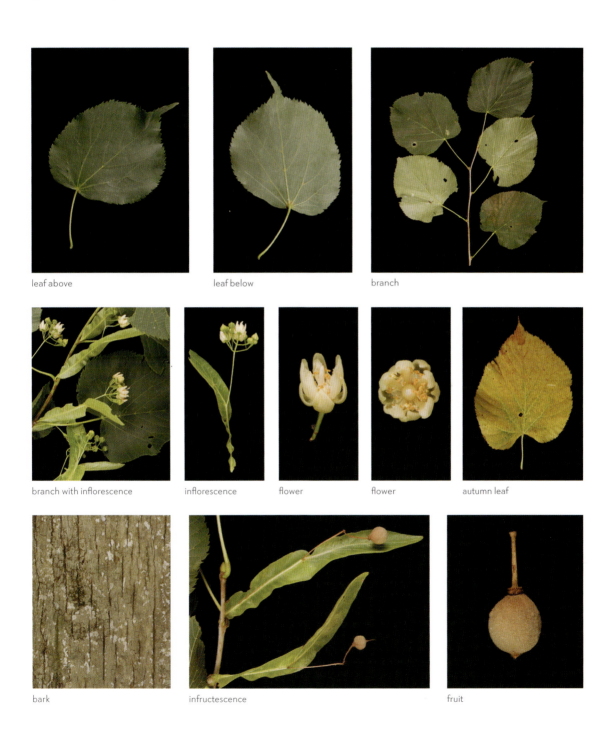

leaf above · leaf below · branch

branch with inflorescence · inflorescence · flower · flower · autumn leaf

bark · infructescence · fruit

Littleleaf Linden
Tilia cordata P. Mill.

Littleleaf linden is native to Europe and western Asia and was introduced into the United States as an ornamental street and shade tree to substitute for the native American Linden (*Tilia americana*). These deciduous trees are characterized by distinctive, alternate, heart-shaped leaves and very fragrant flowers produced in early summer.

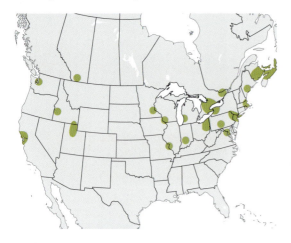

DESCRIPTION. A moderate-sized, deciduous tree, growing up to 100 ft (30 m) or taller. Twigs are green brown or tinged with red, slender, lustrous, and zigzag. Bark is gray brown and becomes ridged and furrowed with age. Leaves are alternate, simple, ovate to cordate, green and glabrous above, paler with axillary pubescence below, with an asymmetrical base and serrate margins, 2–4 in (5–10 cm) long. Flowers are perfect, yellowish, small, borne in clusters of five to seven flowers below a leafy bract, 3.5 in (9 cm) long, blooming in early summer. Fruits are nutlets with gray pubescence, globose, thin shelled, 0.24 in (6 mm) across, in clusters attached to the persistent leafy bract.

USES AND VALUE. Wood not important commercially. Cultivated as a popular shade and ornamental tree often planted along streets in urban areas. Nectar produced by flowers serves as reward for pollinating bees and makes delicious honey. Young leaves eaten in salads.

ECOLOGY. Cultivated as non-native street tree that grows in full sun to part shade and tolerant of a range of growing conditions.

CLIMATE CHANGE. Vulnerability is considered low because of its wide geographic distribution as an ornamental tree.

CONSERVATION STATUS. Least concern.

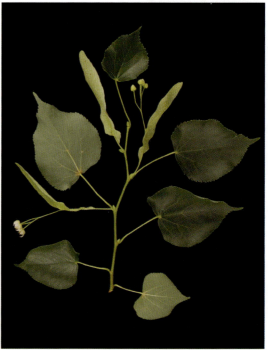
branch

bark

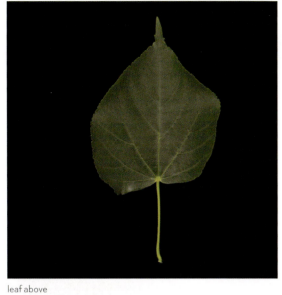
leaf above

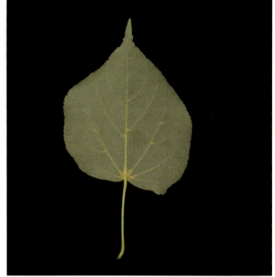
leaf below

branchlet with inflorescence

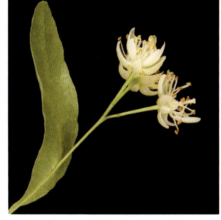
inflorescence

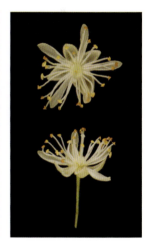
flowers

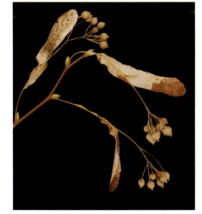
branchlet with infructescence

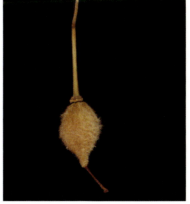
fruit

seed

FAMILY MALVACEAE • 337

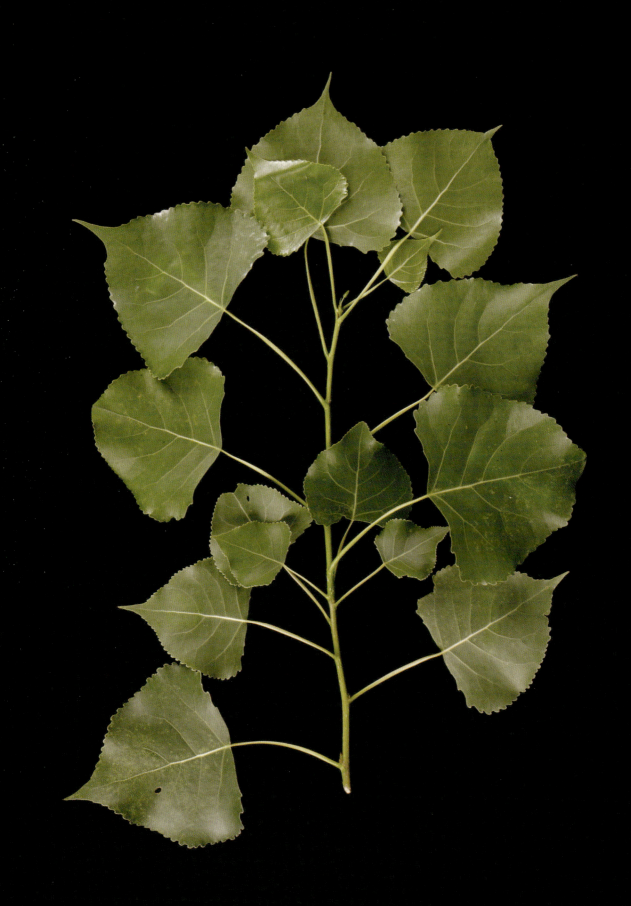

ORDER MALPIGHIALES

The evolutionary relationships among the dozens of families and thousands of species (over 13,000 species in all) in the Malpighiales are still under intense debate and study. Similar to the Rosids as a whole, DNA data provided the evidence for uniting this heterogeneous assemblage of plants into a single order. Very few flower or fruit traits are shared by all the members of the order, which includes the spurges, Saint-John's-worts, red mangroves, Barbados cherries, coca plants, passion flowers, violets, willows, and many other lesser-known species. The largest flower in the world, the parasitic plant *Rafflesia*, is a member of the Malpighiales. In North America, only two families are represented as common trees; most of the common species are in the willow family.

Family Euphorbiaceae

The large family Euphorbiaceae contains between 200 and 300 genera and over 6,000 species. Botanists have had difficulty in determining the closest evolutionary relatives of this family. At one time, it was considered to have evolved with members of the Malvales, but DNA sequence data have shown it to be better allied with other families of the order Malpighiales. Many features of the leaves, flowers and fruits differ among members of the Euphorbiaceae, which are widely distributed in primarily tropical habitats. Some botanists have cited these differences as a reason to the divide the family into several smaller families. Concerted work on the evolution of the Euphorbiaceae is now underway. The name *euphorbia* comes from Euphorbu, who was a Greek court physician to Iuba II, the king of Mauritania in the first century AD. Both common trees in North America in this family are non-native cultivated species.

OPPOSITE Eastern cottonwood (*Populus deltoides*)

GENUS RICINUS

The genus *Ricinus* contains only a single species, which is native from the Mediterranean region to India, but is now cultivated around the world as an ornamental and for the production of castor oil. This fast-growing herbaceous shrub can attain the size of a small tree in a single season. The entire plant, especially the seeds, is highly poisonous.

Castorbean
Ricinus communis L.

Castorbean is a toxic annual small tree or shrub introduced into North America from the Mediterranean, East Africa, and India. Castor oil is used in cosmetic products and to treat numerous ailments even though the seeds are highly toxic to humans.

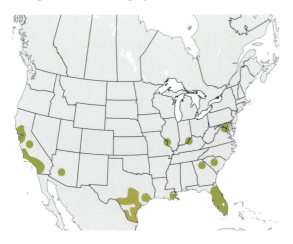

DESCRIPTION. A tall shrublike to rarely treelike multistemmed annual herb. Leaves are alternate, simple, large, red green, palmately lobed with six to eleven lobes. Flowers are white, clustered, blooming from summer to fall. Fruits are prickly red capsules. Seeds are flattened, mottled brown and gray, highly poisonous.

USES AND VALUE. Wood not commercially important. Highly toxic to humans. Ricin, a toxic protein in seeds, is a blood coagulant. Castor oil used to induce labor, treat variety of ailments, and in cosmetic products. Cultivated commercially. Allergies to plant are commonplace and severe.

ECOLOGY. Introduced from the Mediterranean, East Africa, and India; most often cultivated in temperate climates where the environment is wet or moist, frequently on sandy or clay loams.

CLIMATE CHANGE. Vulnerability is considered low because of its wide geographic distribution as a cultivated plant.

CONSERVATION STATUS. Least concern.

fruit and seeds

bark

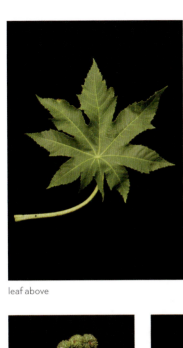
leaf above

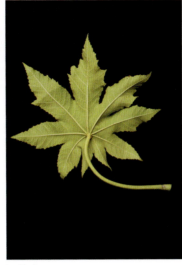
leaf below

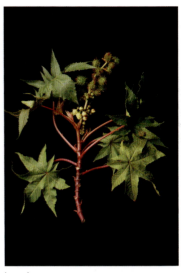
branch

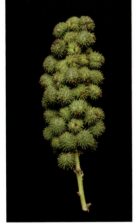
immature infructescence

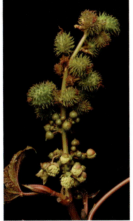
infructescence with immature fruit

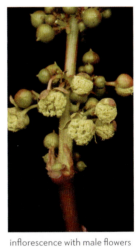
inflorescence with male flowers

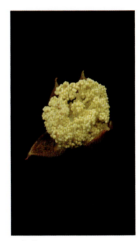
male flowers

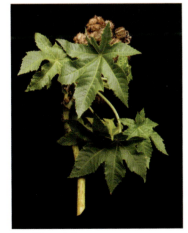
branchlet with fruits

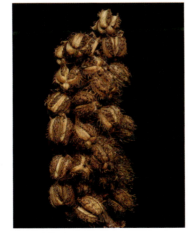
mature infructescence

fruit

FAMILY EUPHORBIACEAE • 341

GENUS TRIADICA

Entertaining and educational how one person's weed is another's garden treasure. This species is just such a double-edged sword, with rampageous, self-seeding, noxious weed status in the coastal South and respectable small tree status in zone 7.

—Michael A. Dirr on *Triadica sebifera* in *Dirr's Encyclopedia of Trees and Shrubs*

The genus *Triadica* is made up of three species, which are all native to eastern Asia, but have been introduced as ornamental trees in some parts of the world, including North America. Only one cultivated species is a common tree in North America.

Chinese Tallow
Triadica sebifera (L.) Small
TALLOWTREE

Chinese tallow is an introduced ornamental tree that has naturalized in the southern United States, where it is weedy and invasive. A fast-growing deciduous tree it can colonize wet open habitats and persists on a wide range of soil types.

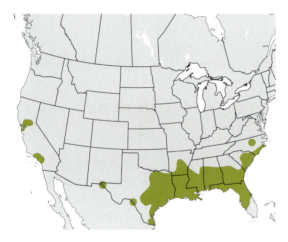

DESCRIPTION. A quick-growing deciduous tree to 23–36 ft (7–11 m) tall, although may reach heights up to 66 ft (20 m). Trunk is gnarled, with deep taproot. Bark is fissured, thickens as the tree ages. Leaves are alternate, simple, oval to triangular, dark green above, paler below, margins smooth, tip long-pointed, 2.6–5.1 in (6.5–13 cm) long. Trees are monoecious with separate male and female flowers produced on the same plant. Flowers are borne in terminal spikes, 2.4–7.9 in (6–20 cm) long, up to five female flowers at the base and fifteen male flowers along the spike. Fruits are three-lobed capsules with three waxy seeds, ripen from August to November.

USES AND VALUE. Wood not commercially important. Formerly cultivated as ornamental because of attractive red foliage and for soap and seed oil production. Now noxious weed in Florida and Texas, where sale is prohibited. Listed as a Category 1 weed species by Southern Region of the United States Forest Service.

ECOLOGY. An invasive weed in most areas of the southern United States, where it invades riparian areas and disturbed moist habitats. Shade tolerant, flood tolerant, and persistent in moderate salinity on a wide range of soil types.

CLIMATE CHANGE. Vulnerability is considered low because of its wide geographic distribution as an invasive.

CONSERVATION STATUS. Least concern.

leaf above

leaf below

fruits

FAMILY EUPHORBIACEAE • 343

Family Salicaceae

The classification and evolutionary position of the family Salicaceae has changed substantially over the last century. Early botanists considered the simple, inconspicuous flowers, which lack petals and are grouped in pendent clusters, as a "primitive" feature and thought the genera *Salix* and *Populus* (poplars) were some of the oldest flowering plants, from which other plants with more conspicuous and colorful flowers evolved. Later taxonomists, using evidence from DNA sequence data, have shown that these plants are not primitive and that the "simple" flowers are highly reduced and have evolved from plants with larger showy flowers. Most recently, the taxonomic concept of the Salicaceae has been broadened even further to include tropical species formerly classified in other families. The small flowers of *Salix* lack petals but have nectaries, and the hanging flower clusters, or catkins, are visited by insects, although wind may also disperse the pollen between flowers on different trees. Two genera with twenty species are common trees in North America.

GENUS POPULUS

Of all of our trees, none is more talkative than this. A breeze that is barely felt on the cheek will set the foliage of the Trembling Aspen into a panic whispering.

—Donald Culross Peattie on *Populus tremuloides* in *A Natural History of Trees of Eastern and Central North America*

A genus of up to thirty species, *Populus* is distributed in cooler regions of the northern Temperate Zone around the world, including North America, Europe, and Asia. Poplars are common in wet riparian habitats, are grown as ornamentals, and used for pulpwood. Individual trees produce either female flowers (and fruits) or male flowers, but not both (a condition called dioecy). One introduced and six native species of *Populus* are common trees in North America. (See p. 745 for leaf shapes of seven species of *Populus*.)

OPPOSITE Bigtooth aspen (*Populus grandidentata*)

White Poplar
Populus alba L.

White poplar, originally imported from Europe and planted as an ornamental tree, is a highly invasive species, vegetatively spreading, and hybridizing with native poplars throughout most of North America.

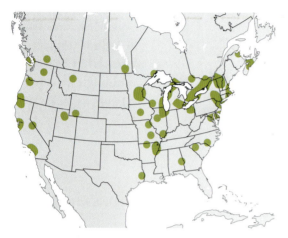

DESCRIPTION. A small deciduous tree that grows to 131 ft (40 m) tall and 7 ft (2 m) in diameter with open, wide, and rounded crown; low branches are persistent, trunk is sometimes divided at the base. Twigs are covered with whitish-gray down, including the small buds. Bark is smooth and greenish white to grayish white with characteristic diamond-shaped dark marks on young trees, becoming blackish and fissured at base of old trees. Leaves are alternate, simple, with three to seven blunt lobes, glossy blue green above, white with dense hairs below, margins toothed to wavy, 1.2–4.7 in (3–12 cm) long, longer than wide. Trees are dioecious with male and female flowers on separate plants, blooming in March and April. Flowers are in catkins, greenish white; female catkins are 1.6–2.8 in (4–7 cm) long, male catkins are 2–4 in (5–10 cm) long. Fruits are silvery-white, dehiscent capsules with seeds bearing long silky hairs. Sexual reproduction is rare for non-hybrids in North America.

USES AND VALUE. Wood not commercially important. A non-native species introduced from Europe, Asia, and northern Africa into North America in the mid-1700s, originally planted as an ornamental tree, often planted in parks and public areas. Now considered an invasive in some regions with sale banned in Connecticut.

ECOLOGY. Grows in open disturbed grasslands, shrublands, and flood-plain woodlands in moist, deep, loamy soils; also occurs on dry well-drained soils.

CLIMATE CHANGE. Vulnerability is considered low because of its wide geographic distribution as an ornamental and invasive.

CONSERVATION STATUS. Least concern.

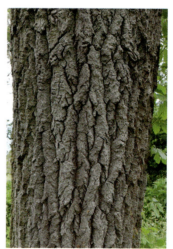
bark

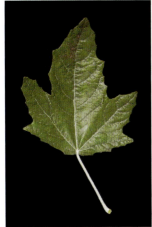
leaf above

leaf below

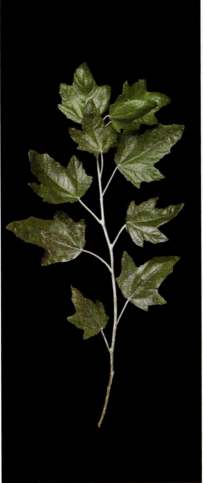
branch above

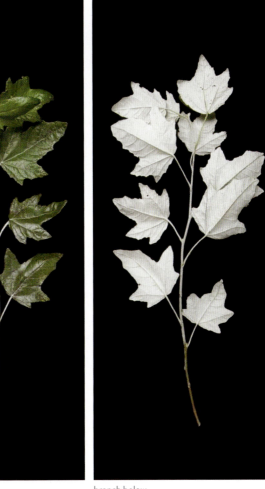
branch below

branchlet with infructescence

infructescence with fruits and seeds

FAMILY SALICACEAE • 347

Narrowleaf Cottonwood

Populus angustifolia E. James

Narrowleaf cottonwood is a medium-sized tree native to the streambanks and foothills of the North American Great Basin. The wood is somewhat important for crates, boxes, pallets, and pulpwood.

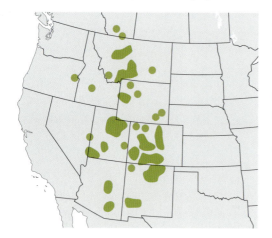

DESCRIPTION. A medium-sized tree that grows up to 66 ft (20 m) tall, usually single-stemmed with narrow or conical crown, spreading by stolons. Branchlets are orange brown, becoming whitish tan, round or five-angled, glabrous, winter buds are reddish brown, glabrous, and resinous. Bark is yellowish green to grayish brown and shallowly furrowed. Leaves are deciduous, simple, alternate, lanceolate to ovate lanceolate, petioles less than 0.6 in (1.5 cm) long, dark green above and slightly paler beneath, turning dull yellow in autumn, margins glandular toothed, base rounded, tip acute, 2–3.5 in (5–9 cm) long, and 0.4–1 in (1–2.5 cm) wide. Trees are dioecious with male and female flowers on separate plants, blooming from March to May. Flowers are densely clustered in catkins, 1.2–3.1 in (3–8 cm) long, borne on pedicels 0.02–0.06 in (0.5–1.5 mm) long. Fruits are capsules, ovoid, 0.24–0.31 in (6–8 mm) long, splitting to release seeds. Seeds are 0.08–0.12 in (2–3 mm) long, each with a tuft of long, white, silky hairs.

USES AND VALUE. Wood somewhat commercially important. Used for crates, boxes, pallets, fence posts, and as pulpwood. Bark contains salicin, or salicylic acid, a major component of aspirin as anti-inflammatory and febrifuge. Tea made from inner bark used in treatment of scurvy. Excellent as bank-stabilizing species for stable riparian communities providing habitat for many vertebrates. Major food plant for beavers.

ECOLOGY. Grows on streambanks, foothills, and high plains in the western United States on moist to mesic soils. Dominant in riparian areas of upper foothills and lower montane zones and principal tree along streams of semiarid regions. Shade intolerant.

CLIMATE CHANGE. Vulnerability is currently considered to be low.

CONSERVATION STATUS. Least concern.

infructescence with fruits and seeds

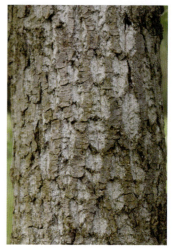

bark

leaf above

leaf below

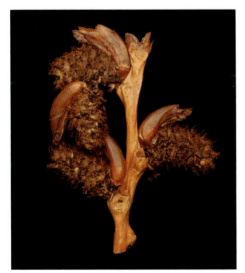
branchlet with male inflorescence

branch above

branch below

FAMILY SALICACEAE • 349

Balsam Poplar
Populus balsamifera L.

Balsam poplar is medium-sized tree native to the creekbanks, moist hillsides, and knolls throughout Canada and the northern United States. The wood is commercially important and the twigs provide browse for many mammals.

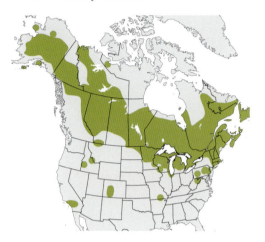

DESCRIPTION. A medium sized deciduous that grows to 98 ft (30 m) tall with an open crown and stoloniferous growth habit. Twigs are stout, round, shiny, and reddish brown with orange lenticels, winter buds are 1 in (2.5 cm) long and exude a sticky resin and a pungent balsam odor. Bark is smooth, light gray to grayish brown, furrowing with age. Leaves are deciduous, simple, alternate, ovate, shiny dark green above, and paler often blotchy orange below, margins finely serrate, petioles long with glands at the base, 2.4–4.3 in (6–11 cm) long, 1.6–2.9 in (4–7.5 cm) wide. Trees are dioecious producing male and female flowers on separate plants, blooming from April to May. Flowers are clustered in yellow-green catkins, 2–3.5 in (5–9 cm) long; male catkins have reddish stamens. Fruits are small, two-valved capsules that split to release the seeds. Seeds with tuft of long, white, silky hairs.

USES AND VALUE. Wood commercially important. Used for pulpwood, light construction lumber, high-grade particle board, and veneer core stock. Flowers and inner bark are edible. Medicinal uses are many, especially as expectorant and antiseptic. Wide variety of mammals browse on twigs, including moose, deer, elk, and snowshoe hare. Wood is a favorite of beavers as forage and building material.

ECOLOGY. Grows on creekbanks, moist hillsides, and knolls throughout Canada and the northern United States. Large seeds crops are produced almost every year; seeds are dispersed over very long distances by the wind. Seeds germinate quickly, as they are viable for only a short period of time. Susceptible to damage from fire, although bark thickens with age, providing better protection. Attacked by poplar and willow wood borer (*Cryptorhynchus lapathi*), bronze poplar borer (*Agrilus liargus*), and poplar borer (*Saperda calcarata*). *Phellinus tremulae* is most common decay-causing fungus; *Pholiota destruens*, *Corticium expallens*, and *Bjerkandra adusta* also cause damage.

CLIMATE CHANGE. Vulnerability is currently considered to be low.

CONSERVATION STATUS. Least concern.

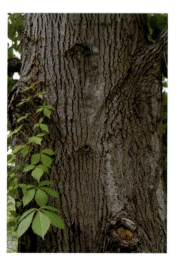

bark

leaf above

leaf below

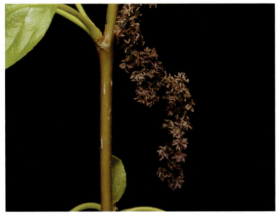
male inflorescence

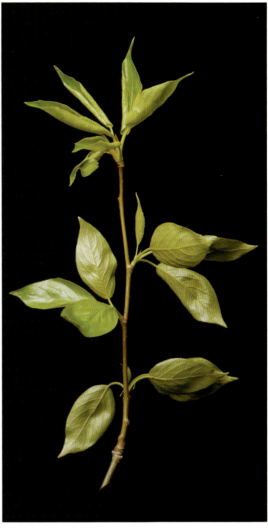
branch

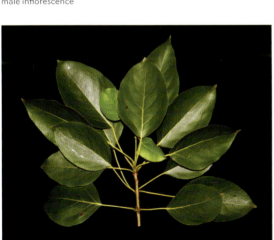
branchlet above

branchlet below

FAMILY SALICACEAE • 351

Eastern Cottonwood
Populus deltoides Bartr. Ex Marsh.

Eastern cottonwood is native to North America and one of the largest North American hardwoods with trunks up to 7 ft (2 m) in diameter. In the early summer the capsular fruits open and release numerous small seeds with cottonlike strands that drift for long distances on the wind.

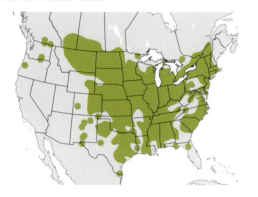

DESCRIPTION. A short-lived deciduous tree, growing to 131 ft (40 m) tall, with long clear trunk and small crown when growing in the forest or a massive trunk and spreading crown when growing in open habitats. Bark is gray and smooth on the branches, dark and deeply furrowed on the trunk. Leaves are alternate, simple, deltoid, dark green above, and pale below, margins crenate to serrate, with glands on top of the petiole, 2–4 in (5–10 cm) long. Trees are dioecious with male and female flowers produced on separate plants, blooming in mid-spring. Male flowers are clustered into aments, 2.9–4.9 in (7.5–12.5 cm) long, with red anthers; female flowers are green, produced in slender aments, 0.8–1.2 in (2–3 cm) long. Fruits are green capsules, 0.24–0.39 in (6–10 mm) long, attached to pedicels 0.12–0.39 in (3–10 mm) long, Seeds numerous, tiny, with cottony tufts.

USES AND VALUE. Wood commercially important. Used for pulpwood and core stock for plywood, often grown in plantations. Planted for erosion control. Inner bark, seeds, and leaves are edible. Leaves are rich in protein with greater amino-acid content than wheat, corn, rice, or barley. Bark contains salicin, or salicylic acid, a major component of aspirin, and used as anti-inflammatory and febrifuge. Deer, rabbits, beaver, and domestic livestock browse on twigs.

ECOLOGY. Grows on streambanks and in bottomlands. Good seed crops are produced annually; silky-haired seeds carried long distances by the wind; germination rates high, but seeds are short-lived. Shade intolerant. Attacked by many insects and fungal pests throughout its range. Susceptible to fire damage.

CLIMATE CHANGE. Vulnerability is currently considered to be low.

CONSERVATION STATUS. Least concern.

female flower

bark

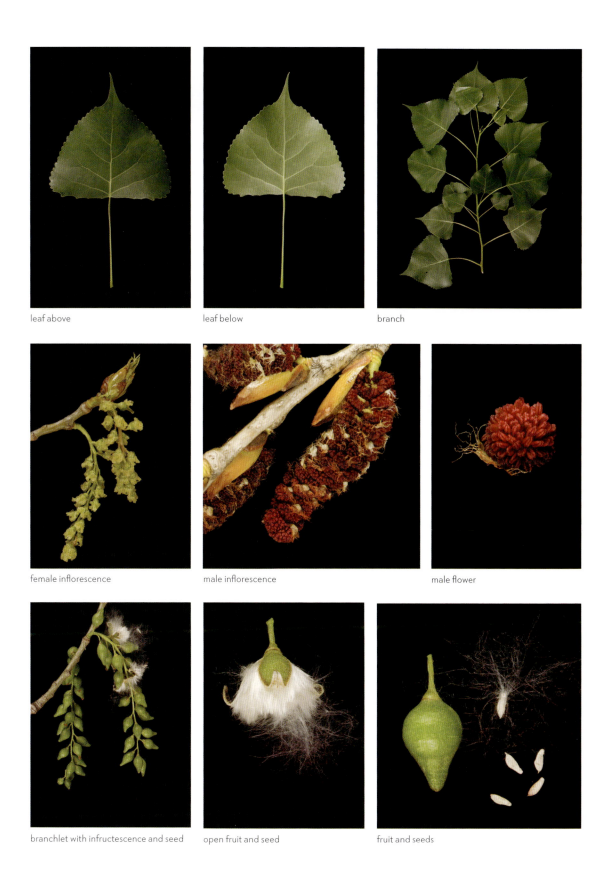

FAMILY SALICACEAE • 353

Fremont Cottonwood

Populus fremontii S. Watson

Populus fremontii is a large deciduous tree that grows in riparian zones of the southwestern United States near rivers, wetlands, and alluvial bottomlands. It is often planted for restoration and erosion control. Two subspecies are recognized.

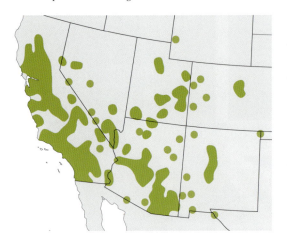

DESCRIPTION. A large deciduous tree that grows 20–112 ft (6–34 m) tall with broad, with yellow trunk graying with age and rounded crown. Winter buds are resinous. Bark is smooth on the trunk, twigs, and branches when young and becomes roughened and deeply furrowed with age. Leaves are simple, alternate, deltate, yellow green, and stained with milky resin, margins coarsely scalloped to dentate. Trees are dioecious with male and female flowers produced in catkins on separate plants, blooming in spring before the leaves appear. Male catkins are 1.5–3.3 in (3.75–8.3 cm) long; female catkins are 4–5 in (10.15–12.7 cm) long. Fruits are light brown, egg-shaped capsules, dehiscing into three sections to release small cottony seeds, 0.04 in (1 mm) long.

TAXONOMIC NOTES. Subspecies *mesetae* is commonly planted and occurs in the more arid, eastern part of the range; ssp. *Fremontii* is found in the western part of the range.

USES AND VALUE. Wood not commercially important. Cultivated as ornamental tree. Used in restoration of disturbed riparian zones, for windbreaks and erosion control, and for shade in recreation facilities, parks, and livestock. Catkins eaten raw or cooked. Young green seedpods chewed as gum. Bark contains salicin, or salicylic acid, a major component of aspirin, and used as anti-inflammatory and febrifuge. Tea made from the inner bark used in treatment of scurvy. Provides valuable habitat for birds and small mammals.

ECOLOGY. Grows in riparian zones of the southwestern United States near streams, rivers, wetlands, and alluvial bottomlands at elevations below 5,662 ft (2,000 m). Prefers well-drained alluvial sands or sandy clay loams. Shade intolerant.

CLIMATE CHANGE. Vulnerability is significant but has a reasonable probability of persistence in the future. Ongoing monitoring is recommended.

CONSERVATION STATUS. Least concern.

bark

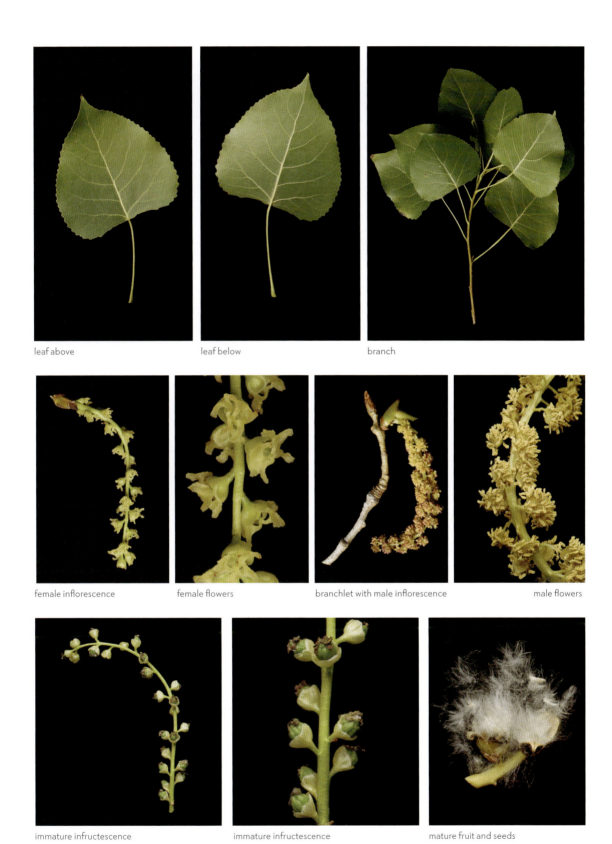

FAMILY SALICACEAE • 355

Bigtooth Aspen
Populus grandidentata Michx.

Bigtooth aspen is a medium-sized deciduous tree native to eastern North America. The leaves have characteristic coarsely toothed edges. The buds and flowers provide year-round food for the ruffed grouse.

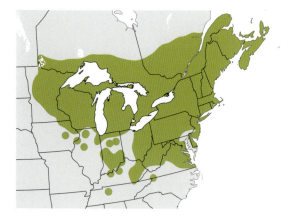

DESCRIPTION. A short-lived deciduous tree growing to 82 ft (25 m) tall with long clear trunk, irregular crown, and shallow wide-spreading root system. Twigs are grayish brown. Bark is greenish gray on branches, reddish and ridged with diamond-shaped lenticels on the trunk. Leaves are alternate, simple, ovate, green above and pale below, bases entire, margins coarsely toothed, 1.4–5.5. in (3.5–14 cm) long, and 2–4.3 in (5–11 cm) wide. Trees are dioecious with male and female flowers produced in drooping catkins on separate plants, blooming in early spring. Male catkins are 2–4 in (5–10 cm) long and 0.4 in (1 cm) in diameter; female catkins are 2.8–4.7 in (7–12 cm) long. Fruits are conical green capsules, 0.24 in (6 mm) long and 0.08 in (2 mm) in diameter. Seeds are brown and cottony.

USES AND VALUE. Wood commercially important. Used for pulpwood and veneer cores. Inner bark is edible and contains salicin, or salicylic acid, a major component of aspirin, and used as anti-inflammatory and febrifuge. Provides browse for deer, moose, and rabbits; ruffed grouse feed on the buds and flowers; beavers cut saplings and branches as food.

ECOLOGY. Grows in moist and sandy uplands. Produces seed annually and good crops every two to three years. Silky-haired seeds dispersed over long distances by the wind. Intolerant of shade. Susceptible to damage from fire. Windfirm, but crown is easily damaged by snow and ice. Attacked by hypoxylon canker (*Hypoxylon mammatum*) and poplar borer (*Saperda calcarata*).

CLIMATE CHANGE. Vulnerability is significant but has a reasonable probability of persistence in the future. Ongoing monitoring is recommended.

CONSERVATION STATUS. Least concern.

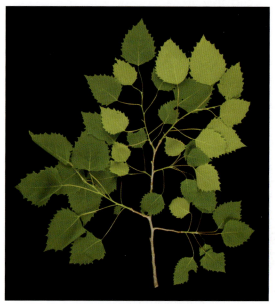
branch

bark

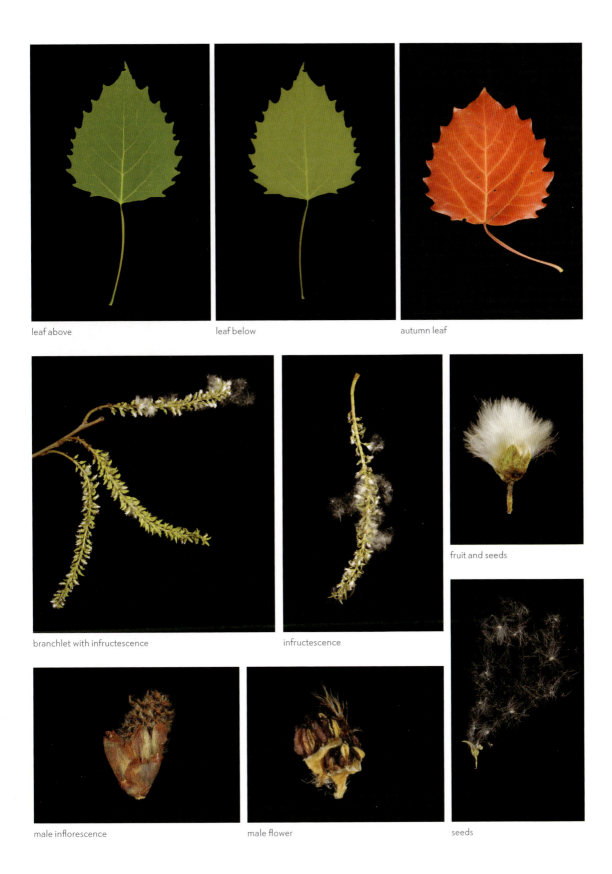

FAMILY SALICACEAE • 357

Quaking Aspen
Populus tremuloides Michx.
TREMBLING ASPEN

Quaking aspen is a deciduous tree native to the cooler regions of North America with glossy green leaves that become golden yellow in fall. Both its scientific name ("*tremuloides*") and one common name ("trembling aspen") are derived from the fluttering quality of its leaves in the wind. It is one of the most widely distributed trees in North America.

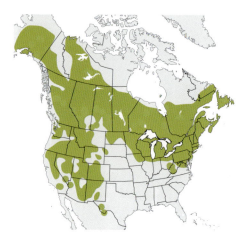

DESCRIPTION. A short-lived, deciduous tree growing to 98 ft (30 m) tall. Twigs are reddish brown with a grayish film. Bark is smooth, greenish white, and thin, peeling when young but thicker and furrowed in older trees. Leaves are alternate, simple, ovate, shiny dark green above, pale below, margins dentate, 1.6–2.4 in (4–6 cm) long. Trees are dioecious producing male and female catkins, 1–3 in (2.5–7.5 cm) long, on separate plants, blooming in early to mid-spring. Male and female flowers are light green. Fruits are narrowly ovoid capsules, 0.20–0.27 in (5–7 mm) long, splitting to release ten brown seeds with white silky hairs, 0.08 in (2 mm) long.

USES AND VALUE. Wood commercially important. Used for pulp, particleboard, veneer, plywood, novelty items, wooden matches, and wood flour. Inner bark, flowers, and sap are all edible. Widely used medicinally by Native North Americans for antiseptic and analgesic qualities to treat wounds and respiratory disorders. Provide habitat for variety of wildlife, including hare, black bear, deer, elk, ruffed grouse, woodcock, and small birds. Ruffed grouse use all age classes for brooding, pole stands for overwintering and breeding, and older stands for nesting cover and winter food. Favorite food of beavers.

ECOLOGY. One of the most widely distributed trees in North America that grows mostly on slopes, in hardwood as well as mixed conifer forests, in a variety of soils. Readily sprouts after fires. Good seed crops produced every three to five years; wind and water are primary dispersal agents. Shade intolerant. Damaging agents include mule deer, white-tailed deer, elk, moose, beaver, and porcupine that browse the bark and stems. Attacked by large number of insect pests and fungi, especially trunk and root rots.

CLIMATE CHANGE. Vulnerability is currently considered to be low.

CONSERVATION STATUS. Least concern.

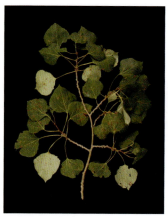
branch

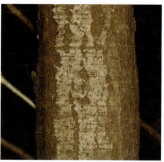
bark

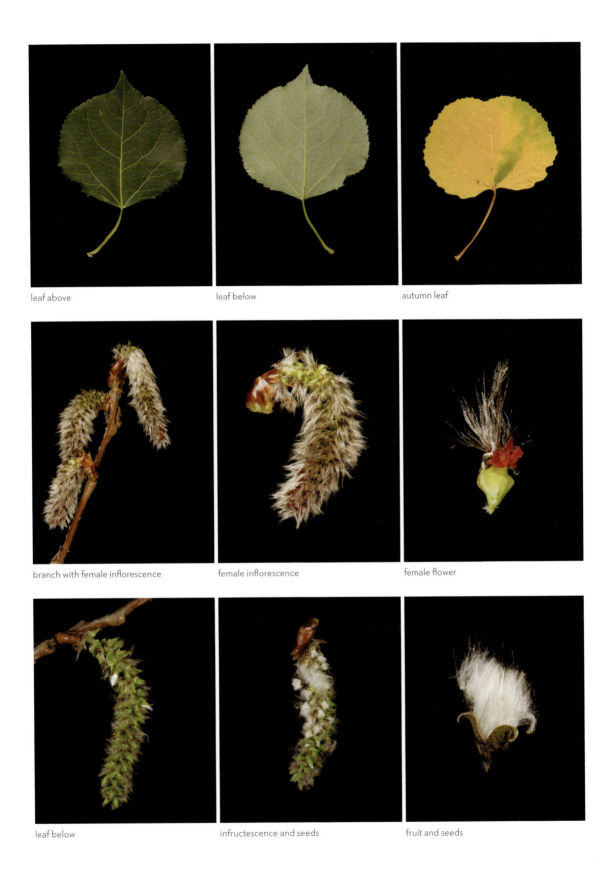

FAMILY SALICACEAE

GENUS SALIX

And though it has the worthless lazy look of some old riverbank loiterer, it plays, too, a heroic role. For where engineers have to face the problem of reinforcing levees, the Willow is unsurpassed for revetments. No other wood is so pliant yet tough, no other is so cheap, nor so ready at hand.

—Donald Culross Peattie on *Salix nigra* in *A Natural History of Trees of Eastern and Central North America*

About 400 species make up the genus *Salix*. They are found in the northern Temperate Zone around the world in Asia, Europe, and the Americas. The plants range from small shrubs to tall trees, and the shape of the leaves can be quite variable among the many species. Similar to their close relatives the poplars, trees in the genus *Salix* are dioecious; separate plants produce either all-male or all-female flowers. Willows prefer wet and riparian habitats. One introduced and twelve native species of *Salix* are common trees in North America. (See p. 750 for leaf shapes of thirteen species of *Salix*.)

White Willow
Salix alba L.
EUROPEAN WHITE WILLOW

White willow is native to Europe, Africa, and Asia that was introduced in the United States as an ornamental shade tree. The silky or hairy leaves above and below are the origin of the common and scientific names of this tree.

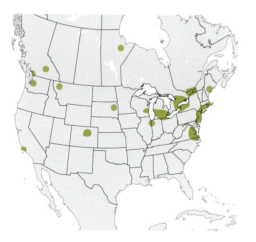

DESCRIPTION. A deciduous tree growing to 33–82 ft (10–25 m) tall and 49–98 ft (15–30 m) wide. Twigs are olive in color. Bark is ridged and olive. Leaves are alternate, simple, lance-shaped, narrower past the midpoint, petiole 0.25–0.5 in (0.6–1.3 cm) long, bright green and hairy above, whitish and hairy below, margins finely serrate, 1.5–4 in (3.8–10 cm) long, 0.25–0.5 in (0.6–1.3 cm) wide. Trees are dioecious with male and female flowers produced in catkins on separate plants, blooming in mid-spring when leaves emerge. Male flowers are in upright showy catkins, 0.8–2.4 in (2–6 cm) long, 0.24–0.5 in (0.6–1.3 cm) wide, slender or stout; female flowers are in upright catkins, 1.2–0.6 in (0.3–1.5 cm) long, 0.16–0.31 in (0.4–0.8 cm) wide. Fruits are two-valved capsules, 0.14–0.20 in (3.5–5 mm) long. Seeds covered in silky hairs.

USES AND VALUE. Wood not commercially important. Inner bark eaten raw or cooked; usually dried, ground into powder, and added to cereal flour for making bread. Original source of salicylic acid (the precursor of aspirin) and used for thousands of years to relieve joint pain and reduce fevers. Bark is anodyne, anti-inflammatory, antiperiodic, antiseptic, astringent, diaphoretic, diuretic, febrifuge, hypnotic, sedative, and tonic.

ECOLOGY. A native of Europe, northern Africa, and central Asia, was introduced as an ornamental shade tree in North America; naturalized along streambanks and in wetlands.

CLIMATE CHANGE. Vulnerability is considered low because of its wide geographic distribution as an ornamental and naturalized tree.

CONSERVATION STATUS. Least concern.

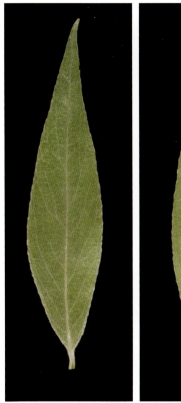
leaf above

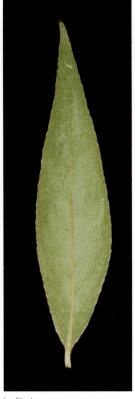
leaf below

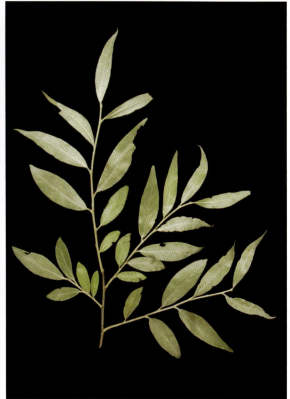
branch

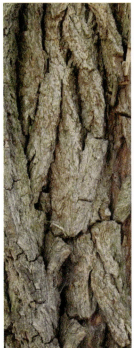
bark

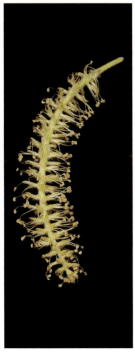
inflorescence

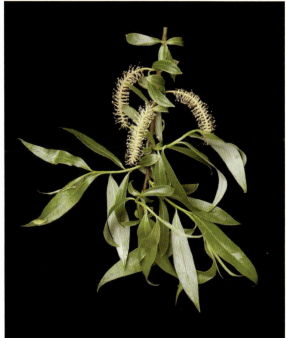
branch with inflorescence

FAMILY SALICACEAE • 361

Peachleaf Willow

Salix amygdaloides Andersson

Peachleaf willow is a tree native to the moist mesic flood plains and lakeshores throughout North America.

DESCRIPTION. A small tree that grows to 13–66 ft (4–20 m) tall, forming single trunk and rounded to slightly elongated crown. Twigs are smooth and brown. Bark is brownish gray, rough, shallowly furrowed, and somewhat scaly. Leaves are deciduous, simple, alternate, narrowly lanceolate to ovate, similar in form to those of a peach or almond, medium green and glabrous above, pale whitish green and glabrous below, slender petioles, 0.5 in (1.3 cm) long, margins finely serrate, apex acuminate, base cuneate or cordate, 1.2–5.1 in (3–13 cm) long, 0.4–1.6 in (1–4 cm) wide. Trees are dioecious producing male and female flowers in catkins on separate plants, blooming from April to June. Flowers are clustered in slender hairy catkins, lack sepals and petals. Fruits are capsules, 0.12–0.27 in (3–7 mm) wide.

USES AND VALUE. Wood not commercially important. Fresh bark contains salicin and used as anodyne and febrifuge; infusion of bark shavings used in treatment of diarrhea and stomach ailments; poultice of bark applied to bleeding wounds. Provides browse for wild ungulates, particularly moose and elk, as well as rabbits and beavers.

ECOLOGY. Grows on sands, silts, and gravels with little organic matter in moist bottomland plains and riparian woodlands. Shade intolerant.

CLIMATE CHANGE. Vulnerability is currently considered to be low.

CONSERVATION STATUS. Least concern.

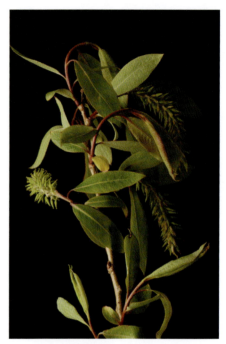

branch with female flowers

bark

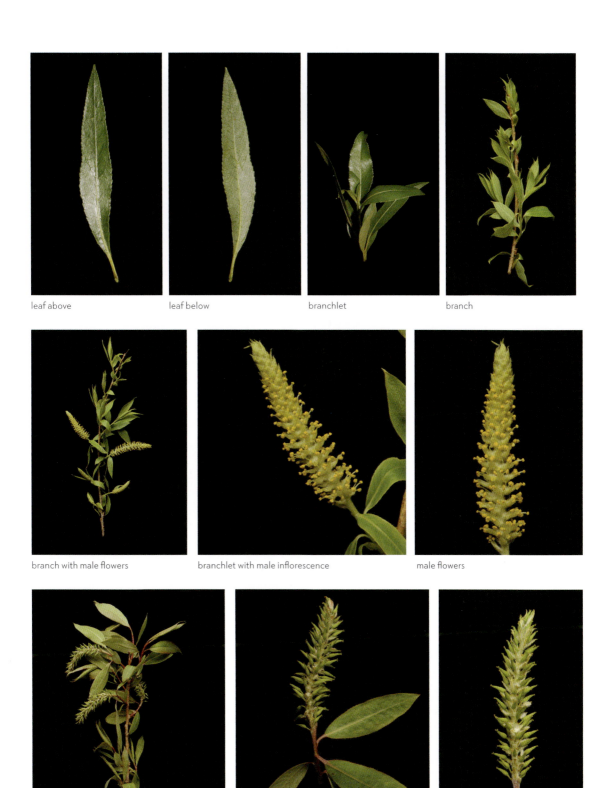

FAMILY SALICACEAE • 363

Bebb Willow
Salix bebbiana Sarg.
GRAY WILLOW

Bebb willow is a small, multistemmed tree native to Canada and the far northern United States. It is the source of "diamond willow" wood popular for carving and whittling.

DESCRIPTION. A deciduous, multistemmed tree growing to 26 ft (8 m) tall with branches upright near the ground and spreading above. Main trunk may have diamond-shaped patches caused by fungus. Bark is reddish brown and furrowed on large stems. Leaves are simple, alternate, narrow to elliptic, tapered at both ends, sometimes toothed near the base, petiole 0.12–0.39 in (3–10 mm) long, upper surface matte green and wrinkled, lower surface whitish and hairy, 1.2–2.8 in (3–7 cm) long. Trees are dioecious producing male and female flowers in catkins on separate plants. Male flowers are 0.4–0.8 in (1–2 cm) long, bloom before leaves emerge; female flowers are yellowish with reddish tips, 0.8–1.6 in (2–4 cm) long, bloom as the leaves appear. Fruits are long-beaked capsules, 0.24–0.31 in (6–8 mm) in length, on long stalks.

USES AND VALUE. Wood not commercially important. Primary producer of "diamond willow," which results from diamond-shaped patterns on trunks; when whittled or carved a diamond-shaped pattern is revealed due to the sharp contrast between white sapwood and reddish-brown heartwood. Used for canes, lamp posts, furniture, and candle holders. Fresh bark contains salicin, the source of aspirin, and used as anodyne and febrifuge. Major source of browse for moose, elk, and deer. Shoots, buds, and catkins eaten by many small mammals, birds, and beaver. Provides cover and protection for birds and mammals; shade for fish in streams and ponds. Larval host for mourning cloak and viceroy butterflies.

ECOLOGY. Grows in wet lowlands, lakes, and riparian areas on wet or damp soils and may persist on drier upland sites. Flowering begins at two to ten years of age, with optimum seed-production from ten to thirty years. Bees are chief pollinators. Shade intolerant.

CLIMATE CHANGE. Vulnerability is significant but has reasonable probability of persistence in the future. Ongoing monitoring is recommended.

CONSERVATION STATUS. Least concern.

branchlet

bark

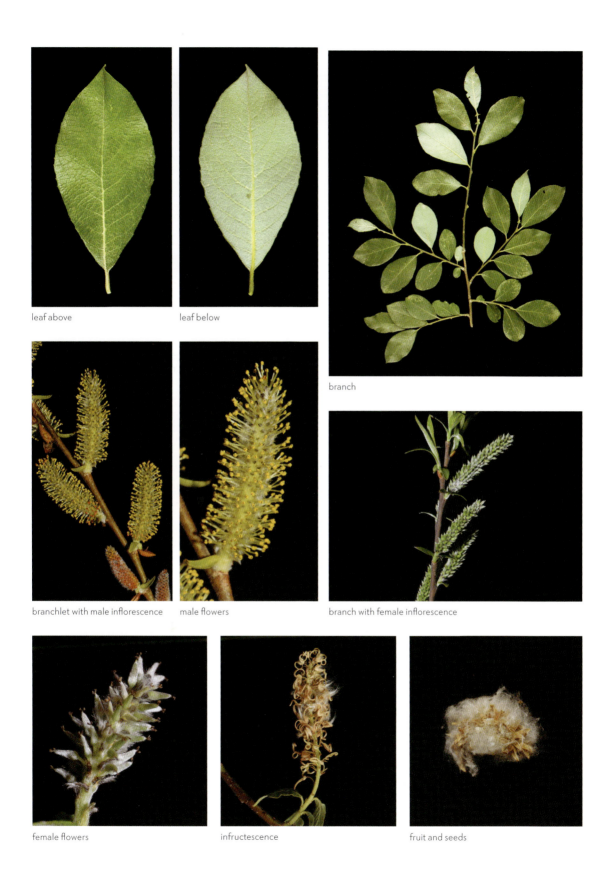

Coastal Plain Willow
Salix caroliniana Michx.

Coastal plain willow is a small tree or shrub native to the southeastern United States into parts of Central America restricted to wetland habitats. The pale yellow flowers emerge simultaneously with the leaves in spring.

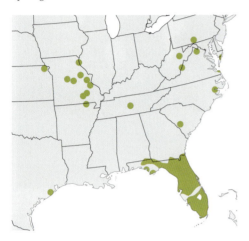

DESCRIPTION. A long-lived deciduous shrub or small tree growing up to 33 ft (10 m) tall with a short and often leaning trunk. Twigs are reddish brown to grayish brown, slender, brittle, and pubescent when young, becoming glabrous. Bark is gray to dark brown, developing ridges and furrows. Leaves are alternate, simple, lanceolate, margins finely serrate, green above, paler or glaucous below, 2–7.1 in (5–18 cm) long, 0.4–1.2 in (1–3 cm) wide. Trees are dioecious producing male and female flowers on separate plants, blooming in early spring. Flowers are pale yellow, very small, in catkins, 1.2–4 in (3–10 cm) long. Fruits are brown, egg-shaped capsules with a pointed tip that is 0.16–0.24 in (4–6 mm) long, glabrous but rough.

USES AND VALUE. Wood not commercially important. Trunks used for basketry and for producing woven wooden structures, such as fences and furniture. Sap contains salicylic acid, which is natural ingredient of aspirin. Provide food and cover for wildlife. Larval host plant for eastern tiger swallowtail, mourning cloak, eastern comma, red-spotted purple, and viceroy (*Limenitis archippus*) butterflies; larval host plant for Io moths (*Automeris io*).

ECOLOGY. Grows along streambanks, swamps, marshes, ponds, and lakes.

CLIMATE CHANGE. Vulnerability is significant but has a reasonable probability of persistence in the future. Ongoing monitoring is recommended.

CONSERVATION STATUS. Least concern.

branch

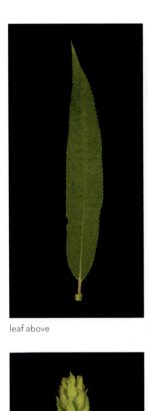
leaf above

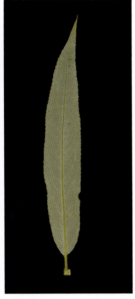
leaf below

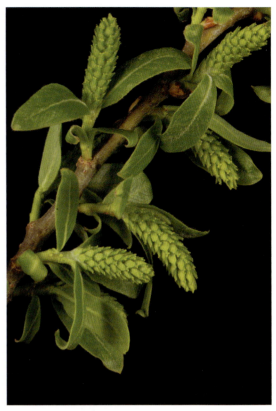
branch with female inflorescence

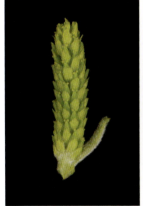
female inflorescence

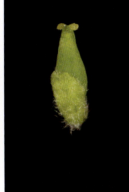
female flower

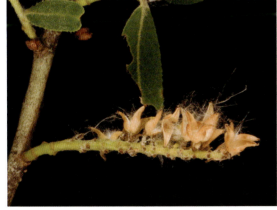
infructescence

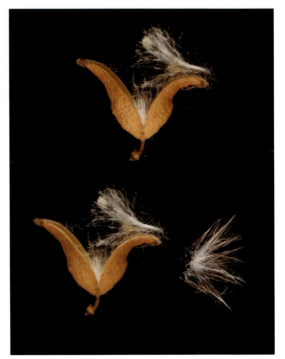
seeds with fruit

FAMILY SALICACEAE • 367

Pussy Willow
Salix discolor Muhl.

Pussy willow is a deciduous small tree or shrub that grows in marshy low-ground areas along streambanks and ditches. The twigs and branches are collected as cut flowers in spring as the fluffy catkins are expanding.

DESCRIPTION. A deciduous tree or shrub growing up to 26 ft (8 m) tall with suckering habit that forms dense stands in moist soils. Twigs are hairy when young, becoming glabrous with age. Bark is shallowly fissured and ridged, with large buds along the stems. Leaves are alternate, simple, oblong or elliptic, margins sometimes toothed, bright shiny green above with yellowish raised veins below, 1.2–5.1 in (3–13 cm) long. Trees are dioecious producing male and female flowers in catkins covered with dense silky hairs on separate plants. Male catkins are 0.6–2 in (1.5–5 cm) long; female catkins are 1–4.7 in (2.5–12 cm) long. Fruits are capsules, 0.20–0.51 in (5–13 mm) long. Seeds are small with rings of silky pubescence.

USES AND VALUE. Wood not commercially important. Branches harvested in spring with expanding flower buds serve as cut flowers. Deer, moose, caribou, muskrats, ruffed grouse, rabbits, and rodents browse stems; ducks and other waterfowl feed on catkins. Leaves host to *Galerucella decora* beetles. Larval host for variety of butterflies.

ECOLOGY. Grow in marshy low-ground areas along streambanks and ditches on poorly drained soils with neutral pH. Seed production begins when shrubs are eight to twenty-five years old; tufted seeds dispersed by wind. Shade intolerant.

CLIMATE CHANGE. Vulnerability is currently unknown. Immediate assessment is recommended.

CONSERVATION STATUS. Least concern.

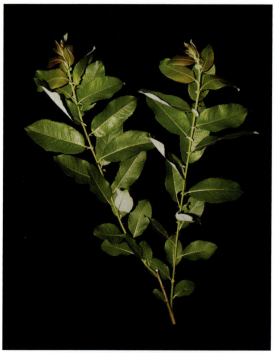

branch

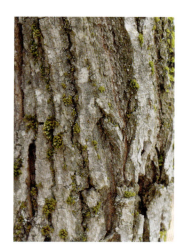

bark

368 • THE DIVERSITY OF TREES

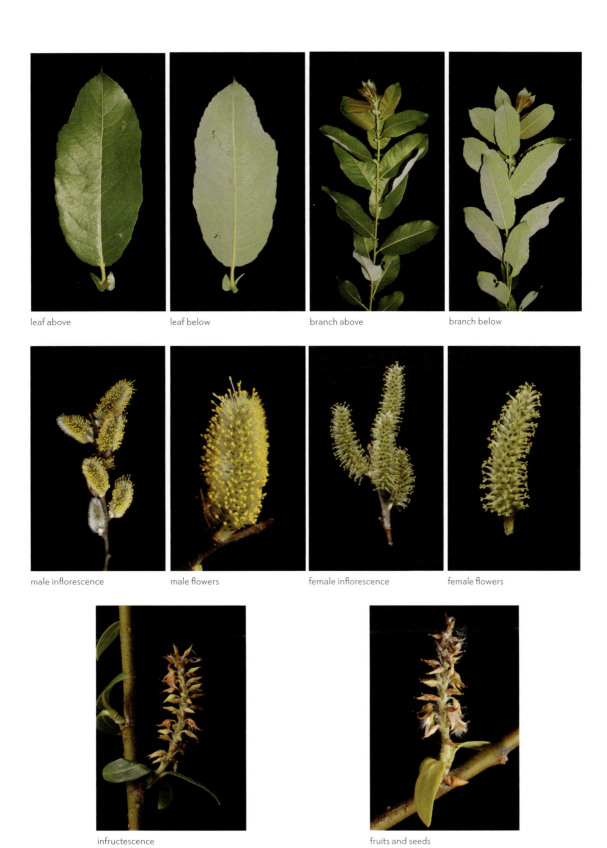

FAMILY SALICACEAE • 369

Sandbar Willow
Salix exigua Nutt.
NARROWLEAF WILLOW

Sandbar willow is a small tree or shrub native to the ditches, sandbars, and streambanks of the northern Great Plains and the northeastern United States. Two varieties are recognized.

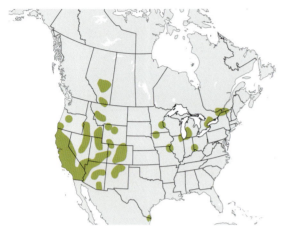

DESCRIPTION. A small tree or shrub that grows to 13–23 ft (4–7 m) tall, spreading by basal shoots to form dense clonal thickets. Twigs are slender, pale green to tan, and reddish in winter. Buds are covered by a single caplike scale. Bark is silvery gray to gray green, becoming shallowly fissured with time. Leaves are deciduous, simple, alternate, lanceolate to linear, apex and base acute; margins entire with scattered teeth, green to gray green above, paler and often pubescent below, 1.6–4.7 in (4–12 cm) long, 0.08–0.39 in (2–10 mm) wide. Trees are dioecious producing male and female flowers in catkins on separate plants, blooming from March to May. Male catkins are up to 4 in (10 cm) long; female catkins are up to 3.1 in (8 cm) long. Fruits are long and pointed capsules in narrow clusters, containing many small seeds embedded in cottony down.

TAXONOMIC NOTES. Variety *exigua* has pistillate flowers 0.01–0.02 in (0.25–0.5 mm) long and fruits 0.16–0.31 in (4–8 mm) long; var. *hindsiana* has pistillate flowers 0.01–0.04 in (0.3–1 mm) long, fruits 0.12–0.18 in (3–4.5 mm) long, and is found only in southwestern Oregon.

USES AND VALUE. Wood not commercially important. Native Americans use flexible willow stems for basket weaving, arrow shafts, scoops, and fish traps. Bark produces salicin, which is important component of aspirin. Medicinally used by Native Americans to treat toothache, venereal disease, dandruff, indigestion, worms, stomach ailments and wounds. Browsed by moose, elk, beaver, and mule deer. Provides migratory waterfowl and non-game birds nesting areas and cover sites during winter months.

ECOLOGY. Grows in the ditches, sandbars, and streambanks of the northern Great Plains and the northeastern United States. Shade intolerant. Flowering and seed production may begin at two or three years of age. Seeds are dispersed primarily by wind and water.

CLIMATE CHANGE. Vulnerability is currently unknown. Immediate assessment is recommended.

CONSERVATION STATUS. Least concern.

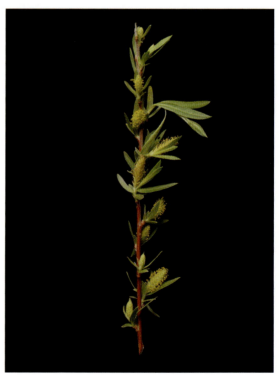

branch

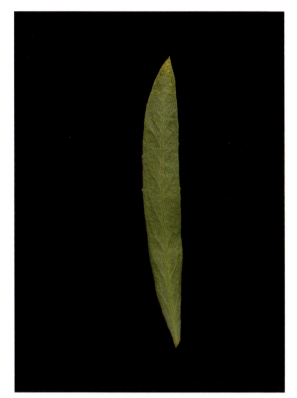
leaf above

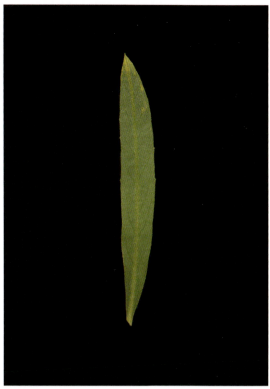
leaf below

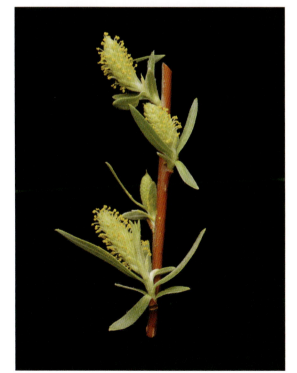
branchlet with male inflorescence

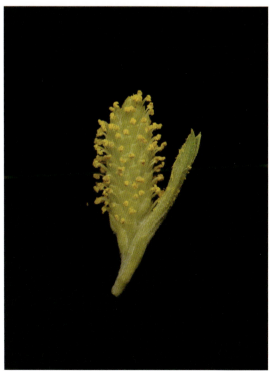
male flowers

FAMILY SALICACEAE • 371

Goodding's Willow

Salix gooddingii C. R. Ball

Goodding's willow is deciduous small tree that is a fast growing and often found inundated by water in riparian areas, marshes, washes, and meadows in the southwestern United States.

DESCRIPTION. A fast-growing, deciduous small tree that grows to 20–59 ft (6–18 m) tall. Twigs are yellow, green or brown. Bark is thick, rough, and deeply furrowed. Stipules are present and leaflike. Leaves are simple, alternate, white, and pubescent when young becoming glossy green, linear, margins finely serrate, 2.6–5.1 in (6.7–13 cm) long, petioles 0.16–0.39 in (4–10 mm) long with glands. Trees are dioecious producing male and female flowers in catkins on separate plants, blooming from March to April along with the leaves. Female catkins are 1.6–3.1 in (4–8 cm) long. Fruits are capsules containing seeds with white pubescence.

USES AND VALUE. Wood not commercially important. Used for streambank stabilization and erosion control. Native Americans use the flexible willow stems to construct baskets, arrow shafts, scoops, and fish traps. Bark produces salicin, which is important component of aspirin. Native Americans used medicinally to treat toothache, venereal disease, dandruff, indigestion, worms, stomach ailments, and wounds. Provides excellent browse and cover for wildlife and domestic animals; preferred food and building material by beavers.

ECOLOGY. Most often grows in inundated habitats and riparian areas, such as marshes, washes, and meadows below elevations of 1,640 ft (500 m) in the southwestern United States. Prefers fine alluvial soils, although also found in alkaline desert soils.

CLIMATE CHANGE. Vulnerability is currently unknown. Immediate assessment is recommended.

CONSERVATION STATUS. Least concern.

branch

bark

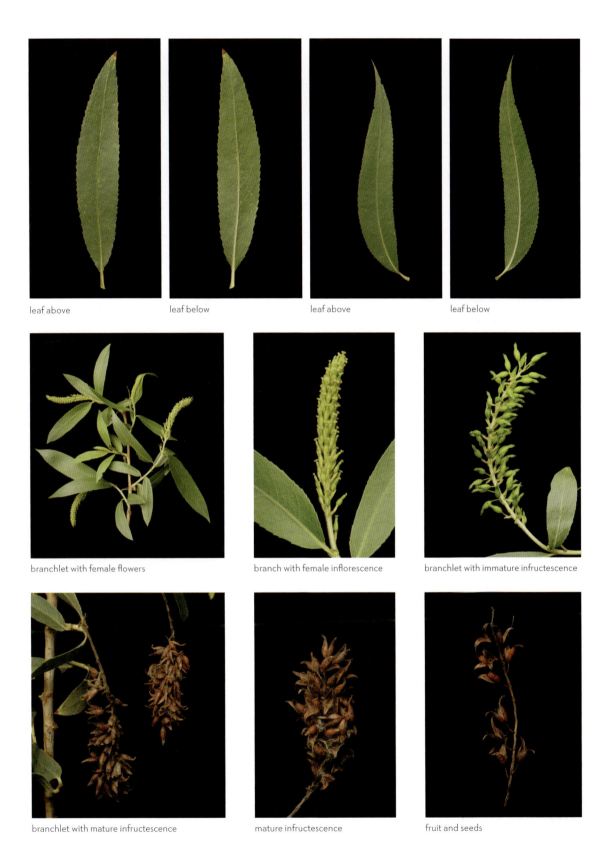

FAMILY SALICACEAE • 373

Hooker Willow
Salix hookeriana Barratt ex Hook.
DUNE WILLOW

Hooker willow is a small deciduous tree that typically grows on wet soils and beaches bordering coniferous forests, such as coastal dunes, flood plains, and meadows at lower elevations.

DESCRIPTION. A small deciduous tree that is typically shorter than 26 ft (8 m). Twigs are slender and greenish to reddish brown. Bark is gray green and dotted with reddish lenticels. Buds are gray, pointed, and appressed with a single scale. Stipules persist near nodes. Leaves are alternate, simple, oval or somewhat lanceolate, margins entire, 2.8–4 in (7–10 cm) long, petioles pubescent. Trees are dioecious producing male and female flowers on separate plants, blooming in spring before leaves. Male and female catkins are creamy white, 3.1 in (8 cm) long. Fruits are pointed, hairy capsules, 0.2 in (0.5 cm) long, in oblong clusters, each containing small pubescent seeds.

USES AND VALUE. Wood not commercially important. Used in bird, bee, and butterfly gardens and for stabilizing shorelines in marine environments. Deer, moose, and rabbits browse the stems; catkins provide food for small mammals and songbirds.

ECOLOGY. Common habitats include coastal dunes, flood plains, and meadows bordering coniferous forests at elevations between 1,640 and 3,281 ft (500–1,000 m). Prefers sandy and alluvial soils.

CLIMATE CHANGE. Vulnerability is currently unknown. Immediate assessment is recommended.

CONSERVATION STATUS. Least concern.

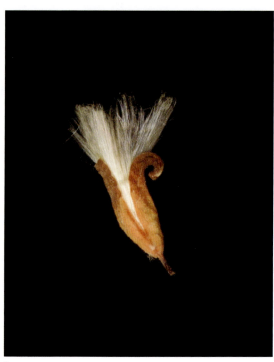

fruit

leaf above

leaf below

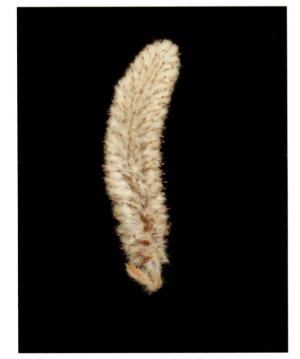

inflorescence

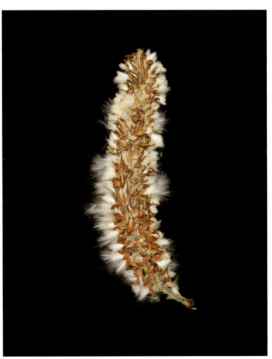

infructescence

FAMILY SALICACEAE • 375

Arroyo Willow
Salix lasiolepis Benth.

Arroyo willow is a small, deciduous tree native to the western United States that grows in riparian areas in canyons, valleys, marshes, and wetlands. It is often used to improve wetland habitats and natural area landscaping.

DESCRIPTION. A small, deciduous native tree that rarely grows beyond 33 ft (10 m) in height. Twigs are yellow green, glabrous, and brittle at the base. Stipules are leaflike. Leaves are simple, alternate, elliptic or strap-shaped, white or rusty pubescent when young, margins variably serrate and rolled under, 1.38–4.9 in (35–125 mm) long, with tomentose to velvety petioles, 0.12–0.63 in (3–16 mm) long. Trees are dioecious producing male and female flowers in catkins on separate plants, blooming in early spring before leaves. Catkins are 0.6–2.8 in (1.5–7 cm) long. Fruits are two-valved capsules, with white pubescent seeds.

USES AND VALUE. Wood not commercially important. Provides important role in streambank stabilization, rehabilitation of riparian zones, improvement of freshwater fisheries, establishment of field windbreaks, natural area landscaping in marsh zones, and wetland creation or enhancement. Bark is antipruritic, astringent, diaphoretic, and febrifuge; infusion of bark used to treat colds, chills, fevers, and measles.

ECOLOGY. Grows in riparian areas in canyons and valleys as well as in marshes and wetlands in the western United States.

CLIMATE CHANGE. Vulnerability is currently unknown. Immediate assessment is recommended.

CONSERVATION STATUS. Least concern.

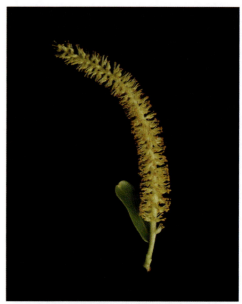

male flowers

bark

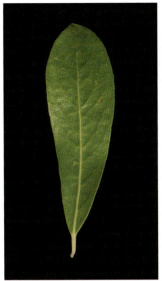
leaf above

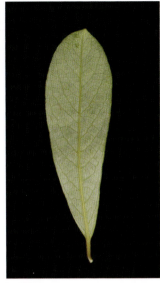
leaf below

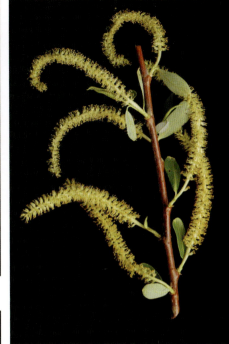
branchlet with male inflorescence

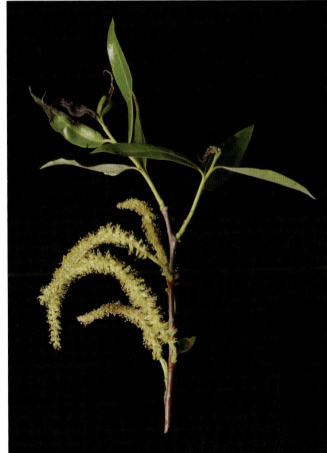
branchlet with flowers

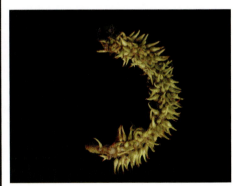
immature infructescence

fruits and seeds

FAMILY SALICACEAE • 377

Shining Willow
Salix lucida Muhl.

Shining willow is a large shrub or small tree native to riverbanks, flood plains, lakeshores, and wet meadows throughout the Great Lakes region and New England and extending north into central and eastern Canada.

DESCRIPTION. A large shrub or small deciduous tree that grows up to 20 ft (6 m) tall, with short trunk and pyramidal crown, often with multiple stems, giving it a shrubby appearance. Twigs and branches are reddish-brown, stout and brittle. Bark is smooth and ruddy brown. Buds are appressed with a single caplike scale; terminal buds are absent. Leaves are deciduous, simple, alternate, lanceolate, glossy dark green above, usually glaucous green below, hairless or thinly hairy, margins finely serrate, 2–5.1 in (5–13 cm) long, leaflike stipules present at base of petiole. Trees are dioecious producing male and female flowers in catkins on separate plants, blooming from March to May. Male catkins are 0.8–1.6 in (2–4 cm) long; female catkins are 0.8–2 in (2–5 cm) long. Fruits are capsules, 0.20–0.27 in (5–7 mm) long, containing many small seeds embedded in cottony down.

USES AND VALUE. Wood not commercially important. Used in riparian, wetland mining-site, and construction-site restoration. Provides browse for white-footed voles, snowshoe hares, American beavers, mule deer, elk, and moose. Used by American beavers for dam material. Provides nesting sites for dusky-footed woodrats in western Oregon, yellow-rumped warblers in Colorado, and the federally endangered least Bell's vireo in California. Ensures shade for trout and other cold-water fish along the streams and waterways.

ECOLOGY. Grows in wet to moist soils with a variety of textures along streams, rivers, lakeshores, and riparian areas in the northeastern to central United States and north into Canada. Common habitats include conifer forests, foothill woodlands, chaparral, valley grassland, and riparian zones below 328 ft (0–100 m) in elevation. Prolific seeder; production begins at ages between five and ten years. Dispersal is by wind and water.

CLIMATE CHANGE. Vulnerability is currently unknown. Immediate assessment is recommended.

CONSERVATION STATUS. Least concern.

bark

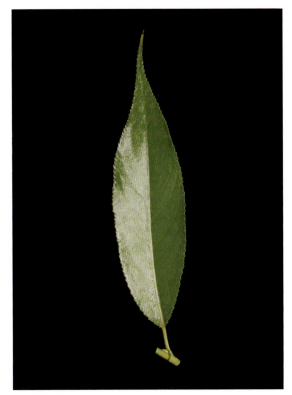
leaf above

leaf below

branchlet above

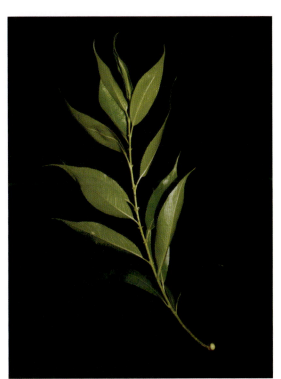
branchlet below

FAMILY SALICACEAE • 379

Black Willow

Salix nigra Marsh.

Black willow is the largest native species of North American willows. The natural glucoside salicin, the basic ingredient of aspirin, was isolated from *S. nigra* in 1829. Today salicylic acid is mostly artificially synthesized rather than extracted from willows.

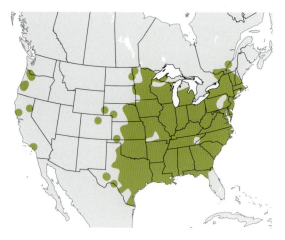

DESCRIPTION. A short-lived deciduous tree growing 39–82 ft (12–25 m) tall or more. Twigs are yellow to reddish brown and slender, becoming glabrous. Bark is dark brown to almost black, furrowed into broad ridges. Leaves are alternate, simple, lanceolate, green and glabrous above, paler and sometimes hairy on veins below, apex acuminate, often curved, margins finely serrate, 2.4–5.9 in (6–15 cm) long, petiole somewhat pubescent, 0.12–0.39 in (3–10 mm) long. Trees are dioecious producing male and female flowers in catkins on separate plants, blooming in early spring. Catkins are 1–3.1 in (2.5–8 cm) long, with hairy yellow bracts. Fruits are glabrous, ovoid conical, reddish-brown capsules, 0.12–0.24 in (3–6 mm) long with tiny cottony seeds.

USES AND VALUE. Wood commercially important. Used for construction of boxes and crates, furniture core stock, turned pieces, tabletops, slack cooperage, wooden novelties, charcoal, and pulp. Important for streambank stabilization and erosion control. Inner bark and leaves are edible. Bark is anodyne, anti-inflammatory, antiperiodic, antiseptic, astringent, diaphoretic, diuretic, febrifuge, hypnotic, and sedative. Beavers browse on leaves in summer and twigs in winter. Shoots are common food of beaver, hares, and rabbits. Larval host for viceroy and red-spotted purple butterflies.

ECOLOGY. Grows along rivers, streambanks, and lakeshores, as well as in bottomlands. Good seed crops produced every year; dispersal by wind and water. Shade intolerant. Attacked by forest tent caterpillar (*Malacosoma disstria*), gypsy moth (*Lymantria dispar*), cottonwood leaf beetle (*Chrysomela scripta*), willow sawfly (*Nematus ventralis*), and imported willow leaf beetle (*Plagiodera versicolora*). Willow blight, the scab canker, and the black canker, all caused by *Pollaccia saliciperda*, are transmitted by borers. Highly susceptible to fire damage.

CLIMATE CHANGE. Vulnerability is currently considered to be low.

CONSERVATION STATUS. Least concern.

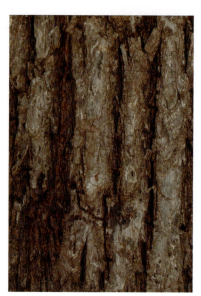

bark

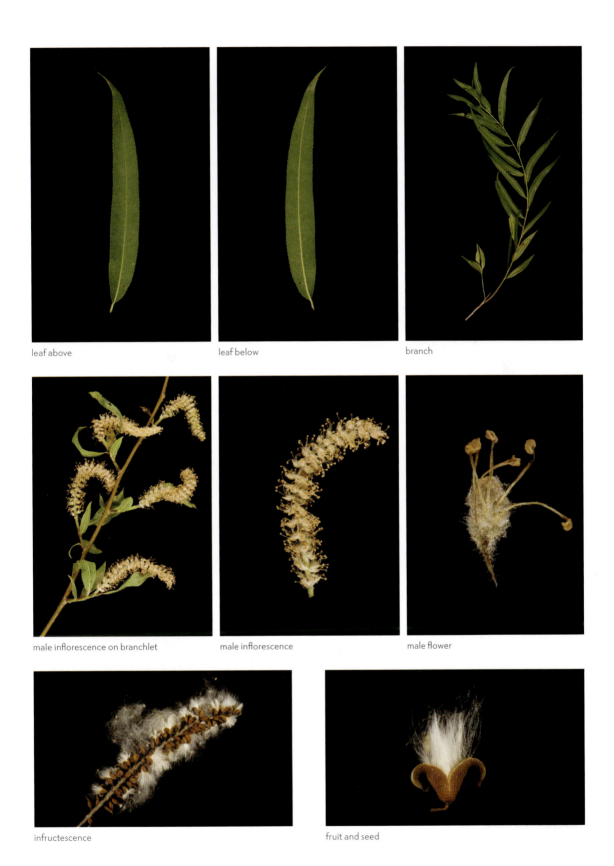

Scouler's Willow

Salix scouleriana Barratt ex Hook.

Scouler's willow is a small tree or large shrub common in the western United States and Canada, occurring in dry to moist forests, meadows, springs, and swamp margins at elevations below 11,155 ft (3,400 m).

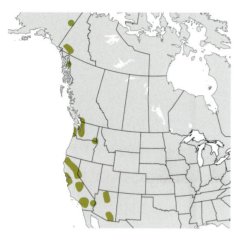

DESCRIPTION. A small tree or shrub that rarely grows taller than 33 ft (10 m). Twigs are yellow green or yellow brown and sparsely pubescent to velvety pubescent. Bark is thin gray to dark brown and furrowed into broad flat ridges. Stipules are leaflike. Leaves are alternate, simple, hairy when young, becoming sparse to densely hairy and silky or woolly at maturity, shiny dark green above, paler below, narrowly elliptic, tip acuminate, margins entire and rolled under, 1.14–3.94 in (29–100 mm) long, with petioles velvety, 0.08–0.51 in (2–13 mm) long. Trees are dioecious producing male and female flowers in catkins on separate plants, blooming before the leaves appear. Female catkins are 0.71–2.36 in (18–60 mm) long; flowers subtended by dark brown bracts. Fruits are pointed, ruddy-colored capsules, 0.4 in (1 cm) long. Seeds covered with hairs for wind dispersal

USES AND VALUE. Wood not commercially important. Used to make prosthetic devices, in erosion control, and as windbreaks. Source of "diamond wood" used in carving and furniture making. Preferred browse for mule deer, white-tailed deer, elk, bighorn sheep, moose, grizzly bears, small mammals, and domestic livestock. Upland ground birds, ducks, and other birds feed on buds, leaves, twigs, and seeds and use for nesting sites. Shoots and buds provide an important winter food source for grouse, Clark's nutcracker, and Canada jay.

ECOLOGY. Grows in dry to moist forests, meadows, springs, and swamp margins at elevations below 11,155 ft (3,400 m) in western United States and Canada. Prefers shallow to moderately deep soils and is tolerant of a range of soil-moisture conditions. Shade intolerant. Begins producing seed before ten years of age. Insects, especially bees, are important pollinators. Seed dispersal in late spring by wind and water.

CLIMATE CHANGE. Vulnerability, though currently considered to be low, may increase in the future. Ongoing monitoring is recommended.

CONSERVATION STATUS. Least concern.

bark

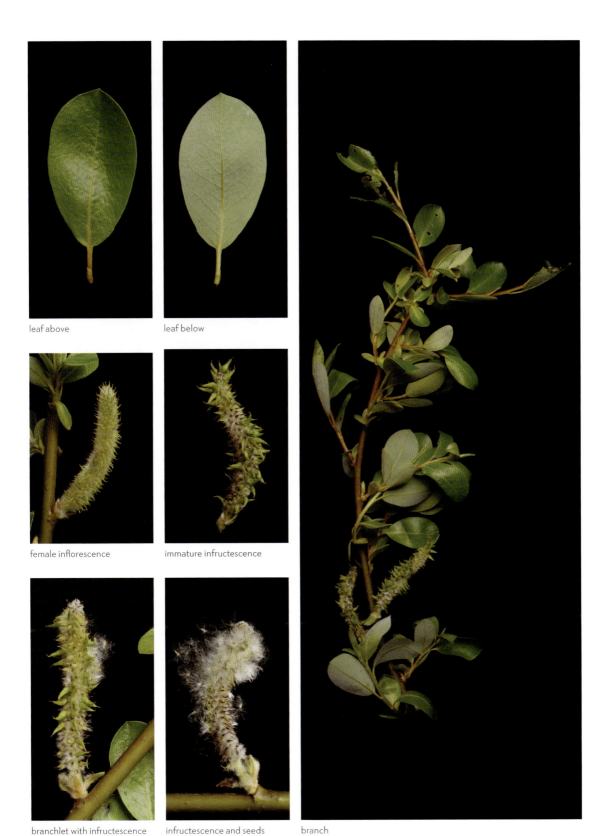

leaf above

leaf below

female inflorescence

immature infructescence

branchlet with infructescence

infructescence and seeds

branch

FAMILY SALICACEAE • 383

Sitka Willow

Salix sitchensis Sanson ex Bong.

Sitka willow is a deciduous small tree or large shrub that occurs on moist soils along beaches and streams in coastal coniferous forests in the northwestern United States and British Columbia.

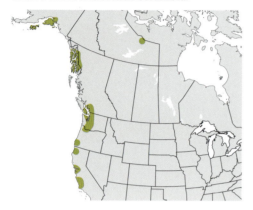

DESCRIPTION. A small tree or shrub typically less than 26 ft (8 m) tall. Trunk and branches are yellow gray, silky and flexible at base. Stipules are leaflike. Leaves are alternate, simple, elliptic to obovate, dark green above, silvery and satiny below, abaxially densely pubescent when young, margins entire, strongly rolled under especially toward base, 1.22–4.72 in (31–120 mm) long, with petioles 0.12–0.51 in (3–13 mm) long. Trees are dioecious producing male and female flowers in catkins on separate plants, blooming in spring before or with new leaves. Male catkins are 2 in (5 cm) long; female catkins are 3.1 in (8 cm) long on leafy shoots. Fruits are hairy, pear-shaped capsules with cottony seeds.

USES AND VALUE. Wood not commercially important. Used as ornamental hedge and in gardens to attract birds, butterflies, and bees. Inner bark and leaves are edible. Produces salicin, which is active component of aspirin. Native Americans use twigs for basket making and bark to heal wounds. Provides nectar to native bees. Larval host to a variety of butterflies.

ECOLOGY. Grows along beaches and steams in coastal coniferous forests on damp heavy soils. Shade intolerant.

CLIMATE CHANGE. Vulnerability is currently unknown. Immediate assessment is recommended.

CONSERVATION STATUS. Least concern.

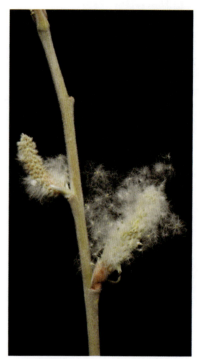

fruits and seeds

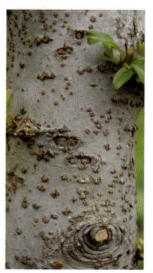

bark

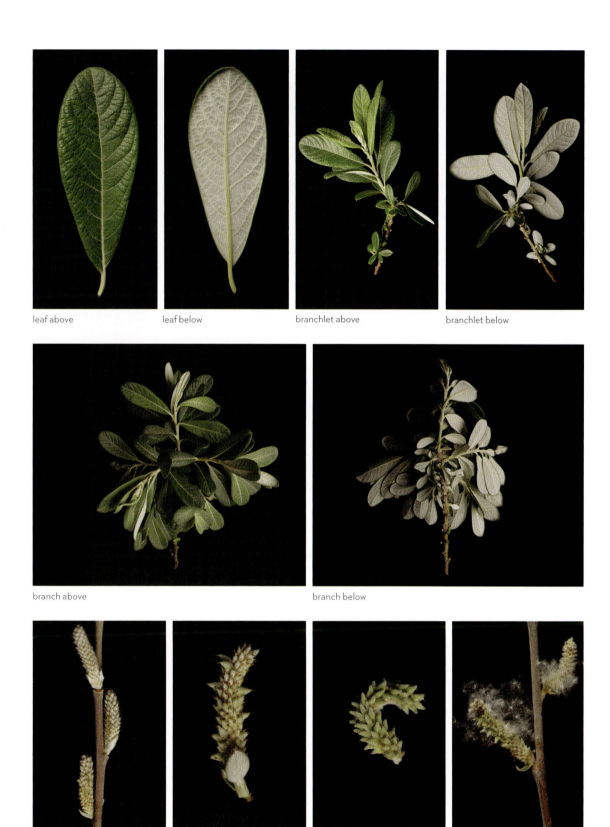

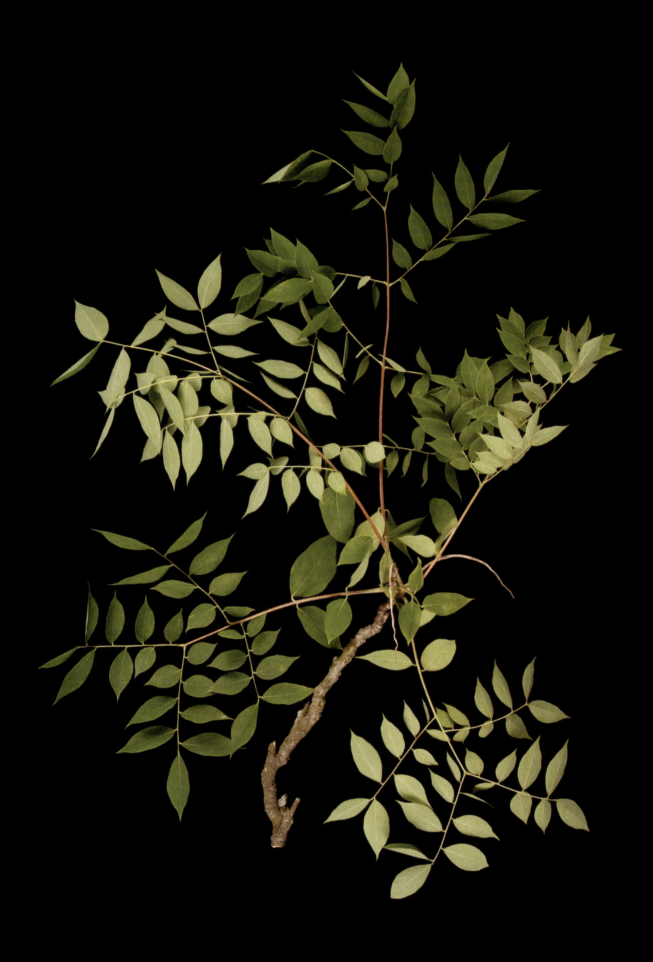

ORDER FABALES

Only four families are recognized within this order. The largest family, the Fabaceae or bean family, accounts for most of the nearly 19,000 species so far described in the Fabales. The large green embryo contained within the seed is one of the few traits, besides DNA similarities, that evolved in the common ancestor of the species of this order. The other large group of species in this order is found in the milkwort family, or Polygalaceae. The legumes are second in importance to the grasses with respect to providing nutrition to human populations. Ten genera and fifteen species of legumes are common trees in North America.

Family Fabaceae

The legumes have always been recognized as a very closely related group of species, but taxonomists differ on whether the family should be classified as one family or three. Many modern botanists believe that DNA sequence data best support the recognition of a single family, the Fabaceae. Legumes are the second most economically important family of plants because of their widespread use as a source of protein and their ability to enrich nutrient-poor soils through the ecological relationship of their roots with a specific type of bacteria. The Fabaceae is the third largest family of flowering plants, containing 750 genera and nearly 20,000 species, which are distributed on every continent but Antarctica. In North America, fifteen species in ten genera of the Fabaceae are common trees, including both native and exotic plants.

OPPOSITE Kentucky coffeetree (*Gymnocladus dioicus*)

GENUS ALBIZIA

Certainly a handsome small tree when the flowers appear like rosy pink brushstrokes across a green canvas.

—Michael A. Dirr on *Albizia julibrissin* in *Dirr's Encyclopedia of Trees and Shrubs*

The attractive "silky" flowers with numerous long, conspicuous, often pink stamens is the basis for the common name "silk tree." About 160 species are found in tropical and subtropical regions around the world. The pinnately compound leaves and often spreading crowns make these trees important ornamentals. Only a single introduced and sometimes invasive species is common in North America.

Silktree
Albizia julibrissin Durazz.
MIMOSA

Silktree, a deciduous tree with a broad crown, is native to Asia and cultivated in North America for its attractive flowers that consist of dense clusters of stamens resembling white or pink silky threads. The sweetly scented flowers attract bees, butterflies, and hummingbirds.

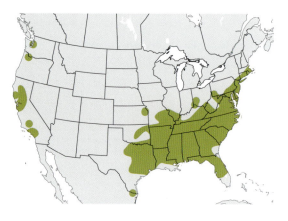

DESCRIPTION. A short-lived (ten to twenty years), fast-growing, deciduous, small to medium-sized tree up to 39 ft (12 m) tall with a broad, open crown of arching branches. Bark is light brown and smooth. Leaves are alternate, bipinnately compound, finely divided, green, 5.1–7.9 in (13–20 cm) long, and 3–4 in (7.6–10 cm) wide. Flowers are perfect, arranged in heads clustered in panicles at the ends of branches with slender pink stamens, 1.5 in (3.8 cm) long, blooming in spring and summer. Fruits are flat, tan pods, 5.9 in (15 cm) long, with light brown oval seeds, ripening in August and September.

USES AND VALUE. Wood not commercially important. Cultivated as an ornamental, particularly in dry climates. Flowers and leaves are edible, serve as a vegetable when cooked. Flower heads and bark are used medicinally to treat variety of ailments, including insomnia. Note that the seeds are poisonous. Flowers are source of nectar for honeybees, butterflies, and hummingbirds.

ECOLOGY. Introduced from Asia and thrives in full sun to partial shade; often found along roadsides and in any disturbed habitats.

CLIMATE CHANGE. Vulnerability is considered low because of its wide geographic distribution as an ornamental.

CONSERVATION STATUS. Least concern.

bark

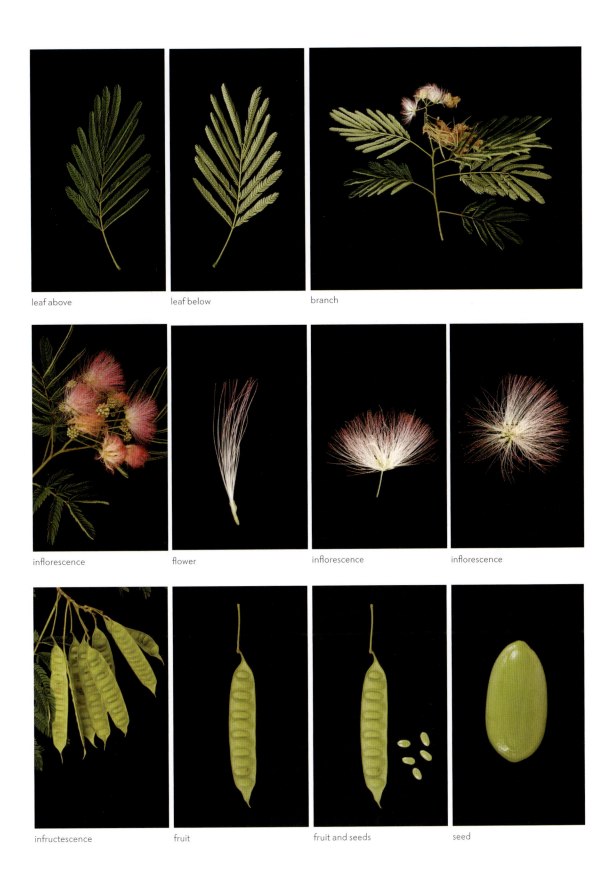

FAMILY FABACEAE • 389

GENUS CERCIS

When the Redbud flowers, the still leafless deciduous woods display its charms down every vista; it shines in the somber little groves of Scrub Pine; it troops up the foothills of the Appalachians; it steps delicately down towards swampy ground in the coastal plain, flaunts its charms beside the red clay wood roads and along old rail fences of the piedmont. Inconspicuous in summer and winter, Redbud shows us in spring how common it is.

—Donald Culross Peattie on *Cercis canadensis* in *A Natural History of Trees of Eastern and Central North America*

Of the ten or so species of the genus *Cercis*, most are native to China and Asia, one is native to Europe, and the remainder are found in North America. They are usually small trees with heart-shaped, simple leaves, unlike most members of the pea family, which have compound leaves. In springtime, many pink or red flowers cover the branches and trunks of the leafless trees, providing a spectacular horticultural display. Two species of *Cercis* are common trees in North America.

Eastern Redbud

Cercis canadensis L.

Eastern redbud, a small tree native to eastern North America, has a short, often twisted trunk covered in dark gray bark. The conspicuous magenta pink flowers appear in clusters along the trunk and stems in early spring, prior to leaf emergence. Long-tongued bees pollinate these flowers; short-tongued bees cannot reach the floral nectaries.

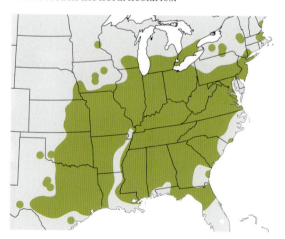

DESCRIPTION. A short-lived deciduous tree, growing to 40 ft (12 m). Trunk is multistemmed and twisted, with wide-spreading crown and deep taproot. Bark is smooth when young and dark gray and scaly when older. Leaves are simple, alternate, light green above and paler below darkening with age, margins entire, 2–4 in (5–10 cm) wide, with a long petiole. Flowers are perfect, pink to lilac, 3.5–4.7 in (9–12 cm) long, clustered along trunk and branches, blooming in early spring, before leaves emerge. Fruits are pods, green turning brown, 1.6–4 in (4–10 cm) long. Seeds are flat, brown, 0.24 in (6 mm) long.

USES AND VALUE. Wood not commercially important. Widely cultivated as ornamental. Flowers, seeds, and seedpods are edible, rich in vitamin C, often added to salads. Unopened flower buds are sometimes substituted for capers. Inner bark made into tea that is strong astringent. Leaves, flowers, and seeds provide food for birds, bees, and deer.

ECOLOGY. Grows in the understory of moist woods in the eastern United States.

CLIMATE CHANGE. Vulnerability is currently considered to be low.

CONSERVATION STATUS. Least concern.

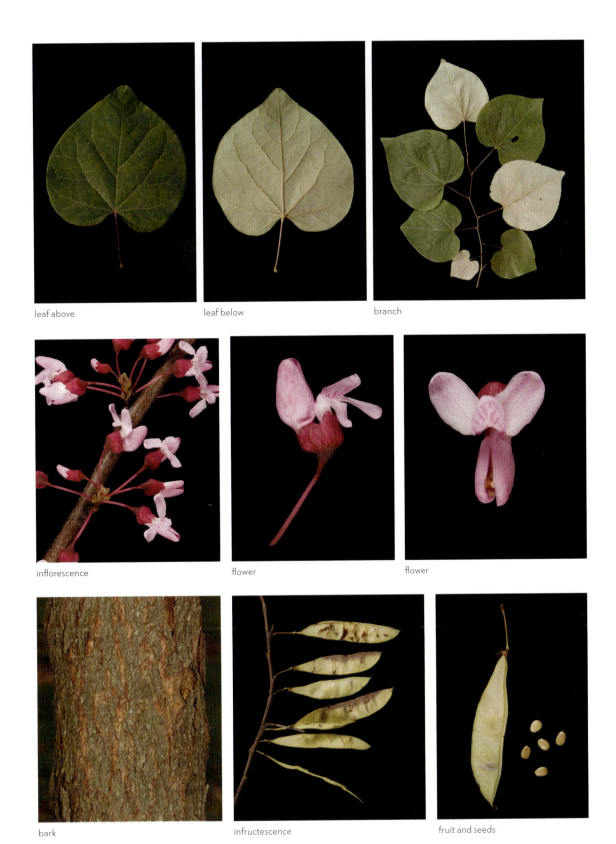

FAMILY FABACEAE • 391

California Redbud

Cercis occidentalis Torr. Ex A. Gray
WESTERN REDBUD

California redbud is a deciduous small tree or shrub growing on dry slopes and rocky plains in canyons, in ravines, along riparian areas, and in washes and chaparral habitat in western North America. It is commonly cultivated as a landscape ornamental.

DESCRIPTION. A deciduous small tree or shrub growing 6–16 ft (2–5 m) tall with trunks clustered and erect, mostly leafless. Young seedlings are densely pubescent. Bark is smooth becoming dark gray and scaly with age. Leaves are simple, alternate, thick, round or reniform, cordate at the base, with seven to nine prominent veins, dark green above, 1.5–3.5 in (3.5–8.9 cm) wide. Flowers are perfect, clustered into two- to five-flowered racemes along the trunks and branches, red to pink, pea-shaped, 0.31–0.47 in (8–12 mm) long, blooming before leaves appear. Fruits are flat pods, 1.6–3.5 in (4–9 cm) long, each contains seven seeds, 0.12–0.16 in (3–4 mm) in diameter.

TAXONOMIC NOTE. Some botanists consider *Cercis orbiculata* Greene to be the correct scientific name.

USES AND VALUE. Wood not commercially important. Cultivated in landscaping as ornamental and for soil-stabilizing in riparian zones. Used by Native Americans in basketry. Attracts butterflies and bumblebees and provides nesting material for native bees.

ECOLOGY. Grows as single stems or forms dense thickets in riparian zones. Found on dry slopes, chaparral habitats, and rocky plains in canyons, ravines, and in washes in a wide range of soils. Intermediate in shade tolerance; resistant to drought. Prolific seeder.

CLIMATE CHANGE. Vulnerability is currently unknown. Immediate assessment is recommended.

CONSERVATION STATUS. Least concern (data deficient).

bark

bark

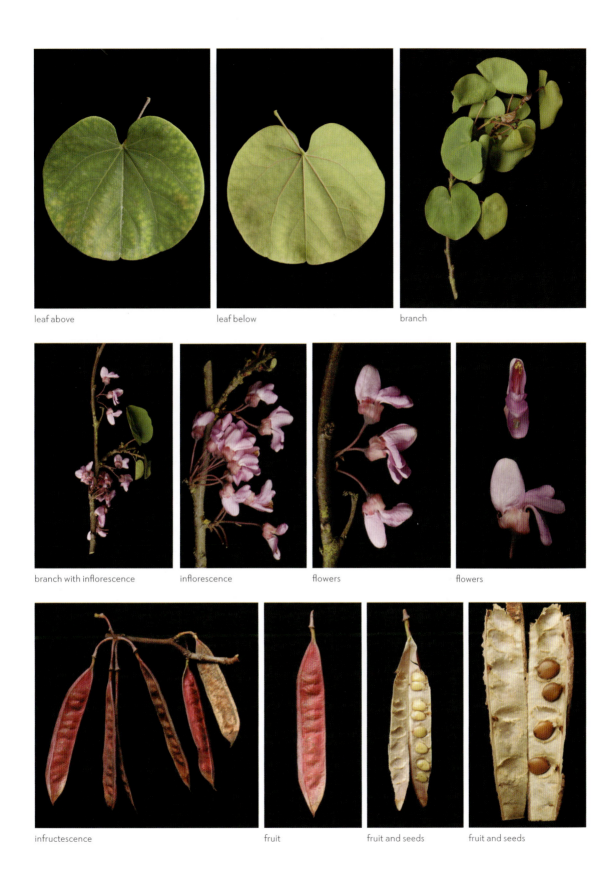

FAMILY FABACEAE • 393

GENUS GLEDITSIA

Although sometime the stout trunk of the Sweet Locust is devoid of thorns, other specimens are beset by a horrendous armory of long, triple-branched thorns that may be a foot long, and are sharp as bayonets. Not even when closely pressed by dogs, it is said, will a squirrel attempt to climb such a tree.

—Donald Culross Peattie on *Gleditsia triacanthos* in *A Natural History of Trees of Eastern and Central North America*

The twelve species of the genus *Gleditsia* are native to Asia and North America. The small to large trees are often armed with sharp spines on their trunks and branches. Of the two species native to North America, only one is a common tree.

Honeylocust
Gleditsia triacanthos L.

Honeylocust, native to eastern North America, is a fast-growing tree that produces fragrant cream-colored flowers in late spring. Although a good source of nectar for honeybees, the common name is derived from the sweet taste of the pulp surrounding the seeds in the fruits, which can be made into a refreshing drink or fermented into beer.

DESCRIPTION. A moderate-lived (up to 100 years) deciduous tree growing to 98 ft (30 m) tall, with a short clear trunk, an open narrow or spreading crown, and a wide and deep root. Trunk and lower branches have unbranched or multibranched thorns, reddish brown, 7.9 in (20 cm) long. Bark is dark gray to brown, with platy patches. Leaves are alternate, pinnately or bipinnately compound, 4–7.9 in (10–20 cm) long, with three to six pairs of side segments with paired leaflets, 0.4–1.2 in (1–3 cm) long, shiny dark green above. Trees are polygamodioecious, with both perfect and separate male or female flowers on the same tree. Flowers are numerous in hanging racemes, 2–5.1 in (5–13 cm) long, blooming in late spring. Fruits are dark brown pods, 5.9–15.7 in (15–40 cm) long, 1–1.4 in (2.5–3.5 cm) wide, twisted, with sticky pulp inside. Seeds 0.4 in (1 cm) long.

USES AND VALUE. Wood not commercially important. Widely planted as windbreaks and in erosion control. Seeds and seedpods are edible. Seeds roasted as substitute for coffee. Pulp of seedpods is sweet, eaten raw, also made into refreshing drink or fermented as beer. Juice of the seedpods is antiseptic. Nectar provides good source for bee honey. Gray squirrels, fox squirrels, white-tailed deer, bobwhite, starlings, crows, and opossum eat the fruits; snowshoe hares and cottontails browse small plants.

ECOLOGY. Grows at edges of woodlands and in open areas; Tolerant of drought and salinity. Good seed crops produced every three to five years; seeds with high viability. Fruits persist on tree and fall throughout the year, often dispersing considerable distances. Pests include mimosa webworm (*Homadaula anisocentra*), a spider mite (*Eotetranychus multidigituli*), and the canker *Thyronectria austro-americana*.

CLIMATE CHANGE. Vulnerability is significant but has reasonable probability of persistence in the future. Ongoing monitoring is recommended.

CONSERVATION STATUS. Least concern.

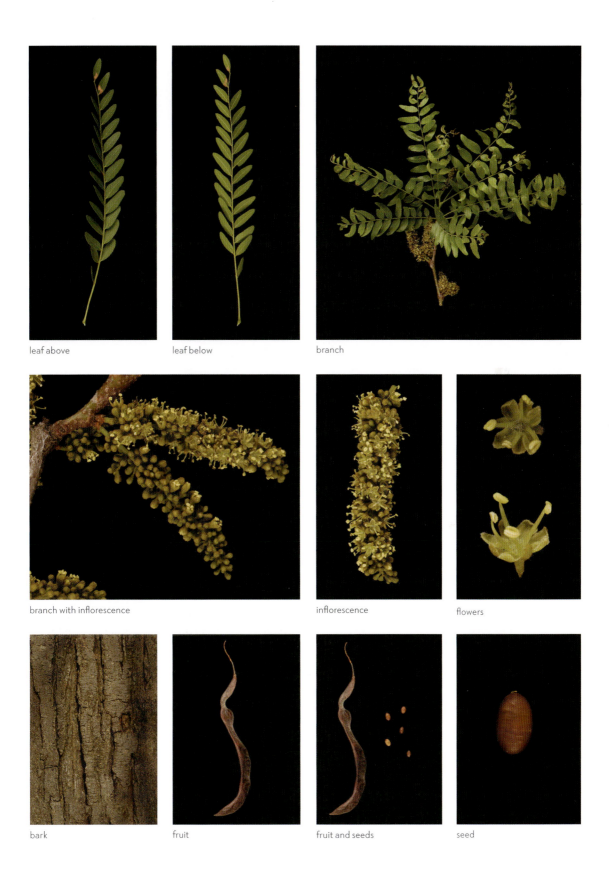

FAMILY FABACEAE • 395

GENUS GYMNOCLADUS

The appearance of the beans or seeds, rather than the taste, must have induced the pioneers to roast and brew them to make what can only by imagination and forbearance be called coffee.

—Donald Culross Peattie on *Gymnocladus dioica* in *A Natural History of Trees of Eastern and Central North America*

The genus *Gymnocladus* is composed of only three species: one is native to China, another is native to the Indian subcontinent, and the third is native to North America. Similar to its close relative *Gleditsia* in the pea family, all the flowers on a single tree are either male or female, a condition called dioecy. The single native species is a common tree in North America.

Kentucky Coffeetree
Gymnocladus dioicus (L.) K. Koch

Kentucky coffeetree, native to midwestern North America, characteristically produces its leaves late in the season and sheds them early in fall. For this reason individual trees may look dead for many months of the year, hence the scientific name *Gymnocladus*, meaning "naked branch."

DESCRIPTION. A long-lived deciduous tree, growing 49–98 ft (15–30 m) tall. Twigs are brown with white or gray patches and pubescent when young, with large heart-shaped leaf scars. Bark is gray to brown, with scaly ridges. Leaves are alternate, bipinnately compound, 30–90 cm long, with forty or more leaflets, each 1–3 in (2.5–7.5 cm) long, ovate, glabrous when mature, and green above, paler below, margins entire. Leaves emerge late and abscise early. Trees are dioecious producing male and female flowers on separate plants, blooming in early summer. Flowers are greenish white, on upright terminal clusters, 0.59–0.79 in (15–20 mm) long. Fruits are reddish-brown pods, leathery, 3.9–9.8 in (10–25 cm) long, with four to eight dark brown seeds.

USES AND VALUE. Wood not commercially important. Commonly cultivated as an ornamental tree along city streets because of the conspicuous leathery seedpods and its wide tolerance for urban environments, including extremes in temperature, drought, insects, disease, road salt, ice, and alkaline soil. Wood used locally in construction and for fence posts. Seeds are roasted as a coffee substitute. The large pods are poisonous to most animals and too heavy for either wind or water dispersal. Therefore it is believed that the fruits may have been eaten and dispersed by now-extinct mammoths and mastodons. Larval host plant for several species of moth.

ECOLOGY. Grows on river flood plains and in moist woods. Shade intolerant.

CLIMATE CHANGE. Vulnerability is significant but may have the capacity to adapt to changing conditions in the future. Ongoing monitoring is recommended.

CONSERVATION STATUS. Vulnerable.

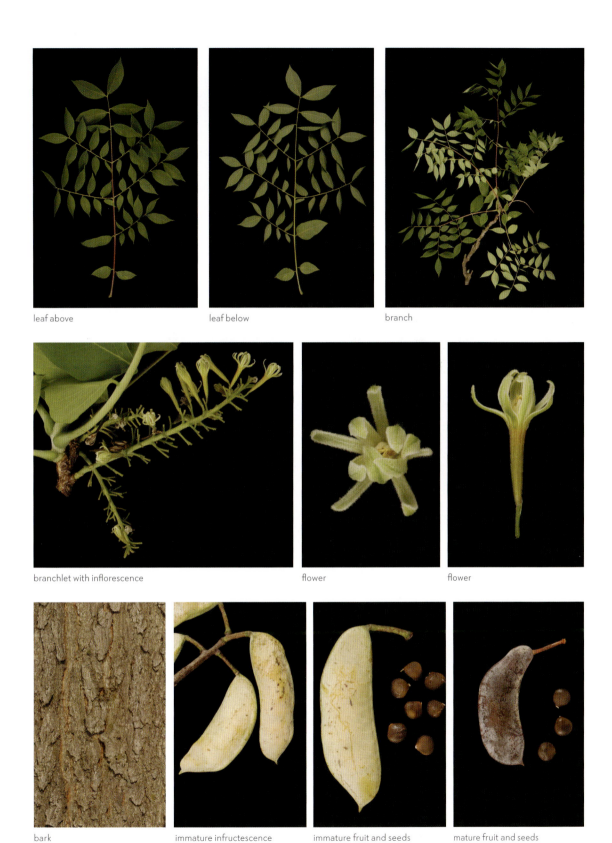

FAMILY FABACEAE • 397

GENUS OLNEYA

But in hardness it is unexcelled, earning its name of Ironwood more thoroughly than any of the other trees that, in other parts of the country, claim the name. The ordinary knifeblade makes as much impression on it as it would on stone—minute slivers may be sliced off, but as for any attempt really to cut it, it defies the ordinary saw and axe driven by muscle.

—Donald Culross Peattie on *Olneya tesota* in *A Natural History of North American Trees*

The genus *Olneya* is "monotypic," meaning that it contains only a single species, which is restricted to dry watercourses in the Sonoran Desert of southwestern North America. Depending on drought conditions, the trees can maintain their leaves for the entire year or periodically lose them. Ecologically, this species plays an important role for other plants and animals living in these harsh and dry conditions. This single species is a common tree where it is native.

Desert Ironwood
Olneya tesota A. Gray
TESOTA

Desert ironwood is a spiny evergreen tree that grows in foothills, washes, and low desert areas of the southwestern United States, where it is said to be an indicator of the Sonoran Desert because of its preference for dry desert soils.

DESCRIPTION. A spiny evergreen tree or tall shrub that grows up to 30 ft (9 m) in height. Branches are armed with spines produced at base of leaves. Bark is brown, thin, scaly and peels away to reveal light gray underbark. Leaves are alternate, evergreen, pinnately compound, 1–3 in (2.5–7 cm) long, with 2–10 pairs of leaflets, grayish green and densely pubescent, may fall from branches in near-freezing conditions or in drought. Flowers are perfect, numerous, arranged in axillary racemes, purple to pink, pea-shaped, 0.5 in (1.2 cm) long, blooming in spring before new leaves.

Fruits are red-brown pods, 2–3.1 in (5–8 cm) long, contain black beanlike seeds.

USES AND VALUE. Wood not commercially important. Seeds eaten either raw or cooked. Immense value to wildlife. Seeds provide food for doves, quail, and small rodents. Insects, birds, and reptiles thrive in canopy. Shade from leaves lowers temperature in understory, providing habitat for wildflowers in harsh desert conditions; over 230 plant species recorded growing under trees. Flowers are eaten by jack rabbits, desert bighorn sheep, Sonoran pronghorns, and mule deer.

ECOLOGY. Commonly grows in foothills, washes, and low desert areas of the southwestern United States. Many consider the presence of these trees to be an indicator of the Sonoran Desert because of preference for dry desert soils that are rocky or sandy in texture.

CLIMATE CHANGE. Vulnerability, though currently considered to be low, may increase in the future. Ongoing monitoring is recommended.

CONSERVATION STATUS. Near threatened.

leaf above

leaf below

branchlet

branchlet above

branchlet below

bark

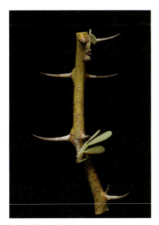
branchlet with spines

branch

FAMILY FABACEAE • 399

GENUS PARKINSONIA

Found in both Africa and the Americas, the twelve species of *Parkinsonia* generally inhabit the drier, semi-desert regions of these continents. The North American species are usually called "paloverde" because of their green stems and branches, which are responsible for carrying on much of the photosynthesis of the trees. Three of the four native species in North America are common trees.

Jerusalem Thorn
Parkinsonia aculeata L.
MEXICAN PALOVERDE

Jerusalem thorn is an erect spiny small tree native to the southern United States to South America that grows in flood plains, bottomland, hillside chaparral, and disturbed grasslands on well-drained soils.

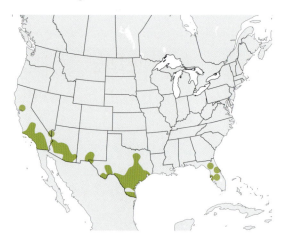

DESCRIPTION. An erect spiny shrub or small tree that grows up to 33 ft (10 m) tall. Trunk and branches are green, glabrous, and drooping. Twigs have sharp stipular spines, 0.12–0.79 in (3–20 mm) long that persist after leaves have been shed. Leaves are nearly sessile, alternate, pinnately compound in young plants, becoming bipinnate with age, with 2–6 linear segments, leaflets are oblong, caducous, 0.04–0.39 in (1–10 mm) long. Leaves may be shed during drought. Flowers are clustered eight to seventeen in elongated axillary racemes, 2–7.9 in (5–20 cm) long, perfect, bright yellow, stamens ten, five reddish-yellow sepals fused into calyx tube, borne on slender pedicels 0.20–0.79 in (5–20 mm) long. Fruits are reddish pods, 2–4 in (5–10 cm) long, with few grayish brown seeds.

USES AND VALUE. Wood not commercially important. Cultivated as ornamental tree. Used in agroforestry, erosion control, charcoal or firewood, and as shade tree and living fence. Seeds edible. Mixture of leaves, fruits, and portions of the stem are taken orally and applied externally to treat fever, atony, and malaria. Birds and small mammals eat seeds.

ECOLOGY. Native to southern United States, northern Mexico, and South America; invasive in Australia, where it was introduced. Grows in flood plains, bottomland, hillside chaparral, and disturbed grasslands on well-drained soils. Tolerant of salinity and flooding. Shade intolerant; very drought resistant.

CLIMATE CHANGE. Vulnerability is considered low because of its wide distribution as an ornamental.

CONSERVATION STATUS. Least concern.

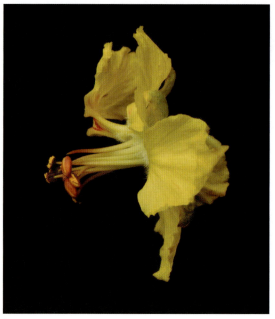
flower

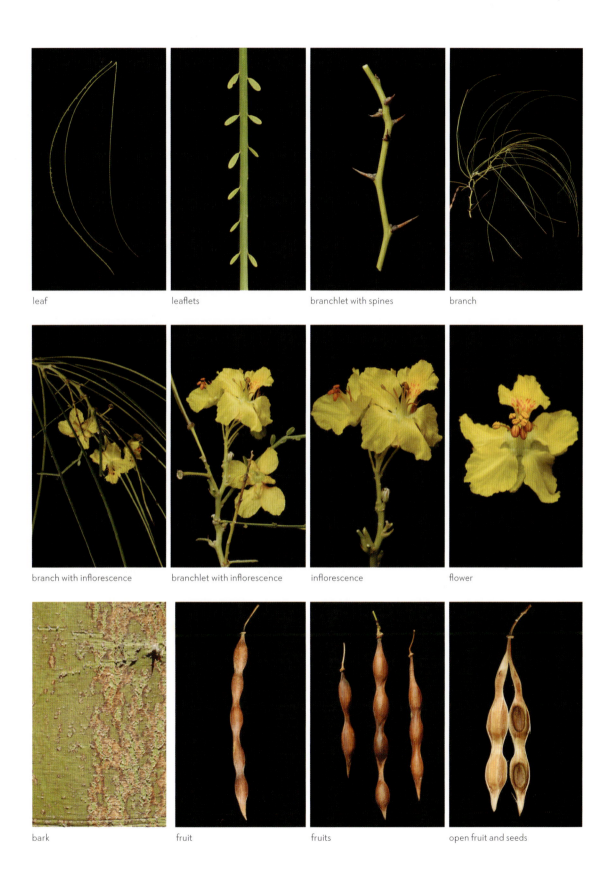

FAMILY FABACEAE • 401

Blue Paloverde

Parkinsonia florida (Benth. ex A. Gray) S. Watson

Blue paloverde is a spiny small tree or subtree with multiple stems that grows in arid and semiarid regions of the western United States at elevations ranging from sea level to 4,003 ft (0–1,220 m). It is the state tree of Arizona.

DESCRIPTION. A spiny small tree or subtree with multiple stems that grows up to 33 ft (10 m) tall. Trunks and branches are glabrous, green, and photosynthetic with young stems more productive than older stems. Bark is thin, gray green. Leaves are alternate, bipinnately compound with two primary segments each with 2–6 leaflets, 0.75–1.5 in (1.5–3.5 cm) long, drought deciduous. Flowers are perfect, yellow, produced in clusters of 4 or 5 in late spring, 1.6–4.7 in (4–12 cm) long, pealike. Fruits are tan, indehiscent, flat pods with beaklike tip, 1.6–4 in (4–10 cm) long, contains up to eight flat seeds.

USES AND VALUE. Wood not commercially important. Sometimes cultivated as ornamental. State tree of Arizona. Native Americans carved wood as cooking utensils; flowers and seeds eaten for food. Twigs and leaves are consumed by mule deer, bighorn sheep, and burros; used for livestock forage. Small mammals eat seeds. Flowers provide nectar for bees, beetles, and flies that serve as pollinators.

ECOLOGY. Grows in arid and semiarid climates of the western United States at elevations from sea level to 4,003 ft (1220 m). Found mostly in desert washes but also persists in upland habitats on terraces, high flood plains, and ephemeral streambeds with deep soil.

CLIMATE CHANGE. Vulnerability is currently unknown. Immediate assessment is recommended.

CONSERVATION STATUS. Least concern.

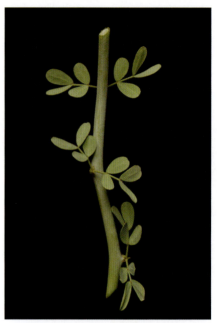
branch

bark

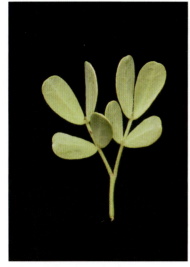
leaf above

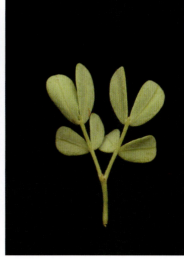
leaf below

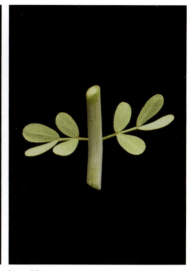
branchlet

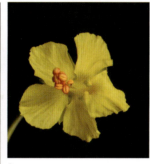
flower

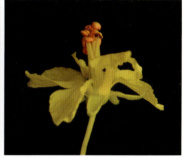
flower

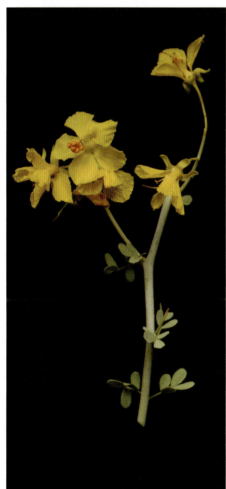
branch with inflorescence

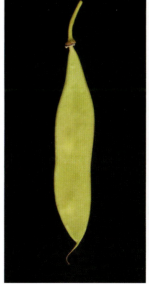
immature fruit

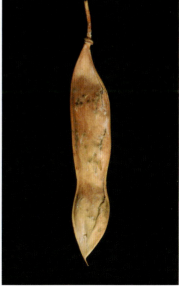
mature fruit

Yellow Paloverde
Parkinsonia microphylla Torr.

Yellow paloverde is a small spiny tree that grows in desert plains and rocky slopes in the foothills and mountains of Arizona and California. It is one of the most common trees of the Sonoran Desert.

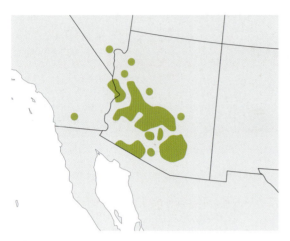

DESCRIPTION. A small spiny tree that grows 16–23 ft (5–7 m) tall and is leafless most of the year. Trunk and stems are yellow-green and photosynthetic. Bark is smooth and green on all twigs and branches, becoming gray at base of trunk. Leaves are borne on thorn-tipped stems, lack petiole, alternate, bipinnately compound, 0.4–2 in (1–5 cm) long, with two primary segments each with four to eight pairs of leaflets, yellow green. Flowers are perfect, in axillary clusters of four to eight, bicolored with four yellow petals and a white banner, 0.5–0.9 in (1.2–1.8 cm) in diameter. Fruits are tan, sparsely pubescent, indehiscent pods, 1.6–3.1 in (4–8 cm) in length.

USES AND VALUE. Wood not commercially important. Sometimes cultivated as ornamental tree. Native Americans dry and roast seeds to make bread called "mush cakes." Green pods eaten raw. Birds and small mammals eat seeds.

ECOLOGY. Yellow paloverde grows in the foothills and mountains of Arizona and California in desert plains and on rocky slopes. Found on dry, rocky, and sandy soils, often of granitic origin.

CLIMATE CHANGE. Vulnerability is currently unknown. Immediate assessment is recommended.

CONSERVATION STATUS. Least concern.

bark

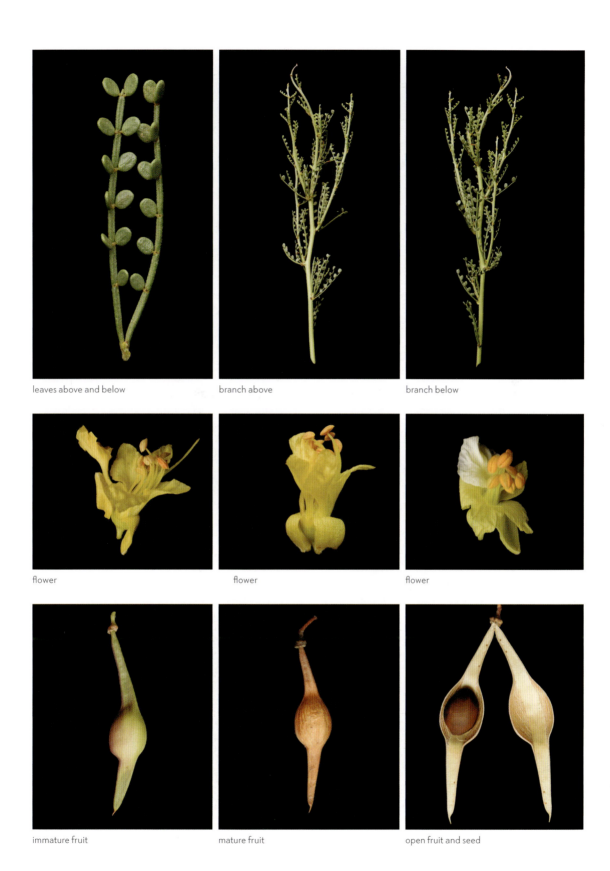

FAMILY FABACEAE

GENUS PROSOPIS

For, where you would not think that any sort of tree could exist, in such arid soil, such flaming heat, or in the depths of the Grand Canyon with its raging floods, the Mesquite, when it comes to leaf, is a blessing on the earth that bears it.

—Donald Culross Peattie on Prosopis juliflora (now *P. glandulosa* and *P. velutina*) in *A Natural History of North American Trees*

The nearly fifty species in the genus *Prosopis*, like many of their tree relatives in the pea family, thrive in dry desert conditions of Asia, Africa, and throughout the Americas. Locally known as "mesquite" in North America, the spiny shrubs and small trees can be invasive and environmentally destructive when introduced into non-native areas, such as Australia. Of the several species native to North America, two are common trees.

Honey Mesquite
Prosopis glandulosa Torr.

Honey mesquite is a shrub or small tree that grows on a wide variety of sites and soil types. It is well known for its long, 1–2 in (2.5–5 cm), tough and persistent spines produced at leaf nodes. This tree is one of the world's most invasive species. Three varieties are recognized.

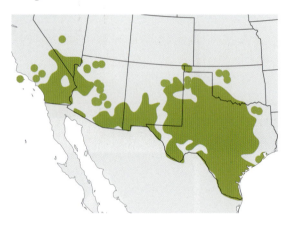

DESCRIPTION. A shrub or small tree growing up to 33 ft (10 m) tall, single or multistemmed with big, rounded, floppy branches. Twigs are armed with sharp thorns up to 1.4 in (3.5 cm) long on young plants. Deep taproot allows it to reach the water table in arid regions, where it thrives. Leaves are deciduous, alternate, bipinnately compound, leaflets up to 1.2 in (3 cm) long, bright green. Flowers are perfect, small, yellow-green, borne in spikelike cylindrical racemes, 1.5–5 in (3.8–12.5 cm) long, blooming in summer.

Fruits are long, yellow pods, flattened and constricted between seeds, 3–10 in (7–25 cm) long.

TAXONOMIC NOTES. Variety *glandulosa* occurs in the northern and eastern part of the range from New Mexico to Louisiana; var. *prostrata* is endemic to Texas; var. *torreyana* occurs in the western portion of the range from western Texas to California.

USES AND VALUE. Wood not commercially important. Cultivated as ornamental, landscape plant, shade tree, and nitrogen fixer. Seeds, seedpods, honey, fruit, and gum from the bark are edible. Reported to be collyrium, emetic, and laxative, and folk remedy for dyspepsia, eruptions, hernias, and skin ailments. Seeds used as a food or spice. Wood provides smoky flavor as charcoal. Provides shelter and nest-building material as well as seasonal food for birds and small mammals. Larval host for long-tailed skipper and Reakirt's blue butterflies. One of the world's 100 most invasive species outside its native range in North America.

ECOLOGY. Grows on a wide variety of sites and soil types in drainages and grasslands, as well as outwash plains, dry lakes, oases, arroyos, and riparian areas in arid regions. Increasingly becoming more common within its native range Shade intolerant.

CLIMATE CHANGE. Vulnerability is considered low because of its widespread distribution as an invasive.

CONSERVATION STATUS. Least concern.

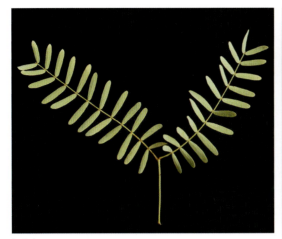
leaf above

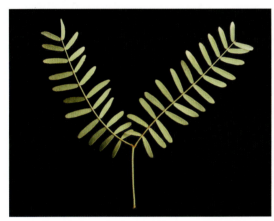
leaf below

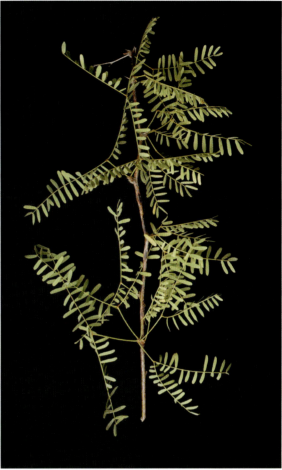
branch

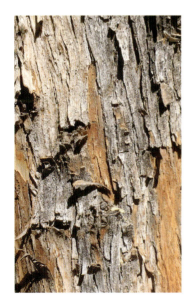
bark

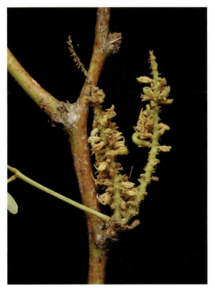
branch with inflorescence

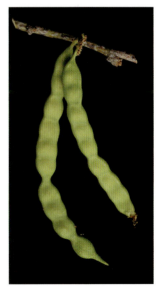
fruits on branchlet

Velvet Mesquite

Prosopis velutina Wooton

Velvet mesquite is a multistemmed tree with velvety foliage, twigs, and pods that grows on washes, slopes, and mesas in deserts and desert grasslands.

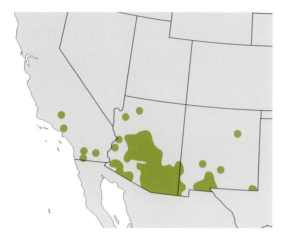

DESCRIPTION. A spiny multistemmed tree growing up to 33 ft (10 m) tall with velvety foliage, twigs, and pods. Young branches are green and photosynthetic. Bark is dark brown, becoming rough, thick, and separating into narrow strips on older branches. Leaves are deciduous, alternate, with long petioles, 3–6 in (7–15 cm) long, bipinnately compound, two primary segments, each composed of twelve to twenty leaflets, 2 in (5 cm) long. Flowers are clustered in spikelike racemes, perfect, tiny, cream-colored with numerous long white stamens that turn yellow. Fruits are pods, tan to yellow in late summer, up to 5.9 in (15 cm) long.

USES AND VALUE. Wood not commercially important. Noxious weed outside its natural range in North American deserts. Wood used for fence posts and firewood. A landscape tree in extremely dry climates. Seedpods are edible, ground to make mesquite meal and flour for cakes, breads, muffins, and pancakes. Hot tea made from blend of clear sap and red inner bark used to treat sore throats; tea made from the fresh leaves used to treat stomachaches. Coyotes, round-tailed ground squirrels, collared peccaries, mule deer, white-tailed deer, jack rabbits, and livestock browse the seedpods; flowers visited by bees for nectar.

ECOLOGY. Grows in the Sonoran, Mojave, and Chihuahuan Desert regions on washes, slopes, and mesas. Commonly found on alluvial or rocky upland soils. Shade intolerant.

CLIMATE CHANGE. Vulnerability is currently considered to be low.

CONSERVATION STATUS. Least concern.

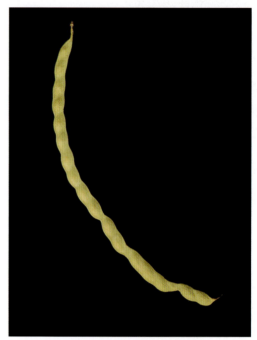

fruit

bark

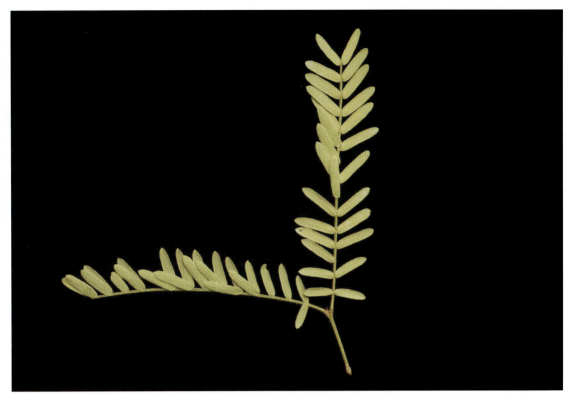
leaf above

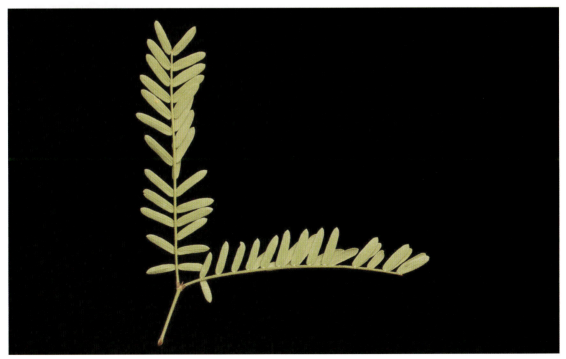
leaf below

FAMILY FABACEAE • 409

GENUS ROBINIA

Among the Locust's numerous familiar charms, most famous is the so-called sleep of the leaves. At nightfall the leaflets droop on their stalklets, so that the whole leaf seems to be folding up for the night.

—Donald Culross Peattie on *Robinia pseudoacacia* in *A Natural History of Trees of Eastern and Central North America*

The genus *Robinia*, otherwise known as "locust," has from four to ten species that are all native to North America. Although the original native distributions of the two common species were somewhat restricted, they have spread extensively through cultivation and are even considered to be invasives in some regions. A combination of ornamental flowers and foliage widely used wood, fast growth, and ability to colonize has made two species of locust very common trees in North America.

New Mexico Locust
Robinia neomexicana A. Gray
ROSE LOCUST

New Mexico locust is a small deciduous tree or shrub that grows in montane areas of the southwestern United States in desert mesas, canyons, and coniferous forests. Two varieties are recognized.

DESCRIPTION. A small deciduous tree or shrub growing up to 33 ft (10 m) tall. Twigs are stout, glandular pubescent, with paired stipular spines. Bark is light gray to brown and furrowed into scaly ridges. Leaves are alternate, pinnately compound, 3.9–9.8 in (10–25 cm long), with ten to twenty-one leaflets, deep green. Flowers are borne in clusters of three to fourteen in racemes, 2–4 in (5–10 cm) long, perfect, pedicel and calyx glandular and puberulent, petals violet to pink. Fruits are oblong, flattened pods, 2.4–4 in (6–10 cm) long.

TAXONOMIC NOTES. Variety *neomexicana* is found throughout the range with densely glandular and hairy inflorescences and seedpods; var. *rusbyi* occurs only in southeastern Arizona and western New Mexico with inflorescences that are pubescent or with scattered bristles and glabrous seedpods.

USES AND VALUE. Wood not commercially important. Cultivated as ornamental and for erosion control. Wood is used locally for fence posts and tool handles. Flowers are eaten uncooked by Native Americans. Mule deer, cattle, and goats browse the foliage, and squirrels and quail eat the seeds. Larval host of the golden-banded skipper and funereal dusky-wing butterflies.

ECOLOGY. Grows in desert mesas, canyons, and coniferous forests in montane areas of the southwestern United States above 4,921 ft (1,500 m) in elevation, Prefers rocky, sandy, loam, and clay soils. Drought tolerant; sprouts prolifically after fire.

CLIMATE CHANGE. Vulnerability, though currently considered to be low, may increase in the future. Ongoing monitoring is recommended.

CONSERVATION STATUS. Least concern.

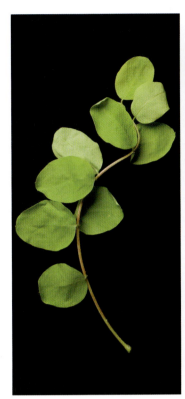
leaf above

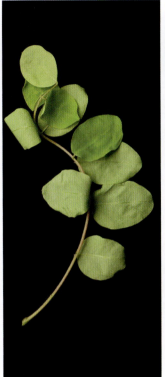
leaf below

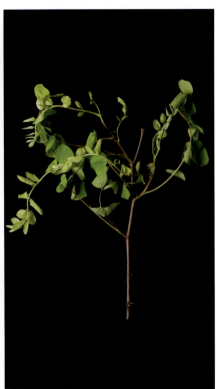
branch

fruit

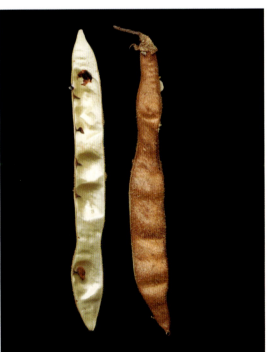
open fruit and seed

Black Locust

Robinia pseudoacacia L.

Black locust is a large tree native to the eastern United States that produces very fragrant clusters of white, edible flowers during a short (about ten days) blooming period in spring. Readily cultivated as an ornamental tree with characteristic deeply furrowed bark, it has greatly expanded its native range and abundance.

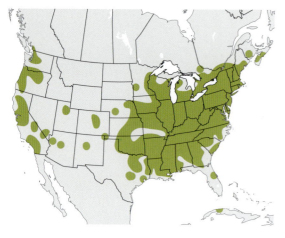

DESCRIPTION. A short-lived (usually less than 100 years), deciduous, medium-sized tree growing up to 79 ft (24 m). Under good conditions it has a long clear trunk and open irregular crown but becomes more shrublike forming thickets on poorer sites. Twigs are reddish brown, zigzag, and smooth, with paired thorns at each node. Bark is gray to brown, becoming deeply furrowed and ridged with age. Leaves are alternate, pinnately compound, 7.9–13.8 in (20–35 cm) long, with seven to twenty-one oval leaflets, glabrous, dark green above, paler below with entire margins. Flowers are perfect, showy, five petals, white with yellow, fragrant, 0.6–0.9 in (1.5–2.3 cm) long, produced in racemes of ten to twenty-five, 3.9–4.7 in (10–12 cm) long, blooming for a short time in spring. Fruits are flat, brown pods, 2.8–4 in (7–10 cm) long, with four to eight small seeds.

USES AND VALUE. Wood not commercially important. Very rot resistant and used for fence posts, mine timbers, poles, railroad ties, insulator pins, ship timber, tree nails for wooden ship construction, boxes, crates, pegs, stakes, pulpwood, and fuelwood. Local artisans prefer the wood for house construction. With fast juvenile growth and nitrogen-fixing capacity suitable as shelterbelt and for reclamation plantings. Often cultivated as ornamental tree, which has thereby greatly expanded its native range. Flowers, oil, seeds, and seedpods are edible. Flowers are antispasmodic, aromatic, diuretic, emollient, and laxative. White-tailed deer and small mammals browse young growth. Older trees provide nest cavities for downy woodpecker, hairy woodpecker, northern flicker, and other birds.

ECOLOGY. Grows on dry to moist soils, especially those derived from limestone, along roadsides and in disturbed sites as well as woodlands and old fields. Good seed crops produced every one to two years. Very shade intolerant. Severely damaged by insects and disease more than any other eastern North American hardwood species. Attacked by locust borer (*Megcallene robiniae*) and several heart-rot fungi (*Phellinus rimosus* and *Polyporus robiniophilus*).

CLIMATE CHANGE. Vulnerability is significant but has reasonable probability of persistence in the future. Ongoing monitoring is recommended.

CONSERVATION STATUS. Least concern.

bark

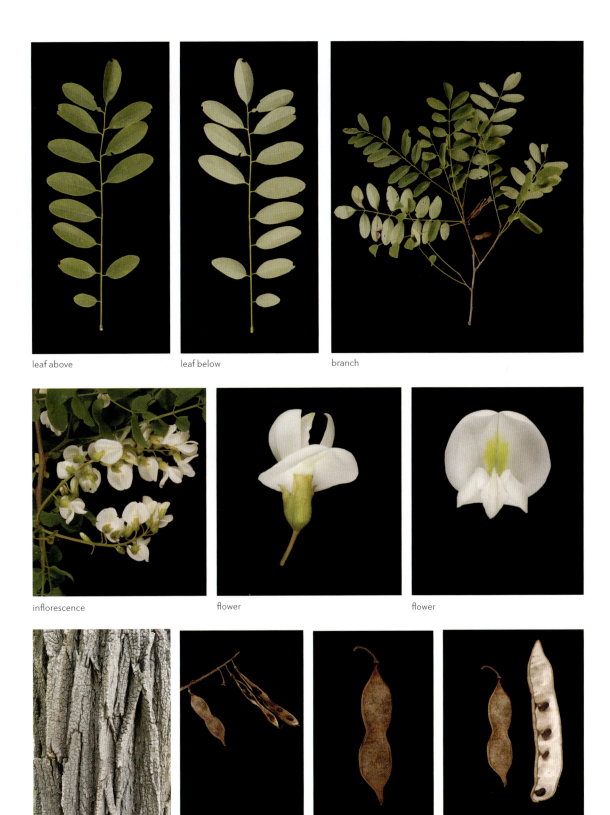

GENUS STYPHNOLOBIUM

In the scheme of great trees, the Japanese pagodatree ranks in the first order. A full-grown tree is an impressive sight, with branches that seem to stretch to infinity, rich green leaves without a care in the world, and fragrant, cream-colored flowers that create a frothy mass over the canopy.

—Michael A. Dirr on *Styphnolobium japonicum* in *Dirr's Encyclopedia of Trees and Shrubs*

The genus *Styphnolobium* includes four to seven species that are native to Asia and the Americas. The trees are small to medium sized and produce profuse clusters of small flowers. The characteristic fruits form pods with distinctive constrictions between seeds that make them look like the beads on a necklace. One introduced species from China is commonly cultivated and has become naturalized in North America.

Japanese Pagoda Tree
Styphnolobium japonicum (L.) Schott

Japanese pagoda tree is a non-native deciduous tree that has naturalized in the northeastern United States. Native to China and Korea, it is a popular ornamental hardy to polluted habitats.

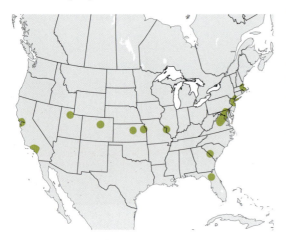

DESCRIPTION. A deciduous tree that grows up to 66 ft (20 m) tall. Twigs are smooth, olive green, and sparsely dotted with tan lenticels. Bark is dark brown and furrowed into rounded, interlacing ridges. Leaves are alternate, pinnately compound, 2 in (5 cm) long, each with seven to seventeen lustrous leaflets, 1–2 in (2.1–5.0 cm) long, margins smooth. Flowers are perfect, pale yellow or creamy white, pealike, 1.2–2.4 in (3–6 cm) in diameter, hang in clusters up to 14 in (35 cm) long, blooming in August. Fruits are green to brown pods, 2–8 in (5–20 cm) long with constrictions between each dark brown seed, somewhat persistent into winter.

USES AND VALUE. Wood not commercially important. Cultivated as ornamental and for landscape use.

ECOLOGY. Non-native but naturalized tree that grows on loamy, well-drained soils. Intermediate in shade tolerance. Resistant to drought and air pollution, which make it suitable as popular ornamental street tree.

CLIMATE CHANGE. Vulnerability is considered low because of wide geographic distribution as an introduced ornamental and naturalization.

CONSERVATION STATUS. Least concern.

bark

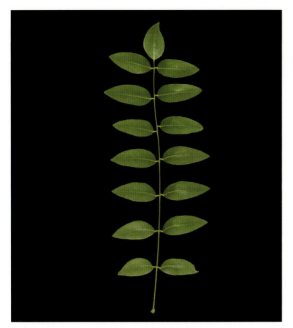
leaf above

leaf below

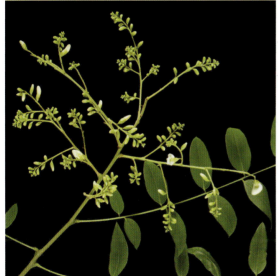
branch with inflorescence

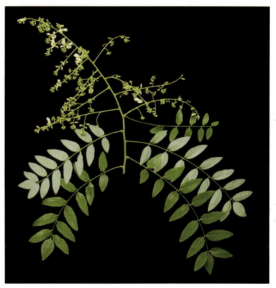
branch with inflorescence

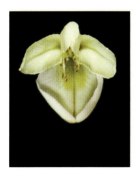
flower

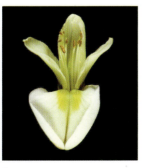
flower

FAMILY FABACEAE • 415

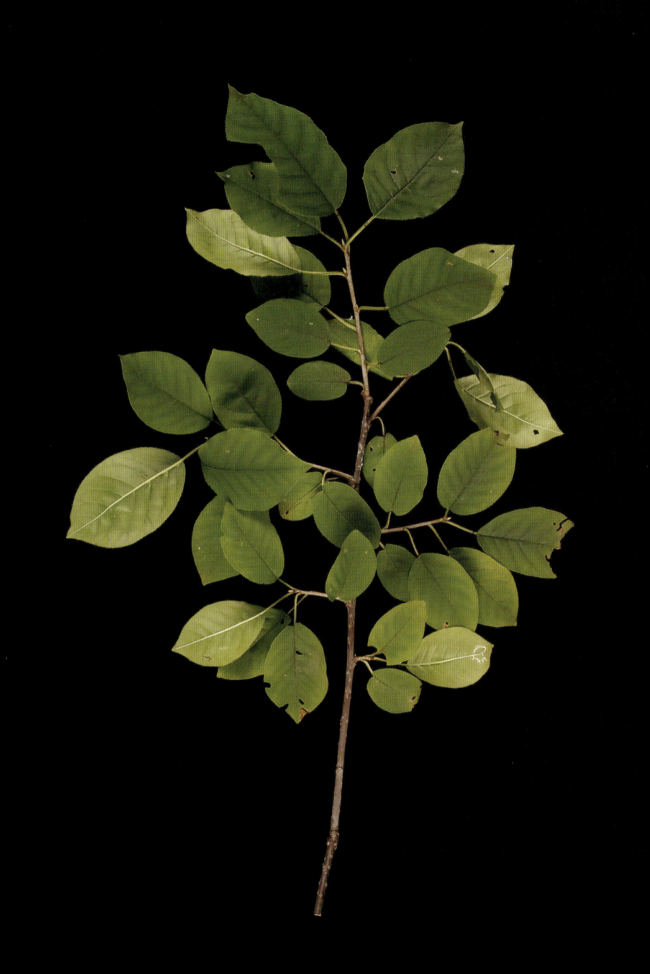

ORDER ROSALES

The Rosales consist of nine families and are now considered to be a strongly supported monophyletic group within the Rosids. Although the various plants within this order are quite heterogeneous in form (and had formerly been regarded as not related evolutionarily), many members of the order share two characters: a lack of (or small amount of) endosperm in the seeds and a specialized floral disk at the base of the flower. Another interesting feature shared by at least some of the families in this order (Cannabaceae, Elaeagnaceae, Rhamnaceae, and Rosaceae) is the ability to fix nitrogen in their root nodules (a feature shared with some members of the Fabales and Fagales). Botanists have recognized the close relationship of the elms, nettles, hackberries, and figs for some time, and these families are now understood to be closely allied with the diverse members of the rose family. Six families of Rosales contain common trees in North America.

Family Rosaceae

The family Rosaceae shows remarkable diversity in their leaves and stems, fruit types, and cell organization, yet this group of flowering plants has always been recognized as very distinctive. No controversy exists in the recognition of the Rosaceae as a well-supported family, and DNA data are concordant with this view. Taxonomists recognize this family by the conspicuous flowers, numerous stamens, and a specialized fleshy tissue in which the seeds are embedded. The majority of the 3,000 species and ninety genera in the Rosaceae are native to the temperate and subtropical regions of the Northern Hemisphere. Many members of this family have evolved through a two-step process: hybridization among closely and distantly related species, followed by an increase in the number of chromosomes. This two-step process has resulted in the origin of both new species and genera in the Rosaceae. Nine genera and twenty-four species are common trees in North America.

OPPOSITE Chokecherry (*Prunus virginiana*)

GENUS AMELANCHIER

In early spring, "when the shad run," according to tradition, Shadblow bursts into flower upon the naked wood. ... The contrast, then, of the long, delicate white petals with the bright red of the scales that hang down from the flower stalks is vivid, and no daintier flowers than these, in their season, star the forest aisles.

—Donald Culross Peattie on *Amelanchier arborea* in *A Natural History of Trees of Eastern and Central North America*

Although botanists disagree on the exact number of species to be included in the genus *Amelanchier*, the twenty or so species are shrubs and small trees found in the temperate regions of North America, Asia, and Europe. The profusion of mainly white flowers in early spring and edible fruits make members of this genus quite popular in the horticultural trade. Many of the species appear to hybridize with each other, which is part of the reason for the taxonomic complexity of *Amelanchier*. Three native species are common trees in North America.

Saskatoon Serviceberry
Amelanchier alnifolia (Nutt.) Nutt. ex M. Roem
WESTERN SERVICEBERRY

Saskatoon serviceberry is a small deciduous tree or shrub that grows in mesic soils of coniferous forests on hillsides, prairies, and riparian zones. The edible, nutty-tasting fruits are used for making jellies and syrups. Three varieties are recognized.

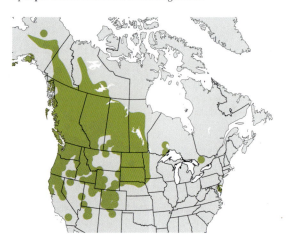

DESCRIPTION. A deciduous small tree or shrub that grows 3–26 ft (1–8 m) tall. Bark is thin, light brown to red brown, and smooth, becoming shallowly fissured with age. Leaves are deciduous, simple, alternate, ovate to nearly round with parallel venation and serrate to dentate margins, 1–1.2 in (2.5–3 cm) long. Flowers are arranged in short dense racemes of five to fifteen flowers, perfect, with twenty stamens, five styles, and ovary that is tomentose at the top, petals straplike, 0.4–0.8 in (1–2 cm) long, sepals hairy on inside becoming reflexed with age. Fruits are berrylike pomes, smooth, dark blue, waxy, sweet, and fleshy, 0.24–0.43 in (6–11 mm) long. Seeds are leathery, four to ten per fruit.

TAXONOMIC NOTES. Variety *pumila* is distinguished by shrubby habit, typically growing less than 7 ft (2 m) tall, and by glabrous or sparsely pubescent ovary apices; var. *alnifolia* occurs primarily in the Great Plains and Rocky Mountains; var. *semiintegrifolia* occurs on the Pacific slopes from Alaska to northern California.

USES AND VALUE. Wood not commercially important. Fruits, which resemble blueberries but have a nutty taste, are grown commercially in Canadian prairies to produce jelly and syrup; are rich in antioxidants and used in a variety of ways by Native North Americans. Black bears, beavers, hares, and other large mammals and birds consume the foliage, fruits, or bark.

ECOLOGY. Grows on hillsides, prairies, and riparian zones of coniferous forests. Also occurs in higher-elevation communities, such as montane chaparral, and in the upper limits of pinyon-juniper communities. Prefers mesic, well drained, infertile soils.

CLIMATE CHANGE. Vulnerability is currently unknown. Immediate assessment is recommended.

CONSERVATION STATUS. Least concern.

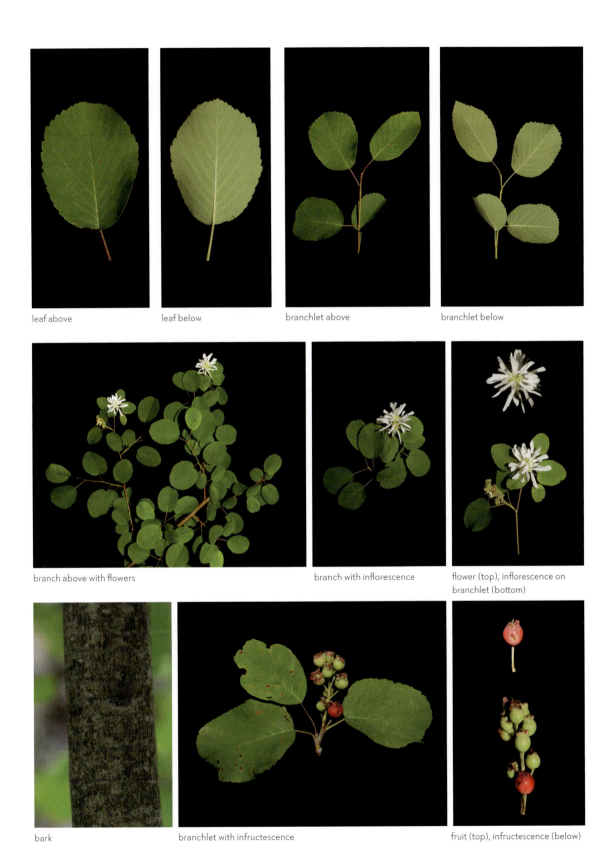

FAMILY ROSACEAE • 419

Downy Serviceberry

Amelanchier arborea (F. Michx.) Fernald
SHADBUSH

Downy serviceberry, native to eastern North America, is a small tree with smooth gray bark. The spherical fruits are reddish purple and seeds that pass through the guts of cedar waxwings have enhanced germination.

ECOLOGY. Grows in dry woodlands, along forest edges, and along streambanks. Intermediate in shade tolerance.

CLIMATE CHANGE. Vulnerability is currently considered to be low.

CONSERVATION STATUS. Least concern.

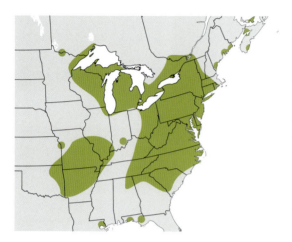

DESCRIPTION. A moderate-aged, deciduous shrub or small tree, growing to 40 ft (12 m) or taller. Twigs are reddish brown to gray, slender, and pubescent when young, becoming glabrous. Bark is gray and smooth when young, becoming grayish brown with vertical fissures. Leaves are alternate, simple, ovate to obovate, dark green and glabrous above, paler and pubescent below, margins finely serrate, 1.6–4 in (4–10 cm) long. Blooming in mid-spring, flowers are produced in racemes, 1.2–2 in (3–5 cm) long, perfect, white, with five petals that are linear to narrowly oblong, 0.4–0.5 in (1–1.4 cm) long. Fruits are pomes, spherical, glaucous, red to purple, 0.24–0.47 in (6–12 mm) in diameter, containing four to ten seeds.

USES AND VALUE. Wood not commercially important. Berries are locally grown to make pies and jams. Native North Americans used berries to make bread. Songbirds and small and large mammals eat the fruits often enhancing germination of seeds. Larval host for red-spotted purple and viceroy butterflies.

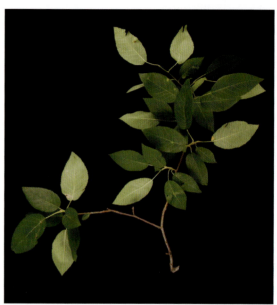

branch

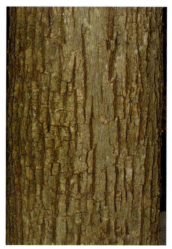

bark

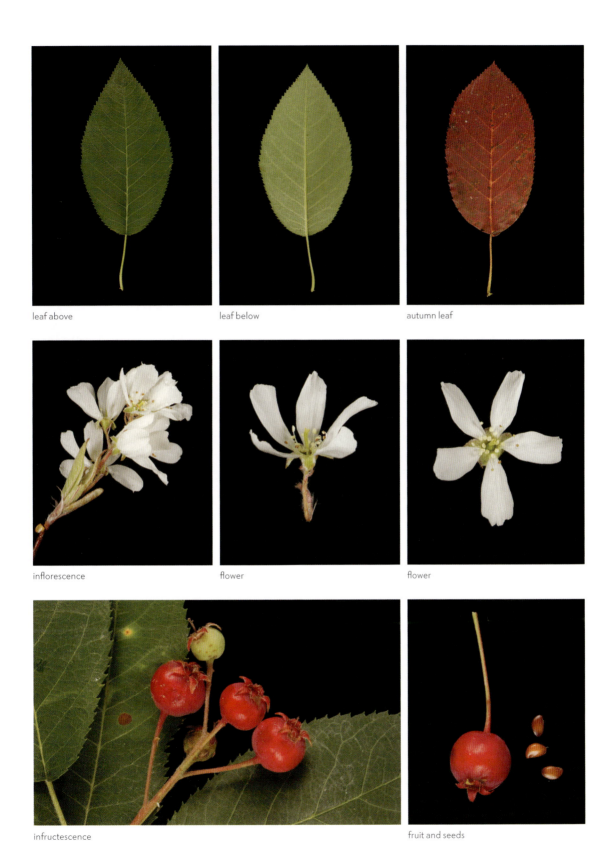

FAMILY ROSACEAE • 421

Utah Serviceberry
Amelanchier utahensis Koehne

Utah serviceberry is a deciduous shrub or small tree native to the western United States, where it grows on dry rocky slopes, canyons, and streambanks.

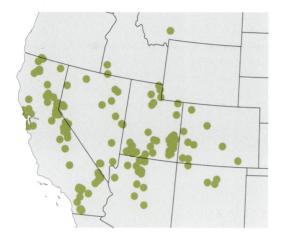

DESCRIPTION. A deciduous shrub or small tree that grows 2–16 ft (0.5–5 m) tall. Twigs are glabrous to white pubescent. Bark is gray with thin ridges. Leaves are deciduous, simple, alternate, hairy below, margins serrate above the middle, 0.51–1.77 in (13–45 mm) long. Flowers are perfect, produced in short racemes, with tomentose hypanthium, pedicel, and sepals, five sepals are reflexed, 0.04–0.12 in (1–3 mm) long, five petals are cream white or pink, 0.20–0.35 in (5–9 mm) long, styles are two or three, stamens are fifteen to twenty. Fruits are round, black pomes, 0.24–0.39 in (6–10 mm) in diameter, dry and pulpy, contain three to six dark brown seeds.

TAXONOMIC NOTE. Species of *Amelanchier* are known to hybridize and have polymorphic characters, which sometimes makes them difficult to identify.

USES AND VALUE. Wood not commercially important. berries are edible and used as substitute for raisins. Infusion of inner bark used medicinally to treat snow blindness. Provides food for desert bighorn sheep, elk, porcupine, mule deer, and many birds. Larval host for Weidemeyer's admiral (*Limenitis weidemeyerii*) butterfly.

ECOLOGY. Native to the western United States, grows on rocky slopes, canyons, and streambanks on coarse to medium textured and well drained soils. Prefers drier habitat than Saskatoon serviceberry (*Amelanchier alnifolia*). Intermediate in shade tolerance.

CLIMATE CHANGE. Vulnerability is currently unknown. Immediate assessment is recommended.

CONSERVATION STATUS. Least concern.

bark

422 • THE DIVERSITY OF TREES

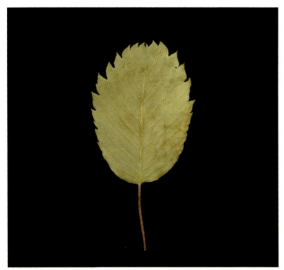
leaf above

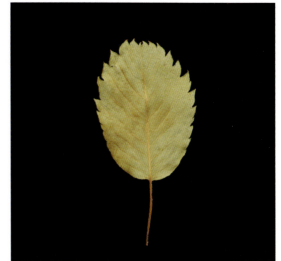
leaf below

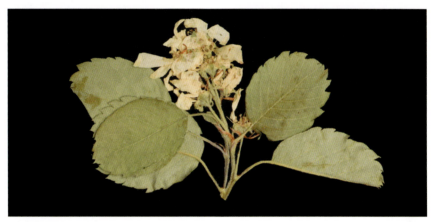
inflorescence

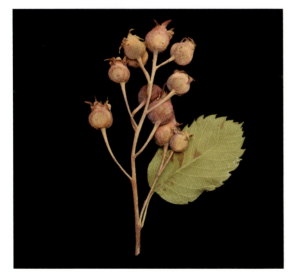
infructescence

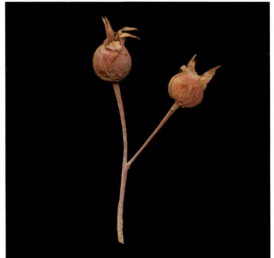
fruits

FAMILY ROSACEAE • 423

GENUS CERCOCARPUS

The nine or ten species in the genus *Cercocarpus* are found primarily in the western part of North America (including Mexico). Ranging from shrubs to small trees, these species favor drier habitats, such as chaparral and woodlands, in the mountains of the West. Two species of *Cercocarpus* are common trees in North America.

Curlleaf Cercocarpus
Cercocarpus ledifolius Nutt.
CURLLEAF MOUNTAIN-MAHOGANY

Curlleaf cercocarpus is an aromatic evergreen shrub or small tree native to the western United States. The dense cuticles, sunken stomata, and revolute margins of the leaves make this drought-tolerant tree well adapted to the high-altitude desert areas and dry rocky slopes where it grows. Three varieties are recognized.

DESCRIPTION. An aromatic and resinous evergreen shrub or small tree that grows 6–36 ft (2–11 m) tall. The distinctive heartwood is rich reddish-brown. Bark is gray brown, dense, and furrowed. Leaves are alternate, simple, entire, linear to oblong and acuminate, thick, resinous, and leathery with dense cuticles, sunken stomata, and revolute leaf margins. Flowers are perfect, apetalous, produced in clusters of one to five, blooming in March or April. Fruits are achenes with persistent plumose style or tail, 1–3.1 in (2.5–8 cm) long.

TAXONOMIC NOTES. Variety *intricatus* is distinguished by shrubby habit and leaf blades 0.04–0.06 in (1–1.5 mm) wide with strongly revolute margins; var. *ledifolius* is shrubby or treelike and distinguished by leaves 0.08–0.35 in (2–9 mm) wide with variable revolute margins; var. *intermontanus* is distinguished by leaves 0.20–0.35 in (5–9 mm) wide with revolute margins that are abaxially sericeous or villous.

USES AND VALUE. Wood not commercially important. Scraped bark made into tea. Native North Americans use various parts to treat several ailments. Provides forage for deer, elk, moose, bighorn sheep, and livestock. Seeds eaten by small mammals and birds.

ECOLOGY. Native to the western United States, grows in high-altitude desert areas and dry rocky slopes on deep, well-drained, and nutrient-poor sandy loam soils with oaks and pines. A number of leaf traits are adaptions to these dry and desert habitats.

CLIMATE CHANGE. Vulnerability is currently unknown. Immediate assessment is recommended.

CONSERVATION STATUS. Least concern.

leaf above

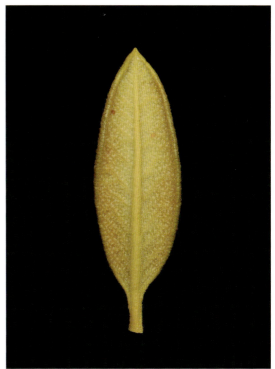
leaf below

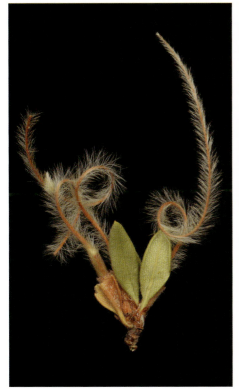
infructescence with leaves

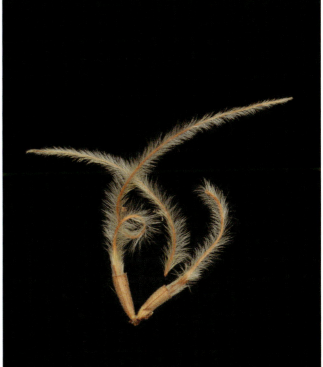
fruits

Birchleaf Mountain-Mahogany
Cercocarpus montanus Raf.
ALDERLEAF CERCOCARPUS, ALDERLEAF MOUNTAIN-MAHOGANY

CLIMATE CHANGE. Vulnerability is currently unknown. Immediate assessment is recommended.

CONSERVATION STATUS. Least concern.

Birchleaf mountain-mahogany is a near-evergreen shrub or small tree that grows in the lower montane regions of the western United States on rocky hillsides, cliffs, open woods, and mesas.

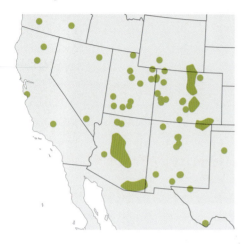

DESCRIPTION. A near-evergreen shrub or small tree that grows from 3–23 ft (1–7 m) in height with deep-colored heartwood. Bark is thin, smooth, and gray. Leaves are simple, alternate, in clusters on short branches, variable in thickness and shape from lanceolate to obovate, usually broadest at midpoint, and slightly revolute to even along margins, degree of deciduousness varies with latitude. Flowers are perfect, apetalous, borne singly or in clusters of up to twelve in axils of short spurlike branches. Fruits are hard, cylindrical achenes, 0.31–0.47 in (8–12 mm) long with feathery style.

USES AND VALUE. Wood not commercially important. Planted for erosion control and as a landscape ornamental. Provides cover for birds and small mammals; deer browse the twigs and leaves.

ECOLOGY. Grows on rocky hillsides, cliffs, open woods, and mesas in the lower mountains of the western United States. Occurs on a variety of well-drained, coarse, and poorly developed soils. Shade intolerant and drought resistant.

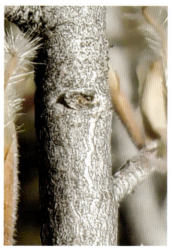

bark

426 • THE DIVERSITY OF TREES

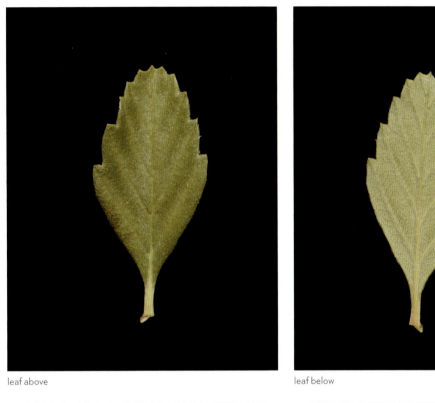
leaf above

leaf below

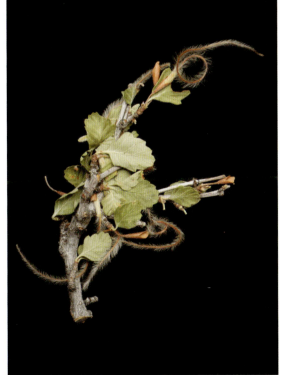
branch with fruits

fruit

FAMILY ROSACEAE • 427

GENUS CRATAEGUS

The Red Haw is host to a large number of little creatures. The song sparrow, mourning dove, indigo bunting, yellow warbler, and goldfinch nest, feed, and sing in the Hawthorn groves all summer long.

—Donald Culross Peattie on *Craetaegus mollis* in *A Natural History of Trees of Eastern and Central North America*

Many species in the genus *Crataegus* are the source of jams, traditional medicines, and folklore in the temperate regions of Asia, Europe, and North America, where they are native. The bright red fruits (resembling small apples) are popular for cooking and also make the plants horticulturally important in the landscape. The taxonomy of this genus has been notoriously difficult because of hybridization and microvariation, resulting in the description of a large number of species and varieties, many probably erroneous. Estimates range from several hundred to a thousand species of *Crataegus*. Three native species are common trees in North America.

Fireberry Hawthorn
Crataegus chrysocarpa Ashe

Fireberry hawthorn, a many-branched small tree with a broad rounded crown, grows in North America east of the Rocky Mountains in moist valleys, thickets, dry slopes, and riparian zones. The fruits are edible but not recommended. Nine varieties are recognized by some taxonomists.

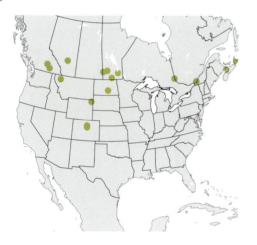

DESCRIPTION. A many-branched shrub or small tree that grows to 23 ft (7 m) tall with a broad rounded crown. Twigs are glabrous to villous, thorny. Leaves are simple, alternate, elliptic to circular, firm and variably glossy green with veins impressed on upper surface, margins jaggy, 0.8–3.5 in (2–9 cm) long. Flowers are perfect, white, glabrous or villous, 0.5–0.8 in (1.2–2 cm) wide, and arranged in compound cymes. Fruits are dark or bright red, succulent pomes, 0.3–0.6 in (0.8–1.5 cm) in diameter, with three to five nutlets.

TAXONOMIC NOTES. Variety *chrysocarpa* occurs in the eastern and southeastern United States and Canada; var. *piperi* is found in the Pacific Northwest and British Columbia; var. *faxonii* grows in eastern Canada and the northeastern United States, with a disjunct population in Illinois and Wisconsin; var. *phoenicea* is found only in Quebec and Ontario; var. *praecox* occurs in the northeastern United States; var. *subrotundifolia* grows in the northern portion the species' distribution; var. *vernonensis* is found only in British Columbia; var. *vigintistamina* occurs in Minnesota, Ontario, and New York; and var. *blanchardii* ranges from Minnesota and Quebec to Vermont and New York.

USES AND VALUE. Wood not commercially important. Planted for erosion control and as landscape ornamental. Fruits edible but not highly recommended. Medicinally, parts of plant used as a cardiotonic, hypotensive, and laxative. Provides cover for birds and small mammals; deer browse twigs and leaves.

ECOLOGY. Grows from northeastern Canada to Kentucky and west to the Rocky Mountains on moist valleys, thickets, dry slopes, and riparian zones. Prefers well-drained and loamy soils. Intermediate in shade tolerance.

CLIMATE CHANGE. Vulnerability is currently considered to be low.

CONSERVATION STATUS. Least concern.

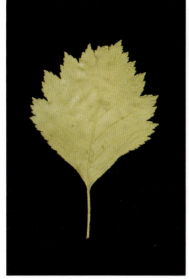
leaf above

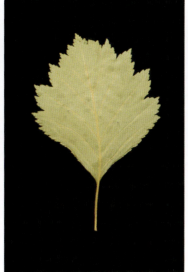
leaf below

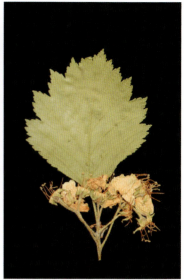
leaf with inflorescence

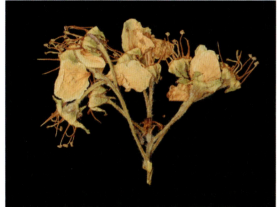
inflorescence

flowers

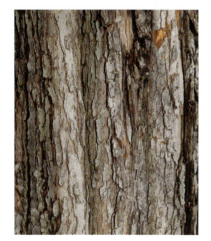
bark

infructescence

FAMILY ROSACEAE • 429

Cockspur Hawthorn
Crataegus crus-galli L.

Cockspur hawthorn, native to eastern North America, is a small tree that bears long thorns on its trunk and branches. It is widely cultivated in horticulture and planted as a hedge or for streambank stabilization.

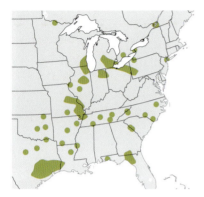

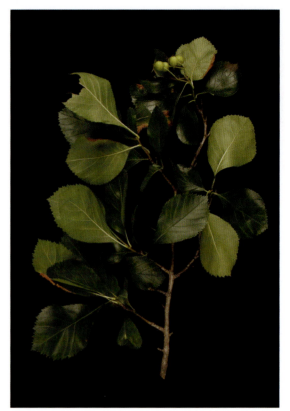

branch

DESCRIPTION. A long-lived deciduous tree, growing to 33 ft (10 m) tall. Trunk with many low branches. Twigs have thorns, 2 in (5 cm) long, downturned on lower half of stems. Leaves are alternate and held above the twigs, simple, obovate with a spatulate base, margins finely serrate on the upper portion, thick, leathery, shiny green above, multicolored in fall, 3 in (7.75 cm) long. Flowers are perfect, white to red, 0.4–0.6 in (1–1.5 cm) in diameter, foul-smelling, clustered in corymbs, blooming in late spring. Fruits are pomes, at first green, turning orange, then red, 0.5 in (1.25 cm) in diameter.

USES AND VALUE. Wood not commercially important. Popular as an ornamental for colorful fruits, planted as a screen or hedge and for streambank stabilization. Fruit is edible but not flavorful. Medicinally, used as a cardiotonic and hypotensive. Birds and mammals eat the fruit.

ECOLOGY. Grows on moist soils and in full sunlight throughout eastern North America. Intermediate in shade tolerance.

CLIMATE CHANGE. Vulnerability is currently considered to be low.

CONSERVATION STATUS. Least concern.

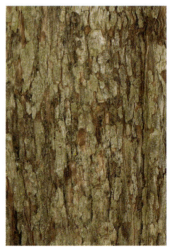

bark

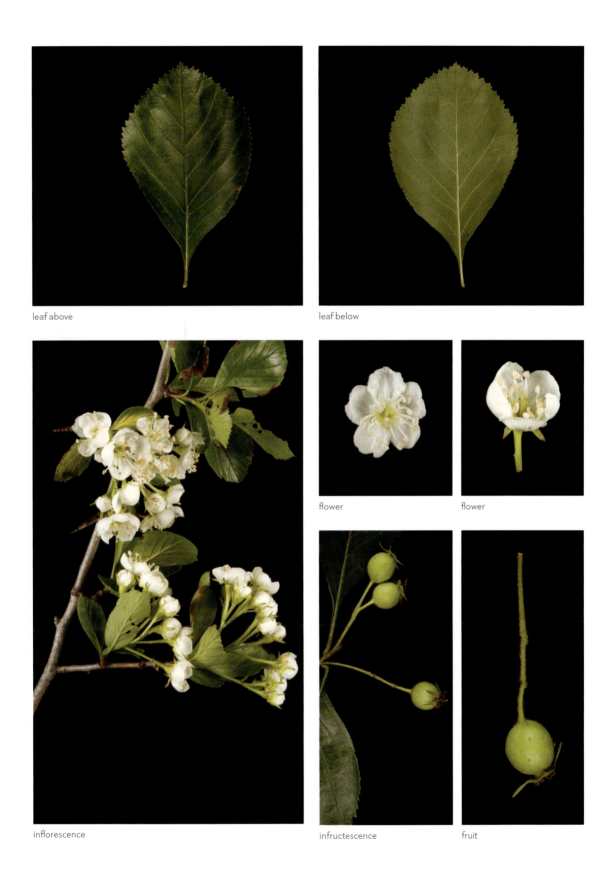

FAMILY ROSACEAE • 431

Green Hawthorn
Crataegus viridis L.
SOUTHERN HAWTHORN

Green hawthorn, native to the southeastern United States, is a small tree with a dense crown of spreading branches. The thin pale gray bark peels away revealing the attractive cinnamon-colored underbark, which adds to its value as an ornamental tree.

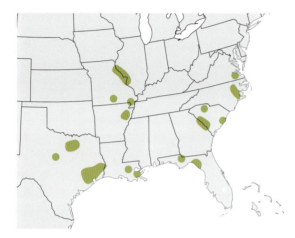

DESCRIPTION. A long-lived deciduous tree that grows up to 39 ft (12 m) tall with spreading branches and a dense, rounded, mostly spineless crown. Twigs may or may not have thorns, 0.8–1 in (2–2.5 cm) long. Bark is pale gray, thin with scales revealing cinnamon-colored underbark. Leaves are simple, alternate, variable in shape from ovate to oblong obovate, elliptic, asymmetric, shiny green above, pale yellowish green below, margins serrate above midpoint, 1–2 in (2.5–5 cm) long, 0.5–1.2 in (1.25–3 cm) wide. Flowers are perfect, white, 0.47–0.59 in (12–15 mm) wide, produced in many-flowered corymbs, blooming in early spring. Fruits are juicy, red, globose pomes, 0.20–0.31 in (5–8 mm) in diameter, containing five nutlets.

USES AND VALUE. Wood not commercially important. Cultivated as popular ornamental. Fruits are eaten by birds; foliage provides cover for birds and mammals.

ECOLOGY. Grows in low-lying woodlands. Intermediate in shade tolerance; drought resistant. One of the most disease resistant hawthorns.

CLIMATE CHANGE. Vulnerability is currently unknown. Immediate assessment is recommended.

CONSERVATION STATUS. Least concern.

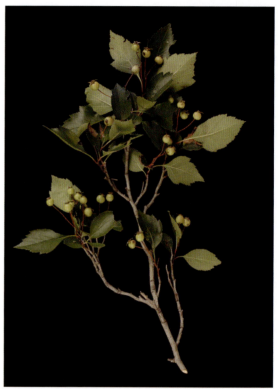

branch with fruits

bark

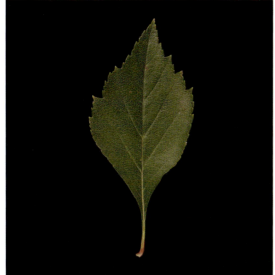
leaf above

leaf below

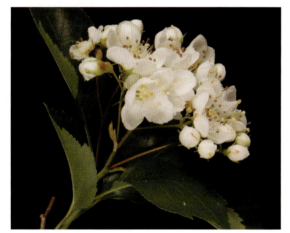
inflorescence

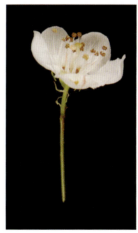
flower

flower

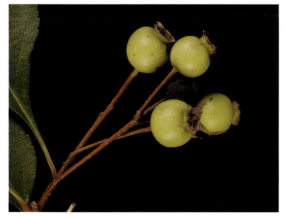
infructescence

fruit and seed

FAMILY ROSACEAE • 433

GENUS HETEROMELES

The genus *Heteromeles* contains only a single species, which is restricted to the West Coast of North America. The plants are primarily shrubs but, in some habitats, can attain the size of small trees, which is why the species is included here. The bright red fruits, technically a type of apple, make these plants popular around Christmastime.

Toyon
Heteromeles arbutifolia (Lindl.) M. Roem.

Toyon, endemic to California and parts of Mexico, is a freely branched evergreen shrub or small tree common in foothills and canyons of chaparral habitats.

DESCRIPTION. A freely branched evergreen shrub or small tree that grows up to 20 ft (6 m) in height. Bark is gray, smooth or shallowly fissured. Leaves are evergreen, simple, alternate, leathery, glossy and dark green above, dull and pale below, margins toothed, 2–4 in (5–10 cm) long. Flowers are perfect, white, with five sepals and petals, arranged in terminal clusters. Fruits are berrylike, bright red pomes, 0.20–0.39 in (5–10 mm) in diameter, containing three to six small brown seeds.

USES AND VALUE. Wood not commercially important, Cultivated as an ornamental tree and popular for use in Christmas decorations. Native North Americans eat the fruit, often made into a jelly. Leaves are made into a tea to treat stomachache. Flowers attract pollinating insects, especially butterflies. Fruits are eaten by birds, including northern mockingbirds, American robins, cedar waxwings, and hermit thrushes, and mammals, including coyotes and bears, all of which are seed dispersers.

ECOLOGY. Common chaparral long-lived tree that grows on semi-dry brushy slopes of foothills and canyons, endemic to California and parts of Mexico. Prefers dry and well-drained soils. Drought tolerant.

CLIMATE CHANGE. Vulnerability is currently unknown. Immediate assessment is recommended.

CONSERVATION STATUS. Least concern.

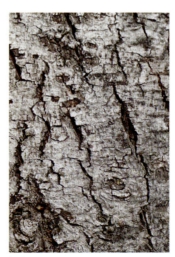

bark

leaf above

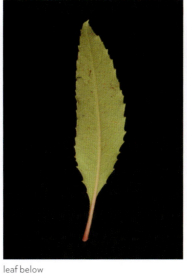
leaf below

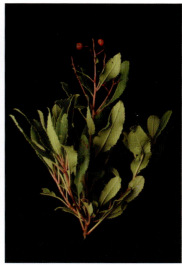
branch

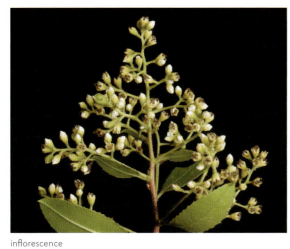
inflorescence

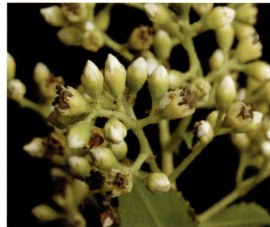
inflorescence

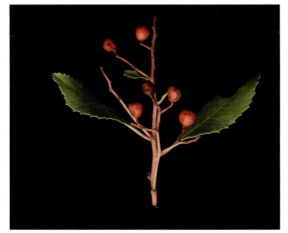
branchlet with infructescence

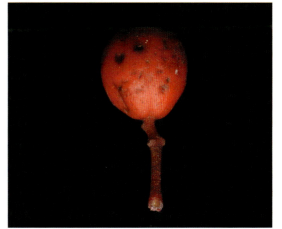
fruit

FAMILY ROSACEAE • 435

GENUS MALUS

And what bloom!—petals at first daintily flushed with shell pink, becoming at last pure white, and breathing a fragrance that the wind may carry far. It is an odor like that of Apple blossoms but more tart and wild and more penetrating. Those who have known it in childhood never forget it. It steals out to us from our earliest memories of things that we were wise enough then to consider precious.

—Donald Culross Peattie on *Malus coronaria* in *A Natural History of Trees of Eastern and Central North America*

The genus *Malus* may contain over fifty species, including our domesticated apples and crab apples. Distributed in northern temperate regions around the world, members of this genus have been cultivated for their fruits and as ornamental trees for many centuries. One introduced and now naturalized species is common in North America.

Paradise Apple
Malus pumila Mill.

Paradise apple is a tall tree native to Europe and Asia. It is naturalized throughout North America, where it is cultivated for its red or yellow fruits that ripen in fall. Johnny Appleseed, an historical disperser of apple seeds in the eighteenth and nineteenth centuries, helped to establish orchards in many parts of the United States.

DESCRIPTION. A deciduous tree that grows up to 43 ft (13 m) tall. Twigs are red, brown, or gray, tomentose when young. Bark is gray, with scales and fissures. Leaves are alternate, simple, elliptic to ovate, green above, paler and tomentose below, margins crenate to serrate, 1.6–4 in (4–10 cm) long, 1.2–2.4 in (3–6 cm) wide. Flowers are perfect, in small clusters, white or pinkish white, with five petals and many stamens, 1.2 in (3 cm) across, blooming in early spring. Fruits are green, red, or yellow pomes, depressed-globose, 2.8–4 in (7–10 cm) long, and 2–3.5 in (5–9 cm) wide, with up to ten seeds in papery core.

USES AND VALUE. Wood not commercially important. One of most commercially important trees because of popularity of fruits and as an ornamental. Cultivation in orchards common; also "wild" apples found around abandoned houses and in former orchards from colonial times and later. Fruit is eaten raw, baked in pies, and made into sauces. Bark, especially from roots, is anthelmintic, refrigerant, and soporific.

ECOLOGY. Almost always cultivated or naturalized in many areas, and found in old fields, thickets, fencerows, old home sites, and roadsides. Intermediate in shade tolerance.

CLIMATE CHANGE. Vulnerability is considered low because of its wide geographic distribution as a cultivated tree.

CONSERVATION STATUS. Least concern.

seeds

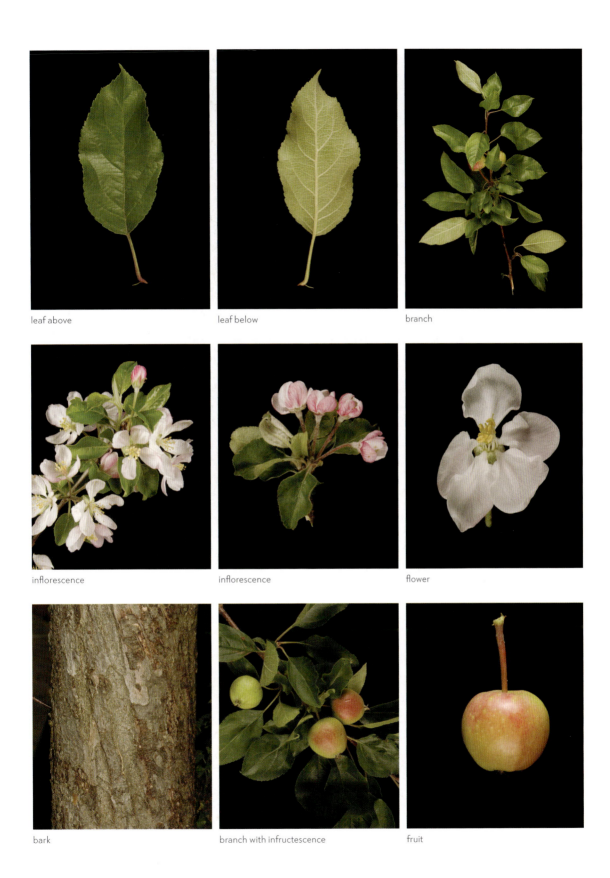

FAMILY ROSACEAE • 437

GENUS PRUNUS

So from pioneer time, Cherry has grown steadily rarer. The assault upon it was twofold, just as in the case of Beech, Tuliptree, and Sycamore, in that the land on which Wild Black Cherry grew being counted the best agricultural soil, the trees were disposed of as fast as possible, even to the extent of girdling magnificent virgin growth, or burning it down, while at the same time there was a constant culling-out of all the finest specimens for the sawmills.

—Donald Culross Peattie on *Prunus serotina* in A Natural History of Trees of Eastern and Central North America

With over 400 species, the genus *Prunus* contains many trees of significant agricultural importance, including the peach, plum, cherries, apricots, and almonds. Plant breeders have artificially created hundreds of cultivated forms, or cultivars, of these species. All of these species are native to the northern temperate regions of Asia, Europe, and North America. Two introduced and nine native species of *Prunus* are common trees of North America. (See p. 745 for leaf shapes of eleven species of *Prunus*.)

American Plum

Prunus americana Marshall

American plum is a small, multistemmed tree or shrub that is native to woodland edges, streambanks, and upland pastures throughout the eastern United States. The sweet fruits are edible fresh and are also made into jellies and jam as well as wine.

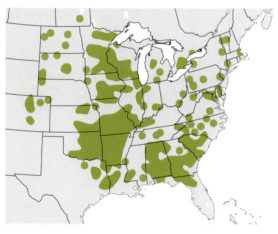

DESCRIPTION. An understory multistemmed and thicket forming tree or large shrub that grows to 33 ft (10 m) tall. Twigs are slender, reddish brown, developing an exfoliating gray film. Buds are reddish to gray and sharp pointed, some twigs becoming thorns. Bark is reddish gray and smooth when young, with many horizontal lenticels, becoming rough with irregular ridges and exfoliating strips. Leaves are deciduous, simple, alternate, ovate to elliptical, green above, slightly paler and hairy below, with finely serrate margins, sharply pointed apex, and cuneate base, 3.1–5.1 in (8–13 cm) long, 1–2 in (2.5–5 cm) wide. Flowers are perfect, fragrant, showy, white, five-petaled, 1 in (2.5 cm) in diameter, borne in two to four flowered umbels, blooming from March to June. Fruits are drupes, yellow or red, 2.0–3.2 cm (0.8–1.3 in) in diameter.

USES AND VALUE. Wood not commercially important. Cultivated as ornamental tree (over 200 cultivars) and for edible fruits. Fruits are sour and sweet, eaten fresh and processed as preserves, jellies, jam, and wine. Used for windbreaks and in highway or riverside plantings. Effective in stabilizing streambanks and gullies. Many birds and mammals eat the fruit; mule and white-tailed deer feed on leaves and twigs. Flowers provide nectar to pollinating insects, especially bees.

ECOLOGY. Most broadly distributed plum in North America. Grows primarily in woodlands along streams, ponds, and lake borders. Prefers fertile, deep, and medium or coarse textured soils. Flood tolerant; not fire or drought tolerant.

CLIMATE CHANGE. Vulnerability is currently considered to be low.

CONSERVATION STATUS. Least concern.

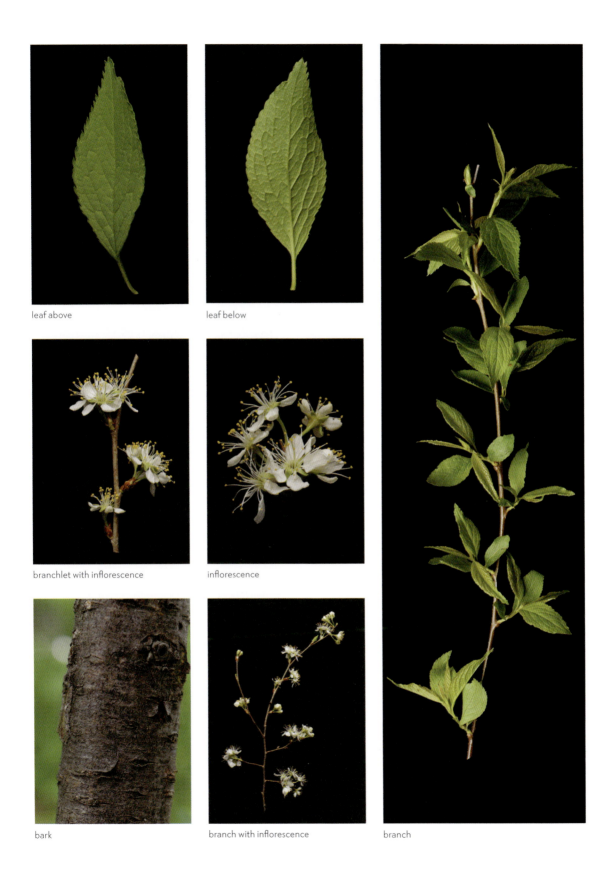

leaf above

leaf below

branchlet with inflorescence

inflorescence

bark

branch with inflorescence

branch

FAMILY ROSACEAE • 439

Chickasaw Plum
Prunus angustifolia Marshall

Chickasaw plum is a small tree or shrub that grows in open woodlands, savannas, prairies, meadows, fencerows, and roadsides. Because of its ability to form dense thickets, it is often planted for erosion control.

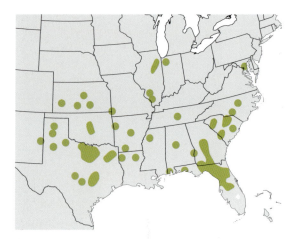

DESCRIPTION. A small tree or shrub growing up to 26 ft (8 m) tall. Depending on light availability, forms dense thickets in open areas and grows as an open-crowned tree in shade. Branches are ruddy, lined with side branches and twigs appearing prickly or thorny. Bark is scaly and nearly black. Leaves are deciduous, alternate, simple, green and shiny above, turn yellow before senescing in fall, margins narrowly toothed, folding upwards, 1–3 in (2–7 cm) long. Flowers are perfect, white, showy, five-petaled, 0.4 in (8 mm) wide, arranged in clusters of two to four, blooming before leaves in spring. Fruits are fleshy, red or yellow, 0.5–0.75 in (1–2 cm) wide, ripen in summer.

USES AND VALUE. Wood not commercially important. Used in erosion control due to extensive root system and ability to form thickets. Fruits are tart and acidic in flavor, edible and delicious when fully ripe; used to make jams, preserves, and pies. Fruits eaten by many animals; foliage provides cover for nesting sites.

ECOLOGY. Grows in open woodlands, forest openings, savannas, prairies, meadows, fencerows, and roadsides. Intermediate in shade tolerance. Prefers loose sandy soils.

CLIMATE CHANGE. Vulnerability is currently considered to be low.

CONSERVATION STATUS. Least concern.

branch

bark

leaf above

leaf below

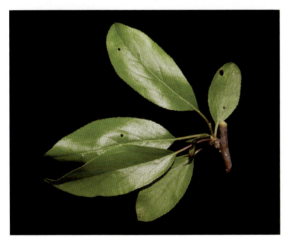
branchlet

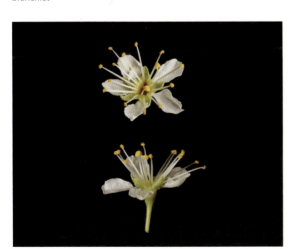
flowers

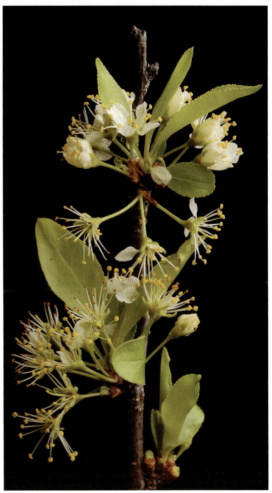
branch with inflorescence

FAMILY ROSACEAE • 441

Carolina Laurelcherry
Prunus caroliniana (Mill.) Aiton

Carolina laurelcherry is a large evergreen shrub or small tree native to moist bottomlands of the southern United States growing in open woodlands and fields. Leaves produce cyanogenic glycosides and can be toxic.

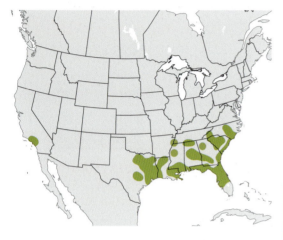

DESCRIPTION. A large evergreen shrub or small tree that grows up to 39 ft (12 m) tall. Bark is smooth and dark gray, turning dark, scaly, and splotched with age. Leaves are simple, alternate, green, glossy, stiff, lanceolate-oblong, margins entire or toothed, 2–3.5 in (5–9 cm) long, release an amaretto scent when crushed. Flowers are perfect, white, five-petaled, 0.2 in (5 mm) across, arranged in short racemes, 2–3.1 in or 5–8 cm long, blooming in spring. Fruits are glossy black drupes, 0.4 in (1 cm) in diameter.

USES AND VALUE. Wood not commercially important. Leaves and branches contain high amounts of cyanogenic glycosides, which make them toxic for grazing livestock and children. Trees considered to be deer resistant, however, and planted as ornamental shade tree and landscape hedge despite their toxicity.

ECOLOGY. Native to moist bottomlands of the southern United States from South Carolina to Texas. Grows in low woods, maritime forests, fields, and thickets on moist, deep, loamy, and well-drained soils. Intermediate in shade tolerance.

CLIMATE CHANGE. Vulnerability is currently considered to be low.

CONSERVATION STATUS. Least concern.

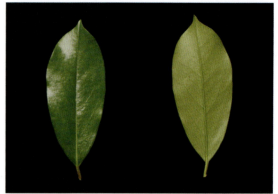
leaf above (left), leaf below (right)

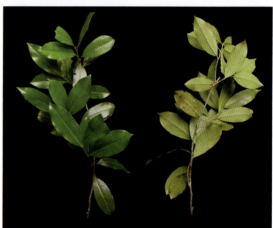
branch above (left), branch below (right)

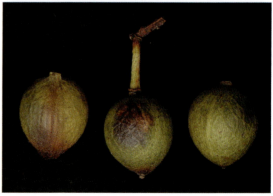
fruits

Bitter Cherry
Prunus emarginata (Douglas) Eaton

Bitter cherry is an evergreen tree or shrub native to western North America that grows in cool, moist habitats in foothills and canyons. Fruits are edible but have a tart, bitter taste.

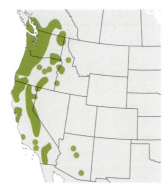

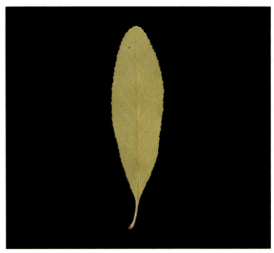
leaf above

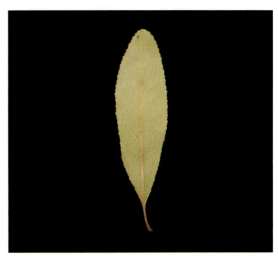
leaf below

DESCRIPTION. An evergreen tree or tall shrub growing up to 52 ft (16 m). Twigs are gray or reddish brown. Bark is dark brown and fissured. Leaves are simple, alternate, lanceolate to ovate, glossy, dark green, margins entire or spiny-serrate, 0.8–4.7 in (2–12 cm) long. Flowers are perfect, white to creamy yellow, sepals and petals glabrous, 0.04–0.12 in (1–3 mm) in length, arranged in racemes of fifteen or more flowers on pedicels 0.04–0.20 in (1–5 mm) long. Fruits are drupes, red or blue black, glabrous, 0.47–0.98 in (12–25 mm) wide, with fleshy, thin, and edible pulp.

USES AND VALUE. Wood not commercially important. Cultivated as ornamentals. Fruits have strong bitter taste but are edible. Bark is blood purifier, laxative, and tonic. Used by Native North Americans to treat variety of ailments. Fruits are consumed by birds and small mammals; black-tailed deer and mountain beavers browse foliage.

ECOLOGY. Grows in cool moist foothills and canyons in western North America. Prefers rich, moist, adequately drained soils. Intermediate in shade tolerance.

CLIMATE CHANGE. Vulnerability is currently considered to be low.

CONSERVATION STATUS. Least concern.

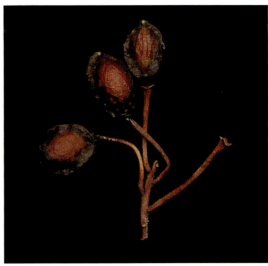
infructescence

Cherry Plum
Prunus cerasifera Ehrhart

Cherry plum, introduced into the United States, is native to the Caucasus and western Asia. With many cultivars producing edible fruits, it has become naturalized in scattered localities in eastern North America.

CLIMATE CHANGE. Vulnerability is considered low because of its wide geographic distribution as a cultivated ornamental.

CONSERVATION STATUS. Least concern.

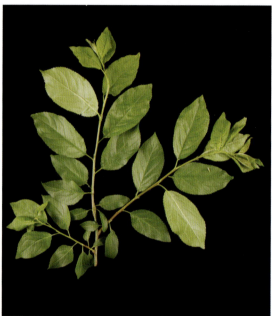
branch

DESCRIPTION. A deciduous tree or shrub growing to 26 ft (8 m) tall and 20 ft (6.5 m) wide, with rounded profile and ascending branches, sometimes spiny. Bark is dark gray. Twigs are dark red. Leaves are alternate, simple, oval to elliptical, light green above, hairy on the midrib and veins below, margins finely to bluntly serrate, with short, pointed tip, 0.8–2.4 in (2–6 cm) long, 1–1.2 in (2.5–3 cm) wide. Flowers are perfect, white, solitary, five-petaled, very fragrant, 0.8–1 in (2–2.5 cm) across, blooming in early spring before leaves appear. Fruits are edible drupes, round, red to black with light bloom, 0.8–1.2 in (2–3 cm) in diameter, ripen in mid- to late summer.

USES AND VALUE. Wood not commercially important. Non-native. Cultivated as ornamental and fruit tree with many cultivars, including some with purple leaves. Fruits are edible and used in pies, jams, and preserves.

ECOLOGY. Introduced into cultivation in North America and is native to the Caucasus and western Asia. Occasionally escapes cultivation to become naturalized. Intermediate in shade tolerance.

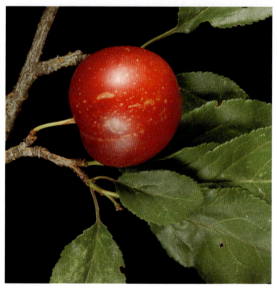
branch with fruit and leaves

leaf above

leaf below

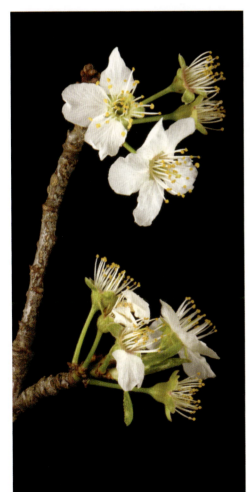
inflorescence

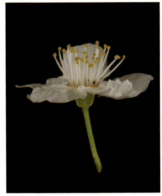
flower

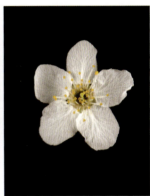
flower

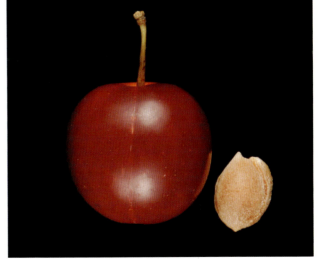
fruit and seed

Hollyleaf Cherry

Prunus ilicifolia (Nutt. ex Hook. & Arn.) D. Dietr.

Hollyleaf cherry is an evergreen tree or large shrub endemic to California and grows in canyons, on slopes, in scrublands and woodlands on dry, rocky soils. Cultivated as an ornamental tree, the fruits are edible and can be eaten raw or dried. Two subspecies are recognized.

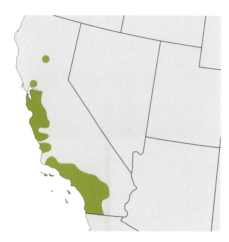

DESCRIPTION. An evergreen tree or shrub that grows up to 52 ft (16 m) tall. Twigs are gray or reddish brown, maturing to dark brown. Bark is dark brown and fissured. Leaves are simple, alternate, wavy or flat, lanceolate to ovate, glossy dark green, margins entire or spiny-serrate, 0.8–4.7 in (2–12 cm) long. Flowers are perfect, white to creamy yellow, sepals and petals glabrous, 0.04–0.12 in (1–3 mm) in length, arranged in racemes of fifteen or more, on pedicels 0.4–2 in (1–5 cm) long. Fruits are glabrous, red or blue black drupes, 0.47–0.98 in (12–25 mm) wide, with fleshy, thin, and edible pulp.

TAXONOMIC NOTES. Subspecies *ilicifolia* is found on the California mainland and has wavy, ovate or round leaf blades with spiny margins and red fruits; ssp. *lyonia* is found on the Channel Islands of California and has flat leaf blades with entire margins and larger blue-black fruits.

USES AND VALUE. Wood not commercially important. Highly prized as ornamental due to showy foliage and edible fruits, which have a pleasant tart taste. Leaves browsed by large mammals; fruits eaten by birds and small mammals.

ECOLOGY. Grows in chaparral habitats of coastal and Baja California. Found on dry rocky soils in canyons, on slopes, and in scrublands and woodlands. Intermediate in shade tolerance. Extremely drought tolerant.

CLIMATE CHANGE. Vulnerability is currently unknown. Immediate assessment is recommended.

CONSERVATION STATUS. Least concern.

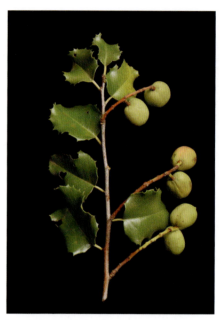

branch with immature infructescence

bark

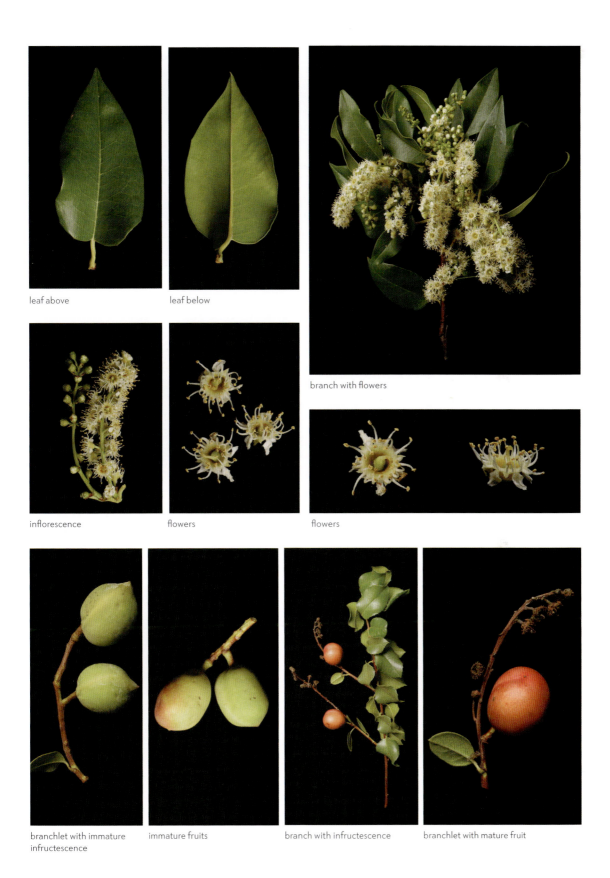

FAMILY ROSACEAE • 447

Mexican Plum
Prunus mexicana S. Watson

Mexican plum is a small, single-trunked tree that grows in woods, river bottoms, and prairies on calcareous and well drained soils. Often cultivated for its edible fruits, it is also well-suited as an ornamental tree.

DESCRIPTION. A small, erect, single-trunked tree that grows up to 26 ft (8 m) tall. Bark is smooth, banded with lenticels, and reddish gray brown when young, becoming dark, roughened, horizontally striated with age exfoliating in patches. Leaves are simple, alternate, deciduous, ovate to elliptic, green, pubescent below, margins double-toothed, turning attractive yellow or orange in fall, 3.1 in (8 cm) long, with minute glands on petiole near blade. Flowers are perfect, showy, white, fragrant, 0.75 in (1.8 cm) across, arranged in racemes, blooming before or with the leaves in early spring. Fruits are edible drupes, 0.8 in (2 cm) in diameter, ripen from yellow to rose or purple with glaucous surface.

USES AND VALUE. Wood not commercially important. Cultivated as ornamental landscape tree. Fruits are edible with varying degrees of palatability. Birds and mammals consume the fruits; flowers provide nectar for pollinating insects; leaves serve as larval host to tiger swallowtail and cecropia moths.

ECOLOGY. Grows in thin woods, river bottoms, and prairies on soils that are calcareous and well drained. Intermediate in shade tolerance; drought tolerant.

CLIMATE CHANGE. Vulnerability is currently unknown. Immediate assessment is recommended.

CONSERVATION STATUS. Least concern.

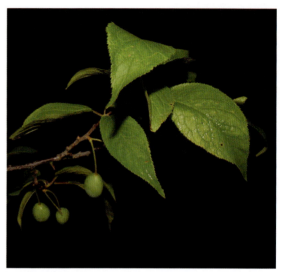
branchlet with fruits

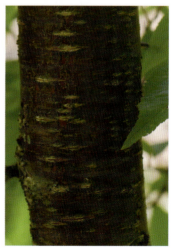
bark

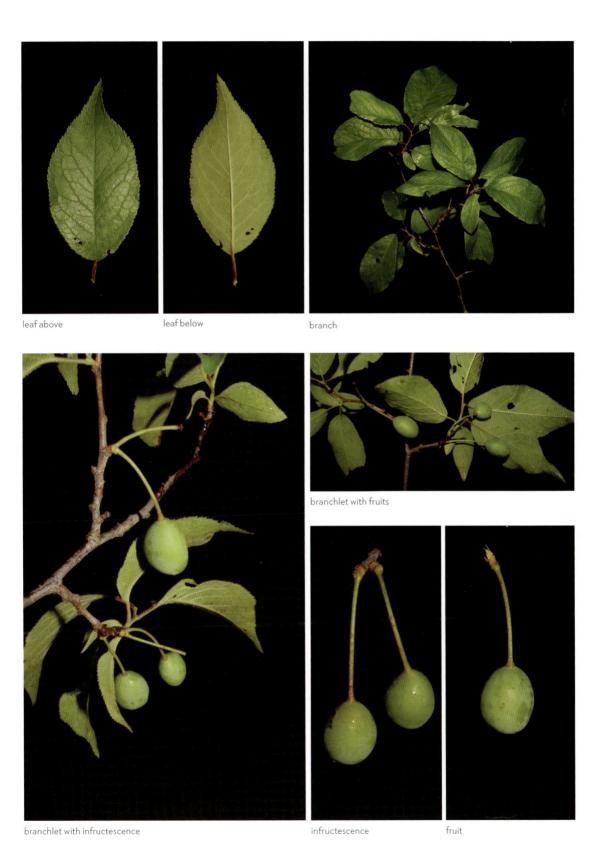

FAMILY ROSACEAE • 449

Pin Cherry

Prunus pensylvanica L. f.
FIRE CHERRY

Fire cherry is native to North America and is an effective small tree in colonizing habitats damaged by fires. The small, vibrant red fruits are edible but not desirable except by many birds and small mammals.

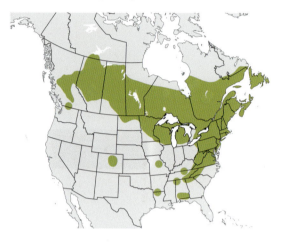

DESCRIPTION. A short-lived, deciduous, large shrub or small tree, growing to 40 ft (13 m) tall. Twigs are reddish brown and glossy. Bark is glossy, reddish brown, and peeling in horizontal strips. Leaves are alternate, simple, lanceolate, green and glossy above, slightly paler below, margins finely serrate, 2.4–4.7 in (6–12 cm) long, 0.8–1.4 in (2–3.5 cm) wide. Flowers are perfect, white, 0.5–0.6 in (1.2–1.6 cm) wide, arranged in umbels of two to five, blooming in early to late spring. Fruits are red drupes, juicy, 0.20–0.27 in (5–7 mm) in diameter.

USES AND VALUE. Wood not commercially important. Fruits are edible, considered by some too sour to eat raw, used mostly in pies and preserves. Infusion of bark used to treat fevers, bronchitis, laryngitis, coughs, colds, infections, and blood poisoning. Many birds and mammals eat the fruits. Buds are eaten by ground birds, especially sharp-tailed and ruffed grouse. Foliage and twigs are browsed by deer.

ECOLOGY. Grows in dry woods, disturbed sites, and clearings in northern zone of North America. A successful pioneer tree after disturbance by fire sweeps. Very shade intolerant. Seeds are dispersed by gravity as well as birds and small animals. Attacked by black knot (*Apiosporina morbosa*), trunk rot (*Fomes pomaceus*), the uglynest caterpillar (*Archips cerasivoranus*), and eastern tent caterpillar (*Malacosoma Americanum*).

CLIMATE CHANGE. Vulnerability is currently considered to be low.

CONSERVATION STATUS. Least concern.

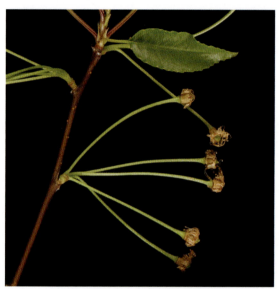
branchlet with immature fruits

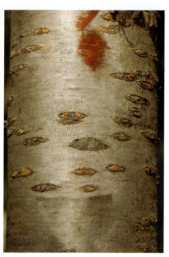
bark

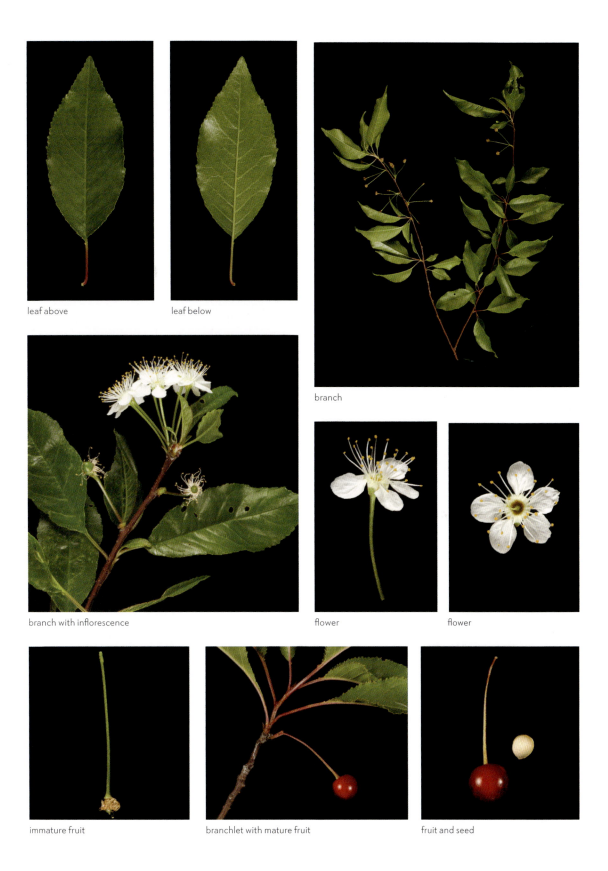

FAMILY ROSACEAE • 451

Peach

Prunus persica (L.) Batsch

The peach is a popular deciduous fruit tree that was introduced into North America from China and is commercially important. In addition to cultivation in groves, it sometimes naturalizes along roadsides, in canyons, and chaparral.

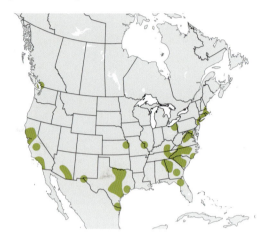

DESCRIPTION. A deciduous fruit tree that grows 16–33 ft (5–10 m) tall. Young twigs are red or green, turning gray brown with age. Buds are blunt and glaucous pubescent with spur shoots. Bark is dark gray with horizonal lenticels, smooth when young, becoming split and scaly with age. Leaves are simple, deciduous, oblong to lanceolate, curved along midrib, glossy dark green adaxially, and paler abaxially, base tapered or obtuse, tip acuminate, margins finely serrate, 2.8–5.9 in (7–15 cm) long. Flowers are perfect, varying shades of pink with ciliate sepals and petals, 0.39–0.67 in (10–17 mm) long, produced in subsessile cluster with one or two flowers, pedicles 0.12 in (3 mm) long. Fruits are drupes with velvety yellow or orange skin and sweet, fleshy pulp, 1.6–3.1 in (4–8 cm) long.

USES AND VALUE. Wood not commercially important. Fruits are edible and delicious, very commercially important. Cultivated in groves for fruit production and as ornamentals along streets and in parking lots. Leaves are astringent, demulcent, diuretic, expectorant, febrifuge, laxative, parasiticide, and mild sedative. Flowers provide nectar for bees and other insect pollinators. Many insects, including aphids, borers, scales, spider mites, and caterpillars, feed on leaves, bark, and fruits.

ECOLOGY. Introduced into North America from China. Widely cultivated and sometimes naturalized on roadsides, canyons, or chaparral, frequently on moist, acidic, well-drained soil. Shade intolerant.

CLIMATE CHANGE. Vulnerability is considered low because of its wide distribution as a cultivated fruit tree and ornamental.

CONSERVATION STATUS. Least concern.

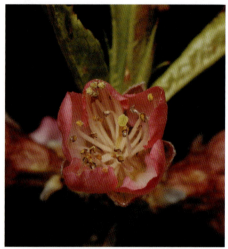

flower on branchlet

bark

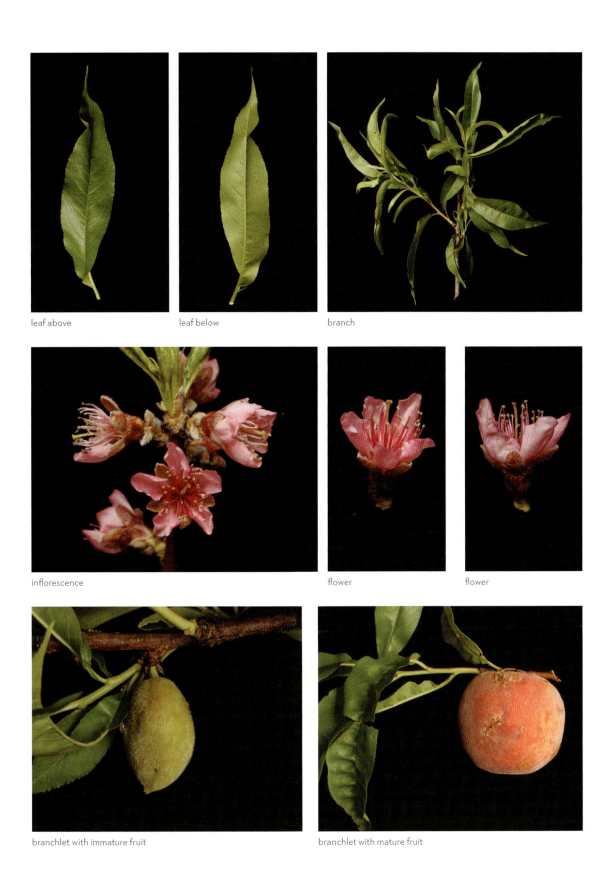

Black Cherry
Prunus serotina Ehrh.

Black cherry is a deciduous tree of varying sizes native to eastern North America. The small fruits are black when ripe, sweet but slightly astringent, and used to flavor drinks, ferment wine, and make jams.

DESCRIPTION. A moderate-lived deciduous tree growing to 98 ft (30 m) in height with a long clear trunk, narrow oblong crown, and shallow root system. Twigs are reddish brown, sometimes with grayish covering. Bark is rough, scaly, and dark gray to nearly black. Leaves are alternate, simple, oblong to lanceolate, glossy, and dark green above, very pale below, with an orange brown and pubescent midrib, base rounded, tip acuminate, margins finely serrate with incurved teeth, 2.4–5.9 in (6–15 cm) long, 1.2–1.8 in (3–4.5 cm) wide. Flowers are perfect, white, 0.27–0.39 in (7–10 mm) wide, produced in narrow racemes with twenty or more flowers, 3.1–5.9 in (8–15 cm) long, terminal on new twigs and blooming in mid-spring. Fruits are drupes, reddish-purple to black, round, 0.27–0.39 in (7–10 mm) in diameter.

USES AND VALUE. Wood commercially very important. Used for "appearance grade" lumber and veneer. Fruits are used for making jelly and wine. Appalachian pioneers flavored rum or brandy with fruits to make "cherry bounce." Bark from young twigs used in cough medicines, tonics, and sedatives. Fruits are consumed by many birds, squirrel, deer, turkey, mice, moles, and other wildlife. Leaves, twigs, and bark contain the cyanogenic glycoside prunasin, which is harmful to livestock but not deer.

ECOLOGY. Grows commonly found in woodlands, in thickets, and along fencerows. Highly susceptible to damage by fire and flooding. Shade intolerant. Produce abundant fruit and seed annually with high rate of germination. Pests include eastern tent caterpillar (*Malacosoma americanum*), cherry scallop shell moth (*Hydria prunivorata*), basidiomycete fungi causing root and butt rot (*Armillaria mellea*, *Coniophora cerebella*, *Polyporus berkeleyi*, and *Tyromyces spraguei*), and other fungi causing trunk rot (*Fomes fomentarius*, *Fomitopsis pinicola*, *Poria prunicola*, *P. mutans*, and *Laetiporus sulphureus*).

CLIMATE CHANGE. Vulnerability is currently considered to be low.

CONSERVATION STATUS. Least concern.

fruit

bark

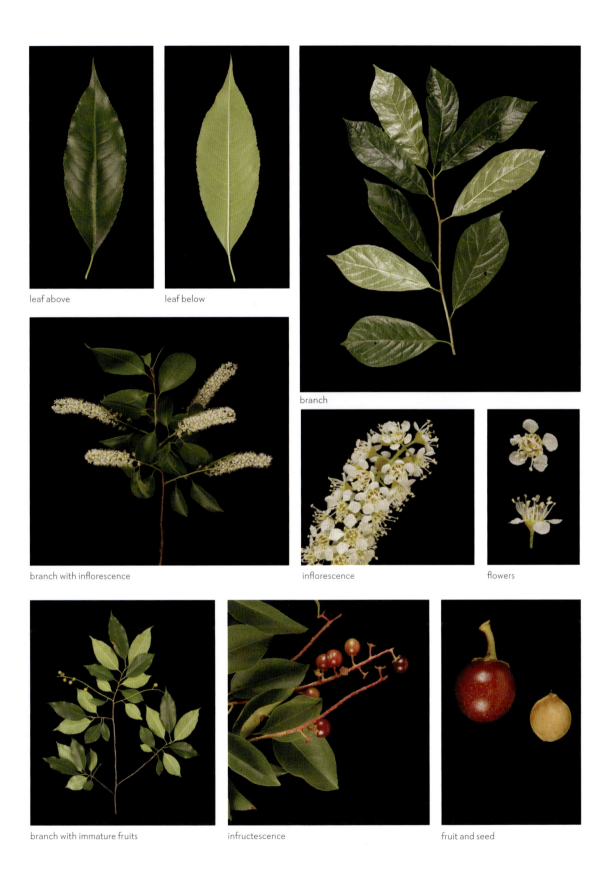

FAMILY ROSACEAE • 455

Chokecherry
Prunus virginiana L.

Chokecherry is a small, short-lived tree native to North America. The dark red fruits contain high concentrations of antioxidant compounds and the leaves are toxic to most grazing mammals. It is the state fruit of North Dakota.

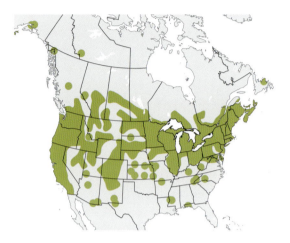

DESCRIPTION. A short-lived, deciduous, small tree, growing to 25 ft (7.5 m) tall. Bark is smooth and dark gray with an unpleasant odor. Leaves are alternate, simple, ovate to obovate, dark green, widest above middle, 2–4 in (5–10 cm) long, 1.2–2.4 in (3–6 cm) wide, margins sharply serrate, base rounded, tip abruptly pointed. Flowers are perfect, white, 0.31–0.39 in (8–10 mm) wide, arranged in terminal racemes with seven to fourteen flowers per raceme, 2.4–5.9 in (6–15 cm) long, blooming in late spring to early summer. Fruits are red, purple, or white drupes, nearly spherical, 0.4–0.5 in (1–1.2 cm) broad, with ovoid seed.

USES AND VALUE. Wood not commercially important. Used in erosion control, streambank stabilization, and as shelterbelts. Fruits are important food of Native North Americans. State fruit of North Dakota, where they are made into craft wines. Roots and bark used as blood tonic, astringent, pectoral, sedative, tonic, and appetite stimulant. Leaves are toxic to most grazing mammals; birds and mammals eat fruits and disperse seeds.

ECOLOGY. Grows in wide variety of habitats, especially along forest borders and old fields. Intermediate in shade tolerance. Tolerates harsh soil and climate conditions. Trunks sprout prolifically when damaged and somewhat weedy.

CLIMATE CHANGE. Vulnerability is currently considered to be low.

CONSERVATION STATUS. Least concern.

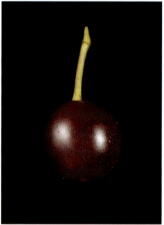

fruit

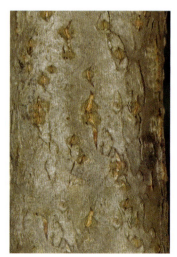

bark

456 • THE DIVERSITY OF TREES

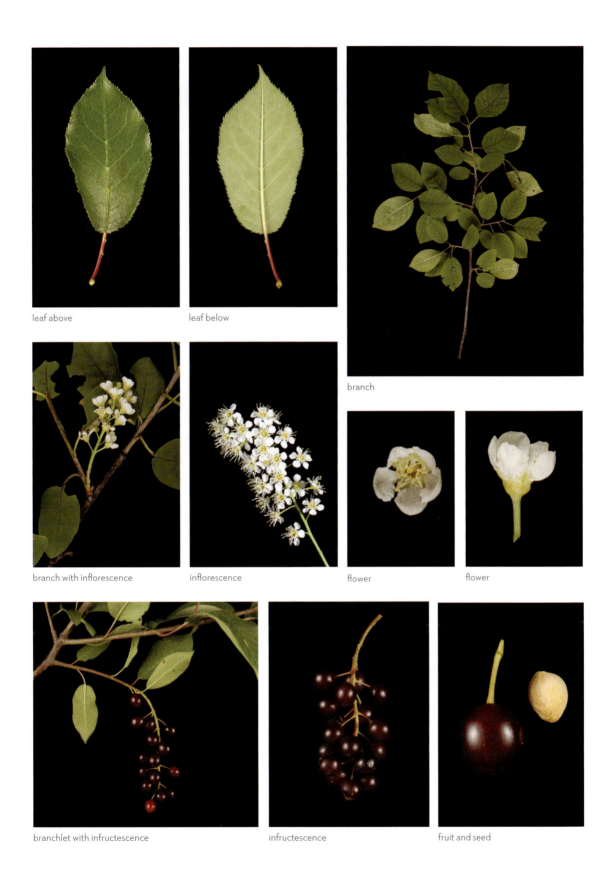

FAMILY ROSACEAE • 457

GENUS PYRUS

True Pyrus calleryana *is a thorny, coarse, irregular tree, the only redeemable characteristic of which is the early spring white flowers, but even they are mildly disagreeable in their odor.*

—Michael A. Dirr on *Pyrus calleryana* in Dirr's Encyclopedia of Trees and Shrubs

The genus *Pyrus*, the pears, contains dozens of species that are native to the temperate regions of Europe, North Africa, and Asia, but are now cultivated around the world. The common pear, *Pyrus communis*, has been grown for its fleshy fruits for probably thousands of years. The one common species of *Pyrus* in North America is not cultivated for its fruit. Rather, it was introduced from China as an ornamental tree because of its striking display of white flowers. As a result of its popularity, this species has become naturalized and invasive throughout its range.

Callery Pear
Pyrus calleryana Decne.
BRADFORD PEAR

Callery pear is native to China and widely planted in the United States for its striking white, fragrant floral display in spring. This small tree, which grows profusely in open habitats, has escaped from cultivation and is now invasive in eastern North America.

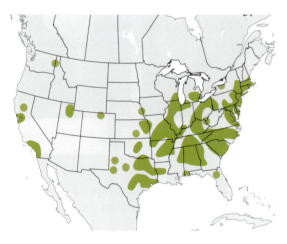

DESCRIPTION. A long-lived deciduous tree growing 20–60 ft (6–18 m) tall with conical to rounded crown. Twigs are brown to reddish brown. Bark is light brown to reddish brown or gray, initially smooth, developing ridges and furrows, with many lenticels. Leaves are alternate, simple, cordate to ovate, shiny green above, paler below, margins crenate or finely serrate, 3 in (7.6 cm) long. Flowers are perfect, white, fragrant, 0.8 in (2 cm) across, arranged in large clusters, 4 in (10 cm) across, blooming in early spring. Fruits are pomes, round, brown. 0.5 in (1.3 cm) across.

USES AND VALUE. Wood not commercially important. Cultivated as ornamental tree; now invasive in much of eastern and midwestern North America, and banned from being sold in several states. Fruits are somewhat edible but rarely eaten by humans; consumed by birds, seeds transported for considerable distances, resulting in invasiveness.

ECOLOGY. Grows in a variety of open habitats, often invasive along roadsides and fields. Intermediate in shade tolerance.

CLIMATE CHANGE. Vulnerability is considered low because of its wide geographic distribution as an ornamental and invasive.

CONSERVATION STATUS. Least concern.

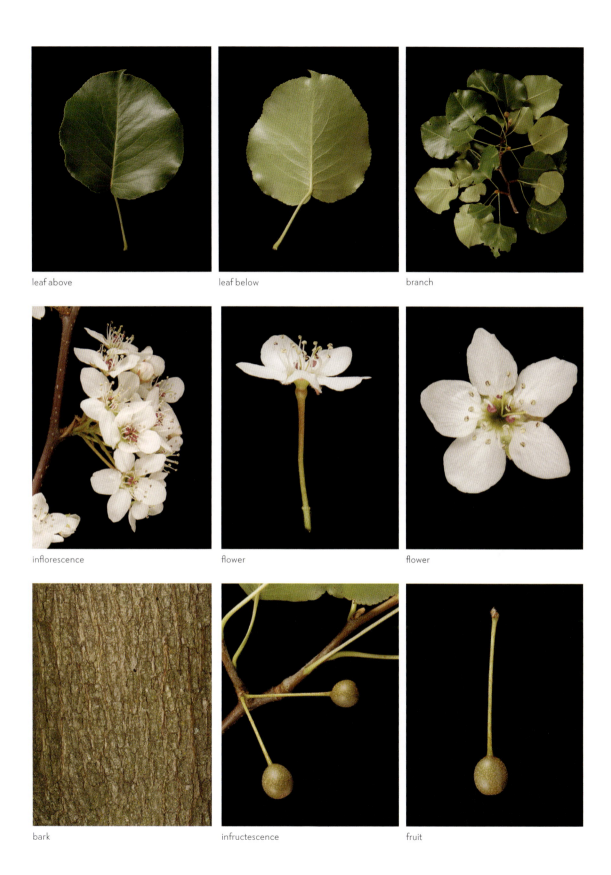

FAMILY ROSACEAE • 459

GENUS SORBUS

But it is in the autumn that this tree comes into its glory, when the big yellow fronds of its foliage are turning a pale clear gold and falling, and the hundreds of shiny red berries—or really little pomes, miniature apples— gleam in the tingling air of a northern Indian summer.

—Donald Culross Peattie on *Sorbus americana* in *A Natural History of Trees of Eastern and Central North America*

The taxonomy of the genus *Sorbus*, similar to that of the genus *Crataegus* in the same family, is confusing because of the widespread microvariation and inbreeding in wild populations. Some botanists recognize several hundred species, others less than 100. The trees are native to cool regions of Europe, North Africa, Asia, China, and North America. Two species of *Sorbus* are common trees in North America.

American Mountain-ash

Sorbus americana Marshall

American mountain-ash is a small tree or large shrub native to rocky hillsides bordering swampy areas in eastern Canada and New England. The fruits are rich in iron and vitamin C.

DESCRIPTION. A deciduous small tree or understory shrub growing 3–9 m (10–30 ft) tall with spreading branches and an open round-topped crown. Twigs are pubescent, becoming glabrous, reddish brown, and lenticular. Bark is light gray and smooth, with a scaly surface. Leaves are alternate, odd-pinnately compound, 6.3–10 in (16–25.5 cm) long, with thirteen to seventeen leaflets, each 1.5–4 in (3.5–10 cm) long, lanceolate, wedge-shaped or rounded at base, sessile, apex acuminate, margins serrate, borne on a dark green or red grooved rachis. Flowers are perfect, fragrant, creamy-white, five-petaled, 0.12 in (3 mm) in diameter, arranged in flat-headed compound cymes, blooming in summer (May–June). Fruits are pomes, orange to bright red, 0.25 in (6.4 mm) in diameter, ripen in autumn and persisting through winter. Seeds are light brown, oblong, and compressed.

USES AND VALUE. Wood not commercially important. Cultivated as an ornamental. Fruits are eaten raw or cooked, rich in iron and vitamin C, used mainly in pies and preserves. Inner bark is astringent and antiseptic, used as a blood purifier and to stimulate appetite. Preferred browse for moose, white-tailed deer, fishers, martens, snowshoe hares, and ruffed grouse. Fruits eaten by numerous birds and small mammals, including ruffed grouse, sharp-tailed grouse, spruce grouse, ptarmigans, American robins, thrushes, waxwings, jays, squirrels, and rodents.

ECOLOGY. Grows in moist habitats on the ecotones of swamps and rocky hillsides commonly in woods, roadsides, and semi-open forest margins. Prefers cool, moist, acidic soils, often granitic. Intermediate in shade tolerance; windfirm.

CLIMATE CHANGE. Vulnerability is significant but has reasonable probability of persistence in the future. Ongoing monitoring is recommended.

CONSERVATION STATUS. Least concern.

 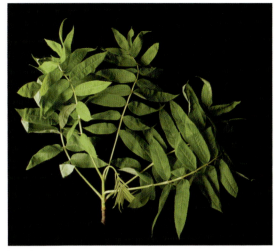

leaf above leaf below branch

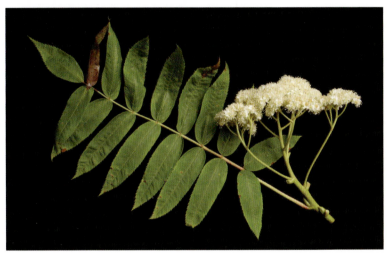 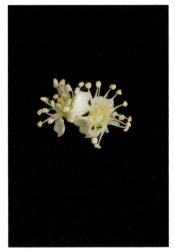

branch with inflorescence flowers

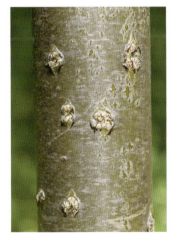 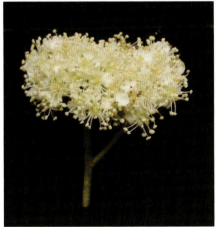 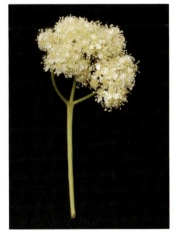

bark inflorescence inflorescence

FAMILY ROSACEAE • 461

European Mountain-ash
Sorbus aucuparia L.
ROWAN

European mountain-ash is native to Europe, Siberia, and western Asia, where it is often planted outside of houses to keep away evil spirits. This medium-sized tree is now naturalized from coast to coast in northern North America.

DESCRIPTION. A deciduous, multistemmed tree growing to 40 ft (12 m) tall, developing a wide crown with low branches. Twigs are shiny grayish brown. Bark is grayish brown with many lenticels when young, becoming shiny and scaly with age. Leaves are alternate, pinnately compound, 5.1–9 in (13–23 cm) long, with nine to fifteen leaflets, each 0.8–2.5 in (2–6.5 cm) long, oblong to lance-shaped, dark green above and paler below, base slightly asymmetrical, margins entire at base and serrate towards apex. Flowers are perfect, white, foul-smelling, 0.3 in (0.8 cm) wide, arranged in flat-topped corymbs, 3–5 in (7.6–12.7 cm) in diameter, blooming in mid-spring after the leaves appear. Fruits are pomes, bright orange-red, round, small, 0.2–0.4 in (0.6–1 cm) in diameter, ripening in late summer.

USES AND VALUE. Wood not commercially important. Introduced to North America as an ornamental and has become naturalized. Fruits are very acidic and high in vitamin C, eaten raw or cooked, used in jams and preserves. Used as astringent, laxative, diuretic, and cholagogue. Provides browse for mammals; birds and rodents eat the fruits.

ECOLOGY. Native to Europe and western Asia, cultivated and has become naturalized in a wide variety of habitats from coast to coast in northern North America. Intermediate in shade tolerance.

CLIMATE CHANGE. Vulnerability is considered low because of its wide geographic distribution as a naturalized ornamental.

CONSERVATION STATUS. Least concern.

branchlet with infructescence

bark

leaf above

leaf below

branch

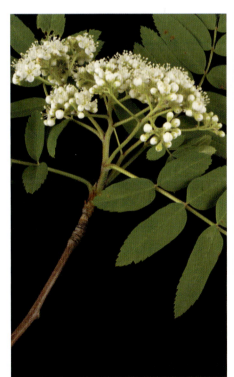
inflorescence

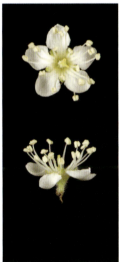
flower

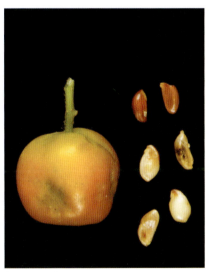
fruit and seeds

Family Rhamnaceae

The trees and shrubs in this family are noted to have thorns on the branches and twigs, hence the common name "buckthorn." Containing about 900 species distributed across fifty-three genera, the buckthorn family is found around the world. The fleshy fruits of some genera are eaten, and a few species are ornamentals. Members of this family are closely related to the elms and mulberries. Five species in three genera are common trees in North America.

GENUS CEANOTHUS

Containing up to sixty species, the genus *Ceanothus* is found only in North America, in habitats ranging from dry open slopes to closed forests. The flowers come in various colors, but the species with intensely fragrant blue blossoms are favored as ornamental shrubs and trees. Only a single native species is a common tree in North America.

Blueblossom

Ceanothus thyrsiflorus Eschsch.

Blueblossom is a large evergreen shrub or small tree that grows on coastal wooded slopes and canyons along the California and Oregon coasts. The fragrant, deep blue to lavender flowers produced in upright clusters make this tree an attractive native ornamental.

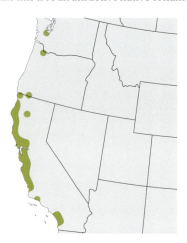

DESCRIPTION. A large (3–20 ft or 1–6 m) evergreen shrub that is occasionally treelike. Twigs are flexible, ridged and green. Leaves are alternate, simple, ovate or elliptic, lustrous and glabrous above, puberulent between veins below, small, 0.39–1.5 in (10–39 mm) long, leaf tips obtuse to rounded, margins variably gland-toothed, stipules scalelike, petiole 0.12–0.35 in (3–9 mm) long. Flowers are perfect, small, light to dark blue with yellow stamens fragrant, arranged in showy racemes, up to 7.9 in (20 cm) long, blooming in late spring. Fruits are three-lobed, sticky capsules, 0.10–0.16 in (2.5–4 mm) wide.

USES AND VALUE. Wood not commercially important. Cultivated in gardens as ornamental small trees. Flowers contain saponins used for making soap. Brightly colored, fragrant flowers provide nectar to pollinating birds and butterflies.

ECOLOGY. Grows along coasts of the California and Oregon on wooded slopes, coniferous forests, and chaparral on fairly dry and well drained soils.

CLIMATE CHANGE. Vulnerability is currently unknown. Immediate assessment is recommended.

CONSERVATION STATUS. Least concern.

branchlet above

branchlet below

branch with flowers

branch with inflorescence

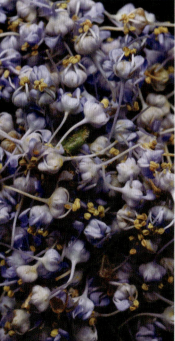
flowers

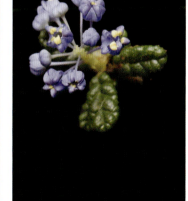
flowers

FAMILY RHAMNACEAE • 465

GENUS FRANGULA

Looked like a buckthorn, but I had never seen one so rich and vibrant with red fruit, ripening black, and the darkest green leaves. Often planted by the birds, it appears in the oddest places, usually as a large shrub or small tree.

—Michael A. Dirr on Frangula caroliniana in Dirr's Encyclopedia of Trees and Shrubs

The genus *Frangula* includes up to thirty-five species of primarily shrubs and some small trees. They are distributed in North America, Europe, northern Africa, and western Asia. Most, if not all, of the species are strong purgatives and used medicinally. Some controversy exists about the taxonomic standing of *Frangula* versus *Rhamnus*, but most evidence points to the recognition of two separate genera. One introduced and two native species of *Frangula* are common trees in North America.

Glossy Buckthorn

Frangula alnus Mill.

Glossy buckthorn, a small deciduous tree is native to Europe, northern Africa, and western Asia, has red to black fruits that are attractive to birds. It is now widely naturalized and invasive across northern North America.

DESCRIPTION. A deciduous large shrub or small tree with a crown of spreading branches that grows to 20 ft (7 m) tall. Twigs are reddish brown and somewhat pubescent. Bark is grayish brown with horizontal lenticels. Leaves are alternate, simple, oblong to broadly elliptic, glossy, dark green above with conspicuous lateral veins, paler below, margins smooth or sparsely toothed, 2–4 in (5–10 cm) long. Flowers are perfect, yellowish green, bell-shaped, with five petals, 0.25–0.45 in (5–8 cm) wide, arranged in clusters in leaf axils, blooming in late spring to summer. Fruits are two-seeded drupes, berrylike, round, red turning black, glabrous, 0.25–0.5 in (5–10 mm) in diameter, ripening in late summer.

USES AND VALUE. Wood not commercially important. Originally cultivated as ornamental, now naturalized and invasive. Bark is purgative.

ECOLOGY. Native to Europe, northern Africa, and western Asia and now invasive in damp woods, wetlands, and fields. Fruits eaten and dispersed by birds and mammals. Intermediate in shade tolerance.

CLIMATE CHANGE. Vulnerability is considered low because of its wide geographic distribution as ornamental and invasive.

CONSERVATION STATUS. Least concern.

bark

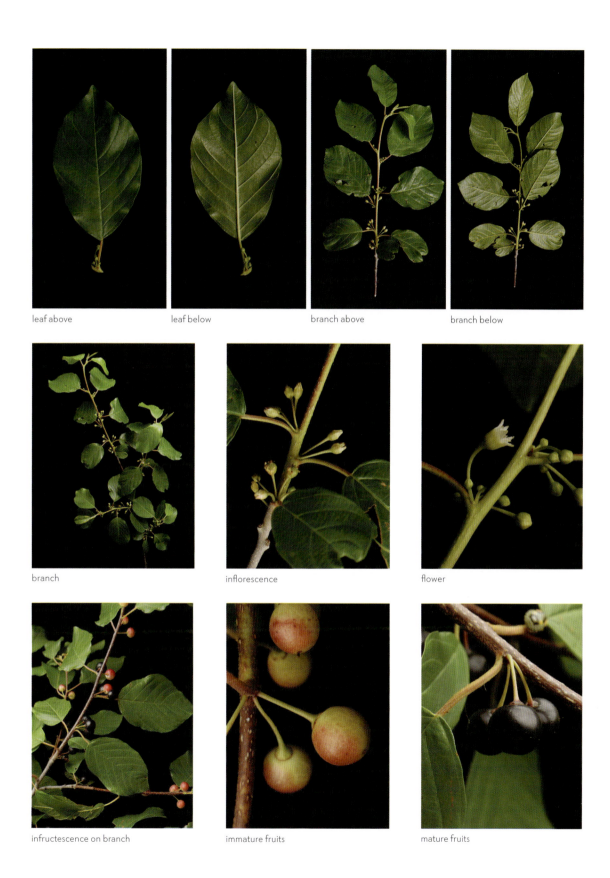

FAMILY RHAMNACEAE • 467

California Buckthorn

Frangula californica (Eschsch.) A. Gray

California buckthorn is an evergreen tall shrub or small tree that is native to the western United States. It is found in a number of habitats on dry sandy or rocky slopes in ravines and hillsides, including chaparral and sage scrub. Six subspecies are recognized.

DESCRIPTION. An evergreen tall shrub or small tree that grows 3–10 ft (1–3 m) tall but may reach 16 ft (5 m) in height in the best environments. Twigs are ruddy brown. Bark is light ashy brown. Leaves are simple, alternate, elliptic to ovate, dark green above, lustrous with white pubescence below, margins entire to minutely serrate, up to 4 in (10 cm) long. Flowers are perfect, tiny, five-petalled, yellow-green, clustered in axillary umbels, blooming in late spring to summer. Fruits are two-seeded drupes, mature from green to black, 0.4 in (1 cm) in diameter.

TAXONOMIC NOTES. Subspecies *californica* has leaves up to 3 in (7.5 cm) long, narrowly to widely elliptic with an acute tip, and paler on the underside; ssp. *crassifolia* has tomentose twigs and leaves with obtuse tips; ssp. *cuspidata* has red twigs, and smaller leaves 2.4 in (6 cm) long and tomentose below; ssp. *occidentalis* has in conspicuous leaf veins and three-stoned fruits; ssp. *tomentella* has gray, pubescent twigs and dull green leaves silvery-velvet below; and ssp. *ursina* has leaf margins entire or serrated, either smooth or covered with minute hairs.

USES AND VALUE. Wood not commercially important. Used as landscaping ornamental and for erosion control. Used medicinally by Native Americans to treat constipation. Leaves provide browse for livestock; flowers produce nectar for pollinating butterflies and bees; and fruits are eaten by birds, mule deer, black bears, and other animals.

ECOLOGY. Grows in a variety of habitats, including chaparral, coastal sage scrub, northern sage scrub, mixed evergreen forest, redwood forest, and oak woodland communities. It is found on dry sandy or rocky slopes in ravines and hillsides. Tolerant of flooding. Shoots sprout readily and grow rapidly after fire.

CLIMATE CHANGE. Vulnerability is currently unknown. Immediate assessment is recommended.

CONSERVATION STATUS. Least concern.

bark

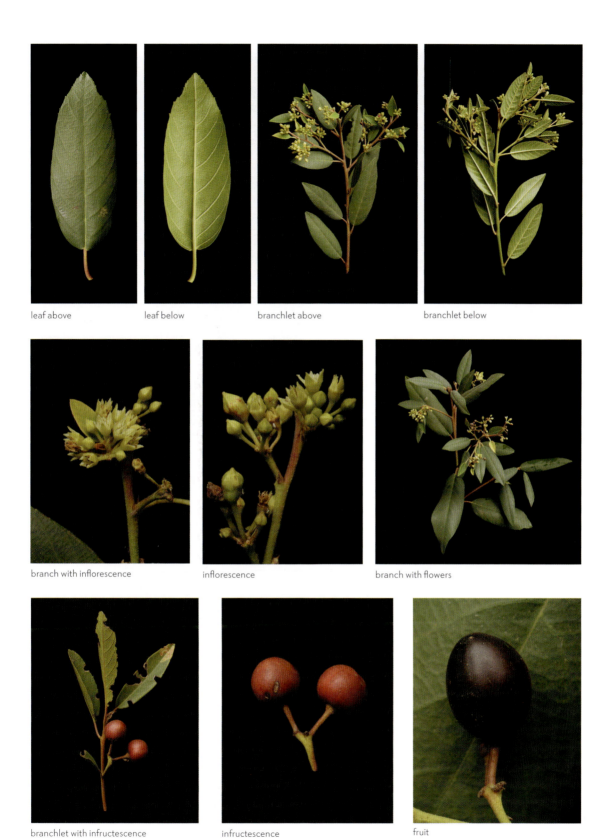

FAMILY RHAMNACEAE • 469

Carolina Buckthorn
Frangula caroliniana (Walter) A. Gray

Carolina buckthorn, native primarily to the southeastern United States, is most commonly found in moist, calcareous, and rocky soils. It is a small tree or large shrub with a spreading open crown.

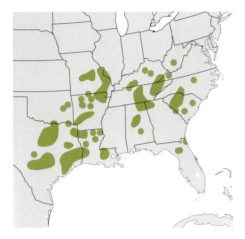

DESCRIPTION. An upright deciduous small tree or shrub that grows 10–20 ft (3–6 m) tall with a spreading open crown and drooping branches. Twigs are slender, ruddy, and covered with a gray pubescence, producing an almond odor when broken. Buds are small and naked with sparse pubescence. Bark is smooth, gray brown, and dotted with light lenticels, becoming shallowly fissured with age. Leaves are alternate, simple, elliptic to oblong, glossy green, with conspicuous parallel lateral veins that curve near edge, margins finely serrate, 1.6–3.1 in (4–8 cm) long. Flowers are perfect, small, inconspicuous, bell-shaped, yellow-green, clustered in leaf axils, blooming in late spring. Fruits are round drupes, turning from red to black at maturity, 0.4 in (1 cm) in diameter.

USES AND VALUE. Wood not commercially important. Cultivated as landscaping plant. Bark and fruits used medicinally as purgative. Birds and mammals feed on the fruits; leaves and bark are browsed by deer.

ECOLOGY. Grows in bottomlands, ravines, and sheltered slopes, often along streams in southeastern United States. Prefers moist, calcareous, rocky soils.

CLIMATE CHANGE. Vulnerability is currently unknown. Immediate assessment is recommended.

CONSERVATION STATUS. Least concern.

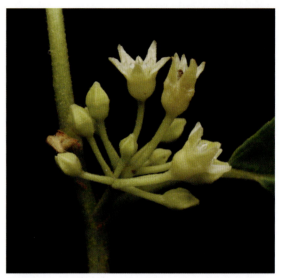
flowers

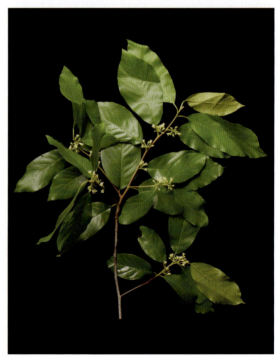
branch

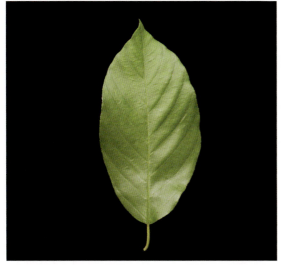
leaf above

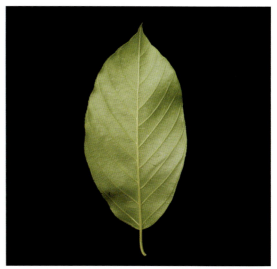
leaf below

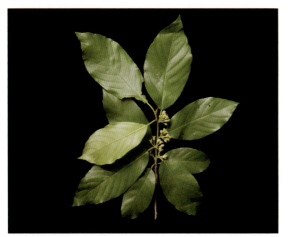
branchlet above

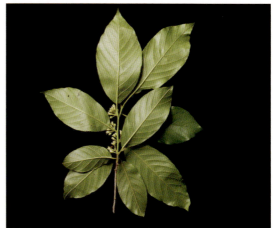
branchlet below

branch with inflorescence

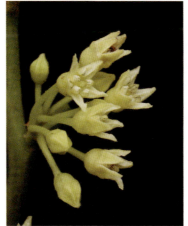
flowers

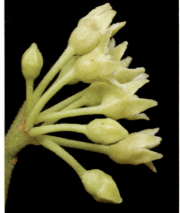
flowers

FAMILY RHAMNACEAE • 471

GENUS RHAMNUS

It plants itself and has created ecological havoc. I see no real use for it. Be leery and forearmed.

—Michael A. Dirr on *Rhamnus cathartica* in *Dirr's Encyclopedia of Trees and Shrubs*

Containing perhaps 150 species, the genus *Rhamnus* is found around the world in both temperate and tropical zones from North America to Europe and Asia to Africa and parts of South America. These species range from shrubs to trees, and some become invasive when introduced to regions outside their native habitats. Taxonomists sometimes unite this genus with *Frangula*, but most considerate them to be separate taxa. Two species, one native and the other introduced, are common trees in North America.

European Buckthorn
Rhamnus cathartica L.
COMMON BUCKTHORN, CAROLINA BUCKTHORN, HART'S THORN

European buckthorn is a species of small tree or shrub introduced to North America from Eurasia that invades disturbed sites, prairies, and roadsides throughout its non-native range. The leaves and fruits are toxic to mammals.

DESCRIPTION. A non-native shrub or small tree growing 7–20 ft (2–6 m) tall. Twigs are slender, reddish brown, and often terminate in a sharp thorn. Buds are scaly, ovate, and reddish brown to dark brown. Bark is smooth and gray brown, peeling with age. Leaves are deciduous, simple, opposite, elliptic to ovate, medium dark green above and light green below, with glabrous surfaces, distinctive parallel veins, margins minutely serrate, 1.4–2.8 in (3.6–7.2 cm) long, 0.3–2.8 in (0.9–7 cm) wide. Trees are typically dioecious producing male and female flowers on separate plants, rarely bisexual. Flowers are four-petaled, greenish-yellow, fragrant, 0.25 in (6.4 mm) wide, arranged in small umbels, blooming from May to June. Fruits are drupes, globose, shiny black, 0.24–0.39 in (6–10 mm) diameter, containing two to four seeds.

USES AND VALUE. Wood not commercially important. Introduced from Europe in 1800s as ornamental shrub, especially as hedge. Now considered invasive. Leaves and fruits are toxic to mammals, including humans. Fruits are consumed by birds. Larval host of brimstone butterflies.

ECOLOGY. Grows in woodlands, forests, savannas, and clearings, often along roadsides in the northern United States and Canada. Often outcompetes other native species, forming dense thickets. Shade tolerant.

CLIMATE CHANGE. Vulnerability is considered low because of its wide geographic distribution as an invasive.

CONSERVATION STATUS. Least concern.

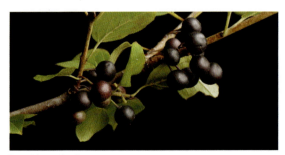

branchlet with infructescence

472 • THE DIVERSITY OF TREES

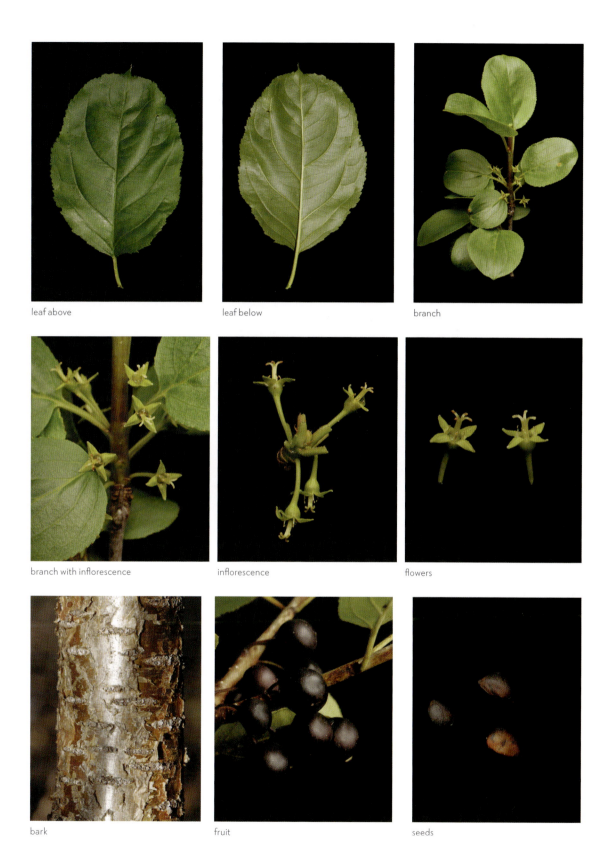

FAMILY RHAMNACEAE • 473

Hollyleaf Buckthorn
Rhamnus crocea Nutt.
REDBERRY BUCKTHORN

Hollyleaf buckthorn is an evergreen shrub native to western North America, grows in coastal sage scrub, chaparral, and woodland habitats on well-drained soils. Although rarely considered a true tree, it is included here for completeness and for comparison with invasive buckthorns.

DESCRIPTION. An evergreen shrub that grows 3–7 ft (1–2 m) tall. Twigs are red or red purple, often thorn-tipped. Bark is gray brown. Leaves are evergreen, simple, alternate, elliptic to obovate, pale green, glabrous, 0.39–0.59 in (10–15 mm) long, margins sharp-toothed, petioles, 0.04–0.16 in (1–4 mm) long. Trees are usually dioecious producing male and female flowers on separate plants, or sometimes flowers bisexual. Flowers are inconspicuous, apetalous with four sepals, hypanthium 0.08 in (2 mm) wide. Fruits are conspicuously red, two-stoned drupes, 0.24 in (6 mm) in diameter.

USES AND VALUE. Wood not commercially important. Sometimes cultivated as ornamental. Birds consume fruits and seeds. Larval host of pale swallowtail (*Papilio eurymedon*) butterfly.

ECOLOGY. Grows in coastal sage scrub, chaparral, and woodland habitats at elevations below 3,773 ft (1,150 m) on dry, well-drained soils on washes and canyon slopes. Intermediate in shade tolerance. Drought resistant.

CLIMATE CHANGE. Vulnerability is currently unknown. Immediate assessment is recommended.

CONSERVATION STATUS. Least concern.

branch

bark

leaf above

leaf below

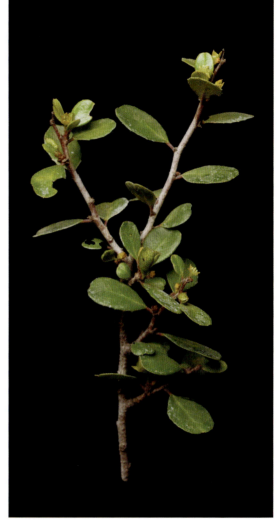
branchlet

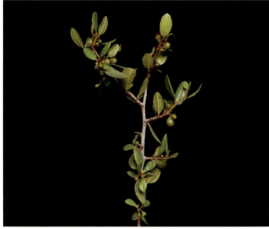
branchlet with infructescence

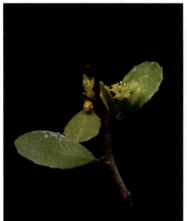
flower

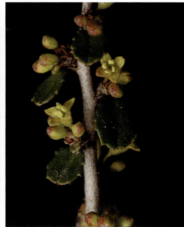
branch with inflorescence

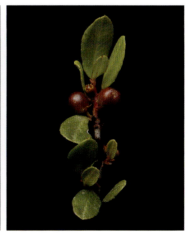
branchlet with infructescence

FAMILY RHAMNACEAE • 475

Family Elaeagnaceae

This small family contains only three genera and about sixty species. It is found primarily in the Temperate Zone, although a few members are native to tropical Asia. The Elaeagnaceae is closely allied to the Rhamnaceae, as suggested by the thorny branches. The silvery peltate scales on the leaves are distinctive. A number of species are cultivated as ornamentals and some have escaped from cultivation to become invaders of open habitats. In North America one such invader is the Russian-olive, which is the only common tree in the family Elaeagnaceae.

GENUS ELAEAGNUS

An excellent plant for its silvery gray foliage effect, as well as its salt tolerance. Utilized along highways in the Midwest, where de-icing salts are common.

—Michael A. Dirr on *Elaeagnus angustifolia* in *Dirr's Encyclopedia of Trees and Shrubs*

The fifty species in the genus *Elaeagnus* are found mostly in Asia in both temperate and tropical habitats. The leaves, shoots, and fruits are covered with silvery scales that are very distinctive. The ability of the plants to fix nitrogen through a relationship with specialized bacteria in their roots has allowed some species to become naturalized and even invasive outside of their native regions. One species introduced from western and central Asia is common in North America.

Russian-Olive

Elaeagnus angustifolia L.

Native to Europe and Asia, Russian-olive is a small, usually thorny, deciduous tree or large shrub that grows up to 23 ft (7 m) tall. Initially introduced as an ornamental, it has naturalized and become invasive in North America, especially in marshlands, watersheds, and open secondary growth.

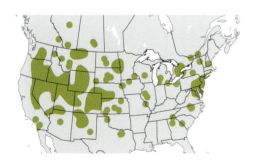

DESCRIPTION. A small, usually thorny, deciduous tree or large shrub that grows up to 23 ft (7 m) tall. Twigs are occasionally thorny. Bark is brown, exfoliating. Leaves are alternate, simple, narrow, willowlike, dark green above, silvery below, covered in silvery scales, margins smooth, 1.6 in (4 cm) long. Flowers are perfect, apetalous with four sepals, fragrant, silvery white to yellow, 0.3–0.7 in (8–15 mm) long, arranged in clusters of one to three, blooming in spring. Fruits are drupelike, rounded, resemble olives with yellowish scales, 0.5–0.9 in (1.2–2 cm) long, turning red in summer and fall.

USES AND VALUE. Wood not commercially important. Widely cultivated as ornamental; now considered an invasive. Fruits are edible, rich in vitamins, especially A, C, and E. Fruits are eaten by birds and carried long distances for effective dispersal.

ECOLOGY. Grows in marshlands, watersheds, and open secondary growth where it has become naturalized and invasive. Outcompetes and replaces cottonwoods and willows along with other species. Prefers dry to medium well-drained soils in sun to part shade. Drought resistant, salt tolerant, and shade intolerant.

CLIMATE CHANGE. Vulnerability is considered low because of its wide geographic distribution as an invasive.

CONSERVATION STATUS. Least concern.

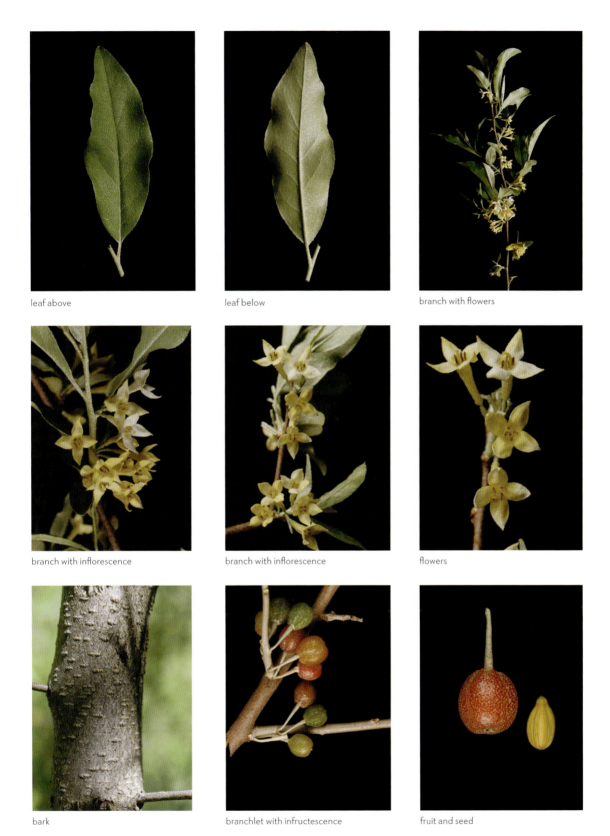

FAMILY ELAEAGNACEAE • 477

Family Ulmaceae

The diversity of the elm family is rather small: it contains only six genera and forty species, but they are widely distributed and common in the Northern Hemisphere. The fruits are dispersed by wind or water. Some former members of this family (*Celtis* and *Trema*) are now placed in the family Cannabaceae. Eight species in three genera are common trees in North America, and several species are commonly cultivated in gardens and as street trees in towns and cities.

GENUS PLANERA

This tree is interesting chiefly as a botanical remnant of its family.

—Julia Ellen Rogers on *Planera aquatica* in *The Tree Book: A Popular Guide to a Knowledge of the Trees of North America and to Their Uses and Cultivation*

The single species in the genus *Planera* is native to southeastern North America and is found mainly in wet areas near lakes and ponds. Closely related to the true elms, these small trees are distinctive in their small leaves and spiky fruits.

Water-Elm
Planera aquatica J. F. Gmel.
PLANERTREE

Water-elm is a small deciduous tree with a broad crown that grows on alluvial flood plains, in wetlands, and riparian zones on soils that are sandy or gravelly. Found only in the southeastern United States, it is distinguished from other elms in the genus *Ulmus* by the very shaggy bark and burlike fruits.

DESCRIPTION. A small deciduous tree up to 43 ft (13 m) tall with spreading branches that form a broad crown. Twigs are slender, reddish brown, and zigzag, initially pubescent becoming glabrous with age. Bark is reddish brown and conspicuously flaked into shaggy, longitudinal strips revealing reddish underbark. Leaves are simple, alternate, ovate and asymmetrical, dark green above, paler below, margins serrate, 0.8–2.8 in (2–7 cm) long. Trees are usually monoecious producing separate male and female flowers on the same plant, sometime mixed with bisexual flowers. Flowers are inconspicuous, sepals fused, petals absent, stigmas curling and fuzzy, arranged in clusters in leaf axils, blooming in early spring with leaves. Fruits are small distinctive, single-seeded drupes, 0.4 in (1 cm) long, covered with fleshy projections.

USES AND VALUE. Wood not commercially important. No known uses.

ECOLOGY. Grows on alluvial flood plains, in wetlands and riparian zones on soils that are sandy or gravelly. Its ecological role where it grows has been poorly studied.

CLIMATE CHANGE. Vulnerability is significant but has reasonable probability of persistence in the future. Ongoing monitoring is recommended.

CONSERVATION STATUS. Least concern.

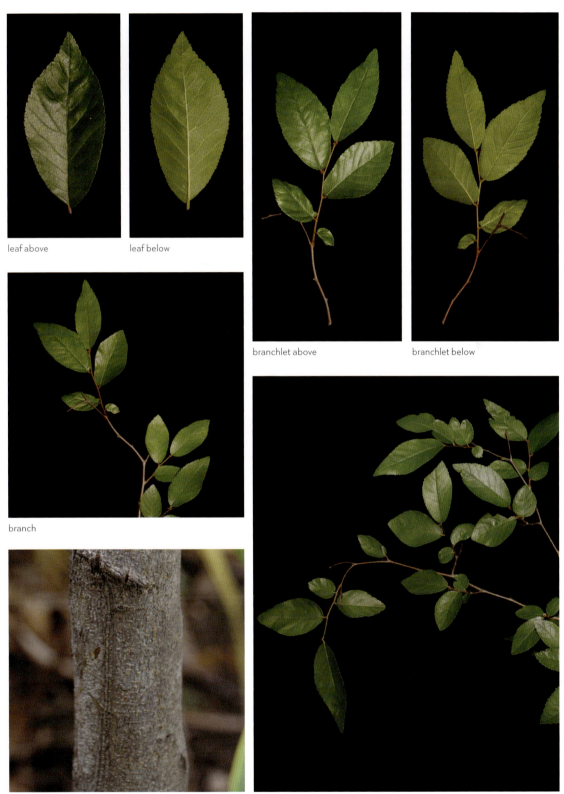

leaf above leaf below branchlet above branchlet below branch bark branch

FAMILY ULMACEAE • 479

GENUS ULMUS

If you want to be recalled for something that you do, you will be well advised to do it under an Elm—a great Elm, for such a tree outlives the generations of men; the burning issues of today are the ashes of tomorrow, but a noble Elm is a verity that does not change with time.

—Donald Culross Peattie on *Ulmus americana* in *A Natural History of Trees of Eastern and Central North America*

The genus *Ulmus* is found across the Northern Hemisphere in Europe, Asia, and North America as well as in a few places south of the equator in tropical Asia. For such a horticulturally important and ecologically well-studied group of plants, it is striking that taxonomic ambiguity remains on the number of species in the genus. Estimates range from thirty to forty species because of confusion resulting from hybridization and levels of intraspecific variation. Some species of elms were once widely distributed in North America and Europe, but the Dutch elm disease has decimated populations. Notwithstanding the threat from diseases, four native species and two introduced species are common trees in North America. (See p. 751 for leaf shapes of six species of *Ulmus*.)

Winged Elm
Ulmus alata Michx.

Winged elm is a relatively small tree native to both uplands and swamps from Virginia south to Florida and from the Midwest south to Texas. The two broad corky wings running parallel along the branches are characteristic.

DESCRIPTION. A deciduous tree growing to 49 ft (15 m) tall with a large trunk, ascending short branches, and a narrow open crown. Twigs are greenish red turning reddish brown, developing two corky wings, 0.5 in (1.25 cm) wide. Bark is brownish red with irregular shallow fissures and flat scaly ridges. Leaves are alternate, simple, blades dark green above, white and hairy beneath, turn yellow in fall, oval to lance-shaped, 1.5–3 in (3.8–7.6 cm) long, margins doubly serrate, base unequal, tips pointed, petiole stout, 0.3 in (0.8 cm) in length. Flowers are perfect, greenish red, without petals, calyx five-lobed, brownish green, arranged in pendent racemes, blooming in early spring before the leaves appear. Fruits are samaras, borne on long slender stalks with deep notch at the tip, covered with long white hairs, 0.4 in (1 cm) long. Seeds are brown, oval, pointed, 0.1 in (0.3 cm) long.

USES AND VALUE. Wood commercially important. Used for furniture, hardwood dimension, flooring, boxes, and crates. Not grown ornamentally. White-tailed deer browse foliage; small mammals and ground birds consume the samaras.

ECOLOGY. Grows along streambanks, in woods and thickets on a variety of soil drainages and textures. Prefers terraces and bottomlands on rich moist loams. Shade tolerant. Susceptible to Dutch elm disease and elm phloem necrosis.

CLIMATE CHANGE. Vulnerability is currently considered to be low.

CONSERVATION STATUS. Least concern.

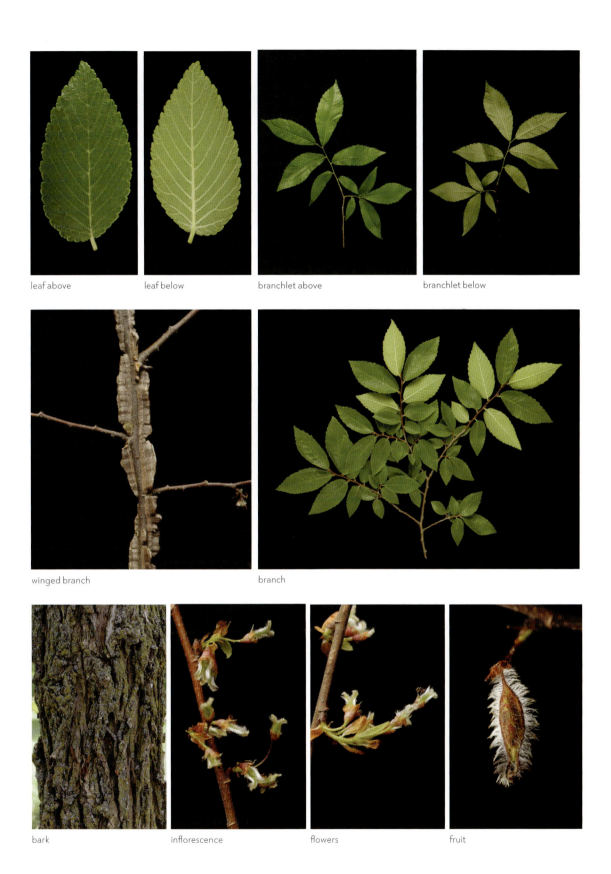

FAMILY ULMACEAE • 481

American Elm

Ulmus americana L.

American elm, native to eastern North America, has a stout trunk that forks into several strong and upright branches forming a vase-shaped crown. Dutch elm disease, caused by a fungus spread by bark beetles, has affected most of the populations in North America.

DESCRIPTION. A long-lived (up to 300 years) deciduous tree growing up to 100 ft (30 m) tall with a stout, straight trunk, sometimes buttressed, with a vase shaped crown. Twigs are reddish brown, slender, glabrous to sparsely hairy, and slightly zigzag. Bark is ashy gray, furrowed into flat-topped ridges. Leaves are alternate, simple, oval to oblong-obovate, dark green and glabrous or scabrous above, paler and glabrous to slightly pubescent below, 3.1–5.9 in (8–15 cm) long, margins sharply doubly serrate, base asymmetrical. Flowers are perfect, calyx green with a red tint, anthers red, arranged in hanging clusters of three or four, less than 1 in (2.5 cm) long, blooming in early spring. Fruits are samaras, round, papery, narrowly winged, with ciliate margins and notched tip, green to yellow tinged reddish-purple, 0.4–0.5 in (1–1.2 cm) long, containing one seed.

USES AND VALUE. Wood commercially important. Used for furniture, hardwood dimension, flooring, construction, mining timbers, and sheet-metal work, incorporated into veneer for making boxes, crates, and baskets, small quantity used for pulp and manufacture of paper. Popular ornamental, especially along urban streets. Leaves eaten raw or cooked. Red inner bark used to make coffeelike drink. Infusion of bark used to treat bleeding from lungs, coughs, colds, influenza, dysentery, eye infections, cramps, and diarrhea. Flower buds, flowers, and fruits eaten by mice, squirrels, opossum, ruffed grouse, northern bobwhite, and gray partridge. Larval host for several butterflies and moths.

ECOLOGY. Grows in rich woods, flood plains, and streambanks, now less common due to introduction of Dutch elm disease. Good seed crops produced annually; wind and water are primary dispersal agents. Intermediate in shade tolerance. Most damaging agent is Dutch elm disease caused by the fungus (*Ceratocystis ulmi*) transferred into vascular system by European elm bark beetle (*Scolytus multistriatus*) and native elm bark beetle (*Hylurgopinus rufipes*).

CLIMATE CHANGE. Vulnerability is currently considered to be low despite stress from the spread of Dutch elm disease.

CONSERVATION STATUS. Endangered.

bark

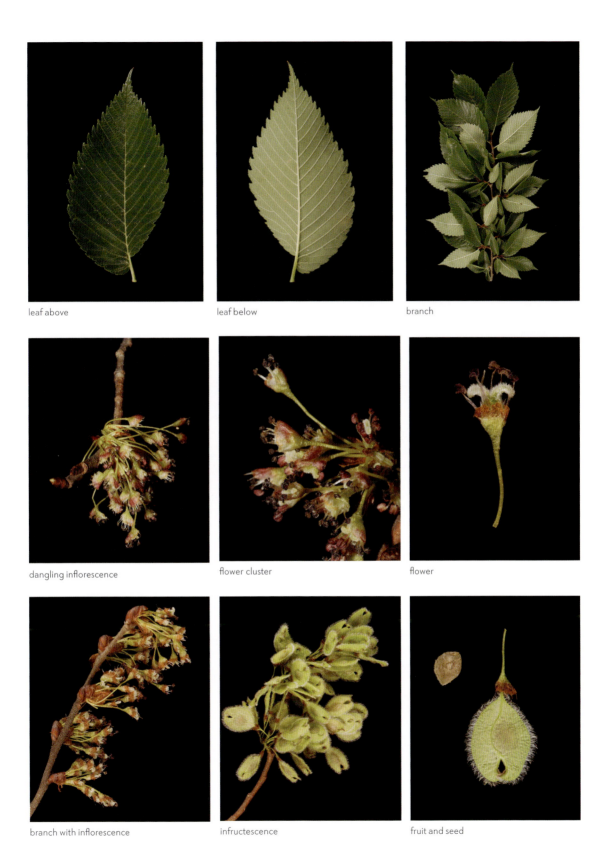

FAMILY ULMACEAE • 483

Cedar Elm

Ulmus crassifolia Nutt.

Cedar elm is a medium-sized, deciduous tree native to the southern United States that frequently grows near streams in woodlands, in ravines, and on open slopes. The wood is commercially important and the trees are often cultivated for shade in cities and parks.

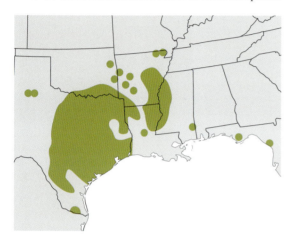

DESCRIPTION. A deciduous tree that grows up to 49–89 ft (15–27 m) tall with a straight trunk and open crown. Twigs are thin, gray brown with a corky wing when young. Bark is gray brown and furrowed into longitudinal plates. Leaves are simple, alternate, elliptic to ovate, dark green turning golden yellow in fall, 1–2 in (2.3–5 cm) long, base asymmetric, margins crenate. Flowers are perfect, inconspicuous, green or reddish, sepals hairy, blooming in summer to early fall. Fruits are winged samaras, green, pubescent with hairs longer at margins, 0.31–0.39 in (8–10 mm) long, with one central seed.

USES AND VALUE. Wood commercially important. Used for furniture, fence posts, and containers, such as boxes, baskets, caskets, crates, and barrels. Cultivated for shade in cities and parks. Seeds provide forage for birds and small mammals. Foliage provides cover for wildlife, nesting sites for birds and small mammals; browse for white-tailed deer. Larval host for mourning cloak and question mark butterflies.

ECOLOGY. Grows frequently near streams in woodlands, in ravines, and on open slopes, often with juniper trees, in the southern United States. Occurs in a variety of soils, most commonly calcareous. Drought tolerant. Intermediate in shade tolerance. Fruits and seeds dispersed by wind. Susceptible to Dutch elm disease caused by a fungus (*Ceratocystis ulmi*), which is carried by native elm bark beetle (*Hylurgopinus rufipes*) and European elm bark beetle (*Scolytus multistriatus*).

CLIMATE CHANGE. Vulnerability is significant but has reasonable probability of persistence in the future. Ongoing monitoring is recommended.

CONSERVATION STATUS. Least concern.

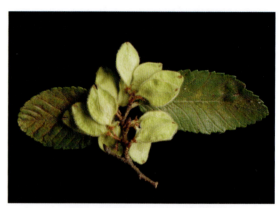

branchlet with infructescence

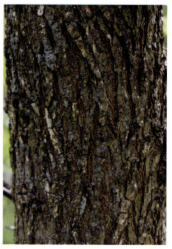

bark

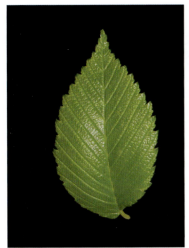
leaf above

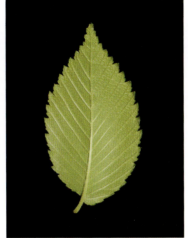
leaf below

branch

branch with infructescence

fruits

branch with infructescence

branchlet above with fruits

branchlet below with fruits

FAMILY ULMACEAE • 485

Chinese Elm
Ulmus parviflora Jacq.
LACEBARK ELM

Chinese elm is a small deciduous tree native to Asia and introduced into North America, where it is cultivated for its striking exfoliating bark that is grayish-brown mottled with red and white. It is resistant but not immune to Dutch elm disease.

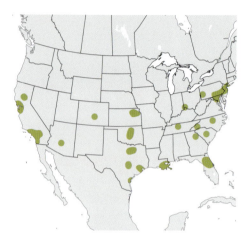

DESCRIPTION. A moderate-lived, deciduous tree growing 33–59 ft (10–18 m) tall. Twigs are brown, slender, glabrous to pubescent, and slightly zigzag, with orange lenticels. Bark is mottled, with green to orange patches, readily flaking to expose green inner bark. Leaves are alternate, simple, elliptic to ovate, dark green and lustrous above, paler and glabrous below, 0.8–2.4 in (2–6 cm) long, margins finely serrate. Flowers are perfect, small, green to reddish brown, sepals hairless, anthers reddish, arranged in tight clusters of two to eight, blooming in late summer. Fruits are samaras, round, winged, green to light brown, glabrous, 0.4 in (1 cm) long, with a notched tip, containing one seed.

USES AND VALUE. Wood not commercially important. Cultivated as popular replacement for ornamental American elms killed by Dutch elm disease.

ECOLOGY. Non-native introduced from Asia into North America in the mid-nineteenth century. Known to escape from cultivation into nearby natural areas; not invasive.

CLIMATE CHANGE. Vulnerability is considered low because of its geographic distribution as an ornamental and naturalization.

CONSERVATION STATUS. Least concern.

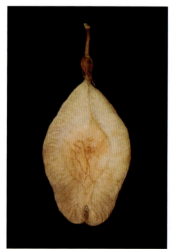
fruit

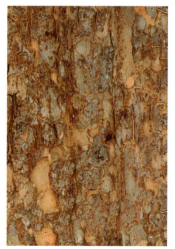
bark

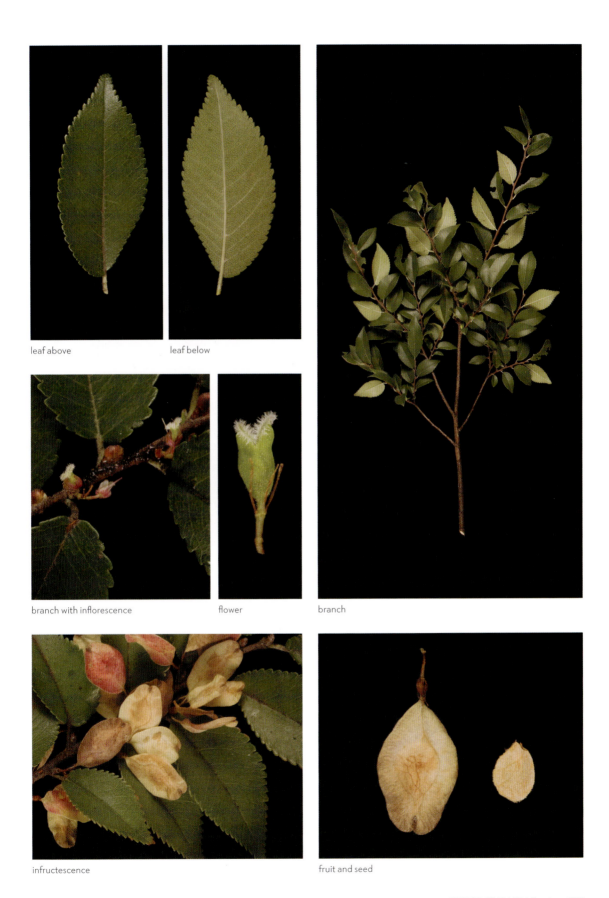

leaf above leaf below

branch with inflorescence flower branch

infructescence fruit and seed

FAMILY ULMACEAE • 487

Siberian Elm
Ulmus pumila L.
ASIATIC ELM

Siberian elm is a medium-sized tree introduced from Asia in the early twentieth century and planted across the Great Plains of North America to alleviate dust storms. Adult trees are extremely hardy and have become invasive in some regions.

DESCRIPTION. A medium-sized deciduous tree growing 33–66 ft (10–20 m) tall with a straight trunk and twisted branches. Twigs are gray brown, glabrous to pubescent, and slightly zigzag. Bark is gray to brown, deeply fissured forming interlacing ridges that reveal orange-colored, mucilaginous inner bark. Leaves are alternate, simple, elliptic to ovate, dark green and glabrous above, paler below, 0.8–2.8 in (2–7 cm) long, base nearly symmetrical, margins finely serrate. Flowers are perfect, small, green, anthers red to purple, arranged in short-stalked, tight clusters of six to fifteen, blooming in mid-spring. Fruits are samaras, round, broadly winged, glabrous, light brown, 0.4–0.6 in (1–1.5 cm) long, with a notched tip, containing one seed.

USES AND VALUE. Wood not commercially important. Introduced into Great Plains of North America in 1905 in aftermath of Dustbowl because of its rapid growth and tolerance for drought and cold. Now considered invasive across eastern and central United States to Ontario, Canada. Immature fruits used to make wine. Dried inner bark pulverized and added soups and breads.

ECOLOGY. Widely planted as windbreak. Now naturalized and invasive in urban areas, roadsides, and open areas.

CLIMATE CHANGE. Vulnerability is considered low because of its wide geographic distribution as an ornamental and invasive.

CONSERVATION STATUS. Least concern.

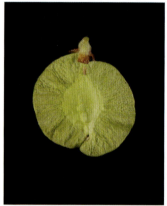
fruit

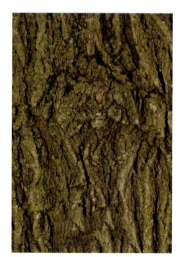
bark

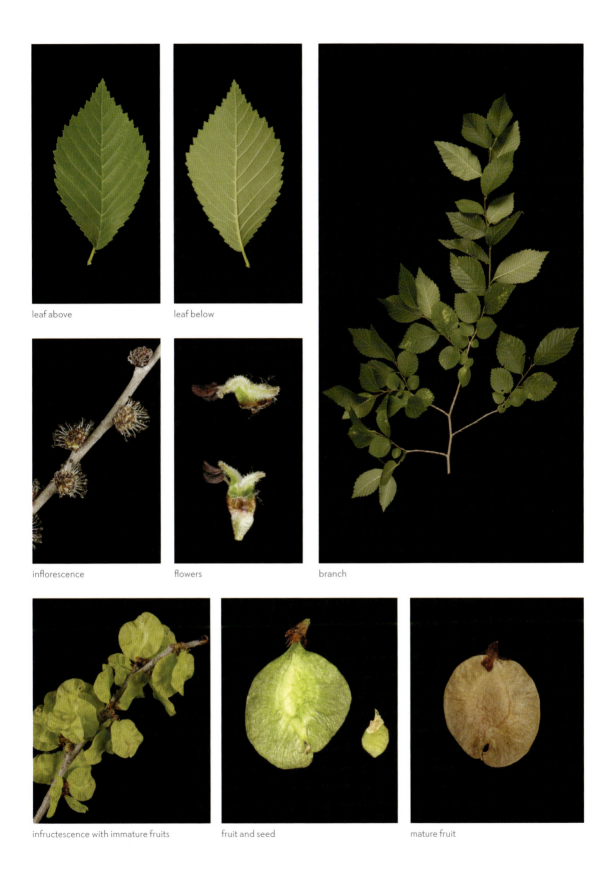

leaf above • leaf below • inflorescence • flowers • branch • infructescence with immature fruits • fruit and seed • mature fruit

FAMILY ULMACEAE • 489

Slippery Elm
Ulmus rubra Muhl.
MOOSE ELM

Slippery elm is a medium-sized deciduous tree native to eastern North America with a straight trunk and spreading, vase-like crown. The outer bark is dark brown and furrowed, with a distinctive mucilaginous ("slippery") reddish-brown inner bark, which is used as a gruel or tea for soothing upset stomach.

DESCRIPTION. A moderate-lived (up to 200 years) native deciduous tree growing 49–80 ft (15–24 m) tall with a straight trunk and spreading, vaselike crown. Twigs are grayish to reddish brown, scabrous, slightly zigzag. Bark is dark reddish brown, furrowed into coarse ridges, with mucilaginous inner bark. Leaves are alternate, simple, ovate to oblong, dark green and very scabrous above, paler and hairy below, 3.9–7.1 in (10–18 cm) long, margins coarsely doubly serrate, base asymmetric. Flowers are perfect, calyx green, anthers reddish, stigma pink to reddish purple, arranged in dense clusters of eight to twenty, 1 in (2.5 cm) long, blooming in late winter. Fruits are samaras, round, papery, broadly winged, green to yellow, 0.4–0.8 in (1–2 cm) long, with entire margins and shallowly notched tip, containing one seed.

USES AND VALUE. Wood not commercially important. Marketed with American elm, used for furniture, panels, and containers. Leaves and inner bark eaten raw or cooked. Bark is dried and ground into a powder used as thickener in soups and in making bread. Medicinally bark used as remedy for irritation of mucous membranes, urinary tract, stomach, and intestines. Birds and small animals eat the seeds; deer and rabbits browse the twigs.

ECOLOGY. Grows in rich, moist soils in bottomlands and along streambanks; also found on drier limestone soils. Shade tolerant. Large seed crops produced every two to four years; dispersed primarily by wind. Susceptible to Dutch elm disease carried by European elm bark beetle (*Scolytus multistriatus*) and several native elm bark beetles (*Hylurgopinus rufipes*, *Scolytus mali*, and *Xylosandrus germane*).

CLIMATE CHANGE. Vulnerability is currently considered to be low despite susceptibility to Dutch elm disease.

CONSERVATION STATUS. Least concern.

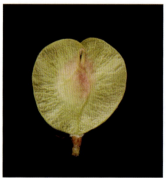

fruit

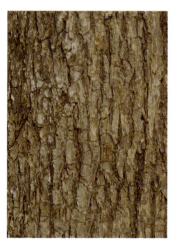

bark

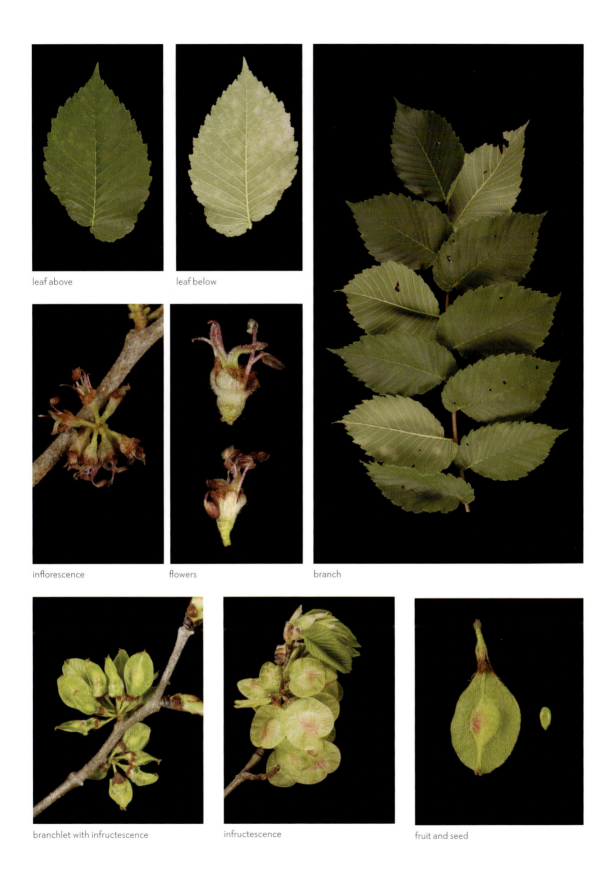

FAMILY ULMACEAE • 491

GENUS ZELKOVA

The habit of this species, typically vase-shaped, with branches diverging at 45 degree angles to the central axis, is similar to that of American elm (Ulmus americana), *but without the dignity and grace.*

—Michael A. Dirr on Zelkova serrata in Dirr's Encyclopedia of Trees and Shrubs

The six species in the genus *Zelkova* are found in the eastern Mediterranean region, eastern Asia, and southwestern Asia. Several species are known from the fossil record of North America, but today none is native in this region. One introduced species is common in North America today.

Japanese Zelkova
Zelkova serrata (Thunb.) Makino
JAPANESE ELM

Japanese zelkova, a medium-sized deciduous tree native to Asia, was introduced into the United States as an ornamental tree because of the attractive bark, leaf color, and shape. Mature trees have a short trunk with many low forming branches that spread into a broad crown. It is also a popular bonsai tree.

DESCRIPTION. A long-lived, deciduous tree growing up to 98 ft (30 m) tall with a short trunk dividing into many upright and erect spreading stems forming a broad round-topped crown. Twigs are red brown, thin, and zigzag. Bark is smooth when young, grayish white to grayish brown exfoliating with age to reveal orange inner bark. Leaves are alternate, simple, ovate, dark green and rough above, paler and glabrous or sparsely pubescent below, with eight to fourteen pairs of veins, 1.2–4 in (3–10 cm) long, 0.6–2 in (1.5–5 cm) wide, margins serrate to crenate. Trees are monoecious with separate male and female flowers, and sometimes bisexual flowers, on the same plant, blooming in mid-spring. Flowers are small, not showy, yellow green, in tight clusters along stems. Fruits are small, green to brown, drupes.

USES AND VALUE. Imported from Japan, Korea, and China. Wood not commercially important. Commonly cultivated as ornamental and street tree.

ECOLOGY. Common and adaptable in cultivation in urban settings throughout North America. Highly resistant to Dutch elm disease.

CLIMATE CHANGE. Vulnerability is considered low because of its wide geographic distribution as an ornamental.

CONSERVATION STATUS. Least concern.

bark

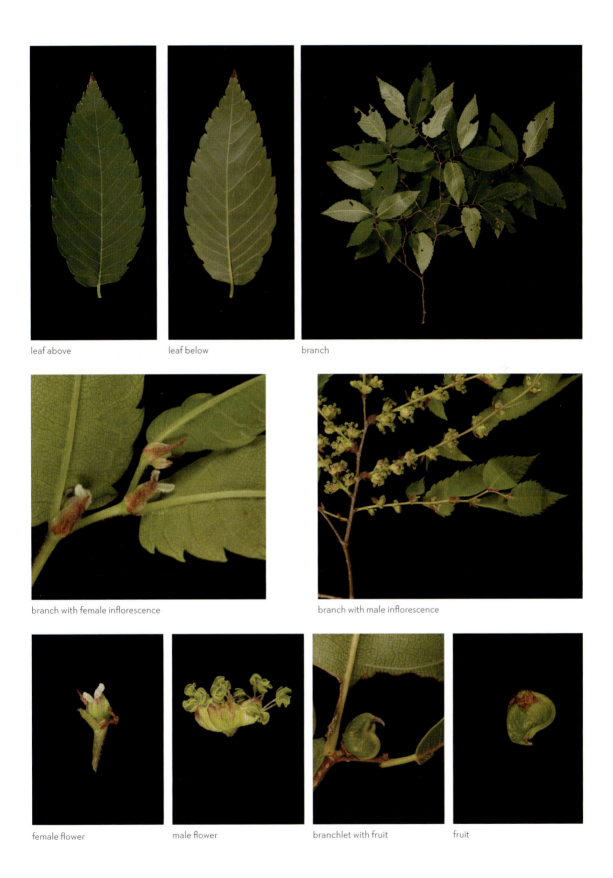

Family Cannabaceae

Species in this family can be herbs, vines, or trees. Some of the woody members of the family, such as *Celtis*, were formerly included in the elm family, but characters of leaf venation, floral sexuality, fruit type, and chemistry, as well as DNA evidence, place these trees in the family Cannabaceae. The family includes eleven genera and about 180 species; most of the species are trees. Members of the Cannabaceae are valued as ornamental plants, as timber trees, for flavoring beer, and as psychotropic herbs.

GENUS CELTIS

The Hackberry simply does not look as though it belonged in its family; its berries do not suggest the fruit of an Elm, and its leaves, with three principal nerves from the base, are unlike most others in venation, and though they have a teasing resemblance to a Linden's, are perversely more like a nettle's than anything else.

—Donald Culross Peattie on *Celtis occidentalis* in *A Natural History of Trees of Eastern and Central North America*

The seventy or so species in the genus *Celtis* are native to warm temperate regions around the world, including North America, Europe, Asia, Africa, and South America. The taxonomic placement of this genus has been problematic, but it appears to be secure in the Cannabis family. These trees are monoecious; separate male and female flowers appear on the same plant. Two native species of *Celtis* are common trees in North America.

Sugarberry

Celtis laevigata Willd.

Sugarberry is a deciduous, medium-sized tree with a broad, rounded, and open crown with spreading or drooping branches that grows in humid climates in thickets, open woodlands, and along riverbanks.

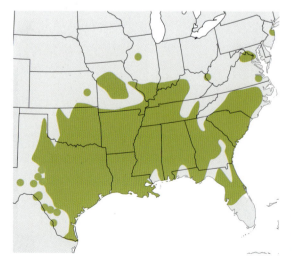

DESCRIPTION. Sugarberry is a deciduous tree with a broad, rounded, and open crown with spreading or drooping branches that grows 59–98 ft (18–30 m) tall. Twigs are slender, zigzag, and reddish brown, dotted with pale lenticels; lateral buds are triangular in shape and appressed. Bark is smooth, pale, dotted with corky outgrowths, developing a warty texture at maturity. Leaves are alternate, simple, lanceolate, ovate, light green above, paler below, 1.6–2.8 in (4–7 cm) long, base asymmetric, tips acuminate, margins serrate. Trees are monoecious with separate male and female flowers produced on the same plant, blooming in late spring. Flowers are small, inconspicuous, green to yellow. Fruits are single-seeded drupes, conspicuous, matures from orange red to black, edible and sweet, 0.25–0.35 in (1–1.5 cm) in diameter.

USES AND VALUE. Wood moderately commercially important. Marketed with hackberry (*Celtis occidentalis*) and used for furniture, veneer, and dimension lumber. Cultivated as shade tree on urban streets and as ornamental in gardens and parks.

Leachates from leaves inhibit the growth of grass and other plants at base of tree. Fruits are edible. Decoction of bark used to treat venereal disease. Birds and small mammals consume the fruits. Cattle and white-tailed deer browse bark and leaves. Larval host to the hackberry emperor (*Asterocampa celtis*) butterfly.

ECOLOGY. Grows in humid climates in thickets, open woodlands, stream sides, and riverbanks on any soil with fair drainage, especially alluvial soils. Flooding intolerant. Shade tolerant. Prolific seeders, producing good crops most years; seeds dispersed by birds and water. Susceptible to damage from fire due to thin bark. Eastern mistletoe (*Phoraedendron flavescens*) is serious pest. Fungal damage is limited.

CLIMATE CHANGE. Vulnerability is currently considered to be low.

CONSERVATION STATUS. Least concern.

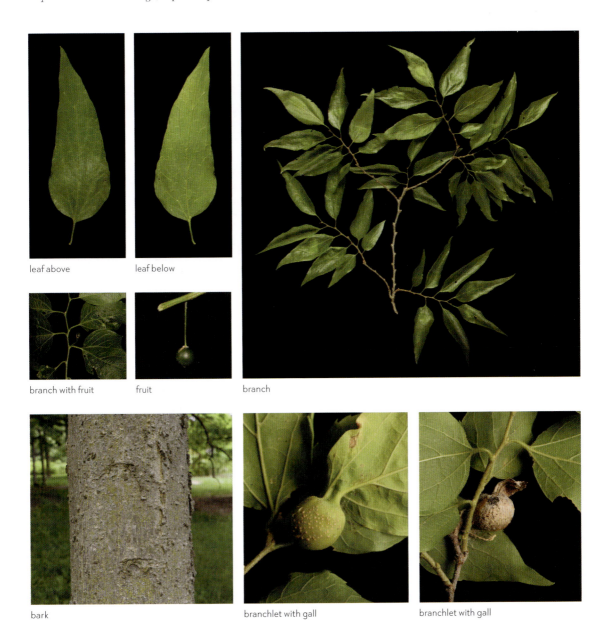

leaf above leaf below

branch with fruit fruit branch

bark branchlet with gall branchlet with gall

FAMILY CANNABACEAE

Common Hackberry

Celtis occidentalis L.

Common hackberry is a medium-sized tree native to North America with distinctive gray furrowed bark covered with warty bumps. Purple cherrylike fruits remain on the tree through winter, providing valuable winter food for many birds.

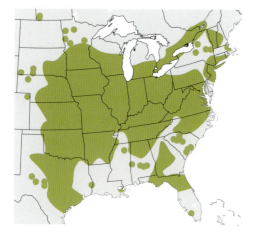

DESCRIPTION. A moderate-lived, medium-sized deciduous tree growing up to 98 ft (30 m) tall with a straight trunk and arching branches. Bark is smooth when young, grayish brown and corky on mature trees. Leaves are alternate, simple, ovate, green and tomentose above, paler and pubescent below, with three distinct veins from the base, 2.0–4.9 in (5–12.5 cm) long, margins serrate, tip acuminate. Flowers are perfect, tiny, light green, calyx four- or five-lobed, 0.12 in (3 mm) across, arranged in axils of leaves, blooming in spring. Fruits are dark red or purple drupes, 0.24–0.32 in (6–8.25 mm) in diameter, ripen in autumn.

USES AND VALUE. Wood moderately commercially important. Used for inexpensive furniture, veneer, and dimension lumber. Planted for erosion control. Fruits are edible, with a sweet and pleasant taste, raw or prepared in jams and preserves. Extract from wood is used to treat jaundice; decoction of bark used to treat venereal disease. Fruits persist through winter, an important food for birds. Larval host plant for hackberry emperor (*Asterocampa celtis*) butterfly.

ECOLOGY. Grows on moist alluvial soils along streams, floodplains, and wooded hillsides. Prolific seeder, producing good crops most years; seeds dispersed by birds, small animals, and water. Intermediate in shade tolerance. Generally free of pests and diseases. Susceptible to fire. Resistant to windthrow due to deep root system.

CLIMATE CHANGE. Vulnerability is currently considered to be low.

CONSERVATION STATUS. Least concern.

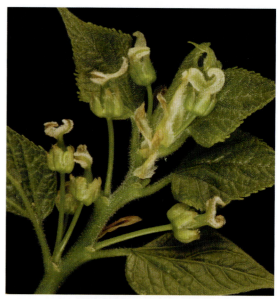

branchlet with female flowers

bark

leaf above

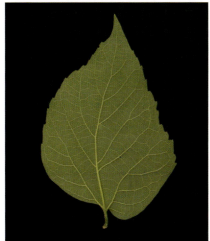
leaf below

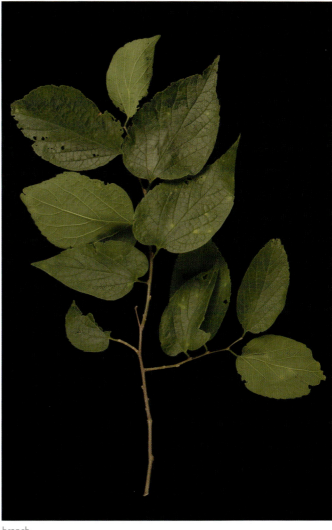
branch

female flower

male flower

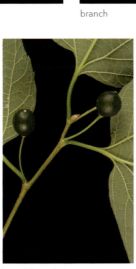
branchlet with immature infructescence

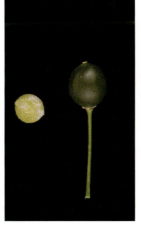
fruit and seed

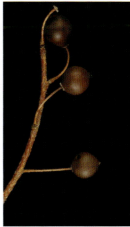
mature infructescence

FAMILY CANNABACEAE • 497

Family Moraceae

Although no single shared trait is found in every member of the family Moraceae, a number of features, including the milky latex distributed throughout the plant in specialized cells, the number of carpels, and the shape of the embryo, unite these species into a coherent evolutionary group. DNA sequence data also show that all of these them are evolutionarily closely related. One of the most distinctive features of figs is the very specialized relationship between the flowers and their wasp pollinators. Fig flowers are unisexual and clustered inside a sac-like structure. A female wasp enters the floral sac through a tiny hole and lays her eggs inside the female flowers, which are pollinated at the same time. The young male and female wasps that hatch from the eggs become adults after feeding on the developing fig fruits inside the floral sac. When the virgin wasps mate, the male flowers of the fig mature and release pollen onto the female wasps as they exit the tiny opening in the sac. The cycle begins again as the pollen-carrying female enters the floral sac of another fig. Five species in three genera are common trees in North America.

GENUS FICUS

Common in old homesteads throughout the South, often outlasting the house itself. Massive rounded shrub—bold leaves and coarse stems (winter) make it difficult to miss.

—Michael A. Dirr on *Ficus carica* in *Dirr's Encyclopedia of Trees and Shrubs*

The hundreds of species of the genus *Ficus* are found in the tropical regions of the world, but a few are native to the warm Temperate Zones of Asia and Europe. Among the 850 species are epiphytes, vines, shrubs, and trees. One of the unique features of *Ficus* is the complex inflorescence, which is made up of numerous tiny flowers embedded inside a vase-like structure that possesses a single opening to admit the pollinating wasps. The wasps pollinate the flowers but also lay their own eggs inside the structure, which eventually becomes the fruit. Because they are tropical, only two introduced species of *Ficus* are common trees in North America.

Weeping Fig
Ficus benjamina L.

Weeping fig, native to India and northern Australia, is a broadleaf evergreen tree that has naturalized in Florida, where it was introduced as an ornamental. It grows best in full sun or partial shade on well-drained soils.

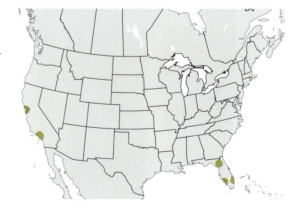

DESCRIPTION. A broadleaf evergreen tree that may grow to 49 ft (15 m) in height. Trunks are straight, pale brown, sometimes braided for ornamental interest, with weeping branches. Aerial roots are large, hanging, can quickly take over gardens. Twigs are arching, with milky latex sap when cut. Leaves are simple, glossy green, oval to elliptic, 2–4 in (5–10 cm) long, with abruptly acuminate tip. Flowers and fruits are enclosed in a fleshy sac. Fruits are figs, fleshy, egg-shaped, changes from green to red to final dark purple or black when mature, 0.75 in (2 cm) in diameter.

USES AND VALUE. Wood not commercially important. Cultivated as outdoor ornamental in in tropical zones, rampant root growth problematic by growing under sidewalks, gardens, and house foundations; also grown in pots as indoor plant.

ECOLOGY. Naturalized in Florida, where it has been introduced from India and northern Australia as an ornamental tree. Grows best in full sun or partial shade on well-drained soils of clay loam or sand that is acidic and moist.

CLIMATE CHANGE. Vulnerability is considered low because of its wide geographic distribution as an ornamental,

CONSERVATION STATUS. Least concern.

leaf

bark

branch

Common Fig

Ficus carica L.

Common fig, native to the Mediterranean and southwestern Asia, is grown throughout the United States for its edible fruits. The short-live small tree is often broader than tall and was one of the first plants cultivated by humans.

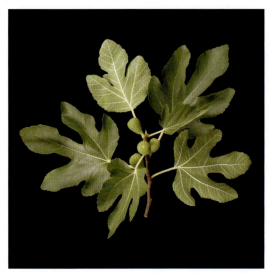

branch with fruit

DESCRIPTION. A short-lived deciduous tree growing 15–31 ft (4.5–9.5 m) tall, usually broader than tall. Bark is smooth and gray. Leaves are alternate, with three to seven irregularly toothed lobes, green and thick above, hairy below, exude latex when cut, 4.0 in (10.2 cm) long and wide. Trees are gynodioecious with some trees producing only female flowers and others producing flowers of both sexes. Flowers are pinkish inside the immature fig fruits, which are reddish green on the outside, obovoid, 1–4 in (2.5–10 cm) long. Flowers and fruits produced in spring and autumn.

USES AND VALUE. Wood not commercially important. Cultivated commercially for fruit production. Fruits are extremely succulent and delicious. Parts of tree used medicinally to treat various ailments. Syrup made from fruits is effective, gentle laxative.

ECOLOGY. An introduced fruit tree, grows best in part- to full sun and well-drained soil. Shade intolerant; drought tolerant.

CLIMATE CHANGE. Vulnerability is considered low because of wide geographic distribution as a cultivated tree.

CONSERVATION STATUS. Least concern.

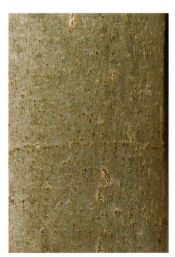

bark

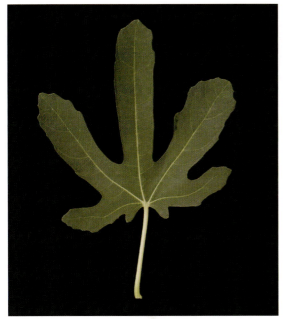
leaf above

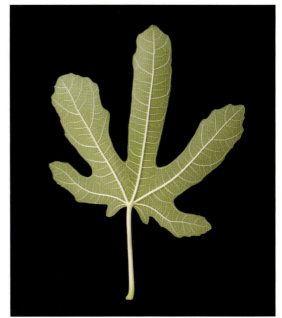
leaf below

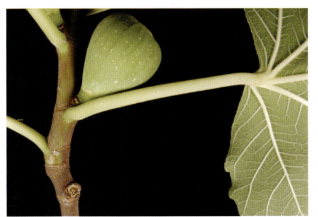
branchlet with fruit

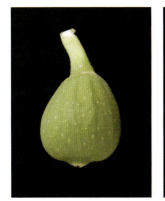
fruit

inflorescence cross section

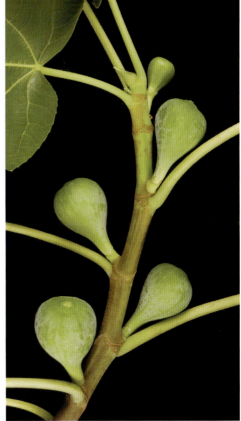
branch with fruit

FAMILY MORACEAE • 501

GENUS MACLURA

For a bow wood, Osage Orange is in first or second rank with archers, amongst all native trees. It is by many considered more reliable than Yew, and the beauty of its grain, often stained in the heartwood with red, makes it the pride of fanciers.

—Donald Culross Peattie on Maclura pomifera in A Natural History of North American Trees

The genus *Maclura* includes a dozen species that are found primarily in the tropical regions of China, Southeast Asia, Africa, and South America. One species is found in North America. Like the genus *Ficus*, the flowers are clustered into a ball-like structure that is transformed into a compound fruit after pollination. One native species is a common tree in North America.

Osage-Orange

Maclura pomifera (Raf.) C. K. Schneid.
HORSE-APPLE

Osage-orange, native to Texas and Arkansas, has been widely planted and naturalized throughout the United States as part of Franklin Delano Roosevelt's Great Plains Shelterbelt Project. This tall tree produces distinctive bumpy, spherical fruits that smell like oranges but are not edible.

DESCRIPTION. A long-lived deciduous tree growing to 49 ft (15 m) tall, with a short trunk and a round-topped crown. Twigs are smooth, orange to brown, with axillary spines. Bark is tan, orange to brown, scaly, irregularly furrowed. Leaves are alternate, simple, ovate, shiny green above, margins entire, 2.8–5.9 in (7–15 cm) long, 2.0–2.8 in (5–7 cm) wide. Trees are dioecious with male and female flowers produced on separate trees, blooming in late spring to early summer. Male flowers are green, 0.08 in (2 mm) long, in racemes 0.4–1 in (1–2.5 cm) long; female flowers are borne in round green clusters, 1 in (2.5 cm) in diameter. Fruits are large, composed of numerous tightly packed achenes, fleshy, round, green, 2.8–5.9 in (7–15 cm) in diameter, with odor of citrus, exude white milky sap.

USES AND VALUE. Wood not commercially important. Used for fence posts and highly prized by Native North Americans for hunting bows. Widely planted and naturalized as an ornamental. Windbreak in prairie states planted by Works Progress Administration during Great Depression. Fruits are not consumed by humans and only rarely by animals.

ECOLOGY. Grows in a wide variety of open habitats, especially rich lowland forests. Intermediate in shade tolerance. Generally free of both insect and fungal pests.

CLIMATE CHANGE. Vulnerability is currently considered to be low.

CONSERVATION STATUS. Least concern.

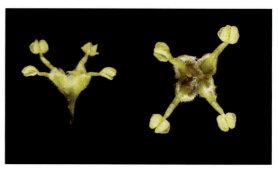

male flowers

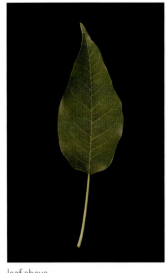
leaf above

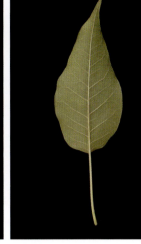
leaf below

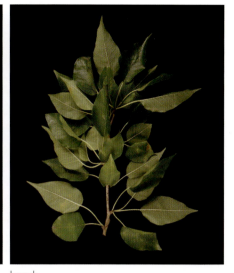
branch

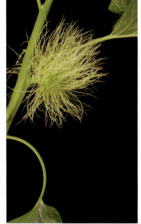
branch with female inflorescence

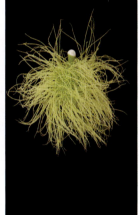
female inflorescence

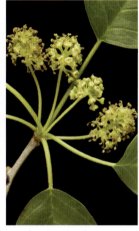
branch with male inflorescence

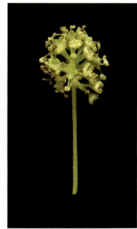
male inflorescence

bark

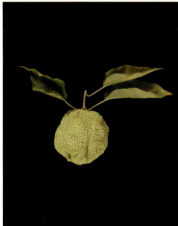
fruit

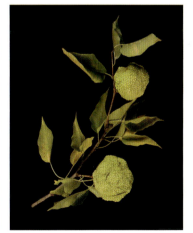
branchlet with fruits

FAMILY MORACEAE • 503

GENUS MORUS

The tree that from the recorded beginning of civilization has served to clothe the fortunate in silk is the White Mulberry, not native of our land. But this Red Mulberry of ours has its own wilderness romance.

—Donald Culross Peattie on Morus rubra in A Natural History of Trees of Eastern and Central North America

Containing up to sixteen species recognized by most botanists (and perhaps 100 more recognize by others), the genus *Morus* is widely distributed in Asia, Africa, and the Americas. The fruits of many species are readily eaten by people, whereas the leaves are the primary food source for silkworms. One introduced species and one native species are common trees in North America.

White Mulberry

Morus alba L.

White mulberry is a fast-growing tree native to China and introduced into the United States as an ornamental plant for its attractive, deep purple fruits. The leaves are the preferred food for silkworms and trees are often cultivated to provide leaf fodder for the larvae of this silk-producing moth.

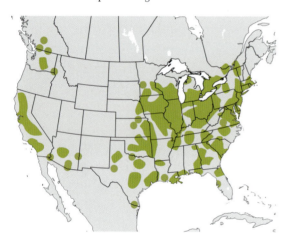

DESCRIPTION. A moderate-lived deciduous tree growing up to 33–50 ft (10–15 m) tall, with a broad crown and low branches. Twig is zigzag, gray to orange brown and smooth. Bark is orange brown, becoming gray with narrow irregular ridges. Leaves are alternate, simple, ovate, sometimes three- to five-lobed, smooth and glossy green above, paler below, margins serrate, 2–5.9 in (5–15 cm) long. Trees are dioecious producing male and female flowers on separate trees, blooming in mid-spring. Male flowers are green, in catkins, 1 in (2.5 cm) long; female flowers are rounder, 0.20–0.47 in (5–12 mm) long. Fruits are multiple drupes, whitish-pink to dark red to black, oblong, 0.4–0.8 in (1–2 cm) long.

USES AND VALUE. Wood not commercially important. Cultivated widely as an ornamental tree, especially in southwestern United States, valued for shade and sweet fruits. Primary food for silkworms and commercially important for silk production outside of North America. Abundant pollen elevates level of allergies. Birds and animals eat fruits.

ECOLOGY. Grows and can be cultivated in a wide variety of habitats. Hybridizes with native red mulberry (*Morus rubra*).

CLIMATE CHANGE. Vulnerability is considered low because of wide geographic distribution as a cultivated ornamental.

CONSERVATION STATUS. Least concern.

bark

504 • THE DIVERSITY OF TREES

leaf above | leaf below | leaf above | leaf below

male inflorescence, flower (inset) | male inflorescence, flower (inset) | branch with female inflorescence | female inflorescence

branchlet with infructescence | fruits and seeds | branch

FAMILY MORACEAE • 505

Red Mulberry

Morus rubra L.

Red mulberry is a tall deciduous tree native to eastern North America. It produces sweet, juicy, and edible purple fruits. The large quantities of fruit are a favorite food for birds.

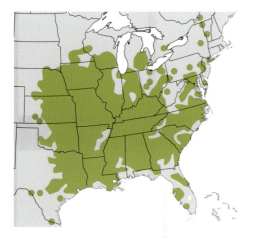

DESCRIPTION. A moderate-lived deciduous tree growing to 33–60 ft (10–18 m) tall with a short trunk and spreading branches. Twigs are light brown, tinged with red. Bark is dark brown and smooth or scaly. Leaves are alternate, simple, ovate to circular, dark green and rough above, softly hairy below, tip pointed, margins serrate-dentate, 2.8–4.7 in (7–12 cm) long, 2.4–4.7 in (6–12 cm) wide. Trees are dioecious producing male and female flowers on separate plants, arranged in catkins, blooming in mid-spring. Male flowers are arranged in green catkins, 1.4–2.8 in (3.5–7 cm) long; female flowers clustered in catkins, 1 in (2.5 cm) long. Fruits are multiple drupes, dark purple, 0.8–1.2 in (2–3 cm) long, on drooping peduncles.

USES AND VALUE. Wood not commercially important. Fruits are soft, juicy, and sweet when fully ripe, widely consumed by humans and wildlife, including birds, opossum, raccoon, fox and gray squirrels; used to make wine. Bark of root is anthelmintic and cathartic.

ECOLOGY. Grows in flood plains, river valleys, and moist hillsides. Good seed crops produced every two to three years; birds and small mammals are primary dispersal agents. Shade tolerant. Biggest threat causing decline in population numbers is loss of genetic integrity through hybridization with non-native white mulberry (*Morus alba*).

CLIMATE CHANGE. Vulnerability is significant but has reasonable probability of persistence in the future. Ongoing monitoring is recommended.

CONSERVATION STATUS. Least concern.

fruits

bark

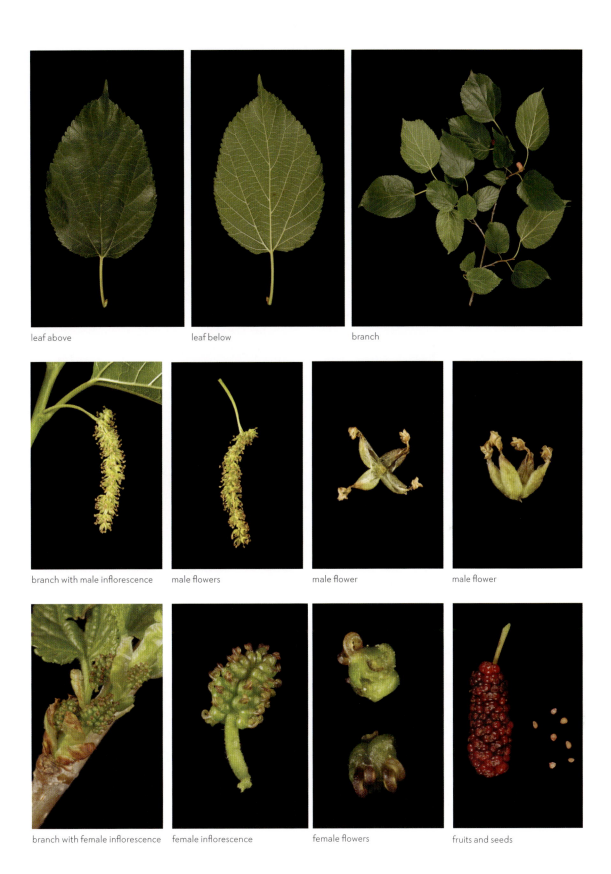

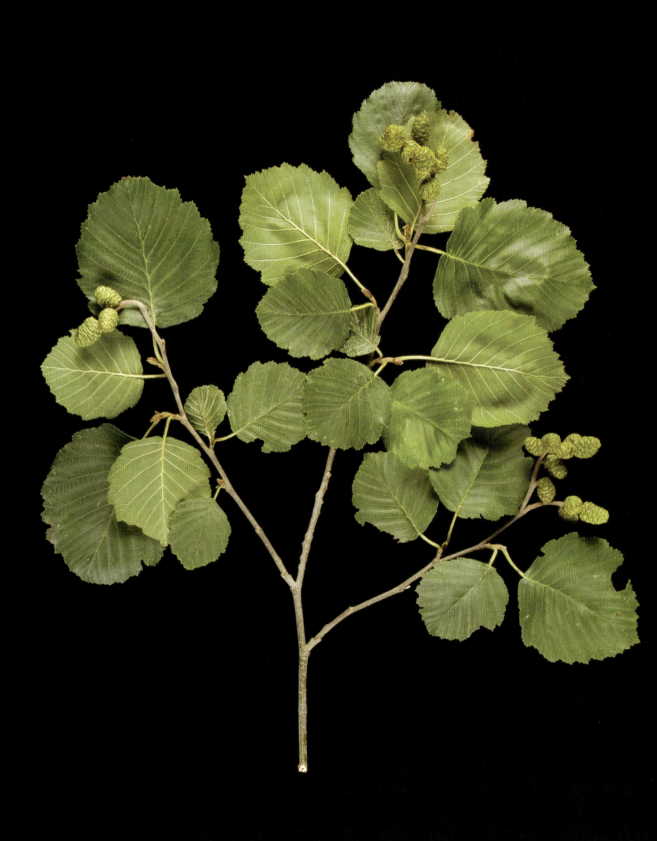

ORDER FAGALES

Members of the Fagales were formerly grouped with the witch-hazels and sycamores but are now generally agreed to have evolved within the Rosids. The eight families that make up this order include trees and shrubs in the beech family, the walnut family, the birch family, and the bayberry family, among others. All have generally small flowers with very reduced sepals and petals, lack nectaries, and are either male or female (unisexual); they are pollinated by the wind and insects. Tannins are present throughout the plant body. Nuts produced by the trees of several families of the Fagales are an important economic crop. Three families contribute species of common trees in North America, especially the oaks.

Family Fagaceae

Members of the family Fagaceae have male flowers that are clustered in catkins and are wind or sometimes insect pollinated. The separate female flowers are solitary or in small groups. Many of the nearly 900 species in the family are found in the Northern Hemisphere, where they are a conspicuous element in the hardwood forests that formerly covered much of the land area in the Temperate Zone. The oaks are also an important component of the tropical evergreen forests of Southeast Asia and southern China, where a set of genera different from those in temperate North America and Europe is found. Fossil evidence indicates that the Fagaceae may have originated over 90 million years ago. Forty-four species in four genera, mostly in the genus *Quercus*, are common trees in North America.

OPPOSITE Speckled alder (*Alnus incana*)

GENUS CASTANEA

But if a king is wholly vanished from our scene, its absence is at least less depressing than were those years when its diseased hosts and gaunt, whitening skeletons saddened the forest prospect.

—Donald Culross Peattie on *Castanea dentata* in *A Natural History of Trees of Eastern and Central North America*

Containing nine species, the genus *Castanea* is widespread in temperate climates of Europe, Asia, and North America. Chestnuts are also commonly cultivated in many parts of the world. The fruits or "nuts" are enclosed in a spiny husk and peeled and readily eaten. Caused by a fungus imported from Asia, the chestnut blight resulted in the destruction of most of the American chestnuts in the early 1900s. Two native species of *Castanea* are common trees in North America.

American Chestnut
Castanea dentata (Marshall) Borkh.

American chestnut is native to eastern North America. Few mature trees remain as a result of the chestnut blight caused by a fungus introduced in the 1930s. Roasted chestnuts are still sold as snacks, most often during the Christmas holiday season.

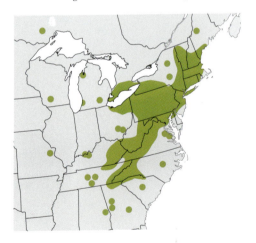

DESCRIPTION. A small tree growing to 98 ft (30 m) tall with a slender trunk and rounded crown. Once dominant in eastern forests, now most often found as stumps sprouts that decline when less than 20 ft (6 m) in height due to chestnut blight. Bark smooth and brown, becoming darker brown with scaly plates with age. Leaves are alternate, simple, oblong to lanceolate, dark green above and hairless below, margins coarsely serrate with bristle tips, 5.1–7.9 in (13–20 cm) long. Trees are monoecious producing both male and female flowers on same plant, blooming in early summer. Male flowers are small, greenish white, arranged in 6–8 in (15.25–20.25 cm) long catkins; female flowers are positioned at base of male catkins. Fruits have round, spiny burlike husk, 2.0–2.6 in (5–6.5 cm) in length, with two to three flattened, shiny brown nuts, 0.5–1 in (1.25–2.5 cm) long.

USES AND VALUE. Wood not commercially important. Before chestnut blight, fruits were a welcome and sustaining food. Used medicinally.

ECOLOGY. Grows in moist well-drained uplands, mountain slopes, and deciduous forests. Although a fast-growing tree, very few mature specimens are known because of the Asian chestnut blight caused by a fungus (*Cryphonectria parasitica*). Remnant individuals are occasionally found in natural habitats. A rigorous program to hybridize American chestnut with both Chinese chestnut and Japanese chestnut has resulted in the development of promising blight-resistant strains.

CLIMATE CHANGE. Vulnerability is high, may have little capacity to adapt to changing conditions, and has a low potential to persist in the future. Ongoing monitoring is required.

CONSERVATION STATUS. Critically endangered.

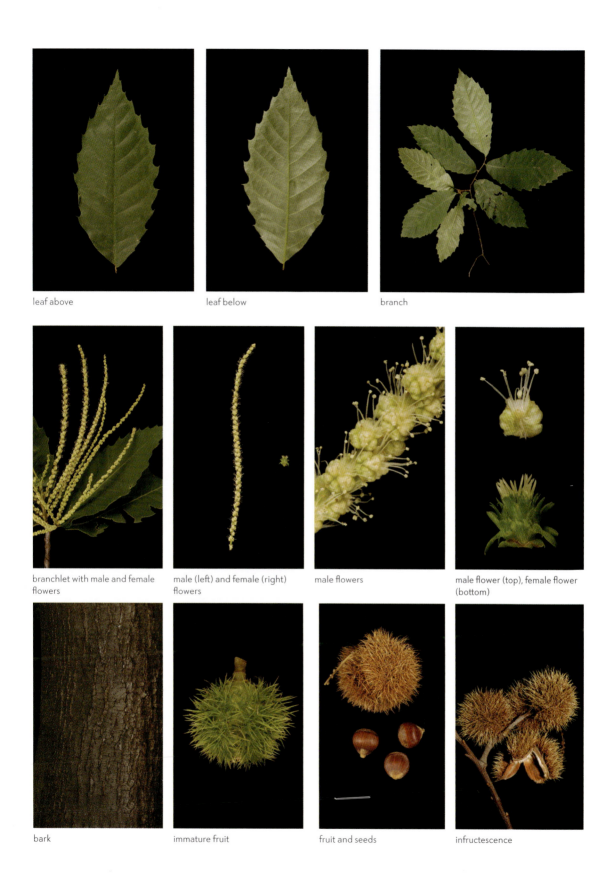

FAMILY FAGACEAE • 511

Chinkapin

Castanea pumila (L.) Mill.
ALLEGHENY CHINKAPIN

Chinkapin is a large shrub or small native to eastern North America. It grows in xeric to mesic mixed woods with oaks and pines. Although a close relative of American chestnut, it does not appear to be susceptible to chestnut blight

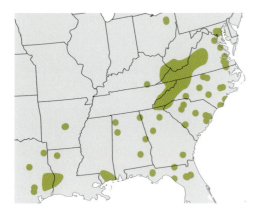

DESCRIPTION. A tree or large shrub growing up to 33 ft (10 m) tall that is native to the eastern United States. Twigs are slender and ruddy brown, with variable glaucous pubescence. Buds are glaucous to pubescent with two or three bud scales. Bark is light reddish brown and shallowly furrowed into scaly plates. Leaves are alternate, simple, oblong to lanceolate, lustrous green above, pale and pubescent below, venation pinnate, margins coarsely dentate, 3.1–5.9 in (8–15 cm) long. Trees are monoecious producing male and female flowers on the same plant, blooming in late spring. Male flowers are small, pale yellow, borne in catkins, 3.1–4.7 in (8–12 cm) long; female flowers in catkins, 0.2–0.4 in (0.5–1 cm) long. Fruits are spiny burs, produced in clusters, 0.4–1.2 in (1–3 cm) in diameter, each contains a single dark brown, round nut.

USES AND VALUE. Wood not commercially important. Used for fence posts and fuel. Nuts are sweet and palatable to humans, flavor similar to chestnut. Infusion of the leaves used as external wash for fevers. Sometimes cultivated as landscape ornamental. Provides food for birds and small mammals, such as fox, squirrels, and white-tailed deer.

ECOLOGY. Grows in xeric to mesic mixed woods in well-drained stream terraces, dry pinelands, and sandhills, such as longleaf pine scrub, scrub oak ridges, and sand pine oak scrub. Prefers dry, rocky, sandy, and loamy soils. Shade intolerant; drought tolerant. Not as susceptible to chestnut blight as American chestnut but shows signs of canker.

CLIMATE CHANGE. Vulnerability is high, may have little capacity to adapt to changing conditions, and has a low potential to persist in the future. Ongoing monitoring is required.

CONSERVATION STATUS. Least concern.

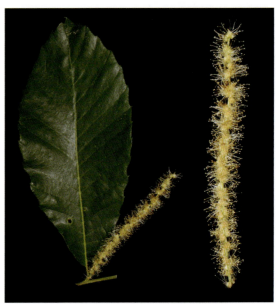

leaf with male inflorescence (left), male inflorescence (right)

bark

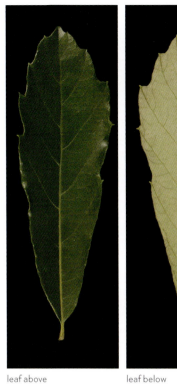

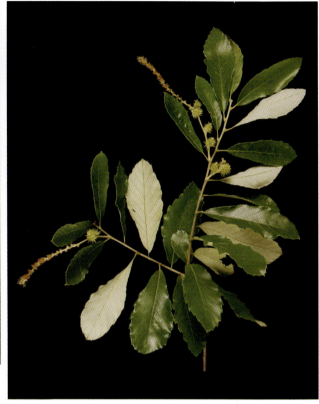

leaf above　　　leaf below

branch

branch with female inflorescence, female flower (inset)　　　fruit

FAMILY FAGACEAE • 513

GENUS CHRYSOLEPIS

The two species of the genus *Chrysolepis* are found only in the western region of North America, where they are native shrubs and tall trees. As with close relatives in the genus *Castanea*, the edible fruits are enclosed in a spiny outer husk. One of the two native species of *Chrysolepis* is a common tree.

Giant Golden Chinquapin

Chrysolepis chrysophylla (Douglas ex Hook.) Hjelmq.

Giant golden chinquapin is a tall tree native to Washington and California in western North America. The edible fruits are enclosed in a spiny husk. Two varieties are recognized.

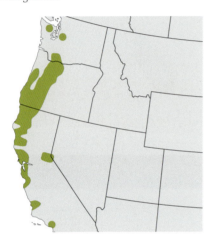

DESCRIPTION. A broad-leaved evergreen shrub or tree growing up to 148 ft (45 m) tall with a long clear trunk, dense ovoid conical crown, and deep taproot. Twigs are yellow, turning reddish brown as they mature, with yellow star-shaped pith. Terminal buds are clustered near the twig ends. Bark is smooth, grayish brown, and mottled, becoming thick, ridged and furrowed into wide longitudinal plates with age. Leaves are alternate, simple, lanceolate, leathery, dark green above with golden yellow pubescence below, margins entire, 1.6–5.1 in (4–13 cm) long. Trees are monoecious with male and female flowers produced on the same plant, blooming in early summer. Male flowers are dull yellow, fragrant, arranged in erect catkins; female flowers are clustered at the base of the male flowers. Fruits with burlike covering, spiny, brown, arranged in clusters, each containing one or two triangular nuts.

TAXONOMIC NOTES. Variety *chrysophylla* is a tree that grows to over 100 ft (30 m) tall with flat leaf blades and occurs in northern part of species' range; var. *minor* is a shrub or small tree that grows less than 33 ft (10 m) tall with folded leaf blades with upturned margins and occurs in the southern part of this species' range.

USES AND VALUE. Wood moderately commercially important. Used for furniture, cabinets, decorative veneer, and paneling. Seeds are very sweet and edible. No known medicinal uses. Important food source for wildlife; provides cover for birds and small mammals.

ECOLOGY. Grows in warm, dry, and exposed locations with mild climates on rocky and infertile soils. More likely to be treelike on sites with deep soils. Produce good seed crops every two to five years; primary dispersal agents are gravity, small mammals, and birds. Generally free of damaging fungal and insect pests.

CLIMATE CHANGE. Vulnerability is currently considered to be low.

CONSERVATION STATUS. Least concern.

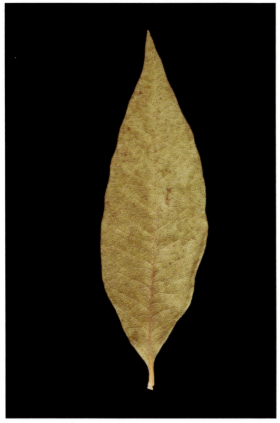
leaf above

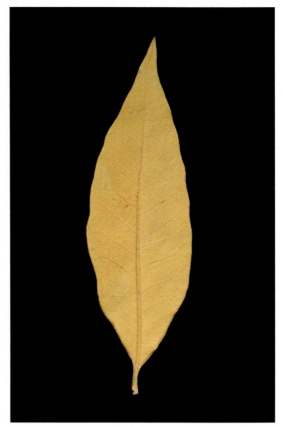
leaf below

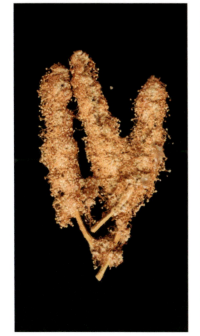
inflorescence

flowers

fruit

FAMILY FAGACEAE • 515

GENUS FAGUS

A Beech is, in almost any landscape where it appears, the finest tree to be seen. There are many taller trees, and many that attain to moments of showier glory. ... But taken in all seasons and judged by all that makes a tree noble—strength combined with grace, balance, longevity, hardiness, health—the Beech is all that we want a tree to be.

—Donald Culross Peattie on *Fagus grandifolia* in *A Natural History of Trees of Eastern and Central North America*

The ten to thirteen species in the genus *Fagus* are native to the cooler regions of Europe, Asia, and North America. These often-large trees are conspicuous elements of the forest where they are native, and they are also commonly cultivated as landscape specimens. The plants produce separate male and female flowers on the same plant, and the fruits are contained inside a spiny husk, like those of other members of the family. One native species of *Fagus* is a common tree in North America.

American Beech
Fagus grandifolia Ehrh.

American beech, a long-lived tree native to eastern North America, produces copious amounts of seeds that are an important food source for many animals. Beechnuts were a primary food of the now-extinct passenger pigeon and clear-cutting of these trees contributed to the decline and eventual extinction of this iconic bird.

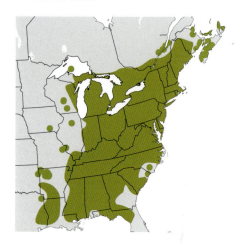

DESCRIPTION. A long-lived (300–400 years) deciduous tree growing to 75 ft (23 m) tall, with an oval or pyramidal crown. Bark is smooth, light gray, sometimes with patches of darker gray or whitish gray. Leaves are alternate, simple, oblong to ovate, green, turning yellow in fall, margins serrate, 3–6 in (7.6–15 cm) long. Trees are monoecious producing both inconspicuous male and female flowers on the same plant, blooming in mid-spring. Male flowers are yellow in long-stemmed heads; female flowers grow in clusters of two to four. Fruits are prickly brown burs with four sections, containing two to three beechnuts. Seeds shiny brown, 0.3–0.5 in (8–12 mm) long.

USES AND VALUE. Wood moderately commercially important. Used for steaming and bending, flooring, furniture, veneer, pallets, pulpwood, and fuelwood. Inner bark, leaves, oil, and nuts are edible. Nuts are both sweet and nutritious. Medicinally, a decoction of boiled leaves used as wash and poultice for frostbite, burns, and poison ivy. An important seed producer providing food for a wide range of wildlife, including deer, small rodents, bears, fox, ruffed grouse, ducks, and blue jays.

ECOLOGY. Grows in damp woods with rich soil, including open forests, slopes, and hammocks. Relative windfirm. Susceptible to fire, due to very thin bark. Very shade tolerant. Producing good seed crops every two to eight years; dispersal by gravity, small rodents, and blue jays. Infected by numerous fungal diseases and insect pests, including beech bark disease caused by the bark canker fungus *Nectria* introduced by the scale insect *Cryptococcus fagisuga*.

CLIMATE CHANGE. Vulnerability is currently considered to be low.

CONSERVATION STATUS. Least concern.

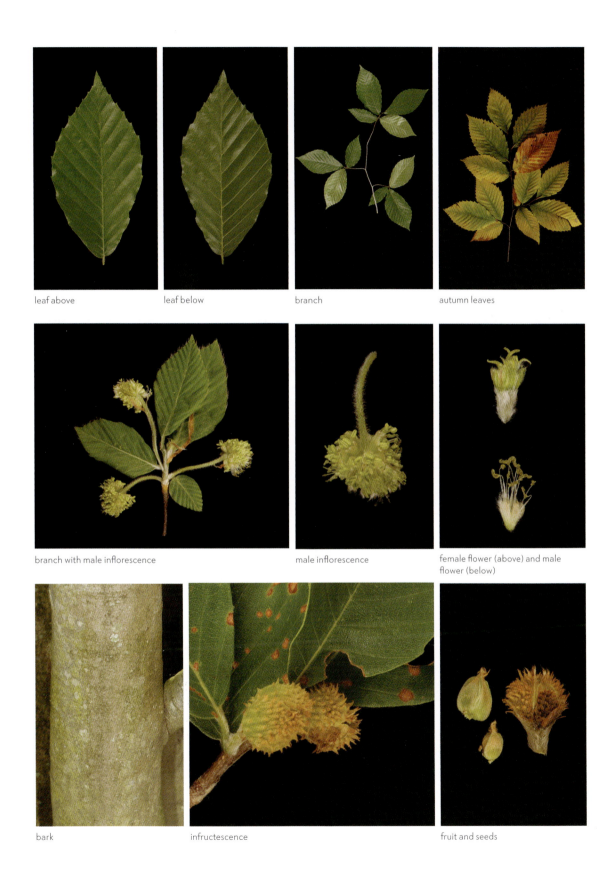

FAMILY FAGACEAE

GENUS QUERCUS

Indeed, the fortunate possessor of an old White Oak owns a sort of second home, an outdoor mansion of shade and greenery and leafy music.

—Donald Culross Peattie on *Quercus alba* in *A Natural History of Trees of Eastern and Central North America*

The genus *Quercus*, the largest genus in the family Fagaceae, contains around 500 species that are distributed in both cool and tropical regions of Asia, Europe, North Africa, and the Americas. Over ninety species of oaks are native to North America alone. These trees play a dominant ecological role in the forest communities where they are found and maintain an obligate relationship with mycorrhizal fungi. Both the lobed or serrated leaves and the nuts borne in cupules, called acorns, are distinctive features of the oaks. Identification of oaks can be quite difficult because of extensive hybridization among species. The hard wood with a high tannin content and distinctive grain is highly prized in construction and furniture making. Forty native species of *Quercus* are common trees in North America. (See pages 746–749 for leaf shapes of forty-one species of *Quercus*.)

Coast Live Oak
Quercus agrifolia Née
CALIFORNIA LIVE OAK

Coast live oak is an evergreen tree that is a dominant overstory species in live oak woodlands along the coast of California.

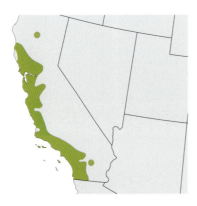

DESCRIPTION. An evergreen tree growing up to 98 ft (30 m) tall with short thick trunk and wide-spreading, irregularly shaped crown. Twigs are slender and initially pubescent, becoming smooth and gray brown with age. Buds are clustered, ruddy, and rounded at the tip. Bark is smooth and grayish brown when young, becoming darker gray brown with lighter gray ridges with age. Leaves are alternate, elliptical to oblong, thick, leathery, glossy, abaxially dull with pubescent veins, margins spiny and curved under, 3–6 in long. Trees are monoecious producing male and female flowers on the same plant, blooming from March to May. Male catkins are yellow, drooping, 1.6–3.5 in (4–9 cm) long; female flowers are inconspicuous, produced in reddish spikes in leaf axils. Fruits are elongated, narrow, light brown acorns, 1.2 in (3 cm) long, with pointed, conical ends, scaly and ashy-brown cap covers the top of the acorn, mature in one year by early fall.

USES AND VALUE. Not commercially important. Planted for soil stabilization and as a landscape ornamental. Acorns are staple food for Native North Americans. Galls produced on trees are strongly astringent and sometimes used medicinally. Provides cover for wildlife; deer browse on the young foliage.

ECOLOGY. Grows in coastal environment in California and typically found within 62 mi (100 km) of the Pacific Ocean. A dominant overstory species in live oak woodlands in well-drained soils on coastal hills and plains. Intermediate in shade tolerance. Maintains an obligate relationship with mycorrhizal fungi. Larval host of California oak moth (*Phryganidia californica*); larvae appear in eight- to ten-year cycles in sufficient abundance to defoliate trees. Susceptible to Sudden Oak Death caused by the fungus-like pathogen *Phytophthora ramorum*.

CLIMATE CHANGE. Vulnerability is currently considered to be low.

CONSERVATION STATUS. Least concern.

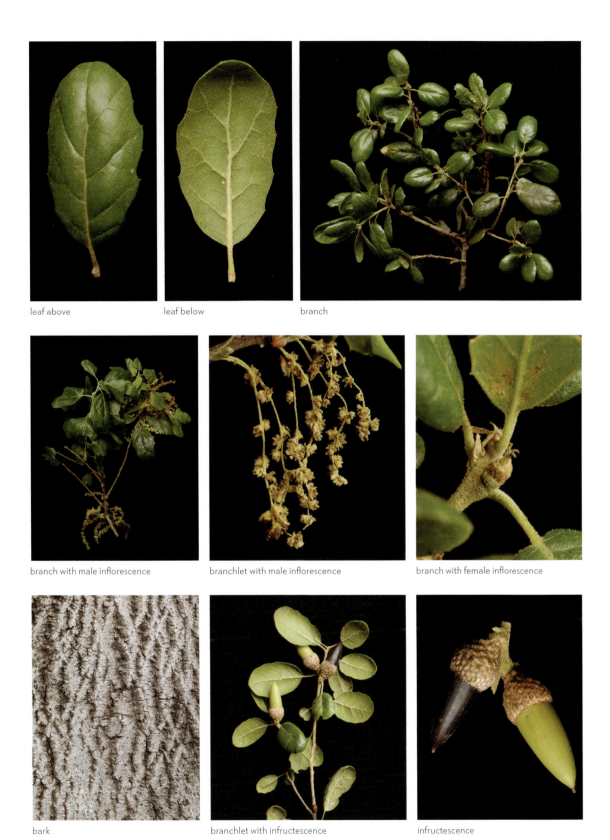

leaf above　　　leaf below　　　branch

branch with male inflorescence　　　branchlet with male inflorescence　　　branch with female inflorescence

bark　　　branchlet with infructescence　　　infructescence

FAMILY FAGACEAE • 519

White Oak

Quercus alba L.

White oak, native to eastern North America, is one of the longest-lived oaks (living for over 600 years). Though called "white oak," trees have fissured ashen-gray bark. The high-grade wood is used to make tight barrels to hold whiskey and other liquids. It is the state tree of Connecticut, Illinois, and Maryland.

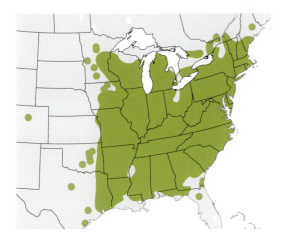

DESCRIPTION. A long-lived deciduous tree growing up to 98 ft (30 m) tall with long clear trunk and dense crown in the forest; in more open habitats has short stocky trunk and wide-spreading crown. Twigs are reddish brown to gray and hairy when young, becoming glabrous. Bark is light gray and shallowly furrowed or broken into scaly blocks. Leaves are alternate, simple, obovate to elliptical, green to grayish green and glabrous above, pale or glaucous below, with five to nine rounded lobes and shallow to deep sinuses, 3.9–9.8 in (10–25 cm) long. Trees are monoecious producing male and female flowers on the same plant, blooming in mid-spring. Male flowers are yellow green, on hanging catkins, 2–3.1 in (5–8 cm) long; female flowers are reddish green, in spikes near leaf axils. Fruits are oblong to ovoid, light brown acorns, 0.4–1.2 in (1–3 cm) long, with a warty cup that covers a quarter of the nut.

USES AND VALUE. Wood commercially important. Used for cabinetry, furniture, interior trim, flooring, boat building, barrels, and veneer. The state tree of Connecticut, Illinois, and Maryland. Acorns are edible and contain 6 percent protein and 65 percent carbohydrates; seeds are roasted and eaten after leaching out tannins. Used by Native North Americans as antiseptic, astringent, and for treatment of many ailments. Over 180 different birds and mammals use acorns as food, including squirrels, blue jays, crows, red-headed woodpeckers, deer, turkey, quail, mice, chipmunks, ducks, and raccoons. Twigs and foliage are browsed by deer.

ECOLOGY. Grows in dry to moist soils in uplands and bottomlands. Good seed crops are produced every four to ten years. Acorns dispersed by squirrels and germinate in fall of same year. Intermediate in shade tolerance. Attacked by gypsy moth (*Lymantria dispar*), orange striped oakworm (*Anisota senatoria*), variable oakleaf caterpillar (*Heterocampa manteo*), and several oak leaf tiers (*Psilocorsis* spp.). Most destructive disease is Oak wilt caused by a fungus (*Ceratocystis fagacearum*) throughout the central region of North America.

CLIMATE CHANGE. Vulnerability is currently considered to be low.

CONSERVATION STATUS. Least concern.

bark

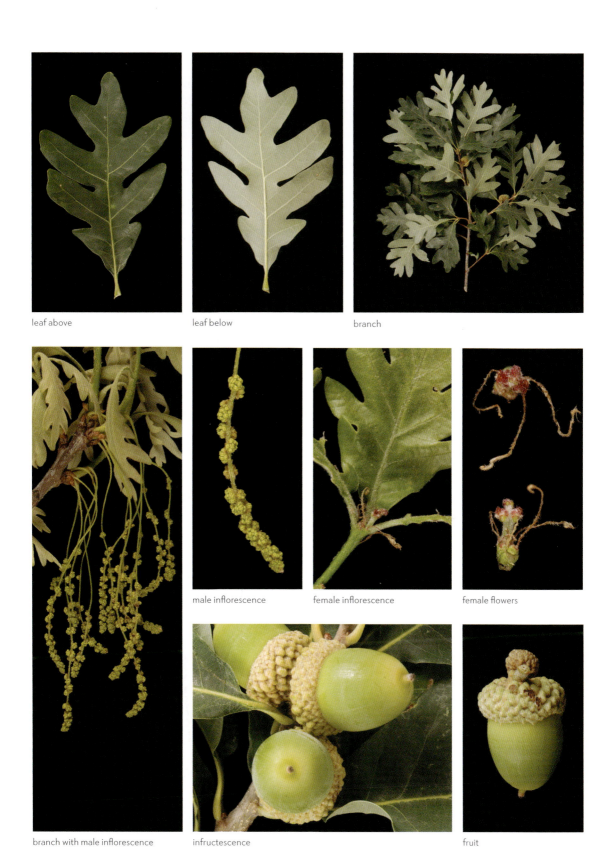

Arizona White Oak

Quercus arizonica Sarg.

Arizona white oak is a medium-sized evergreen tree with a short trunk and twisted branches that grows on slopes and canyons in the southwestern United States.

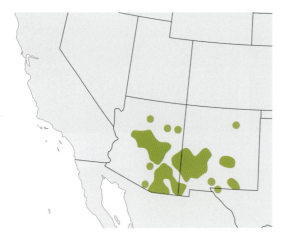

DESCRIPTION. A medium-sized evergreen tree that grows up to 56 ft (17 m) tall with short trunk, fat branches, and spreading crown. Branches are twisted and borne at right angles to the trunk. Twigs are alternate and light reddish brown, and pubescent, with clustered terminal buds that are sharp and stout. Bark is light gray, thin, and dotted with lenticels, becoming thick and fissured with scaly ridges with age. Leaves are simple, alternate, oblong, leathery and stiff, blue-green, parallel veins are sunken above, raised and pubescent below, margins entire or toothed, base cordate, 1.5–3 in (3.7–7 cm) long, shed in spring. Trees are monoecious producing male and female flowers on the same plant, blooming after leaves are shed in early spring from March to May. Male flowers borne in drooping, yellow-green catkins; female flowers borne in small spikes in leaf axils. Fruits are oblong, 1.2 in (3 cm) long acorns with finely pubescent scales, ripen in one year.

USES AND VALUE. Wood not commercially important. Used for furniture. Cattle, birds, and small mammals consume acorns. Buds, seedlings, and leaves browsed by white-tailed deer and mule deer.

ECOLOGY. Grows on slopes and canyons in the Rocky Mountains of the southwestern United States. Occurs on rocky and sandy soils, including clay loam, clay, medium loam, and gravelly textures. Drought and cold tolerant; intermediate in shade tolerance.

CLIMATE CHANGE. Vulnerability, though currently considered to be low, may increase in the future. Ongoing monitoring is recommended.

CONSERVATION STATUS. Least concern.

bark

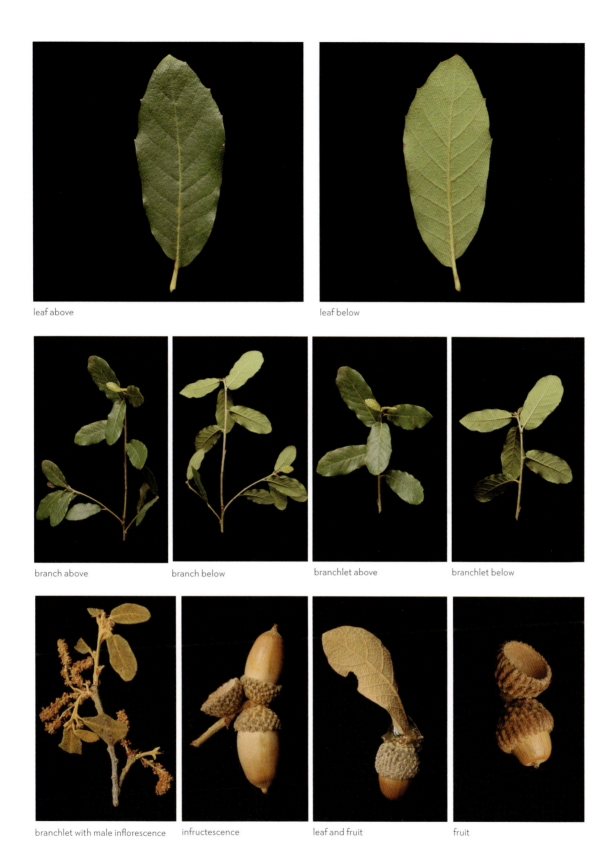

FAMILY FAGACEAE • 523

Swamp White Oak
Quercus bicolor Willd.

Swamp white oak, found primarily in wetlands throughout eastern and midwestern North America, is a long-lived tree. The acorns are consumed by many birds—27 percent of the diet of wild ducks—and mammals.

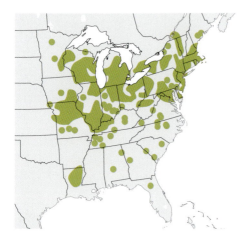

DESCRIPTION. A long-lived deciduous tree growing to 82 ft (25 m), with an irregular crown and drooping lower branches. Twigs are green to brown. Bark is irregularly fissured, flaking off in curly strips. Leaves are alternate, simple, obovate to oblong-obovate, shiny dark green above, much paler below, margins blunt-toothed or crenately lobed, base wedge-shaped, tips rounded, 0.5–0.6 in (1.2–1.5 cm) long, 2–4 in (5–10 cm) wide. Trees are monoecious producing male and female flowers on the same plant, blooming in early to mid-spring. Male flowers are clustered in catkins, with five to nine lobed calyx, yellowish green, hairy, 2–4 in (5–10 cm) long; female flowers are green to red, very small, and borne on long peduncles. Fruits are ovoid, tan acorns, 0.8–1.2 in (2–3 cm) long, grow singly or doubly on peduncle, 1–2.4 in (2.5–6 cm) long, the cup covers one-third of nut.

USES AND VALUE. Wood commercially important. Marketed with other white oaks and used for cabinetry, furniture, interior trim, flooring, boat building, barrels, and veneer. After leaching the tannins acorns are sweet and edible. Galls produced on trees are strongly astringent. Acorns are eaten by squirrels, other mammals, wild ducks and ground birds.

ECOLOGY. Typically grows along streambanks, in swamps, and in bottomlands. Intermediate in shade tolerance. Good seed crops produced every three to five years, with lesser crops in intervening years. Susceptible to oak wilt fungus (*Ceratocystis fagacearum*), canker (*Phomopsis*), and dieback (*Coniothyrium*).

CLIMATE CHANGE. Vulnerability is high, may have little capacity to adapt to changing conditions, and has a low potential to persist in the future. Ongoing monitoring is required.

CONSERVATION STATUS. Least concern.

female inflorescence

bark

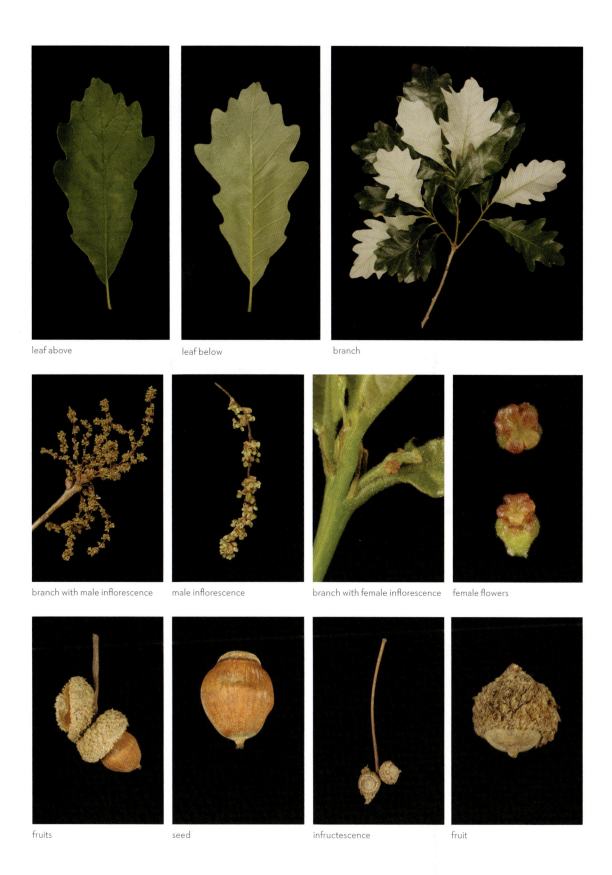

Canyon Live Oak
Quercus chrysolepis Liebm.

Canyon live oak is a spreading tree with a short, crooked trunk, sometimes multistemmed. It is most commonly found on steep rocky ridges and canyon slopes from Oregon through California into Arizona.

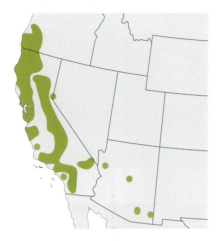

DESCRIPTION. A highly variable evergreen tree growing 16–98 ft (5–30 m) tall with a short, often crooked trunk and spreading branches. Habit varies with soil depth and water availability. Twigs are densely pubescent when young, becoming smooth as they mature. Bark is thin, with a smooth or flaky texture, becoming deeply furrowed with age. Leaves are simple, alternate, thick, oblong, bright green above, pubescent or glabrous below, margins often spiny in young trees to smooth in older trees (both types may be present on same individual), 0.5–4 in (1.3–10 cm) long. Trees are monoecious producing male and female flowers on the same plant, blooming from March to May. Male flowers are borne in catkins, 2–4 in (5–10 cm) long; female flowers are borne in spikes or singly along with new growth. Fruits are acorns, ellipsoidal, 1–3 in (2.5–7.5 cm) long, occur in clusters of two to five, with flat bottomed cup covered in golden warty scales enclosing one-quarter of nut.

USES AND VALUE. Wood not commercially important. Used historically for tool handles, boat building, fuelwood, and veneer. Acorns, after leaching tannins and roasting, used as staple food by Native North Americans. Acorns also used as coffee substitute. Galls produced on trees are strongly astringent and used to treat hemorrhages, chronic diarrhea, and dysentery. Fruits consumed by variety of wildlife, including acorn woodpecker, California ground squirrel, dusky-footed wood rat, western harvest mouse, and black-tailed deer. Provide habitat for perching and nesting birds, and shade and cover for diverse mammals, including mountain lion. Leaves browsed by black-tailed jack rabbit, beaver, bush rabbit, red-backed vole, Sonoma chipmunk, cactus mouse, deer mouse, and porcupine.

ECOLOGY. Inhabits coastal mountains of southwestern Oregon south through California and into northern Baja California, and Arizona. Grows from canyon bottoms to ridgetops, typically in cool and moist micro sites, including riparian zones and ravines. Tolerates wide variety of soils, growing best in the deep rich soils of canyon bottoms. Shade tolerant. Good seed crops produced every two to four years; small rodents serve as primary dispersal agent. Susceptible to fire but sprouts prolifically afterwards. Some insect and fungal pests, but none with serious impact.

CLIMATE CHANGE. Vulnerability is currently considered to be low.

CONSERVATION STATUS. Least concern.

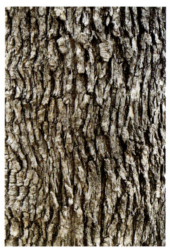

bark

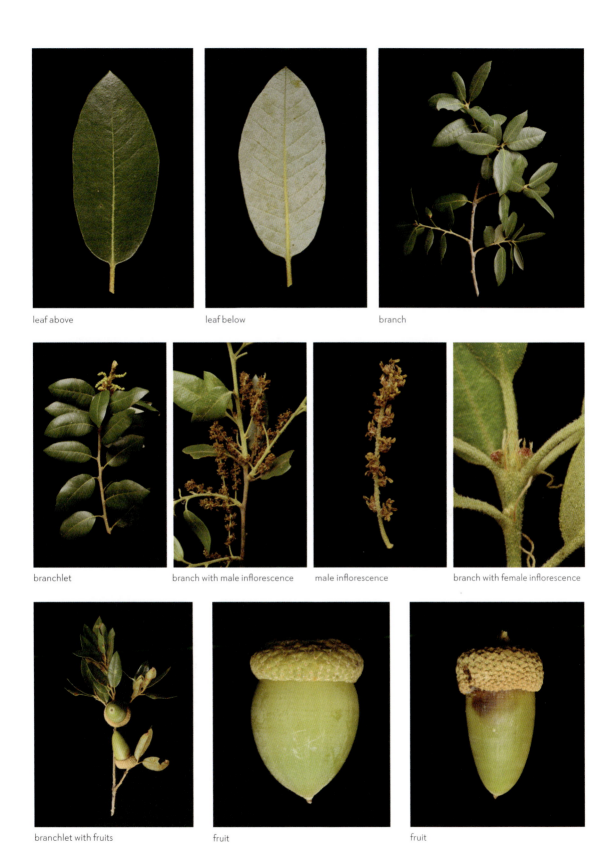

FAMILY FAGACEAE • 527

Scarlet Oak
Quercus coccinea Münchh.

Scarlet oak, a medium-sized deciduous tree with an open rounded crown, is native to the eastern United States and grows mostly on dry sandy soils. The glossy green, deeply lobed leaves turn shades of scarlet red in autumn.

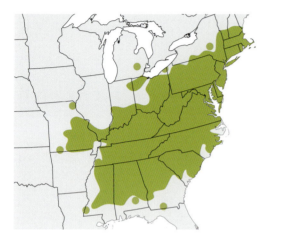

DESCRIPTION. A long-lived deciduous tree growing to 82 ft (25 m), usually with many dead branches. Twigs are smooth and reddish brown. Bark is grayish to light brown. Leaves are alternate, simple, oval with deep five to nine pinnate lobes that are bristle-tipped, glossy green above, pale yellow green below, bases cuneate to truncate, 0.3–0.8 in (0.7–2) cm long, 0.2–0.4 in (0.6–1 cm) wide. Trees are monoecious producing male and female flowers on the same plant, blooming in mid-spring. Male flowers are borne in catkins, bright red before anthesis, 2.8–4 in (7–10 cm) long; female flowers are red on short spikes. Fruits are shiny brown acorns, ovoid to subglobose, 0.47–0.79 in (12–20 mm) long, 0.31–0.63 in (8–16 mm) wide, cup with tight, glossy, reddish scales, 0.6–0.9 in (1.5–2.2 cm) wide.

USES AND VALUE. Wood commercially important. Marketed with other red oaks and used for cabinetry, furniture, interior trim, flooring, and veneer. Widely cultivated as an ornamental due to brilliant scarlet foliage in fall. Acorns are edible after tannins leached out and roasted; also used as a substitute for coffee. Galls produced on trees are strongly astringent and used in treatment of hemorrhages, chronic diarrhea, and dysentery. Acorns are choice food of eastern gray squirrels, chipmunks, mice, wild turkey, deer, and many birds, including blue jays and red-headed woodpeckers.

ECOLOGY. Grows on dry soils forming almost pure stands east of the Appalachian Mountains. Shade intolerant. Good seed crops produced every three to five years; primary dispersal agent is small rodents. More than 80 percent of mature acorns may be damaged by insects, including nut weevils (*Curculio* spp.), moth larvae, and cynipid gall wasps (Cynipidae). Very susceptible to fire damage due to thin bark. Attacked by oak wilt (*Ceratocystis fagacearum*), cankers caused by *Strummella coryneoidea* and *Nectria* spp. Insect defoliators are oak leafshredder (*Croesia semipurpurana*), fall cankerworm (*Alsophila pometaria*), forest tent caterpillar (*Malacosoma disstria*), gypsy moth (*Lymantria dispar*), and orange-striped oakworm (*Anisota senatoria*).

CLIMATE CHANGE. Vulnerability is currently considered to be low.

CONSERVATION STATUS. Least concern.

bark

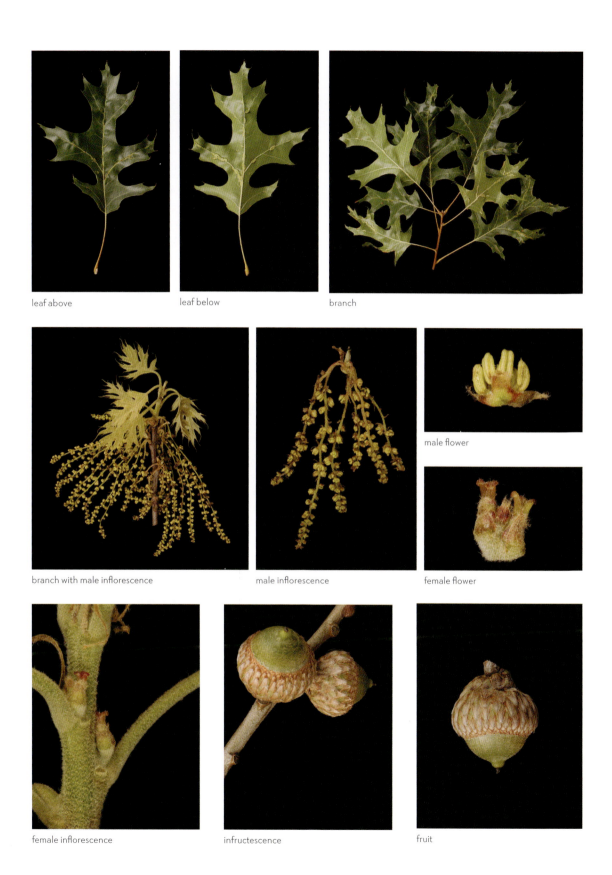

FAMILY FAGACEAE • 529

Blue Oak

Quercus douglasii Hook. & Arn.

Blue oak is a deciduous oak endemic to California that occurs on low-elevation slopes and foothills in Mediterranean climates. The distinctive blue green leaves have three to five shallow lobes.

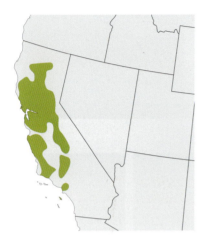

DESCRIPTION. A deciduous tree growing up to 66 ft (20 m) tall with a dense, round canopy supported by crooked branches. Twigs are stout, brittle, and gray to reddish brown in color. Bark is light gray and checkered. Leaves are simple, alternate, blue green with three to five shallow lobes, thick and waxy, margins wavy, spineless, 1–3.1 in (2.5–8 cm) long. Trees are monoecious producing male and female flowers on the same plant, blooming in spring. Male flowers are borne in pendulous, yellow-green catkins; female flowers are small, arranged in leaf axils on new growth. Fruits are oval to tapering acorns, 0.8–1.2 in (2–3 cm) long, with a shallow cap and warty scales.

USES AND VALUE. Wood not commercially important. Used locally for fuelwood and fence posts. Cultivated as landscaping ornamental. Acorns are edible once tannins are leached out and roasted. Native Americans ground and processed acorns into meal, wove branch sprouts into baskets, and used wood to make tools. Fruits also used as a substitute for coffee. Galls produced on trees are strongly astringent and employed to treat hemorrhages, chronic diarrhea, and dysentery. Acorns eaten by acorn woodpecker, scrub-jay, band-tailed pigeon, California quail, western gray squirrel, and California ground squirrel. Fresh and dead leaves are browsed by deer, cattle, sheep, and hogs.

ECOLOGY. Grows on low-elevation slopes and foothills in Mediterranean climates on the West Coast of North America. Typically restricted to dry sites on shallow, infertile, and excessively well drained soils. Shade intolerant. Good seed crops produced every two to three years, with bumper crops every five to eight years; primary dispersal agent is small rodents. Susceptible to damage by fire due to thin bark. Attacked by wide range of fungal pests: trunk-rot fungus (*Inonotus dryophilus*), sulphur conk (*Laetiporus sulphureus*), hedgehog fungus (*Hydnum erinaceum*), and artist's fungus (*Ganoderma applanatum*). More than forty species of cynipid wasps form galls throughout tree on roots, catkins, buds, acorns, stems, and leaves.

CLIMATE CHANGE. Vulnerability is currently considered to be low.

CONSERVATION STATUS. Least concern.

bark

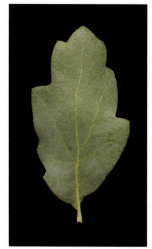 leaf above
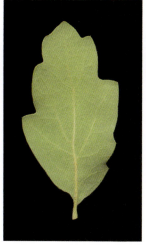 leaf below
 branch

 branchlet with male inflorescence
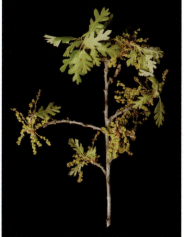 branch with male inflorescence
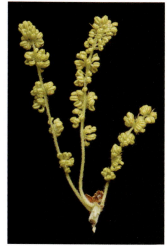 male inflorescence

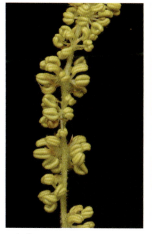 male flowers
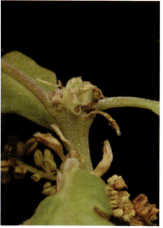 female flower
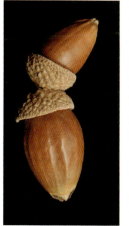 infructescence
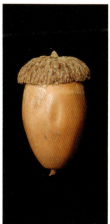 fruit

FAMILY FAGACEAE • 531

Northern Pin Oak

Quercus ellipsoidalis E. J. Hill

Northern pin oak is a medium-sized tree native to the sandy and dry upland sites in the Great Lakes region. Marketed with other red oaks, wood is used for furniture, flooring, and interior finish.

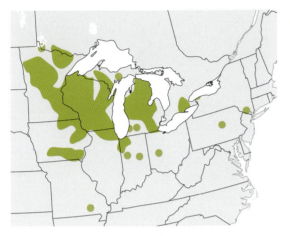

DESCRIPTION. A deciduous tree that grows to 69 ft (21 m) tall with short trunk, irregularly shaped crown and low hanging branches. Twigs are dark reddish brown and glabrous. Terminal buds are dark reddish brown, ovoid, and silvery pubescent. Bark is dark gray brown and shallowly fissured with an orangish inner bark. Leaves are deciduous, simple, alternate, elliptic-obovate to elliptic-oblong, bright green above with tufts of hairs in vein axils below, turning brilliant red in fall, five to seven bristled lobes, 3.1–4.7 in (8–12 cm) long, 2.4–5.9 in (6–15 cm) wide, apex acute, base truncate, petiole 0.8–2 in (2–5 cm) long and glabrous. Trees are monoecious producing male and female flowers on the same plant, blooming from March to May. Male flowers are yellow-green, borne in catkins; female flowers are solitary or borne in groups of two to three. Fruits are acorns, ellipsoid to ovoid, 0.5–0.8 in (1.2–2 cm) long, with shallow to deep cup covered in hairy scales enclosing one-third to one-half of nut.

USES AND VALUE. Wood commercially important. Marketed with other red oak species and used for furniture, flooring, and interior finish; used locally for fuel, fence posts, and construction lumber. Cultivated as popular ornamental for brilliant colorful foliage in fall. Acorns are edible once tannins have been leached and roasted; also used as a substitute for coffee. Galls produced on trees are strongly astringent and used to treat hemorrhages, chronic diarrhea, and dysentery. Acorns provide food for variety of wildlife, including gray squirrels, white-tailed deer, and blue jays. Wood ducks and eastern kingbirds utilize trunk cavities as nesting sites; threatened Kirtland's warbler makes nests below.

ECOLOGY. Commonly grows in central upland deciduous forests in xeric habitats with dry sandy soils with little organic content. Forms dense stands on sandy plains and hills. Shade intolerant; very drought tolerant. Good annual seed crops seldom produced with many acorns destroyed by weevils; dispersal by squirrels, blue jays, and gravity. Susceptible to oak wilt caused by fungus (*Ceratocystis fagacearum*), which is spread through root grafts and sap-feeding beetles (family Nitidulidae).

CLIMATE CHANGE. Vulnerability is significant but has reasonable probability of persistence in the future. Ongoing monitoring is recommended.

CONSERVATION STATUS. Least concern.

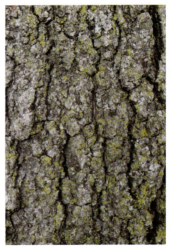

bark

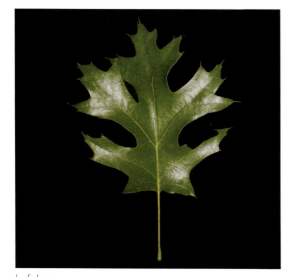
leaf above

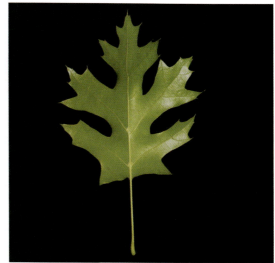
leaf below

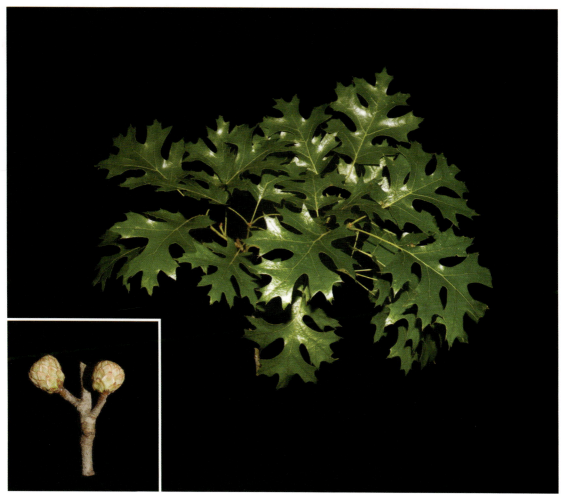
branch, young fruit (inset)

FAMILY FAGACEAE • 533

Emory Oak

Quercus emoryi Torr.

Emory oak is a shrub or small tree native to the southwestern United States that grows in arid to semiarid climates in canyons at the upper edges of deserts or desert grasslands.

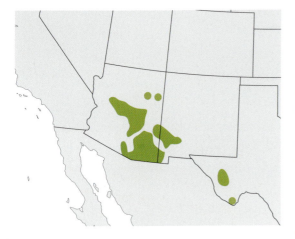

DESCRIPTION. A shrub or small tree growing up to 66 ft (20 m) tall characterized by a short trunk, a rounded crown, and short limbs but often much smaller and bushier due to browsing by livestock. Twigs are fuzzy and yellow brown in color, with long pointed buds that are pubescent, becoming more so toward the twig apex. Bark is dark gray to black and splits into irregular furrows and scales with age. Leaves are drought deciduous, simple, alternate, narrow ovate or lance shaped, stiff and leathery, yellow green, veins are sunken above and raised below, 0.8–2.4 in (2–6 cm) long, margins entire or toothed. Trees are monoecious producing male and female flowers on the same plant, blooming from March to May. Male flowers are arranged in drooping, yellow-green catkins; female flowers are in small clusters in leaf axils. Fruits are bowl shaped acorns, 0.4–0.8 in (1–2 cm) long, with thick scaly cup enclosing one-quarter to one-half of nut.

USES AND VALUE. Wood not commercially important. Used locally for fuel and occasionally furniture. Raw acorns are sweet, edible, and gathered for commercial markets. Galls produced on trees are strongly astringent and used to treat hemorrhages, chronic diarrhea, dysentery. Acorns are valuable food for cattle and other livestock, mule and white-tailed deer, small mammals, collared peccary, wild turkey, band-tailed pigeon, and other birds; used extensively by migratory birds during breeding season. Provides cover for diverse amphibians, reptiles, black bear, white-tailed deer, antelope squirrel, mice, gray fox, and raccoon in woodland communities. Leaves are browsed by pronghorn, white-tailed deer, and mule deer.

ECOLOGY. Grows in arid to semiarid climates in canyons at upper edge of deserts and desert grasslands or on small hills at moderate altitudes in Texas, New Mexico, and Arizona. Occurs in many communities along diverse elevation and moisture gradients, such as pine-oak, pinyon-juniper, Madrean evergreen, and open oak woodlands; also in chaparral and riparian areas. Found most often on shallow soil along drainages with gravelly sandy loams. Intermediate in shade tolerance. Acorn production highly variable; jays and rodents are important dispersal agents. Resists damage from pests and diseases; susceptible to wood-decay fungus (*Inonotus andersonii*).

CLIMATE CHANGE. Vulnerability is significant but has reasonable probability of persistence in the future. Ongoing monitoring is recommended.

CONSERVATION STATUS. Least concern.

bark

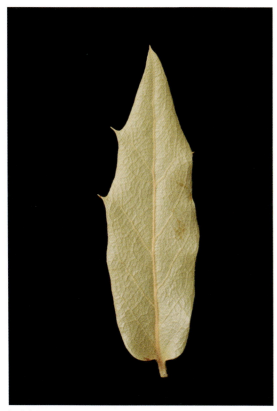
leaf above

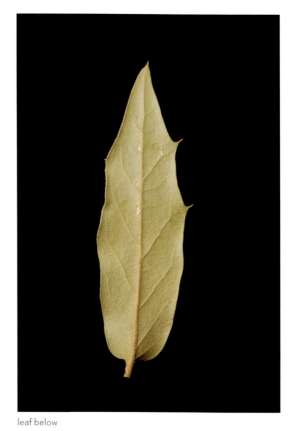
leaf below

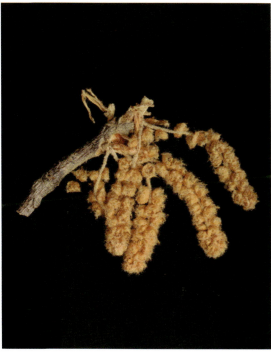
male inflorescence

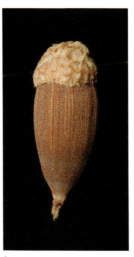
fruit

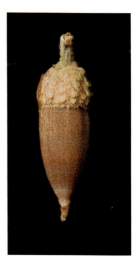
fruit

FAMILY FAGACEAE • 535

Southern Red Oak
Quercus falcata Michx.
SPANISH OAK

Southern red oak is a medium-sized tree native to the southeastern United States. The rounded leaf bases give the leaves a distinctive shape resembling an inverted bell or turkey's foot. It grows in dry, sandy, upland forests.

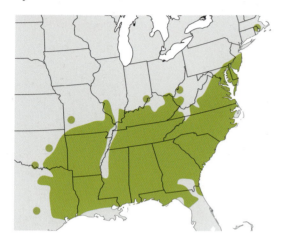

DESCRIPTION. A long-lived deciduous tree growing to 98 ft (30 m) tall with a deep root system, short, limb-free trunk, and extensive round crown. Twigs are reddish brown or gray. Bark is darker and shallowly fissured on large trees. Leaves are alternate, simple, obovate, shiny green above, pale below, with three lobes and shallow sinuses on young trees and five to seven lobes with deeper sinuses on older trees, 0.4–1 in (1–2.5 cm) long, 3.1–4.7 in (8–12 cm) wide. Trees are monoecious producing male and female flowers on the same plant, blooming in mid-spring. Male flowers are arranged in yellowish green catkins with a red tinge, hairy, 2.8–4.7 in (7–12 cm) long; female flowers are reddish, on short peduncles. Fruits are nearly round, orange-brown acorns, 0.4–0.6 in (1–1.5 cm) long, cup grayish-brown, hairy with funnel-shaped base.

USES AND VALUE. Wood moderately commercially important. Used mainly for factory lumber, railroad ties, and timbers. Cultivated as a shade tree. Acorns are edible after tannins leached out and roasted; also used as a substitute for coffee. Bark is used as antiseptic, astringent, febrifuge, and tonic; as infusion used to treat chronic dysentery, indigestion, asthma, lost voice, and intermittent fevers. Galls produced on trees are strongly astringent and used to treat hemorrhages, chronic diarrhea, and dysentery. Crown provides cover and nesting sites for birds and mammals; acorns are important food for waterfowl, wild turkey, blue jay, red-headed and red-bellied woodpeckers, white-breasted nuthatch, common grackle, raccoon, white-tailed deer, and squirrels.

ECOLOGY. Grows primarily in dry uplands and sometimes fertile mesic valleys. Intermediate in shade tolerance. Good seed crops produced every one to two years; squirrels and blue jays serve as primary dispersal agents. Highly susceptible to oak wilt (*Ceratocystis fagacearum*) and several fungal species (*Hypoxylon*). Susceptible to fire damage due to thin bark.

CLIMATE CHANGE. Vulnerability is currently considered to be low.

CONSERVATION STATUS. Least concern.

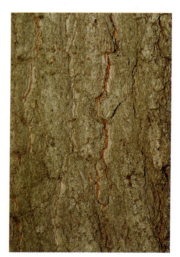

bark

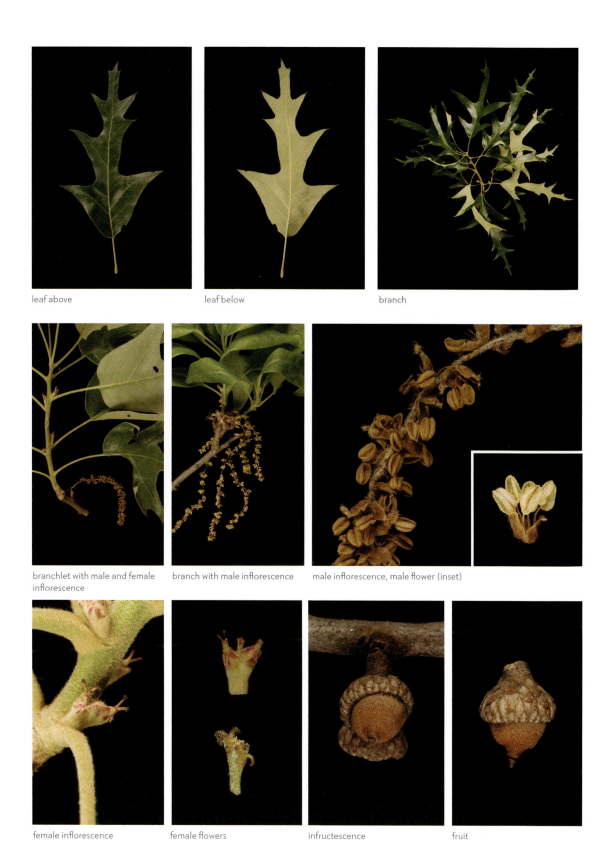

Gambel Oak

Quercus gambelii Nutt.

Gambel oak is a small to medium-sized deciduous tree that occurs in the western United States in dry high-elevation hills, slopes, and canyons. The only oak in the Rocky Mountains, it sometimes forms shrubby thickets.

DESCRIPTION. A small to medium-sized deciduous small tree with short trunk or thicket-forming shrub. Twigs are stout, reddish brown, and sparsely pubescent when young becoming dark and smooth when older. Terminal buds are clustered and have overlapping scales. Bark is thin and light brown, becoming darker and furrowed into irregular ridges with age. Leaves are deciduous, simple, alternate, deeply lobed, with five to nine lobes, green to yellow green, leathery, pubescent below, 2–5.1 in (5–13 cm) long. Trees are monoecious producing male and female flowers on the same plant, blooming from March to May. Male flowers are borne in catkins, 0.8 in (2 cm) long; female flowers are in small clusters in leaf axils. Fruits are acorns, arranged singly or in clusters, 0.8 in (2 cm) long, with a rounded shallow cup enclosing one-third of nut.

USES AND VALUE. Wood not commercially important. Used locally for fuel. Acorns are an important source of food for Native North Americans. Provides browse for large mammals; habitats for rabbits and rodents. Acorns are consumed by Albert's squirrels, band-tailed pigeons, Merriam's wild turkeys, elk, and deer. Dead crowns and hollow trunks are nesting sites for small mammals and birds.

ECOLOGY. Grows in dry high-elevation hills, slopes, and canyons on a variety of dry, rocky, and calcareous soils. Intermediate in shade tolerance, and drought resistant. Fire-adapted, sprouting readily after fire. Reproduces from seed and through vegetative propagation. Seed dispersal is by birds and small mammals. Attacked by wood-decay fungus (*Inonotus andersonii*), but not a major threat.

CLIMATE CHANGE. Vulnerability is currently considered to be low.

CONSERVATION STATUS. Least concern.

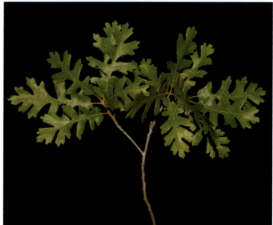

branch

bark

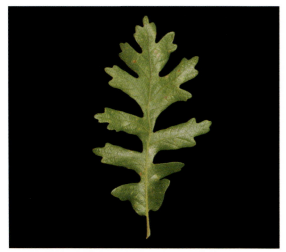
leaf above

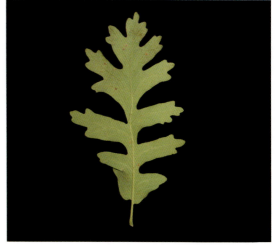
leaf below

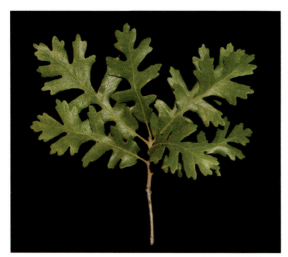
branchlet above

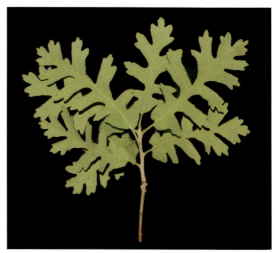
branchlet below

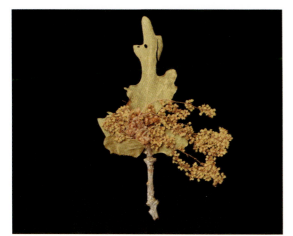
branchlet with male inflorescence

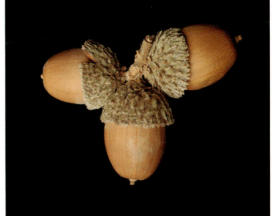
infructescence

FAMILY FAGACEAE • 539

Oregon White Oak

Quercus garryana Douglas ex Hook.

Oregon white oak is tree or shrub native to the inland mixed evergreen and coniferous forests of the Pacific Coast. Three varieties are recognized.

DESCRIPTION. A single- or multistemmed tree or shrub 10–66 ft (3–20 m) tall with short trunk and broad-spreading crown when growing in open or long clear trunk with dense crown in forest conditions. Twigs are brown, red, or yellowish and densely pubescent. Buds are brown or yellowish and ovoid or fusiform, with acute apex. Bark is scaly and light gray or almost white. Leaves are deciduous, simple, alternate, obovate or elliptic, moderately to deeply lobed with five to nine lobes, dark green, pubescent below, base cuneate, apex broadly rounded, 2–5.9 in (5–15 cm) long, 0.8–3.1 in (2–8 cm) wide. Trees are monoecious producing male and female flowers on the same plant, blooming from March to May. Male flowers are arranged in catkins, pale yellow, 1.2–4 in (3–10 cm) long; female flowers are in small clusters, deep red, covered in whitish hairs, 0.8 in (2 cm) long. Fruits are acorns, oblong to globose, light brown, 0.8–1.2 in (2–3 cm) long, with a saucer-shaped cup that has yellowish or reddish-brown scales enclosing one-quarter to one-third of nut.

TAXONOMIC NOTES. Variety *garryana* grows to 49 ft (15 m) tall and is single-trunked with twigs covered by spreading hairs; var. *breweri* is a shrub less than 16 ft (5 m) tall with glabrous twigs and leaf blades velvety below; var. *semota* is a shrub less than 16 ft (5 m) tall with glabrous twigs and leaf blades not velvety below.

USES AND VALUE. Wood not commercially important. Used for furniture, cooperage staves, cabinet stock, insulator pins, woodenware, novelties, baskets, handle stock, felling wedges, agricultural implements, vehicles, and ship construction. Highly prized for fuel because of high density. Sometimes cultivated as a landscape ornamental. Host of gourmet truffles (*Tuber melanosporum*). Acorns an important source of food for Native North Americans. Used by wildlife for cover, perching, nest material, and source of food. Young leaves and raw acorns poisonous to humans and cattle.

ECOLOGY. Grows on slopes in mixed evergreen and coniferous forests on dry to poorly draining, gravelly and clay soils. Acorn production variable; principal dispersal agents are gravity, small rodents, and birds. Intermediate in shade tolerance. Windfirm and resistant to fire. Attacked by numerous fungal and insect pests, but none is damaging.

CLIMATE CHANGE. Vulnerability is currently considered to be low.

CONSERVATION STATUS. Least concern.

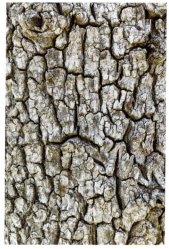

bark

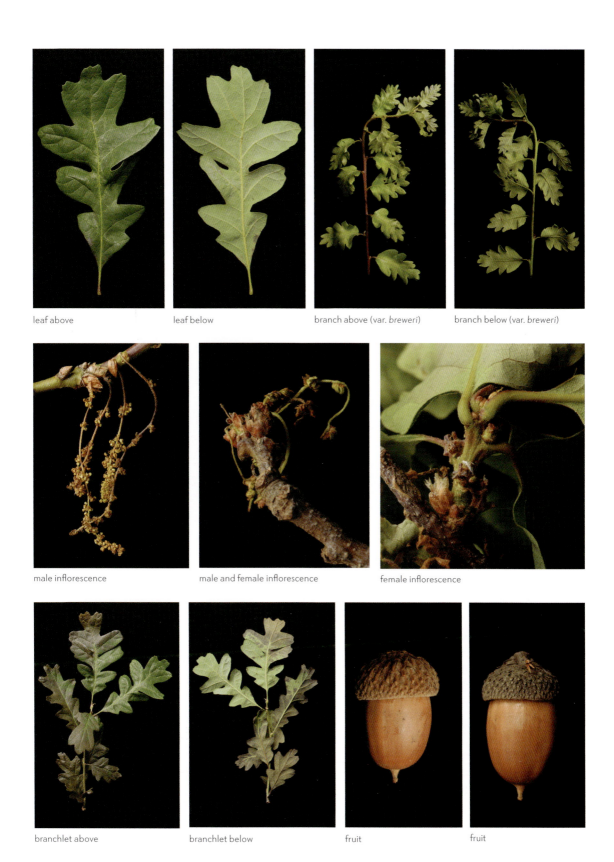

FAMILY FAGACEAE • 541

Sand Live Oak
Quercus geminata Small

Sand live oak is an evergreen or subevergreen tree native to the southeastern United States, where it grows on coastal plains from Louisiana to North Carolina. The leaves with deeply revolute margins are characteristic.

DESCRIPTION. An evergreen or subevergreen tree growing up to 65 ft (20 m) tall with a single, erect trunk and spreading crown. Twigs are yellow when young and become light gray and tomentose in second year. Buds are ruddy, ovoid with glabrous scale margins. Bark is dark brown or black, scaly. Leaves are simple, alternate, narrowly lanceolate to elliptic, deep green above, white or glaucous below with fused-appressed stellate hairs, margins entire and strongly revolute, 0.8–4.8 in (2–12 cm) long. Trees are monoecious producing male and female flowers on the same plant, blooming is from March to May. Male flowers are borne in catkins, 0.8 in (2 cm) long; female flowers in small clusters in leaf axils. Fruits are acorns, dark brown, barrel-shaped, 0.6–1.0 in (1.6–2.5 cm) long, borne in clusters of one to three on peduncle 0.4–3.94 in (1–10 cm) long, with goblet-shaped cup, scales whitish or grayish.

USES AND VALUE. Wood not commercially important. Sometimes planted as landscape ornamental. Provides food and cover for threatened Florida scrub-jay, wild turkey woodpeckers, deer, squirrels, and other small mammals. Larval host for oak hairstreak (*Fixsenia favonius*), Horace's dusky-wing (*Erynnis horatius*), red-banded hairstreak (*Calycopis cecrops*), and white-M hairstreak (*Parrhasius m-album*) butterflies.

ECOLOGY. Grows on coastal plains of southeastern United States on deep sandy soils in mixed pine or hardwood stands. Drought tolerant, wind resistant, and sprouts readily after fire.

CLIMATE CHANGE. Vulnerability is currently unknown. Immediate assessment is recommended.

CONSERVATION STATUS. Least concern.

fruit

bark

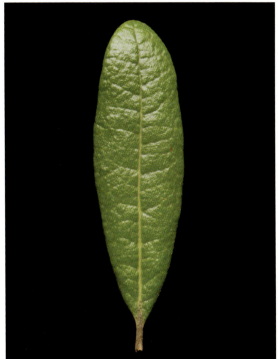
leaf above

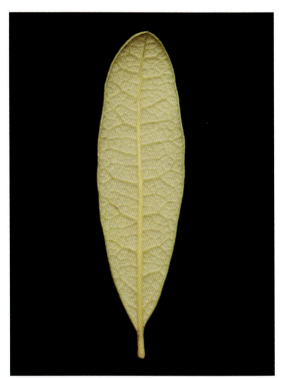
leaf below

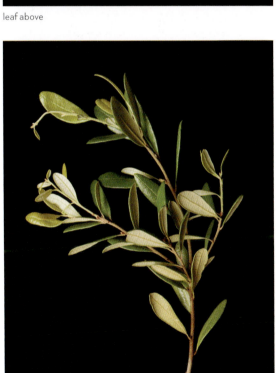
branch above

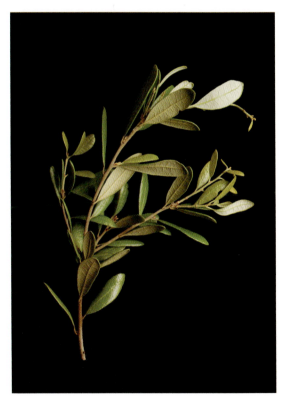
branch below

FAMILY FAGACEAE • 543

Gray Oak
Quercus grisea Liebm.

Gray oak is a deciduous or subevergreen tree native to the southwestern United States, where it grows in drainages, arroyos, rocky slopes, foothills, and riparian zones of semiarid climates.

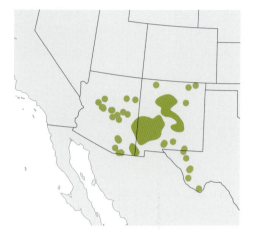

DESCRIPTION. A deciduous or subevergreen tree growing up to 33 ft (10 m), with branching trunk and dense crown, often displaying a low, shrubby growth form. Bark is gray and fissured into loose plates. Leaves are simple, alternate, oblong to elliptic, thick and leathery, gray green above, minutely stellate pubescent below, 0.98–1.38 in (25–35 mm) long, margins entire or dentate, minutely revolute. Trees are monoecious producing male and female flowers on the same plant, blooming from March to May. Male flowers are borne in long, drooping, yellow-green catkins; female flowers are clustered in small spikes in leaf axils. Fruits are acorns, solitary or paired, 0.5–0.7 in (1.2–1.8 cm) in diameter, subsessile or on peduncle, 0.12 in (3 mm) long, with goblet-shaped cup, scales densely felty enclosing one-third to one-half of nut.

USES AND VALUE. Wood not commercially important. Used locally for fuel and fence posts. Rarely grazed by livestock; provides valuable browse for pronghorn, elk, white-tailed deer, and mule deer. Squirrels, rodents, Arizona porcupine, Merriam's wild turkeys, thick-billed parrots, band-tailed pigeons, and other birds consume the acorns. Shrubby form provides good cover for jack rabbits, cottontails, encinal mice, gray fox, and raccoon.

ECOLOGY. Grows in drainages, arroyos, rocky slopes, foothills, and riparian zones in semiarid climates on shallow rocky soils with textures ranging from clays to sandy loam. Acorns produced annually; dispersal is primarily by gravity, but sometimes by birds and small mammals. Shade tolerance variable.

CLIMATE CHANGE. Vulnerability is significant but may have capacity to adapt to changing conditions in the future. Ongoing monitoring is recommended.

CONSERVATION STATUS. Least concern.

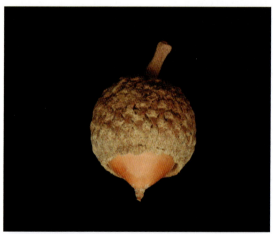

fruit

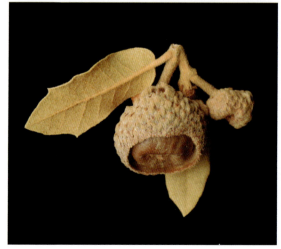

branchlet with infructescence

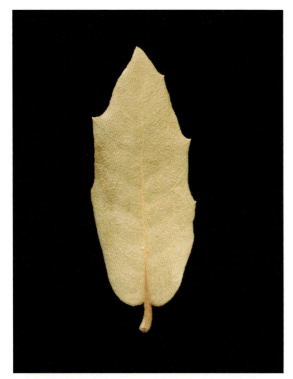
leaf above

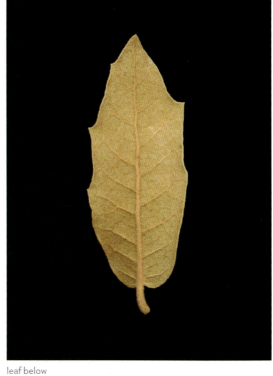
leaf below

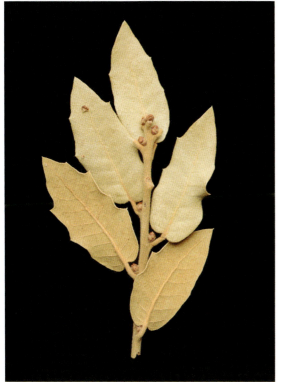
branchlet above

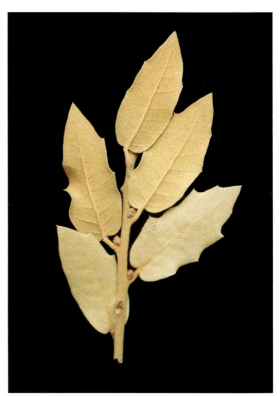
branchlet below

FAMILY FAGACEAE • 545

Silverleaf Oak

Quercus hypoleucoides A. Camus

Silverleaf oak is an evergreen tree or shrub native to the southwestern United States, where it grows in moist canyons and on ridges in woodlands with other evergreen oaks.

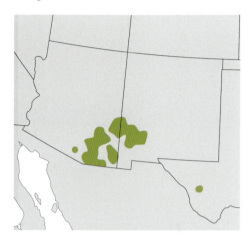

DESCRIPTION. A native evergreen rounded shrub or tree growing to 60 ft (20 m) tall with single trunk and variable dense crown. Twigs are gray with stellate pubescence when young. Buds are dark ruddy brown and ovoid, with stellate hairs casting yellowish hue. Bark is dark brown and deeply furrowed. Leaves are simple, alternate, evergreen, ovate or elliptic, thick, leathery, dark green and glabrous above, densely tawny or white tomentose below, 1.77–4.72 in (45–120 mm) long, margins entire or spinose, strongly revolute, petioles densely pubescent. Trees are monoecious producing male and female flowers on the same plant, blooming from March to May. Male flowers are borne in long, drooping, yellow-green catkins; female flowers are clustered in very small spikes in leaf axils. Fruits are ellipsoid or oblong acorns, glabrous, 0.31–0.63 in (8–16 mm) long, cup saucer shaped, scales gray brown, pubescent, enclosing one-third of nut.

USES AND VALUE. Wood not commercially important. Cultivated as landscape ornamental. Acorns are edible after tannins leached and roasted. Squirrels and birds eat acorns; canopies provide cover for birds and small mammals.

ECOLOGY. Grows in moist canyons and on ridges between 4,921 and 8,858 ft (1,500–2,700 m) of elevation in woodlands with other evergreen oaks on well-drained acidic or neutral soils. Extremely drought tolerant; cold tolerant; and sprouts vigorously after fire.

CLIMATE CHANGE. Vulnerability is currently considered to be low.

CONSERVATION STATUS. Least concern.

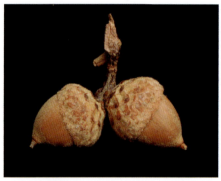

infructescence

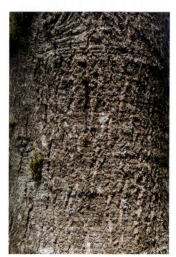

bark

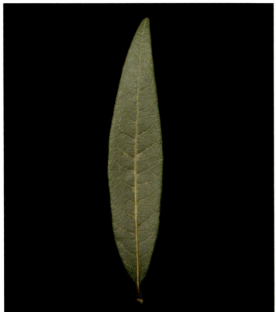
leaf above

leaf below

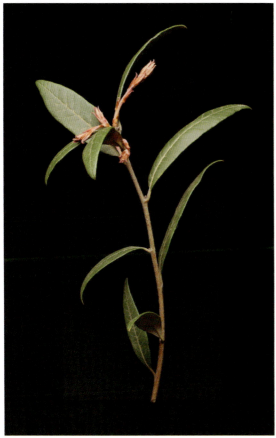
branch above

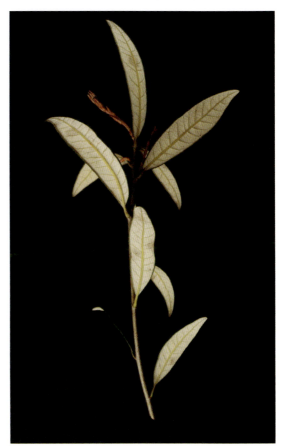
branch below

FAMILY FAGACEAE • 547

Shingle Oak
Quercus imbricaria Michx.

Native to North America, shingle oak is a medium-sized tree distinguished from other oaks by its laurel-shaped leaves that are hairy below. The Latin name, *imbricaria*, means "overlapping" and refers to the use of the wood for making shingles.

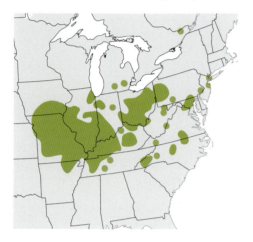

DESCRIPTION. A moderate-lived deciduous tree growing to 60 ft (18 m) tall with a tall trunk and symmetrical crown of spreading branches. Leaves are alternate, simple, entire, lanceolate or elliptic, unlobed, leathery and glossy dark green above, paler and pubescent below, with a single terminal bristle-tip, 3.9–5.9 in (10–15 cm) long, 0.8–2.4 in (2–6 cm) wide. Trees are monoecious producing male and female flowers on the same plant, blooming in mid- to late spring. Male flowers are yellowish brown, arranged in catkins; female flowers are tiny, clustered in short spikes. Fruits are ovoid to globose, dark brown acorns, 0.47–0.71 in (12–18 mm) long, with cup moderately shallow, scales reddish-brown, finely hairy, enclosing one-third of nut.

USES AND VALUE. Wood is commercially important. Used for beams, boards, railroad ties, and furniture; historically used for shingles; locally used for fuelwood. Cultivated as ornamental shade tree. Acorns are important food source for large birds, deer, squirrels, and small mammals.

ECOLOGY. Grows on dry to moist slopes, along streambanks and in bottomlands.

CLIMATE CHANGE. Vulnerability is significant but has reasonable probability of persistence in the future. Ongoing monitoring is recommended.

CONSERVATION STATUS. Least concern.

bark

leaf above	leaf below	branch
branch with male inflorescence	male inflorescence	female inflorescence
branchlet with infructescence	infructescence	fruit

FAMILY FAGACEAE • 549

Bluejack Oak
Quercus incana W. Bartram

Bluejack oak is a small tree or thicket-forming shrub with irregular and often numerous dead branches. It grows on well-drained sandy soils of the Atlantic and Gulf coastal plains in upland barrens and ridges as well as shaded woods.

DESCRIPTION. A small tree or thicket-forming shrub that grows up to 33 ft (10 m) tall with a short stem, stout and crooked limbs, and an open and irregular crown, often with numerous dead branches. Twigs are slender, light brown, pubescent, becoming glabrous and darker with age. Buds are sharp, ruddy brown, and clustered at the branch apex. Bark is dark gray or nearly black, becoming blocky or rough with age. Leaves are simple, alternate, narrowly elliptic with the broadest point above the middle, margins entire, apex bristle-tipped, blue green above, bluish gray and pubescent below, 1.2–2.8 in (3–7 cm) long. Trees are monoecious producing male and female flowers on the same plant, blooming from March to May. Male flowers are borne in yellow-green catkins, 1.6–2.8 in (4–7 cm) long; female flowers are clustered in leaf axils. Fruits are acorns, round, 0.4 in (1 cm) in diameter with brown, shallow cup, enclosing one-quarter of nut.

USES AND VALUE. Wood not commercially important. Used locally for fuelwood and fence posts. Occasionally cultivated as ornamental. Acorns are consumed by fox squirrels, rare Sherman's fox squirrel, white-tailed deer, wild turkey, and quail. Thickets provide brushy cover for birds in oak pine communities.

ECOLOGY. Grows on well-drained sandy soils of the Atlantic and Gulf coastal plains of the southeastern United States in upland barrens and ridges as well as shaded woods. Sometimes found on xeric sites with dry sandy loams. Intermediate in shade tolerance. Reproduces both by seed and shoot sprouting. Good seed crops produced annually. Fire adapted.

CLIMATE CHANGE. Vulnerability is significant but may have the capacity to adapt to changing conditions in the future. Ongoing monitoring is recommended.

CONSERVATION STATUS. Least concern.

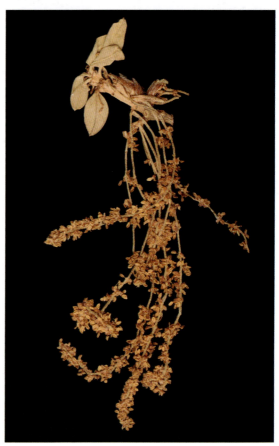

male inflorescence

leaf above

leaf below

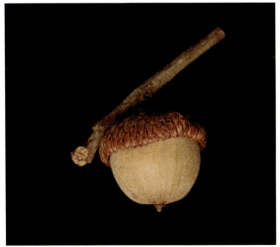
fruit

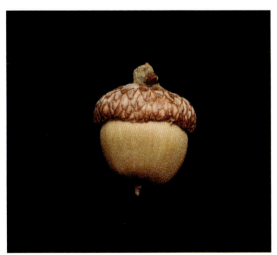
fruit

FAMILY FAGACEAE • 551

California Black Oak
Quercus kelloggii Newberry

California black oak is a broad-leaved deciduous tree with an open rounded crown found in the coastal ranges and Sierra Nevada regions in California and Oregon.

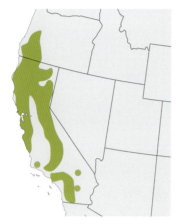

DESCRIPTION. A broad-leaved deciduous medium sized tree growing to 80 ft (27 m) with an open rounded crown. Twigs are ruddy brown, ridged, smooth or minutely pubescent. Terminal buds are large, pointed, and clustered at the twig apex. Bark is initially smooth or dark gray, maturing into dark brown with irregularly plated ridges. Leaves are deciduous, alternate, simple with seven to nine lobes, each lobe three-toothed with bristle-tip, dark green above, paler below, sometimes pubescent, 1.6–3.5 in (4–9 cm) long. Trees are monoecious producing male and female flowers on the same plant, blooming from May to June appearing with leaves. Male flowers are borne in large drooping, yellow-green catkins; female flowers are clustered in spikes in leaf axils. Fruits are acorns, 1.2–1.8 in (3–4.5 cm) long, with light brown cup, covered in thin scales, enclosing one-half of nut, mature in two seasons.

USES AND VALUE. Wood commercially important locally. Used for high-grade lumber and pallets, industrial timbers, sawdust for mulching, and fuelwood. Cavities in trees provide dens and nest sites for owls, woodpeckers, squirrels, and American black bears; crowns provide valuable shade for livestock and wildlife during summers; leaves and bark browsed by mule deer and livestock; acorns are consumed by livestock, mule deer, feral pigs, rodents, mountain quail, Steller's jay, and woodpeckers. Associated with acorn woodpecker, Bullock's oriole, and Nashville warbler. Pests include common parasitic plant Pacific mistletoe (*Phoradendron villosum*).

ECOLOGY. Grows in the coastal ranges and Sierra Nevada regions from southern California to Oregon in mixed woodlands on slopes and valleys in well-drained soils. Shade intolerant. Seeds produced every year in varying quantities; dispersal by gravity, large birds, and small rodents, especially squirrels. Susceptible to fire damage. Prone to trunk rot caused by fungus (*Inonotus dryophilus* and *Laetiporus sulphureus*).

CLIMATE CHANGE. Vulnerability is currently considered to be low.

CONSERVATION STATUS. Least concern.

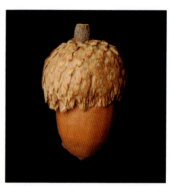
fruit

bark

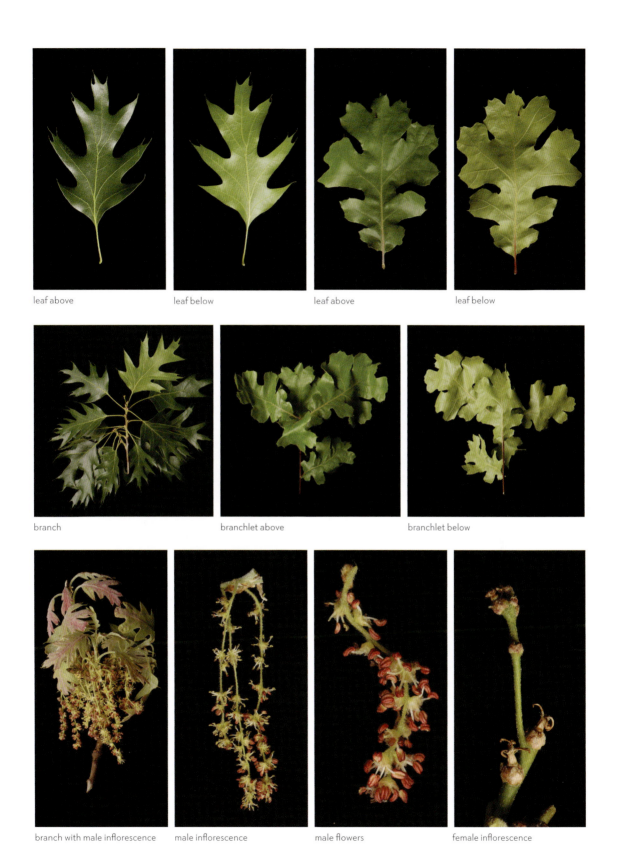

FAMILY FAGACEAE • 553

Turkey Oak
Quercus laevis Walter

Turkey oak is a small deciduous tree or shrub native to the sand hills of southeastern United States. It is fire adapted with an irregular crown and deeply lobed leaves that resemble the footprint of a turkey.

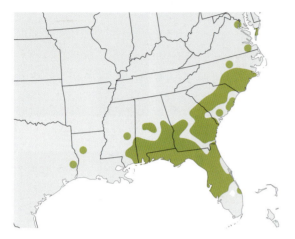

DESCRIPTION. A small deciduous tree or shrub that grows 20–49 ft (6–15 m) tall with a single trunk and irregular crown with crooked branches. Twigs are stout and gray to reddish brown, with large, pointed terminal buds reddish brown and pubescent. Bark is thick and rough, dark brown or black, with deep furrows and scaly ridges. Leaves are alternate, simple, with three to seven bristle-tipped deep lobes, yellow green above, with rusty pubescence below, 3.5–6.7 in (9–17 cm) long. Trees are monoecious producing male and female flowers on the same plant, blooming from March to May. Male flowers are borne in drooping, yellow-green catkins, 2.8–3.5 in (7–9 cm) long; female flowers are borne either singly or in pairs. Fruits are acorns, brown, 1 in (2.5 cm) long, with thin reddish-brown cup covered by pubescent scales, enclosing one-half of nut.

USES AND VALUE. Wood not commercially important. Used locally for fuel. Acorns are consumed in large quantities by mammals and birds, including black bear, white-tailed deer, fox squirrel, scrub-jay, northern bobwhite, and wild turkey. Provides good habitats for numerous reptiles and amphibians in coastal regions.

ECOLOGY. Grows on dry, sandy, and well-drained soils on ridges, sandhills, and hammocks with pines in the southeastern coastal plains. Shade intolerant. Seed crops produced annually; dispersed by gravity, birds, and mammals. Strongly fire adapted, but susceptible to oak wilt (*Ceratocystis fagacearum*).

CLIMATE CHANGE. Vulnerability is significant but may have the capacity to adapt to changing conditions in the future. Ongoing monitoring is recommended.

CONSERVATION STATUS. Least concern.

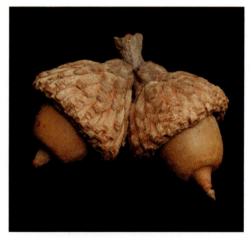
infructescence

bark

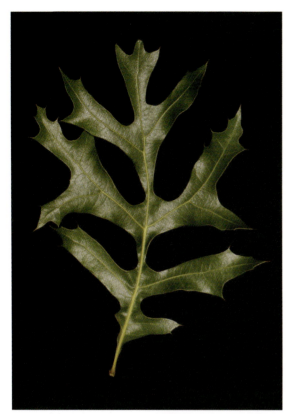
leaf above

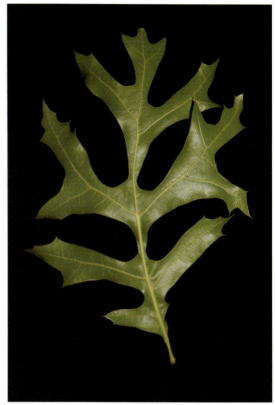
leaf below

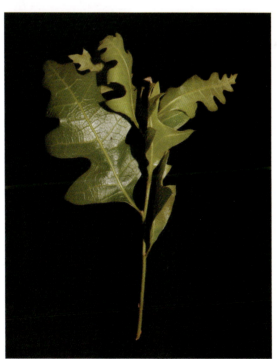
branch

FAMILY FAGACEAE • 555

Laurel Oak
Quercus laurifolia Michx.

Laurel oak is a semi-evergreen, medium sized tree with a straight trunk and rounded crown. Native to the southeastern United States, it grows on moist, well-drained, sandy soils in coastal floodplain forests.

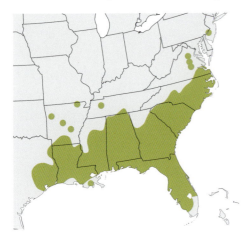

DESCRIPTION. A semi-evergreen tree that grows up to 148 ft (45 m) tall with a straight, often buttressed trunk and rounded crown. Twigs are light ruddy brown, glabrous with clustered ruddy-brown buds at the terminus. Bark is dark brown and smooth, becoming shallowly fissured and rough with age. Leaves are simple, alternate, elliptic, widest near the middle, thick, tapering to base, lustrous green above, paler below, glabrous, margins entire (occasionally with shallow lobes), persistent throughout the year, 2.8–4.3 in (7–11 cm) long. Trees are monoecious producing male and female flowers on the same plant, blooming from March to May. Male flowers are borne in drooping catkins, 1.6–2.8 in (4–7 cm) long; female flowers are arranged either singly or in pairs. Fruits are nearly round, striated, dark brown acorns, 0.4–0.8 in (1–2 cm) in diameter, with shallow cup covered in reddish-brown scales enclosing one-quarter of nut.

USES AND VALUE. Wood not commercially important. Used locally for pulp. Cultivated as an ornamental. Consistent and abundant acorn crops are important food for many animals, including white-tailed deer, raccoon, squirrels, wild turkey, ducks, quail, smaller birds, and rodents.

ECOLOGY. Grows from Texas to Florida and north to Virginia on moist, well-drained, sandy soils of coastal plains in typical mesic hardwoods. Shade tolerant. Seed crops prolific with good production most years; dispersal is mainly by squirrels, gravity and water. No serious fungal or insect pests; highly susceptible to fire.

CLIMATE CHANGE. Vulnerability is currently considered to be low.

CONSERVATION STATUS. Least concern.

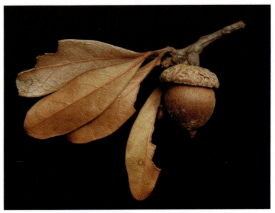

branchlet with fruit

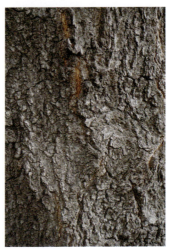

bark

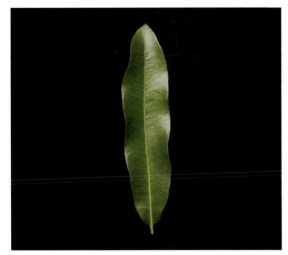
leaf above

leaf below

branchlet above

branchlet below

male inflorescence

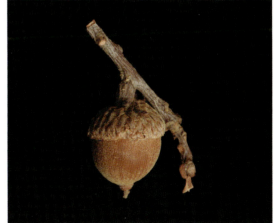
fruit

Valley Oak
Quercus lobata Née
CALIFORNIA WHITE OAK

Valley oak is a large deciduous long-lived tree with massive, often drooping limbs and a rounded spreading crown. This near-threatened species, native to California, is typically found on the deep rich soils of savannas and valley floors.

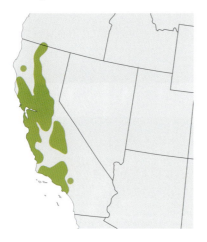

DESCRIPTION. A large deciduous tree 30–90 ft (10–30 m) tall, with massive limbs and a rounded spreading crown. Terminal branches are drooping and occasionally rest on the ground. Twigs are gray brown to brown and pubescent, becoming glabrous with maturity; often with spherical galls caused by native wasps. Bark is thin, gray, and checkered when young, becoming dark and deeply fissured with flattened ridges with age. Leaves are simple, alternate, with nine to eleven deep rounded lobes, dark green and pubescent above, pale green and sparsely pubescent below, 2–3.1 in (5–8 cm) long. Trees are monoecious producing male and female flowers on the same plant, blooming between March and May. Male flowers are borne in hanging, yellow-green catkins, 1.2–2 in (3–5 cm) long; female flowers are borne singly or in clusters of two or three in leaf axils of new growth. Fruits are bright chestnut brown acorns, typically elongated to a point, 1–2.4 in (2.5–6 cm) long, with shallow or deep cups with warty knobs, enclosing one-third of nut.

USES AND VALUE. Wood moderately commercially important locally. Used for wine barrels, cabinets, and firewood. Provide critical environments for wildlife supporting sixty-seven species of birds and mammals for cavity-nesting and cavity-storing. Provide browse for livestock, black-tailed deer, lagomorphs, and various rodents. Acorns are important in diet of California ground squirrel, pocket gopher, scrub-jay, yellow-billed magpie, acorn woodpecker, black-tailed deer, feral pig, and cattle.

ECOLOGY. This near-threatened species is native to habitats in California with Mediterranean climates. Decline due in part to human population expansion. Grows on slopes in woodlands, savannas, and valley floors on deep rich soils. Intermediate in shade tolerance. Good seed crop produced annually; viability 60 percent; important dispersal agents are seed-caching animals, such as scrub-jays and California ground squirrels. Diseases are rare with exception of heart-rot fungus (*Armillaria mellea*).

CLIMATE CHANGE. Vulnerability is currently considered to be low.

CONSERVATION STATUS. Near threatened.

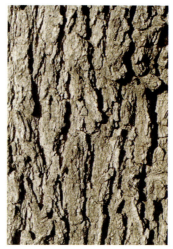

bark

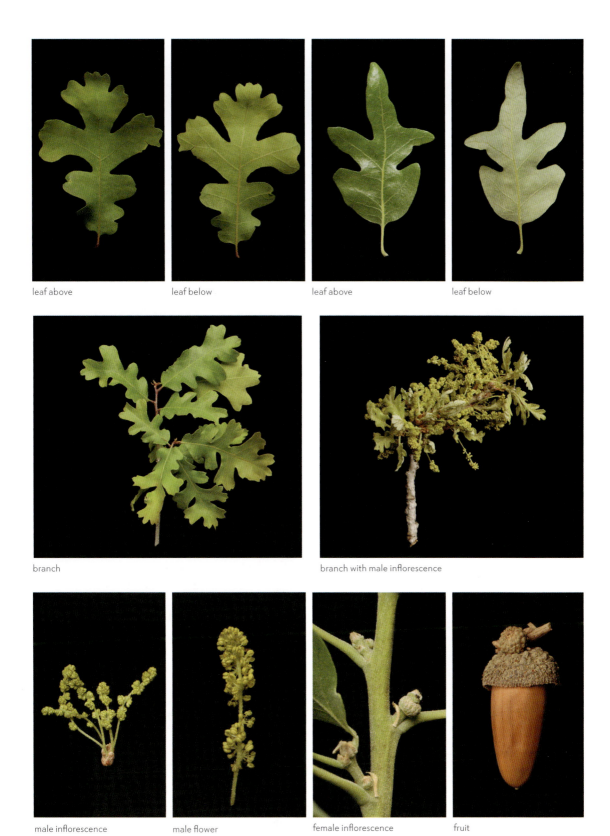

FAMILY FAGACEAE • 559

Overcup Oak
Quercus lyrata Walter

Overcup oak is a medium- to large-sized deciduous tree with short trunk and pyramidal broad crown with a round twisted form. It is found in the low wet soils of flood-plain forests, bottomlands, streambanks, and bayous of the southeastern United States.

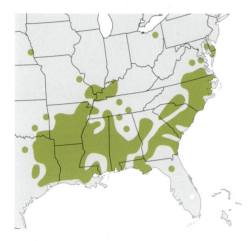

DESCRIPTION. A medium- to large-sized deciduous tree growing 59–89 ft (18–27 m) tall with a short, crooked stem and a large open crown with crooked branches. Twigs are slender, gray, and glabrous, with small light brown buds clustered at the apex. Bark is gray brown and scaly, with irregular plates. Leaves are simple, alternate, with five to nine lobes with irregular sinuses, dark green above, paler below with or without white pubescence, margins highly variable, 2.8–4.7 in (7–12 cm) long. Trees are monoecious producing male and female flowers on the same plant, blooming with the leaves in spring. Male flowers are green, borne in naked catkins, 2–3.5 in (5–9 cm) long; female flowers are red, arranged in single spikes. Fruits are round acorns, 0.4–1.0 in (1–2.5 cm) long, cup covered by warty downy scales, enclosing almost entire nut.

USES AND VALUE. Wood not commercially important. Planted as ornamental. Ducks, wild turkeys, squirrels, and white-tailed deer consume acorns.

ECOLOGY. Grows in low wet soils of flood-plain forests, bottomlands, streambanks, and bayous of the southeastern United States. Intermediate in shade tolerance. Good seed crops produced every three to four years; primary dispersal agents are flood waters and squirrels. Flood tolerant but susceptible to fire. Pests include trunk rot after scarring from fire and spot-worm borer (*Agrilus acutipennis*).

CLIMATE CHANGE. Vulnerability is significant but has reasonable probability of persistence in the future. Ongoing monitoring is recommended.

CONSERVATION STATUS. Least concern.

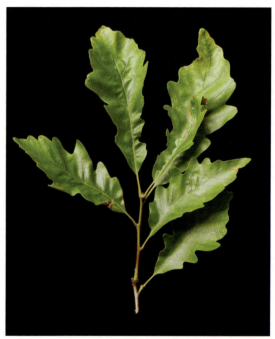
branch

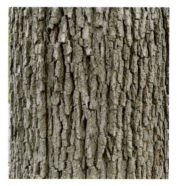
bark

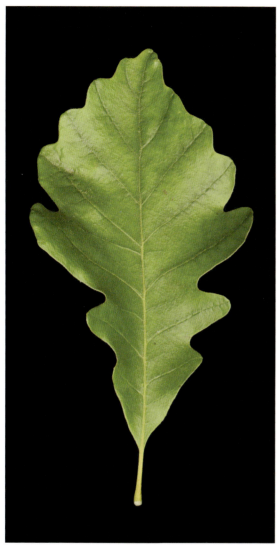
leaf above

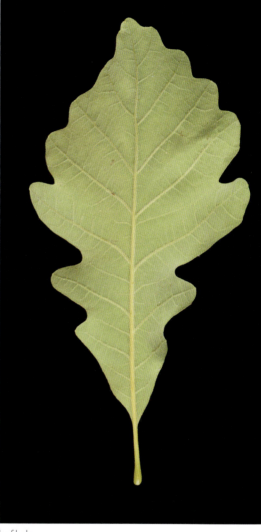
leaf below

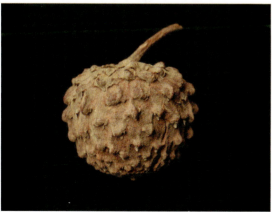
fruit

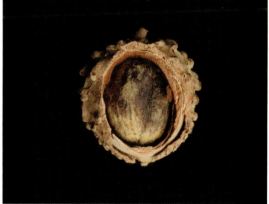
fruit with seed inside

FAMILY FAGACEAE • 561

Bur Oak
Quercus macrocarpa Michx.
MOSSY-CUP OAK

Bur oak is a large, sometimes massive, deciduous tree native to central North America. The acorns are the largest of any North American oak, are adorned with a furry, burlike cup resembling a chestnut, and are eaten by a variety of wildlife, including American black bears.

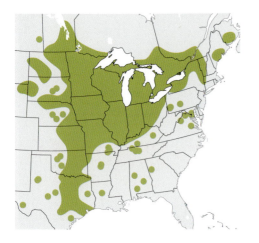

DESCRIPTION. A long-lived, deciduous tree, growing to 82 ft (25 m) tall with a massive stem and broad crown with thick branches; the branches and branchlets have corky-winged projections. Twigs are robust and yellowish brown. Bark is dark, ridged vertically, and flaky. Leaves are alternate, simple, obovate or oblong, with five to seven pairs of blunt lobes and deep rounded sinuses, middle pair of sinuses are deepest, lobes near the tip resemble a crown, green above, pale and fuzzy below, base cuneate, 0.4–1 in (1–2.5 cm) long, 2.8–5.9 in (7–15 cm) wide. Trees are monoecious producing male and female flowers on the same plant, blooming in early to mid-spring. Male flowers are arranged in slender catkins, 2–5.9 in (5–15 cm) long; female flowers have four to six deeply toothed lobes. Fruits are acorns, 1–2 in (2.5–5 cm) long and wide, with deep-fringed, burlike cup enclosing one-half to three-quarters of nut.

USES AND VALUE. Wood commercially important. Used for cabinetry, furniture, interior trim, flooring, boat building, barrels, and veneer. Planted as ornamental and in shelterbelts. Acorns are important food of red squirrels, wood ducks, white-tailed deer, New England cottontails, mice, thirteen-lined ground squirrels, and American black bears.

ECOLOGY. Grows in dry uplands and moist bottomlands. Intermediate in shade tolerance. Good seed crops produced every two to three years; acorns dispersed by gravity, squirrels, and water. Very drought and fire resistant. Susceptible to flooding. Various fungal and insect pests attack the tree, including oak lacebug (*Corythucha arcuata*) that can cause severe defoliation.

CLIMATE CHANGE. Vulnerability is currently considered to be low.

CONSERVATION STATUS. Least concern.

bark

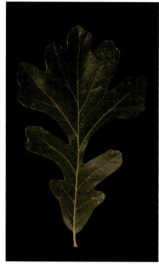
leaf above

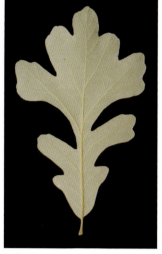
leaf below

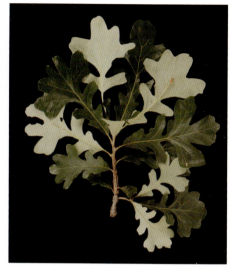
branch

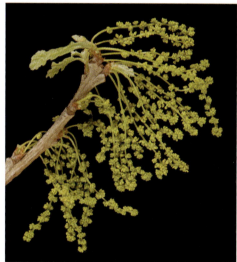
branch with male inflorescence

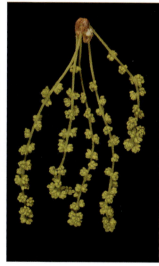
male inflorescence

male flower

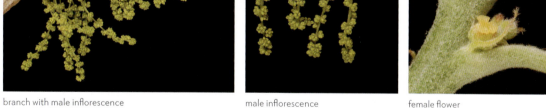
female flower

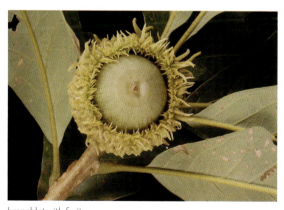
branchlet with fruit

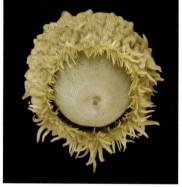
fruit

FAMILY FAGACEAE • 563

Sand Post Oak
Quercus margarettae (Ashe) Small
RUNNER OAK

Sand post oak is a small deciduous tree or shrub native to the southeastern United States from Texas to Florida and north to Virginia growing in pine woodlands and sandhills.

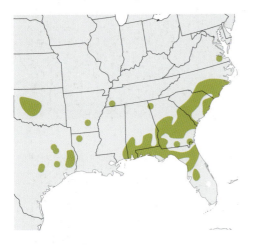

DESCRIPTION. A small deciduous tree or shrub that grows up to 49 ft (15 m) tall with a broad crown and twisted branches. Twigs are gray and glabrous or sparsely pubescent, with multiple large terminal buds. Bark is gray or gray brown and scaly in texture developing vertical ridges with age. Leaves are deciduous, simple, alternate, with two to five irregular rounded lobes, the middle pair somewhat square, thick, dark green and hairless above, paler with downy pubescence below, 3.9–5.9 in (10–15 cm) long. Trees are monoecious producing male and female flowers on the same plant, blooming when leaves appear in spring. Male flowers are borne in light green catkins, 2.0–2.8 in (5–7 cm) long; female flowers are small, red, clustered in short spikes. Fruits are light brown acorns, 0.4–0.6 in (1–1.5 cm) long, with thinly scaled, pubescent cup, enclosing half of nut.

USES AND VALUE. Wood not commercially important. Sometimes cultivated as ornamental. Provides habitat for variety of animals; turkeys, ground birds, squirrels and other small rodents consume acorns.

ECOLOGY. Grows in oak-pine forests, savannas, sandhills, and scrublands on the coastal plains of the southeastern United States west to Texas. Prefers acidic, deep, sandy or gravelly soils. Drought resistant.

CLIMATE CHANGE. Vulnerability is significant but has reasonable probability of persistence in the future. Ongoing monitoring is recommended.

CONSERVATION STATUS. Least concern.

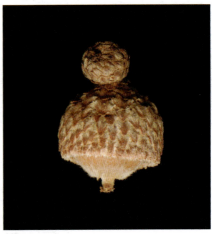

fruit

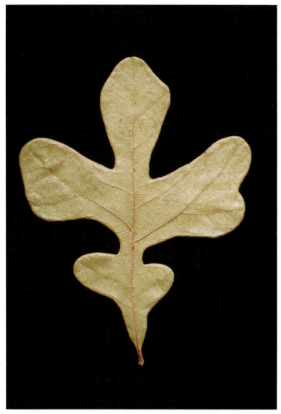
leaf above

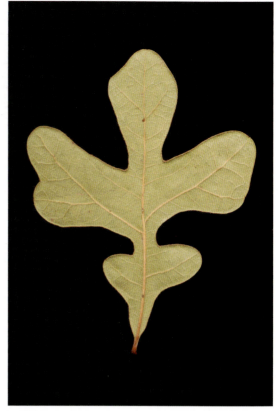
leaf below

male inflorescence

FAMILY FAGACEAE

Blackjack Oak
Quercus marilandica Münchh.

Blackjack oak is a small deciduous tree native to the southern and central United States that grows on rock outcrops, dry ridges, and upland woodlands. The dense wood burns hot as a fuelwood and can quickly dull the blade of a chainsaw.

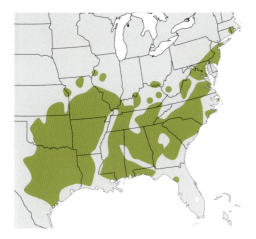

DESCRIPTION. A long-lived deciduous tree, growing to 66 ft (20 m) tall with stout trunk and irregular crown, often appearing stressed from dry sterile habitats. Twigs are dark brown and hairy. Bark is rough, with nearly black ridges in blocky plates. Leaves are alternate, simple, obovate, with three to five broad, blunt lobes above middle, thick and glabrous green above, orange brown and pubescent below, margins entire, base rounded or cordate, 0.4–1 in (1–2.5 cm) long. Trees are monoecious producing male and female flowers on the same plant, blooming in midspring to early summer. Male flowers are arranged in catkins, 2–4 in (5–10 cm) long, with four or five calyx lobes pubescent on outer surface; female flowers are tiny, produced on brown peduncles. Fruits are ovoid, light brown acorns, 0.6–0.8 in (1.5–2 cm) long, short-stalked, cup with loose hairy scales, enclosing one-half of nut.

USES AND VALUE. Wood not commercially important. Used mostly for fuelwood, fence posts, and railroad ties. Turkey, white-tailed deer, fox squirrels, and small rodents consume the acorns.

ECOLOGY. Grows on rock outcrops, dry ridges, and upland woodlands on sandy or shaly soils. Shade intolerant; drought resistant; susceptible to flooding. Seed production starts at young age; primary dispersal agents are gravity and small animals.

CLIMATE CHANGE. Vulnerability is currently considered to be low.

CONSERVATION STATUS. Least concern.

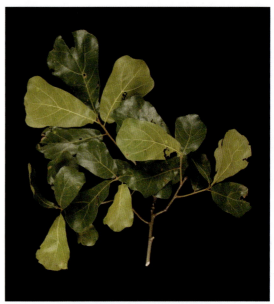

branch

bark

leaf above leaf below leaf above leaf below

branch with male inflorescence branch with female inflorescence male flower

female flower

infructescence fruit fruit and seed

FAMILY FAGACEAE • 567

Swamp Chestnut Oak

Quercus michauxii Nutt.

BASKET OAK

Swamp chestnut oak is native to wetlands and mixed hardwood forests in the southern and central United States. The long, egg-shaped acorns mature in fall about six months after pollination.

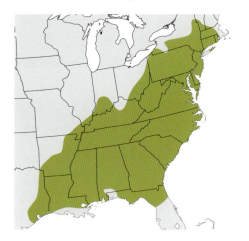

DESCRIPTION. A moderate-lived deciduous tree growing to 100 ft (32 m) tall with a straight massive trunk and narrow crown of ascending branches. Twigs are green when young, turning orange brown. Bark is gray and scaly. Leaves are alternate, simple, obovate, with ten to fifteen pairs of blunt teeth or lobes, shiny dark green above, paler and pubescent below, base acute to cordate, tip acuminate to acute, 4.7–7.9 in (12–20 cm) long, 2.8–4.7 in (7–12 cm) wide. Trees are monoecious producing male and female flowers on the same plant, blooming in mid-spring. Male flowers are arranged in yellowish green, hairy catkins, 2.8–4 in (7–10 cm) long; female flowers are tiny, green to reddish. Fruits are ovoid to conical, chestnut-brown acorns, 1–1.4 in (2.5–3.5 cm) long, with cup covered by grayish brown, knobby scales, enclosing one-third to one-half of nut.

USES AND VALUE. Wood very commercially important. Used for cabinetry, furniture, interior trim, flooring, boat building, barrels, and veneer. Acorns are important food for variety of birds and mammals, including white-tailed deer, black bear, red fox, wild turkey, northern bobwhite, various waterfowl, squirrels, and cattle. Vegetation along waterways provides cover and shade for fish as well as for birds, mammals, and reptiles.

ECOLOGY. Grows in bottomlands, swamp margins, and flood plains. Generally shade intolerant. Good seed crops produced every three to five years; primary dispersal agents are gravity and squirrels. Fungal pests include wood-decaying fungi (species of *Fomes*, *Polyporus*, and *Stereum*), oak leaf blister (*Taphrina caerulescens*), and oak anthracnose (*Gnomonia veneta*). Acorns attacked by weevils (e.g., *Curculio pardalis*, *Conotrachelus naso*, and *C. posticatus*).

CLIMATE CHANGE. Vulnerability, though currently considered to be low, may increase in the future. Ongoing monitoring is recommended.

CONSERVATION STATUS. Least concern.

bark

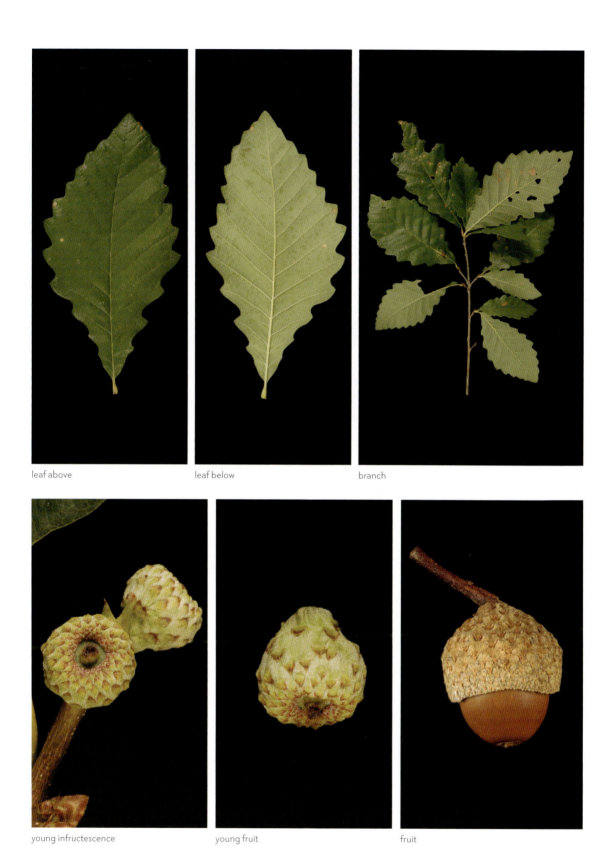

leaf above leaf below branch

young infructescence young fruit fruit

FAMILY FAGACEAE • 569

Chestnut Oak

Quercus montana Willd.

Chestnut oak is a medium-sized, deciduous tree native to the eastern United States distinguished from other white oaks by its very thick, deeply ridged, dark gray-brown bark. Because of the high tannin content, the bark was once used to tan leather.

DESCRIPTION. A long-lived deciduous tree growing to 59–80 ft (18–24 m) tall with deeply fissured bark, a short but clear trunk, and irregular crown. Leaves are alternate, simple, obovate to elliptical, with ten to sixteen pairs of rounded teeth or lobes, base wedge-shaped, widest toward tip, shiny yellow green above and paler below, 0.4–0.8 in (1–2 cm) long, 1.6–4 in (4–10 cm) wide. Trees are monoecious producing male and female flowers on the same plant, blooming in mid-spring. Male flowers are arranged in hairy, yellowish-green catkins, 2–4 in (5–10 cm) long; female flowers are reddish. Fruits are ovoid, lustrous brown acorns, 0.8–1.4 in (2–3.5 cm) long, with thin, warty, teacup-shaped cup, enclosing one-quarter to one-half of nut.

USES AND VALUE. Wood somewhat commercially important. Sometimes marketed as white oak and used for cabinetry, furniture, interior trim, flooring, boat building, barrels, and veneer. Acorns are important food for wildlife, such as deer, turkeys, squirrels, chipmunks, and mice.

ECOLOGY. Grows on steep mountain slopes and dry rocky ridges. Intermediate in shade tolerance. Good seed crops produced every three to five years; dispersal by gravity and squirrels. Susceptible to fire. Attacked by oak wilt (*Ceratocystis fagacearum*), twig-blight fungus (*Diplodia longispora*), branch canker (*Botryodiplodia*), stem cankers (*Nectria galligena* and *Strumella coryneoidea*). Insect pests include the gypsy moth (*Lymantria dispar*), spring and fall canker-worms (*Paleacrita Vernata* and *Alsophila pometaria*), forest tent caterpillar (*Malacosoma disstria*), and half-wing geometer (*Phigalia titea*).

CLIMATE CHANGE. Vulnerability is currently unknown. Immediate assessment is recommended.

CONSERVATION STATUS. Least concern.

bark

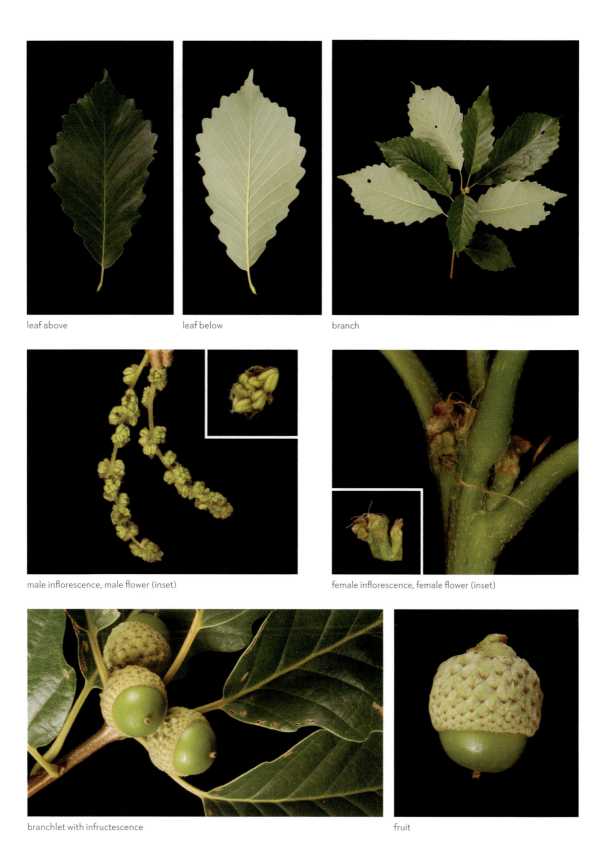

Chinkapin Oak
Quercus muehlenbergii Engelm.

Chinkapin oak is native to eastern and central North America and commonly grows on calcium rich soils in fertile valleys and woodlands. The acorns are sweet and provide an excellent source of food for wildlife despite its somewhat low population abundance.

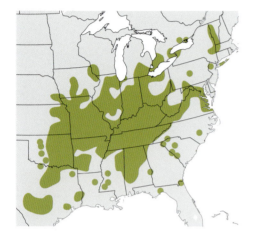

DESCRIPTION. A long-lived deciduous tree growing 49–100 ft (15–33 m) tall; in forest habitats develops straight columnar trunk with dense rounded crown and small branches, while in more open environments, a short trunk with broad-spreading crown is more common. Twigs are orange brown or gray and glabrous. Bark is light gray, shallowly furrowed, and flaky. Leaves are alternate, simple, obovate to oblong, margins coarsely serrate to undulate with eight to thirteen teeth per side, green and glabrous above, paler and pubescent below, 3.9–7.1 in (10–18 cm) long. Trees are monoecious producing male and female flowers on the same plant, blooming in mid-spring. Male flowers are yellow, arranged in hairy catkins, 2.8–4 in (7–10 cm) long; female flowers are clustered in woolly spikes. Fruits are ovoid, brown to almost black acorns, 0.5–1 in (1.2–2.5 cm) long, sessile or on short peduncle, with grayish-brown, tomentose cup that covers one-third to one-half of nut.

USES AND VALUE. Wood not commercially important. Used locally for fuel. Sweet and palatable acorns are eaten by squirrels, mice, voles, chipmunks, deer, turkeys and other birds. Larval host for the gray hairstreak (*Strymon melinus*) butterfly.

ECOLOGY. Grows on dry, rocky, calcium-rich, and limestone soils in canyons, valleys, and woodlands. Shade intolerant. Good seed crops produced at infrequent intervals; dispersal by gravity and rodents. Fire susceptible, but trunks quickly resprout. Diseases include oak wilt (*Ceratocystis fagacearum*), cankers (*Strumella coryneoidea* and *Nectria galligena*), shoestring root rot (*Armillaria mellea*), anthracnose (*Gnomonia veneta*), and leaf blister (*Taphrina* spp.). Defoliating insect pests are gypsy moth (*Lymantria dispar*), orange-striped oakworm (*Anisota senatoria*), and variable oakleaf caterpillar (*Heterocampa manteo*).

CLIMATE CHANGE. Vulnerability is significant but has reasonable probability of persistence in the future. Ongoing monitoring is recommended.

CONSERVATION STATUS. Least concern.

female inflorescence

bark

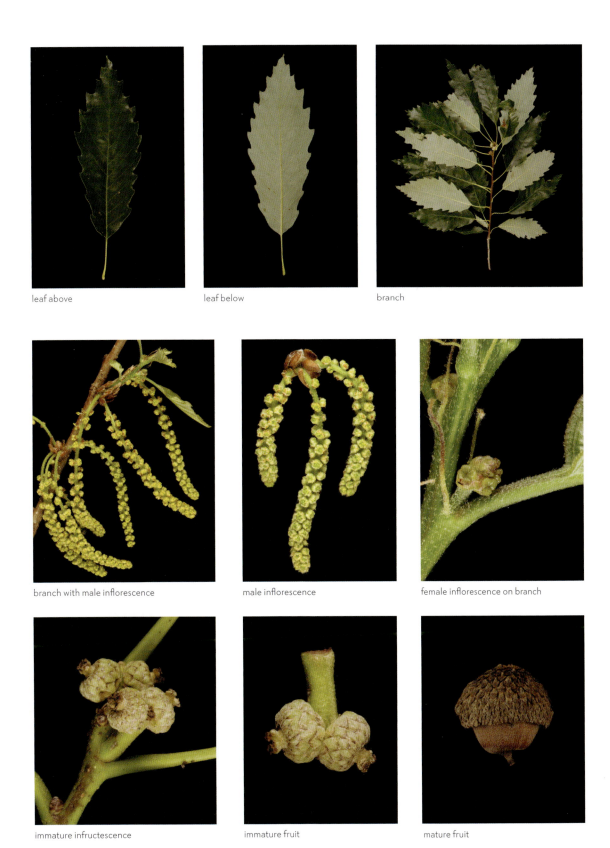

Water Oak

Quercus nigra L.

Water oak is a medium-sized deciduous tree native to the southeastern United States with a tall thin trunk and rounded crown with ascending branches. The leaves are bluish green and variable in shape, usually with three broad rounded lobes at the tip.

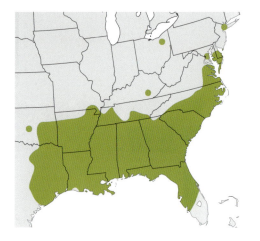

DESCRIPTION. A moderate-lived deciduous tree growing to 70 ft (21 m) tall with a tall thin trunk and semi-symmetrical to rounded crown with densely packed branches. Leaves are alternate, simple, very variable in shape, widest near the tip, often with three broadly rounded lobes, shiny blue green above, paler below with hairy veins, 2–4.7 in (5–12 cm) long, 0.8–2 in (2–5 cm) wide. Trees are monoecious producing male and female flowers on the same plant, blooming in mid-spring. Male flowers are reddish, hairy, arranged in catkins, 2–2.8 in (5–7 cm) long; female flowers are reddish, clustered in spikes. Fruits are nearly black acorns, 0.4–0.6 in (1–1.5 cm) long, with saucer shaped cup, enclosing one-quarter of nut.

USES AND VALUE. Wood not commercially important. Used as plywood for fruit and vegetable containers. Cultivated widely for shade in southern United States. Acorns a staple food of Native North Americans. Infusion of bark is antiseptic, astringent, febrifuge, and tonic. Utilized by cavity-nesting birds, such as red-bellied woodpecker, great crested flycatcher, and hairy woodpecker. Provides habitats for the southern flying squirrel. Acorns are consumed by squirrels, chipmunks, waterfowl, blue jay, wild turkey, and northern bobwhite.

ECOLOGY. Grows along streambanks and in wet woodlands; more recently colonizing upland woods, roadsides, and secondary growth. Shade intolerant. Seed production alternates between prolific and lean years; dispersal by gravity, water, and small mammals. Damaging insects include trunk borers (*Enaphalodes* and *Prionoxystus* spp.) and leaf hoppers (*Erythroneura* spp.). Fungal pests include cone rusts (*Cronartium* spp.), root rot (*Ganoderma curtisii*), trunk canker, and heart rot.

CLIMATE CHANGE. Vulnerability is currently considered to be low.

CONSERVATION STATUS. Least concern.

bark

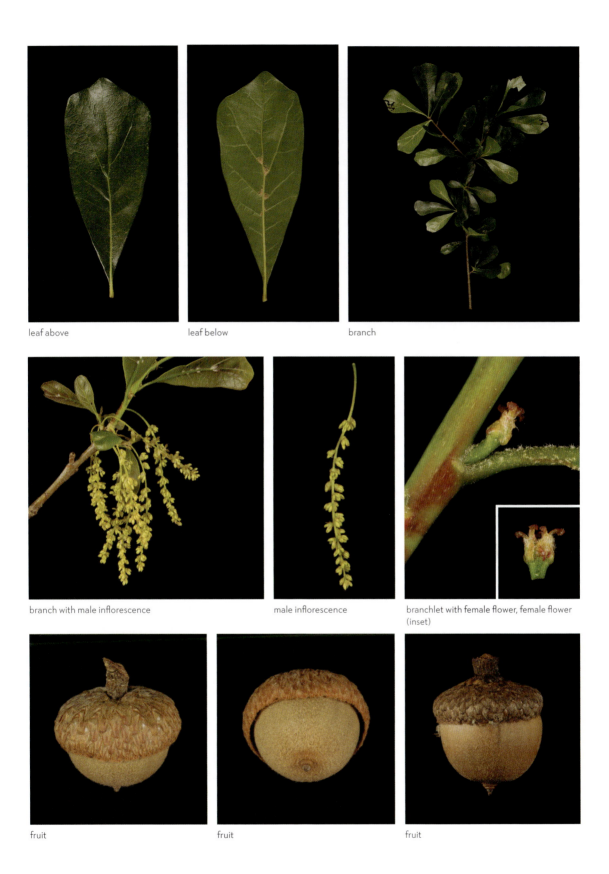

FAMILY FAGACEAE • 575

Cherrybark Oak
Quercus pagoda Raf.
PAGODA OAK

Cherrybark oak is a deciduous tree with a tall straight trunk and a narrow to spreading crown. It grows in floodplains and bottomlands along streams of the Atlantic and Gulf Coastal plains throughout the Mississippi River Valley.

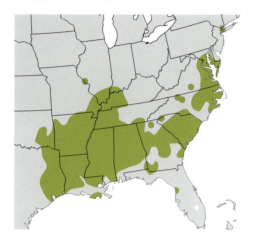

DESCRIPTION. A deciduous tree that grows up to 98 ft (30 m) tall with a straight trunk and narrow to spreading crown. Twigs are ruddy brown, often pubescent, becoming glabrous with maturity. Multiple terminal buds are pointed, reddish, and pubescent on the upper half. Bark is smooth when young, becoming dark, scaly, and rough with age (similar to bark of cherry trees). Leaves are simple, alternate, ovate to elliptic, with five to nine bristle-tipped lobes often diverging nearly perpendicular to the midrib, shiny dark green and glabrous above, paler and whitish pubescent below, 5.1–7.9 in (13–20 cm) long. Trees are monoecious producing male and female flowers on the same plant, blooming with leaves in spring. Male flowers are yellow green, arranged in drooping catkins; female flowers are small, green clustered on short stalks. Fruits are orange-brown acorns, pubescent when young, 0.5–1 in (1.2–2.4 cm) long, with pubescent cup enclosing one-third of nut.

USES AND VALUE. Wood commercially important and one of most valuable red oaks in the South. Heavy and strong lumber used in furniture and interior finish. Cultivated as a shade tree. Infusion of bark is antiseptic, astringent, febrifuge, and tonic. Many birds and mammals consume acorns, including gray squirrel, wild turkey, blue jay, wood duck, red-bellied woodpecker, red-headed woodpecker, white-breasted nuthatch, common grackle, raccoon, white-tailed deer, and eastern fox squirrel.

ECOLOGY. Grows on floodplains, bottomlands, and slopes along rivers of the Atlantic and Gulf coastal plains, often with post oaks, hickories, and pines. Soils are usually poor, dry, acidic, and loamy. Shade intolerant. Good seed crops produced at one- or two-year intervals; squirrels, gravity, and water are dispersal agents. Susceptible to windthrow and fire damage. Insect pests are carpenterworm (*Prionoxystus robiniae*), red oak borer (*Enaphalodes rufulus*), oak clearwing borer (*Paranthrene simulans*), and living-beech borer (*Goes pulverulentus*). Susceptible to oak wilt (*Ceratocystis fagacearum*).

CLIMATE CHANGE. Vulnerability is significant but has reasonable probability of persistence in the future. Ongoing monitoring is recommended.

CONSERVATION STATUS. Least concern.

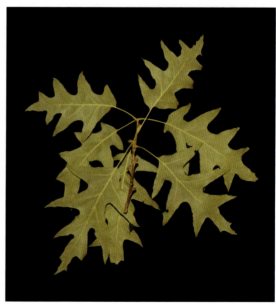

branch below

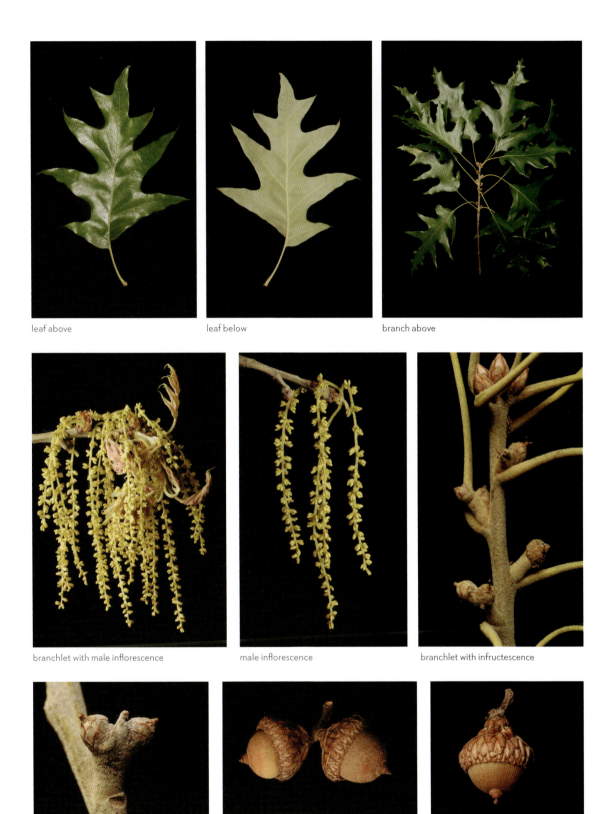

FAMILY FAGACEAE • 577

Pin Oak

Quercus palustris Münchh.

Pin oak is native to wet, swampy areas in eastern North America, which is reflected in the Latin name, *palustris*, meaning "of swamps." The deeply cut leaves are very characteristic with the lower two pairs of lobes held nearly perpendicular to the midvein.

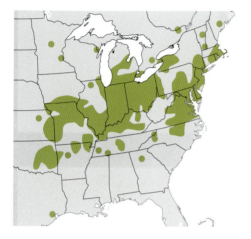

DESCRIPTION. A moderate-lived deciduous tree growing to nearly 100 ft (30 m) tall, with trunk studded with small tough persistent branchlets, drooping lower branches, and broadly pyramidal crown. Twigs are reddish brown and lustrous. Bark is grayish brown, smooth, and tight. Leaves are alternate, simple, obovate to oval, with five to nine bristle-tipped lobes and irregular, deep, U-shaped sinuses extending nearly to the midrib, lower two pairs of lobes perpendicular to midvein, dark green and glossy above, yellowish green and pubescent below, base wedge-shaped, 3–6 in (7–14 cm) long. Trees are monoecious producing male and female flowers on the same plant, blooming in mid-spring. Male flowers are arranged in yellowish-green, hairy catkins, 2.0–2.8 in (5–7 cm) long; female flowers are reddish green, clustered in short spikes. Fruits are nearly round, light brown acorns, 0.4–0.6 in (1–1.5 cm) long, with very shallow cup covered by hairy brown close scales, enclosing one-quarter of nut.

USES AND VALUE. Wood commercially important. Marketed as "red oak" and used in general construction applications and for fuelwood. Popular as ornamental, frequently planted along streets. Acorns are staple food of Native North Americans. Infusion of inner bark used to treat intestinal pains. Galls produced on the tree are strongly astringent and used to treat hemorrhages, chronic diarrhea, and dysentery. Acorns provide food for deer, squirrels, turkeys, woodpeckers, blue jays, mallards and wood ducks during fall migration.

ECOLOGY. Grows on river margins, bottomlands, swamps, and poorly drained slopes. Shade intolerant. Good seed crops produced most years, with poor crops every three to four years; dispersal by squirrels, mice, blue jays, and woodpeckers. Susceptible to fire due to thin bark. Diseases similar to other oaks, including oak wilt (*Ceratocystis fagacearum*), leaf blister fungus (*Taphrina caerulescens*), twig canker fungus (*Dothiorella quercina*), and pin oak blight (*Endothia gyrosa*). Common insect pests are wood borers, gall wasps, and acorn weevils; a preferred host for gypsy moth (*Lymantria dispar*).

CLIMATE CHANGE. Vulnerability is significant but has reasonable probability of persistence in the future. Ongoing monitoring is recommended.

CONSERVATION STATUS. Least concern.

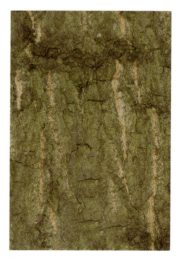

bark

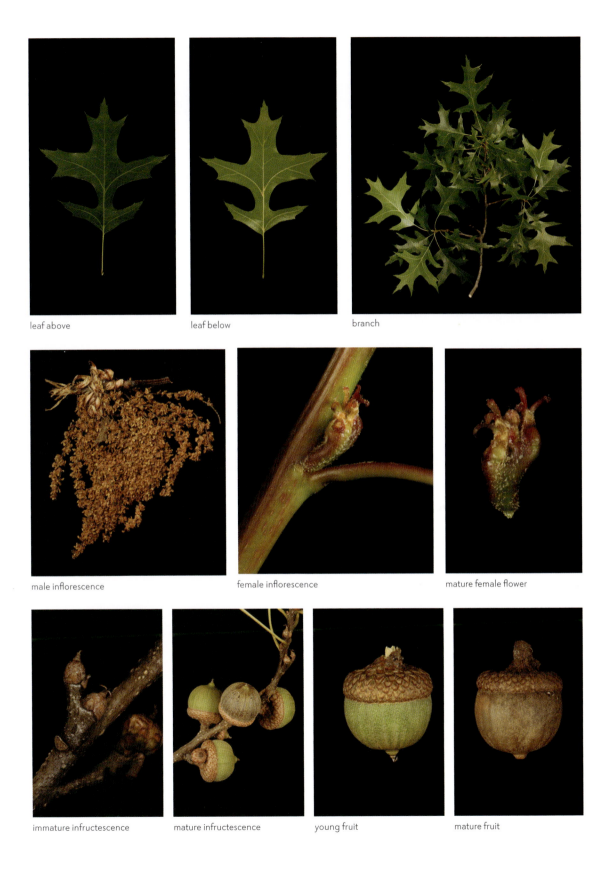

FAMILY FAGACEAE • 579

Willow Oak
Quercus phellos L.

Willow oak is a medium-sized tree native to eastern North America from New Jersey to Texas. It is distinguished from other oaks by the bright deep green willowlike leaves and is a very popular tree for roadsides and ornamental plantings

DESCRIPTION. A long-lived deciduous tree growing to 85 ft (25 m) tall with a slender trunk, persistent often drooping lower branches, and full rounded crown. Twigs are reddish brown turning darker brown. Bark is brown and finely ridged. Leaves are alternate, simple, lanceolate, widest near middle, with a bristle tip, margins entire, bright green above and below, glabrous, 2–4.3 in (5–11 cm) long, 1.7–3 cm wide. Trees are monoecious producing male and female flowers on the same plant, blooming in midspring. Male flowers are yellowish green, arranged in catkins, 5–7.5 cm long; female flowers are red, in short spikes. Fruits are round, yellowish green to brown acorns, 0.4 in (1 cm) long, with thin saucer-shaped cup covering one-quarter of nut.

USES AND VALUE. Wood commercially important. Used for lumber and pulp. Cultivated as popular ornamental. Acorns are staple food of Native North Americans. Preparation of wood chips or bark applied externally as analgesic and as bath for aches, pains, sores, cuts, and hemorrhoids. Galls produced on trees are strongly astringent and used to treat hemorrhages, chronic diarrhea, and dysentery.

Provides acorns as food for ducks, squirrels, deer, turkeys, blue jays, and red-headed woodpeckers. Branches provide nesting sites and cover for grackles, flickers, mice, and flying squirrels.

ECOLOGY. Commonly grows in bottomlands, floodplains, and river terraces on moist alluvial soils from the Mississippi River to the Atlantic coast. Shade intolerant. Good seed crops produced nearly every year; water and small animals are primary dispersal agents. Very susceptible to fire. Attacked by common canker (*Polyporus hispidus*). Most serious insect pests are red oak borer (*Enaphalodes rufulus*), carpenterworm (*Prionoxystus robiniae*), and living-beech borer (*Goes pulverulentus*).

CLIMATE CHANGE. Vulnerability is currently considered to be low.

CONSERVATION STATUS. Least concern.

bark

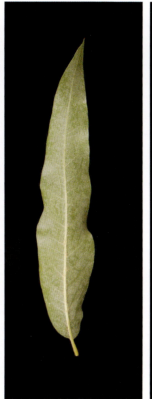
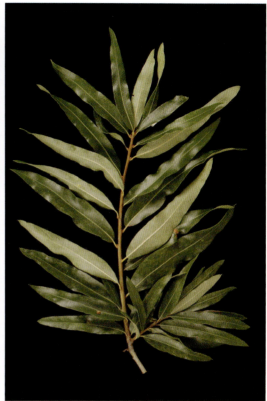

leaf above leaf below branch

female inflorescence, female flower (inset) young infructescence, young fruit (inset)

FAMILY FAGACEAE • 581

Northern Red Oak
Quercus rubra L.
RED OAK

Northern red oak is native to eastern North America growing in woodlands on moist slopes and valleys. A rapidly growing tree, it is one of the most commercially important timber oaks used for a multitude of purposes.

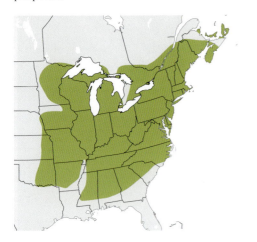

DESCRIPTION. A long-lived deciduous tree growing to 98 ft (30 m) tall with a tall straight trunk and small rounded crown. Twigs are brownish purple. Bark is dark, with deep furrows. Leaves are simple, alternate, ovate to elliptic, with eight to eleven primary wavy lobes possessing irregular bristle-tipped teeth, middle sinus extends less than half the distance to the midrib, dark green above, paler below, 3.9–9.8 in (10–25 cm) long, 3.1–5.9 in (8–15 cm) wide. Trees are monoecious producing male and female flowers on the same plant, blooming in mid-spring to early summer. Male flowers are arranged in yellowish, hairy catkins, 3.9–4.7 in (10–12 cm) long; female flowers red, clustered in spikes. Fruits are ovoid, lustrous brown acorns, 0.8–1.4 in (2–3.5 cm) long, with pubescent cup enclosing one-quarter to one-half of nut.

USES AND VALUE. Wood commercially important. Used for cabinetry, interior trim, furniture, flooring, veneer, pallets, and fuel. Cultivated as popular ornamental. Acorns are edible after leaching tannins and roasting. Staple food of Native North Americans. Infusion of outer and inner bark is antiseptic, astringent, emetic, febrifuge, and tonic used to treat diarrhea, chronic dysentery, indigestion, asthma, severe coughs, hoarseness, intermittent fevers, and bleeding. Acorns provide important food for squirrels, deer, turkey, mice, voles, and other mammals and birds. Buds and twigs of seedlings and saplings are heavily browsed by deer and moose.

ECOLOGY. Widespread in the eastern North America growing in moist forests on slopes and in valleys of the mountains and piedmont. Intermediate in shade tolerance. Good to excellent seed crops produced irregularly every three to five years, with high predation from mammals, insects, and birds; dispersal agents include birds and caching mammals, such as squirrels and mice. Fire and various fungal and insect pests may cause severe damge to northern red oak. Infected by a number of fungal diseases, including oak wilt (*Ceratocystis fagacearum*), shoestring root rot (*Armillaria mellea*), and cankers (*Strumella* and *Nectria* spp.). Most destructive insect pest is introduced gypsy moth (*Lymantria dispar*).

CLIMATE CHANGE. Vulnerability is currently considered to be low.

CONSERVATION STATUS. Least concern.

bark

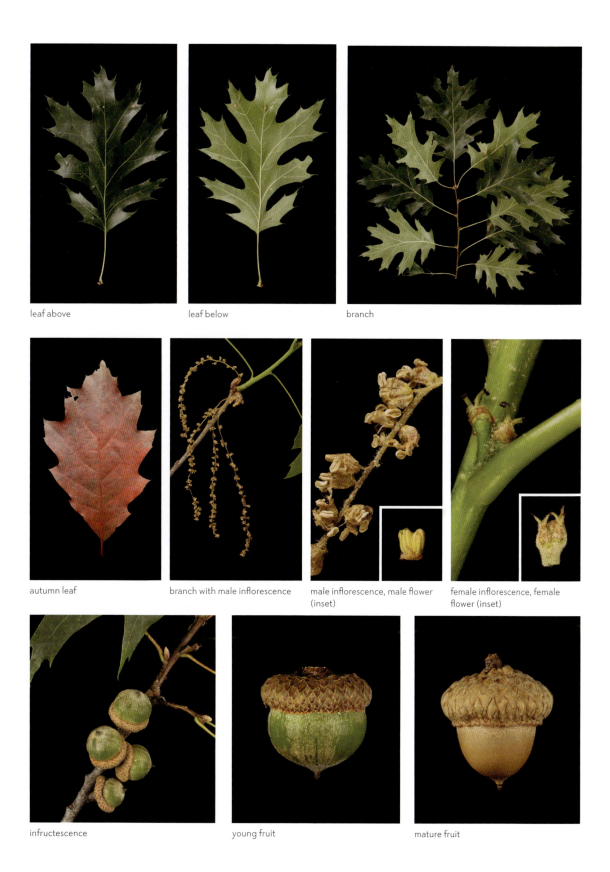

FAMILY FAGACEAE • 583

Netleaf Oak

Quercus rugosa Née

Netleaf oak is a small, shrubby, evergreen tree with a spreading round crown often forming thickets in wooded canyons from Texas to Arizona.

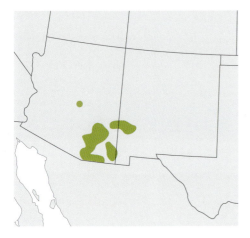

DESCRIPTION. A small, evergreen tree that can be shrubby and thicket-forming with a spreading round crown that grows up to 33 ft (10 m) tall. Twigs are light brown and pubescent, with clustered gray buds at the tips. Bark is gray with lenticels, becoming fissured into ridges with age. Leaves are evergreen, simple, alternate, ovate to round, margins toothed near tip, dark green above, green to gray green with conspicuous raised veins below, 1–4 in (2.5–10 cm) long. Trees are monoecious producing male and female flowers on the same plant, blooming with appearance of leaves from March to May. Male flowers are arranged in drooping, yellow-green catkins; female flowers are minute, clustered in spikes in leaf axils. Fruits are oblong acorns, 0.4–1.2 in (1–3 cm) long, with cup covered in warty brown scales, enclosing one-third of nut, borne on long stalks, 1.2–2.8 in (3–7 cm) in length.

USES AND VALUE. Wood not commercially important. Used for tools, pulp for paper making, and firewood. Planted as ornamentals. Acorns are toasted for human consumption, fed raw to cattle, pigs, and goats, and used as coffeelike drink. In Mexico used medicinally: bark used to treat dysentery, toothache, and hemorrhages; tea brewed from leaves relieves muscle pain and coughing.

ECOLOGY. Grows on wooded slopes in canyons between 6,562 and 8,202 ft (2,000–2,500 m) in elevation in the Trans-Pecos region of Texas, southern New Mexico, and Arizona. Common in oak and conifer forests on dry alkaline soils.

CLIMATE CHANGE. Vulnerability is significant but may have the capacity to adapt to changing conditions in the future. Ongoing monitoring is recommended.

CONSERVATION STATUS. Least concern.

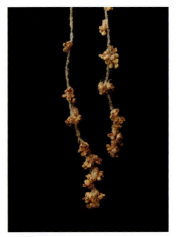
male inflorescence

bark

584 • THE DIVERSITY OF TREES

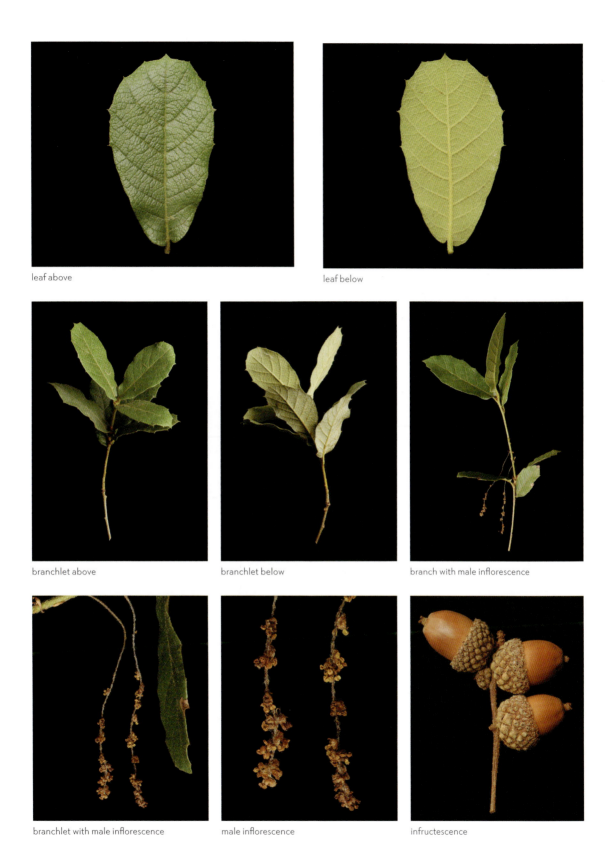

FAMILY FAGACEAE • 585

Shumard Oak

Quercus shumardii Buckley
SPOTTED OAK

Shumard oak is native to eastern North America, where it grows in woodlands along rivers and bottomlands. Growth is straight with a tall, often buttressed trunk and open, spreading crown.

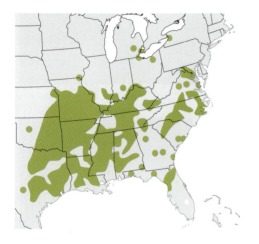

DESCRIPTION. A long-lived deciduous tree growing up to 131 ft (40 m) tall with a long, clear, symmetrical trunk, buttressed base, and open and wide-spreading crown. Twigs are gray to brown and glabrous. Bark is grayish brown to dark gray, furrowed into ridges. Leaves are alternate, simple, obovate to oval, with five to nine bristle-tipped lobes and deep sinuses, dark green and glabrous above, and paler and hairy in vein axils below, 3.1–7.9 in (8–20 cm) long. Trees are monoecious producing male and female flowers on the same plant, blooming in early spring. Male flowers are glabrous, yellow green, arranged in catkins, 5.5–7.1 in (14–18 cm) long; female flowers are clustered on pubescent stalks. Fruits are oblong-ovoid, light brown acorns, 0.6–1.2 in (1.5–3 cm) long, with saucer-shaped cups enclosing less than one-third of nut, require two years to mature.

USES AND VALUE. Wood is commercially important. Marketed with other red oaks and used for flooring, furniture, interior trim, and cabinetry. Planted as ornamental. Acorns are consumed by numerous birds and mammals. Larval host for the Horace's duskywing *(Erynnis horatius)* butterfly.

ECOLOGY. Grows in bottomland forests, in moist upland forests, and along streambanks. Shade intolerant. Good seed crops produced every two to three years; primary dispersers are small mammals, particularly squirrels. Damage caused by oak leaf blister (*Taphrina caerulescens*), oak wilt (*Ceratocystis fagacearum*), and common wood-rotting fungi in genera *Fomes*, *Polyporus*, and *Stereum*. Insect pests are red oak borer (*Enaphalodes rufulus*), carpenterworms (*Prionoxystus* spp.), and Columbian timber beetle (*Corthylus columbianus*).

CLIMATE CHANGE. Vulnerability is significant but has reasonable probability of persistence in the future. Ongoing monitoring is recommended.

CONSERVATION STATUS. Least concern.

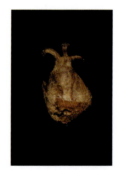
female flower

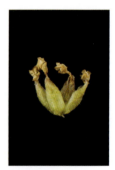
male flower

bark

586 • THE DIVERSITY OF TREES

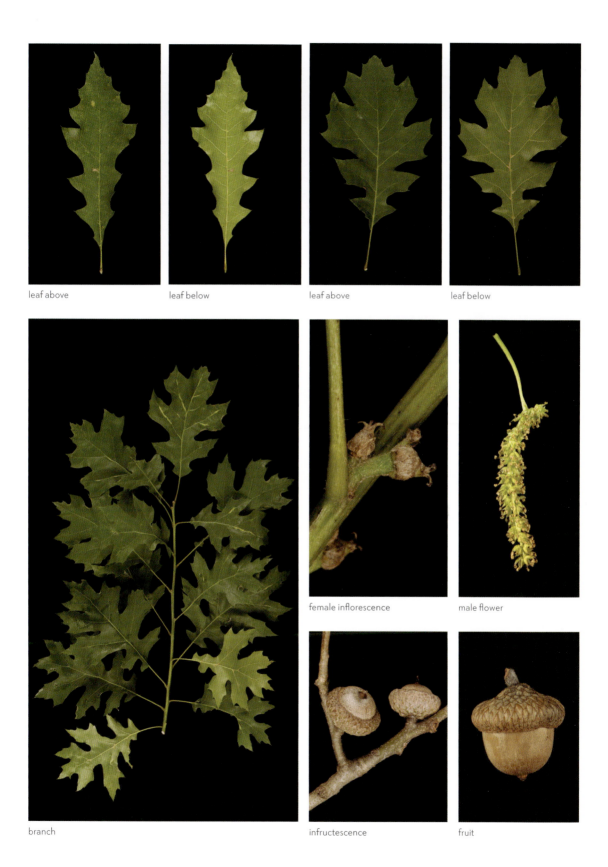

FAMILY FAGACEAE • 587

Post Oak
Quercus stellata Wangenh.

Post oak is native to the eastern and central United States growing in dry woodlands with pines and other oaks. As the common name implies, the wood is hard, rot-resistant, and durable and used as fence posts, railway ties, and mining timbers.

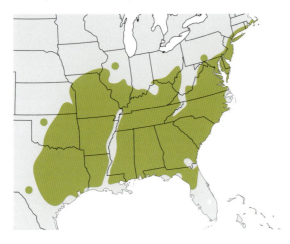

DESCRIPTION. A long-lived deciduous tree growing to 33–55 ft (10–18 m) tall, sometimes adapting a more shrublike appearance in dry habitats. Trunk is short and erect with crooked branches and rounded crown. Twigs are gray or brownish and hairy, with numerous lenticels. Bark is gray and flaking. Leaves are alternate, simple, oblong, with four to eight lobes, two middle lobes square or rectangular giving a cross-like appearance, base tapering, shiny dark green, scratchy above, paler below with yellowish hairs, 0.4–0.8 in (1–2 cm) long, 2.4–4 in (6–10 cm) wide. Trees are monoecious producing male and female flowers on the same plant, blooming in early spring to early summer. Male flowers are arranged in green catkins, 2–4 in (5–10 cm) long; female flowers are reddish, clustered in spikes. Fruits are ovoid acorns, brown with dark striations, 0.5–1 in (1.2–2.5 cm) long, with warty, scaly cup enclosing one-third to one-half of nut.

USES AND VALUE. Wood not commercially important. Because of strength and durability, used locally for fence posts, mine timbers, railroad ties and for smoking meat. Infusion of bark is astringent, disinfectant, emetic, febrifuge, and tonic and used to treat chronic dysentery, indigestion, asthma, lost voice, and intermittent fevers. Acorns provide high-energy food and are considered critical for diets of wild turkey, white-tailed deer, squirrels, and many other rodents. Leaves are used for nest building by birds, squirrels, and raccoons; trunk cavities provide nests and dens for birds and mammals.

ECOLOGY. Grows in dry woodlands with pines and other oaks as well as mixed deciduous forests. Shade intolerant. Good seed crops produced every two to three years. Pests include weevils, leafrollers, tent caterpillars, gypsy moths, sawflies, and leaf miners. Fungal diseases include oak wilt (*Ceratocystis fagacearum*).

CLIMATE CHANGE. Vulnerability is currently considered to be low.

CONSERVATION STATUS. Least concern.

bark

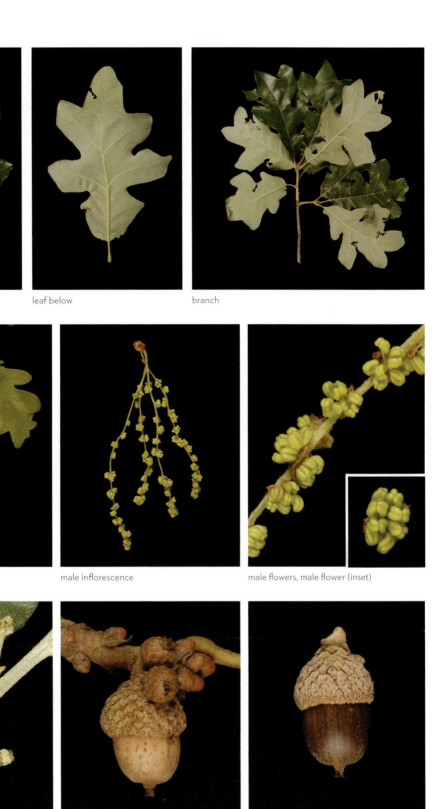

leaf above · leaf below · branch

branch with male inflorescence · male inflorescence · male flowers, male flower (inset)

branch with female inflorescence · infructescence · fruit

FAMILY FAGACEAE • 589

Texas Red Oak
Quercus texana Buckley
NUTTALL'S OAK

Texas red oak is a deciduous medium size to large narrow-crowned tree with conspicuous red foliage in autumn. Found in flood plains and bottomlands commonly on wet clay soils in the Mississippi River drainage basin.

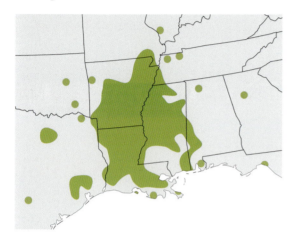

DESCRIPTION. A deciduous medium to large sized, narrow-crowned tree that grows up to 85 ft (26 m) tall with conspicuous red fall foliage. Twigs are reddish brown or gray, glabrous, with glaucous terminal buds. Bark is dark brown and shallowly fissured into flat ridges. Leaves are deciduous, simple, alternate, ovate to obovate, with six to eleven lobes each with secondary pointy lobes and bristle tips, dark green above turning bright crimson in fall, glabrous below with tufts of hairs in axils of veins, 3–7.9 in (7.5–20 cm) long. Trees are monoecious producing male and female flowers on the same plant, blooming when leaves appear between March and May. Male flowers are arranged in drooping yellow-green catkins; female flowers are small, clustered in leaf axils of new foliage. Fruits are egg shaped acorns, 0.75–1.25 in (2.0–3.2 cm) long, with thin deep cup constricted at base, enclosing one-third to one-half of nut.

USES AND VALUE. Wood commercially important. Marketed as red oak and used for cabinetry, interior trim, furniture, flooring, veneer, pallets, and fuel. Acorns are staple food of Native North Americans. Acorns that persist on trees through winter are consumed by squirrels, deer, ducks, and turkeys during periods of flooding.

ECOLOGY. Grows on flood plains and bottomlands in wet clay soils in the Mississippi River drainage basin. Shade intolerant. Good seed crops produced every three to four years, with some production annually; dispersed by water, birds, and rodents. "Bark pocket," a serious wood defect, is caused by sap-feeding beetles (family Nitidulidae) in combination with carpenterworms (*Prionoxystus* spp.). Other insect pests include basswood leafminer (*Baliosus nervosus*) and pink-striped oakworm (*Anisota virginiensis*). Attacked by three canker rot fungi: *Polyporus hispidus*, *Poria spiculosa*, and *Spongipellis pachyodon*.

CLIMATE CHANGE. Vulnerability is significant but may have the capacity to adapt to changing conditions in the future. Ongoing monitoring is recommended.

CONSERVATION STATUS. Least concern.

bark

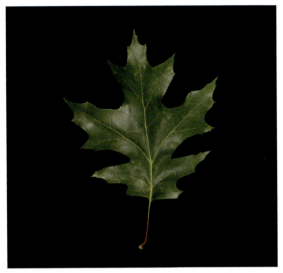
leaf above

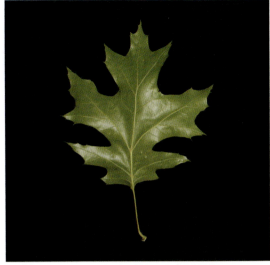
leaf below

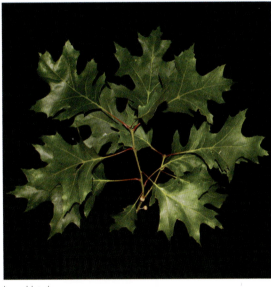
branchlet above

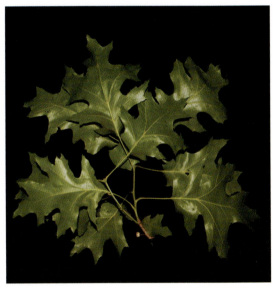
branchlet below

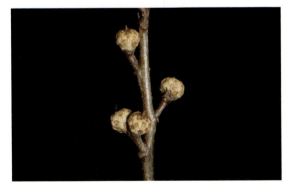
young infructescence

young fruit

FAMILY FAGACEAE • 591

Black Oak
Quercus velutina Lam.

Black oak is native to most of eastern North America, where it is commonly found on dry upland woods and rocky ridges. Identification is sometimes difficult and easily confused with other oaks. The inner bark is rich in tannins and used for tanning leather.

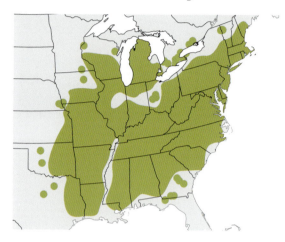

DESCRIPTION. A moderate-lived (up to 200 years) deciduous tree growing up to 80 ft (25 m) tall with a highly branched trunk, irregularly rounded crown, and deep taproot. Twigs are reddish brown to grayish green. Bark is thick, nearly black, and deeply furrowed vertically, with horizontal cuts on older trees. Leaves are alternate, simple, obovate or ovate, asymmetrical, with five to nine bristle-tipped primary lobes, usually with secondary lobes, sinuses are rounded and moderately deep, shiny green above, and pale pubescent below, 4–10 in (10–30 cm) long, 3–6 in (8–15 cm) wide. Trees are monoecious producing male and female flowers on the same plant, blooming in mid-spring. Male flowers are arranged in hairy, yellowish-green catkins, 2.0–2.8 in (5–7 cm) long; female flowers are reddish-green clustered on short spikes. Fruits are round, light brown acorns, 0.4–0.6 in (1–1.5 cm) long, with very shallow cup with loose, fuzzy scales, enclosing one-half of nut.

USES AND VALUE. Wood commercially important. Marketed as red oak and used for cabinetry, interior trim, furniture, flooring, veneer, pallets, and fuel. Acorns are staple food of Native North Americans. Squirrels, white-tailed deer, mice, voles, turkeys and other birds consume fruits.

ECOLOGY. Grows in dry upland woods and rocky ridges on well-drained, somewhat infertile soils. Intermediate in shade tolerance. Good seed crops produced every two to three years; squirrels, mice, blue jays, and gravity are primary dispersal agents. Susceptible to wildfires. Pests include oak wilt (*Ceratocystis fagacearum*) and gypsy moth (*Lymantria dispar*).

CLIMATE CHANGE. Vulnerability is currently considered to be low.

CONSERVATION STATUS. Least concern.

bark

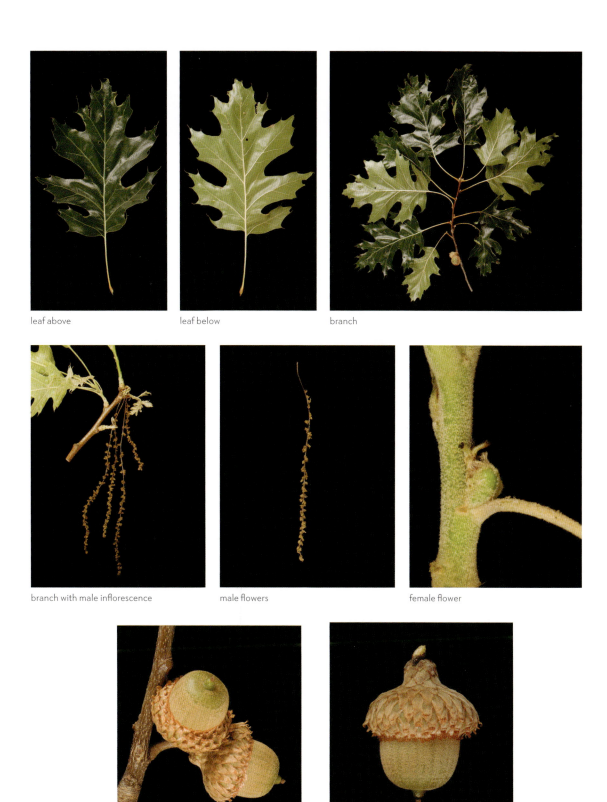

Live Oak
Quercus virginiana Mill.

Live oak, native to the southeastern United States, grows in a diversity of habitats across its distribution from dry to wet sites, uplands to flatwoods, and fertile to infertile soils. These massive trees with short trunks, large branches, and broad crowns are often draped with the flowering plant called Spanish moss (*Tillandsia usneoides*).

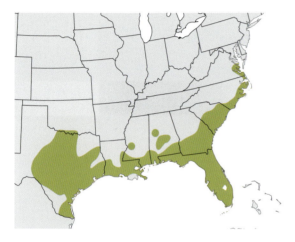

DESCRIPTION. A long-lived, evergreen to semi-evergreen tree growing up to 49 ft (15 m) in height, with short trunk, enlarged buttress, and several wide-spreading large branches, with a closed, round-topped crown. Twigs are gray and pubescent, becoming smoother with age. Bark is dark, deeply furrowed, and scaly. Leaves are alternate, simple, oblong or elliptical, margins usually entire, untoothed, apex with rounded tip, shiny dark green above, and paler with gray pubescent below, 1.5–4 in (~10 cm) long, 0.75–2 in (1.9–5.1 cm) wide. Trees are monoecious producing male and female flowers on the same plant, blooming in early spring. Male flowers are arranged in hairy catkins, 0.6 in (1.5 cm) long; female flowers are clustered in spikes of one to five flowers, 0.6–1.2 in (1.5–3 cm) long. Fruits are oblong, dark chestnut brown acorns, 0.6–1 in (1.2–2.5 cm) long, on 0.39–0.75 in (1.0–1.9 cm) peduncles, with grayish cup enclosing one-quarter to one-half of nut.

USES AND VALUE. Wood not commercially important today. Formerly, highly prized for constructing frameworks of sailing ships. Cultivated as popular ornamental tree. Acorns are staple food of Native North Americans. Fruits are consumed by many birds and mammals. Evergreen canopies serve as a nesting site for birds.

ECOLOGY. Grows in a wide variety of habitats from moist to dry woodlands in fertile to infertile soils. Prefers sandy sites of the lower coastal plain of the southern United States. Intermediate in shade tolerance. Large seed crops produced annually; primary dispersal agents are gravity and animals. Highly susceptible to fire when young due to thin bark. Also susceptible to damage by freezing temperatures. A wilt disease called live oak decline (attributed to *Ceratocystis fagacearum*) is a major threat.

CLIMATE CHANGE. Vulnerability, though currently considered to be low, may increase in the future. Ongoing monitoring is recommended.

CONSERVATION STATUS. Least concern.

immature fruit

bark

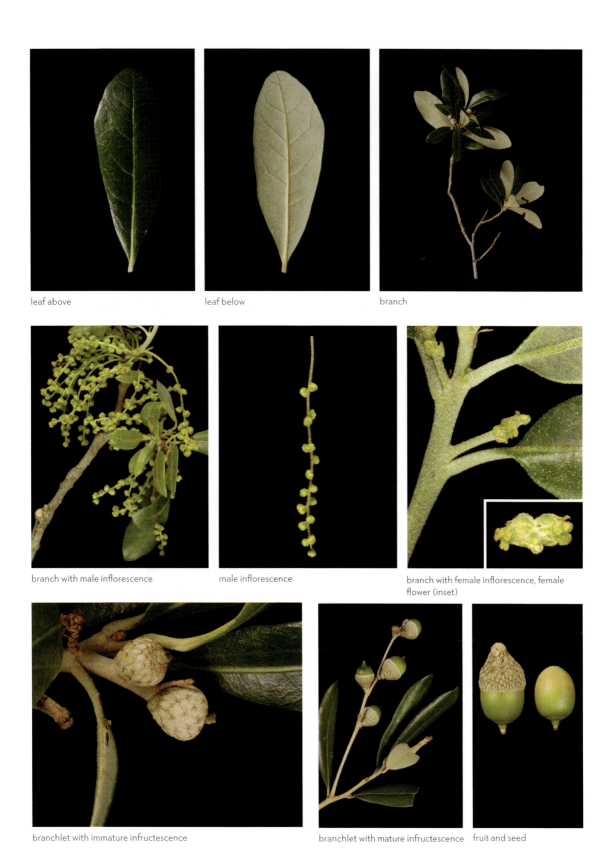

FAMILY FAGACEAE • 595

Interior Live Oak

Quercus wislizeni A. DC.

Interior live oak is a short-trunked evergreen tree with a broad crown that is endemic to the Californian Sierra Nevada and inner coastal ranges on dry soils of foothills, valleys, and slopes.

DESCRIPTION. A short-trunked, broad-crowned evergreen tree growing 33–72 ft (10–22 m) tall. Twigs are green brown and pubescent with triangular orange-brown buds clustered at the apex. Bark is smooth and gray or green brown, becoming furrowed and checkered into scaly ridges with age. Leaves are evergreen, simple, alternate, ovate to elliptical, variable in shape with margins entire, wavy, or dentate, leathery, dark green and glossy above, yellow green and shiny below, 0.8–2 in (2–5 cm) long, petioles 0.12–0.59 in (3–15 mm) in length. Trees are monoecious producing male and female flowers on the same plant, blooming when new leaves appear in spring. Male flowers are arranged in yellow-green catkins, 1.4–2.8 in (3.5–7 cm) long; female flowers are in clusters of two to four in leaf axils. Fruits are acorns, brown with linear striations, 0.75–1.5 in (2–4 cm) long, with deep cup covered in flat scales enclosing one-third to one-half of nut.

USES AND VALUE. Wood not commercially important. Sometimes used for fuel. Cultivated as ornamental. Acorns consumed by many animals, including bears, mule deer, squirrels and other rodents, acorn woodpeckers, scrub-jays, and band-tailed pigeons. Used as bedding and foraging sites by feral hogs in the Sierra Nevada.

ECOLOGY. Grows on a variety of dry soils in the Californian Sierra Nevada and inner coastal ranges on foothills, sandy chaparral, valleys, and slopes below 5,000 ft (1,500 m) in elevation. Intermediate in shade tolerance. Good seed crops produced every five to seven years; gravity and scrub-jays are primary dispersers. Fire plays critical role in maintaining chaparral and woodland habitats where these trees occur. Resistant to sudden oak death disease.

CLIMATE CHANGE. Vulnerability is currently considered to be low.

CONSERVATION STATUS. Least concern.

branchlet with male inflorescence

bark

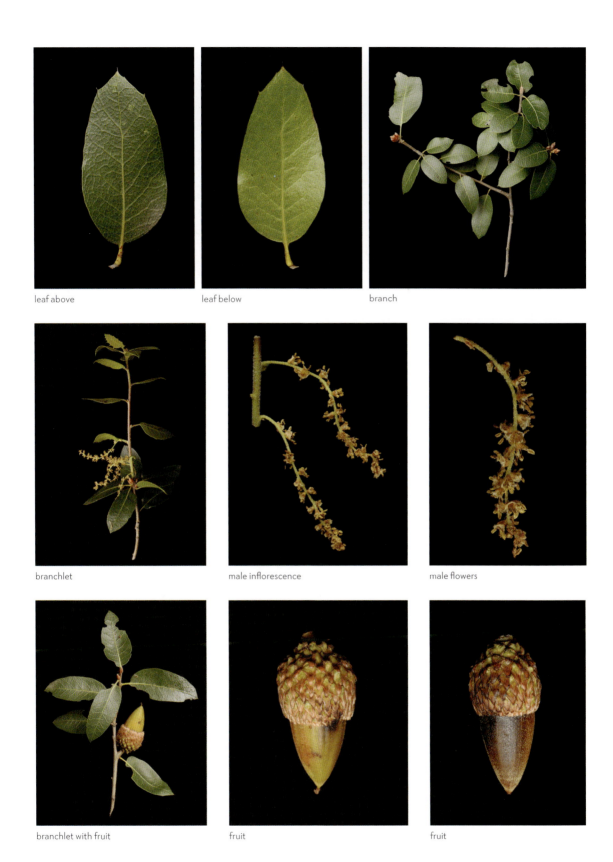

FAMILY FAGACEAE • 597

Family Betulaceae

The family Betulaceae is small, containing only six genera and a little over 150 species. The filberts (formerly in family Corylaceae) are also included. All the members of the Betulaceae are similar in possessing leaves with margins that have two levels of serrations as well as separate male and female flowers arranged in hanging clusters called catkins. These dangling catkins have evolved to facilitate the transfer of pollen between flowers by the wind. Most species in the Betulaceae are native to northern, cool, temperate habitats, but some occur in the mountains of Central and South America. Thirteen species in five genera are common trees in North America.

GENUS ALNUS

And always there is the reflection on the undersides of this Alder's light canopy, of water, running, or windwhipped, or troubled into concentric ripples where a big fish has plopped....

—Donald Culross Peattie on *Alnus rubra* in *A Natural History of North American Trees*

The genus *Alnus* is made up of thirty-five species that are distributed around the world in the cooler northern Temperate Zone and at high elevations in tropical America. The trees are usually found along streams and in wet areas. They have evolved a symbiotic relationship with specialized bacteria that fix nitrogen in the roots and greatly add to the fertility of the soils in the forest communities where they are found. Four native species of *Alnus* are common trees in North America.

Speckled Alder
Alnus incana (L.) Moench
THINLEAF ALDER, GRAY ALDER

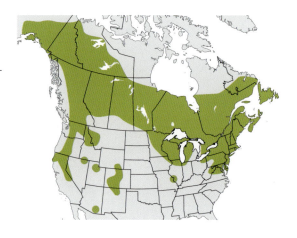

Speckled alder is a small tree native to the northern regions of North America growing in bottomlands, swamps, and lake shores. It readily colonizes wet habitats forming dense thickets. Two subspecies are recognized.

DESCRIPTION. A small tree or large shrub with clump-forming habit, growing 26 ft (8 m) tall with single or multiple trunks and open crowns. Bark is smooth, gray with warty, horizontal lenticels and reddish-brown twigs. Leaves are simple, alternate, ovate, widest below the middle, wavy-lobed, thick, matte green with veins sunken above, whitish and hairy with prominent ladder-like veinlets below, margins doubly serrate, 2–4 in (5–10 cm) long, and 1.2–3 in (3–7.5 cm) wide. Trees are monoecious producing male and female flowers on the same plant. Male flowers are produced in catkins in winter, 0.4–1 in (1–2.5 cm) long, by early spring, drooping catkins elongate to 1.6–2.9 in (4–7.5 cm) long; young female flowers are arranged in erect oval, and short-stalked catkins, 0.24 in (6 mm) long. Fruits are woody cone-like clusters of samaras, oval, blackish, 0.47–0.59 in (1.2–1.5 cm) long; samaras are tiny, round with very narrow wings.

TAXONOMIC NOTES. Subspecies *tenuifolia* (thinleaf alder) is primarily in western North America in Rocky Mountains, arborescent, leaf margins double toothed, blade rusty below; ssp. *rugosa* (speckled alder) is primarily in eastern North America, more shrubby, leaf margins coarsely single-toothed, blade white green below.

USES AND VALUE. Wood not commercially important. Few edible or medicinal uses. Used by beavers for food.

ECOLOGY. Native to the northern regions of North America. Grows United States in bottomlands, swamps and lake margins. Roots fix nitrogen; prolific seeders; and shade intolerant.

CLIMATE CHANGE. Vulnerability is currently unknown. Immediate assessment is recommended.

CONSERVATION STATUS. Least concern.

leaf above

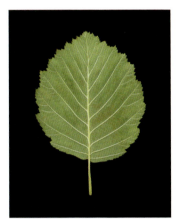
leaf below

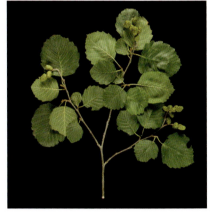
branch

mature female inflorescence

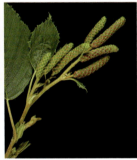
branchlet with immature male inflorescence/catkins

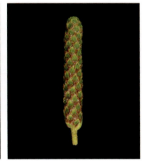
immature male inflorescence/catkins

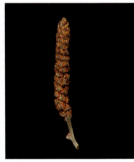
mature male inflorescence/catkins

bark

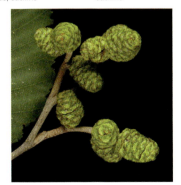
branchlet with immature infructescence

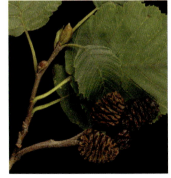
branchlet with mature infructescence

FAMILY BETULACEAE • 599

White Alder
Alnus rhombifolia Nutt.
CALIFORNIA ALDER

White alder is a deciduous tree native to the northwestern United States growing in chaparral, mixed conifer forest, and riparian woodlands on moist to wet soils.

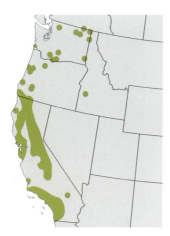

DESCRIPTION. A deciduous tree growing 49–82 ft (15–25 m) tall with a straight trunk and rounded, open crown. Twigs are brown, thin, becoming silver green with age. Bark is silvery gray and smooth, mature texture rough and scaly. Leaves are simple, alternate, rhombic to narrow-elliptic, dark green above, yellow green and sparsely pubescent below, margins finely serrate, 1.6–4 in (4–10 cm) long. Trees are monoecious producing male and female flowers on the same plant. Male flowers are arranged in catkins, yellow, in clusters of two to seven, 1.2–4 in (3–10 cm) long; Female flowers are in conelike catkins, 0.39–0.87 in (10–22 mm) long. Fruits are woody, conelike clusters of samaras, 0.5 in (1.2 cm) long; samaras with flat wings.

USES AND VALUE. Wood not commercially important. Cultivated as an ornamental. Bark used to make a red dye or tea and is astringent and emetic. Flowers and inner bark are edible, although with bitter taste. Able to fix nitrogen in soils due to its unique relationship with nitrogen-fixing bacteria (*Frankia* spp.).

ECOLOGY. Grows in chaparral, mixed conifer forest, and riparian woodlands of the Northwest often along streambanks on moist to wet soils. Intermediate in shade tolerance. Prolific seeder. Because of its nitrogen-fixing capabilities, able to inhabit infertile sites. Pests include borers and tent caterpillars that feed on leaves.

CLIMATE CHANGE. Vulnerability is significant but may have the capacity to adapt to changing conditions in the future. Ongoing monitoring is recommended.

CONSERVATION STATUS. Least concern.

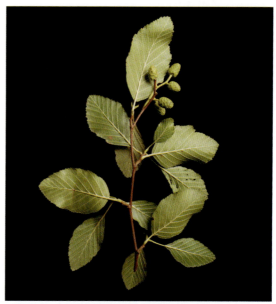
branch below

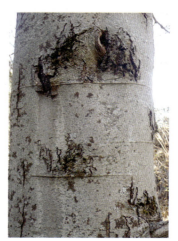
bark

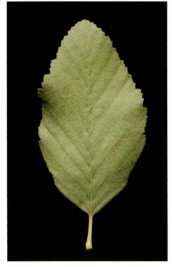
leaf above

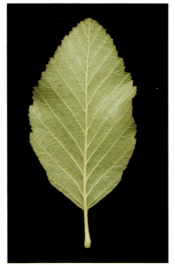
leaf below

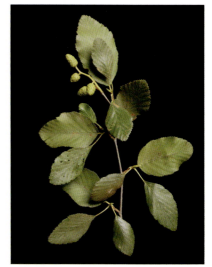
branch above

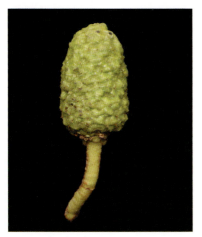
immature female inflorescence

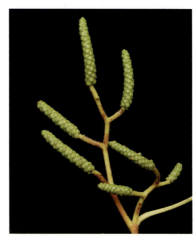
immature male inflorescence

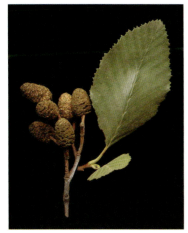
branchlet with infructescence

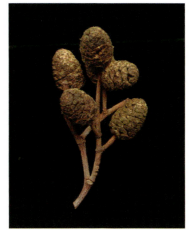
infructescence

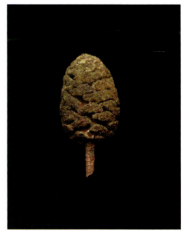
fruit cluster

FAMILY BETULACEAE • 601

Red Alder
Alnus rubra Bong.

Red alder is a species of moderately sized tree growing in moist flood plains, disturbed montane forests, and wooded hills along the Rocky Mountains and in western Canada. It is the tallest of North American alders,

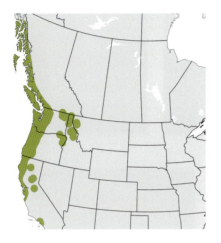

DESCRIPTION. A deciduous tree growing 66–98 ft (20–30 m) tall, with clear trunk, cylindrical crown, and a wide shallow root system. Bark is gray and smooth, darkening and breaking into shallow rectangular plates with age, often covered with lichens. Leaves are simple, alternate, ovate to elliptic, leathery, dark green above, paler and glabrous to sparsely pubescent below, base broadly cuneate to rounded, margins strongly revolute, deeply doubly serrate or crenate, with distinct larger secondary teeth, 2.4–5.9 in (6–15 cm) long. Trees are monoecious producing male and female flowers on the same plant, blooming before new growth in early spring. Catkins develop the season before flowering. Male flowers are produced in red, pendulous catkins in clusters of two to six, 1.4–5.5. in (3.5–14 cm) long; female flowers are in erect catkins in clusters of three to eight. Fruits are woody, conelike clusters of samaras, ovoid to nearly globose, 0.4–1.4 in (1–3.5 cm) long; on peduncles 0.04–0.39 in (1–10 mm) long; samaras irregularly ovate or elliptic, with wings much narrower than body.

USES AND VALUE. Wood commercially important in Pacific Northwest. Used for veneer, cabinetry, paneling, furniture, and wooden novelties as well as for pulp and fuel. Red dye made from inner bark, which also produces chemical similar to aspirin. Flowers, inner bark, and sap are edible. Medicinally used by Native North Americans. Beaver, black-tailed deer, and meadow mice feed on bark and leaves. Valuable pioneer species because of symbiotic relationship with nitrogen-fixing bacteria.

ECOLOGY. Grows along Pacific Coast from southeastern Alaska to southern California in lowland forests and streamsides. Prefers deep well-drained alluvial loams or sandy loams. Shade intolerant. Prolific seeder, producing large crops every four years. Roots fix nitrogen that enriches soil, improving growing conditions for other successional species. Generally free of insect and fungal pests.

CLIMATE CHANGE. Vulnerability is currently considered to be low.

CONSERVATION STATUS. Least concern.

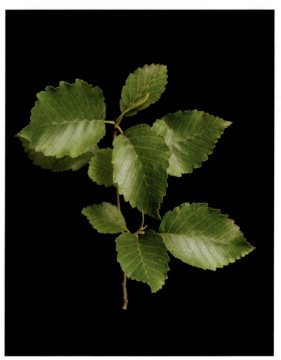

branch

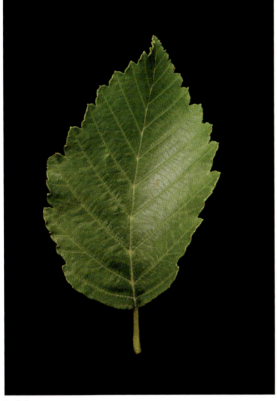
leaf above

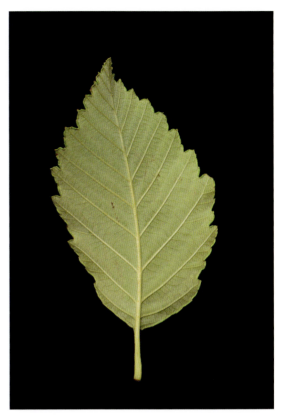
leaf below

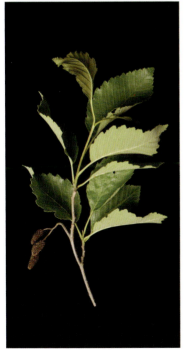
branch with infructescence

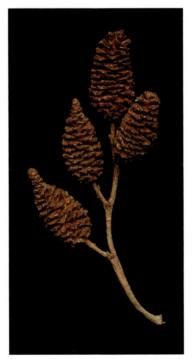
multiple infructescence

single infructescence

FAMILY BETULACEAE • 603

Green Alder
Alnus viridis (Chaix) DC.
SITKA ALDER

Green alder is a species of large shrub or small tree growing in gravelly screes, shallow stony slopes, and open areas throughout the Northern Hemisphere. Some botanists may not consider it a true tree, but it is included here for completeness. Three subspecies are recognized.

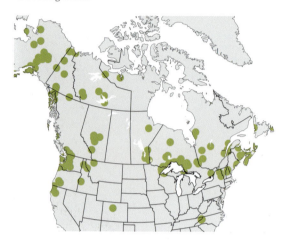

DESCRIPTION. A deciduous short lived, large shrub or small tree growing 10–39 ft (3–12 m) tall with a shallow root system and sprouts prolifically from roots and stump. Twigs are sweet scented when young. Bark is smooth and gray. Leaves are deciduous, alternate, simple, ovoid, shiny yellowish green above, light green below, margins finely to densely to doubly serrate, 1.6–4.6 in (4–12 cm) long, 0.8–2.4 in (2–6 cm) broad. Trees are monoecious producing male and female flowers on the same plant, blooming in spring after leaves emerge. Male flowers are in pendulous catkins, 1.6–3.1 in (4–8 cm) long in clusters of two to four; female flowers are in catkins clusters of two to ten, each 0.4 in (1 cm) long and 0.3 in (0.7 cm) broad. Fruits are woody, conelike clusters of samaras, ovoid to ellipsoid, peduncles relatively long and thin; samaras small, 0.04–0.08 in (1–2 mm) long, light brown, elliptic to obovate, with wings wider than body.

TAXONOMIC NOTES. Subspecies *crispa* is shrubby with leaf margins finely serrated; ssp. *fruticosa* has firm blades with margins densely serrate, occurring from sea level to 1,640 ft (500 m) in elevation; ssp. *sinuata* has thin flexible blades with margins doubly serrate, occurring 656 to 8,530 ft (200–2,600 m) in elevation.

USES AND VALUE. Wood not commercially important. Catkins are edible when cooked but with taste bitter. Bark is astringent and emetic. Valuable as pioneer species because of its symbiotic relationship with nitrogen-fixing bacteria. Plant sometimes consumed by moose and caribou as well as small mammals, such as muskrats, beavers, and hares. Buds, seeds, and catkins are consumed by birds, including the white-tailed ptarmigan.

ECOLOGY. Grows along streams and lakes as well as rocky screes, shallow stony slopes, and open areas in sandy moist soils. Shade intolerant.

CLIMATE CHANGE. Vulnerability is currently unknown. Immediate assessment is recommended.

CONSERVATION STATUS. Least concern.

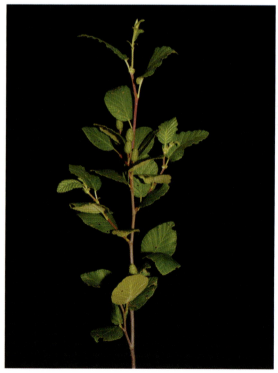

branch

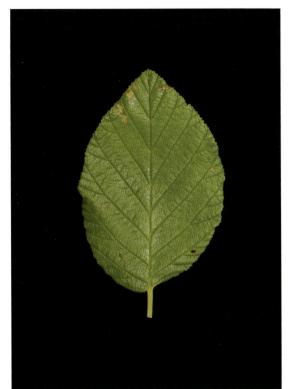
leaf above

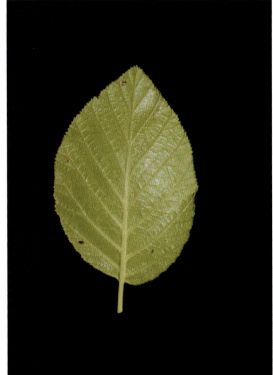
leaf below

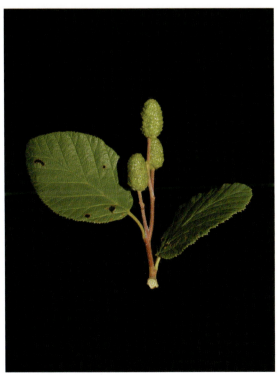
branchlet with catkins

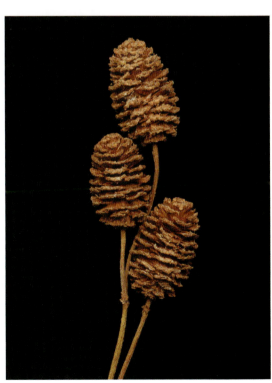
infructescence

FAMILY BETULACEAE • 605

GENUS BETULA

Wherever it grows the Paper Birch delights in the company of Conifers and in the presence of water; it loves a white and rushing stream; it loves a cold clear lake where its white limbs are reflected.

—Donald Culross Peattie on *Betula papyrifera* in *A Natural History of Trees of Eastern and Central North America*

The genus *Betula* contains up to sixty species native to cooler regions, including boreal habitats, of North America, Asia, and Europe. These pioneer species are early inhabitants of disturbed areas and grow quickly. The characteristic peeling bark is distinguished by horizontally oriented marks called lenticels. Six native species of *Betula* are common trees in North America. (See p. 743 for leaf shapes of six species of *Betula*.)

Yellow Birch
Betula alleghaniensis Britton

Yellow birch is a medium-sized to large deciduous tree native to eastern North America. The bark is smooth, yellowish bronze with black scars, and flakes off in horizontal strips. The twigs and inner bark are aromatic with the taste of wintergreen.

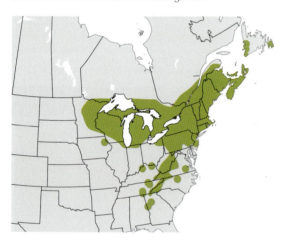

DESCRIPTION. A long-lived (up to 300 years) deciduous tree that grows to 98 ft (30 m) in height with irregularly rounded crown and clear stem with shallow wide-spreading root system. Bark is dark reddish brown in young trees, and yellowish or grayish, smooth, and exfoliating on older trees. Leaves are alternate, simple, narrow, ovate, dark green above, yellow green and fine pubescence on veins below, margins doubly serrate, base rounded, 2.4–4 in (6–10 cm) long, and 1.2–2.2 in (3–5.5 cm) wide. Trees are monoecious producing male and female flowers on the same plant, blooming in late spring. Male flowers are arranged in hanging catkins, reddish brown, 2–3 in (5–7 cm) long; female flowers are arranged in ovoid catkins, 0.6–1.2 in (1.5–3 cm) long. Fruits are woody, conelike clusters of samaras, ovoid, erect, 0.75–1.5 in (1.75–3.3 cm) long; samaras are 0.6–1.2 in (1.5–3 cm) long, tan, with wings narrower than body of fruit.

USES AND VALUE. Wood commercially important. Used for veneer, high-grade lumber, pallet lumber, pulp, and fuel. Inner bark and sap are palatable; sap with strong taste of wintergreen is made into satisfying drink. Medicinal uses are limited. Native North Americans made tea from bark used as emetic. Provides browse and food for moose, white-tailed deer, snowshoe hare, squirrels, and porcupine. Spring and summer source of nutrients for yellow-bellied sapsucker, redpoll, and other songbirds.

ECOLOGY. Grows along mountain streambanks, and on moist, often rocky, forested slopes. Intermediate in shade tolerance. Prolific seeder, producing crops annually with especially good crops at irregular intervals; wind is main dispersal agent. Windfirm on deep soils, susceptible in shallow soils. Very thin bark easily damaged by fire. Cankers, twig blight, and crown dieback caused by fungus *Nectria galligena*. Most serious insect pest is bronze birch borer (*Agrilus anxius*).

CLIMATE CHANGE. Vulnerability is currently considered to be low.

CONSERVATION STATUS. Least concern.

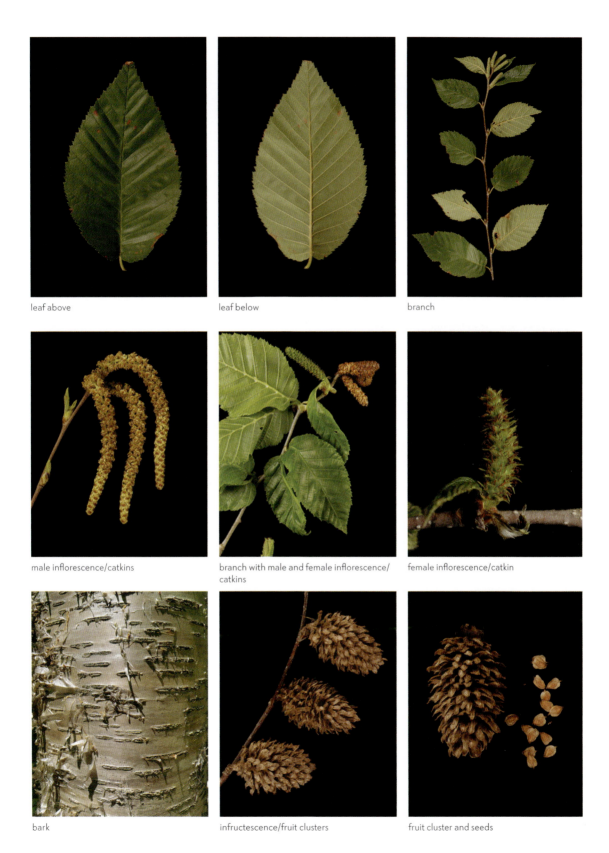

Sweet Birch
Betula lenta L.
BLACK BIRCH, CHERRY BIRCH

Sweet birch is native to eastern North America with bark, unlike most birches, dark brown, rough, and cracked irregularly into plates. When scraped, twigs smell of wintergreen and this tree has been a primary source of this essential oil.

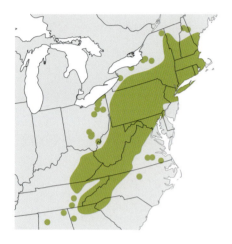

DESCRIPTION. A moderate-lived, deciduous, straight-trunked tree, with dense crown growing up to 80 ft (26 m) tall. Bark is reddish brown or black on young trees and grayish black on older trees, with long scaly plates. Leaves are alternate, simple, ovate, dark shiny green above, pale below with finely pubescent veins, margins serrate, base cordate, tip acute, 2–4 in (5–10 cm) long, with robust petiole. Trees are monoecious producing male and female flowers on the same plant, blooming in mid-spring. Male flowers are arranged in green catkins, 0.8–1 in (2–2.5 cm) long, borne near the ends of twigs; female flowers are arranged in upright, greenish red catkins, 0.5–0.8 in (1.25–2 cm) long. Fruits are woody, conelike clusters of samaras, 1–1.5 in (2.5–3.75 cm) long; samaras are brown, with small winged nutlets.

USES AND VALUE. Wood commercially important. Used for veneer, furniture, cabinets, finish trim, pallets, pulp, and fuel. Inner bark and sap are palatable; sap with strong taste of wintergreen is into satisfying drink and was source of flavoring for birch beer. Essential oil distilled from bark is anti-inflammatory, analgesic, and used to treat rheumatism and bladder infections. Larval host for green comma (*Polygonia faunus*) butterfly.

ECOLOGY. Grows in rocky forested coves and mountain slopes in hardwood forests in Appalachian Mountains. Good seed crops produced every two years; winged fruits dispersed by wind. Shade intolerant. Susceptible to ground fires due to thin bark. Susceptible to canker caused by *Nectria*. Major insect pest is gypsy moth (*Lymantria dispar*).

CLIMATE CHANGE. Vulnerability is currently considered to be low.

CONSERVATION STATUS. Least concern.

bark

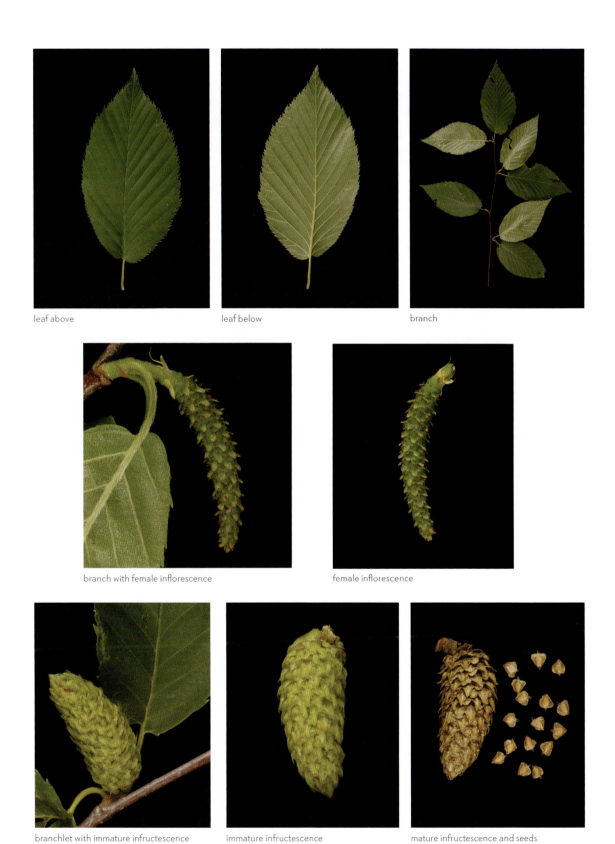

FAMILY BETULACEAE • 609

River Birch
Betula nigra L.

River birch is a deciduous tree commonly found in swamps and floodplains throughout its native range in the eastern United States. Unlike other birches, it produces its fruits in spring.

DESCRIPTION. A moderate-lived, deciduous, rapid-growing tree that grows up to 80 ft (26 m) tall with trunk that often forks into multiple stems 20–23 ft (6–7 m) from the ground. Crown is broad and rounded. Bark is smooth and rusty colored; older trees horizontally exfoliate and are coarsely scaly. Leaves are alternate, simple, triangular to ovate, green, shiny above, pale and fuzzy below, margins doubly serrate, base broadly pointed, 1.5–3 in (3.8–7.6 cm) long. Trees are monoecious producing male and female flowers on the same plant, blooming in mid-spring. Male flowers are arranged in reddish green catkins, positioned near end of twigs, 2–3 in (5–7.6 cm) long; female flowers are in upright, light green catkins, 0.25–0.5 in (0.64–1.25 cm) long. Fruits are woody, conelike clusters of samaras, reddish brown, 1–1.5 in (2.5–3.8 cm) long, samaras with hairy scales and wings.

USES AND VALUE. Wood not commercially important. Planted as ornamental and used in mine reclamation and riparian stabilization. Sap is edible and used as a sweetener. Medicinally, leaves are chewed to treat dysentery. Provides important nesting site for many birds, including waterfowl, ruffed grouse, and wild turkey, which also eat seeds.

ECOLOGY. Grows at low to medium elevations along streams, rivers, floodplains, and swamps. Seeds are dispersed by wind and water. Shade intolerant. Generally free of fungal and insect pests.

CLIMATE CHANGE. Vulnerability is currently considered to be low.

CONSERVATION STATUS. Least concern.

younger bark

older bark

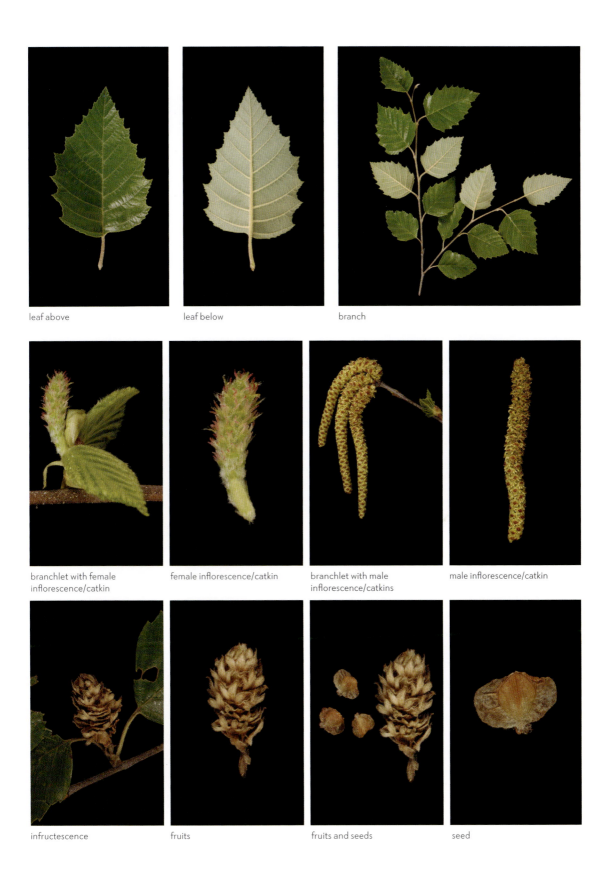

FAMILY BETULACEAE

Water Birch

Betula occidentalis Hook.

Water birch is a small tree or shrub native to wooded mountain ravines and streambanks throughout much of Canada and the western United States, where it is one of the only tree-sized members of the genus. The leaves, much like those of aspens (*Populus tremuloides*), will flutter in the slightest breeze.

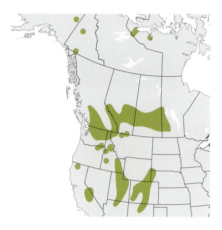

DESCRIPTION. A deciduous small tree or shrub that grows to 25 ft (8.2 m) tall often vigorously sprouting at the base with multiple trunks. Twigs lack the taste of wintergreen and are covered with conspicuous, reddish, resinous glands. Bark is dark reddish brown to bronze, smooth, close, and not readily exfoliating, with pale horizontal lenticels. Leaves are deciduous, alternate, simple, broadly ovate to rhombic-ovate, dark green above, paler below and sparsely to moderately pubescent with minute resinous glands, base truncate to rounded or cuneate, margins sharply to coarsely serrate or irregularly doubly serrate, apex acute to occasionally short-acuminate, 0.8–2.3 in (2–5.8 cm) long. Trees are monoecious producing male and female flowers on the same plant, blooming before or with the leaves. Male flowers are arranged in catkins, yellow, 2.4 in (6 cm) long; female flowers are in slender, pendulous catkins, 0.8–1.2 in (2–3 cm) long. Fruits are woody, conelike clusters of samaras, pendulous, slender, cylindrical, 0.8–1.2 in (2–3 cm) long; samaras with wings broader than the body.

USES AND VALUE. Wood not commercially important. Inner bark, leaves, and flowers are edible and used as condiment and for thickening soups and stews. Sap made into a refreshing drink or beer. Medicinally, bark serves as astringent and sedative. Provides forage, nesting sites, and thermal cover for wildlife.

ECOLOGY. Grows in moist soils of wooded mountain ravines, marshes, bogs, and streambanks throughout Canada and the western United States. Intermediate in shade tolerance and windfirm.

CLIMATE CHANGE. Vulnerability is significant but may have the capacity to adapt to changing conditions in the future. Ongoing monitoring is recommended.

CONSERVATION STATUS. Least concern.

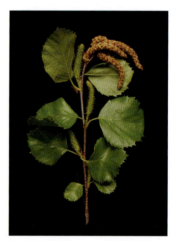

branch with inflorescence/male and female catkins

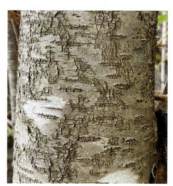

bark

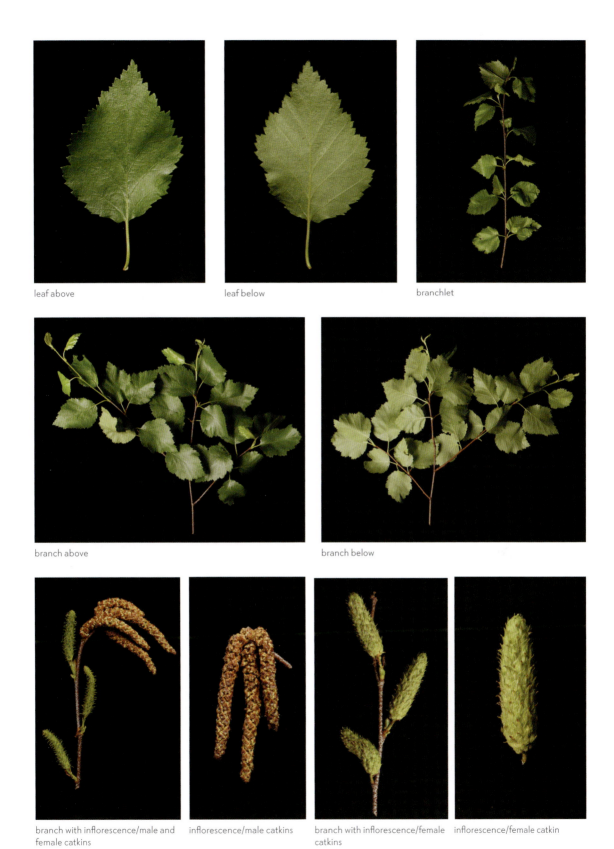

leaf above / leaf below / branchlet

branch above / branch below

branch with inflorescence/male and female catkins / inflorescence/male catkins / branch with inflorescence/female catkins / inflorescence/female catkin

FAMILY BETULACEAE • 613

Paper Birch
Betula papyrifera Marshall
WHITE BIRCH

Paper birch, also often called white birch, is native to the northeastern United States and Canada. The white and papery bark, which is durable and water resistant, was used by Native North Americas as the outer covering in the construction of birch bark canoes.

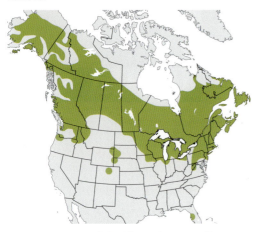

DESCRIPTION. A deciduous tree, usually single-stemmed, growing to about 70 ft (24 m) tall with irregularly rounded crown and shallow root system. Bark, one of the outstanding features of this tree, is shiny and reddish brown with lenticels when young and turns white exfoliating in large sheets when older. Leaves are simple, alternate, ovate, dark green above, yellow green with hairy veins below, turn golden in fall, apex sharp-pointed, heart-shaped at base, margins doubly serrate, 4 in (10 cm) long, and 3 in (7.5 cm) wide. Trees are monoecious producing male and female flowers on the same plant, blooming in early spring. Male flowers are arranged in pendulous catkins, hanging from tips of twigs, 4 in (10 cm) long; female flowers are green, borne in erect conelike catkins, 1–1.5 in (2.4–3.5 cm) long. Fruits are woody, conelike clusters of samaras, cylindrical, drooping, brown; samaras with wings broader than the body.

USES AND VALUE. Wood commercially important. Used for veneer, plywood, furniture, pallets, pulp and fuel. Cultivated as ornamental. Bark used by Native Americans to construct canoes. Inner bark, leaves, and flowers are edible and used as condiment and for thickening soups and stews. Sap boiled down to make a refreshing drink and fermented to make beer. Used medicinally by Native North Americans to treat skin problems. Preferred browse for deer and moose; seeds are important food for many birds, including the redpoll, pine siskin, and chickadee. Ruffed grouse consumes male catkins and buds; yellow-bellied sapsucker feeds on sap.

ECOLOGY. Grows in deciduous or mixed evergreen-deciduous forests at low to medium elevations usually in young, cut-over woodlands, where it is pioneer species. Shade intolerant. Very susceptible to fire damage due to thin and highly flammable bark. Good seed crops produced every two years; dispersed long distances by the wind. Insect pests include bronze birch borer (*Agrilus anxius*), forest tent caterpillar (*Malacosoma disstria*), birch skeletonizer (*Bucculatrix canadensisella*), birch leafminer (*Fenusa pusilla*), and birch leaf-mining sawflies (*Heterarthrus nemoratus* and *Profenusa thomsoni*).

CLIMATE CHANGE. Vulnerability is currently considered to be low.

CONSERVATION STATUS. Least concern.

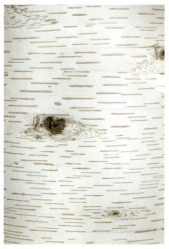

bark

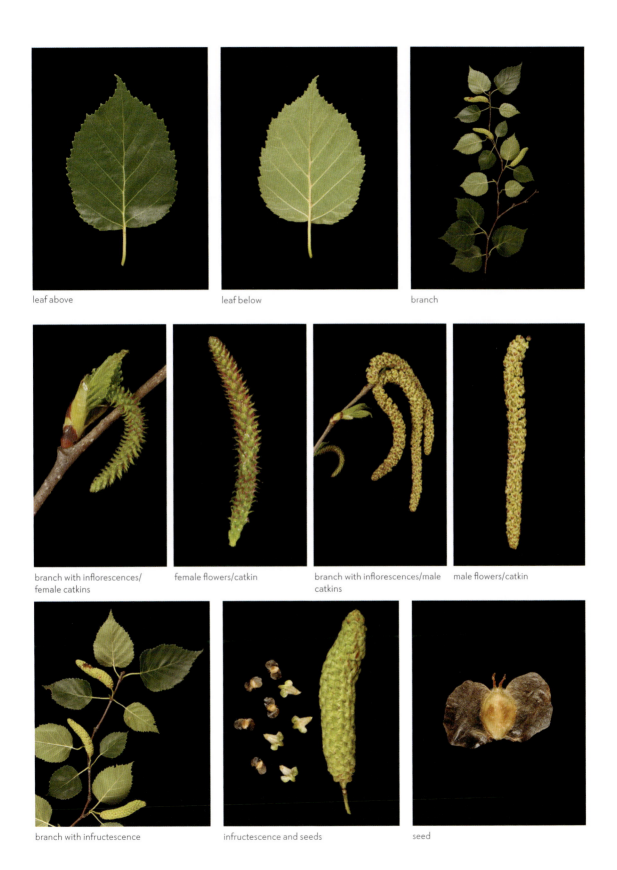

FAMILY BETULACEAE

Gray Birch

Betula populifolia Marshall

Gray birch, native to northeastern North America, grows in poor, dry, upland soils in forests and old abandoned pastures. This small deciduous tree is characterized by multiple trunks with chalky grayish-white bark and slender drooping branches.

DESCRIPTION. A short-lived, deciduous, small tree growing rapidly up to 30 ft (9 m) tall, with poorly formed stem, multiple trunks, droopy branches, irregular pyramidal crown, and shallow root system. Bark is reddish brown with many lenticels on young stems, becoming smooth grayish white on older trees. Leaves are alternate, simple, triangular, glossy green above, pale below, with elongated acuminate tip, margins doubly serrate, 2–3 in (5–7.6 cm) long. Trees are monoecious producing male and female flowers on the same plant, blooming in early spring. Male flowers are arranged in catkins near the end of twigs, 0.8 in (2 cm) long; female flowers are in upright catkins, 0.5 in (1.25 cm) long. Fruits are woody, cone-like clusters of samaras, cylindrical, hairy, 0.8 in (2 cm) long; samaras two-winged.

USES AND VALUE. Wood not commercially important. Sometimes used for pulp and fuel. Often planted as ornamental due to tolerance of harsh growing conditions. Important for natural reforestation of disturbed sites. Inner bark used as thickener for soups and stews; sap boiled down to make refreshing drink or beer. Medicinally, applied as astringent. Larval host of eastern and Canadian tiger swallowtails, white admiral, mourning cloak, Compton tortoiseshell, and dreamy duskywing butterflies. Juncos, blue jays, titmice, chickadees, waxwings, and other birds eat flower buds and seeds.

ECOLOGY. Grows in both wet and dry habitats, rocky or sandy forests, often in very disturbed sites, and old fields, where it is a pioneer species. Prolific seeders. Shade intolerant. serve as pioneers in barren zones (including old mine sites). Highly susceptible to snow and ice damage. Attacked by a variety of fungal and insect pests.

CLIMATE CHANGE. Vulnerability is currently considered to be low.

CONSERVATION STATUS. Least concern.

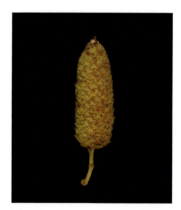

infructescence

bark

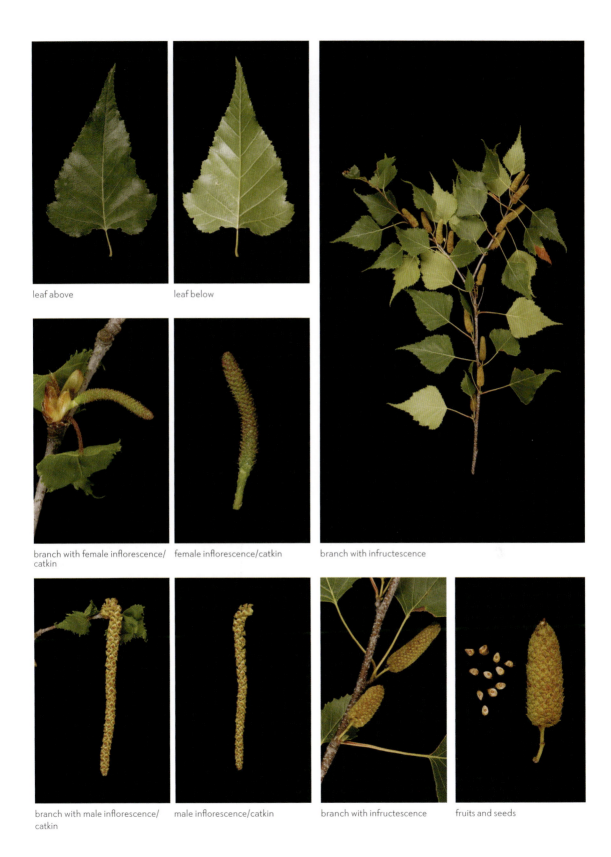

leaf above

leaf below

branch with female inflorescence/catkin

female inflorescence/catkin

branch with infructescence

branch with male inflorescence/catkin

male inflorescence/catkin

branch with infructescence

fruits and seeds

FAMILY BETULACEAE • 617

GENUS CARPINUS

[T]he smooth bark seems to be corrugated with some sort of swelling or twisting inside the wood itself, as if the life within showed itself proudly, as a young man will flex his arm in the joy of its strength.

—Donald Culross Peattie on *Carpinus caroliniana* in *A Natural History of Trees of Eastern and Central North America*

The genus *Carpinus* contains about forty species, which are native to the cooler regions of North America, Asia, and Europe, although one species is found in Mexico and Central America. The fruits, which are nuts, are embedded in a leaflike bract at the ends of branches. The exceptional hardness of the wood and the smooth sinewy bark give some of these trees the common name "ironwood." One native species of *Carpinus* is a common tree in North America.

American Hornbeam
Carpinus caroliniana Walter

American hornbeam is a small tree native to eastern North America. The smooth greenish-gray bark covering its trunk becomes ridged with age to resemble the muscles of a flexed arm. Beavers heavily use this tree for food and construction material.

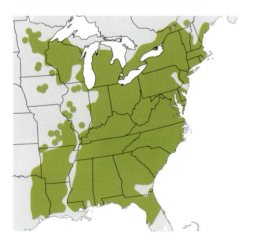

DESCRIPTION. A moderate-lived deciduous large shrub or small tree growing to 16–40 ft (5–13 m) tall, with twisted, fluted stem dark gray to blue resembling the muscles of a flexed arm. Twigs are red to gray and hairy when young, becoming glabrous. Bark is gray to bluish gray, smooth, coarsely fluted, and musclelike. Leaves are alternate, simple, oblong to ovate, green and glabrous above, paler and glabrous to pubescent below, margins doubly serrate, 2–4.7 in (5–12 cm) long. Trees are monoecious producing male and female flowers on the same plant, blooming in mid-spring. Male flowers are arranged in yellow-green pendulous catkins, 0.8–2.4 in (2–6 cm) long; female flowers are in yellow green catkins, with hairy scales, 0.4–1 in (1–2.5 cm) long. Fruits are ribbed, brown nuts, 0.16–0.24 in (4–6 mm) long, attached to three-lobed, toothed bracts that grow in clusters, 1–4.7 in (2.5–12 cm) long, on hanging stalks.

USES AND VALUE. Wood not commercially important. Used for making handles for tools. Seeds are edible but not preferred. Inner bark used by Native North Americans as astringent. Gray squirrels, songbirds, ruffed grouse, ring-necked pheasants, bobwhite, turkey, fox, cottontails, beaver, and white-tailed deer consume buds, leaves, twigs, and seeds. Larval host or nectar source for several species of butterflies.

ECOLOGY. Grows in moist soils in woods, bottomlands, and along streams. Very shade tolerant. Good seed crops produced in five- to six-year intervals; germination rates are relatively low. Susceptible to damage from fire due to thin bark. Generally free of both insect and fungal pests.

CLIMATE CHANGE. Vulnerability is currently considered to be low.

CONSERVATION STATUS. Least concern.

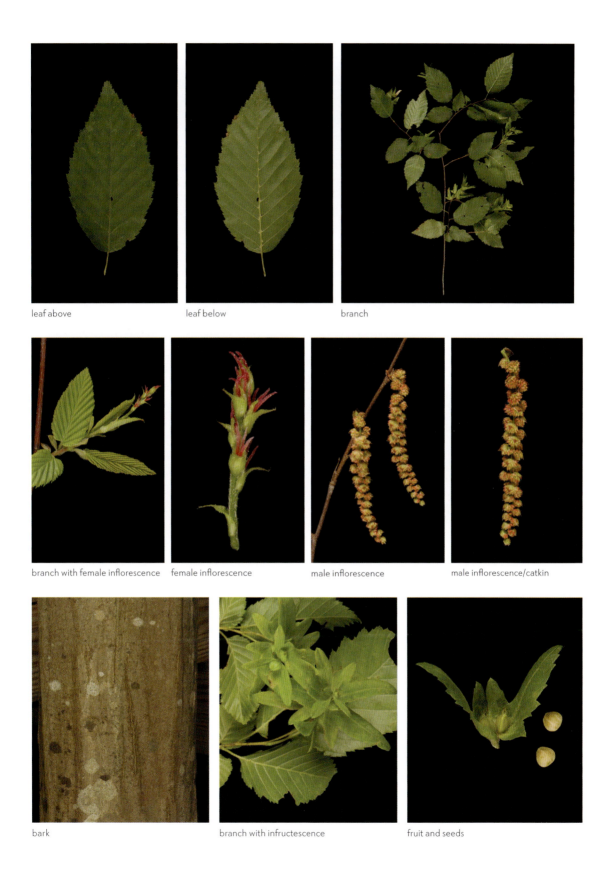

FAMILY BETULACEAE • 619

GENUS CORYLUS

The eighteen species in the genus *Corylus* are distributed in the cool northern temperate regions of Asia, Europe, and North America. The fruits are nuts that are encased in a tough husk. The trunks readily sprout new shoots from the base, and it is not uncommon for local people to "coppice" the trees to multiply the number of stems for nut production, firewood, and other uses. One native species of *Corylus* is a common small tree in North America.

Beaked Hazelnut
Corylus cornuta Marshall
WESTERN HAZEL

Beaked hazelnut is a species of large clonal shrub, sometimes a small tree, native to upland forests and thickets across Canada's lower territories and northern west and east coasts. The very flavorful fruits are edible. Two subspecies are recognized.

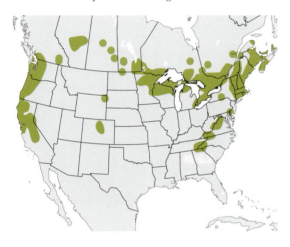

DESCRIPTION. A deciduous small tree or multistemmed shrub growing 12–20 ft (4–6 m) tall, often with low branches at the base. Twigs are glabrous to sparsely villous. Bark is smooth and gray. Leaves are simple, alternate, oblong-obovate, dark green above, paler with pubescent veins below, base broadly rounded, margins irregularly doubly serrate, 1.2–4 in (3–10 cm) long. Trees are monoecious producing male and female flowers on the same plant, blooming from late spring through summer (March–June). Male flowers are arranged in pale yellow catkins, 1.8–2.4 in (4.5–6 cm) long, in clusters of two or three; female flowers are clustered in catkins mostly hidden behind buds with extended bright red style and exposed stigma. Fruits are hazelnuts, copper-brown, 0.8 in (2 cm) broad, in clusters of two to six, and enveloped by a hard, elongated, beak-shaped and husklike involucre, ripen in late summer and early fall.

TAXONOMIC NOTES. Subspecies *californica* occurs along the Pacific coast and is distinguished by broadly elliptic leaves, acute or obtuse leaf apices, and twigs with glandular pubescence; ssp. *cornuta* occurs in remaining parts of range in eastern, central, and northern North America and is distinguished by narrowly elliptic leaves, acuminate leaf apices, and glabrous twigs.

USES AND VALUE. Wood not commercially important. Flavorful fruits are edible; Native North Americans used fire to encourage sprouting for increased hazelnut production. Bark extraction used to alleviate pain of teething in young children. Mule deer, moose, elk, and beaver sometimes consume the foliage. Seeds eaten by birds and small mammals.

ECOLOGY. Grows on mesic wooded hillsides and streambanks in coves or canyons as well as along forest margins, roadsides, and disturbed sites. Prefers moist well-drained soils, including sands, sandy loams, and gravels. Intermediate in shade tolerance.

CLIMATE CHANGE. Vulnerability is currently unknown. Immediate assessment is recommended.

CONSERVATION STATUS. Least concern.

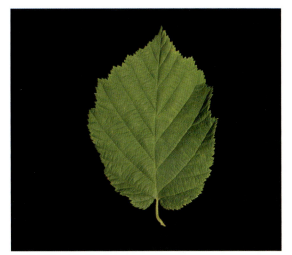
leaf above

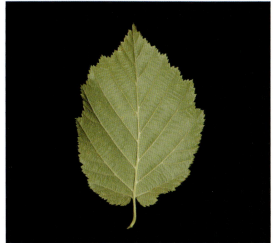
leaf below

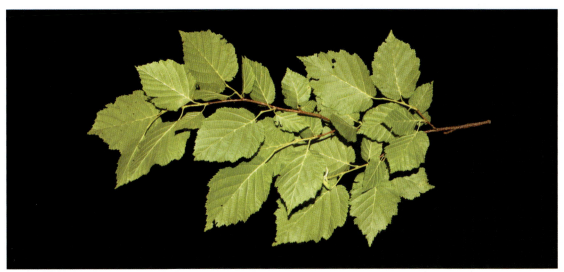
branch below

bark

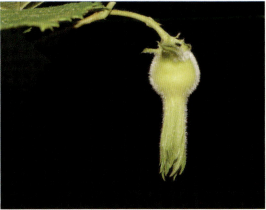
branchlet with fruit

FAMILY BETULACEAE • 621

GENUS OSTRYA

For the beauty of Ironwood is subtle, with its dainty beechen leaves which turn a soft, dull gold in autumn, and in summer shut out all the heat of the sun but only a little of the light. ... Everything about this little tree is at once serviceable and self-effacing. Such members of any society are easily overlooked, but well worth knowing.

—Donald Culross Peattie on *Ostrya virginiana* in A Natural History of Trees of Eastern and Central North America

The ten species in the genus *Ostrya* are found in Asia, China, southern Europe, and North America into Central America. These small trees, which are generally found in the understory of deciduous forests, are monoecious. The female flowers produce a bundle of nuts, each one encased inside an inflated sac, at the end of branches. One native species of *Ostrya* is a common tree in North America.

Eastern Hophornbeam
Ostrya virginiana (Mill.) K. Koch
AMERICAN HOPHORNBEAM

Eastern hophornbeam is a medium-sized understory tree native to eastern North America. Tree trunks are covered in gray-brown bark that flakes off in shaggy, narrow plates. The nuts are enclosed in inflated sacs, resembling hops clustered at the ends of twigs.

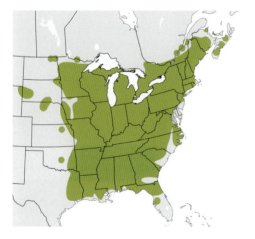

DESCRIPTION. A short-lived deciduous tree growing to 49 ft (15 m) tall with trunk often divided, ascending branches, and rounded crown. Twigs are reddish brown. Bark is scaly, with flaky narrow plates. Leaves are simple, alternate, oblong-ovate, yellow green above, paler below and pubescent especially along veins, margins doubly serrate, base unequal and cordate, apex tapering, 2.4–4 in (6–10 cm) long, and 1–1.5 in (2.5–3.75 cm) wide. Trees are monoecious producing male and female flowers on the same plant, blooming in mid-spring and fruiting in mid-summer. Male flowers are arranged in slender, pendulous catkins, green turning reddish brown, 1.5–2.5 in (4–6 cm) long, in clusters of three; female flowers are arranged in hanging catkins, light green, 0.5 in (1.25 cm) long. Fruits are pale-green nutlets with bristly hairs at base, each enclosed in an inflated sac clustered in a conelike arrangement at tips of twigs, 1.2–2 in (3–5 cm) long.

USES AND VALUE. Wood not commercially important. Used locally for tool handles and long bows because of density and durability. Name "hophornbeam" derived from the conelike clusters of flowers and fruits, which in spring and summer look like hops. No parts of trees are edible. Medicinally, bark is used as astringent, blood tonic, and haemostatic. Buds and catkins provide food for numerous birds and mammals, especially ruffed grouse, sharp-tailed grouse, wild turkey, bobwhite, ring-necked pheasant, purple finch, rose-breasted grosbeak, downy woodpecker, red and gray squirrels, cottontails, and white-tailed deer.

ECOLOGY. Grows primarily in rich woodlands, slopes, and ridges on a wide variety of well-drained, limestone soils. Shade tolerant. Seeds are light in weight and dispersed by wind and water. Relatively free of insect and fungal pests.

CLIMATE CHANGE. Vulnerability is currently considered to be low.

CONSERVATION STATUS. Least concern.

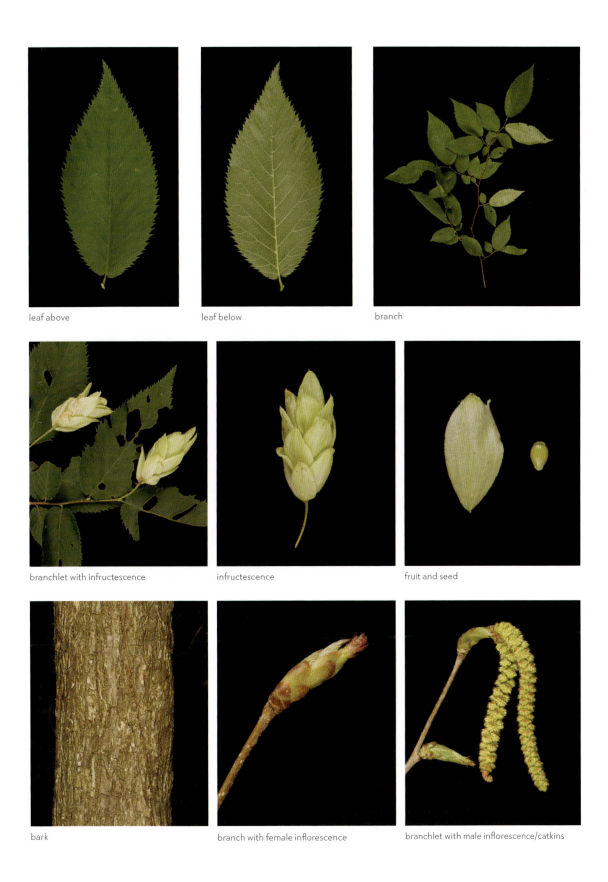

FAMILY BETULACEAE • 623

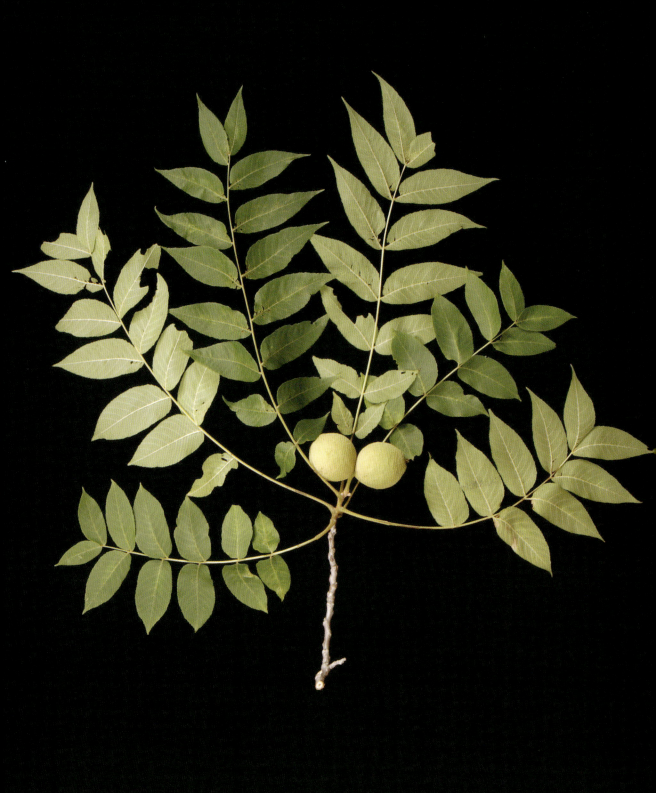

Family Juglandaceae

Another small family in the order Fagales is the walnut family, the Juglandaceae, which contains only fifty-nine species distributed across eight genera. The members of this family have always been recognized as close evolutionary relatives, but their position in the plant tree of life was not always clear. Early botanists thought they may be related to the orange family or witch-hazels, but DNA evidence indicates their evolutionary relationship to the oaks and birches. Members of the Juglandaceae are large trees that have separate male and female flowers present on the same tree and are wind pollinated. To ensure cross-fertilization among trees rather than within the same tree, the male and female flowers of a single tree open at different times over the course of a few days. Cross-fertilization prevents inbreeding and provides the genetic variation upon which natural selection may act. Two genera and eight species are common trees in North America.

GENUS CARYA

But Hickory fights back towards survival in its own stubborn way. Like backwoods children flourishing, the seedlings can come up through dense shade. So Hickory is a "pushing" species, able to succeed other hardwoods in the ecological course of events, even to succeed itself, generation after generation, on the same land.

—Donald Culross Peattie on *Carya glabra* in *A Natural History of Trees of Eastern and Central North America*

The twenty-five or so species in the genus *Carya* are found in Asia (including China and India), North America, and Mexico. Similar to fruits of members of the Betulaceae, those of *Carya* species are nutlike and encased in a tough skin or husk that splits open at maturity. The fruits are edible. The wood of many species is very hard and used for tool making and fuel. Six native species of *Carya* are common trees in North America. (See p. 743 for leaf shapes of six species of *Carya*.)

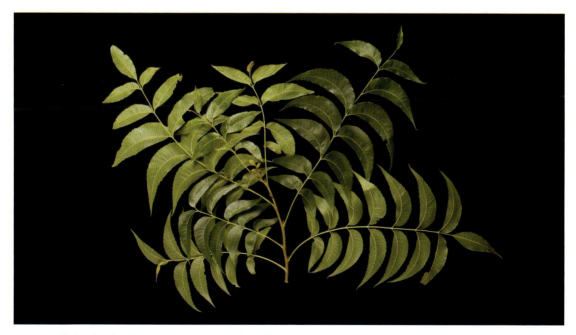

OPPOSITE Black walnut (*Juglans nigra*). **ABOVE** Pecan (*Carya illinoinensis*).

Water Hickory
Carya aquatica (F. Michx.) Elliott
BITTER HICKORY, SWAMP HICKORY

Water hickory is a large deciduous tree native to the southeastern United States that grows in swamps and along riverbanks on wet or saturated soils. It is a larval host for luna moths, funeral daggers, and giant regal moths.

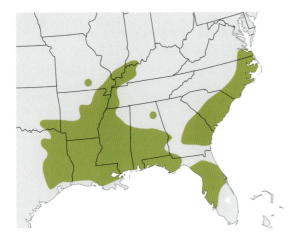

DESCRIPTION. A large deciduous tree growing to 95–115 ft (30–38 m) tall, with a straight and clear trunk, slender and upward-leaning branches, and a shallow wide-spreading root system. Twigs are ruddy brown or black and villous, becoming glabrous with age. Bark is ashy gray brown and exfoliates into long strips or broad plates with age. Terminal buds are dark, oblong, and yellow-scaly, with valvate bud scales. Leaves are alternate, pinnately compound, 15.8–23.6 in (40–60 cm) long, with nine to eleven leaflets on short petioles, each leaflet 2.5–5.5 in (7–15 cm) long, margins serrate to entire, dark green above and villous, paler below and villous along midrib near base, glabrous between veins. Trees are monoecious producing male and female flowers on the same plant, blooming in spring. Male flowers are arranged in yellow-green catkins, 8.3 in (21 cm) long, on villous stalks; female flowers are inconspicuous, yellow green, and angled. Fruits are brown nuts, covered with thin four-winged husks; nuts conspicuously flattened, 0.6–1.2 in (1.5–3 cm) long.

USES AND VALUE. Wood not commercially important. Used for fuel. Seeds are edible and very bitter. No known medicinal uses. Squirrels, feral hogs, and other mammals sometimes feed on nuts. Provide cover and nesting sites for birds and mammals. Larval host for the luna moth *(Actias luna)*, funerary dagger *(Acronicta funeralis)*, and regal moth *(Citheronia regalis)*.

ECOLOGY. Grows in swamps, floodplains, and on riverbanks in wet or saturated soils. Intermediate in shade tolerance. Prolific seeders, producing good crops most years; dispersal primarily by water, particularly floodwaters. Insect pests are limited, include living-hickory borer *(Goes pulcher)*. Fungal pests are few; heart rot may occur after disturbance. Mistletoe *(Phoradendron serotinum)* is common parasite in some areas.

CLIMATE CHANGE. Vulnerability is significant but has reasonable probability of persistence in the future. Ongoing monitoring is recommended.

CONSERVATION STATUS. Least concern.

fruit

bark

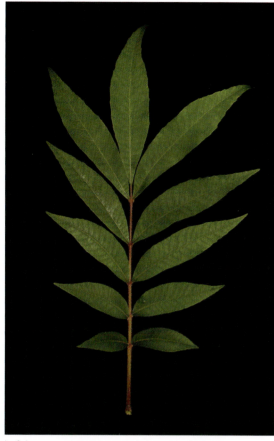
leaf above

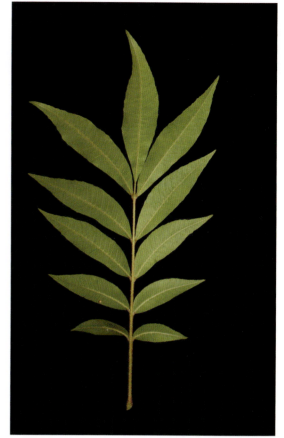
leaf below

branch

Bitternut Hickory

Carya cordiformis (Wangenh.) K. Koch

Bitternut hickory, native to the eastern United States, produces inedible, extremely bitter fruits and seeds. Native Americans use its hard durable wood for making bows.

DESCRIPTION. A moderate-lived (to 200 years) deciduous tree growing up to 98 ft (30 m) tall with clear trunk, open crown, and dense root system with prominent taproot. Bark is thin and smooth on young trees, becoming shallowly ridged at maturity. Leaves are alternate, pinnately compound, 7–10 in (17.75–25.5 cm) long, with seven to eleven lanceolate leaflets, each 4–6 in (10–15 cm) long, margins serrate, dark yellow green above, pale with rusty pubescence below. Trees are monoecious producing male and female flowers on the same plant, blooming in mid-spring. Male flowers are arranged in yellowish green catkins, 3.1–4 in (8–10 cm) long, pendulous, in clusters of three, open before the female flowers; female flowers are short, 0.51 in (13 mm) in diameter, four-angled on a terminal spike. Fruits are conical nuts, covered with yellowish-green husks, 1–1.5 in (2.5–3.75 cm) long, either solitary or in clusters of two or three.

USES AND VALUE. Wood commercially important. Used for furniture, paneling, flooring, pallets, tool handles, ladders, pulp, and fuel (especially for smoking fish and meats). Seeds are barely edible, extremely bitter, and usually avoided. Oil from seeds was used to treat rheumatism. Wildlife feed on hickory nuts; small rodents occasionally feed on the bark.

ECOLOGY. Grows in moist mountain valleys, riverbanks, and floodplains as well as dry uplands. Shade intolerant. Produces good seed crops every three to five years with 75 percent viability; gravity and water are primary dispersal agents. Most serious fungal disease is white heart rot (*Poria spiculosa*). Insect pests include hickory bark beetle (*Scolytus quadrispinosus*). Windfirm due to deep root system. Susceptible to fire because of relatively thin bark.

CLIMATE CHANGE. Vulnerability is significant but has reasonable probability of persistence in the future. Ongoing monitoring is recommended.

CONSERVATION STATUS. Least concern.

male flower

bark

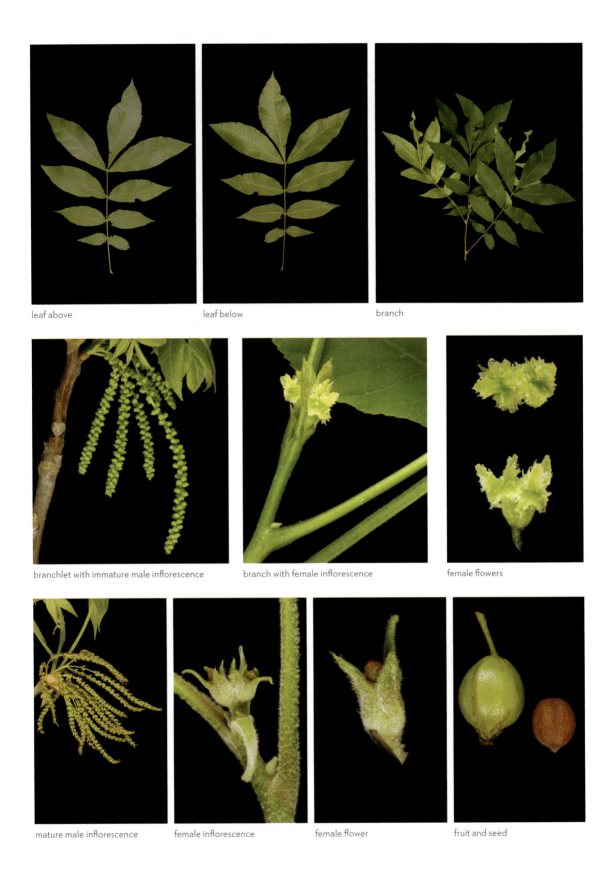

FAMILY JUGLANDACEAE • 629

Pignut Hickory

Carya glabra (Mill.) Sweet

Pignut hickory, a large tree with a forked trunk and spreading crown, grows in broadleaf woodlands throughout the eastern United States. The pear-shaped nuts ripen in the fall, are high in crude fat, and provide food for numerous species of animals.

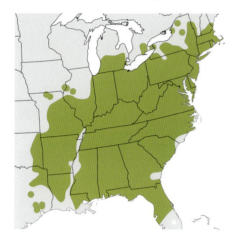

DESCRIPTION. A long-lived (up to 300 years) deciduous tree growing up to 98 ft (30 m) tall, with forked trunk, rounded spreading crown, and dense root system with prominent taproot. Bark is gray with scaly, interlaced, shaggy ridges. Leaves are deciduous, alternate, pinnately compound, 7.9–11.8 in (20–30 cm) long, with five to seven lanceolate leaflets with margins sharply serrate, green and glabrous above, paler below and variable in indument. Trees are monoecious producing male and female flowers on the same plant, blooming in spring. Male flowers are arranged in yellowish-green catkins, 2–2.7 in (5–7 cm) long, pendulous, cluster in sets of three; female flowers are clustered at ends of twigs, 0.24 in (6 mm) long. Fruits are round, flattened nuts, covered by green husks turning brown that split into four pear-shaped sections, 1–2 in (2.5–5) cm long.

USES AND VALUE. Wood commercially important. Used for lumber, pulp, and home-heating fuel. Nuts are edible but variable in quality. Sap used to make refreshing drink. No known medicinal uses. Nuts are favored by squirrels and constitute 10–20 percent of their diet. Turkey, various songbirds, black bears, foxes, rabbits, raccoons, and white-tailed deer consume nuts, flowers, bark, and leaves.

ECOLOGY. Grows in a variety of broadleaf woodlands, including dry ridgetops, slopes, and margins of floodplains. Intermediate in shade tolerance. Good seed crops produced every one or two years; germination rates 50–75 percent; seed dispersal primarily by gravity and small rodents. Windfirm but susceptible to fire damage. Most important insect predator is hickory bark beetle (*Scolytus quadrispinosus*). Infected by *Poria spiculosa* causing trunk rot.

CLIMATE CHANGE. Vulnerability is currently considered to be low.

CONSERVATION STATUS. Least concern.

bark

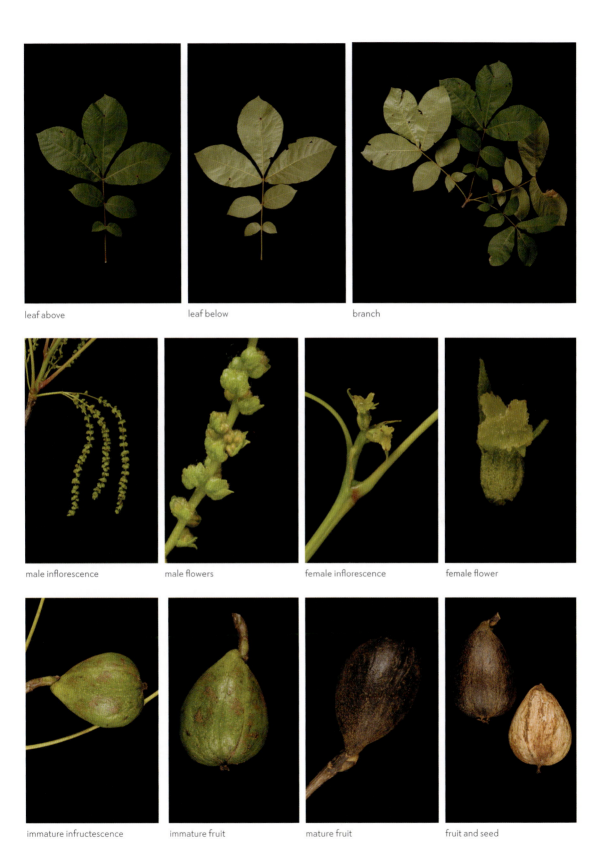

FAMILY JUGLANDACEAE • 631

Pecan

Carya illinoinensis (Wangenh.) K. Koch

The pecan is a large tree native to the Mississippi Valley west to Texas. Because the nuts are edible and delicious, it is widely planted in commercial orchards.

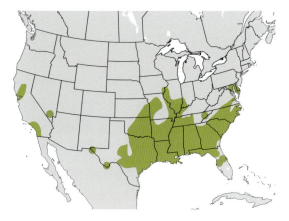

DESCRIPTION. A deciduous, potentially large tree growing to 150 ft (45 m) tall, with buttressed trunk, branching near the base, and broad oval open crown. Twigs are sturdy, reddish brown to gray, and hairy, with conspicuous lenticels. Bark is gray to brown and grooved or closely ridged. Leaves are deciduous, alternate, pinnately compound, 12–19.7 in (30.5–50 cm) long, with nine to seventeen leaflets, short-stalked, lance-shaped or obovate, curved, margins finely serrate, 3–7.9 in (7.6–20 cm) long. Trees are monoecious producing male and female flowers on the same plant, blooming from March to May. Male flowers are arranged in catkins, 4.5–7 in (12–18 cm) long, clustered in groups of three; female flowers are tiny, 0.2 in (0.6 cm) long, either solitary or in small spiky clusters. Fruits are oblong nuts, 1.2–2 in (3–5 cm) long, covered in thin, reddish brown, four-part husk that splits to base, arranged in clusters of three to twelve nuts.

USES AND VALUE. Wood commercially important. Used for veneer, furniture, cabinetry paneling, and pallets. Widely cultivated as ornamental. Source of pecan nuts, which are edible, delicious, and commercially produced in orchards. Important oil expressed from nuts. Bark and leaves used as astringent. Nuts are consumed by birds, fox and gray squirrels, opossums, raccoons, and peccaries.

ECOLOGY. Native to the Mississippi Valley west to Texas but also widely planted in commercial orchards, where it often escapes from cultivation. Grows in rich, moist, well-drained soils of streambanks and wooded bottomlands. Good seed crops produced every one to three years; seed dispersal primarily by water and small animals. Shade intolerant. Very susceptible to fire damage. Significant pests are trunk rot (caused by *Poria spiculosa*) and hickory bark beetle (*Scolytus quadrispinosus*). Many other insects feed on nuts, leaves, twigs, roots, and stem.

CLIMATE CHANGE. Vulnerability is significant but has reasonable probability of persistence in the future. Ongoing monitoring is recommended.

CONSERVATION STATUS. Least concern.

fruit (left), fruit cross section (right)

bark

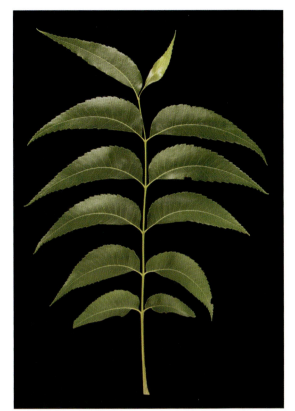
leaf above

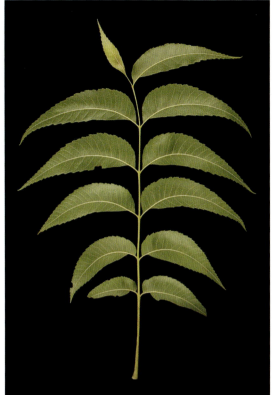
leaf below

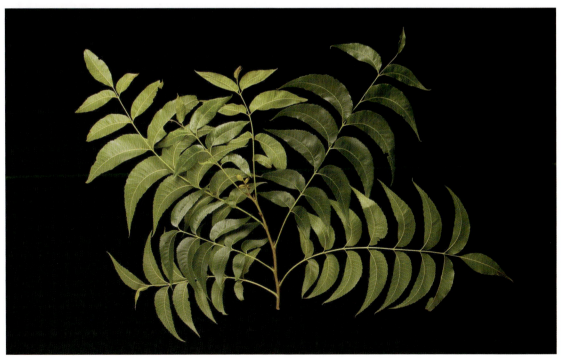
branch

FAMILY JUGLANDACEAE • 633

Shagbark Hickory

Carya ovata (Mill.) K. Koch

Shagbark hickory is native to eastern North America and grows in a wide variety of habitats from well-drained woodlands to wet bottomlands. One of the most conspicuous features in mature trees is the shaggy gray bark that exfoliates into long strips lifting away from the trunk at both the top and bottom ends.

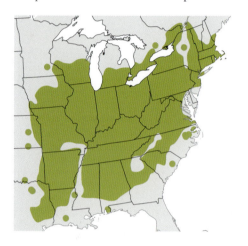

DESCRIPTION. A moderate-lived (up to 200 years) deciduous tree growing up to 125 ft (40 m) tall with a straight trunk that usually forks towards the top forming an irregularly shaped crown. Bark is smooth and gray on young trees but becomes shaggy in older specimens as it exfoliates into long, 1–3 ft (.3–1 m) strips that detach from the trunk at both ends of the strips. Leaves are alternate, pinnately compound, 7.9–14.2 in (20–36 cm) long, with five to seven leaflets, 5–7 in (12–20 cm) long, terminal leaflet largest, ovate, obovate, or elliptic, green above and paler below, finely serrate margins, tips pointed. Trees are monoecious producing male and female flowers on the same plant, blooming in spring, after leaves have appeared. Male flowers are arranged in catkins, 3.9–5.9 in (10–15 cm) long; female flowers are 0.31 in (8 mm) long, on peduncles. Fruits are compressed, brownish-white nuts, 1.2–2.4 in (3–6 cm) long, covered in thick, yellow green to brown, 4-parted husk, variable in size and shape, splitting open from top to base.

USES AND VALUE. Wood commercially important. Used for lumber, flooring, tool handles, ladders, pulp, fuel, and charcoal; preferred for smoking meats and fish. Nuts are edible and delicious. Sap tapped for refreshing drink. Many animals, such as black bears, gray and red foxes, rabbits, squirrels, eastern chipmunks, white-footed mice, mallards, wood ducks, bobwhites, and wild turkey, consume nuts. Exfoliating bark is summer roosting site for bats.

ECOLOGY. Grows in variety of habitats from dry ridgetops and slopes to wet bottomlands. Prolific seeders, producing good crops every other year; primary dispersal agents include numerous animals. Intermediate in shade tolerance. Windfirm and highly susceptible to fire damage. Fungal pests include canker rot (*Poria spiculosa*). Hickory bark beetle (*Scolytus quadrispinosus*) is most prevalent insect predator.

CLIMATE CHANGE. Vulnerability is significant but has reasonable probability of persistence in the future. Ongoing monitoring is recommended.

CONSERVATION STATUS. Least concern.

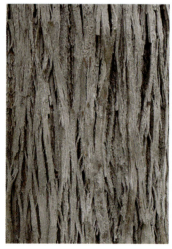

bark

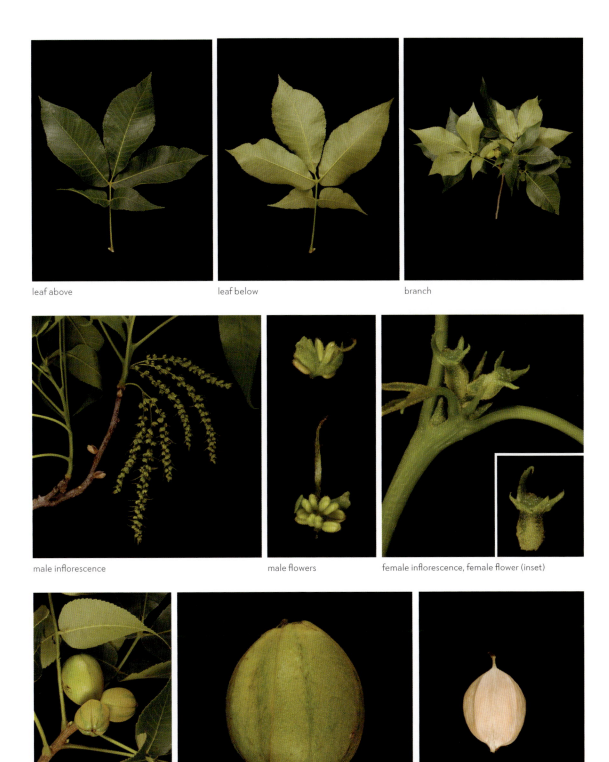

FAMILY JUGLANDACEAE • 635

Mockernut Hickory
Carya tomentosa (Poir.) Nutt.

Mockernut hickory is native primarily to the southeastern United States but reaches northward to Massachusetts. It is one of the most abundant of all hickories with nuts that are the most difficult to crack.

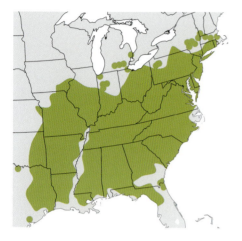

DESCRIPTION. A long-lived (up to 500 years) deciduous tree growing slowly up to 100 ft (33 m) tall, with slender trunk often swollen at the base, thick branches, open broad crown, and pronounced deep taproot. Bark is gray and smooth on young trees becoming light gray with ridges and shallow furrows on mature trees. Leaves are deciduous, alternate, pinnately compound, 9.1–14.2 in (23–36 cm) long, with seven to nine lanceolate to obovate leaflets, 4–8 in (10–20 cm) long, lowermost pair smaller than the others, shiny yellowish green and tomentose above, and paler and pubescent below, margins serrate, tip abruptly pointed. Trees are monoecious producing male and female flowers on the same plant, blooming in mid-spring. Male flowers are yellowish green, arranged in catkins, 6–8 in (15–20 cm) long, pendulous, in clusters of three; female flowers are tiny, in clusters of two to five near end of twig. Fruits are ellipsoidal, four-ribbed nuts, 1.5–2 in (3.8–5 cm) long, with a green husk turning dark reddish brown and splitting into four parts from top to middle.

USES AND VALUE. Wood commercially important. Used for lumber, tool handles, baseball bats, ladders, flooring, pulp, and fuel; preferred for charcoal, smoking fish and meats. Important in watershed protection. Nuts are edible, but difficult to crack. Sap provides ingredient for refreshing drink. Inner bark used as astringent and detergent. Nuts consumed by black bears, white-tailed deer, foxes, rabbits, beavers, white-footed mice, and especially squirrels.

ECOLOGY. Grows on dry upland woods, rocky slopes, and ridges. Good seed crops produced every two to three years; germination rates 50–75 percent; dispersed by gravity and small rodents. Moderately shade tolerant. Susceptible to fire due to thin bark. Windfirm. Generally free of diseases and pests with exception of trunk-rot fungus (*Poria spiculosa*), bark beetle (*Scolytus quadrispinosus*), hickory spiral borer (*Argilus arcuatus torquatus*), and pecan carpenterworm (*Cossula magnifica*).

CLIMATE CHANGE. Vulnerability is currently unknown. Immediate assessment is recommended.

CONSERVATION STATUS. Least concern.

bark

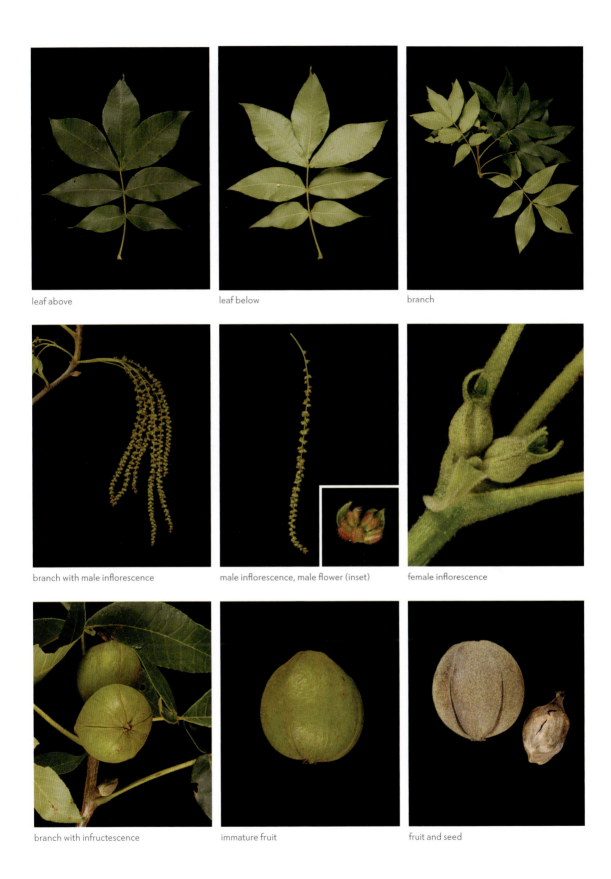

FAMILY JUGLANDACEAE • 637

GENUS JUGLANS

At all times its appearance suggests massive strength, the trunk solid and heavily furrowed, the catkins, which appear with the leaves in midspring, heavy and vivid, and the clusters of fruits in fall hard and solid on the tree.

—Donald Culross Peattie on *Juglans nigra* in *A Natural History of Trees of Eastern and Central North America*

The genus *Juglans* is made up of twenty-one species distributed around the world in eastern Europe, Asia, North America, Central America, South America, and the Caribbean. These usually large trees have long, compound leaves. The nutlike fruits are surrounded by a thick sinewy husk and woody shell that must be removed to get to the edible seeds inside. Many of the species are commonly cultivated and harvested for their wood and edible nuts. Two native species of *Juglans* are common trees in North America.

Butternut
Juglans cinerea L.
WHITE WALNUT

Butternut is a fast-growing but short-lived deciduous tree native to eastern North America. Butternut canker, a fungal disease, is rapidly decimating populations of these trees across its range.

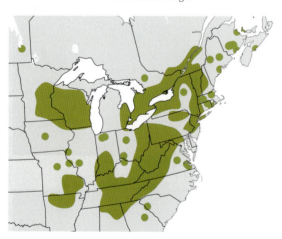

DESCRIPTION. A short-lived deciduous tree growing up to 66 ft (20 m) tall, with short clear trunk, broad, open, irregular, rounded or flat crown, and deep taproot with wide-spreading laterals roots. Twigs have three-lobed leaf scars with distinctive vascular markings. Bark is brown to light gray, deeply furrowed. Leaves are alternate, pinnately compound, 11.8–29.5 in (30–75 cm) long, with pubescent petiole and eleven to nineteen oblong-lanceolate leaflets, each 2–4.5 in (5–12 cm) long, 1.2–2 in (3–5 cm) wide, green above and pale below covered with hairs, margins serrate. Trees are monoecious producing male and female flowers on the same plant, blooming in late spring. Male flowers are arranged in thick, yellowish-green catkins, 2.9–4.7 in (7.5–12 cm) long; female flowers are 0.8 in (2 cm) long, on short spikes at ends of twigs. Fruits are oblong, four-angled nuts, 2.0–2.8 in (5–7 cm) long, covered in yellowish green husk with sticky hairs.

USES AND VALUE. Wood not commercially important. Used for cabinets and furniture. Nuts are used commercially in some foods, such as ice cream. Seeds with sweet oily taste are edible. Sap boiled down into syrup. Inner bark used as laxative. Mammals consume the seeds.

ECOLOGY. Grows in open woodlands, in moist valleys, and on dry rocky slopes. Good seed crops produced every two to three years, germination rates high; dispersed by gravity and small rodents. Shade intolerant; very susceptible to fire damage; windfirm. Insect pests include butternut curculio (*Conotrachelus juglandis*), which injures young stems and fruit. Most significant fungal pest (*Sirococcus clavigignenti-juglandacearum*) causes butternut canker, which is reducing population numbers.

CLIMATE CHANGE. Vulnerability is significant but may have the capacity to adapt to changing conditions in the future. Ongoing monitoring is recommended.

CONSERVATION STATUS. Endangered.

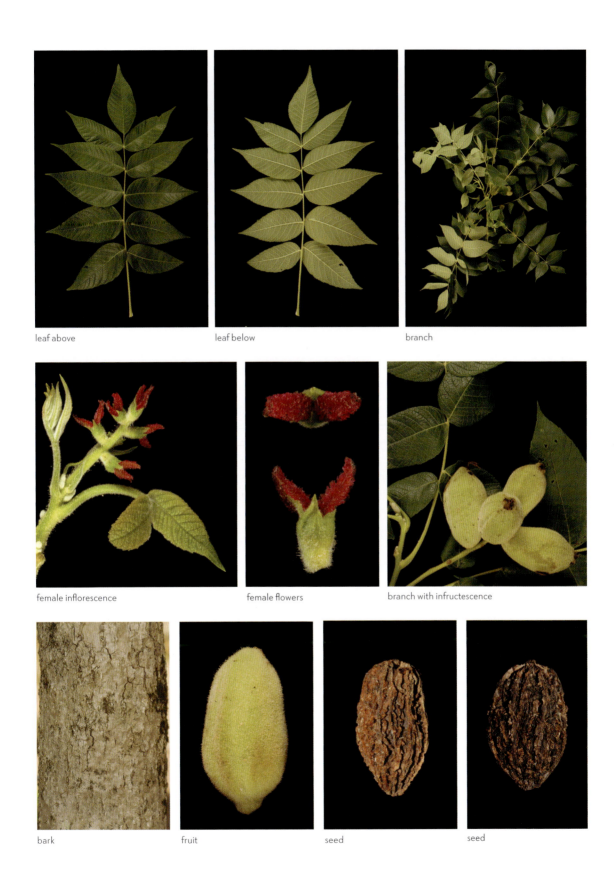

FAMILY JUGLANDACEAE • 639

Black Walnut
Juglans nigra L.

Black walnut, a large deciduous tree native to eastern North America, is valued for its fruits and as an ornamental. The beautiful wood is prized for making furniture.

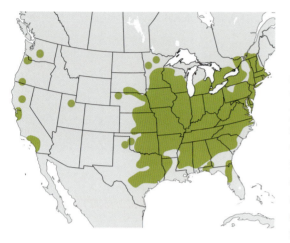

DESCRIPTION. A long-lived deciduous tree growing up to 115 ft (35 m) tall, with a long clear trunk, small open crown, and deep wide-spreading root system. Twigs are light brown with three-lobed leaf scars and distinctive vascular markings. Bark is dark brown to black, with rough ridges in diamond pattern. Leaves are alternate, pinnately compound, 12–24 in (30–60 cm) long, with pubescent rachis and thirteen to twenty, ovate-lanceolate leaflets, each 2–5 in (5–12.5 cm) long, 1–1.2 in (2.5–3 cm) wide, green above, paler below and pubescent, margins finely serrate, tip pointed. Trees are monoecious producing male and female flowers on the same plant, blooming in late spring. Male flowers are greenish with purple stamens, arranged in catkins, 2.9–4.9 in (7.5–12.5 cm) long; female flowers are greenish, 0.7–1 in (1.8–2.5 cm) long, on short spikes at ends of twigs. Fruits are spherical nuts with green, thick, sticky husks, 1.2–3.1 in (3–8 cm) in diameter, solitary or in pairs, contains single furrowed hard seed.

USES AND VALUE. Wood commercially important. High quality hardwood used for furniture, veneer, and gun stocks. Nuts in high demand for baked goods and ice cream. Sap prepared as refreshing drink or boiled down into syrup. Medicinal uses are many: bark and leaves are anodyne, astringent, emetic, laxative, and good for treating skin diseases. Ground walnut shells are biodegradable, non-toxic, durable, and cost-effective soft abrasive grit used in blast cleaning, paint stripping, deburring, and engine cleanout. Many mammals eat the nuts, deer browse saplings, and yellow-bellied sapsucker penetrates bark.

ECOLOGY. Grows in fertile woodlands, rocky slopes, and fields. Some seed produced annually with good crops at irregular intervals; dispersal primarily by small rodents. Shade intolerant. Trees are allelopathic and produce chemicals that prevent other plants from growing under canopy. Insect pests include walnut caterpillar (*Datana integerrima*) and fall webworm (*Hyphantria cunea*). Fungal pests are few and include root-rot diseases (*Phytophthora citricola* and *Cylindrocladium* spp). Native insect-fungus combination (walnut twig beetle, *Pityophthorus juglandis*, and fungus *Geosmithia morbida*) may potentially affect large numbers of trees.

CLIMATE CHANGE. Vulnerability is significant but has reasonable probability of persistence in the future. Ongoing monitoring is recommended.

CONSERVATION STATUS. Least concern.

bark

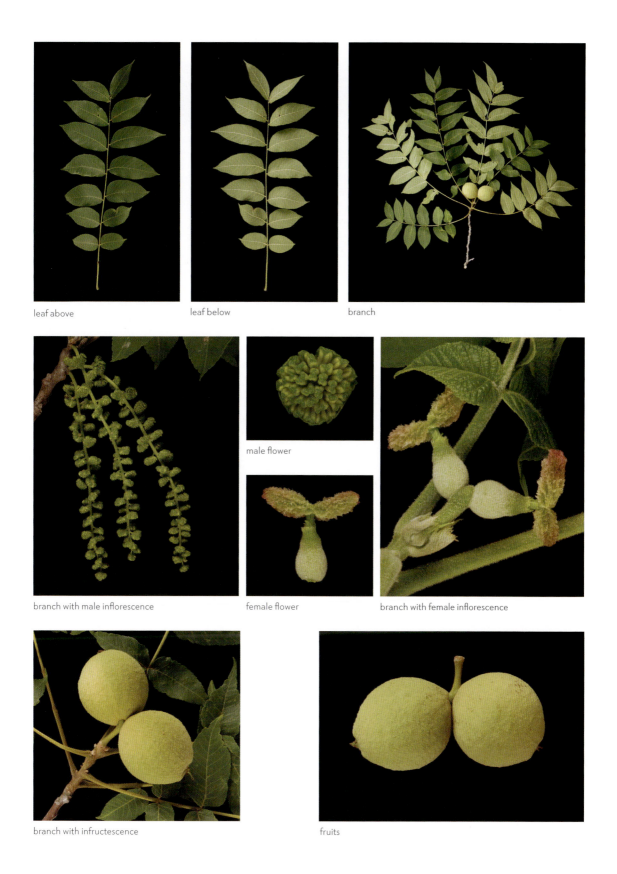

FAMILY JUGLANDACEAE • 641

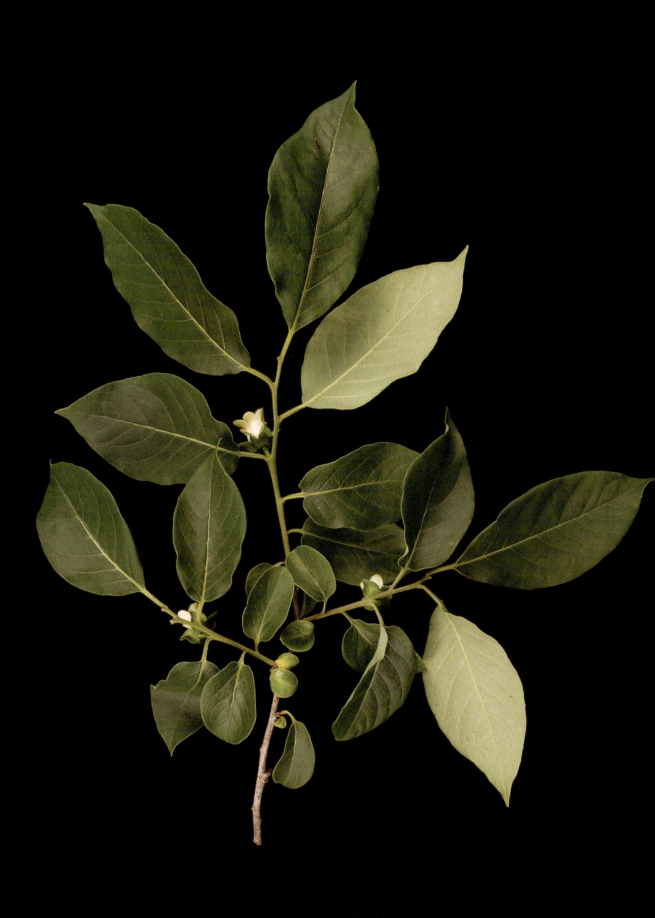

Asterids: Trees Related to Dogwoods, Ashes, and Hollies

Containing nearly 80,000 species, the Asterids are diverse with almost as many species as the Rosids. They began to diversify nearly 110 million years ago. Species in this group have a number of specialized features, such as fused petals, unique chemical compounds (such as iridoids and alkaloids), and a distinctive ovule structure, as well as distinctive DNA sequence data. Botanists are in general agreement about the evolutionary relationships among the major subgroups within the Asterids—for example, uniting the heaths with the primulas, brasil nuts, and camellias; grouping the gentians with the potatoes, African violets, and mints; and classifying the hollies with the carrots, viburnums, and asters. Seventeen families in nine orders of Asterids contain forty-four tree species that are common in North America.

ORDER CARYOPHYLLALES

Botanists still do not agree on the classification of the Caryophyllales. Some taxonomists have a very broad idea of what plants should be included in this order; others maintain a much more circumscribed concept. From eighteen to thirty-six families are put into this order, depending on which botanist is consulted. Plants in a large part of the Caryophyllales were once called the "Centrospermae" because many of them possessed a circular embryo inside the seed. Plants, such as the cacti, carnations, pokeweeds, four o'clocks, purslanes, and stone plants, are contained in the order, but only one genus is a species of tree that is common in North America.

Family Cactaceae

Members of the family Cactaceae show various evolutionary adaptations for living in dry habitats. They often have much-reduced leaves and inflated, water-storing, and photosynthetic stems. A specialized type of photosynthesis has also evolved in the cacti that allows the plants to open their pores at night to take in carbon dioxide, and thereby reduce the loss of water, which is converted into sugars the next day. Currently, 110–125 genera and about 1,400–1,750 species are recognized in the family. All but one are native in the Americas. Some species are shrublike, and only a single species can truly be called a common tree, the saguaro.

OPPOSITE Common persimmon (*Diospyros virginiana*)

GENUS CARNEGIEA

"Sage of the Desert" is a common allusion to these ancients. Despite their wild fantasies of form, their ponderous awkwardness, they have an inherent dignity. After sitting down amongst them and laughing at their attitudes till the tears come, one leaves the Saguaros with the feeling that, after all, there is about them something deeply wise, if unconsciously so.

—Donald Culross Peattie on *Carnegiea gigantea* in *A Natural History of North American Trees*

Carnegiea gigantea, the only species in the genus, is native to the Sonoran Desert of the southwestern United States and northern Mexico. Day-foraging white-winged doves and night-foraging nectar bats visit the flowers of this cactus to sip nectar and pollinate it. The genus *Carnegiea* was named for the Scottish American steel industrialist and philanthropist Andrew Carnegie (1835–1919). The one species of *Carnegiea* is a common tree in North America.

Saguaro

Carnegiea gigantea (Engelm.) Britton & Rose

Carnegiea gigantea is the largest columnar cactus in the United States and is a well-known species found in rocky foothills, canyons, washes, and sandy or gravelly desert plains.

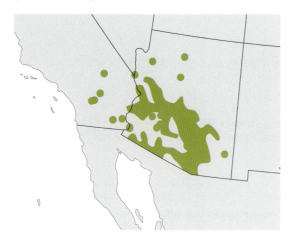

DESCRIPTION. An arborescent stem succulent growing 10–52 ft (3–16 m) tall with a single trunk and one to five lateral, erect branches. Stems have twelve to twenty-four ribs armed by dense spines, 2.8 in (7 cm) long, with wooly apices. Spines are yellow to reddish brown, turning black with age, central spines are three to five per areole, basal spine is the longest, radial spines finer, twelve to fifteen per areole. Flowers are perfect, white, 3.5–4.9 in (9–12.5 cm) long, borne at branch terminus, flower tubes broadly triangular or rounded with red apices, blooming at night in May and June. Fruits are oblong, glabrous 1.6–3.1 in (4–8 cm) long, red when mature, juicy. Seeds numerous, finely pitted, 0.08 in (2 mm) long.

USES AND VALUE. Wood not commercially important. Parts of plants are often used by local people. For Tohono O'odham, an important source of food and shelter. Fruit is edible. A drink made from the fermented fruit is used in Native American ceremonies. Birds, such as Gila woodpeckers and gilded flickers, create holes in the stems for nesting. Owls, flycatchers, purple martins, and house finches occupy the same cavities, living inside the holes for years.

ECOLOGY. Grows in rocky foothills, canyons, washes, and desert plains of the Southwest. Dominant or codominant species in paloverde/saguaro habitats and desert scrub confined to dry, sandy, gravelly, and well-drained soils.

CLIMATE CHANGE. Vulnerability, though currently considered to be low, may increase in the future. Ongoing monitoring is recommended.

CONSERVATION STATUS. Least concern.

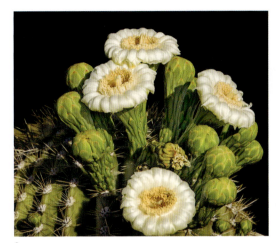
flowers

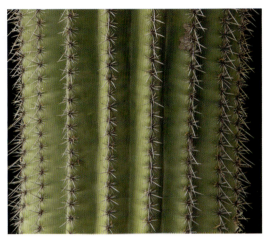
bark/present

bark/past

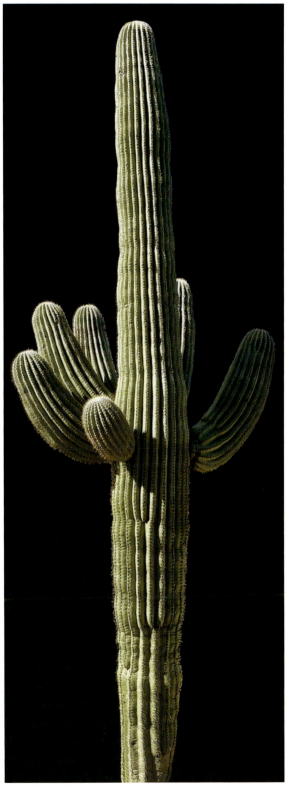
trunk with branches

FAMILY CACTACEAE • 645

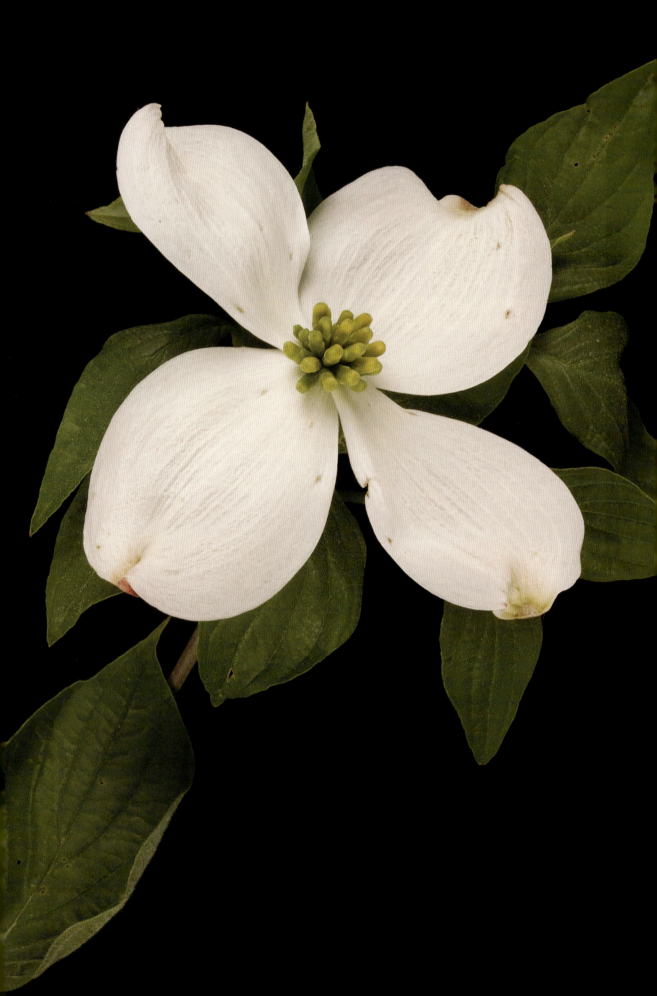

ORDER CORNALES

The Cornales comprise six to ten families, depending on which taxonomist you ask. The two most important families are the dogwood family and the hydrangea family. In addition to DNA data, which strongly unite these families, all members have ovaries placed below the sepals and petals (called an "inferior" ovary) and a unique nectary disc in the flowers. Most produce fruits that contain pips, also called drupes. The Cornales contain fewer than 600 species in total. Two genera and eight species are common trees in North America.

Family Cornaceae

The dogwood family is widespread in its distribution and especially common in the northern temperate regions of Asia and the Americas. Recent classifications of the family are often contradictory. Some botanists have increased the number of genera assigned to the family to make it more inclusive. Most taxonomists recognize just two tree genera (*Cornus* and *Alangium*) and eighty-five species. The genus *Cornus* has a number of special flower features and chemical attributes, and DNA evidence supports its status as a distinctive evolutionary unit within the family. The conspicuous, white, modified leaves (called bracts) that surround the flowers of *Cornus florida* attract pollinating insects and ensure successful fertilization. The bright red fruits are an important source of food for migrating birds along the East Coast of the United States. One genus and five species are common in North America.

OPPOSITE Flowering dogwood (*Cornus florida*)

GENUS CORNUS

Stepping delicately out of the dark woods, the startling loveliness of Dogwood in bloom makes each tree seem a presence, calling forth an exclamation of praise, a moment of worship from our eyes.

—Donald Culross Peattie on *Cornus florida* in A Natural History of Trees of Eastern and Central North America

Dogwoods are shrubs and small trees native to the temperate regions of Europe, Asia, and North America and include up to sixty species. Because of their distinctive "layered" branching structure and conspicuous petal-like bracts subtending the small flowers, many species are commonly cultivated in gardens and landscapes outside their native ranges. In the understory of their native forests. Many species of mammals and birds eat the brightly colored fruits, called drupes. One introduced and five native species in the genus *Cornus* are common trees in North America. (See p. 744 for leaf shapes of six species of *Cornus*.)

Pagoda Dogwood
Cornus alternifolia L. f.
ALTERNATE-LEAVED DOGWOOD

Pagoda dogwood has a conspicuous layered growth form with distinctive horizontal branches. The alternate leaves also make this small tree a unique member of the genus in North America.

DESCRIPTION. A deciduous shrub or small tree growing 4–10 ft (1.4–3 m) tall with spreading crown and horizontally layered branches. Twigs are green when young, dark green and red purple when older. Bark is reddish brown. Leaves are simple, distinctly alternate and sometimes appearing whorled at branch tips, dark green without hairs above, paler with hairs below, margins smooth, 2–4.1 in (5–12 cm) long. Flowers are perfect, creamy white, tiny with four petals 0.08–0.16 in (2–4 mm) long, arranged in flat cymes, blooming in spring to early summer. Fruits are blue drupes, 0.15–0.2 in (4–6 mm) wide.

USES AND VALUE. Wood not commercially important. Cultivated as ornamental because of distinctive leaves and horizontal branching pattern. Many birds and some mammals eat fruits; twigs and leaves are browsed by deer and rabbits. Flowers visited by bees and butterflies.

ECOLOGY. Grows along streambanks, forest margins, and slopes in wooded or open areas throughout northeast and into southern North America. Susceptible to golden canker (*Cryptodiaporthe corni*).

CLIMATE CHANGE. Vulnerability is currently unknown. Immediate assessment is recommended.

CONSERVATION STATUS. Least concern.

autumn leaf

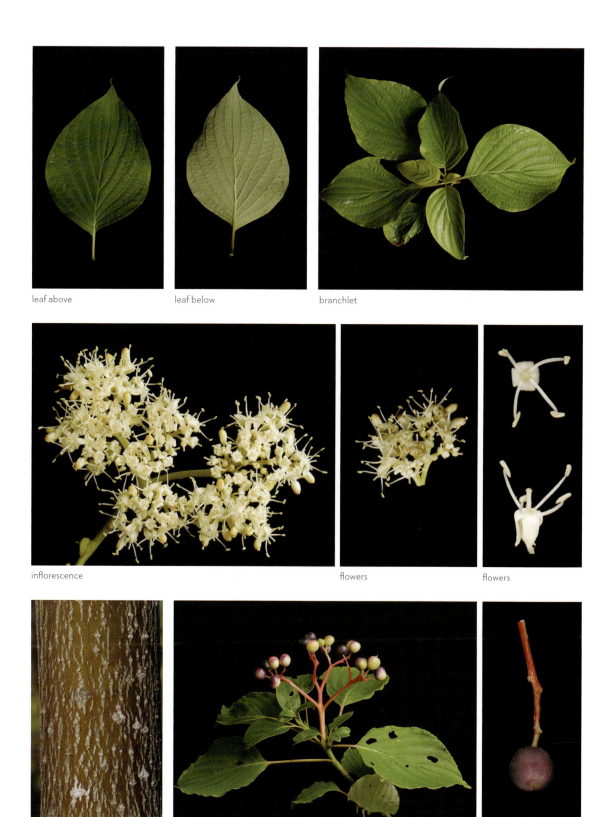

FAMILY CORNACEAE • 649

Roughleaf Dogwood

Cornus drummondii C. A. Mey.

Roughleaf dogwood is a species of large shrub or small tree native to a wide variety of habitats in the Midwest. The fruits provide food for many species of birds.

DESCRIPTION. A deciduous, single-stemmed tree or thicket-forming shrub growing to 30 ft (9 m) tall. Twigs vary in color from light brown to greenish brown, reddish to purple, and are slender, with rusty hairs. Bark is grayish-brown, flaky and blocky on older trees. Leaves are opposite, simple, oval to elliptical, 2–4 in (5–10 cm) long, dark green above and lighter below, hairy on both sides, in autumn turn red before falling. Flowers are perfect, white, fragrant, 0.24 in (0.6 cm) wide, borne in showy, flat, 2–3.9 in (5–10 cm) long clusters at the ends of twigs, blooming in spring. Fruits are white drupes, 0.24 in (0.6 cm) long, with one-two seeds, in loose clusters on red stalks; ripe in late summer.

USES AND VALUE. Wood not commercially important. Trees sometimes planted in buffer and median strips along highways, around homes, and in shelterbelts. No known food or medicinal uses. More than forty species of birds are known to feed on the fruits.

ECOLOGY. Grows along the borders of forests in wet habitats, such as swamps, marshes, woodlands and thickets, riparian zones, and on dry limestone hills. Found in alkaline soils of a variety of drainages and textures.

CLIMATE CHANGE. Vulnerability is currently unknown. Immediate assessment is recommended.

CONSERVATION STATUS. Least concern.

older bark

younger bark

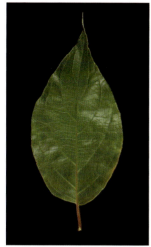 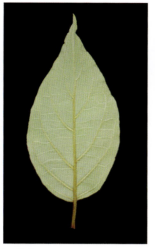 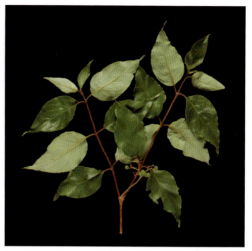

leaf above leaf below branch

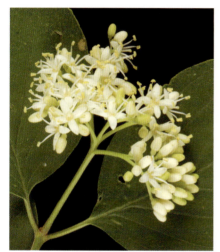 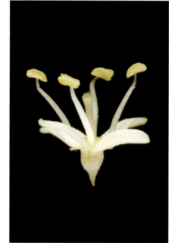 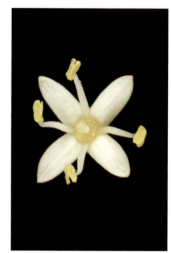

branch with mature inflorescence flower flower

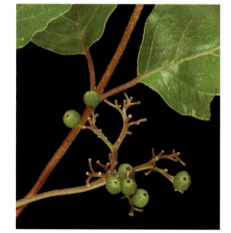 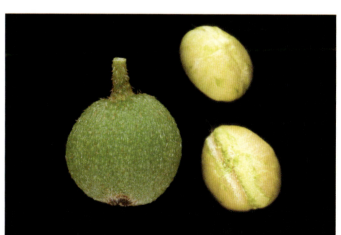

branchlet with infructescence fruit and seeds

FAMILY CORNACEAE • 651

Flowering Dogwood
Cornus florida L.

Flowering dogwood is a small deciduous tree native to eastern North America. As a mature tree it is often wider than it is tall. The bright red fruits are poisonous to humans, but serve as an attractive food source to numerous bird species.

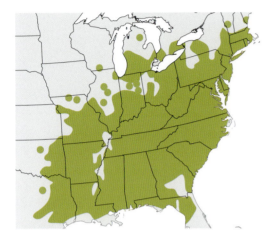

DESCRIPTION. A short-lived deciduous tree growing to 33 ft (10 m) tall, with short trunk, low large-spreading branches, and dense crown. Twigs are green or purple when young, turning gray. Bark is dark grayish brown in blocky plates. Leaves are opposite, simple, ovate, dark green above, pale below, 2.4–4.7 in (6–12 cm) long, 2–2.8 in (5–7 cm) wide. Flowers are perfect, tiny, greenish white to yellow, with four white subtending bracts, notched, 1.2–2.4 in (3–6 cm) long, blooming in mid-spring, Fruits are oval, shiny, red drupes, 0.39–0.59 in (10–15 mm) long.

USES AND VALUE. Wood not commercially important. Popular ornamental and garden tree. Employed medicinally by Native North Americans for its astringent and antiperiodic properties. Very important for wildlife, with seeds, fruits, flowers, twigs, bark, and leaves, which are high in calcium and fat, utilized for food. Thirty-six species of birds, including ruffed grouse, bobwhite quail, and wild turkey, as well as many mammals, such as chipmunks, foxes, skunks, rabbits, deer, beaver, black bears, and squirrels, have been observed feeding on the fruit. Deer and rabbits browse the foliage and twigs.

ECOLOGY. Grows as an understory tree in moist woodlands and is tolerant of shade. Good seed crops produced every other year; birds and small animals are the principal dispersal agents. The thin bark makes it susceptible to fire damage. Insect and fungal pests are most prominent on cultivated varieties due to their effects on the appearance of the foliage and stem. In forests, target cankers *(Nectria galligena)* sometimes occur on the trunk and branches, with *Armillaria mellea* also infecting trees.

CLIMATE CHANGE. Vulnerability is currently considered to be low.

CONSERVATION STATUS. Least concern.

bark

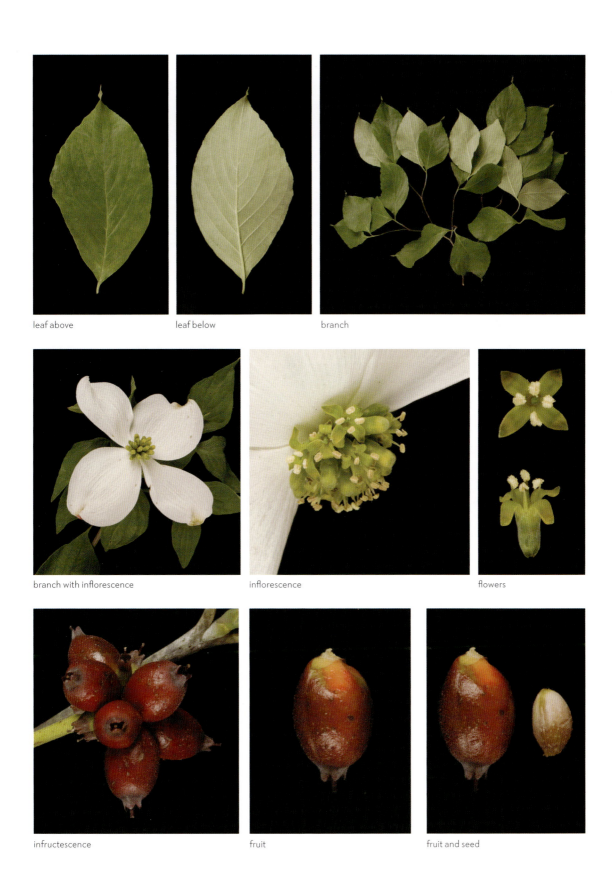

FAMILY CORNACEAE • 653

Cornelian Cherry
Cornus mas L.

Cornelian cherry is native to parts of Europe and Asia and has been introduced to the eastern United States as an ornamental fruit-bearing tree. The oval, ruby-red fruits, which taste similar to cranberries and sour cherries, are used in making jam.

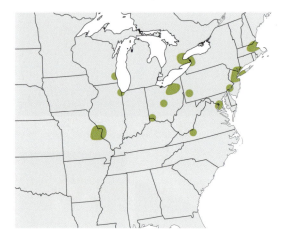

DESCRIPTION. A moderate-lived, multistemmed, deciduous shrub or small tree growing to 18–25 ft (5.4–7.5 m) tall. Twigs are purplish red to brown and slender. Bark is dark gray to reddish brown and flaky. Leaves are opposite, simple, ovate to elliptic, green and glossy above, paler below, margins entire, up to 3.9 in (10 cm) long and 2.5 in (6.5 cm) across. Flowers are perfect, yellow, small, and borne in umbels 1 in (2.5 cm) across, blooming in mid-spring. Fruits are oblong bright red drupes, up to 0.8 in (2 cm) long.

USES AND VALUE. Wood not commercially important. Used to make tool handles. Ancient Greeks considered wood superior to other species and in the seventh century BCE used it to make spears, javelins, and bows. Cultivated as ornamental tree in the landscape. Fruits with a nice acidic flavor are edible and excellent in jams and jellies. Eaten by birds. Bark and fruit are astringent, febrifuge, and nutritive.

ECOLOGY. Planted as ornamental and may naturalize in open woodlands. Intermediate in shade tolerance.

CLIMATE CHANGE. Vulnerability is currently considered to be low because of wide geographic distribution as ornamental and invasive.

CONSERVATION STATUS. Least concern.

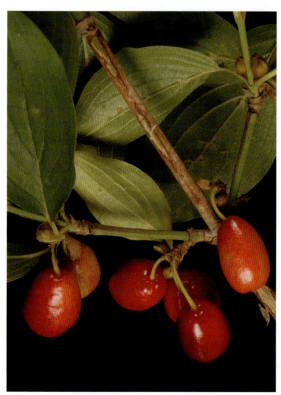

branch with infructescence

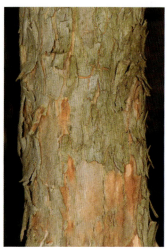

bark

leaf above

leaf below

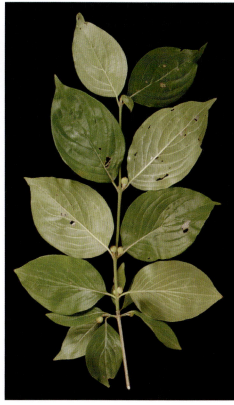
branch

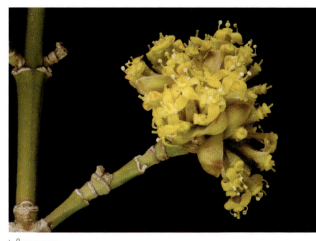
inflorescence

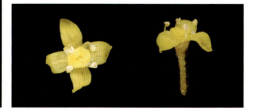
flowers

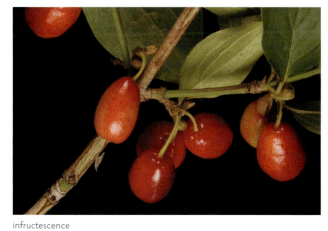
infructescence

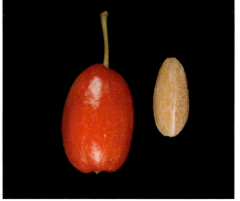
fruit and seed

FAMILY CORNACEAE • 655

Pacific Dogwood
Cornus nuttallii Audubon

Pacific dogwood is a small tree native to the coastal region west of the Cascade Mountains from British Columbia to southern California. The trees are important as ornamentals with many other uses from cabinet making to treating malaria.

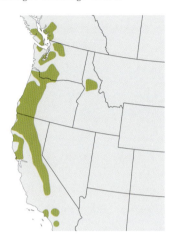

DESCRIPTION. A small deciduous tree, irregularly branched, growing up to 66 ft (20 m) tall, with slightly tapered stem and compact crown when growing under forest conditions but display a short stem with wide-spreading crown in the open. Twigs are slender when young, green, and minutely pubescent; older twigs become dark reddish purple and smooth. Bark is thin and gray, smooth when young but breaking into rectangular scales and blocks with age. Leaves are opposite, simple, oval, deep green above, and grayish brown below, turning red in fall, characteristic veins curve parallel to the leaf edge, 3.1–4.7 in (8–12 cm) long, 2–3.1 in (5–8 cm) broad. Flowers are perfect, small, inconspicuous, 0.08–0.12 in (2–3 mm) across, and produced in dense, rounded, greenish-white flower heads 0.8 in (2 cm) wide, blooming from April to July. Fruits are pink-red berries, 1.2 in (3 cm) wide, with 50–100 small seeds.

USES AND VALUE. Wood not commercially important. Used to make tools and cabinets, and by native peoples of the Sierra Nevada for basket making. One of most important commercial ornamentals on West Coast. Provincial flower of British Columbia. Bark is antiperiodic, cathartic, febrifuge, laxative, and tonic, and an infusion has been used to treat malaria. Young sprouts are valuable as food for livestock and wildlife. Fruits are eaten by birds and small mammals.

ECOLOGY. Grows in Mediterranean-marine climates west of the Cascade Mountains from British Columbia to southern California. An interesting disjunct population occurs in Idaho. Common in mountain woods and along streambanks where soil is well-drained, rich, and moist. Shade tolerant.

CLIMATE CHANGE. Vulnerability is currently considered to be low.

CONSERVATION STATUS. Least concern.

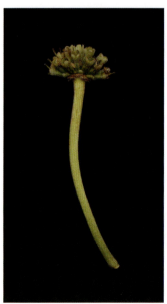

immature infructescence

leaf above

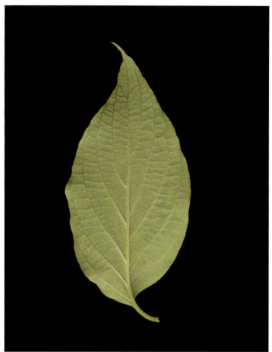
leaf below

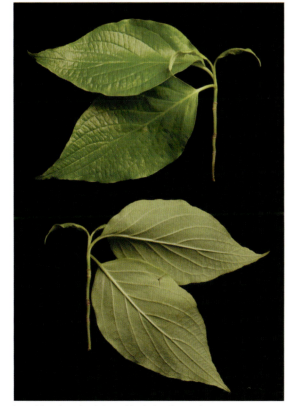
branchlet above (top), branchlet below (bottom)

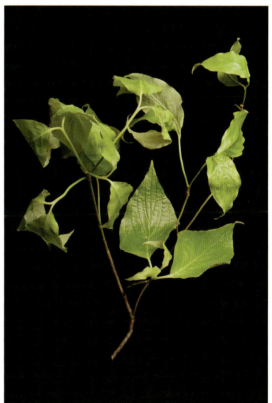
branch

Redosier Dogwood

Cornus sericea L.
REDOSIER

Redosier dogwood is an adaptable deciduous shrub or small tree native to northern and western North America. Most often found in wet areas with well-drained soils. Two subspecies are recognized.

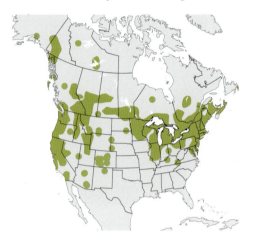

DESCRIPTION. A deciduous shrub or small tree growing 5–20 ft (1.4–6 m) tall. Twigs are bright green in spring and summer. Bark is reddish purple in late spring and autumn. Leaves are simple, opposite, dark green and hairy above, and pale below, with smooth margins, 2–3.9 in (5–10 cm) long. Flowers are perfect, white, tiny with four petals 0.08–0.16 in (2–4 mm) long, arranged in flat cymes, blooming in mid-summer. Fruits are white drupes approximately 0.24 in (6 mm) wide.

TAXONOMIC NOTES. Subspecies *occidentalis* is distinguished by its abaxially rough hairy leaves, 0.12–0.18 in (3–4.5 mm) long petals, and three-ridged stones; ssp. *sericea* has leaves that are glabrous to strigose abaxially, 0.08–0.12 in (2–3 mm) long petals, and smooth stones.

USES AND VALUE. Wood not commercially important. Host plant for the spring azure (*Celastrina ladon*) butterfly. Birds and mammals eat the fruits, twigs, and leaves, and deer browse throughout the year. Provides cover for many local species of vertebrates.

ECOLOGY. Grows along riverbanks and lakeshores of wooded or open wet areas on moist well-drained soils throughout northern and western North America. Adaptable to many soil textures and climatic conditions.

CLIMATE CHANGE. Vulnerability is currently unknown. Immediate assessment is recommended.

CONSERVATION STATUS. Least concern.

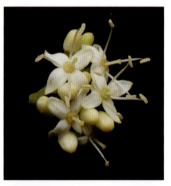
flowers

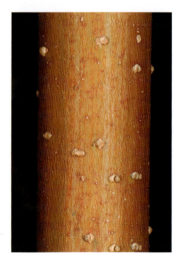
bark

leaf above

leaf below

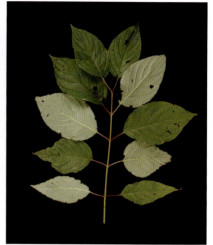
branch

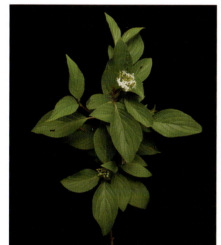
branch above with inflorescence

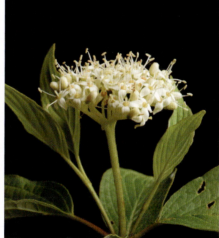
branch with inflorescence

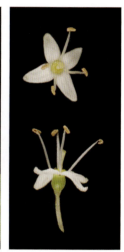
flowers

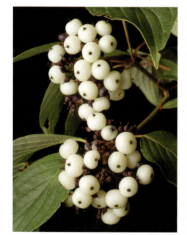
branchlet with infructescence

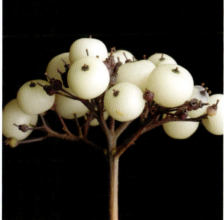
infructescence

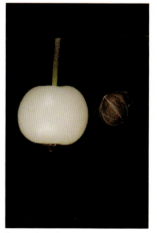
fruit and seed

FAMILY CORNACEAE • 659

Family Nyssaceae

This family is sometimes included within the dogwood family, the Cornaceae. The five genera and thirty or so species placed in this family form a distinctive group based on DNA features and some morphological traits, so the Nyssaceae is usually recognized as a distinctive lineage. The species are found in both temperate and tropical America and Asia. Only three species of the genus *Nyssa* are common trees in North America.

GENUS NYSSA

Growing in swampy woods throughout its wide range, this water nymph of the forest has, in the full tide of summer, an almost tropical look about its glossy, leathery leaves. One would think they were evergreen.

—Donald Culross Peattie on *Nyssa sylvatica* in *A Natural History of Trees of Eastern and Central North America*

The genus *Nyssa* is named after the Greek water nymph because its members prefer inundated soils and wet zones. The ten species of medium-sized trees are all native to tropical and subtropical North and Central America as well as temperate and tropical eastern Asia. Commonly called "tupelo." The wood of these species is used in carving and furniture making, and the copious nectar produced by the flowers is an important source for honey. Three native species of *Nyssa* are common trees in North America.

Water Tupelo
Nyssa aquatica L.

Water tupelo is a flood-tolerant deciduous tree that grows in moist or saturated areas of the southeastern United States, such as swamps, flood-plain forests, and pond margins.

DESCRIPTION. A large aquatic deciduous tree with a buttressed base, a long narrow trunk, an open crown, and large glossy leaves that grows up to 98 ft (30 m) tall. Roots often grow out from the soil. Twigs are stout, yellow brown or red brown, with cordate leaf scars, small buds, and spur shoots. Bark is gray, with scaly ridges. Leaves are simple, alternate, large, glossy, pinnately veined, with entire or dentate margins, 3.5–6.7 in (9–17 cm) long. Trees are dioecious with male and female flower on separate plants, blooming when leaves appear in March or April. Flowers are small, green or white, and hang in clusters. Fruits are oblong drupes, 0.4–1.6 in (1–4 cm) long, with thick epicarp and fleshy mesocarp, dark purple and spotted when mature. Drupes contain a bony one-seeded stone.

USES AND VALUE. Wood commercially important. Used in furniture, pallets, crates, and pulp. Honey derived from the flower nectar ("tupelo honey"). Wood ducks and other birds and mammals, such as squirrels, raccoons, and deer, consume the fruit. Deer browse leaves, twigs, and stump sprouts.

ECOLOGY. Grows in saturated habitats, such as swamps, flood-plain forests, and lake and pond margins, in standing water or moist, well-drained, and fertile soils. Intolerant of shade. Prolific seeders and produce good crops annually. Fruits are heavy and dispersed by water. Fire is extremely damaging to this thin-barked species. Forest tent caterpillars (*Malacosoma disstria*) cause severe defoliation periodically in some localities.

CLIMATE CHANGE. Vulnerability is significant but has reasonable probability of persistence in the future. Ongoing monitoring is recommended.

CONSERVATION STATUS. Least concern.

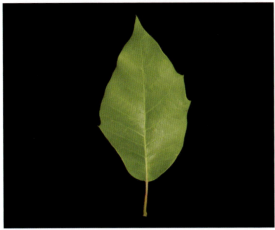

leaf above

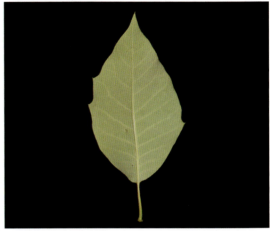

leaf below

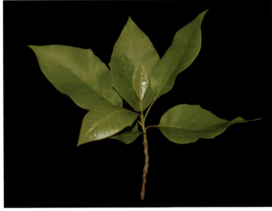

branchlet above

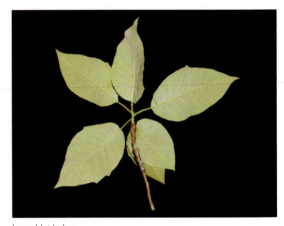

branchlet below

bark

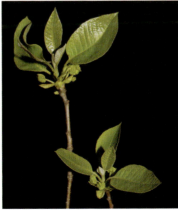

branch with inflorescence

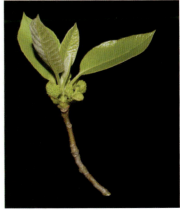

branch with inflorescence

FAMILY NYSSACEAE • 661

Swamp Tupelo
Nyssa biflora Walter
BLACKGUM

Swamp tupelo is a deciduous tree with a narrow crown and native to swamps on the Atlantic coastal plain from Delaware to eastern Texas. Similar to other tupelos this species typically grows in wet, fertile, and heavy bottomland soils and organic mucks. Two varieties are recognized.

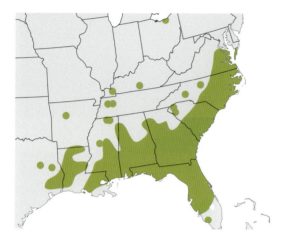

DESCRIPTION. A deciduous tree with a narrow crown growing 59–79 ft (18–24 m) tall. Twigs are reddish brown or gray, dark brown at maturity, with a diaphragmed pith, green buds and spur shoots. Bark is grayish brown and exfoliates into longitudinal ridges as it matures. Leaves are simple, alternate, deciduous, and elliptical or narrowly obovate, 2–5 in (5–13 cm) long, leathery, dark green, pale or pubescent abaxially margins entire. Trees are dioecious with male and female flowers on separate plants, blooming from March to June. Male flowers are small and green to white and borne singly or in clusters; female flowers are borne in small clusters and appear with the leaves. Fruits are dark blue, longitudinal drupes, 0.6–0.8 in (1.5–2 cm) long, with a ribbed pit.

TAXONOMIC NOTES. Variety *biflora* occurs in most of the species' range as described above; var. *ursina* is endemic to six Floridian counties and is a shrub with 1.2–2.4 in (3–6 cm) long leaf blades and globose fruits with a 0.2–0.8 in (0.5–2 cm) long peduncle.

USES AND VALUE. Wood not commercially important. Sometimes used for lumber and flooring. An attractive ornamental. Flower nectar yields an excellent honey. Fruit is edible and used to make preserves. Bark is emetic, ophthalmic, and vermifuge. An important wildlife tree, a variety of birds and mammals consume its fruits, which are high in crude fat, fiber, phosphorous, and calcium. Deer browse the foliage, twigs, and stump sprouts. Large cavities in trunks are used as dens.

ECOLOGY. Grows in swamps, ponds, and estuaries of the eastern North American coastal plains, typically in wet, fertile, and heavy bottomland soils and organic mucks. Shade tolerant. Seeds are dispersed by water and animals, but seed production is highly variable. Fire easily damages this thin-barked species. Forest tent caterpillars (*Malacosoma disstria*) cause severe defoliation in some years.

CLIMATE CHANGE. Vulnerability is currently considered to be low.

CONSERVATION STATUS. Least concern.

bark

leaf above

leaf below

branchlet

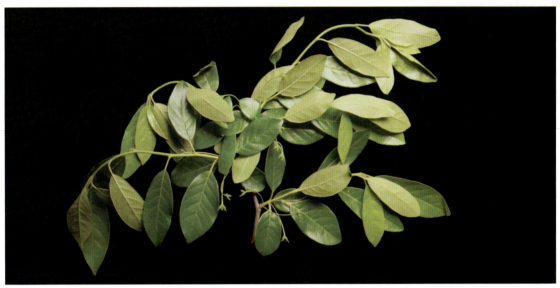
branch

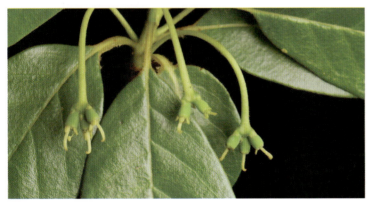
branchlet with flowers

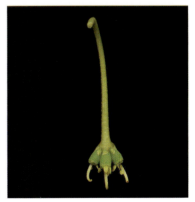
flower

FAMILY NYSSACEAE • 663

Black Tupelo
Nyssa sylvatica Marshall
BLACKGUM, SOURGUM

Black tupelo is a medium-sized deciduous tree native to eastern North America. The leaves change color in early autumn, alerting migrating birds to the presence of ripe fruits on the tree, a process known as "foliar fruit flagging."

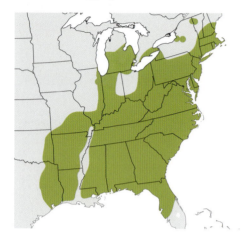

DESCRIPTION. A moderate-lived deciduous tree, growing 66–82 ft (20–25 m) tall. Twigs are reddish brown or gray and hairy but become smooth at maturity. Bark is dark gray to reddish brown and furrowed into blocky ridges or plates that resemble alligator hide. Leaves are alternate, simple, oval to obovate, leathery, dark green and glabrous above, paler and glabrous below, margins entire, 1.2–5.9 in (3–15 cm) long. Flowers are perfect or unisexual (then dioecious), green, blooming in late spring. Male flowers appear in clusters; female flowers are borne in clusters of two or more. Fruits are blue-black drupes, sour, ovoid, 0.3–0.6 in (0.8–1.5 cm) long, borne in clusters of one to three, each with a grooved pit.

USES AND VALUE. Wood not commercially important. Used for lumber, pulp, and veneer. An attractive ornamental. Flowers produce an excellent honey. Fruit is edible and used to make preserves. The bark is emetic, ophthalmic, and vermifuge. Similar to other species of this genus, an important wildlife tree: many birds and other animals eat the fruit, which is high in crude fat, fiber, phosphorous, and calcium, deer browse the foliage, twigs, and stump sprouts, trunk cavities used for dens.

ECOLOGY. Grows in swamps, flood-plain forests, ponds, and estuaries of the eastern North American coastal plains where the soil is constantly saturated. Shade tolerant. Seeds are dispersed by water and animals. Fire can cause damage to this thin-barked species. Forest tent caterpillars (*Malacosoma disstria*) cause severe defoliation.

CLIMATE CHANGE. Vulnerability is currently considered to be low.

CONSERVATION STATUS. Least concern.

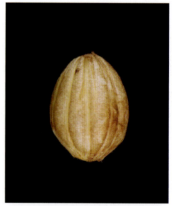
seed

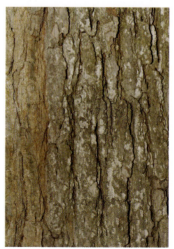
bark

leaf above leaf below branch

branch with inflorescence branchlet with inflorescence inflorescence flowers

branchlet with infructescence fruit and seed

FAMILY NYSSACEAE • 665

ORDER ERICALES

The Ericales is a large group containing slightly fewer than 10,000 species. It includes the kiwi fruits, sapodillas, ebony, primroses, tea, the heaths, pitcher plants, Brazil nuts, phlox, and other familiar plant families, twenty-two to twenty-four in all. Evidence for the evolutionary relatedness of this diverse group of plants is provided mainly by DNA sequence data; very few, if any, flower, leaf, wood, or chemical features are shared by all the members of the Ericales, although most seem to have twice as many stamens as petals. The actual relationships of the families within the Ericales are still not resolved. Some of these plants, such as the Brazil nuts, sapodillas, and ebony, grow in the tropics, while others are mainly found in the temperate regions of the world. Of the large number of tree species in the Ericales, only thirteen species in five families are common trees in North America.

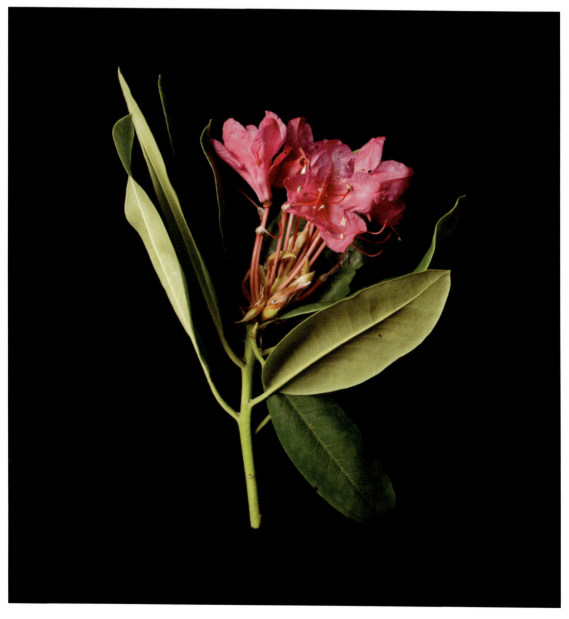

OPPOSITE Mountain laurel (*Kalmia latifloria*). **ABOVE** Pacific rhododendron (*Rhododendron macrophyllum*).

Family Sapotaceae

This medium-sized family contains fifty-three genera and over 1,000 species and most are found in the tropical regions of the world, especially rain forest habitats. The rich milky latex present throughout the plants is characteristic of the trees and shrubs that make up the Sapotaceae. Some species are cultivated for their appealing tropical fruits, while others are attractive ornamentals. Only a single species of tree in the genus *Sideroxylon* is common in the warmer regions of North America.

GENUS SIDEROXYLON

Members of the genus *Sideroxylon*, eighty species in total, are broadly distributed in both subtropical and tropical regions of the Americas, Africa, and Asia. Their uses are limited and our knowledge of their taxonomy is still under review. One native species of the genus *Sideroxylon* is a common tree in North America.

Gum Bully

Sideroxylon lanuginosum Michx.

Gum bully is a small tree that is native to the southern United States and found in sandy woods and along riverways. Three subspecies are recognized.

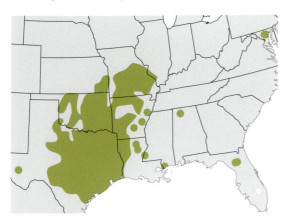

DESCRIPTION. A small tree that grows up to 49 ft (15 m) tall with an open crown and branches close to the ground. Twigs are slender gray or ruddy-pubescent and often armed with thorns at the tip. Bark is gray to brown, darkening with age. Leaves are simple, alternate, arranged in clusters or whorled on spur shoots, margins entire, tips rounded, base tapering, glossy above, glaucous-pubescent below, 0.8–2.8 in (2–7 cm) long. Flowers are perfect, inconspicuous, arranged in small clusters, 0.07–0.12 in (1.9–3.2 mm) long, white, sweetly fragrant, blooming in mid-summer. Fruits are edible blue-black berries, oval in shape, ripening in fall.

TAXONOMIC NOTES. Subspecies *lanuginosum* is distinguished by its tawny leaf hairs below and leaves 2.05–3.82 in (52–97 mm) long; ssp. *oblongifolium* is distinguished by white or gray hairs the appear on undersides of leaves, 2.05–3.82 in (52–97 mm) long; and ssp. *rigidum* has leaves 0.59–1.97 in (15–50 mm) long.

USES AND VALUE. Wood not commercially important. Local Native Americans used the outer bark as chewing gum. Fruits are eaten by birds; white-tailed deer browse the leaves; and the flowers provide nectar for honeybees.

ECOLOGY. Grows along streams, in sandy woods, and in open areas in the southern United States. Drought tolerant and often found on dry, shallow, and rocky soil.

CLIMATE CHANGE. Vulnerability is significant but has reasonable probability of persistence in the future. Ongoing monitoring is recommended.

CONSERVATION STATUS. Least concern.

leaf above

leaf below

branch with inflorescence

branchlet

bark

branch

FAMILY SAPOTACEAE • 669

Family Ebenaceae

Members of the persimmon family, the Ebenaceae, are easily recognized by their urn-shaped flowers with the petals fused together and the green sepals that persist and enlarge as the fruits mature. The flowers are unisexual; male and female flowers appear on different plants. Species of the family are distributed widely in the tropics and warm regions of Europe, the Americas, Africa, and Asia. Four genera and about 500 species comprise this family. Only a single species in the genus *Diospyros* is common in North America.

GENUS DIOSPYROS

Yet it is esteemed by connoisseurs, who will travel miles to gather the fruit of a particularly fine tree, and they tell you that the art of eating a persimmon consists (in addition to persuading one's self that a fruit may be a perfect mush and yet delicious) in avoiding the skin altogether, for the intensely tannic taste never leaves that part of the fruit.

—Donald Culross Peattie on *Diospyros virginiana* in *A Natural History of Trees of Eastern and Central North America*

The true persimmons in the genus *Diospyros*, which has about 480 species, are very diverse in Madagascar, North America, Asia, and Australia. The flowers are mostly pollinated by bees. The name *diospyros* comes from the Greek word *dios*, denoting Zeus or God, and *pyros*, meaning "wheat" or "grain," together meaning "divine fruit." Only a single species of *Diospyros* is a common tree in North America.

Common Persimmon

Diospyros virginiana L.

The common persimmon is native to the United States and has been cultivated for its fruit and wood since prehistoric times. Trees produce large, tasty, orange fruits that ripen in late autumn. Persimmon fruits are high in vitamin C and are used in a variety of desserts.

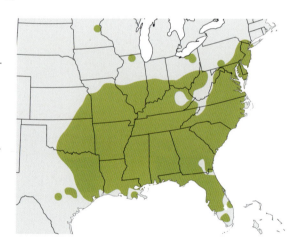

DESCRIPTION. A long-lived deciduous tree growing 49–66 ft (15–20 m) tall with a short stem, rounded crown, and taproot. Twigs are grayish brown, glabrous or pubescent. Bark is gray brown, becoming darker with age, and fissured, breaking into square plates. Leaves are alternate, simple, oval to oblong, 2.4–5.9 in (6–15 cm) long, glossy and green above, and paler below, margins entire. Trees are dioecious producing male and female flowers on separate plants, blooming in summer. Flowers are white to greenish yellow; male flowers are usually in clusters of two or three and 0.31–0.51 in (8–13 mm) long; female flowers are solitary and 0.6–0.8 in (1.5–2 cm) long. Fruits are spherical, 0.8–1.6 in (2–4 cm) long, orange to purple berries, with one to eight flat seeds.

USES AND VALUE. Wood not commercially important. Extremely dense and hard, used for turnery and heads of golf clubs. Cultivated as ornamentals because of edible fruits and flowers that make a delicious honey. Leaves are rich in vitamin C and used as antiscorbutic. decoction of inner bark is highly astringent. Birds and other animals feed on fruits; deer consume leaves and twigs.

ECOLOGY. Grows along forest margins, along roadsides, and adjacent to old fields. Very shade tolerant.

Good seed crops produced every two years; birds, small animals, and water are the primary dispersal agents. Attacked by number of insects, but are not damaging. Fungal pest *Cephalosporium diospyri* causes persimmon wilt in the southeastern states.

CLIMATE CHANGE. Vulnerability is significant but has reasonable probability of persistence in the future. Ongoing monitoring is recommended.

CONSERVATION STATUS. Least concern.

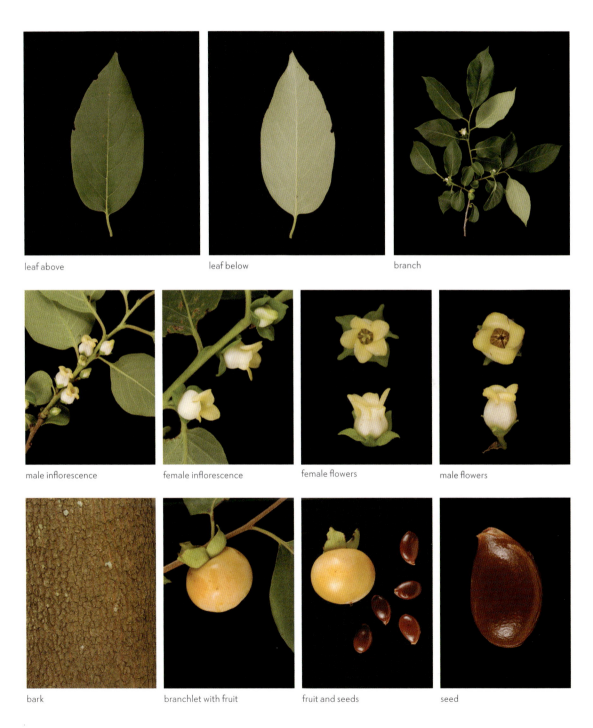

leaf above · leaf below · branch

male inflorescence · female inflorescence · female flowers · male flowers

bark · branchlet with fruit · fruit and seeds · seed

FAMILY EBENACEAE • 671

Family Theaceae

The family Theaceae as recognized today is less than half the size of the family that was accepted by botanists thirty years ago. The family now includes from seven to twenty genera and maybe 200–300 species that are found in tropical and subtropical zones of the Americas and Asia. Only one species is a common tree in North America.

GENUS GORDONIA

Most of the species of this medium-sized genus (around forty species) in the Camellia family are found in the tropical regions of Asia. Two are found in the Americas: one in the tropics of South America and one in southeastern North America. The large white flowers are very attractive and make some species popular as ornamental trees, like their relatives in the genera *Camellia*, *Stewartia*, and *Franklinia*. One native species of *Gordonia* is a common tree in North America. *Franklinia*, also native to the Americas, is extinct in the wild.

Loblolly Bay
Gordonia lasianthus (L.) J. Ellis
LOBLOLLYBAY GORDONIA

Loblolly bay is a small, erect tree with a narrow crown that is native to the southeastern United States. The trees occur on the Atlantic and Gulf coastal plains, where the climates are warm and moist.

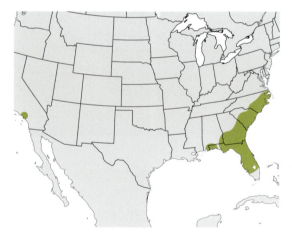

DESCRIPTION. A small tree with a narrow crown and straight habit that grows up to 66 ft (20 m) tall. Twigs are stout and gray, maturing darker with buds that are gray or ruddy-pubescent and pointed at the tips. Bark is thin, with flat-topped ridges and narrow furrows. Leaves are evergreen, simple, alternate, leathery, green above, paler below, margins finely serrulate, 2.4–5.1 in (6–13 cm) long. Inflorescences are axillary on new growth and bloom in mid-summer. Flowers are perfect, showy and five-petalled, 1.6–2.8 in (4–7 cm) in diameter, corollas white. Fruits are woody, five-parted capsules, 0.4–1 in (1–2.5 cm) long, borne on a stalk.

USES AND VALUE. Wood not commercially important. Bark is used as a tanning agent, pulp, and fuel with low commercial value. In the Southeast, valued as an ornamental for its glossy dark green leaves and abundant white flowers. Deer heavily browse stump sprouts.

ECOLOGY. Grows in warm, wet, temperate climates, found in acidic swampy pineland soils on the Atlantic Ocean and Gulf coastal plains. Though typically found in wetlands, this species occurs on moist, fertile, and acidic soils, but is tolerant of dry sandy soil, where its growth form is stunted. Shade tolerant.

CLIMATE CHANGE. Vulnerability is currently considered to be low.

CONSERVATION STATUS. Least concern.

leaf above

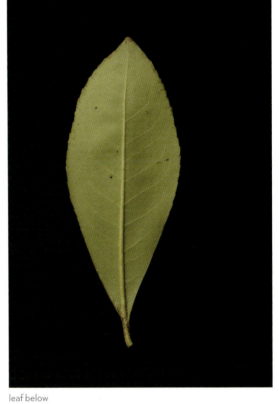
leaf below

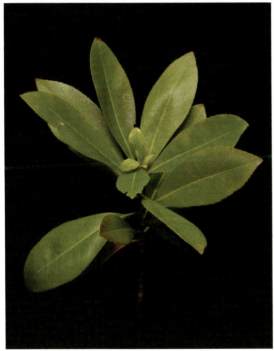
branchlet above

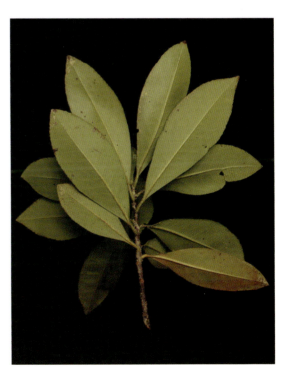
branchlet below

GENUS STYRAX

Unlike *Halesia*, which has few species (also in the family Styracaceae), the genus *Styrax* has many species (up to 130) and is distributed in Southeast Asia and North America (with several species in South America). The attractive, conspicuous flowers make them popular as ornamental shrubs and small trees. A distinctive resin produced by the non-American species of *Styrax* and used medicinally and as incense made these trees commercially important in the Middle Ages, but not so today. Two native species of *Styrax* are common trees in North America.

American Snowbell

Styrax americanus Lam.

American snowbell is a shrub to small tree native to the coastal plain and piedmont of the southeastern United States. It likes its feet wet and grows best in swamps and boggy areas in acidic soils and loams.

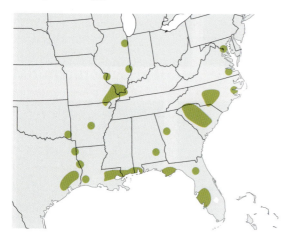

DESCRIPTION. A shrub to small tree that grows up to 16 ft (5 m) tall. Twigs are gray brown, zigzag, and pubescent, becoming glabrous at maturity, with small, blunt, and scruffy buds. Bark is smooth, thin, and gray brown, developing shallow fissures as the tree ages. Leaves are simple, deciduous, alternate, entire or shallowly dentate, with stellate hairs on the petioles, 0.8–2.8 in (2–7 cm) long. Flowers are perfect, bell-shaped, hang in clusters of one to four from leaf axils, 0.4 in (1 cm) long, with five white petals becoming reflexed with age, blooming in mid- to late spring. Fruits are ovate, hairy, 0.4 in (1 cm) long drupes, becoming gray brown when ripe.

USES AND VALUE. Wood not commercially important. Cultivated as ornamental in gardens and landscapes. Flowers provide nectar to pollinating insects. Birds and small mammals eat the fruits. Larval host of the promethea moth.

ECOLOGY. Native to the southeastern United States, where it occurs in wooded flood plains, swamps, and boggy slopes. Common on wet, cool, acidic soils and sandy, peaty loams. Intermediate in shade tolerance.

CLIMATE CHANGE. Vulnerability is currently unknown. Immediate assessment is recommended.

CONSERVATION STATUS. Least concern.

bark

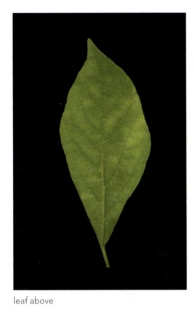
leaf above

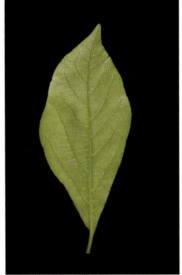
leaf below

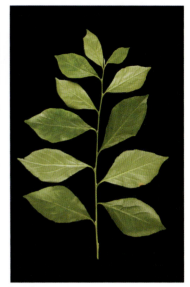
branch

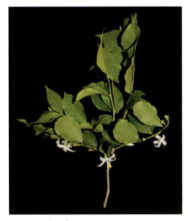
branch with inflorescence

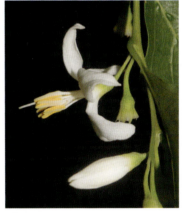
inflorescence

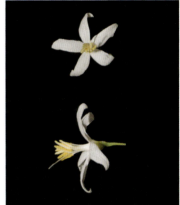
flowers

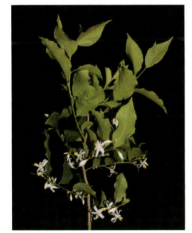
branch with inflorescence

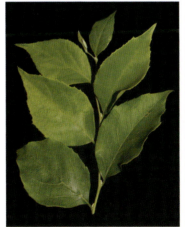
branchlet above

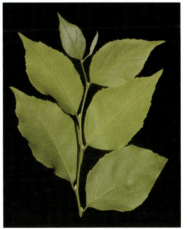
branchlet below

FAMILY STYRACACEAE • 677

Bigleaf Snowbell

Styrax grandifolius Aiton.

Bigleaf snowbell is a shrub or small tree that grows up to 30 ft (9 m) tall and is native to the southeastern United States. It is found in the moist or wet soils of valleys and uplands. It may also be found in the understory of hardwood forests.

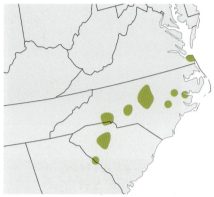

DESCRIPTION. A shrub or small tree that grows up to 30 ft (9 m) tall. Bark is smooth, thin, and gray brown, developing shallow fissures as the tree ages. Leaves are simple, deciduous, alternate, 2.8–7.9 in (7–20 cm) long, with five to eight secondary veins, and occasionally lobed, margins denticulate to serrate, petioles 0.16–0.47 in (4–12 mm) long. Inflorescence is comprised of one to nineteen flowers. Flowers are perfect, axillary, 1.2–4.5 in (3–11.5 cm) long, pedicels 0.16–0.35 in (4–9 mm) long, calyx 0.16–0.24 in (4–6 mm) long, and corolla 0.39–0.83 in (10–21 mm) long, with lobes slightly reflexed, blooming in April and May. Fruits are nutlike, globose, 0.31–0.47 in (8–12 mm) long, yellowish gray, and stellate-pubescent, indehiscent or possesses one to three longitudinal slits.

USES AND VALUE. Wood not commercially important. Cultivated as ornamental in gardens and landscapes. Flowers provide nectar for pollinating insects. Birds and small mammals eat the fruits.

ECOLOGY. Native to the southeastern United States, where it grows in moist or wet soils of valleys and uplands as well as the understory of hardwood forests. Intermediate in shade tolerance.

CLIMATE CHANGE. Vulnerability is currently unknown. Immediate assessment is recommended.

CONSERVATION STATUS. Least concern.

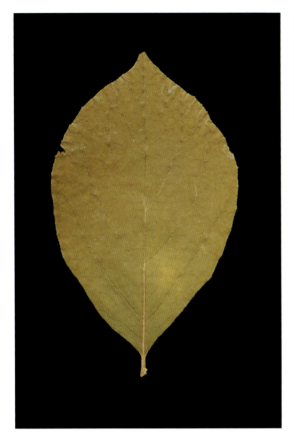
leaf above

leaf below

branch with inflorescence

inflorescence

flower

Family Ericaceae

Taxonomists recently expanded the family Ericaceae, now containing 130 genera and 3,000–4,000 species, to include five additional families formerly recognized as separate entities. By excluding these families, the smaller Ericaceae was not a coherent evolutionary group. A number of lines of evidence from DNA data suggested that combining all of these families into a single larger Ericaceae was the best solution to this taxonomic problem. Members of this family are found around the world, especially in tropical montane regions. They often favor acidic soils.

GENUS ARBUTUS

The skin is tight on the crooked and seemingly muscle-bound limbs, and peels off in vertical strips and thin quills, revealing the beautiful green under-bark whose destiny it is at last to turn ruddy.

—Donald Culross Peattie on *Arbutus menziesii* in *A Natural History of North American Trees*

The twelve species in the genus *Arbutus* are distributed across temperate regions of North America, western Europe, and the Mediterranean zone. They are usually evergreen shrubs or small trees with distinctive bright red edible fruits. Only a single species, Pacific madrone (*Arbutus menziesii*), is common along the northwestern coast of North America.

Pacific Madrone

Arbutus menziesii Pursh

Pacific madrone is a species of tree native to humid coastal sites and dry foothill slopes of the Pacific Northwest.

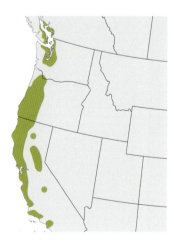

DESCRIPTION. An evergreen tree that grows to 111 ft (34 m) tall with an often crooked or leaning trunk that divides into several twisting upright branches and an irregularly rounded crown. Bark is a showy rich orange red that peels away in thin sheets when mature, leaving a greenish, silvery appearance that has a satin sheen. Leaves are simple, arranged spirally, thick, with a waxy texture, oval, glossy dark green above, lighter grayish green beneath, margins entire, 2.8–5.9 in (7–15 cm) long. Flowers are borne in dense racemes of terminal panicles, perfect with five fused petals, small, 0.31 in (8 mm) in diameter, whitish, fragrant, and urn-shaped, blooming in mid- to late spring. Fruits are bright reddish-orange berries, 0.31–0.47 in (8–12 mm) in diameter, with dry mealy flesh; mature from mid-September to mid-November.

USES AND VALUE. Wood not commercially important. Used for fine furniture and veneer. Cultivated as ornamental tree. Fruit is edible, though tasteless. Bark and leaves have been used as astringent and for treating sore throats. Provides important habitat for cavity-nesting birds. Black-tailed deer and mule deer browse foliage; berries are important source of food for many vertebrates in winter.

ECOLOGY. Grows in the Pacific Northwest of North America on dry foothills, wooded slopes, and canyons from 295 to 4,265 ft (90–1300 m) in elevation. Found on a variety of soils, although prefers rocky well-drained sites. Intermediate in shade tolerance:

saplings require shade, more mature trees need more light. Prolific seeder, good crops produced most years; seed viability is high. Susceptible to fire because of thin bark. Insect damage is limited; damage from fungal pests can be severe, including dieback caused by *Fusicoccum aesculi* (asexual stage) and *Botryosphaeria dothidea* (sexual stage). Several fungi cause serious damage through trunk rot.

CLIMATE CHANGE. Vulnerability is currently considered to be low.

CONSERVATION STATUS. Least concern.

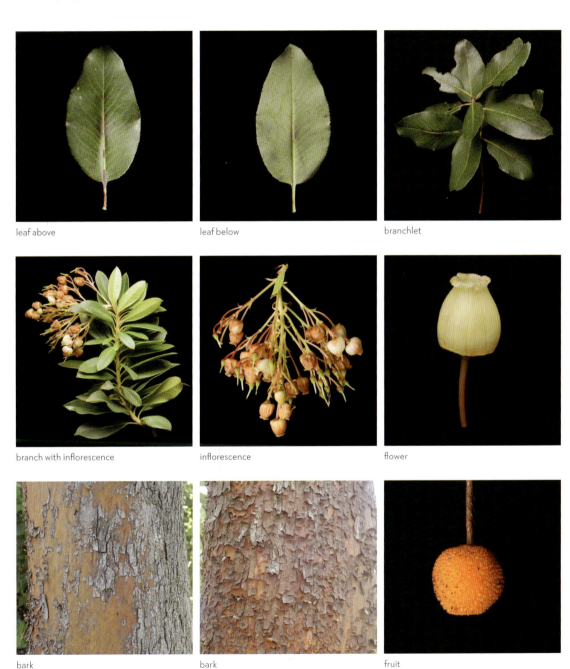

GENUS ARCTOSTAPHYLOS

The branches are always crooked, flattened this way or that, with twisted grain, so that when these little trees grow densely they lock their brawny red arms and arthritic, haggish fingers into an impenetrable thicket or low forest of the type that in California is sometimes called an elfin wood.

—Donald Culross Peattie on *Arctostaphylos manzanita* in A Natural History of North American Trees

This genus of shrubs and small trees in the heath family is composed of perhaps sixty species found mostly in coastal and montane areas of western North America. Several species live in arctic and subarctic zones and are native to Europe, Asia, and North America. The fruits are small berries that can be edible. Only a single species of *Arctostaphylos* is a common small tree or shrub in North America.

Bigberry Manzanita

Arctostaphylos glauca Lindl.

Bigberry manzanita is an evergreen shrub or small tree endemic to California found in middle-elevation forests and chaparral. Some naturalists may not consider this species a true tree, but this large common shrub is included here for completeness.

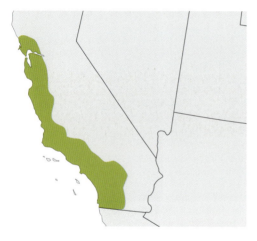

DESCRIPTION. An evergreen shrub or small tree growing 3–26 ft (1–8 m) tall. Height may vary depending on water availability, shortest in desert regions. Twigs are glabrous. Bark is reddish brown. Leaves are simple, evergreen held erect, borne on long petioles, oblong to ovate, dark green above, white glaucous to glabrous, below, tip pointed, margins entire, 1–2 in (2.5–5 cm) long. Inflorescence is a panicle, 0.8–1.2 in (2–3 cm) long, with bracts 1.2–2.4 in (3–6 cm) long. Flowers are perfect, white, ovaries glandular sticky, blooming from December to March. Fruits are spherical drupes, glabrous, 0.39–0.59 in (10–15 mm) wide.

USES AND VALUE. Wood not commercially important. Fruits are edible and eaten raw or made into a cider-like drink. Dried leaves as an infusion are astringent, diuretic, and antiseptic; formerly used to treat urinary tract infections. Flowers and berries attract pollinating insects and frugivorous birds.

ECOLOGY. Grows on rocky slopes, chaparral, and woodlands below 7,218 ft (2,200 m) in elevation; endemic to California. Tolerates heavy soils on slopes as well as serpentine and sodic soils, but grows best in well-drained granitic soils. Intermediate in shade tolerance. Trees are allelopathic, leaching arbutin and phenolic acids from foliage when it rains, thereby inhibiting growth of other surrounding plants.

CLIMATE CHANGE. Vulnerability is currently unknown. Immediate assessment is recommended.

CONSERVATION STATUS. Least concern.

bark

leaf above　　　leaf below　　　branch

 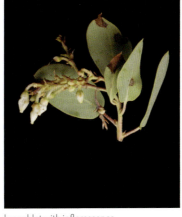 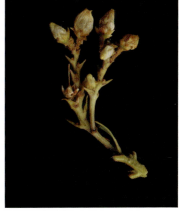

branch with inflorescence　　　branchlet with inflorescence　　　inflorescence

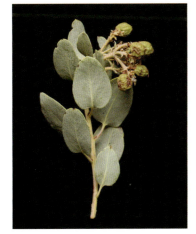 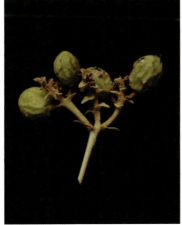

branchlet with infructescence　　　infructescence　　　fruit

GENUS KALMIA

These dainty corollas, like tiny starched crinoline or calico skirts of some child long ago, gave this Laurel its alternative name of Calicoflower, or Calicotree.

—Donald Culross Peattie on *Kalmia latifolia* in *A Natural History of Trees of Eastern and Central North America*

Sometimes called "sheeplaurel" or "lambkill" because the leaves are toxic to livestock, the ten species of *Kalmia* are restricted to eastern North America with one peculiar species in the Greater Antilles. They are usually evergreen shrubs, but sometimes reach tree height, so they are included here. Linnaeus named this genus after his colleague and friend, the botanist Pehr Kalm, who had first collected this species in the 1700s. Only one species of the genus is considered a common small tree in North America.

Mountain Laurel
Kalmia latifolia L.

Mountain laurel is native to eastern and southeastern United States from Maine south to Louisiana. This evergreen shrub or small tree has a broad tolerance for open and closed habitats as well as soil types.

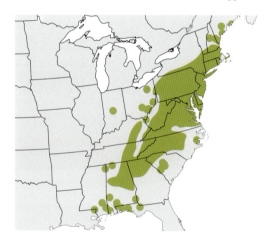

DESCRIPTION. A broadleaf evergreen shrub or small tree with stiff twisted stems growing 10–33 ft (3–10 m) tall. Twigs are twisted, forked, and greenish red, turning to brownish red. Bark is thin and brownish red, shredding and splitting. Leaves are simple, mostly alternate and crowded at apex of twigs, broadly elliptical, acute at both ends, thick, dark green above, and yellowish green below, 2–3.9 in (5–10 cm) long. Flowers are perfect, showy with pink, white, and purple markings and distinctive anthers held in pockets in the corolla, 0.4–1.2 in (1–3 cm) long, arranged in corymbs, blooming in late spring to early summer. Fruits are round brown capsules, 0.20–0.27 in (5–7 mm) wide; seeds very small.

USES AND VALUE. Wood not commercially important. Prized commercially as an ornamental for gardens and landscaping; new shoots with emerging flowers are used in flower arrangements. State flower of Connecticut and Pennsylvania. All parts of the plant are poisonous, containing the compounds grayanotoxin and arbutin. Thickets provide cover for birds and mammals and nectar for pollinating insects.

ECOLOGY. Grows in wet or dry woodlands and pastures with moist, acidic, rocky or sandy soils. Especially abundant in the southern Appalachian Mountains. Shade tolerant. Often forms large thickets that block light and therefore prevent establishment of other plants on the forest floor.

CLIMATE CHANGE. Vulnerability is currently unknown. Immediate assessment is recommended.

CONSERVATION STATUS. Least concern.

leaf above

leaf below

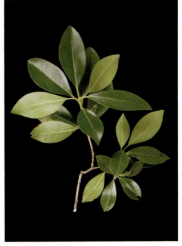
branch

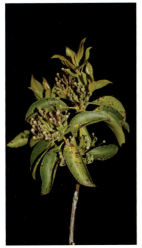
branch with immature inflorescence

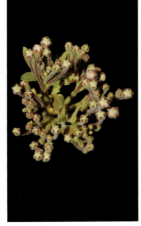
young inflorescence

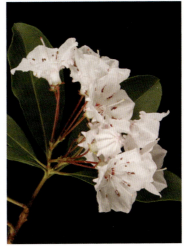
mature inflorescence

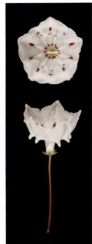
flowers

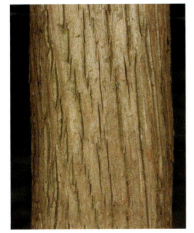
bark

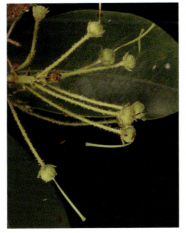
immature infructescence

immature fruit

GENUS OXYDENDRUM

One buys Sourwood honey as one buys any such rare product from its producers—not in a commercial spirit, paying for it and carrying away the wares—but with all the due ceremony observed between a collector and a creative artist.

—Donald Culross Peattie on *Oxydendrum arboreum* in *A Natural History of Trees of Eastern and Central North America*

Only a single species is included in the genus *Oxydendrum*. These small trees are native to eastern North America and produce distinctive drooping clusters of white flowers in the summer months. *Oxydendrum* is allied to the blueberries, but is somewhat distinctive in the heath family. The one species is a common tree in North America.

Sourwood
Oxydendrum arboreum (L.) DC.

Sourwood is a small deciduous tree native to eastern North America with spirally arranged leaves and conspicuous loose clusters of white flowers. The leaves can be chewed to alleviate thirst. The name *Oxydendrum* means "sour tree," and along with the common name refers to the acidic taste of the foliage.

DESCRIPTION. A moderate-lived deciduous tree growing to 49 ft (15 m) with a slender short stem and dense crown. Twigs are olive green turning to red. Bark is grayish brown, thick with scale ridges and deep furrows. Leaves are alternate, simple, elliptic to ovate or lanceolate, green above and pale below, tips long, and margins entire or finely serrate, 3.1–7.9 in (8–20 cm) long. Flowers are perfect, white, 0.24 in (0.6 cm) long, urn-shaped, and borne in racemes 2–5.9 in (5–15 cm) long, blooming in mid-summer. Fruits are brown capsules with tiny two-winged seeds.

USES AND VALUE. Wood not commercially important. Leaves have a pleasant acidic flavor, hence the name "sourwood" and reportedly relieve thirst and have cardiac, diuretic, refrigerant, and tonic properties. Tea made from leaves used to treat asthma, diarrhea, and indigestion and to check excessive menstrual bleeding. Nectar collected from the flowers by bees are an important source of honey for local markets.

ECOLOGY. Grows in upland forest understory habitats, as well as on well-drained bluffs and in ravines. Shade tolerant. Trees generally free of both insect and fungal pests.

CLIMATE CHANGE. Vulnerability is significant but may have the capacity to adapt to changing conditions in the future. Ongoing monitoring is recommended.

CONSERVATION STATUS. Least concern.

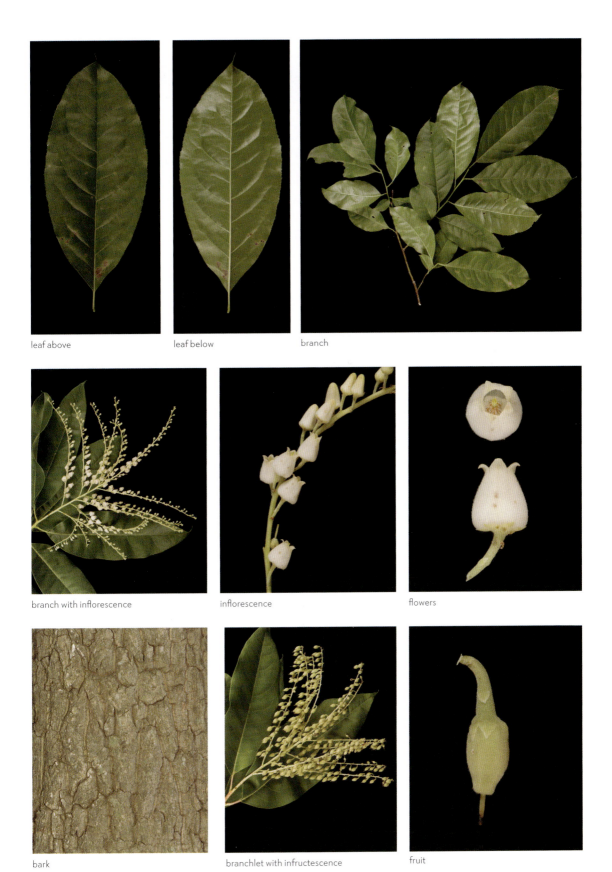

GENUS RHODODENDRON

Rhododendrons have a hard reputation. Their juice is considered poisonous to man and beast. Honey made from these flowers was believed to have crazed Xenophon's retreating host. Browsing animals were hurt by tasting the leaves and shoots.

—Julia Ellen Rogers on Rhododendron in *The Tree Book: A Popular Guide to a Knowledge of the Trees of North America and to Their Uses and Cultivation*

Rhododendron is one of the largest genera in the heath family, containing over 1,000 species. These plants tend to be medium-to-large deciduous or evergreen shrubs, but some attain the height of small trees, so they are included here. Members of the genus are distributed mainly in Asia, especially in the high mountainous zones of the Himalayas. Others are native to the highlands of North America. Only a single species is considered a common small tree in North America.

Pacific Rhododendron
Rhododendron macrophyllum D. Don
CALIFORNIA RHODODENDRON

Pacific rhododendron is an evergreen shrub to small tree that is native to the Cascade Mountain range and coastal regions of the Pacific North America. Some naturalists may not consider this species a true tree because of its size, but it is included here for completeness.

DESCRIPTION. An evergreen shrub to small tree that grows 10–11.5 ft (3–3.5 m) tall. Twigs are stout, green, and glabrous when young, becoming reddish brown with maturity; buds are large and pointed with imbricate scales. Bark is grayish brown, smooth, and scaly. Leaves are evergreen, simple, alternate and persistent, usually whorled at branch tips, oblong, thick, leathery, margins revolute, 1.6–2.8 in (4–7 cm) long. Inflorescences are large and showy with ten to twenty perfect pink, violet, or white flowers subtended by deciduous bracts, corollas widely funnel-shaped and brown flecked on the inside, each flower with ten unequal stamens, blooming from April to July. Fruits are small five-parted capsules borne in clusters, dehiscent from tip to base.

USES AND VALUE. Wood not commercially important. Cultivated as an ornamental. Leaves and bark are consumed by mountain beaver; dense foliage provides cover for small mammals and birds. State flower of Washington.

ECOLOGY. Grows in coastal and montane conifer forests on dry-to-moist, acidic, and well-drained soils.

CLIMATE CHANGE. Vulnerability is currently unknown. Immediate assessment is recommended.

CONSERVATION STATUS. Least concern.

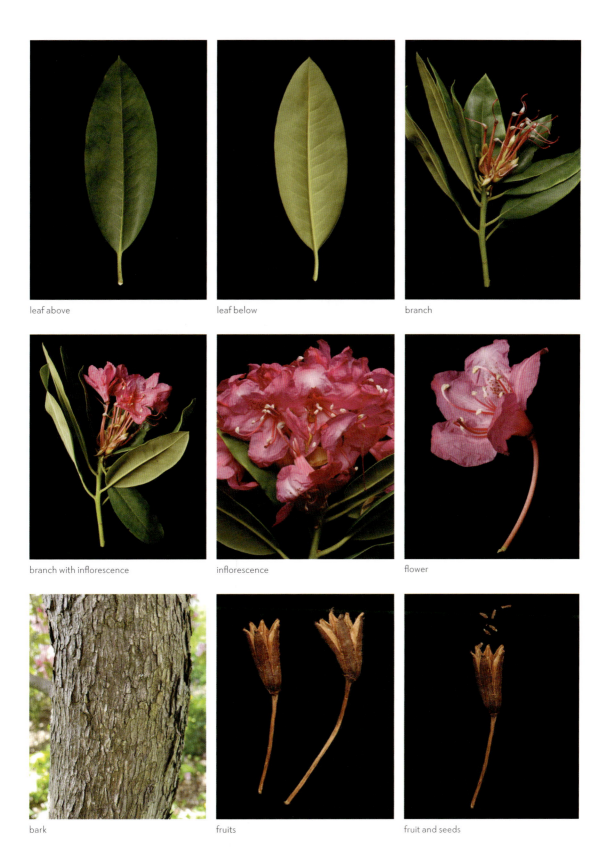

FAMILY ERICACEAE • 689

GENUS VACCINIUM

Spring brings small, white flowers in profusion; summer the leathery, glossiest foliage imaginable; fall provides rich red to crimson leaves and shiny black fruit; and winter the exposed bark in grays, rich browns, oranges, and reddish browns. Sound worthy?

—Michael A. Dirr on *Vaccinium arboretum* in Dirr's Encyclopedia of Trees and Shrubs

Although most of the numerous species of the genus *Vaccinium* are shrubs of various sizes, the farkleberry (*Vaccinium arboretum*) deserves to be called a small tree, so it is included here. Nearly all 450 species are native to the Northern Hemisphere in temperate climates around the world, although a few can be found in tropical zones. The berries are eaten by many animals, including humans. The plants generally prefer to grow in acidic soils common to bogs and heathlands. Only a single native species of *Vaccinium* is considered a small common tree in North America.

Farkleberry
Vaccinium arboreum Marsh
TREE SPARKLEBERRY, TREE HUCKLEBERRY

Farkleberry is an upright shrub or small tree that is native to the southeastern United States. It occupies a variety of habitats from granitic outcrops to meadows. Some naturalists may not consider this species a tree because of its size but is included here for completeness.

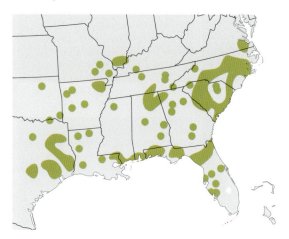

DESCRIPTION. An upright shrub or small tree that grows 7–10 ft (2–3 m) tall. Twigs are slender, reddish brown or gray, glaucous, glabrous or glandular-pubescent. Bark is gray and mottled brown or reddish brown, exfoliating. Leaves are simple, deciduous, alternate, variable in size and shape, most commonly simple, glabrous, and adaxially glossy, margins entire or minutely denticulate, 1.2–3.1 in (3–8 cm) long.

Flowers are arranged in leafy-bracted racemes or panicles, 0.8–2.8 in (2–7 cm) long, perfect, showy, white to pink, blooming from March to June. Fruits are lustrous black berries, 0.20–0.35 in (5–9 mm) in diameter, contains eight to ten dark glossy seeds.

USES AND VALUE. Wood not commercially important. Sometimes used to make tool handles and for tanning leather. Fruits with dry and slightly astringent but pleasant flavor are eaten raw or cooked. Berries, root bark, and leaves are very astringent and are taken internally to treat diarrhea and dysentery. White-tailed deer browse leaves; hares and rabbits also feed on leaves and twigs. Bobwhite quail, American robin, ruffed grouse, tanagers, black bear, rabbit, chipmunk and many other birds and mammals eat the fruits. Various bees visit the flowers for nectar.

ECOLOGY. Forms loose thickets on sand dunes, hammocks, granitic outcrops, sterile hillsides, and abandoned meadows in the southeastern United States. May also grow in moist areas, such as wet bottomlands and riparian zones. Shade tolerant. Fruit production is erratic. Birds and mammals serve as dispersal agents.

CLIMATE CHANGE. Vulnerability is currently unknown. Immediate assessment is recommended.

CONSERVATION STATUS. Least concern.

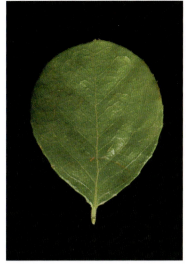
leaf above

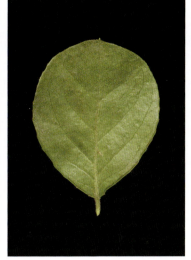
leaf below

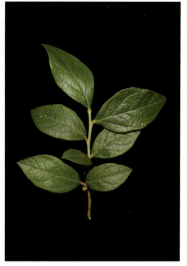
branchlet

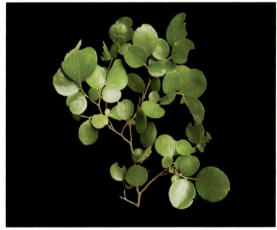
branch above

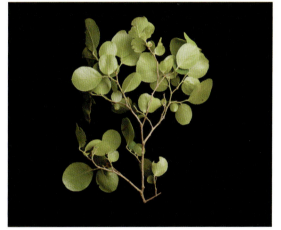
branch below

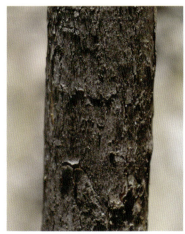
bark

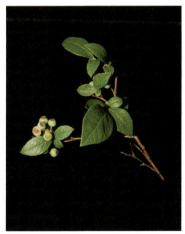
branchlet with infructescence

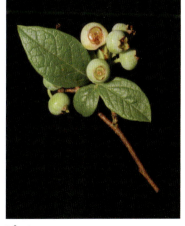
infructescence

FAMILY ERICACEAE • 691

ORDER GARRYALES

The order Garryales, although rather isolated within the Asterids, is most closely allied to the gentians, tomatoes, and mints. These woody plants can be either evergreen or deciduous and have unisexual flowers on separate plants. The order includes two families with three genera.

Family Garryaceae

The family Garryaceae is composed of only two genera and about twenty species, which are found in a variety of habitats in the Americas and eastern Asia. These shrubs and trees are evergreen, exude an elastic latex, and produce their male and female flowers in distinctive hanging catkins on separate plants. A single species of this family is a common tree in North America.

GENUS GARRYA

Distributed from the West Coast of North America through Mexico to the Caribbean, the genus *Garrya* is composed of about fifteen recognized species. Although most are shrubs, the single common species that is native to North America can attain the stature of a small tree, so it is included here.

Wavyleaf Silktassel
Garrya elliptica Douglas ex Lindl.

Wavyleaf silktassel is an irregular shrub or small tree that under ideal conditions may grow to be over 30 ft (10 m) in height. The plants are often found in drier habitats overlooking the ocean. Some naturalists may not consider this species to be a tree, but is included here for completeness.

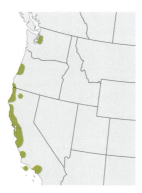

DESCRIPTION. An irregular shrub or small tree that grows up to 10 ft (3 m) tall and, in ideal conditions, may become a tree up to 33 ft (10 m) tall. Twigs are variably four-angled, stout, green, and pubescent, becoming brown at maturity. Bark is gray brown and smooth when young, becoming rough and scaly with age. Leaves are evergreen, simple, opposite, leathery, ovate, margins entire and wavy revolute, dark green above, woolly-pubescent below, up to 3.1 in (8 cm) long. Trees are dioecious producing male and female flowers on separate plants, blooming in mid-winter. Flowers are apetalous, pale purple or yellow; male flowers are arranged in silky drooping spikes, 2–4.7 in (5–12 cm) long; female flowers are produced on less conspicuous catkins. Fruits are berrylike drupes borne in pairs on 0.8–2.8 in (2–7 cm) long tassels, drupe 0.2 in (0.5 cm) wide, glaucous-pubescent, and persistent.

USES AND VALUE. Wood not commercially important. Sometimes cultivated as ornamental. Plants are not palatable to deer or small mammals, but may be consumed by goats.

ECOLOGY. Grows on sea cliffs, sand dunes, chaparral, and foothill pine woodland in Oregon and California at elevations below 2,625 ft (800 m) on well-drained soils.

CLIMATE CHANGE. Vulnerability is currently unknown. Immediate assessment is recommended.

CONSERVATION STATUS. Least concern.

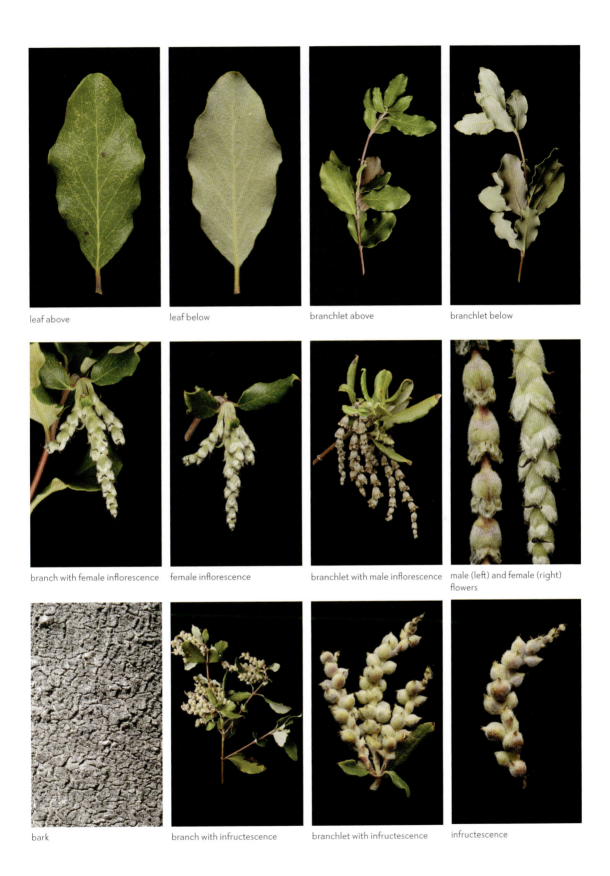

FAMILY GARRYACEAE • 693

ORDER GENTIANALES

The Gentianales contain five families and are united by a number of shared leaf, flower, and chemical features, including opposite leaves, appendages on the leaves called stipules, and twisted floral buds. In addition to the gentians, this order also contains coffee and its relatives, as well as the milkweeds and periwinkles, over 1,100 genera and nearly 20,000 species in total.

Family Rubiaceae

Members of this family are found everywhere on the planet, but most species are native to the tropics. They are herbs, vines, shrubs, and trees. Many of the plants contain active chemical properties that serve as stimulants, drugs, and dyes, such as coffee and quinine. The family is extremely diverse, containing over 11,000 species in 660 genera, yet, despite its diversity, only a single species is considered a common tree in North America.

GENUS CEPHALANTHUS

Short on ornamental attributes—except for its 2- to 6-in-long, lustrous green leaves and the curious 1- to 1¼-in-wide, rounded, creamy white flowers in summer—the plant labors in obscurity.

—Michael A. Dirr on *Cephalanthus occidentalis* in *Dirr's Encyclopedia of Trees and Shrubs*

The shrubs and small trees of the genus *Cephalanthus* are native to the Americas, Africa, and Asia, primarily in tropical zones. Of the six species that make up this genus, just one is a common tree in North America. These plants are generally found in wetlands with inundated soils.

Buttonbush
Cephalanthus occidentalis L.
COMMON BUTTONBUSH

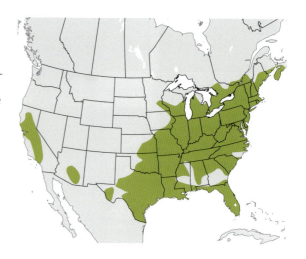

Buttonbush is shrub or small tree, often with multiple stems, that is native to southern and eastern North America. This species is dependent on habitats with plentiful water, such as ponds and swamps. Some naturalists may not consider this species a tree because of its size and multiple stems, but it is included here for completeness.

DESCRIPTION. A deciduous multistemmed shrub or small tree that grows to a height of 16 ft (5 m), base often swollen. Twigs mature from green to brown. Bark is smooth on young plants, becoming scaly with maturity. Leaves are simple, opposite or whorled, tip pointed, margins entire, lustrous dark green above, 9 in (15 cm) long, 2.8 in (7 cm) wide. Flowers are perfect, four-lobed, white, tubular, about 0.4 in (1 cm) long, borne in attractive round clusters, 1.2 in (3 cm) in diameter, blooming in mid-summer. Fruits are brown nutlets in round clusters.

USES AND VALUE. Wood not commercially important. Planted to control erosion in riparian zones. Plants contain poison called cephalathin and no parts are known to be edible. Tea made from bark is astringent, emetic, and febrifuge. Shorebirds and waterfowl consume seeds and twigs; also browsed by white-tailed deer but poisonous to many mammals. Bees and hummingbirds feed on nectar.

ECOLOGY. Grows in wetlands, swamps, ponds, and riparian zones on a variety of moist-to-saturated soils. Tolerates calcareous conditions. Intermediate in shade tolerance.

CLIMATE CHANGE. Vulnerability is currently unknown. Immediate assessment is recommended.

CONSERVATION STATUS. Least concern.

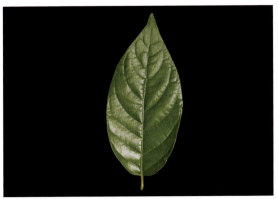
leaf above

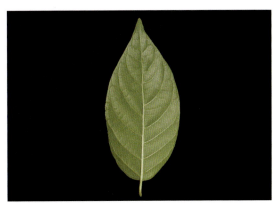
leaf below

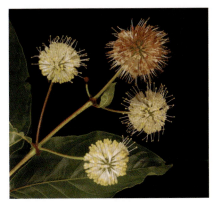
branchlet with multiple inflorescences

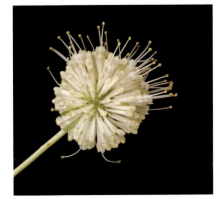
single inflorescence

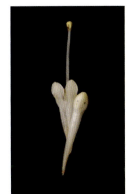
flower

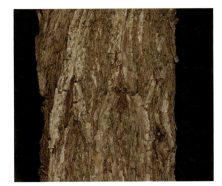
bark

branch segment with inflorescence

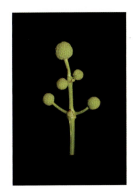
young inflorescence

FAMILY RUBIACEAE

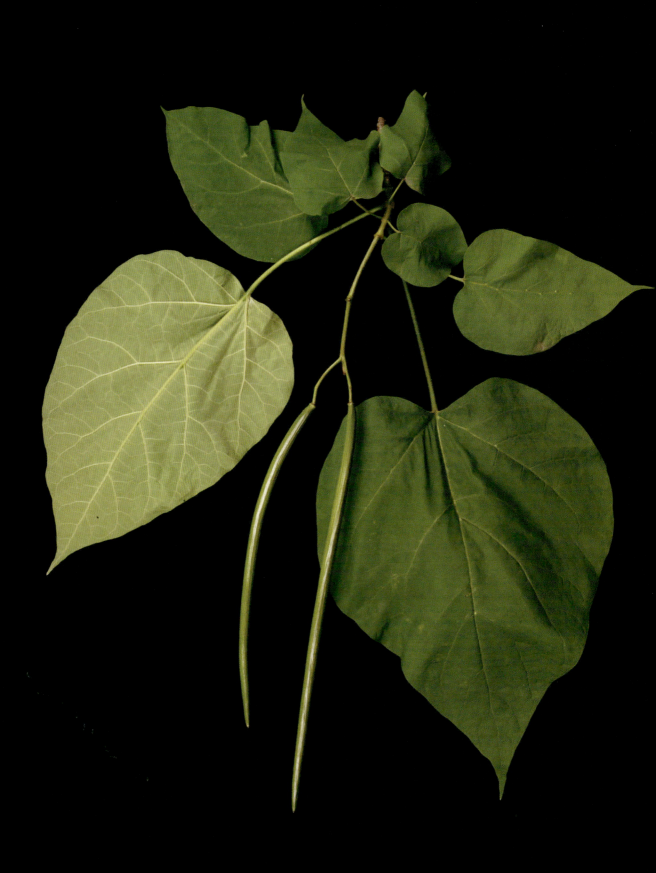

ORDER LAMIALES

The Lamiales, a large group with over 20,000 species spread across 1,100 genera and two dozen plant families, include a long list of familiar garden plants, such as African violets, snapdragons, figworts, trumpet creepers, acanthus, verbenas, and mints. They are distinguished by unique biochemical pathways, leaf traits, seed features, and DNA sequence similarities. Three of the twenty-five families contain trees that are common in North America.

Family Oleaceae

The very fragrant flowers of members of the Oleaceae are somewhat unique in being small and circular with four petals and only two stamens. The family contains nearly 600 species, mostly trees and shrubs, in twenty-five genera, which are widely dispersed mostly in temperate climates. Olives, timber, and many ornamental plants are included in the Oleaceae. Two genera and eight species are common as native and introduced trees in North America.

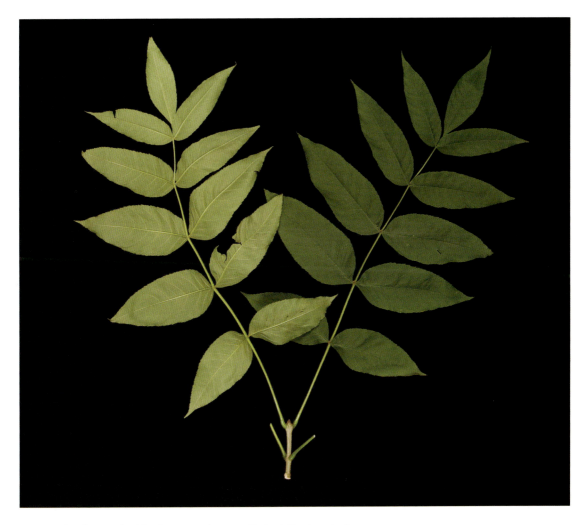

OPPOSITE Northern catalpa (*Catalpa speciosa*). **ABOVE** Black ash (*Fraxinus nigra*).

GENUS FRAXINUS

Strong, tall, cleanly, benignant, the Ash tree with self-respecting surety waits, until you have sufficiently admired all the more obvious beauties of the forest, for you to discover at last its unadorned greatness.

—Donald Culross Peattie on *Fraxinus americana* in *A Natural History of Trees of Eastern and Central North America*

The ashes are an important component of the woodlands of North America. Of the sixty to sixty-five species found in temperate forests across Asia, Europe, and North America, seven are common trees. The distinctive opposite, compound leaves and dangling maplelike fruits, called samaras, readily distinguish our native species of ash from other genera. Most species have male and female flowers that appear on separate trees (dioecious), which is why only some individuals produce fruits. Lamentably, the emerald ash borer (*Agrilus planipennis*), a wood-boring beetle, was inadvertently introduced into North America from Asia around 1990 and is rapidly killing many of the dominant species of *Fraxinus* in our forests. No method to prevent the spread of the beetle has been determined. (See p. 744 for leaf shapes of seven species of *Fraxinus*.)

White Ash

Fraxinus americana L.

White ash, a commercially important tree native to eastern North America, has distinctive compound leaves that turn red, yellow, or purple in autumn. As a result of insects and other pests, this species is undergoing rapid decline.

DESCRIPTION. A moderate-lived (up to 200 years) deciduous tree growing 66–98 ft (20–30 m) tall with long clear trunk, narrow open crown, and a root system deep in porous soils and more spreading on rocky sites. Twigs are dark green becoming gray brown and usually glabrous, flaking and peeling on older growth. Bark is dark gray or brown, deeply furrowed, and ridged. Leaves are opposite, pinnately compound, 7.9–11.8 in (20–30 cm) long, with five to nine (typically seven) leaflets, 2–5.9 in (5–15 cm) long, ovate to lanceolate, dark green and hairless above, pale to white and sometimes pubescent below, margins entire to serrate. Trees are dioecious producing male and female flowers on separate plants, blooming in mid-spring. Flowers are green to purple, with four-lobed, bell-shaped calyx, petals absent, in branched clusters. Fruits are one-seeded samaras, cylindrical, 1–2 in (2.5–5 cm) long, brown, in hanging clusters on twigs.

USES AND VALUE. Wood commercially important. Used for veneer, lumber, plywood, oars, baseball bats, tool handles, pulp, and fuel. No parts of the plant are edible. Seeds are aphrodisiac; bark is astringent. Winged seeds are important source of food for variety of birds. Bark is eaten by mammals; trunks provide important nesting cavities for many birds and mammals. Larval host for several butterflies.

ECOLOGY. Grows on well-drained soils in woods, flood plains, and streambanks. Intermediate in shade tolerance. Good seed crops produced every three to five years; germination rates vary between 40 and 60 percent. A number of native fungal and insect pests are problematic. Ash decline (possibly caused by mycoplasma-like organisms) and invasive emerald ash borer (*Agrilus planipennis*) are devastating populations, causing almost 100 percent mortality in many parts of range. Restrictions on movement of plant material are in place in some states to prevent spread of borer.

CLIMATE CHANGE. Vulnerability is currently considered to be low.

CONSERVATION STATUS. Critically endangered.

leaf above

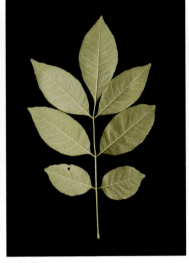
leaf below

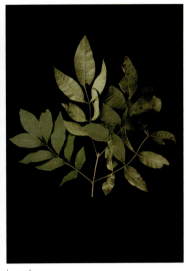
branch

female inflorescence

female flower

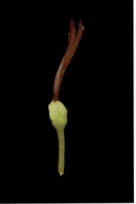
male inflorescence

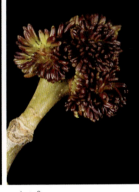

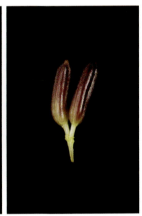
male flower

bark

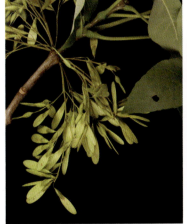
branch with infructescence

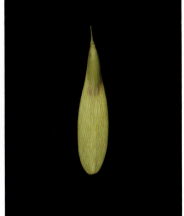
fruit

FAMILY OLEACEAE • 699

Carolina Ash
Fraxinus caroliniana Mill.
POP ASH

Carolina ash is an endangered small tree native to the southeastern United States growing in wet soils of swamps, streams, flatwoods, riverbanks, and swamp forests.

DESCRIPTION. A small tree, growing to 33 ft (10 m) tall. Twigs are glabrous to sparsely pubescent and gray, leaf scars opposite and oval. Bark is scaly, gray or slightly orange brown, and splotched. Leaves are deciduous, opposite, pinnately compound, 6.9–11.8 in (17.5–30 cm) long, with five to seven leaflets, 1.6–6 in (4–15 cm) long, elliptic, dark green above, margins serrate, tip pointed. Trees are dioecious producing male and female flowers on separate plants, blooming from March to May. Flowers are arranged in clusters, yellowish green to purple. Fruits are broad-winged samaras, sometimes three-winged, 1.2–2 in (3–5 cm) long, with an indistinct seed cavity.

USES AND VALUE. Wood not commercially important. Sometimes planted as ornamental. Deer browse foliage, and waterfowl eat seeds. Larval host for eastern tiger swallowtail (*Papilio glaucus*), mourning cloak (*Nymphalis antiopa*), and viceroy (*Limenitis archippus*) butterflies.

ECOLOGY. Grows in wet soils in swamps, streams, flatwoods, riverbanks, and swamp forests in eastern coastal plain. Shade and flood tolerant.

CLIMATE CHANGE. Vulnerability is high, may have little capacity to adapt to changing conditions, and has low potential to persist in the future. Ongoing monitoring is required.

CONSERVATION STATUS. Endangered.

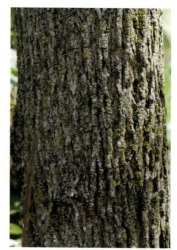
bark

bark with beetle damage

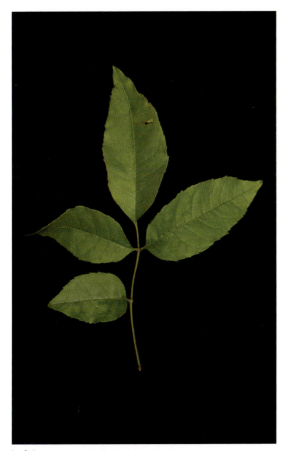
leaf above

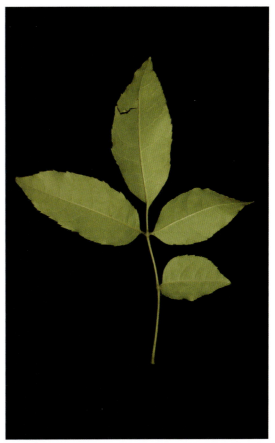
leaf below

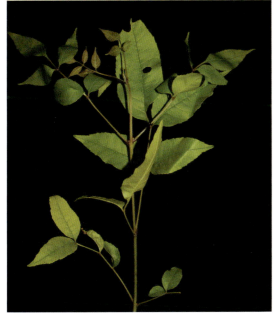
branch

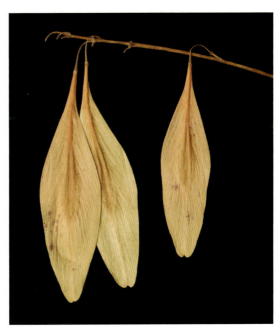
infructescence

FAMILY OLEACEAE • 701

California Ash
Fraxinus dipetala Hook. & Arn.
TWO-PETAL ASH

California ash is a shrub or small tree native to the western United States, where it occurs on canyon slopes, chaparral, and oak-pine woodlands.

DESCRIPTION. A single-stemmed deciduous shrub or small tree growing 49–98 ft (15–30 m) tall. Twigs are greenish brown, stout, and four-angled or round, with scruffy bud scales and large shield-shaped leaf scars. Bark is gray brown and smooth when young, developing scaly rectangular pattern with age. Leaves are opposite, pinnately compound, 5–15 cm (2–6 in) long, with five to seven glossy dark green leaflets, 0.8–2 in (2–5 cm) long, elliptic, margins serrate, tip pointed. Flowers are perfect, conspicuous, with two petal-like lobes, arranged in clusters, 2.8–4.7 in (7–12 cm) long, blooming in mid- to late summer. Fruits are broad straight-winged samaras, 1 in (2.5 cm) long with a notched or square tip; wing of samara nearly extends to the base of flattened seed.

USES AND VALUE. Wood not commercially important. Provides cover for small mammals and birds. Larval host to pale swallowtail, two-tailed swallowtail, and western tiger swallowtail butterflies.

ECOLOGY. Grows on canyon slopes, chaparral, and oak-pine woodland at elevations from 331 to 4,265 ft (100–1,300 m). Found in soils with a variety of textures and drainages; drought resistant.

CLIMATE CHANGE. Vulnerability is currently unknown. Immediate assessment is recommended.

CONSERVATION STATUS. Least concern.

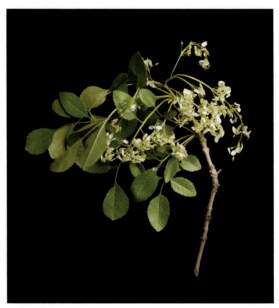
branch with inflorescence

bark

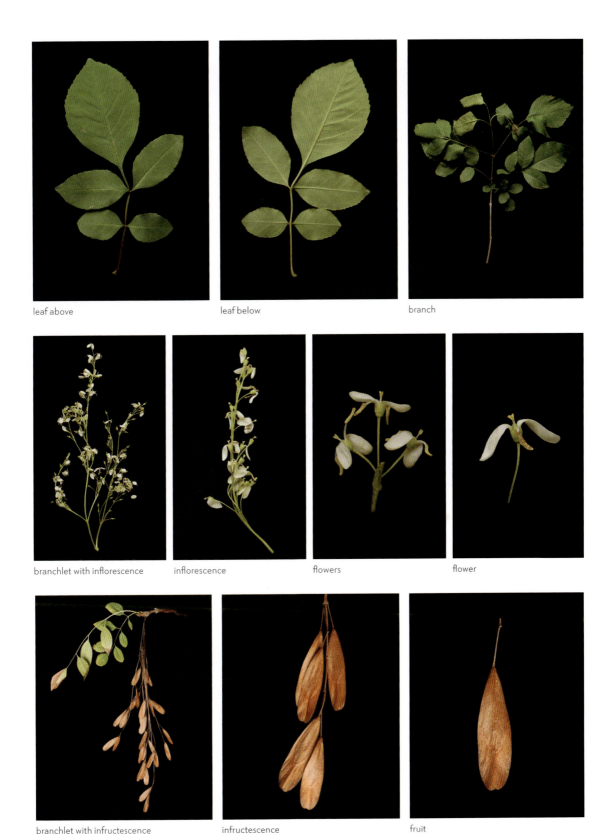

FAMILY OLEACEAE • 703

Oregon Ash

Fraxinus latifolia Benth.

Oregon ash is a deciduous tree native to the Pacific Northwest, where it occurs on moist canyon margins and streambanks.

DESCRIPTION. A deciduous tree growing to 82 ft (25 m) tall with a clear symmetrical trunk, compact crown, and wide-spreading, shallow root system. Twigs are stout, round and flattened at the nodes, olive gray pubescent when young, becoming glabrous. Leaf scars are large, crescent shaped. Bark is smooth and gray green when young becoming thick and furrowed into thin, flat, gray ridges. Leaves are opposite, pinnately compound, 4.7–11.8 in (12–30 cm) long, with five to seven leaflets, 2–3.5 in (5–9 cm) long, obovate, light green, pubescent below, margins entire, tip pointed. Trees are dioecious producing male and female flowers on separate plants, blooming in April and May. Flowers are green, inconspicuous and apetalous, borne in dense clusters; male flowers are typically less than 0.02 in (0.5 mm) long, four-toothed with two anthers, 0.08–0.14 in (2–3.5 mm) long; female flowers with calyx 0.04 in (1 mm) long and irregularly cut, style 0.12 in (3 mm) long. Fruits are dry samaras, 1–2 in (2.5–5 cm) long, with terminal wings, 1.2–2.8 in (3–7 cm) long, attached singly to twigs, hanging in dense clusters.

USES AND VALUE. Wood not commercially important. Used locally for fuel. Planted for revegetation and erosion control. No edible parts. Crushed fresh roots used by some Native North Americans to treat serious wounds. Birds and squirrels eat seeds; deer and elk browse saplings.

ECOLOGY. Occurs on moist canyon sites and streambanks in elevations below 5,577 ft (1,700 m) and most commonly found on moist, rich, well-drained soils. Shade tolerant in sapling stage, less so when mature; windfirm. Good seed crops produced every three to five years; germination rates moderately high; dispersed primarily by wind. Subject to variety of fungal and insect pests, but none seriously damaging.

CLIMATE CHANGE. Vulnerability is significant but may have the capacity to adapt to changing conditions in the future. Ongoing monitoring is recommended.

CONSERVATION STATUS. Near threatened.

male inflorescence

female inflorescence

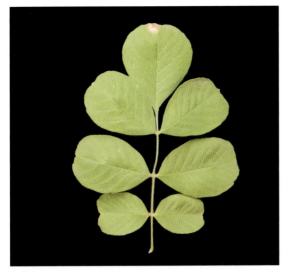
leaf above

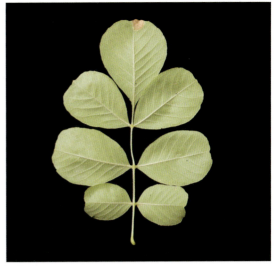
leaf below

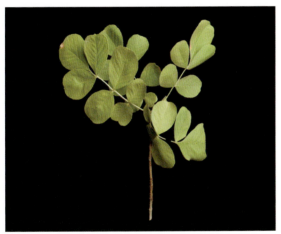
branch above

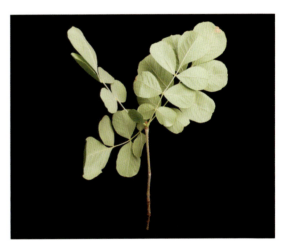
branch below

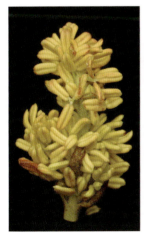
male flowers

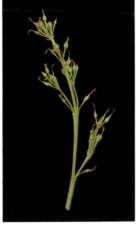
female flowers

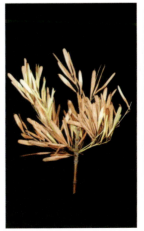
infructescence

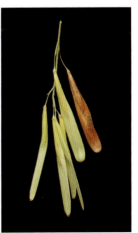
fruits

FAMILY OLEACEAE • 705

Black Ash

Fraxinus nigra Marshall

Black ash is a medium-sized deciduous tree native to northeastern North America with thick gray bark that becomes fissured with age. The wood splits easily and is often used to make baskets. It is critically endangered.

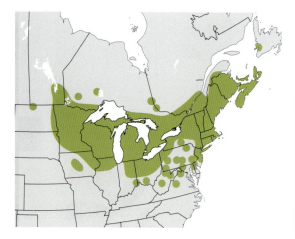

DESCRIPTION. A moderate-lived (up to 130 years or more) deciduous tree growing 39–82 ft (12–25 m) tall with poorly shaped trunk, small open crown, and shallow root system. Twigs are green, becoming gray brown and warty. Bark is ashy gray, becoming scaly. Leaves are opposite, pinnately compound, 9.8–15.7 in (25–40 cm) long, with seven to eleven (often nine) leaflets, 2.8–5.9 in (7–15 cm) long, oblong-lanceolate, dark green and glabrous above, paler with veins hairy below, margins finely serrate. Flowers are perfect or unisexual (then trees dioecious), purplish, petals are absent, produced in clusters, blooming in early spring. Fruits are light brown samaras, 1–1.8 in (2.5–4.5 cm) long in hanging clusters with a flat and wide wing, usually, one seeded.

USES AND VALUE. Wood not commercially important. Used locally for fuel. Native North Americans used wood and bark to make baskets. No edible parts. Medicinally, leaves are diaphoretic, diuretic, and laxative. Seeds important source of food for songbirds and small mammals; saplings and branches browsed by deer and moose.

ECOLOGY. Grows in swamps, in moist woods, and along streams; intolerant of shade. Good seed crops produced every three years. Damage through trunk rot caused by wide range of fungi. Restrictions on the movement of plants are in place in many states to prevent the spread of the emerald ash borer.

CLIMATE CHANGE. Vulnerability is significant but has reasonable probability of persistence in the future. Ongoing monitoring is recommended.

CONSERVATION STATUS. Critically endangered.

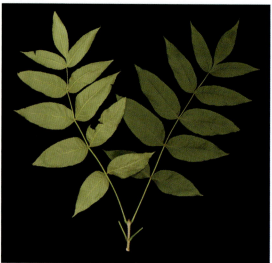
branch

bark

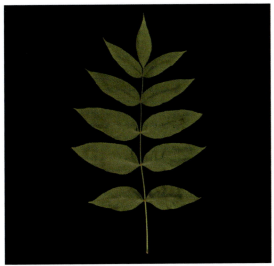
leaf above

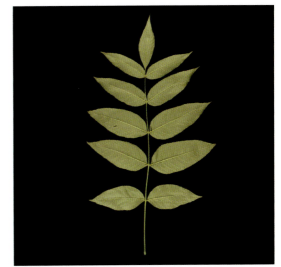
leaf below

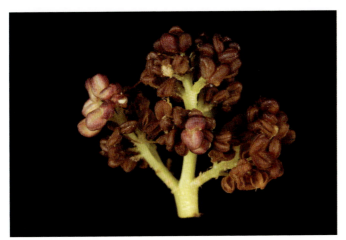
male inflorescence

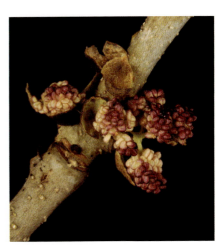
branchlet with male inflorescence

branchlet with infructescence

fruit

FAMILY OLEACEAE • 707

Green Ash

Fraxinus pennsylvanica Marshall

Green ash is native to and widely distributed in eastern and central North America. One of the first trees to change color in autumn with bright golden yellow leaves, it is now critically endangered.

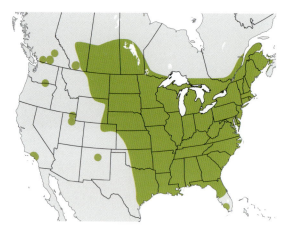

DESCRIPTION. A short-lived deciduous tree growing to 82 ft (25 m) tall with a broad irregular crown, a generally poorly formed trunk, and shallow fibrous root system. Bark is brown and shallowly furrowed. Leaves are opposite, pinnately compound, 8–12 in (20–30 cm) long, petioles are winged and grooved, usually with seven lanceolate leaflets, green above, pale below, margins entire below middle and slightly toothed towards tip, 3.1–5.9 in (8–15 cm) long, 1–1.5 in (2.5–3.75 cm) wide. Flowers are perfect, greenish purple, with no petals and cup-shaped calyx, 0.24 in (0.6 cm) long, arranged in compound clusters, blooming in mid-spring. Fruits are flattened and tapered, tan to reddish samaras, 4–7.5 cm long, 3–6 mm wide, round in cross section.

USES AND VALUE. Wood moderately commercially important. Marketed with white ash and used for tool handles, baseball bats, and construction. Used in forest restoration, especially streamside stabilization. Inner bark edible when cooked. Infusion of inner bark used to treat depression and fatigue. Seeds are eaten by numerous birds; saplings and branches are browsed by deer.

ECOLOGY. Commonly grows along streambanks and in swamps; may be invasive or weedy. Intermediate in shade tolerance. Fruits are dispersed by wind and water. Many insect pests, including oyster-shell scale (*Lepidosaphes ulmi*) distributed throughout the Northeast that causes serious damage to seedlings and small trees. Fungal pests include leaf-spot and root-rot species. Restrictions on the movement of plants are in place in many states to prevent the spread of the emerald ash borer.

CLIMATE CHANGE. Vulnerability is currently considered to be low.

CONSERVATION STATUS. Critically endangered.

bark

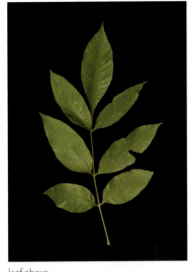
leaf above

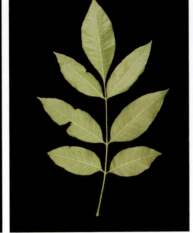
leaf below

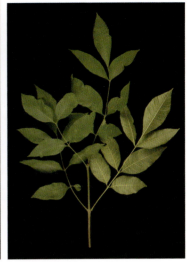
branch

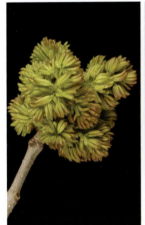
male inflorescence with unopen flowers

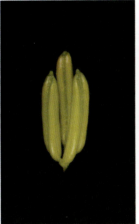
male flower

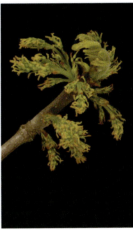
female inflorescence

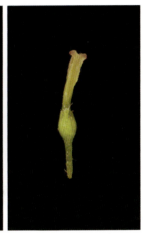
female flower

male inflorescence with open flowers

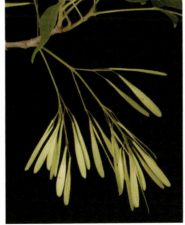
infructescence

fruit

FAMILY OLEACEAE • 709

Velvet Ash
Fraxinus velutina Torr.

Velvet ash is a deciduous tree native to the western United States found in desert, canyon, and chaparral habitats.

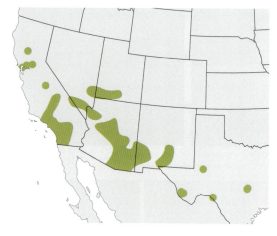

DESCRIPTION. A deciduous tree growing to 33 ft (10 m) tall with a single trunk and moderately dense, round crown. Twigs are pubescent when young, turning from gray to brown with fairly large leaf scars. Bark is smooth and gray when young, developing ridges in an irregular diamond pattern. Leaves are opposite, pinnately compound, 3–7.9 in (7.5–20 cm) long, with five elliptical to ovate leaflets, 1–4 in (3–10 cm) long, green above, pubescent below, margins entire and wavy-toothed towards tip. Trees are dioecious producing male and female flowers on separate plants, blooming from March to June before leaves appear. Male flowers are inconspicuous, pale yellow green; female flowers are light green; both are borne in dense clusters. Fruits are single-winged, straight samaras, 0.6–1.6 in (1.5–4 cm) long, with plump seeds, hanging in clusters by late summer.

USES AND VALUE. Wood not commercially important. Used by Native Americans to make bows and sharp tools for gathering agave. Planted widely as ornamental shade or landscape tree. In cultivation, tendency to grow multiple stems and aggressive root systems damage sidewalks and paved surfaces.

ECOLOGY. Grows on desert and chaparral streambanks and canyons at elevations from 656 to 5,249 ft (200–1,600 m), most commonly on dry rocky soils.

CLIMATE CHANGE. Vulnerability, though currently considered to be low, may increase in the future. Ongoing monitoring is recommended.

CONSERVATION STATUS. Least concern.

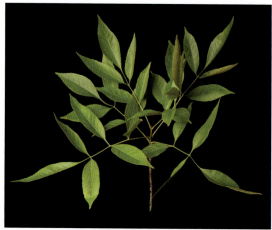
branch

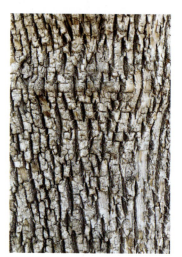
bark

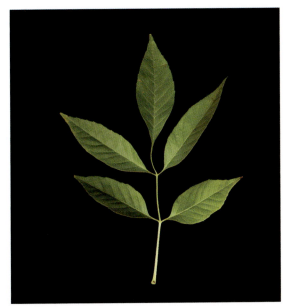
leaf above

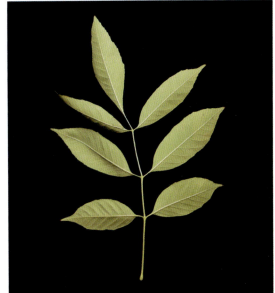
leaf below

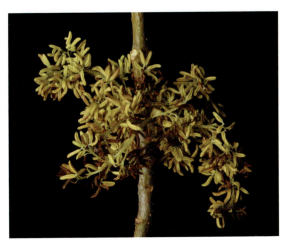
male inflorescence

female inflorescence

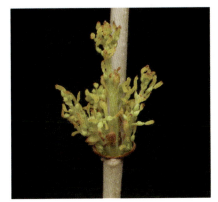
female flowers

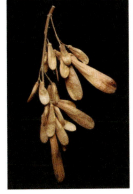
infructescence

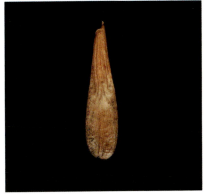
fruit

FAMILY OLEACEAE • 711

GENUS OLEA

Species of the genus *Olea* are native to almost every continent but North America. The forty species of this genus is represented in North America by the introduced *Olea europaea*, the olive of commerce, which came to California via the Mediterranean region. Olives are mostly found as cultivated small trees, but some have also naturalized in specific regions.

Olive
Olea europaea L.

Introduced from Europe and Asia, olives are shrubs or trees with a single, often twisted trunk. Commercially important for fruit and oil products this species may also naturalize in areas where it is cultivated. Two subspecies are recognized in North America.

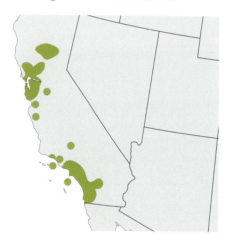

DESCRIPTION. A small, often shrubby tree that grows to 33 ft (10 m) tall with a single wide, twisted trunk. Twigs are stout, light gray or green, and finely pubescent. Bark is light gray to brown, smooth and becoming scaly and gnarled in older individuals. Leaves are evergreen, opposite, simple, lanceolate, blue or gray green, much paler below, margins entire, 1–2.8 in (2.5–7 cm) long. Flowers are perfect, produced in small clusters in the axils of leaves, small, creamy white, with four petals joined into a short tube at the base, blooming in spring and early summer. Fruits are oblong drupes, up to 1.6 in (4 cm) long, glossy and smooth, initially green and turning dark red or purple when ripe, single seed is 0.39–0.59 in (10–15 mm) long, surrounded by oily flesh.

TAXONOMIC NOTES. Subspecies *cuspidata* is characterized by leaves with pale greenish-brown undersides, prominently hooked tips, and a yellow mid-vein; ssp. *europaea* has leaves with silvery-gray undersides and leaf tips lacking hooks.

USES AND VALUE. Wood commercially important. Used for making kitchen utensils, cutting boards, and fine furniture because it is hard, durable, and colorful. Trees are grown in plantations primarily in California for production of olives and associated products, such as olive oil. Olives were among the first trees to be cultivated, dating back to 2500 BCE. Provides cover and fruit for wildlife.

ECOLOGY. Introduced into North America and grows in warm, temperate, Mediterranean climates. Often found on sandy loam or clay soil but best in well-drained soil. Tolerates infertile soils. May naturalize in woodlands, parks, grasslands, and disturbed areas along roadsides and waterways.

CLIMATE CHANGE. Vulnerability is considered low because of wide geographic distribution as an ornamental and/or invasive.

CONSERVATION STATUS. Least concern.

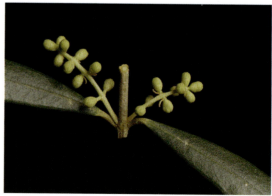

branch with inflorescence/buds

leaf above leaf below branchlet

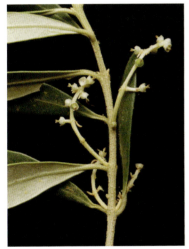 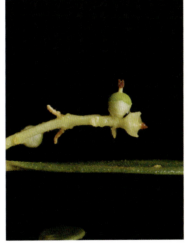 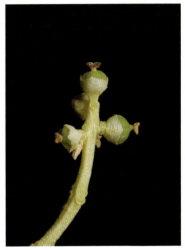

branch with inflorescence branchlet with immature infructescence immature fruits

younger bark older bark

FAMILY OLEACEAE • 713

Family Bignoniaceae

The Bignoniaceae is a family of shrubs, trees, and lianas containing over 800 species worldwide. These plants are all found in the tropics and subtropics, where they form a conspicuous element of the forest with usually large colorful flowers. Many different animals pollinate these plants, which have evolved diverse floral forms to adapt to visitors. Large bees, birds, bats, and other mammals have been recorded visiting the flowers of various genera. Two species are common and conspicuous trees in North America.

GENUS CATALPA

Out of the deadest-looking branches, which show no sign of life until spring has sown meadow and wood with blossoms, a luxuriant crown of bright foliage comes, and with a rush, as if to make up lost time, the tree bursts into bloom.

—Julia Ellen Rogers on *Catalpa Catalpa* (now *C. bignonioides*) in *The Tree Book: A Popular Guide to a Knowledge of the Trees of North America and to Their Uses and Cultivation*

Species in the genus *Catalpa* are native to the regions of North America, Asia, and the Caribbean Islands. Of the forty species, only two are found in North America. The straight trunks, large leaves, conspicuous white flowers, and dangling seedpods produced at the end of summer are distinctive features of these popular ornamental trees. One native species of *Catalpa* is a common tree in North America.

Northern Catalpa

Catalpa speciosa Warder ex Engelm.

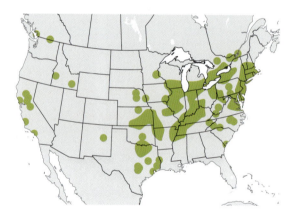

Northern catalpa is native to the midwestern United States. Leaves fall in autumn before changing color, and fruits are long, thin, beanlike pods that resemble brown icicles. The soft light wood of this species is excellent for carving.

DESCRIPTION. A short-lived (approximately sixty years), deciduous, moderate- to fast-growing tree that grows up to 80 ft (24 m) in height with an open crown. Bark is gray to reddish brown and scaly. Leaves are simple, deciduous, whorled in groups of three, cordate, light green above and pubescent below, margins entire, 5–12 in (12.7–30.5 cm) long. Flowers are perfect, white, five-lobed with ruffled edges, yellow streaks inside, and orange or purple interior, blooming in May and June. Fruits are green, pod-like capsules, 10–24 in (25.4–61 cm) long, splits lengthwise when dry and mature, turning brown in autumn.

USES AND VALUE. Wood commercially important. Used for fence posts, carving, and cabinetry. Especially popular as ornamental shade tree. Few food or medicinal uses. Hummingbirds and bees are attracted to conspicuous flowers for nectar. Sole larval host of catalpa sphinx month.

ECOLOGY. Prefers sun to partial shade and is found along streambanks and in moist areas but also grows in many other habitats.

CLIMATE CHANGE. Vulnerability is significant but may the capacity to adapt to changing conditions in the future. Ongoing monitoring is recommended.

CONSERVATION STATUS. Least concern.

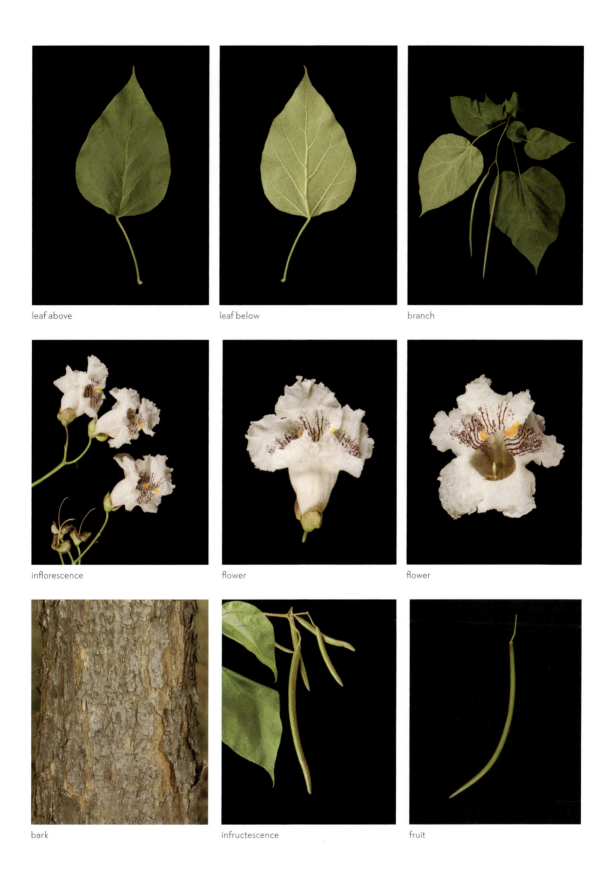

GENUS CHILOPSIS

When the summer stars come forth, and hot Antares blazes in the Scorpion, then and only then steals forth from the lips of Desert Catalpa's blossoms the odor of sweet violets.

—Donald Culross Peattie on *Chilopsi linearis* in *A Natural History of North American Trees*

The genus *Chilopsis* gets its Latin name from the large lavender to pink flowers resembling a pair of lips. It contains only a single species that is restricted to the southwestern United States and Mexico. Usually found in dry areas along washes, these plants are common shrubs or small trees and therefore included here. Although the leaves are somewhat willow-like, the plants are not related at all to members of the genus *Salix*.

Desert-Willow

Chilopsis linearis (Cav.) Sweet

Desert-willow is a large deciduous shrub or small tree that is native to the southwestern United States. It grows in dry habits where some water is available and has attractive lavender and yellow flowers. Two subspecies are recognized.

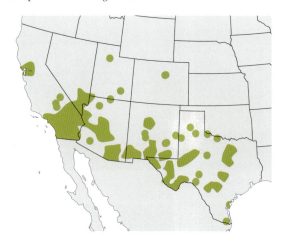

DESCRIPTION. A large deciduous shrub or small tree that grows 10–30 ft (3–9 m) tall, with an open-spreading crown. Twigs are slender and green, turning gray brown, with minute buds. Bark is ashy brown, split and cracked lighter and eventually becoming scaly. Leaves are deciduous, alternate, opposite or whorled, linear, often curved, 2.4–4.3 in (6–11 cm) long. Flowers are perfect, clustered at the ends of twigs, lavender and striped with yellow at the throat, bell-shaped, 1 in (2.5 cm) long, blooming in late spring and summer. Fruits are long, thin, twisted capsules, 4.7–11 in (12–28 cm) long, with numerous tufted winged seeds.

TAXONOMIC NOTES. Subspecies *arcuata* with scythe-shaped leaves occurs west of the Rio Grande; ssp. *linearis* with straight linear leaves occurs east of the Rio Grande in eastern New Mexico and western Texas.

USES AND VALUE. Wood not commercially important. Cultivated as ornamental for showy flowers. Used for soil stabilization and planted by the CCC in shelterbelts in western region of North America. Native North Americans used wood to make bows and baskets. Flowers and seedpods are edible. Parts of plant were used to treat fungal infections, wounds, and bronchial ailments. Unpalatable to livestock and wildlife. Flowers provide nectar for bees and hummingbirds.

ECOLOGY. Grows in desert washes and watercourses, in moist canyons in deserts, and in mountain foothills on well-drained sandy soils and gravelly alluvium with neural pH Intermediate in shade tolerance.

CLIMATE CHANGE. Vulnerability is currently unknown. Immediate assessment is recommended.

CONSERVATION STATUS. Least concern.

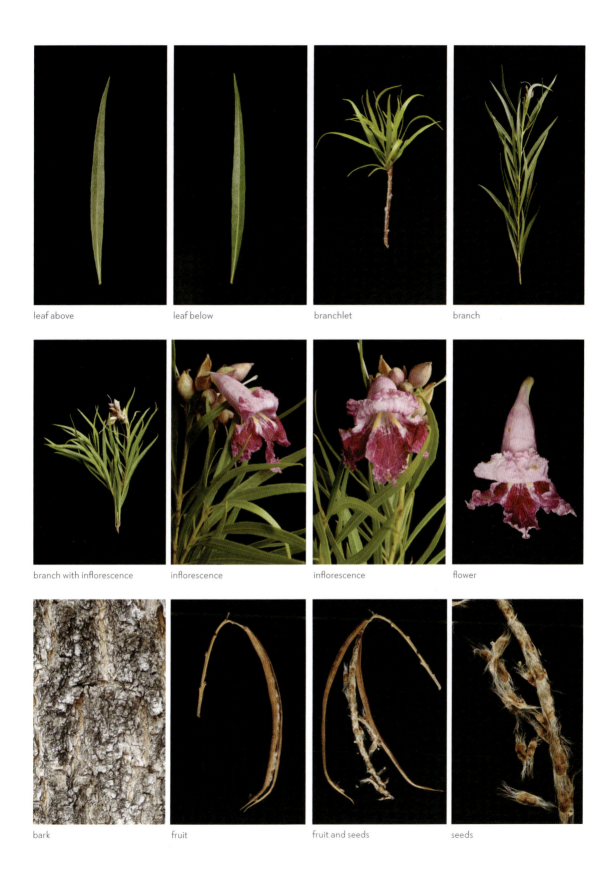

FAMILY BIGNONIACEAE • 717

Family Paulowniaceae

Paulownia has been segregated from the former large widespread family Scrophulariaceae into its own family, the Paulowniaceae. At one time, taxonomists had also placed this genus in the family Bignoniaceae. However, the opposite leaves with flowers clustered at the tips of the branches and the dense brown hairs covering the base of the flowers are traits that distinguish *Paulownia* as a separate family. The genus *Paulownia* includes six species native to East Asia and was named after Princess Anna Paulowna (1795–1865), the daughter of the Tsar of Russia. Only one naturalized species is a common tree on North America

GENUS PAULOWNIA

Blue is unusual among tree blossoms, and these trees, like great blue-flowered catalpas, are striking objects in parks and along avenues. Native to Japan and China, the paulownia feels enough at home in America to run wild in some places.

—Julia Ellen Rogers on *Paulownia imperialis* (now *P. tomentosa*) in *The Tree Book: A Popular Guide to a Knowledge of the Trees of North America and to Their Uses and Cultivation*

Paulownia, which is native to Asia (China to Laos and Vietnam), is an important tree in China, Japan, and Korea. It is cultivated as an ornamental and the wood is used extensively for making furniture and musical instruments. The single species that is common in North America is an invasive tree that establishes easily in disturbed areas. The taxonomy is not settled, and the genus may have from six to fifteen species.

Princesstree
Paulownia tomentosa (Thunb.) Steud.
EMPRESSTREE

The princesstree is a deciduous tree native to China that was brought to the United States as a flowering ornamental. The trees grow rapidly and produce clusters of tubular, pale purple flowers in early spring before the leaves appear. This species has been classified as an invasive plant in parts of eastern North America.

DESCRIPTION. A short-lived deciduous tree growing rapidly to 66 ft (20 m) tall. Trunk is hollow in large trees. Twigs are light brown and round but compressed at the nodes, with large lenticels. Bark is thin, grayish brown, and flaky. Leaves are opposite, simple, entire or slightly lobed, ovate to almost circular, base cordate, dark green and pubescent above, pale below with branched hairs, 5–12 in (15–30 cm) long and wide. Flowers are perfect, tubular, 2–2.8 in (5–7 cm) long, lavender, fragrant, and borne in terminal panicles, blooming in mid-spring. Fruits are oval, two-valved capsules, 1–1.5 in (2.5–3.75 cm) long, green turning brown, and containing thousands of flattened winged seeds.

USES AND VALUE. Wood not commercially important. Outside of North America grown in plantations for sawtimber production. Introduced in the eastern United States as an ornamental tree for gardens and landscapes; now classified as an alien invasive and is very aggressive rapidly inhabiting disturbed sites.

ECOLOGY. Grows in a wide variety of soils, is intolerant of shade, and may be invasive or weedy in all parts of its North American range. Prolific seeder.

CLIMATE CHANGE. Vulnerability is considered low because of its wide geographic distribution as an ornamental and/or invasive.

CONSERVATION STATUS. Least concern.

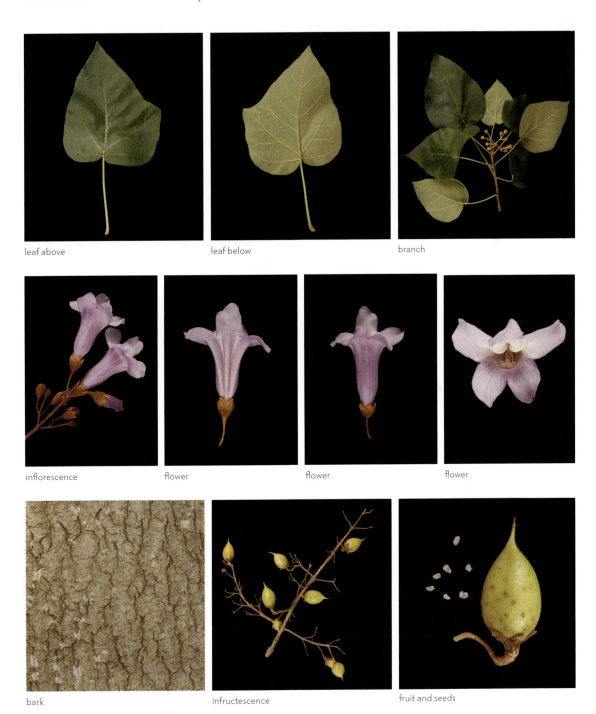

leaf above

leaf below

branch

inflorescence

flower

flower

flower

bark

infructescence

fruit and seeds

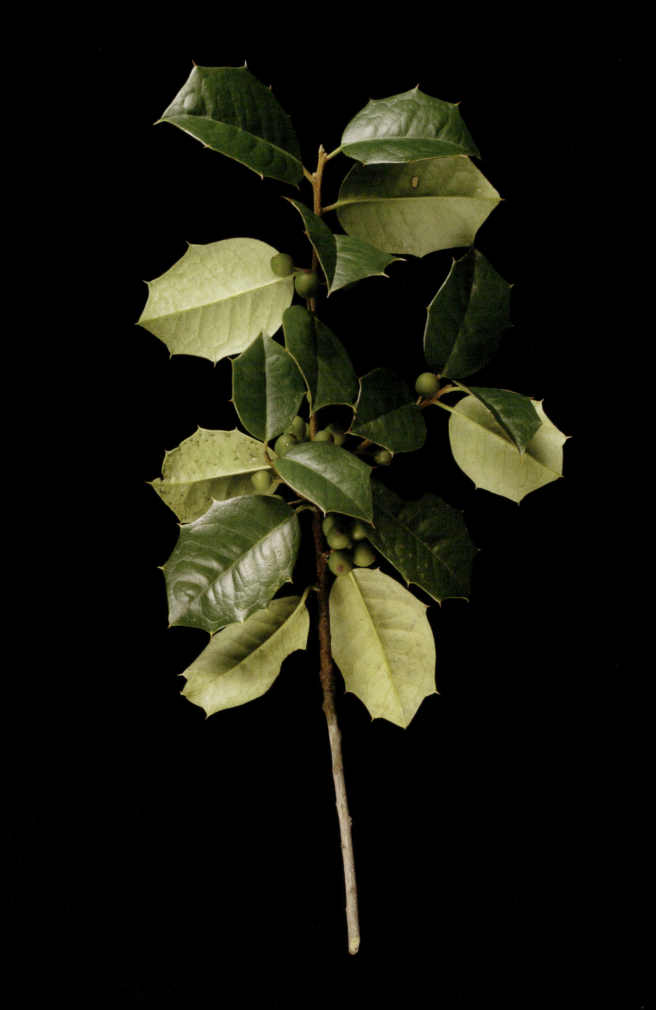

ORDER AQUIFOLIALES

The order Aquifoliales contains the holly family plus four additional rather obscure groups. Evidence that these families are related to each other and that they should be placed in the Asterids comes from DNA sequence data. The flowers in these plants are male or female and each sex is produced on separate plants. The fruits are fleshy and peachlike. Only two species of holly are common trees in North America.

Family Aquifoliaceae

A number of species of *Ilex*, the large and only genus in the primarily tropical family Aquifoliaceae, produce secondary compounds that are found in the leaves and bark. For this reason some of the species are used in local cultures as stimulant beverages and hallucination-causing tonics. These secondary compounds evolved in *Ilex* and other plant families, such as the tomato, milkweed, and willow families, to protect the plants from insects that eat them. Such herbivores can cause substantial damage to the plants, so any mechanism that discourages these attackers, such as spines or irritating and distasteful chemicals, are favored by natural selection. Human use of these plants and their chemical compounds is a secondary by-product of the evolution of anti-herbivore properties. Of the nearly 400 species of *Ilex*, only three are common trees in North America.

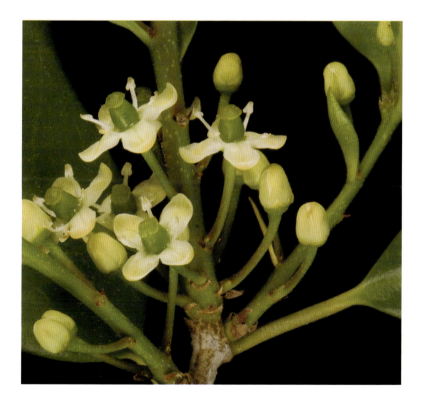

OPPOSITE AND ABOVE American holly (*Ilex opca*).

GENUS ILEX

It is rare to find a wood which so closely imitates ivory in colour and texture as holly wood does. This makes it the delight of the carver and decorator.

—Julia Ellen Rogers on *Ilex opaca* in *The Tree Book: A Popular Guide to a Knowledge of the Trees of North America and to Their Uses and Cultivation*

The numerous species of *Ilex* are found in both temperate and tropical regions of the world. Ranging from shrubs to vines to small trees, the plants are unisexual, bearing either male or female flowers but generally not both. The genus originated over 80 million years ago and has since spread around the planet. The bright red fruits contain a host of chemicals, including caffeine, and some can be toxic. The hard wood is often used for carving. Three native species of *Ilex* are common trees in North America.

Possumhaw
Ilex decidua Walter

Possumhaw, native to the southeastern United States, is a shrub or small deciduous tree with stiff branches that grows in wet and moist areas. It is a popular plant for decorations at Christmas.

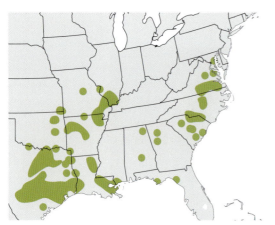

DESCRIPTION. A deciduous shrub or small tree that grows to 33 ft (10 m) tall, with stiff branches. Twigs are gray to greenish brown, with light lenticels. Bark is thin, smooth, and sometimes warty. Leaves are alternate, simple, thick, oblong to oblanceolate, lustrous green above, paler below, margins crenate, 1.2–2.8 in (3–7 cm) long, and 0.6–1 in (1.5–2.5 cm) wide. Trees are dioecious with male and female flowers on separate plants, blooming in mid-spring. Flowers are arranged in short-peduncled clusters, greenish white with four petals. Fruits are attractive round red drupes on short stalks, 0.24–0.31 in (6–8 mm) in diameter, with nutlets that are grooved on the back.

USES AND VALUE. Wood not commercially important. Branches and fruits are used for Christmas decorations. Fruits attract and are eaten by songbirds and mammals; deer browse on the twigs. Larval host plant for Henry's elfin (*Callophrys henrici*) butterfly.

ECOLOGY. Grows in low wet woodlands and riparian zones in the Atlantic and Gulf coastal plains of the southeastern United States. Tolerant of drought and a variety of soil types, including calcareous soils.

CLIMATE CHANGE. Vulnerability is currently unknown. Immediate assessment is recommended.

CONSERVATION STATUS. Least concern.

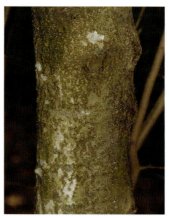

bark

leaf above

leaf below

branch

branchlet above

branchlet below

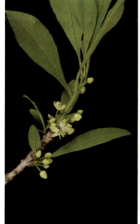
branch with inflorescence

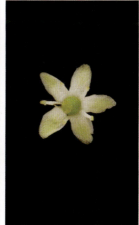
flower

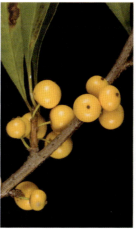
branchlet with infructescence

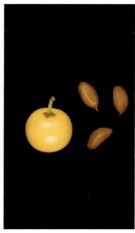
fruit and seeds

American Holly
Ilex opaca Aiton

American holly is native to the eastern United States and has stiff, evergreen leaves with characteristic spiky margins. This holly is popularly used in ornamental plantings and for Christmas decorations.

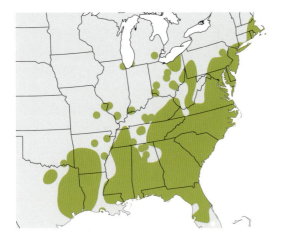

DESCRIPTION. A moderate-lived evergreen tree growing up to 50 ft (15 m) tall, with branches at right angles. Twigs are rusty pubescent. Bark is smooth and light gray. Leaves are alternate, simple, elliptical, thick, shiny dark green above and pale below, margins spiny-tipped, 1.6–3.1 in (4–8 cm) long, 0.8–1.6 in (2–4 cm) wide. Trees are dioecious producing male and female flowers on separate plants, blooming in late spring. Flowers are greenish white with four petals; male flowers are clustered in three- to seven-flowered cymes; female flowers are solitary. Fruits are round, 0.27–0.47 in (7–12 mm) long, red drupes, with four nutlets.

USES AND VALUE. Wood not commercially important. With shiny green leaves and bright red berries, used as ornamental and especially popular at Christmastime. Roasted leaves used as tea substitute. Fruits are laxative, emetic, and diuretic. Many birds consume fruits, including songbirds, mourning doves, wild turkeys, and bobwhite quail. Important seed dispersers are winter migrating flocks of small birds, such as cedar waxwings and American goldfinches.

ECOLOGY. Grows in mixed upland and bottomland forests as well as borders of swamps. Very shade tolerant. Good seed crops are produced most years. Many insect and fungal pests affect the aesthetic quality of leaves and fruit for commercial purposes; none causes serious damage. Fire is significant threat.

CLIMATE CHANGE. Vulnerability is currently considered to be low.

CONSERVATION STATUS. Least concern.

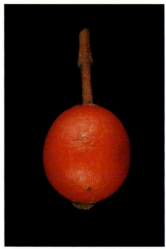
fruit

bark

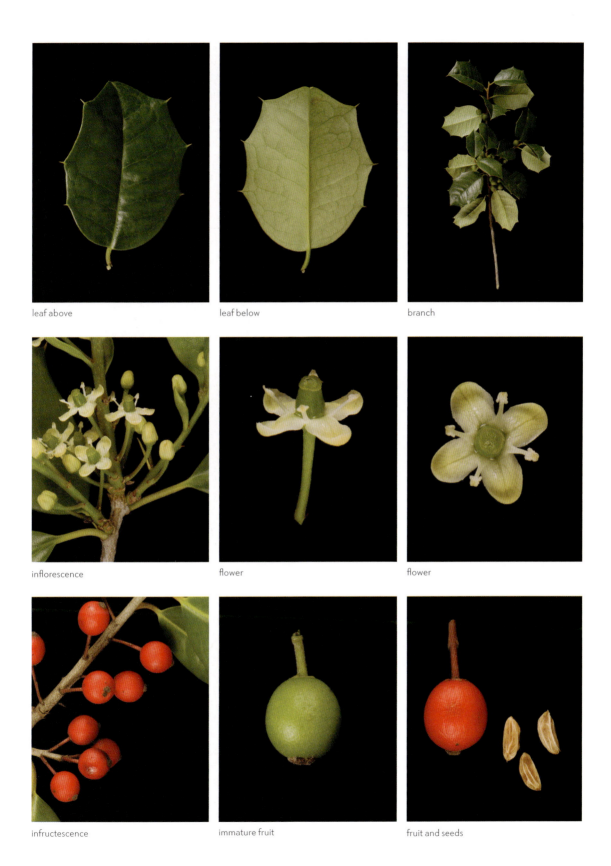

Yaupon
Ilex vomitoria Aiton

Yaupon is an evergreen shrub or small tree native to the southeastern United States that grows in a variety of habitats. Caffeine is produced by the leaves which can serve as a coffee substitute.

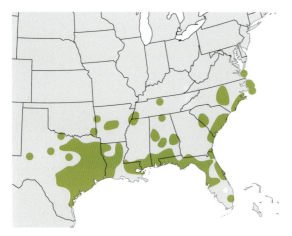

DESCRIPTION. An evergreen shrub or small tree that grows up to 26 ft (8 m) tall. Twigs are slender, stiff, and initially purple and pubescent, becoming gray and glabrous at maturity; buds are small and dark in color. Bark is smooth and light gray and may be scaly in older individuals. Leaves are simple, alternate, glossy green above, margins with rounded teeth, 0.4–0.8 in (1–2 cm) long. Trees are dioecious producing male and female flowers on separate plants, blooming in spring. Flowers are small, greenish white; male flowers are numerous and arranged in clusters; female flowers may be solitary or in small clusters. Fruits are berrylike drupes, numerous, red in color, approximately 0.2 in (0.5 cm) in diameter, and persistent into winter.

USES AND VALUE. Wood not commercially important. Cultivated as ornamental tree. Leaves contain caffeine and used to make a coffee substitute that is commercially available. Decoction of leaves is emetic and used by Native North Americans in rituals that induced vomiting, hence the species name *vomitoria*. Fruits are important food for many birds, including mottled duck, American black duck, mourning dove, ruffed grouse, bobwhite quail, wild turkey, northern flicker, sapsuckers, cedar waxwing, eastern bluebird, American robin, gray catbird, northern mockingbird, and white-throated sparrow, and mammals, such as nine-banded armadillo, black bear, gray fox, racoon, and skunk.

ECOLOGY. Grows in a variety of habitats, including low maritime woods, hammocks, sandy pinelands, and limestone uplands in the southeastern United States. Prefers soils that are moist or well drained, sandy, loamy, clay, limestone, or gravelly. Tolerates drought, poor drainage, and shade.

CLIMATE CHANGE. Vulnerability is currently unknown. Immediate assessment is recommended.

CONSERVATION STATUS. Least concern.

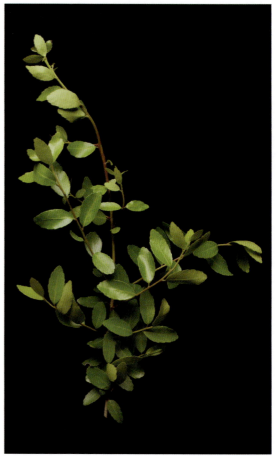

branch

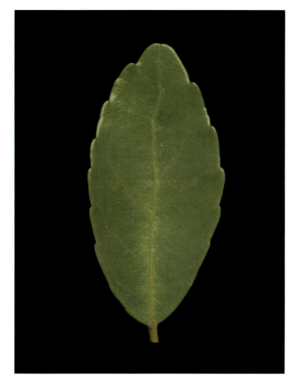
leaf above

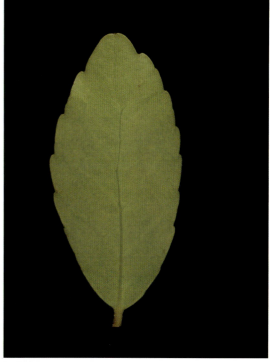
leaf below

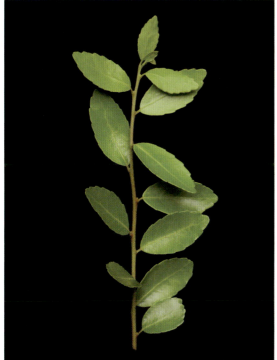
branchlet above

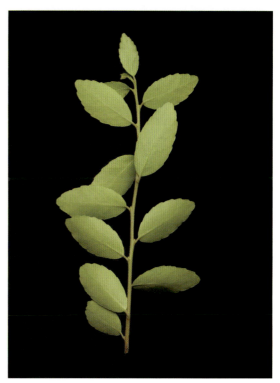
branchlet below

FAMILY AQUIFOLIACEAE • 727

ORDER APIALES

Botanists earlier thought the seven plant families in this order were closely allied to the rose family and relatives, but DNA data have shown that these plants most certainly evolved with families in the Asterids. Many of our cooking herbs, such as dill, caraway, coriander, cumin, fennel, parsley, and anise, are in this order. Of the approximately 500 genera and 5,500 species in the Apiales, only two species in the genus *Aralia* are common trees in North America.

Family Araliaceae

The Araliaceae is now recognized as a separate family distinct from the carrot family (Apiaceae). The taxonomy and biology of members of the Araliaceae are relatively unknown and much remains to be learned. Some flowers in the family produce a strong and, to some, disagreeable fragrance that attracts a number of types of insects to the flowers, including caddisflies, crane flies, blowflies, and mosquitoes. The fact that these insects also feed on carrion may account for the evolution of the flowers' unpleasant odor, which mimics that of rotting flesh. Only two species are common trees in North America.

GENUS ARALIA

Back in the last century when trees were often cultivated for their very grotesqueness, this strange, clumsy, disproportionate, at once pretentious and yet somehow insignificant little tree or tall shrub was in fashion.

—Donald Culross Peattie on Aralia spinosa in A Natural History of Trees of Eastern and Central North America

The nearly seventy species in the genus *Aralia* (the exact number of species is yet to be determined) are native to either Asia or the Americas, including North and South America. The trees have uniquely large leaves that are split into two ranks, called "double (or even triple) compound." Both common species of trees in this family in North America are characterize by large nasty spines on the stems and leaves.

Japanese Angelica Tree

Aralia elata (Miq.) Seem.

The Japanese angelica tree is a species of shrub or small tree that is native to east Asia and the Russian Far East. Introduced as an ornamental it has naturalized in the northern United States.

DESCRIPTION. A deciduous tree growing to a maximum of 26 ft (8 m) tall with branches covered in sparse prickles. Bark is light gray. Leaves are deciduous, alternate, bipinnately to tripinnately compound, up to 39.8 in (100 cm) long, half to two-thirds as wide, rachis prickly, with five to nine leaflets per pinna, 2–5 in (5–13 cm) long, dark green, sessile, margins

serrate, tips pointed. Flowers are perfect (sometimes monoecious), with five petals, white, tiny, 0.12 in (0.3 cm) long, produced in large panicles at the ends of branches, 12–18 in (30.4–45.7 cm) long; sometimes male flowers are borne in separate lateral umbels on the same plant; blooming in mid-summer. Fruits are purplish-black drupes, 0.12–0.16 in (3–4 mm) in diameter, with three to five seeds.

USES AND VALUE. Wood not commercially important. Introduced into North America as an ornamental because of exotic shape and appearance, now naturalized in the northern United States. Leaves and young shoots are edible when raw; used in salads. Roots and stems are anodyne. Fruits are eaten birds.

ECOLOGY. Grows along forest margins, fields, and roadsides; prefers moist fertile loams. Shade and drought tolerant.

CLIMATE CHANGE. Vulnerability is considered low because of its wide geographic distribution as an ornamental and/or invasive.

CONSERVATION STATUS. Least concern.

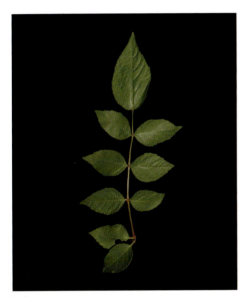
leaflet

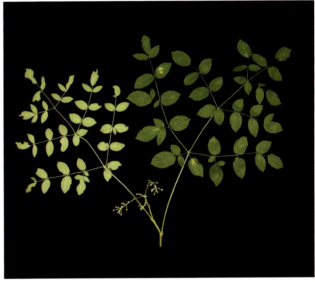
branch

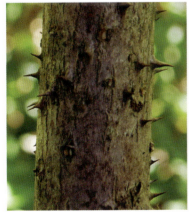
bark

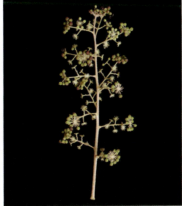
branchlet with infructescence

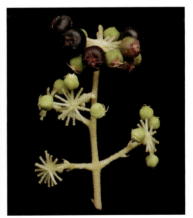
branchlet with infructescence

Devil's Walking Stick

Aralia spinosa L.

Devil's walking stick is an aromatic large shrub or small tree that is native to the eastern and southeastern United States. Commonly cultivated, the trees are also naturally found in woodlands and pastures growing in well-drained soils.

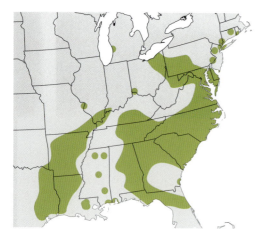

DESCRIPTION. An aromatic deciduous large shrub or small tree, often forming clonal thickets, that grows up to 30 ft (9 m) tall with branches thickly spined. Bark is grayish-brown and broken into spiny ridges. Leaves are alternate, bipinnately or tripinnately compound, up to 5 ft (1.5 m) long, rachis spiney, with 6–12 primary segments, each with 6–15 leaflets, 2–4 in (5.1–10.2 cm) long, dark green above, paler below, margins serrate. Flowers are perfect, minute, borne in 12–18 in (30.5–45.7 cm) long clusters at the ends of branches, white, umbrella-shaped, blooming in late summer. Fruits are drupes, round, 0.25 in (0.64 cm) in diameter, purplish black, produced in large quantities.

USES AND VALUE. Wood is not commercially important. Popular landscape plant selected for its bright fall colors and showy blooms. Young leaves are edible with antimicrobial properties, used medicinally. Birds consume fruits and seeds; and deer browse leaves.

ECOLOGY. Native to the eastern and southeastern United States grows in open woods, flood plains, and rocky pastures on soils that are loamy, well drained, and moist. Tolerates variability in soil fertility and pH as well as shade.

CLIMATE CHANGE. Vulnerability is currently unknown. Immediate assessment is recommended.

CONSERVATION STATUS. Least concern.

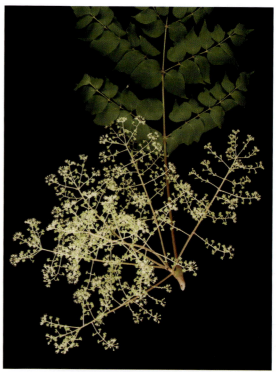

branch with leaf and inflorescence

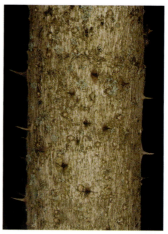

bark

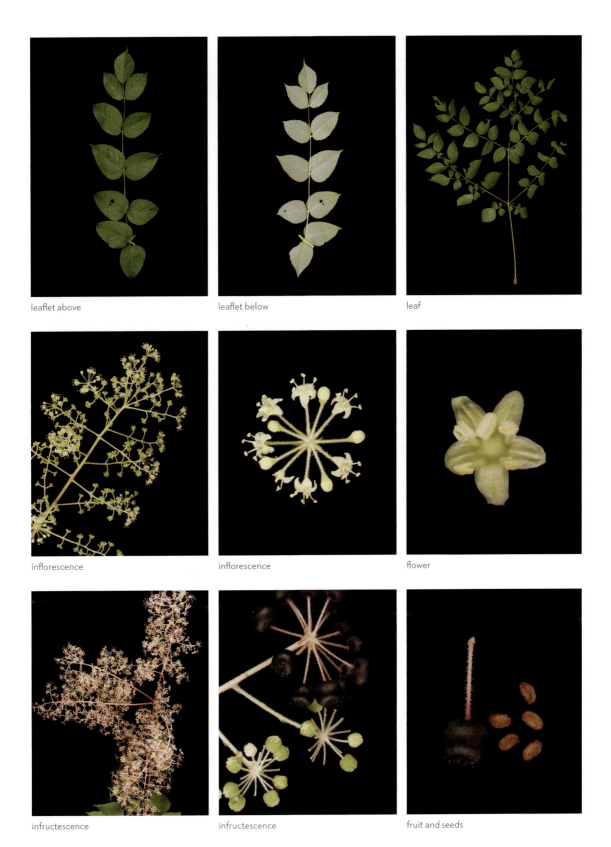

FAMILY ARALIACEAE

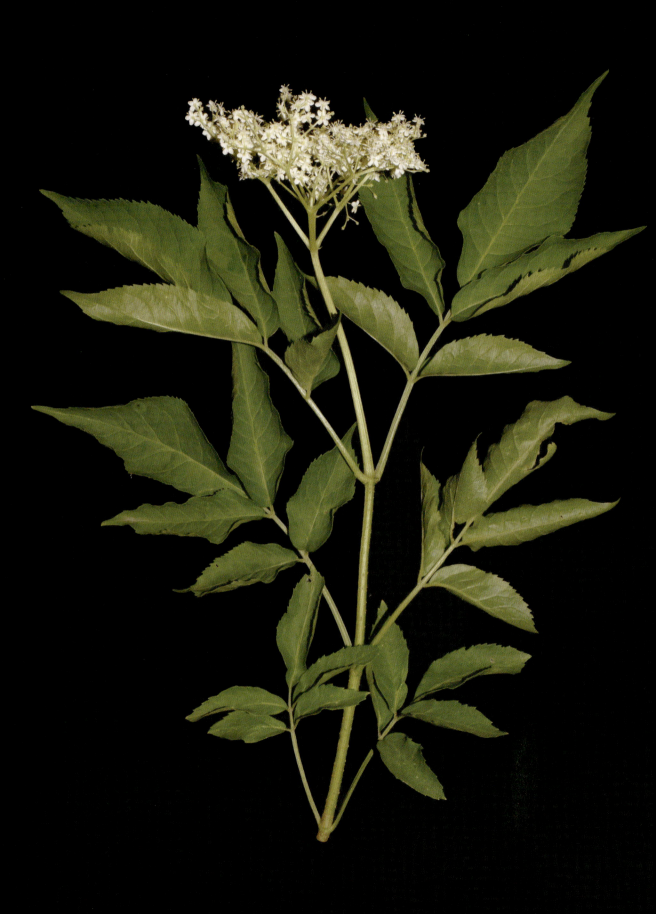

ORDER DIPSACALES

One of the most specialized groups of flowering plants, the Dipsicales includes two plant families, about forty-six genera, and around 1,000 species. These plants are distinctive in having opposite leaves, three carpels per flower, and a unique form of endosperm development in the seeds. Honeysuckle, viburnum, and teasel are found within this order, whose members are distributed widely in cooler Temperate Zone regions. Only one of the two families in the Dipsacales includes trees that are common in North America.

Family Adoxaceae

The family Adoxaceae is closely associated with the honeysuckle family (Caprifoliaceae) but is well supported as a separate family by DNA sequence data and by features of the flowers, nectaries, and pollen. The largest genus *Viburnum* was formerly included in the Caprifoliaceae but is more properly classified in the Adoxaceae. Species in this family have flat-topped clusters of fragrant flowers. The flowers around the margins of the clusters are often non-fertile and have very conspicuous petals that have evolved to attract insect pollinators. These attractive marginal flowers in the Adoxaceae are very similar in appearance to the marginal flowers found in the hydrangeas. However, in the hydrangeas, it is the outer sepals of the flowers that have evolved the conspicuous display, not the inner petals, as in Adoxaceae. Natural selection has achieved the same function in two groups of unrelated plants in very different fashions. Four species in this family are common shrubs or small trees in North America.

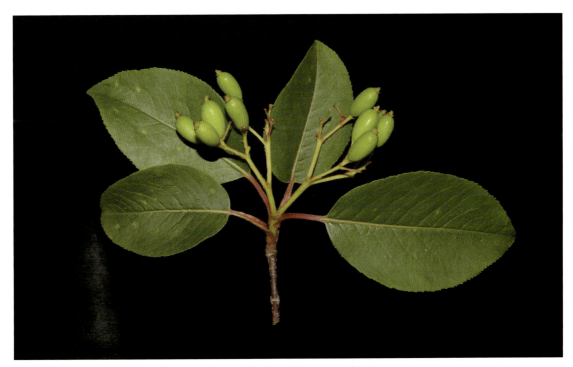

OPPOSITE Common elderberry (*Sambucus nigra*). **ABOVE** Blackhaw (*Viburnum prunifolium*).

GENUS SAMBUCUS

Sambucus has up to twenty-five or more species and the final taxonomy is still being investigated. The species are distributed around the world, primarily in northern temperate regions. Similar to the ashes in the genus *Fraxinus*, the elderberries have opposite, compound leaves. Unlike the dry winged fruits of the ashes, however, elderberries produce fleshy fruits that are consumed by many birds and mammals, including humans. Two species of *Sambucus* are considered to be common shrubs or small trees in North America.

Common Elderberry
Sambucus nigra L.
EASTERN COMMON ELDERBERRY, EUROPEAN BLACK ELDER

Common elderberry is a deciduous shrub or small tree that grows in forests and open areas in a variety of soils. It is native to a wide area in North America as well as Europe, southwestern Asia, and northern Africa. The sweet fruits are eaten by humans, birds, and other mammals. Three subspecies are recognized.

DESCRIPTION. A deciduous shrub or small tree that grows up to 26 ft (8 m) tall. Twigs are gray with warty lenticels, lateral small buds are ruddy and pointed, terminal buds lacking. Bark is smooth and brown with distinctive warts, may be furrowed in older individuals. Leaves are opposite, pinnately compound, up to 10.2 in (26 cm) long, with five to nine leaflets, 4.7 in (12 cm) long, ovate to elliptic, margins serrate; leaves release an unpleasant scent when crushed. Flowers are perfect, aromatic, arranged in umbellate cymes, up to 9.4 in (24 cm) across, blooming in late spring or early summer. Fruits are edible berrylike drupes, juicy, purple, up to 0.4 in (1 cm) in diameter, arranged in flat-topped clusters.

TAXONOMIC NOTES. Subspecies *canadensis* is native to North America and occurs in much of the continental United States and Canada (some botanists treat this subspecies as a species, *S. canadensis*); ssp. *nigra* is introduced and occurs in the northeastern United States and Canada (Connecticut, Pennsylvania, Virginia, and Ontario); and ssp. *caerulea* is native and occurs in the western United States and British Columbia.

USES AND VALUE. Wood not commercially important. Cultivated as ornamentals, often for fruits. Fruits are edible, medicinal, and used for jelly preserves, baking, and making wine. A long history of household use as medicinal herb. Inner bark, which has low toxicity and contains cyanogenic cytosides and alkaloids, collected from young trees is diuretic, a strong purgative, and, in large doses, emetic; used to treat constipation and arthritic conditions. Fruits are eaten by animals, such as mule deer, elk, sheep, and small birds; in northern California a favorite food for migrating band-tailed pigeons. Sprawling branches are good nesting habitat for many birds, including hummingbirds, warblers, and vireos.

ECOLOGY. Grows in alluvial forests, bogs, ditches, and old fields. Thrives in rich, moist, slightly acidic soil, but tolerant of a variety of soils and drainages. Intermediate in shade tolerance. Native to North America as well as Europe, southwestern Asia, and northern Africa. The non-native subspecies has been known to be weedy and/or potentially invasive.

CLIMATE CHANGE. Vulnerability is currently unknown. Immediate assessment is recommended.

CONSERVATION STATUS. Least concern.

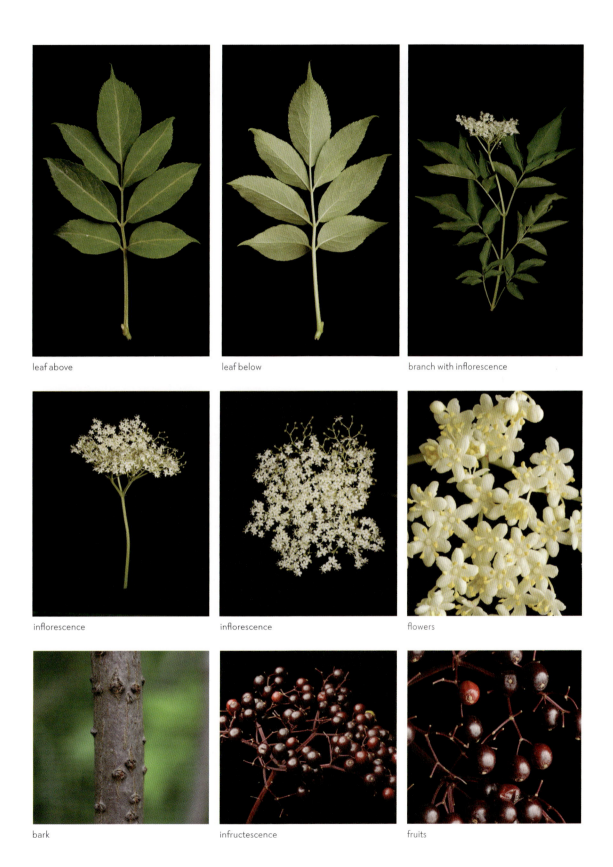

FAMILY ADOXACEAE

Red Elderberry
Sambucus racemosa L.
EUROPEAN RED ELDER, SCARLET ELDERBERRY

Red elderberry is a deciduous shrub or small tree native to North America and Eurasia that grows in a variety of habitats and has many uses by humans and wildlife. Two varieties are recognized in North America.

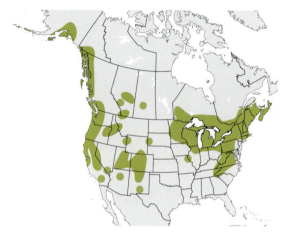

DESCRIPTION. A deciduous shrub or small tree that grows 10–20 ft (3–6 m) tall. Bark is gray to brown with raised lenticels. Leaves are opposite, pinnately compound, 5.9–11.8 in (15–30 cm) long, with 5–9 leaflets, 2–2.8 in (5–7 cm) long, lanceolate, smooth, green above, paler below, margins serrate. Flowers are perfect, white, borne in pyramidal clusters, 2–4.7 in (5–12 cm) long, 0.12–0.16 in (3–4 mm) wide, blooming in May and June. Fruits are small red drupes, each containing two to five seeds.

TAXONOMIC NOTES. Variety *racemosa* is characterized by its red fruit and inflorescence, 1.2–4.7 in (3–12 cm) in diameter; var. *melanocarpa* has purple-black fruits and inflorescences, 1.6–2.8 in (4–7 cm) in diameter.

USES AND VALUE. Wood not commercially important. Flowers and fruit are used to make pies, jelly, and wine. Small trees are planted as ornamentals. Fruits contain toxins that are dispersed during cooking. Bark and leaves are diuretic and purgative. Flowers used to treat measles. Mammals, including eastern fox squirrels, white-footed mice, and other rodents and northern raccoons, American black bears, brown bears, and grizzly bears, consume fruits. Grizzly bears, common porcupines, mice, and snowshoe hares consume the foliage, buds, roots, and bark in winter.

ECOLOGY. Grows in deciduous forests, riparian areas, roadsides, and fencerows in deep, well-drained, loamy soils. In the western portion of range grows in submontane habitats; in the east, more often occurs in high-elevation zones. Intermediate in shade tolerance.

CLIMATE CHANGE. Vulnerability is currently unknown. Immediate assessment is recommended.

CONSERVATION STATUS. Least concern.

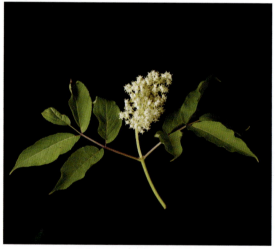

branch with inflorescence

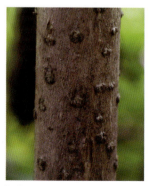

bark

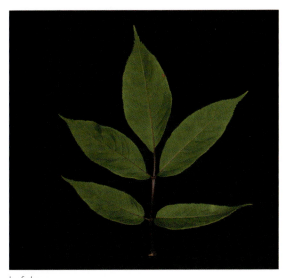
leaf above

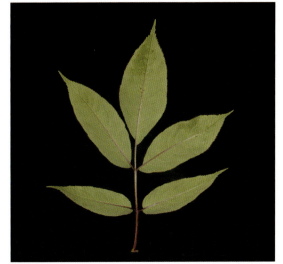
leaf below

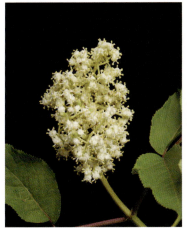
branch with inflorescence

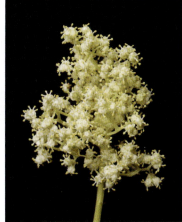
inflorescence

flowers

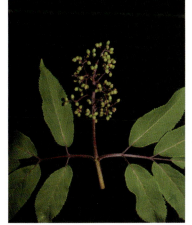
branchlet with immature infructescence

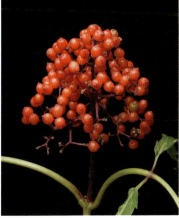
branchlet with mature infructescence

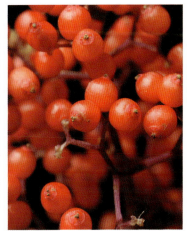
fruits

FAMILY ADOXACEAE • 737

GENUS VIBURNUM

Roadsides and fencerows, dry rocky hillsides and prairie groves, are the habitats of this bushy understory tree, with its short, crooked, spindling, bandy-legged trunk and its graceless rigid branches like widespread arms.

—Donald Culross Peattie on *Viburnum prunifolium* in *A Natural History of Trees of Eastern and Central North America*

The genus *Viburnum* may include up to 150 species, although the taxonomy of these shrubs and small trees is still under study. The species are native to temperate habitats in the Northern Hemisphere, but a few species occur in montane regions of the tropics. Because of the very conspicuous, attractive, flat-topped clusters of often fragrant flowers, some species of *Viburnum* are popular plants for the garden. Two native species of *Viburnum* are common trees in North America.

Blackhaw

Viburnum prunifolium L.

Blackhaw is a deciduous shrub or small tree native to the eastern United States and found in both forest and open habitats. It is sometimes planted as an ornamental.

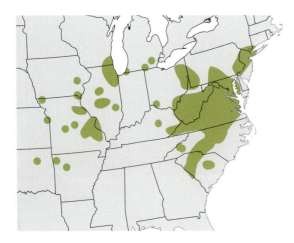

DESCRIPTION. A deciduous shrub or small tree growing to 26 ft (8 m) in height, with a short, crooked stem and stout branches. Twigs are brown to reddish brown, resembling a fish skeleton when leaves are absent. Bark is gray brown and broken into small plates. Leaves are opposite, simple, oval to obovate, shiny green above, glabrous, margins finely serrate, 1.2–3.1 in (3–8 cm) long. Flowers are perfect, white with five-lobed corollas, 0.16–0.27 in (4–7 mm) wide, arranged in three- or four-rayed cymes, 2–4.7 in (5–12 cm) wide, blooming in spring. Fruits are bluish-black drupes, 0.31–0.59 in (8–15 mm) long, with one seed.

USES AND VALUE. Wood not commercially important. Sometimes planted in gardens as ornamentals. Fruits may be eaten raw or used to make jam. Fruits are eaten by birds and mammals, especially in early winter.

ECOLOGY. Grows in open woods, forest edges, thickets, fencerows, and roadsides on well-drained soils of varying moisture levels. Tolerant of calcareous soils.

CLIMATE CHANGE. Vulnerability is currently unknown. Immediate assessment is recommended.

CONSERVATION STATUS. Least concern.

bark

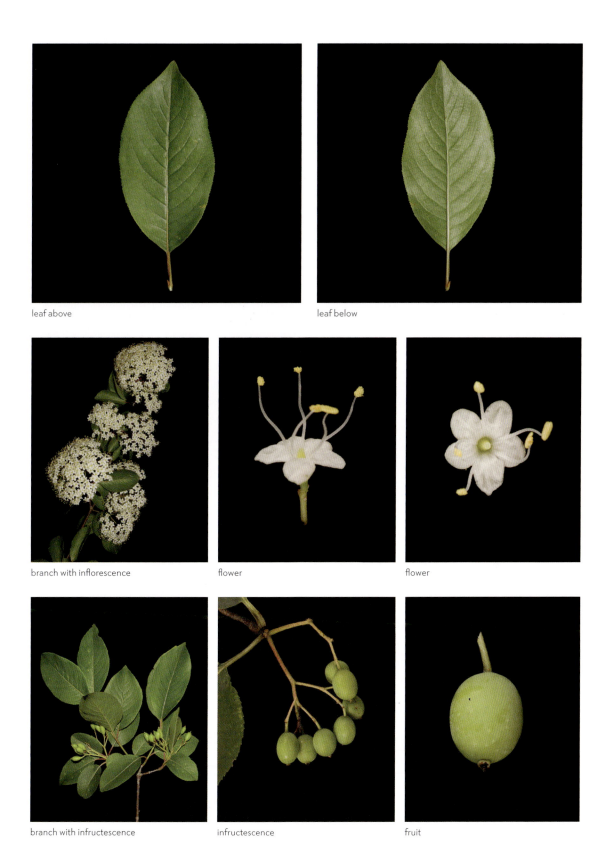

FAMILY ADOXACEAE • 739

Rusty Blackhaw
Viburnum rufidulum Raf.
RUSTY VIBURNUM

Rusty blackhaw is a small tree native to a variety of habitats ranging from moist areas to uplands, along forest edges, and in understory.

CLIMATE CHANGE. Vulnerability is currently unknown. Immediate assessment is recommended.

CONSERVATION STATUS. Least concern.

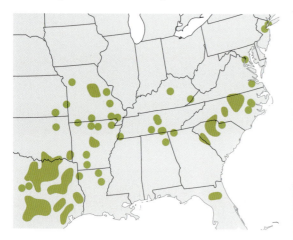

branchlet with mature infructescence

DESCRIPTION. A deciduous tree growing to 25 ft (7.6 m) tall with trunk often divided near the ground. Twigs are slender, reddish brown to gray, and hairy when young, becoming smooth with age. Bark is reddish-brown to black appearing as block-like plates in older trees. Leaves are opposite, simple, ovate, shiny and leathery above, orange red and hairy below, margins finely toothed, 0.5–3 in (1.3–7.6 cm) long, and 1–1.5 in (2.5–3.8 cm) wide, petioles are hairy, grooved, and sometimes winged; foliage turns bronze and red in fall. Flowers are perfect, white, with five petals, in large stalkless clusters, 5.9 in (15 cm) long, blooming in early spring when the leaves appear. Fruits are round to ellipsoidal, dark blue to purple drupes, 0.5 in (1.27 cm) long, borne on hanging stalks, mature in mid- to late-summer.

USES AND VALUE. Wood not commercially important. Sometimes planted in gardens as ornamentals. Flowers provide nectar to pollinating insects and birds.

ECOLOGY. Grows in thickets, open woodlands, and riparian zones as well as dry rocky woods. Most often found on well-drained calcareous soils of a variety of textures. Drought tolerant and usually pest free.

bark

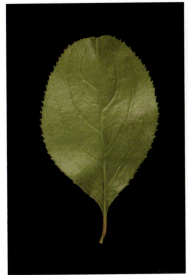
leaf above

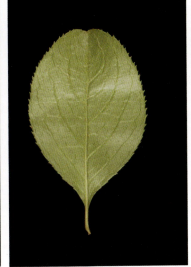
leaf below

branch

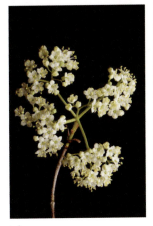
inflorescence

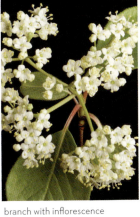
branch with inflorescence

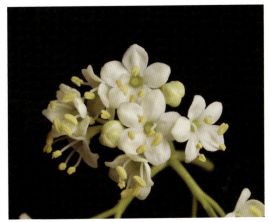
flowers

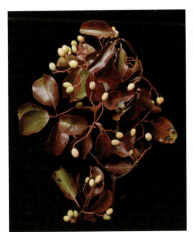
branch with infructescence

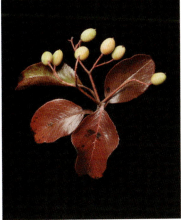
branchlet with immature infructescence

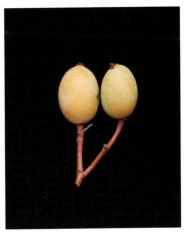
immature fruits

LEAF SHAPES OF SELECT GENERA
GENUS ACER

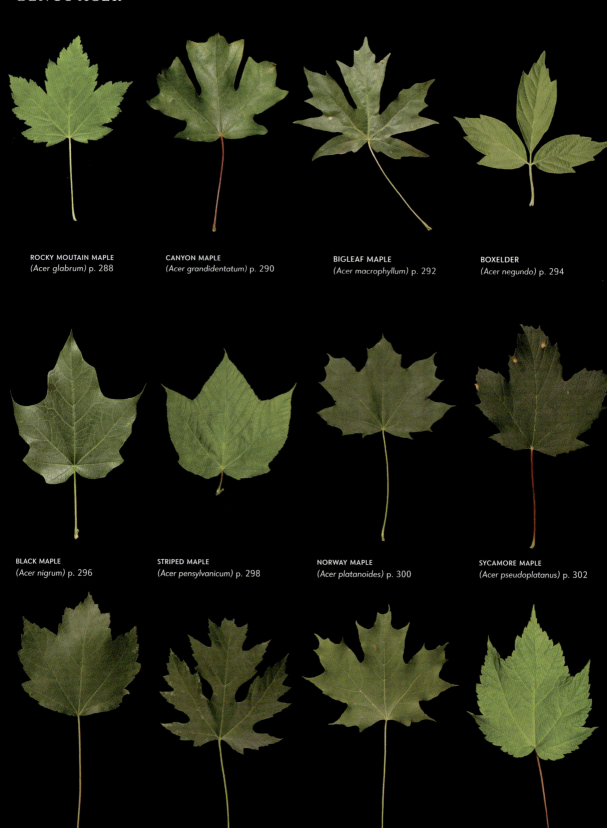

ROCKY MOUTAIN MAPLE
(Acer glabrum) p. 288

CANYON MAPLE
(Acer grandidentatum) p. 290

BIGLEAF MAPLE
(Acer macrophyllum) p. 292

BOXELDER
(Acer negundo) p. 294

BLACK MAPLE
(Acer nigrum) p. 296

STRIPED MAPLE
(Acer pensylvanicum) p. 298

NORWAY MAPLE
(Acer platanoides) p. 300

SYCAMORE MAPLE
(Acer pseudoplatanus) p. 302

RED MAPLE
(Acer rubrum) p. 304

SILVER MAPLE
(Acer saccharinum) p. 306

SUGAR MAPLE
(Acer saccharum) p. 308

MOUNTAIN MAPLE
(Acer spicatum) p. 310

GENUS BETULA

YELLOW BIRCH
(Betula alleghaniensis) p. 606

SWEET BIRCH
(Betula lenta) p. 608

RIVER BIRCH
(Betula nigra) p. 610

WATER BIRCH
(Betula occidentalis) p. 612

PAPER BIRCH
(Betula papyrifera) p. 614

GRAY BIRCH
(Betula populifolia) p. 616

GENUS CARYA

WATER HICKORY
(Carya aquatica) p. 626

BITTERNUT HICKORY
(Carya cordiformis) p. 628

PIGNUT HICKORY
(Carya glabra) p. 630

PECAN
(Carya illinoinensis) p. 632

SHAGBARK HICKORY
(Carya ovata) p. 634

MOCKERNUT HICKORY
(Carya tomentosa) p. 636

LEAF SHAPES • 743

GENUS CORNUS

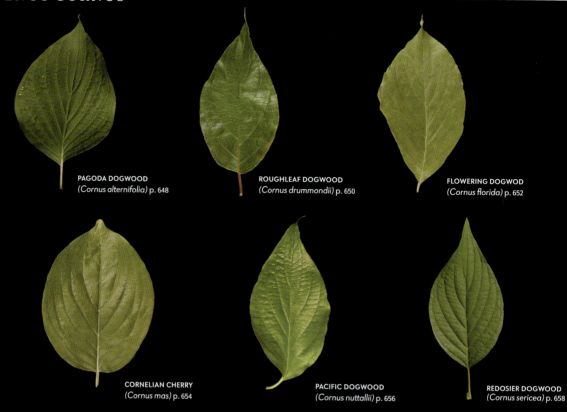

PAGODA DOGWOOD
(Cornus alternifolia) p. 648

ROUGHLEAF DOGWOOD
(Cornus drummondii) p. 650

FLOWERING DOGWOD
(Cornus florida) p. 652

CORNELIAN CHERRY
(Cornus mas) p. 654

PACIFIC DOGWOOD
(Cornus nuttallii) p. 656

REDOSIER DOGWOOD
(Cornus sericea) p. 658

GENUS FRAXINUS

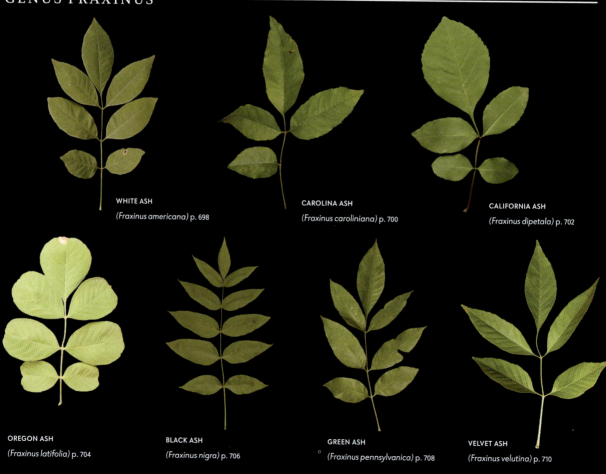

WHITE ASH
(Fraxinus americana) p. 698

CAROLINA ASH
(Fraxinus caroliniana) p. 700

CALIFORNIA ASH
(Fraxinus dipetala) p. 702

OREGON ASH
(Fraxinus latifolia) p. 704

BLACK ASH
(Fraxinus nigra) p. 706

GREEN ASH
(Fraxinus pennsylvanica) p. 708

VELVET ASH
(Fraxinus velutina) p. 710

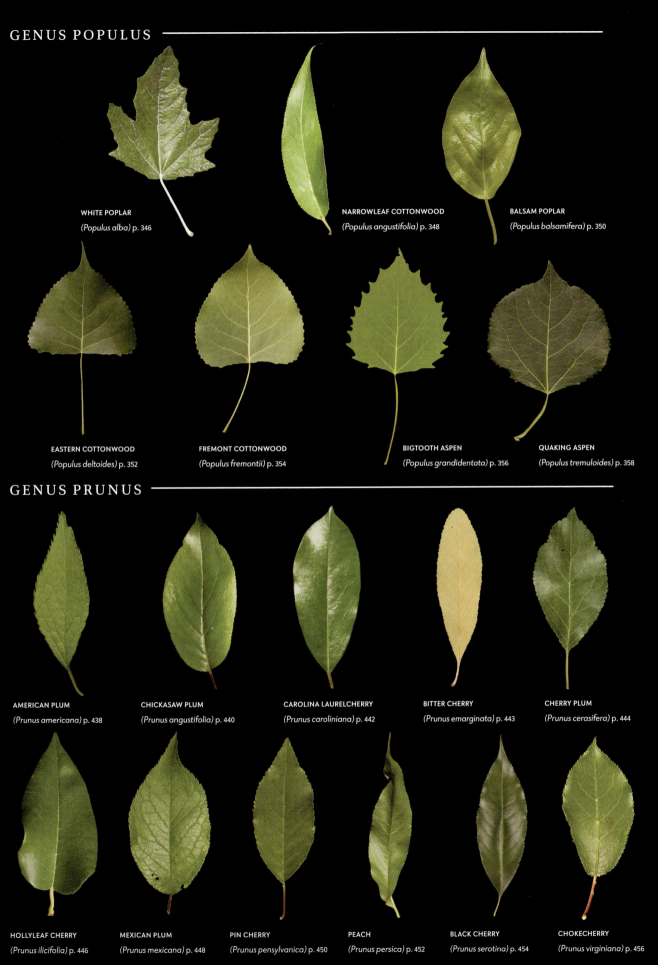

GENUS QUERCUS

COAST LIVE OAK

(Quercus agrifolia) p. 518

WHITE OAK

(Quercus alba) p. 520

ARIZONA WHITE OAK

(Quercus arizonica) p. 522

SWAMP WHITE OAK

(Quercus bicolor) p. 524

CANYON LIVE OAK

(Quercus chrysolepis) p. 526

SCARLET OAK

(Quercus coccinea) p. 528

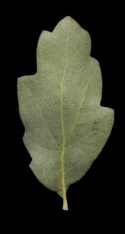

BLUE OAK

(Quercus douglasii) p. 530

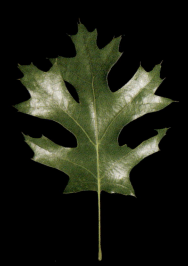

NORTHERN PIN OAK

(Quercus ellipsoidalis) p. 532

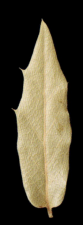

EMORY OAK

(Quercus emoryi) p. 534

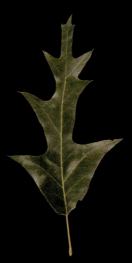

SOUTHERN RED OAK

(Quercus falcata) p. 536

GAMBEL OAK

(Quercus gambelii) p. 538

OREGON WHITE OAK

(Quercus garryana) p. 540

GENUS QUERCUS

SAND LIVE OAK
(Quercus geminata) p. 542

GRAY OAK
(Quercus grisea) p. 544

SILVERLEAF OAK
(Quercus hypoleucoides) p. 546

SHINGLE OAK
(Quercus imbricaria) p. 548

BLUEJACK OAK
(Quercus incana) p. 550

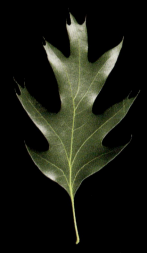
CALIFORNIA BLACK OAK
(Quercus kelloggii) p. 552

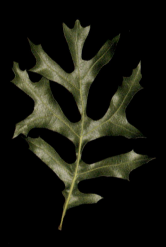
TURKEY OAK
(Quercus laevis) p. 554

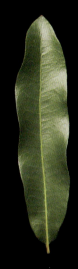
LAUREL OAK
(Quercus laurifolia) p. 556

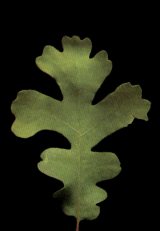
VALLEY OAK
(Quercus lobata) p. 558

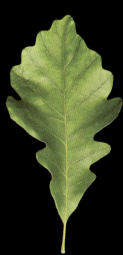
OVERCUP OAK
(Quercus lyrata) p. 560

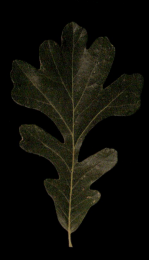
BUR OAK
(Quercus macrocarpa) p. 562

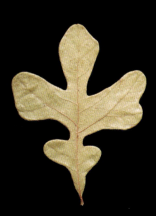
SAND POST OAK
(Quercus margarettae) p. 564

LEAF SHAPES • 747

GENUS QUERCUS

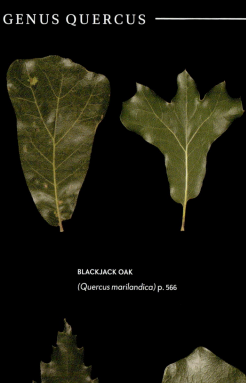
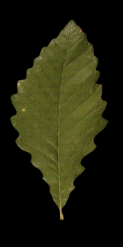

BLACKJACK OAK
(Quercus marilandica) p. 566

SWAMP CHESTNUT OAK
(Quercus michauxii) p. 568

CHESTNUT OAK
(Quercus montana) p. 570

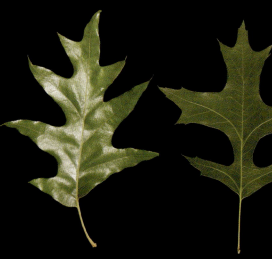

CHINKAPIN OAK
(Quercus muehlenbergii) p. 572

WATER OAK
(Quercus nigra) p. 574

CHERRYBARK OAK
(Quercus pagoda) p. 576

PIN OAK
(Quercus palustris) p. 578

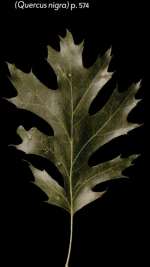
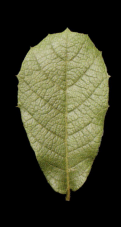
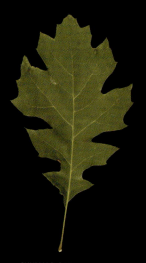

WILLOW OAK
(Quercus phellos) p. 580

NORTHERN RED OAK
(Quercus rubra) p. 582

NETLEAF OAK
(Quercus rugosa) p. 584

SHUMARD OAK
(Quercus shumardii) p. 586

748 • LEAF SHAPES

GENUS QUERCUS

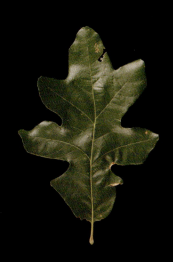

POST OAK
(Quercus stellata) p. 588

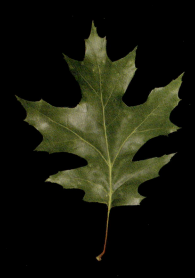

TEXAS RED OAK
(Quercus texana) p. 590

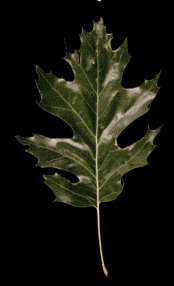

BLACK OAK
(Quercus velutina) p. 592

LIVE OAK
(Quercus virginiana) p. 594

INTERIOR LIVE OAK
(Quercus wislizeni) p. 596

LEAF SHAPES • 749

GENUS SALIX

WHITE WILLOW
(Salix alba) p. 360

PEACHLEAF WILLOW
(Salix amygdaloides) p. 362

BEBB WILLOW
(Salix bebbiana) p. 364

COASTAL PLAIN WILLOW
(Salix caroliniana) p. 366

PUSSY WILLOW
(Salix discolor) p. 368

SANDBAR WILLOW
(Salix exigua) p. 370

GOODDING'S WILLOW
(Salix gooddingii) p. 372

HOOKER WILLOW
(Salix hookeriana) p. 374

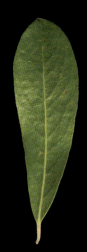

ARROYO WILLOW
(Salix lasiolepis) p. 376

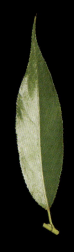

SHINING WILLOW
(Salix lucida) p. 378

BLACK WILLOW
(Salix nigra) p. 380

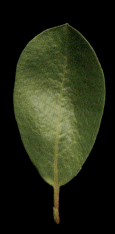

SCOULER'S WILLOW
(Salix scouleriana) p. 382

SITKA WILLOW
(Salix sitchensis) p. 384

750 • LEAF SHAPES

GENUS ULMUS — LEAF SHAPES

WINGED ELM
(Ulmus alata) p. 480

AMERICAN ELM
(Ulmus americana) p. 482

CEDAR ELM
(Ulmus crassifolia) p. 484

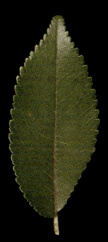

CHINESE ELM
(Ulmus parviflora) p. 486

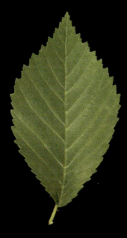

SIBERIAN ELM
(Ulmus pumila) p. 488

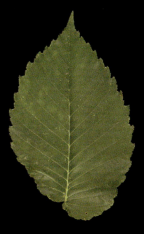

SLIPPERY ELM
(Ulmus rubra) p. 490

Species List

This list includes the 326 species with full accounts covered in this book in phylogenetic order.

GENUS AND SPECIES	COMMON NAME	FAMILY	ORDER	MAJOR GROUP
Ginkgo biloba	ginkgo	Ginkgoaceae	Ginkgoales	Gymnosperms
Abies amabilis	Pacific silver fir	Pinaceae	Pinales	Gymnosperms
Abies balsamea	balsam fir	Pinaceae	Pinales	Gymnosperms
Abies concolor	white fir	Pinaceae	Pinales	Gymnosperms
Abies grandis	grand fir	Pinaceae	Pinales	Gymnosperms
Abies lasiocarpa	subalpine fir	Pinaceae	Pinales	Gymnosperms
Abies magnifica	California red fir	Pinaceae	Pinales	Gymnosperms
Abies procera	noble fir	Pinaceae	Pinales	Gymnosperms
Cedrus deodara	deodar cedar	Pinaceae	Pinales	Gymnosperms
Larix laricina	tamarack	Pinaceae	Pinales	Gymnosperms
Larix occidentalis	western larch	Pinaceae	Pinales	Gymnosperms
Picea abies	Norway spruce	Pinaceae	Pinales	Gymnosperms
Picea engelmannii	Engelmann spruce	Pinaceae	Pinales	Gymnosperms
Picea glauca	white spruce	Pinaceae	Pinales	Gymnosperms
Picea mariana	black spruce	Pinaceae	Pinales	Gymnosperms
Picea pungens	blue spruce	Pinaceae	Pinales	Gymnosperms
Picea rubens	red spruce	Pinaceae	Pinales	Gymnosperms
Picea sitchensis	Sitka spruce	Pinaceae	Pinales	Gymnosperms
Pinus albicaulis	whitebark pine	Pinaceae	Pinales	Gymnosperms
Pinus aristata	bristlecone pine	Pinaceae	Pinales	Gymnosperms
Pinus attenuata	knobcone pine	Pinaceae	Pinales	Gymnosperms
Pinus banksiana	jack pine	Pinaceae	Pinales	Gymnosperms
Pinus clausa	sand pine	Pinaceae	Pinales	Gymnosperms
Pinus contorta	lodgepole pine	Pinaceae	Pinales	Gymnosperms
Pinus echinata	shortleaf pine	Pinaceae	Pinales	Gymnosperms
Pinus edulis	pinyon	Pinaceae	Pinales	Gymnosperms
Pinus elliottii	slash pine	Pinaceae	Pinales	Gymnosperms
Pinus flexilis	limber pine	Pinaceae	Pinales	Gymnosperms
Pinus glabra	spruce pine	Pinaceae	Pinales	Gymnosperms
Pinus halepensis	aleppo pine	Pinaceae	Pinales	Gymnosperms
Pinus jeffreyi	Jeffrey pine	Pinaceae	Pinales	Gymnosperms
Pinus lambertiana	sugar pine	Pinaceae	Pinales	Gymnosperms
Pinus monophylla	singleleaf pinyon	Pinaceae	Pinales	Gymnosperms
Pinus monticola	western white pine	Pinaceae	Pinales	Gymnosperms
Pinus nigra	Austrian pine	Pinaceae	Pinales	Gymnosperms
Pinus palustris	longleaf pine	Pinaceae	Pinales	Gymnosperms
Pinus pinea	Italian stone pine	Pinaceae	Pinales	Gymnosperms
Pinus ponderosa	ponderosa pine	Pinaceae	Pinales	Gymnosperms

GENUS AND SPECIES	COMMON NAME	FAMILY	ORDER	MAJOR GROUP
Pinus pungens	Table Mountain pine	Pinaceae	Pinales	Gymnosperms
Pinus resinosa	red pine	Pinaceae	Pinales	Gymnosperms
Pinus rigida	pitch pine	Pinaceae	Pinales	Gymnosperms
Pinus sabiniana	gray pine	Pinaceae	Pinales	Gymnosperms
Pinus serotina	pond pine	Pinaceae	Pinales	Gymnosperms
Pinus strobiformis	southwestern white pine	Pinaceae	Pinales	Gymnosperms
Pinus strobus	eastern white pine	Pinaceae	Pinales	Gymnosperms
Pinus sylvestris	Scots pine	Pinaceae	Pinales	Gymnosperms
Pinus taeda	loblolly pine	Pinaceae	Pinales	Gymnosperms
Pinus virginiana	Virginia pine	Pinaceae	Pinales	Gymnosperms
Pseudotsuga macrocarpa	bigcone Douglas-fir	Pinaceae	Pinales	Gymnosperms
Pseudotsuga menziesii	Douglas-fir	Pinaceae	Pinales	Gymnosperms
Tsuga canadensis	eastern hemlock	Pinaceae	Pinales	Gymnosperms
Tsuga heterophylla	western hemlock	Pinaceae	Pinales	Gymnosperms
Tsuga mertensiana	mountain hemlock	Pinaceae	Pinales	Gymnosperms
Calocedrus decurrens	incense-cedar	Cupressaceae	Cupressales	Gymnosperms
Chamaecyparis lawsoniana	Port-Orford-Cedar	Cupressaceae	Cupressales	Gymnosperms
Chamaecyparis thyoides	Atlantic white-cedar	Cupressaceae	Cupressales	Gymnosperms
Juniperus ashei	Ashe juniper	Cupressaceae	Cupressales	Gymnosperms
Juniperus californica	California juniper	Cupressaceae	Cupressales	Gymnosperms
Juniperus communis	common juniper	Cupressaceae	Cupressales	Gymnosperms
Juniperus deppeana	alligator juniper	Cupressaceae	Cupressales	Gymnosperms
Juniperus monosperma	oneseed juniper	Cupressaceae	Cupressales	Gymnosperms
Juniperus occidentalis	western juniper	Cupressaceae	Cupressales	Gymnosperms
Juniperus osteosperma	Utah juniper	Cupressaceae	Cupressales	Gymnosperms
Juniperus pinchotii	Pinchot juniper	Cupressaceae	Cupressales	Gymnosperms
Juniperus scopulorum	Rocky Mountain juniper	Cupressaceae	Cupressales	Gymnosperms
Juniperus virginiana	eastern redcedar	Cupressaceae	Cupressales	Gymnosperms
Sequoia sempervirens	redwood	Cupressaceae	Cupressales	Gymnosperms
Sequoiadendron giganteum	giant sequoia	Cupressaceae	Cupressales	Gymnosperms
Taxodium distichum	baldcypress	Cupressaceae	Cupressales	Gymnosperms
Thuja occidentalis	northern white-cedar	Cupressaceae	Cupressales	Gymnosperms
Thuja plicata	western redcedar	Cupressaceae	Cupressales	Gymnosperms
Xanthocyparis nootkatensis	Alaska-cedar	Cupressaceae	Cupressales	Gymnosperms
Taxus brevifolia	Pacific yew	Taxaceae	Cupressales	Gymnosperms
Torreya californica	California torreya	Taxaceae	Cupressales	Gymnosperms
Cinnamomum camphora	camphor-tree	Lauraceae	Laurales	Magnoliids
Lindera benzoin	spicebush	Lauraceae	Laurales	Magnoliids
Persea borbonia	redbay	Lauraceae	Laurales	Magnoliids
Sassafras albidum	sassafras	Lauraceae	Laurales	Magnoliids
Umbellularia californica	California bay	Lauraceae	Laurales	Magnoliids
Asimina triloba	pawpaw	Annonaceae	Magnoliales	Magnoliids

GENUS AND SPECIES	COMMON NAME	FAMILY	ORDER	MAJOR GROUP
Liriodendron tulipifera	tuliptree	Magnoliaceae	Magnoliales	Magnoliids
Magnolia acuminata	cucumber-tree	Magnoliaceae	Magnoliales	Magnoliids
Magnolia fraseri	Fraser magnolia	Magnoliaceae	Magnoliales	Magnoliids
Magnolia grandiflora	southern magnolia	Magnoliaceae	Magnoliales	Magnoliids
Magnolia macrophylla	bigleaf magnolia	Magnoliaceae	Magnoliales	Magnoliids
Magnolia virginiana	sweetbay	Magnoliaceae	Magnoliales	Magnoliids
Phoenix canariensis	Canary Island date palm	Arecaceae	Arecales	Monocots
Sabal palmetto	cabbage palm	Arecaceae	Arecales	Monocots
Syagrus romanzoffiana	queen palm	Arecaceae	Arecales	Monocots
Washingtonia filifera	California fan palm	Arecaceae	Arecales	Monocots
Washingtonia robusta	Mexican fan palm	Arecaceae	Arecales	Monocots
Yucca brevifolia	Joshua tree	Asparagaceae	Asparagales	Monocots
Yucca elata	soaptree yucca	Asparagaceae	Asparagales	Monocots
Yucca schidigera	Mohave yucca	Asparagaceae	Asparagales	Monocots
Platanus occidentalis	American sycamore	Platanaceae	Proteales	Early Diverging Eudicots
Platanus racemosa	California sycamore	Platanaceae	Proteales	Early Diverging Eudicots
Hamamelis virginiana	witch-hazel	Hamamelidaceae	Saxifragales	Rosids
Liquidambar styraciflua	sweetgum	Altingiaceae	Saxifragales	Rosids
Lagerstroemia indica	crapemyrtle	Lythraceae	Myrtales	Rosids
Eucalyptus globulus	bluegum eucalyptus	Myrtaceae	Myrtales	Rosids
Eucalyptus sideroxylon	red-ironbark eucalyptus	Myrtaceae	Myrtales	Rosids
Melaleuca quinquenervia	punktree	Myrtaceae	Myrtales	Rosids
Staphylea trifolia	American bladdernut	Staphyleaceae	Crossosomotales	Rosids
Pistacia chinensis	Chinese pistachio	Anacardiaceae	Sapindales	Rosids
Rhus copallinum	shining sumac	Anacardiaceae	Sapindales	Rosids
Rhus glabra	smooth sumac	Anacardiaceae	Sapindales	Rosids
Rhus integrifolia	lemonade sumac	Anacardiaceae	Sapindales	Rosids
Rhus ovata	sugar sumac	Anacardiaceae	Sapindales	Rosids
Rhus typhina	staghorn sumac	Anacardiaceae	Sapindales	Rosids
Schinus molle	Peruvian peppertree	Anacardiaceae	Sapindales	Rosids
Schinus terebinthifolius	Brazilian peppertree	Anacardiaceae	Sapindales	Rosids
Acer glabrum	Rocky Moutain maple	Sapindaceae	Sapindales	Rosids
Acer grandidentatum	canyon maple	Sapindaceae	Sapindales	Rosids
Acer macrophyllum	bigleaf maple	Sapindaceae	Sapindales	Rosids
Acer negundo	boxelder	Sapindaceae	Sapindales	Rosids
Acer nigrum	black maple	Sapindaceae	Sapindales	Rosids
Acer pensylvanicum	striped maple	Sapindaceae	Sapindales	Rosids
Acer platanoides	Norway maple	Sapindaceae	Sapindales	Rosids
Acer pseudoplatanus	sycamore maple	Sapindaceae	Sapindales	Rosids
Acer rubrum	red maple	Sapindaceae	Sapindales	Rosids
Acer saccharinum	silver maple	Sapindaceae	Sapindales	Rosids
Acer saccharum	sugar maple	Sapindaceae	Sapindales	Rosids

GENUS AND SPECIES	COMMON NAME	FAMILY	ORDER	MAJOR GROUP
Acer spicatum	mountain maple	Sapindaceae	Sapindales	Rosids
Aesculus californica	California buckeye	Sapindaceae	Sapindales	Rosids
Aesculus flava	yellow buckey	Sapindaceae	Sapindales	Rosids
Aesculus glabra	Ohio buckeye	Sapindaceae	Sapindales	Rosids
Koelreuteria paniculata	goldenrain tree	Sapindaceae	Sapindales	Rosids
Sapindus saponaria	soapberry	Sapindaceae	Sapindales	Rosids
Ailanthus altissima	tree of heaven	Simaroubaceae	Sapindales	Rosids
Melia azedarach	chinaberry	Meliaceae	Sapindales	Rosids
Ptelea trifoliata	common hoptree	Rutaceae	Sapindales	Rosids
Zanthoxylum americanum	common pricklyash	Rutaceae	Sapindales	Rosids
Fremontodendron californicum	California flannelbush	Malvaceae	Malvales	Rosids
Tilia americana	American basswood	Malvaceae	Malvales	Rosids
Tilia cordata	littleleaf linden	Malvaceae	Malvales	Rosids
Ricinus communis	castorbean	Euphorbiaceae	Malpighiales	Rosids
Triadica sebifera	Chinese tallow	Euphorbiaceae	Malpighiales	Rosids
Populus alba	white poplar	Salicaceae	Malpighiales	Rosids
Populus angustifolia	narrowleaf cottonwood	Salicaceae	Malpighiales	Rosids
Populus balsamifera	balsam poplar	Salicaceae	Malpighiales	Rosids
Populus deltoides	eastern cottonwood	Salicaceae	Malpighiales	Rosids
Populus fremontii	Fremont cottonwood	Salicaceae	Malpighiales	Rosids
Populus grandidentata	bigtooth aspen	Salicaceae	Malpighiales	Rosids
Populus tremuloides	quaking aspen	Salicaceae	Malpighiales	Rosids
Salix alba	white willow	Salicaceae	Malpighiales	Rosids
Salix amygdaloides	peachleaf willow	Salicaceae	Malpighiales	Rosids
Salix bebbiana	Bebb willow	Salicaceae	Malpighiales	Rosids
Salix caroliniana	coastal plain willow	Salicaceae	Malpighiales	Rosids
Salix discolor	pussy willow	Salicaceae	Malpighiales	Rosids
Salix exigua	sandbar willow	Salicaceae	Malpighiales	Rosids
Salix gooddingii	Goodding's willow	Salicaceae	Malpighiales	Rosids
Salix hookeriana	Hooker willow	Salicaceae	Malpighiales	Rosids
Salix lasiolepis	arroyo willow	Salicaceae	Malpighiales	Rosids
Salix lucida	shining willow	Salicaceae	Malpighiales	Rosids
Salix nigra	black willow	Salicaceae	Malpighiales	Rosids
Salix scouleriana	Scouler's willow	Salicaceae	Malpighiales	Rosids
Salix sitchensis	Sitka willow	Salicaceae	Malpighiales	Rosids
Albizia julibrissin	silktree	Fabaceae	Fabales	Rosids
Cercis canadensis	eastern redbud	Fabaceae	Fabales	Rosids
Cercis occidentalis (orbiculata)	California redbud	Fabaceae	Fabales	Rosids
Gleditsia triacanthos	honeylocust	Fabaceae	Fabales	Rosids
Gymnocladus dioicus	Kentucky coffeetree	Fabaceae	Fabales	Rosids
Olneya tesota	desert ironwood	Fabaceae	Fabales	Rosids
Parkinsonia aculeata	Jerusalem thorn	Fabaceae	Fabales	Rosids

GENUS AND SPECIES	COMMON NAME	FAMILY	ORDER	MAJOR GROUP
Parkinsonia florida	blue paloverde	Fabaceae	Fabales	Rosids
Parkinsonia microphylla	yellow paloverde	Fabaceae	Fabales	Rosids
Prosopis glandulosa	honey mesquite	Fabaceae	Fabales	Rosids
Prosopis velutina	velvet mesquite	Fabaceae	Fabales	Rosids
Robinia neomexicana	New Mexico locust	Fabaceae	Fabales	Rosids
Robinia pseudoacacia	black locust	Fabaceae	Fabales	Rosids
Styphnolobium japonicum	Japanese pagoda tree	Fabaceae	Fabales	Rosids
Amelanchier alnifolia	Saskatoon serviceberry	Rosaceae	Rosales	Rosids
Amelanchier arborea	downy serviceberry	Rosaceae	Rosales	Rosids
Amelanchier utahensis	Utah serviceberry	Rosaceae	Rosales	Rosids
Cercocarpus ledifolius	curlleaf cercocarpus	Rosaceae	Rosales	Rosids
Cercocarpus montanus	birchleaf mountain-mahogany	Rosaceae	Rosales	Rosids
Crataegus chrysocarpa	fireberry hawthorn	Rosaceae	Rosales	Rosids
Crataegus crus-galli	cockspur hawthorn	Rosaceae	Rosales	Rosids
Crataegus viridis	green hawthorn	Rosaceae	Rosales	Rosids
Heteromeles arbutifolia	toyon	Rosaceae	Rosales	Rosids
Malus pumila	paradise apple	Rosaceae	Rosales	Rosids
Prunus americana	American plum	Rosaceae	Rosales	Rosids
Prunus angustifolia	Chickasaw plum	Rosaceae	Rosales	Rosids
Prunus caroliniana	Carolina laurelcherry	Rosaceae	Rosales	Rosids
Prunus cerasifera	cherry plum	Rosaceae	Rosales	Rosids
Prunus emarginata	bitter cherry	Rosaceae	Rosales	Rosids
Prunus ilicifolia	hollyleaf cherry	Rosaceae	Rosales	Rosids
Prunus mexicana	Mexicum plum	Rosaceae	Rosales	Rosids
Prunus pensylvanica	pin cherry	Rosaceae	Rosales	Rosids
Prunus persica	peach	Rosaceae	Rosales	Rosids
Prunus serotina	black cherry	Rosaceae	Rosales	Rosids
Prunus virginiana	chokecherry	Rosaceae	Rosales	Rosids
Pyrus calleryana	Callery pear	Rosaceae	Rosales	Rosids
Sorbus americana	American mountain-ash	Rosaceae	Rosales	Rosids
Sorbus aucuparia	European mountain-ash	Rosaceae	Rosales	Rosids
Ceanothus thyrsiflorus	blueblossom	Rhamnaceae	Rosales	Rosids
Frangula alnus	glossy buckthorn	Rhamnaceae	Rosales	Rosids
Frangula californica	California buckthorn	Rhamnaceae	Rosales	Rosids
Frangula caroliniana	Carolina buckthorn	Rhamnaceae	Rosales	Rosids
Rhamnus cathartica	European buckthorn	Rhamnaceae	Rosales	Rosids
Rhamnus crocea	hollyleaf buckthorn	Rhamnaceae	Rosales	Rosids
Elaeagnus angustifolia	Russian-olive	Elaeagnaceae	Rosales	Rosids
Planera aquatica	water-elm	Ulmaceae	Rosales	Rosids
Ulmus alata	winged elm	Ulmaceae	Rosales	Rosids
Ulmus americana	American elm	Ulmaceae	Rosales	Rosids
Ulmus crassifolia	cedar elm	Ulmaceae	Rosales	Rosids

GENUS AND SPECIES	COMMON NAME	FAMILY	ORDER	MAJOR GROUP
Ulmus parvifolia	Chinese elm	Ulmaceae	Rosales	Rosids
Ulmus pumila	Siberian elm	Ulmaceae	Rosales	Rosids
Ulmus rubra	slippery elm	Ulmaceae	Rosales	Rosids
Zelkova serrata	Japanese zelkova	Ulmaceae	Rosales	Rosids
Celtis laevigata	sugarberry	Cannabaceae	Rosales	Rosids
Celtis occidentalis	hackberry	Cannabaceae	Rosales	Rosids
Ficus benjamina	weeping fig	Moraceae	Rosales	Rosids
Ficus carica	common fig	Moraceae	Rosales	Rosids
Maclura pomifera	Osage-orange	Moraceae	Rosales	Rosids
Morus alba	white mulberry	Moraceae	Rosales	Rosids
Morus rubra	red mulberry	Moraceae	Rosales	Rosids
Castanea dentata	American chestnut	Fagaceae	Fagales	Rosids
Castanea pumila	chinkapin	Fagaceae	Fagales	Rosids
Chrysolepis chrysophylla	giant golden chinkapin	Fagaceae	Fagales	Rosids
Fagus grandifolia	American beech	Fagaceae	Fagales	Rosids
Quercus agrifolia	coast live oak	Fagaceae	Fagales	Rosids
Quercus alba	white oak	Fagaceae	Fagales	Rosids
Quercus arizonica	Arizona white oak	Fagaceae	Fagales	Rosids
Quercus bicolor	swamp white oak	Fagaceae	Fagales	Rosids
Quercus chrysolepis	canyon live oak	Fagaceae	Fagales	Rosids
Quercus coccinea	scarlet oak	Fagaceae	Fagales	Rosids
Quercus douglasii	blue oak	Fagaceae	Fagales	Rosids
Quercus ellipsoidalis	northern pin oak	Fagaceae	Fagales	Rosids
Quercus emoryi	Emory oak	Fagaceae	Fagales	Rosids
Quercus falcata	southern red oak	Fagaceae	Fagales	Rosids
Quercus gambelii	Gambel oak	Fagaceae	Fagales	Rosids
Quercus garryana	Oregon white oak	Fagaceae	Fagales	Rosids
Quercus geminata	sand live oak	Fagaceae	Fagales	Rosids
Quercus grisea	gray oak	Fagaceae	Fagales	Rosids
Quercus hypoleucoides	silverleaf oak	Fagaceae	Fagales	Rosids
Quercus imbricaria	shingle oak	Fagaceae	Fagales	Rosids
Quercus incana	bluejack oak	Fagaceae	Fagales	Rosids
Quercus kelloggii	California black oak	Fagaceae	Fagales	Rosids
Quercus laevis	turkey oak	Fagaceae	Fagales	Rosids
Quercus laurifolia	laurel oak	Fagaceae	Fagales	Rosids
Quercus lobata	valley oak	Fagaceae	Fagales	Rosids
Quercus lyrata	overcup oak	Fagaceae	Fagales	Rosids
Quercus macrocarpa	bur oak	Fagaceae	Fagales	Rosids
Quercus margarettae	sand post oak	Fagaceae	Fagales	Rosids
Quercus marilandica	blackjack oak	Fagaceae	Fagales	Rosids
Quercus michauxii	swamp chestnut oak	Fagaceae	Fagales	Rosids
Quercus montana	chestnut oak	Fagaceae	Fagales	Rosids

GENUS AND SPECIES	COMMON NAME	FAMILY	ORDER	MAJOR GROUP
Quercus muehlenbergii	chinkapin oak	Fagaceae	Fagales	Rosids
Quercus nigra	water oak	Fagaceae	Fagales	Rosids
Quercus pagoda	cherrybark oak	Fagaceae	Fagales	Rosids
Quercus palustris	pin oak	Fagaceae	Fagales	Rosids
Quercus phellos	willow oak	Fagaceae	Fagales	Rosids
Quercus rubra	northern red oak	Fagaceae	Fagales	Rosids
Quercus rugosa	netleaf oak	Fagaceae	Fagales	Rosids
Quercus shumardii	Shumard oak	Fagaceae	Fagales	Rosids
Quercus stellata	post oak	Fagaceae	Fagales	Rosids
Quercus texana	Texas red oak	Fagaceae	Fagales	Rosids
Quercus velutina	black oak	Fagaceae	Fagales	Rosids
Quercus virginiana	live oak	Fagaceae	Fagales	Rosids
Quercus wislizeni	interior live oak	Fagaceae	Fagales	Rosids
Alnus incana	speckled alder	Betulaceae	Fagales	Rosids
Alnus rhombifolia	white alder	Betulaceae	Fagales	Rosids
Alnus rubra	red alder	Betulaceae	Fagales	Rosids
Alnus viridis	green alder	Betulaceae	Fagales	Rosids
Betula alleghaniensis	yellow birch	Betulaceae	Fagales	Rosids
Betula lenta	sweet birch	Betulaceae	Fagales	Rosids
Betula nigra	river birch	Betulaceae	Fagales	Rosids
Betula occidentalis	water birch	Betulaceae	Fagales	Rosids
Betula papyrifera	paper birch	Betulaceae	Fagales	Rosids
Betula populifolia	gray birch	Betulaceae	Fagales	Rosids
Carpinus caroliniana	American hornbean	Betulaceae	Fagales	Rosids
Corylus cornuta	beaked hazelnut	Betulaceae	Fagales	Rosids
Ostrya virginiana	eastern hophornbeam	Betulaceae	Fagales	Rosids
Carya aquatica	water hickory	Juglandaceae	Fagales	Rosids
Carya cordiformis	bitternut hickory	Juglandaceae	Fagales	Rosids
Carya glabra	pignut hickory	Juglandaceae	Fagales	Rosids
Carya illinoinensis	pecan	Juglandaceae	Fagales	Rosids
Carya ovata	shagbark hickory	Juglandaceae	Fagales	Rosids
Carya tomentosa	mockernut hickory	Juglandaceae	Fagales	Rosids
Juglans cinerea	butternut	Juglandaceae	Fagales	Rosids
Juglans nigra	black walnut	Juglandaceae	Fagales	Rosids
Carnegiea gigantea	Saguaro	Cactaceae	Caryophyllales	Asterids
Cornus alternifolia	pagoda dogwood	Cornaceae	Cornales	Asterids
Cornus drummondii	roughleaf dogwood	Cornaceae	Cornales	Asterids
Cornus florida	flowering dogwood	Cornaceae	Cornales	Asterids
Cornus mas	Cornelian cherry	Cornaceae	Cornales	Asterids
Cornus nuttallii	Pacific dogwood	Cornaceae	Cornales	Asterids
Cornus sericea	redosier dogwood	Cornaceae	Cornales	Asterids
Nyssa aquatica	water tupelo	Nyssaceae	Cornales	Asterids

GENUS AND SPECIES	COMMON NAME	FAMILY	ORDER	MAJOR GROUP
Nyssa biflora	swamp tupelo	Nyssaceae	Cornales	Asterids
Nyssa sylvatica	black tupelo	Nyssaceae	Cornales	Asterids
Sideroxylon lanuginosum	gum bully	Sapotaceae	Ericales	Asterids
Diospyros virginiana	common persimmon	Ebenaceae	Ericales	Asterids
Gordonia lasianthus	loblolly bay	Theaceae	Ericales	Asterids
Halesia tetraptera	mountain siverbell	Styracaceae	Ericales	Asterids
Styrax americanus	American snowbell	Styracaceae	Ericales	Asterids
Styrax grandifolius	bigleaf snowbell	Styracaceae	Ericales	Asterids
Arbutus menziesii	Pacific madrone	Ericaceae	Ericales	Asterids
Arctostaphylos glauca	bigberry manzanita	Ericaceae	Ericales	Asterids
Kalmia latifolia	mountain-laurel	Ericaceae	Ericales	Asterids
Oxydendrum arboreum	sourwood	Ericaceae	Ericales	Asterids
Rhododendron macrophyllum	Pacific rhododendron	Ericaceae	Ericales	Asterids
Vaccinium arboreum	farkleberry	Ericaceae	Ericales	Asterids
Garrya elliptica	wavyleaf silktassel	Garryaceae	Garryales	Asterids
Cephalanthus occidentalis	buttonbush	Rubiaceae	Gentianales	Asterids
Fraxinus americana	white ash	Oleaceae	Lamiales	Asterids
Fraxinus caroliniana	Carolina ash	Oleaceae	Lamiales	Asterids
Fraxinus dipetala	two-petal ash	Oleaceae	Lamiales	Asterids
Fraxinus latifolia	Oregon ash	Oleaceae	Lamiales	Asterids
Fraxinus nigra	black ash	Oleaceae	Lamiales	Asterids
Fraxinus pennsylvanica	green ash	Oleaceae	Lamiales	Asterids
Fraxinus velutina	velvet ash	Oleaceae	Lamiales	Asterids
Olea europaea	olive	Oleaceae	Lamiales	Asterids
Catalpa speciosa	northern catalpa	Bignoniaceae	Lamiales	Asterids
Chilopsis linearis	desert-willow	Bignoniaceae	Lamiales	Asterids
Paulownia tomentosa	princesstree	Paulowniaceae	Lamiales	Asterids
Ilex decidua	possumhaw	Aquifoliaceae	Aquifoliales	Asterids
Ilex opaca	American holly	Aquifoliaceae	Aquifoliales	Asterids
Ilex vomitoria	yaupon	Aquifoliaceae	Aquifoliales	Asterids
Aralia elata	Japanese angelica tree	Araliaceae	Apiales	Asterids
Aralia spinosa	devil's walkingstick	Araliaceae	Apiales	Asterids
Sambucus nigra	common elderberry	Adoxaceae	Dipsacales	Asterids
Sambucus racemosa	red elderberry	Adoxaceae	Dipsacales	Asterids
Viburnum prunifolium	blackhaw	Adoxaceae	Dipsacales	Asterids
Viburnum rufidulum	rusty blackhaw	Adoxaceae	Dipsacales	Asterids

Glossary

ACHENE A tiny, one-seeded, dry, indehiscent fruit with a hard outer layer.

ACORN A fruit of an oak consisting of a nut partly enclosed by a scale-covered cup.

ADAPTATION Any morphological, physiological, developmental, or behavioral character resulting from natural selection that enhances the survival and reproductive success of an organism.

ADVENTITIOUS Arising from a site that is more or less unusual, such as roots sprouting from a stem, or branches from the trunk.

AERIAL ROOTS Aboveground roots, usually adventitious, often found in mangroves and figs.

ALPINE Above the tree line.

ANTHROPOCENE A geologic period referring to planet Earth in the Age of Humans.

ARBORESCENT Appearing like a tree in structure and size.

ARIL An outer covering on some seeds, commonly fleshy, sometimes brightly colored, often derived from the small stalk that connects the seed to the placenta.

AROMATIC OIL Fragrant substance with a pleasant odor produced by a plant.

ATTRACTANTS Usually referring to products, such as nectar and pollen, to entice pollinators to visit flowers.

BARK The outermost, often more or less corky or leathery, cell layers on stems, branches, twigs, and roots, formed by the cambium cells. The bark of trees usually has two layers, the outer and the inner, more or less distinct in structure, texture, color, etc.

BERRY A fleshy fruit containing few to many seeds within.

BINOMIAL A scientific name for a species, usually in Latin, consisting of a generic name followed by a specific name.

BIODIVERSITY The variety and variability of all of life on Earth.

BIOME A complex of terrestrial and/or marine communities of very wide extent, characterized by its climate and soil.

BIPINNATE Refers to a compound leaf that is twice divided, with its primary segments branching from an axis, and each segment divided into separate leaflets along a secondary axis.

BISEXUAL Having the parts or organs of both sexes simultaneously on a plant, as in a flower that contains both pollen and ovules.

BLADE The leaf, apart from its stalk.

BOREAL The most northerly biome where trees can grow, dominated by evergreen conifers.

BRACT A scale or modified leaflike structure, associated with the seed-bearing cone scales of conifers; also found below the bases of some flowers, fruits, and flower or fruiting clusters.

BRANCH A secondary division of a tree trunk.

BUD An incipient shoot bearing embryonic leaves or flowers or both.

BUR A dry fruit that is covered with prickles or spines.

CALYX The outermost of the four whorls of parts that make up a flower, formed by the sepals.

CANOPY The upper layer of a forest formed by the crowns of mature trees, including other plants and animals inhabiting the zone.

CAPSULE A dry, dehiscent fruit derived from a compound pistil, which may have one or several chambers.

CARBONIFEROUS A geological time period within the Palaeozoic Era (ca. 365–290 million years BP).

CARPEL A unit of the female reproductive organ of a flower; each carpel is comprised of a stigma, style, and ovary, which contains one or more ovules.

CATKIN A small, usually elongate cluster of highly reduced unisexual flowers, often deciduous as a unit.

CHAPARRAL An ecological community of shrubs and trees adapted to dry summers and moist winters, mainly found in southern California.

CLADOGRAM A branching diagram or "tree" representing hypothesized phylogenetic or evolutionary relationships of a group of organisms.

CLASSIFICATION The organized categorization of organisms and species based on various features of those taxa.

CLIMAX HABITAT The final stage in a successional series of an environment.

COASTAL PLAIN Broad, generally flat, often water-dominated habitats bordering the ocean.

COEVOLUTION The simultaneous evolution of adaptations in two or more populations or species, which interact so closely that each is a strong selective force on the other.

COMMON ANCESTOR A shared lineage that has given rise to two or more lineages over evolutionary time.

COMMON NAME A colloquial and often local designation of a species.

COMMUNITY All the organisms inhabiting a common environment and interacting with each other.

COMPOUND LEAF A blade that is divided to the midrib or to the tip of the petiole, thereby separated into smaller individual leaflets, each arising from an axis or central point.

CONE A dense conical mass of flowers or fruits, or (more strictly) of seed-bearing scales, on a central axis. Loosely used for the fruits of magnolias, alders, etc., but more specifically for the female reproductive structures of the conifers, which are composed of woody, leathery, papery, or fleshy seed-bearing scales arranged on a central axis forming a homogeneous fruit that detaches as a unit.

CONIFEROUS FOREST A habitat of primarily cone-bearing trees.

CONSERVATION STATUS The level of risk of extinction of a species based on an established set of categories of environmental threat.

CORDATE In the shape of a heart, usually referring to the base of a leaf blade, having two rounded lobes, one on each side of the petiole.

COROLLA The whorl of parts formed by the petals of a flower.

CORYMB A flat-topped inflorescence in which the flowers mature from the outer edge inward.

COTYLEDON The first leaf, or pair of leaves, of an embryo within the seed, that may store food reserves for the developing seedling.

CRETACEOUS A geological period of the Mesozoic Era (ca. 140–65 million years BP).

CROWN The portion of a tree above the trunk formed by the branches and leaves.

CULTIVAR A variety of a plant produced through hybridization, artificial selection, or any other cultivation process.

CUNEATE Wedge-shaped.

CYME A terminal cluster of successive three-flowered units, the terminal flower of each cluster opening first with the pattern repeated many times, producing a flat-topped or convex flower cluster.

DARWIN, CHARLES A nineteenth-century naturalist and biologist who proposed in his book *On the Origin of Species* that all species of life have descended from a common ancestor through the process of natural selection, which serves as the basis for our modern-day classifications of plants, animals, and fungi.

DATA DEFICIENT Insufficient data available to assess conservation status of a species.

DECIDUOUS A type of plant that sheds its leaves during an unfavorable season of the year.

DEFORESTATION The degradation of forests usually through destructive activities by humans.

DEHISCENT Regarding a dry fruit, splitting or otherwise opening at maturity.

DESERT A dry and arid habitat with little rain and often high temperatures.

DICOTYLEDON A plant whose embryo has two cotyledons, i.e., a pair of seed leaves. The dicotyledons, or "dicots," include most species of flowering plants but are no longer considered to be a valid taxonomic category.

DIOECIOUS The presence of female and male flowers on separate individual plants of the same species.

DISJUNCT A non-continuous distribution of a population or species of plant or animal.

DISPERSAL The means by which fruits and seeds are distributed by an individual plant, usually by wind, water, or animals.

DISTURBED HABITAT A disrupted environment resulting from a human- or weather-caused impact.

DIVERSIFICATION The formation over evolutionary time of two (or more) separate lineages from one common ancestral lineage.

DNA Deoxyribonucleic acid, the primary genetic material of a cell, is a large molecule made up of four nucleotides (adenine, guanine, cytosine, thymine), which appear as chains in the form of a double helix. Analysis of the sequence of nucleotide pairings in the two chains provides information on the evolutionary history of organisms.

DNA BARCODE A standardized short sequence of DNA that can be easily isolated and is unique enough to identify one species from another.

DRUPE A fruit, such as a plum, with a three-layered ovary wall consisting of an outer skin over a fleshy layer and an innermost hard, bony layer forming one or more stones, each surrounding one seed.

ECOLOGY The life habits and interrelationships of plants and animals with each other and with environmental influences.

ECOSYSTEM A major interacting system that involves both living organisms and their physical environment.

ENDANGERED Very high risk of extinction in the wild.

ENDOSPERM The triploid (three sets of chromosomes), fleshy tissue that protects and nourishes the growing embryo in angiosperm seeds.

EPIPHYTE A plant that grows on another plant for support, but not to obtain water or nutrients.

EVERGREEN Remaining green through the seasons; never naked of foliage. All "evergreens" eventually shed their leaves but are unlike deciduous trees, which defoliate all at once or before new growth appears.

EVOLUTION The derivation of progressively more complex forms of life from more simpler ancestors. Natural selection is often considered the principal mechanism by which evolution takes place.

EVOLUTIONARY CLASSIFICATION A natural, usually hierarchical classification that reflects the Darwinian principle of evolution by common descent.

EXFOLIATING Peeling away in papery plates or strips, as the bark of sycamore, birch, eucalyptus, etc.

EXOCARP The outermost layer of the ripened ovary walls of a fruit.

EXOTIC A species brought to a new habitat by humans either intentionally to cultivate for some purpose or unintentionally as a weed.

EXTINCT A population or species in which all individuals no longer exist.

FAMILY A rank within the hierarchy of taxonomic classification that falls between the higher rank of order and the lower rank of genus.

FASCICLE A small, closely held bundle or cluster.

FEMALE SEED CONE A cone of a gymnosperm that only produces female gametes and eventually seeds.

FIRE ADAPTED Environments suited to periodic impacts by fire and burning through naturally occurring processes or, more often, human-caused activities. Fire-prone habitats are unsuited to such processes.

FLORAL BIOLOGY The mechanisms of form and function that determine reproductive success in a flower.

FLOWER The reproductive structure of angiosperms; a complete flower includes calyx, corolla, androecium (stamens), and gynoecium (carpels), although one or more of these parts may be absent.

FOLLICLE A dry, podlike fruit derived from a single carpel that splits along one seam to release the seeds.

FOSSIL The remains, impressions, or traces of an organism that have been preserved in rocks found in Earth's crust.

FRUIT The seed-bearing organ of flowering plants; the ovary or pistil and sometimes adjacent coherent parts.

GAMETE A haploid reproductive cell; gametes fuse in pairs, forming zygotes, which are diploid.

GENUS A rank within the hierarchy of taxonomic classification that falls between the higher rank of family and the lower rank of species.

GLABROUS Without hairs, usually implying the surface to be smooth.

GLAUCOUS Having an impermanent powdery or waxy covering that often imparts a bluish tint, often easily rubbed off.

GRASSLAND A habitat dominated by grasses with few and scattered trees.

GYNODIOECY A breeding system of flowering plants in which both female and hermaphroditic plants coexist within a population.

HEARTWOOD The hard, inner cylinder of a woody stem, consisting of dead, heavy, and dense wood elements, usually darker than the sapwood due to the deposition of tannin, gums, resins, and pigments.

HERBIVORE An animal that feeds upon plants.

HYBRID The offspring of two organisms that belong to different species.

HYPANTHIUM An often cuplike structure surrounding the ovary formed by the fused bases of the sepals, petals, and stamens; may be either free or fused to the ovary.

IDENTIFICATION The process of determining the correct species name using a set of standardized features and characters.

IMAGE-RECOGNITION TECHNOLOGY A modern method of species identification based on mathematical algorithms to define and categorize appearances.

IMPERFECT FLOWER A flower lacking either stamens or carpels.

INDEHISCENT Remaining closed at maturity.

INFLORESCENCE An arrangement or aggregation of one or more flowers.

INFRUCTESCENCE The fruit-bearing portion of a plant; the inflorescence in a fruiting stage.

INTRODUCED Not native.

INVASIVE A non-native species that becomes aggressive and invades new habitats, ecologically displacing native species.

LANCEOLATE A narrow shape much longer than wide, widest below the middle and tapering to a pointed tip, like the head of a spear.

LEAF The lateral outgrowth of a stem or shoot, appearing from a bud and usually flattened, veinous, and, at maturity, green from the presence of chlorophyll; the principal photosynthetic organ of a tree.

LEAF BASE The bottom of a leaf blade above the petiole.

LEAF SCAR A mark left on a twig after a leaf drops.

LEAST CONCERN Unlikely to become extinct in the near future.

LEGUME The fruit of the Fabaceae, or bean, family; a dry pod derived from a simple pistil that splits along two seams.

LENTICEL A pore in the bark of a tree.

LINNAEUS, CARL An eighteenth-century naturalist who developed the system of hierarchical classification and binomial naming of species. The Linnaean system classifies organisms according to ordered ranks, such as kingdom (largest), phylum, class, order, family, genus, and species.

MALE POLLEN CONE A cone of a gymnosperm that only produces male gametes as pollen.

MANGROVE A tree that grows in habitats inundated by salt water.

MARITIME CLIMATE An ocean climate usually in the Temperate Zone featuring cool summers and mild winters with few temperature extremes.

MEDITERRANEAN CLIMATE A climate usually near the ocean with warm to hot, dry summers and mild wet winters.

MESOCARP The middle layer of the part of a ripe fruit formed from the ovary wall.

MONOECIOUS Having the male and female reproductive parts on the same plant.

MONOPHYLETIC A group of taxa that are all derived from of a common ancestor and are defined by shared characters possessed by that ancestor.

MORPHOLOGY The study of form and its development.

MUTUALISM The living together of two or more organisms in an association that is mutually advantageous to all.

MYCORRHIZAE The symbiotic association between a fungus and the root system of a plant in which nutrients are supplied to the plant by the fungi.

NATIVE Originating through evolution in a given region.

NATURALIZED A non-native species that becomes common and established as though native, reproducing naturally and spreading to new habitats.

NEAR THREATENED Close to being at high risk of extinction in the near future.

NECROSIS Cell injury resulting in the premature death of cells in living plant tissue.

NECTARY Glands in a flower that produce nectar, a sugary liquid, as a reward for visiting pollinators.

NEEDLE The peculiar, very long, and narrow leaf, commonly triangular or plano-convex in cross-section, of pines and other conifers.

NUT An indehiscent one-seeded fruit with a hard outer wall and starchy kernel inside.

ORDER A rank within the hierarchy of classification that falls between the higher rank of class and the lower rank of family.

ORNAMENTAL PLANT A species that is primarily grown and cultivated for its beauty or other interesting characteristics.

OVARY The part of the pistil enclosing and bearing the ovules.

OVULE A structure within a plant ovary that develops into a seed.

PALMATE In the shape of a hand or a fan, with lobes or veins radiating from a common point.

PANICLE A large multibranched inflorescence in which the secondary branches are often racemes.

PATHOGEN An organism that causes a disease.

PEDICEL The stalk that attaches a single flower to an inflorescence.

PEDUNCLE The stalk of an inflorescence.

PERFECT Referring to flowers when they are bisexual, containing both carpels and stamens.

PERIANTH The portions of a flower outside the stamens and pistil, usually consisting of the calyx and corolla (sometimes only the calyx). In some small, often wind-pollinated flowers, the perianth may be absent.

PERMIAN A geological period of the Palaeozoic Era (ca. 290–245 million years BP).

PETAL A unit of the corolla, the second whorl of the parts that make up a flower.

PETIOLE The stalk of a leaf that attaches it to the stem.

PHLOEM The food-conducting tissue of vascular plants.

PHOTOSYNTHESIS The biochemical process in plants that uses light energy from the sun to synthesize carbohydrates from carbon dioxide and water in the presence of the green pigment chlorophyll.

PHYLOGENY The evolutionary history of a group of organisms that indicates the pattern of ancestor-descendant relationships.

PINNATE Refers to a pinnately compound leaf in the pattern of a feather with a central axis and secondary axes extending from it in a plane on either side.

PISTIL The female reproductive organ of a flowering plant that consists of one or more carpels, which are made up of the ovary, style, and stigma.

PITH The central tissue within a twig or root, usually soft and more or less spongy, originating from the apical meristem and consisting of thin-walled cells.

POD A dry fruit derived from a simple pistil that splits at maturity along two seams characteristic of the Fabaceae, or bean, family.

POLLEN Tiny spores of a seed plant that produce sperm or sperm cells that fertilize the ovules.

POLLINATION The transfer of pollen from the anthers to the stigma within or between flowers usually by a variety of vectors, such as wind, water, and animals, which are referred to as pollinators.

POLYGAMODIOECIOUS Having both unisexual and bisexual flowers on the same individual.

POME A fruit, such as an apple, formed by the thickened, fleshy hypanthium joined to the inferior ovary.

PRIMARY HABITAT A generally undisturbed and pristine habitat.

PRIMITIVE A feature that is thought to be ancestral to a lineage of plants.

PROPAGULE An organ, such as a seed or fruit, that allows a plant to reproduce.

PROTOGYNOUS A flower opening in which the female reproductive structure matures before the male parts, inhibiting self-pollination.

PUBESCENCE Soft short hairs.

PYRENE The seed containing a stone of a small drupe, such as that of a holly; also called a nutlet.

RACEME A loose (as compared to a spike), narrow inflorescence with stalked flowers along an elongate axis.

RACHIS In a compound leaf, the central axis along which the leaflets are arranged; it begins where the petiole ends, at the first leaflet at the base of the pinnately divided blade.

RAIN FOREST A forest habitat, usually in the warm tropics or subtropics, that is characterized by abundant rainfall and evergreen vegetation.

REFORESTATION The regeneration of forests following disturbance and degradation through planting and natural recovery processes.

REMOTE SENSING The use of satellite- and aircraft-based sensor technologies to detect and classify the atmosphere, surface, and oceans of Earth.

RENIFORM Kidney-shaped.

RESIN Secretions, usually formed in special passages or glands, either hard or liquid, usually aromatic, insoluble in water, soluble in alcohol, and burning with a sooty flame.

RHIZOMATOUS Possessing a horizontal stem, often underground or on the surface of the ground, that persists from season to season and bears roots and leafy shoots.

RIPARIAN HABITAT The interface zone between land and a river or stream.

ROOT The usually underground part of a tree distinguished from the trunk by its origin at the opposite end of the embryo, and by its generally downward growth; roots give rise to rootlets but never to buds or stems.

SAMARA A hard, dry, indehiscent fruit with one or more wings, such as that of a maple.

SAPONIN A group of toxic, soaplike compounds that are present in many plants.

SAPWOOD The woody cylinder between the bark and the heartwood, usually paler than the heartwood, less heavy and dense, and more permeable.

SAVANNA A grassland habitat with scattered trees.

SCALE A term used variously for different organs and appendages; often employed in connection with much reduced stem leaves and, in conifers, with the small leaflike appendages of the cone between the woody bracts.

SCLEROPHYLL Vegetation characteristic of long periods of heat and dryness with stiff and leathery leaves.

SECONDARY HABITAT Environments resulting from disturbance.

SEED The ovule after fertilization, containing the embryonic plant, within one or more layers of tissue, and often accompanied by a store of starch, called the endosperm in flowering plants.

SELF-PRUNING A plant or tree that sheds its leaves or branches without involvement of an external force.

SEPAL A member of the outer whorl, or calyx, of the floral perianth that is typically green and leaflike, functioning to protect the unopened flower.

SEROTINOUS Referring to cones that remain closed until opened by heat (usually fire) or considerable age and only then releasing the seeds.

SHADE TOLERANT The ability to withstand and thrive under low light conditions for significant periods of time.

SIMPLE LEAF An undivided blade that may be toothed or deeply lobed but not divided to the midrib or tip of the petiole.

SPECIES The basic unit of biological classification. By one definition, a distinct lineage of sexually reproducing organisms forming interbreeding populations that are reproductively isolated from other such lineages.

SPECIOSE Comprising a large number of species.

SPIKE A tight, long, narrow inflorescence in which the individual flowers lack stalks.

SPINE A needlelike structure that is derived from a leaf or a portion of a leaf, such as a cactus spine or mesquite spine.

SPIRALLY ARRANGED Leaves or branches organized in a corkscrew orientation.

STAMEN The pollen-producing male reproductive organ of a flower composed of a filament (stalk) and anther (pollen sacs or sporangia).

STAMINODE A sterile stamen producing no pollen.

STEM The main axis of growth aboveground, bearing the buds, leaves, and flowers as contrasted to the root-bearing axis.

STIPULE One of a pair of structures at the base of the petiole of a leaf, which are usually small, green, and leaflike but may be modified into scales, bristles, or spines.

STOLON An elongated, slightly underground stem with long internodes that form new plants at the tips.

STOMATAL BANDS Conspicuous parallel lines of stomates usually on the underside of gymnosperm needles.

STOMATE An small opening between two cells in the outer cellular layer of the leaves of vascular plants (and mosses). The size of the opening is controlled by the plant and allows diffusion of gases and water vapor into and out of the photosynthesizing leaves.

STROBILUS A reproductive structure consisting of a number of modified leaves (sporophylls) or ovule-bearing scales grouped terminally on a stem; a cone.

STYLE The often elongate portion of a pistil between the ovary at the base and the stigma at the tip.

SUBALPINE Below the tree line at higher montane elevations.

SUBSPECIES A taxonomic category below the species level designating subgroups of a species that are closely related and capable of interbreeding but typically do not, usually because of geographic separation.

SUBTROPICS Climatic zones to the north and south of the tropics with hot summers and mild, usually frost-free winters.

SUCCESSION The progression of changes in community composition that occurs during the development of vegetation from initial colonization to the attainment of climax structure.

SYMBIOTIC RELATIONSHIP The close ecological relationship between two or more species. Three types of symbiosis are found in nature: mutualism (both organisms benefit from the relationship), parasitism (the relationships is harmful to one organism and beneficial to the other), and commensalism (one organism benefits and the other is unharmed by the relationship).

TAPROOT A vertical, strong central root that continues growth straight down in line with the axis of the stem.

TAXONOMIST A person trained in the discipline of identification and classification of organisms.

TEMPERATE ZONE Middle-latitude habitats found between the tropics and the polar regions, with seasonal climates.

TEPAL A segment of the perianth of a flower that is not clearly distinguished as either a sepal or a petal.

TOMENTOSE Covered with densely matted or woolly hairs.

TREE OF LIFE The representation of evolutionary relationships in the form of a branching tree with the most advanced lineages at the tips of the branches.

TRIPINNATE Refers to a compound leaf that is thrice divided, with its primary segments divided into secondary segments, and each of those divided into individual leaflets.

TROPICS The region of Earth surrounding the equator, bounded on the north by the Tropic of Cancer and on the south by the Tropic of Capricorn, with usually hot and wet climates.

TRUNK The main portion of a tree's stem between the roots and the crown; bole.

TUNDRA A treeless circumpolar region, best developed in the Northern Hemisphere and mostly found north of the Arctic Circle.

TWIG The ultimate portion of a young branch produced by the current year's growth; a branchlet.

UMBEL An often flat-topped inflorescence in which the stalks of the individual flowers originate from a common point.

UNDERSTORY The zone of forest growth below the tree canopy, often characterized by low light environments.

UNISEXUAL Composed of one sex only, referring to a flower that has pollen or ovules but not both.

VARIETY A taxonomic category below the species level designating subgroups of a species that are closely related and capable of interbreeding but typically do not, usually because of geographic separation. Variety is of lower rank than subspecies, but in plants when only one category below species is used, variety and subspecies are conceptually equivalent.

VASCULAR SYSTEM All the vascular tissues (xylem, phloem, vascular cambium) in their specific arrangement in a plant or plant organ.

VENATION The variously patterned system of midrib and veins in a leaf or petal.

VULNERABLE High risk of unnatural (human-caused) extinction without further human intervention.

WHORL Three or more leaves or other organs arising in a circle from one node of a shoot.

WINDFIRM Possessing the quality to resist treefall due to high winds.

WINDTHROW Lacking the quality to resist treefall due to high winds.

WOOD Secondary xylem.

XERIC Dry and arid, usually referring to habitats.

XYLEM The vascular tissue through which most of the water and minerals of a plant are conducted.

Notes

Preface

1. Janzen, "Conserve Wild Plants," x.

Chapter One: What Is a Tree?

1. Farrar, *Trees of Northern United States*; Little, *Checklist*, 3; BGCI, *State of the World's Trees*, 6.
2. Thomas, *Trees*, 1.
3. Sibley, *Sibley Guide to Trees*, x.
4. Dirr, *Encyclopedia of Trees*; Dirr and Warren, *Tree Book*, 14.
5. Knoll, Niklas, and Tiffney, "Phanerozoic Land-Plant Diversity," 1400–02.
6. Nic Lughadha et al., "Counting Counts," 82–88.
7. Humphreys et al., "Global Dataset," 1043–47.
8. Cazolla Gatti et al., "Number of Tree Species," 1–11; Thomas, *Trees*; GlobalTree Portal.
9. Crowther et al., "Mapping Tree Density," 201–5.
10. ter Steege et al., "Hyperdominance."
11. Crowther et al., "Mapping Tree Density," 201–5.
12. ForestPlots.net et al., "Taking the Pulse"; Brandt et al., "Count of Trees," 78–82.
13. PLANTS Database; Global Biodiversity Information Facility.
14. GlobalTree Portal.
15. Carrero et al., "Data Sharing," 1–17.

Chapter Two: Value of Trees

1. Gerard Manley Hopkins, 1879.
2. Nadkarni, *Between Earth and Sky*.
3. Dirr and Warren, *Tree Book*, 14.
4. Ellison et al., "Foundation Species," 479–86.
5. Lewis et al., "Regenerate Natural Forests," 25–28.
6. Bastin et al., "Global Tree Restoration," 76–79; Carrington, "Tree Planting"; Fox, "Billion Hectares."
7. Lewis et al., "Regenerate Natural Forests," 25–28; Gurevitch, "Managing Forests," 792–93.
8. Del Tredici, "Urban Nature," 58–61.
9. GlobalTree Portal.
10. Nadkarni, *Between Earth and Sky*.
11. McMahon, "Temperate Forests," 53–57.
12. Thoreau, *Maine Woods*, 26.
13. Proulx, *Barkskins*; Powers, *Overstory*.
14. Wildlands, Woodlands, Farmlands & Communities.
15. Howard, "Timber Yield," 198–209.
16. Chazdon and Brancalion, "Restoring Forests," 24–25.
17. Jonnes, "Tree Worth," 34–41.
18. United States Forest Service, Davey Tree Expert Company, Arbor Day Foundation, Society of Municipal Arborists, International Society of Arboriculture, Casey Trees, and SUNY College of Environmental Science and Forestry, "MyTree," accessed April 27, 2023, https://mytree.itreetools.org/#/.

Chapter Three: Structure and Reproduction

1. Ennos, *Trees*.
2. Kershner et al., *Field Guide*; Nelson, Earle, and Spellenberg, *Trees*; Spellenberg, Earle, and Nelson, *Trees of Western North America*.
3. Simard, *Mother Tree*.
4. Harlow, *Fruit Key*.
5. Del Tredici, "Sprouting," 121–40.

Chapter Four: Ecology and Conservation

1. Carrero et al., "Data Sharing," 1–17.
2. Kershner et al., *Field Guide*.
3. Nelson, Earle, and Spellenberg, *Trees*.
4. Humboldt, *Geography of Plants*.
5. Potter, Crane, and Hargrove, "National Prioritization Framework," 275–300.
6. Carrero et al., "Data Sharing," 1–17.
7. Popkin, "Deadly Pest," 356.
8. IUCN Red List of Threatened Species; NatureServe Explorer.
9. Carrero et al., "Data Sharing," 1–17.
10. Kress and Stine, *Anthropocene*.
11. Intergovernmental Science-Policy Platform on Biodiversity and Ecosystem Services, "Global Assessment."

Chapter Five: Names and Identification

1. Flora of North America; PLANTS Database; Little, *Checklist*.
2. Kershner et al., *Field Guide*.
3. Kress et al., "Citizen Science," 348–58.
4. iNaturalist (website), California Academy of Sciences and the National Geographic Society, accessed April 27, 2023, https://www.inaturalist.org/.
5. Lowman, *Arbornaut*.
6. Kress and Erickson, *DNA Barcodes*.
7. Kress, "Plant DNA Barcodes," 297–301.

Chapter Six: Evolutionary Relationships of Trees: A Natural Classification

1. Darwin, *Origin of Species*.
2. Judd et al., *Plant Systematics*.
3. Soltis et al., *Phylogeny and Evolution*.
4. Royal Botanic Gardens, Kew, "Tree of Life."

Works Cited

Bastin, Jean-Francois, Yelena Finegold, Claude Garcia, Danilo Mollicone, Marcelo Rezende, Devin Routh, Constantin M. Zohner, and Thomas W. Crowther. "The Global Tree Restoration Potential." *Science* 365, no. 6448 (July 5, 2019): 76–79. https://doi.org/10.1126/science.aax0848.

BGCI. *State of the World's Trees*. Richmond: BGCI, 2021.

Brandt, Martin, Compton J. Tucker, Ankit Kariryaa, Kjeld Rasmussen, Christin Abel, Jennifer Small, Jerome Chave, et al. "An Unexpectedly Large Count of Trees in the West African Sahara and Sahel." *Nature* 587, no. 7832 (November 2020): 78–82. https://doi.org/10.1038/s41586-020-2824-5.

Carrero, Christina, Emily Beckman Bruns, Anne Frances, Diana Jerome, Wesley Knapp, Abby Meyer, Ray Mims, David Pivorunas, DeQuantarius Speed, Amanda Treher Eberly, and Murphy Westwood. "Data Sharing for Conservation: A Standardized Checklist of US Native Tree Species and Threat Assessments to Prioritize and Coordinate Action." *Plants, People, Planet* (2022): 1–17. Accessed April 27, 2023. https://doi.org/10.1002/ppp3.10305.

Carrington, Damian. "Tree Planting 'Has Mind-Blowing Potential' to Tackle Climate Crisis." *The Guardian*, July 4, 2019, Environment. https://www.theguardian.com/environment/2019/jul/04/planting-billions-trees-best-tackle-climate-crisis-scientists-canopy-emissions.

Cazzolla Gatti, Roberto, Peter B. Reich, Javier G. P. Gamarra, Tom Crowther, Cang Hui, Albert Morera, Jean-Francois Bastin, et al. "The Number of Tree Species on Earth." *Proceedings of the National Academy of Sciences of the United States of America* 119, no. 6 (February 8, 2022): e2115329119. https://doi.org/10.1073/pnas.2115329119.

Chazdon, Robin, and Pedro Brancalion. "Restoring Forests as a Means to Many Ends." *Science* 365, no. 6448 (July 5, 2019): 24–25. https://doi.org/10.1126/science.aax9539.

Crowther, T. W., H. B. Glick, K. R. Covey, C. Bettigole, D. S. Maynard, S. M. Thomas, J. R. Smith, et al. "Mapping Tree Density at a Global Scale." *Nature* 525, no. 7568 (September 2015): 201–5. https://doi.org/10.1038/nature14967.

Darwin, Charles. *On the Origin of Species by Means of Natural Selection*. London: Watts, 1859.

Del Tredici, Peter. "Sprouting in Temperate Trees: A Morphological and Ecological Review." *Botanical Review* 67, no. 2 (April 1, 2001): 121–40. https://doi.org/10.1007/BF02858075.

Del Tredici, Peter. "Urban Nature/Human Nature." In *Living in the Anthropocene: Earth in the Age of Humans*, edited by W. John Kress and Jeffrey K. Stine, 58–61. Washington, DC: Smithsonian Books, 2017.

Del Tredici, Peter. *Wild Urban Plants of the Northeast: A Field Guide*. Ithaca and London: Cornell University Press, 2010.

Dirr, Michael A. *Dirr's Encyclopedia of Trees and Shrubs*. Portland and London: Timber Press, 2011.

Dirr, Michael A., and Keith S. Warren. *The Tree Book: Superior Selections for Landscapes, Streetscapes, and Gardens*. Portland: Timber Press, 2019.

Ellison, Aaron M., Michael S. Bank, Barton D. Clinton, Elizabeth A. Colburn, Katherine Elliott, Chelcy R. Ford, David R. Foster, et al. "Loss of Foundation Species: Consequences for the Structure and Dynamics of Forested Ecosystems." *Frontiers in Ecology and the Environment* 3, no. 9 (2005): 479–86. https://doi.org/10.1890/1540-9295(2005)003[0479:LOFSCF]2.0.CO;2.

Ennos, Roland. *Trees: A Complete Guide to Their Biology and Structure*. Ithaca: Cornell University Press, 2016.

Farrar, John Laird. *Trees of the Northern United States and Canada*. Ames: Iowa State University Press, 1995.

Flora of North America (database). Accessed April 27, 2023. http://floranorthamerica.org.

ForestPlots.net, Cecilia Blundo, Julieta Carilla, Ricardo Grau, Agustina Malizia, Lucio Malizia, Oriana Osinaga-Acosta, et al. "Taking the Pulse of Earth's Tropical Forests Using Networks of Highly Distributed Plots." *Biological Conservation* 260 (August 1, 2021): 108849. https://doi.org/10.1016/j.biocon.2020.108849.

Fox, Alex. "Adding 1 Billion Hectares of Forest Could Help Check Global Warming." *Science* (July 2019). https://doi.org/10.1126/science.aay6188.

Global Biodiversity Information Facility (database). Accessed April 27, 2023. https://www.gbif.us/.

GlobalTree Portal (database). Botanic Gardens Conservation International. Accessed on April 27, 2023. https://www.bgci.org/resources/bgci-databases/globaltree-portal/.

Gurevitch, Jessica. "Managing Forests for Competing Goals." *Science* 376 (May 19, 2022): 792–93. https://doi.org/10.1126/science.abp8463.

Harlow, William M. *Fruit Key and Twig Key to Trees and Shrubs*. New York: Dover, 1946.

Hopkins, Gerard Manley. "Binsey Poplars" https://www.poets.org/.

Howard, Andrew F. "The Effects of the New Hampshire Timber Yield Tax on Potential Financial Returns from Forest Management on Private Land." *Journal of Forestry* 117, no. 3 (April 30, 2019): 198–209. https://doi.org/10.1093/jofore/fvz001.

Humboldt, Alexander von. *Essay on the Geography of Plants*. Chicago: University of Chicago Press, 2009.

Humphreys, Aelys M., Rafaël Govaerts, Sarah Z. Ficinski, Eimear Nic Lughadha, and Maria S. Vorontsova. "Global Dataset Shows Geography and Life Form Predict Modern Plant Extinction and Rediscovery." *Nature Ecology & Evolution* 3, no. 7 (July 2019): 1043–47. https://doi.org/10.1038/s41559-019-0906-2.

Intergovernmental Science-Policy Platform on Biodiversity and Ecosystem Services. "Summary for Policymakers of the Global Assessment Report on Biodiversity and Ecosystem Services." Zenodo, November 25, 2019. https://doi.org/10.5281/zenodo.3553579.

IUCN Red List of Threatened Species (database). International Union for Conservation of Nature. Accessed May 1, 2023. https://www.IUCNredlist.org.

Janzen, Daniel H. "How to Conserve Wild Plants? Give the World the Power to Read Them." Foreword in *Plant Conservation: A Natural History Approach*, edited by Gary A. Krupnick and W. John Kress, ix–xiii. Chicago: University of Chicago Press, 2005.

Jonnes, Jill. "What Is a Tree Worth?" *Wilson Quarterly* 35, no. 1 (Winter 2011): 34–41.

Judd, Walter J., Christopher S. Campbell, Elizabeth A. Kellogg, Peter F. Stevens, and Michael J. Donoghue. *Plant Systematics: A Phylogenetic Approach*. Sunderland, MA: Sinauer Associates, 2018.

Kershner, Bruce, Daniel Mathews, Gil Nelson, and Richard Spellenberg. *National Wildlife Federation Field Guide to Trees of North America*. New York: Sterling, 2008.

Knoll, Andrew H., Karl J. Niklas, and Bruce H. Tiffney. "Phanerozoic Land-Plant Diversity in North America." *Science* 206, no. 4425 (December 21, 1979): 1400–02. https://doi.org/10.1126/science.206.4425.1400.

Kress, W. John. "Plant DNA Barcodes: Applications Today and in the Future." *Journal of Systematics and Evolution* 55, no. 4 (2017): 291–307. https://doi.org/10.1111/jse.12254.

Kress, W. John, and David L. Erickson, eds. *DNA Barcodes: Methods and Protocols*. New York: Springer, 2012.

Kress, W. John, and Shirley Sherwood. *The Art of Plant Evolution*. Kew, United Kingdom: Royal Botanic Gardens, 2009.

Kress, W. John, and Jeffrey K. Stine, eds. *Living in the Anthropocene: Earth in the Age of Humans*. Washington, DC: Smithsonian Books, 2017.

Kress, W. John, Carlos Garcia-Robledo, João V. B. Soares, David Jacobs, Katharine Wilson, Ida C. Lopez, and Peter N. Belhumeur. "Citizen Science and Climate Change: Mapping the Range Expansions of Native and Exotic Plants with the Mobile App Leafsnap." *BioScience* 68, no. 5 (May 1, 2018): 348–58. https://doi.org/10.1093/biosci/biy019.

Lewis, Simon L., Charlotte E. Wheeler, Edward T. A. Mitchard, and Alexander Koch. "Regenerate Natural Forests to Store Carbon." *Nature* 568 (2019): 25–28. https://doi.org/10.1038/d41586-019-01026-8.

Little, Elbert L., Jr. *Checklist of United States Trees (Native and Naturalized)*. Washington, DC: United States Department of Agriculture, Forest Service, 1979.

Lowman, Margaret D. *The Arbornaut: A Life Discovering the Eighth Continent in the Trees above Us*. New York: Farrar, Straus and Giroux, 2021.

McMahon, Sean. "Temperate Forests: A Tale of the Anthropocene." In *Living in the Anthropocene: Earth in the Age of Humans*, edited by W. John Kress and Jeffrey K. Stine, 53–57. Washington, DC: Smithsonian Books, 2017.

Nadkarni, Nalini M. *Between Earth and Sky: Our Intimate Connections to Trees*. Berkeley: University of California Press, 2008.

NatureServe Explorer (database). NatureServe. Accessed May 1, 2023. https://explorer.natureserve.org.

Nelson, Gil, Christopher J. Earle, and Richard Spellenberg. *Trees of Eastern North America*. Princeton: Princeton University Press, 2014.

Nic Lughadha, Eimear, Rafaël Govaerts, Irina Belyaeva, Nicholas Black, Heather Lindon, Robert Allkin, Robert E. Magill, and Nicky Nicolson. "Counting Counts: Revised Estimates of Numbers of Accepted Species of Flowering Plants, Seed Plants, Vascular Plants and Land Plants with a Review of Other Recent Estimates." *Phytotaxa* 272, no. 1 (August 26, 2016): 82–88. https://doi.org/10.11646/phytotaxa.272.1.5.

Peattie, Donald Culross. *A Natural History of North American Trees*. Boston: Houghton Mifflin, 2007.

Peattie, Donald Culross. *A Natural History of Trees of Eastern and Central North America*. Boston: Houghton Mifflin, 1966.

PLANTS Database. United States Department of Agriculture, Natural Resources Conservation Service. Accessed January 2020. https://plants.sc.egov.usda.gov.

Popkin, Gabriel. "Deadly Pest Reaches Oregon, Sparking Fears for Ash Trees." *Science* 377 (2022): 356.

Potter, Kevin M., Barbara S. Crane, and William W. Hargrove. "A United States National Prioritization Framework for Tree Species Vulnerability to Climate Change." *New Forests* 48 (2017): 275–300. https://doi.org/10.1007/s11056-017-9569-5.

Powers, Richard. *The Overstory: A Novel*. New York: W. W. Norton, 2018.

Proulx, Annie. *Barkskins: A Novel*. New York: Scribner, 2016.

Rogers, Julia Ellen. *The Tree Book: A Popular Guide to a Knowledge of the Trees of North America and to Their Uses and Cultivation*. New York: Doubleday, Doran, 1905.

Royal Botanic Gardens, Kew. "The Tree of Life Initiative." Accessed April 27, 2023. https://www.kew.org/science/our-science/projects/plant-and-fungal-trees-of-life.

Sibley, David A. *The Sibley Guide to Trees*. New York: Alfred A. Knopf, 2009.

Simard, Suzanne. *Finding the Mother Tree*. New York: Alfred A. Knopf, 2021.

Simpson, Michael G. *Plant Systematics*. New York: Elsevier, 2005.

Soltis, Douglas, Pamela Soltis, Peter Endress, Mark Chase, Steven Manchester, Walter Judd, Lucas Majure, and Evgeny Mavrodiev. *Phylogeny and Evolution of Angiosperms*. Chicago: University of Chicago Press, 2018.

Spellenberg, Richard, Christopher J. Earle, and Gil Nelson. *Trees of Western North America*. Princeton: Princeton University Press, 2014.

ter Steege, Hans, Nigel C. A. Pitman, Daniel Sabatier, Christopher Baraloto, Rafael P. Salomão, Juan Ernesto Guevara, Oliver L. Philips, et al. "Hyperdominance in the Amazonian Tree Flora." *Science* 342, no. 6156 (2013). https://doi.org/10.1126/science.1243092.

Thomas, Peter A. *Trees: Their Natural History*. Cambridge: Cambridge University Press, 2000.

Thoreau, Henry David. *The Maine Woods*. New York: Penguin Books, 1864.

United States Department of Agriculture, Forest Service. *Important Forest Trees of the Eastern United States*. Washington, DC: United States Department of Agriculture, 1991.

Wildlands, Woodlands, Farmlands & Communities (website). Accessed April 28, 2023. https://wildlandsandwoodlands.org/.

Further Reading

American Conifer Society. Accessed April 28, 2023. https://conifersociety.org/.

Burns, Russell M., and Barbara H. Honkala. *Conifers*, Vol. 1, and *Hardwoods*, Vol. 2, of *Silvics of North America*. Washington, DC: United States Department of Agriculture, Forest Service, 1990.

Cirigliano, Jim, ed. *National Audubon Society Trees of North America*. New York: Fieldstone, 2021.

Coombes, Allen J. *Smithsonian Handbook of Trees*, 2nd ed. New York: Dorling Kindersley, 2002.

Drori, J. *Around the World in 80 Trees*. London: Laurence King, 2018.

Ennos, Roland. *The Age of Wood*. New York: Scribner, 2020.

Grimm, William Carey. *The Book of Trees*. New York: Hawthorn, 1962.

Gymnosperm Database. Accessed March 2023. https://www.conifers.org/.

Haskell, David George. *The Songs of Trees*. New York: Penguin Books, 2017.

Kirkman, L. Katherine, Claud L. Brown, and Donald J. Leopold. *Native Trees of the Southeast: An Identification Guide*. Portland: Timber Press, 2007.

Logan, William Bryant. *Sprout Lands: Tending the Endless Gift of Trees*. New York: W. W. Norton, 2019.

North Carolina State University Cooperative Extension Service. "Plant fact sheets." Accessed April 28, 2023. https://gardening.ces.ncsu.edu/gardening-plants/trees-3/.

Peattie, Donald Culross. *A Natural History of Western Trees*. Boston: Houghton Mifflin, 1980.

Petrides, George A., and Janet Wehr. *A Field Guide to Eastern Trees*. New York: Houghton Mifflin, 1998.

Russell, Tony, Catherine Cutler, and Martin Walters. *The World Encyclopedia of Trees*. London: Lorenz Books, 2003.

Sargent, Charles Sprague. *The Silva of North America*. 14 vols. New York: Houghton Mifflin, 1891–1902.

Sargent, Charles Sprague. *Manual of the Trees of North America (Exclusive of Mexico)*. New York: Dover, 1965.

Smith, Paul. *Trees: From Root to Leaf*. London: Thames & Hudson, 2022.

Tudge, Colin. *The Tree: A Natural History of What Trees Are, How They Live, and Why They Matter*. 1st U.S. ed. New York: Crown Publishers, 2006.

Virginia Tech. "Virginia Tech Dendrology Factsheets." Accessed April 28, 2023. https://dendro.cnre.vt.edu/dendrology/factsheets.cfm.

Wohlleben, Peter. *The Heartbeat of Trees*. Vancouver & Berkeley: Greystone Books, 2021.

Acknowledgments

One could trace the genesis of this book to the early 2000s, when I temporarily switched my research from tropical plants to Temperate Zone trees. Intrigued by modern computer technologies that could enhance our ability to collect and identify plants in the field, I started a project with computer scientists along with a team of botanists at the Smithsonian to build a system that would allow a curious user to get to know plants with a mobile phone. The project, which was focused on local trees, had the goal to eventually enable me to identify every plant in a tropical rain forest where I had worked for years. That ambitious aspiration was never realized, but my interest in the trees of North America had been kindled and my appreciation of the beauty of these trees was ignited. Although I was side-tracked by a number of administrative jobs at the Smithsonian in the following decade, I never lost the desire to complete a book on trees to celebrate their splendor and diversity through words and photography. The help and inspiration of the many coworkers and teammates with whom I collaborated and on whom I depended during this decadal pathway were invaluable. I am indebted to them all.

During my career as a research scientist at the Smithsonian's National Museum of Natural History in Washington, DC, I relied on many staff and hosted many visitors and students to advance our knowledge of plants. This book and the material in it could not have been assembled and organized without the critical assistance at the Smithsonian of Ida Lopez, Sue Lutz, Alice Tangerini, Gary Krupnick, Serenity and Enrique Montano, and Eric Schuettpelz. Lonnie G. Bunch III, Secretary of the Smithsonian Institution, provided vital support during the latter stages of this endeavor and I am most thankful for his welcoming words at the beginning of the volume.

Similarly, my sabbatical and positions as Visiting Scholar at both Dartmouth College and the Arnold Arboretum of Harvard University over the last five years have been indispensable. I thank Mark McPeek, Katheryn Cottingham, Tom Jack, Matt Ayers, Ann Lavanway, Craig Layne, and Brian Beaty at Dartmouth and Ned Friedman, Michael Dossman, Peter Del Tredici, and Kathryn Richardson at the Arboretum for their support on this project.

The most important element in getting this book on the trees of North America off the ground was the development of the mobile phone application *Leafsnap*. *Leafsnap* was developed to allow scientists and citizen scientists to automatically identify plants by taking a photograph of their leaves. I am very grateful for the work of two computer scientists, Peter Belhumeur of Columbia University and David Jacobs of the University of Maryland, and their team of associates who worked with me and my group at the Smithsonian to apply their advanced knowledge of computer technologies to explore trees. The funding support from the National Science Foundation for this project was invaluable.

The core of this book on trees is the thousands of diverse, detailed, and highly informative photographs of bark, branches, leaves, cones, flowers, fruits, and seeds of the 326 species, 119 genera, 49 families, and 26 orders of gymnosperms and angiosperms contained in its pages. The inspiration and model for these magnificent images, which originated during the *Leafsnap* project, were a team of botanists and photographers— Finding Species— which was led by Bejat McCracken and Gorky Villa. By traveling to botanical gardens and arboreta, they located the trees and produced the stunning images for nearly half the species covered. They provided invaluable support and instruction for me to continue this task in generating the photographs for the remaining species. This book would not have happened without their expertise and outstanding efforts.

It was a daunting undertaking for me to set out in search of the remaining tree species only to be

confronted by a major roadblock that stopped many of us in our work: the COVID-19 pandemic. I had only just begun my photographic journey when my efforts were halted for nearly two years by travel restrictions. Not to be daunted, I reached out to my botanical colleagues across the continent, who sent me fresh specimens and samples via overnight mail, which I was able to photograph in my own home image lab. Invaluable help in sending these samples was provided by Chuck Cannon, Matt Lobdell, and Ed Hedborn at the Morton Arboretum; Raymond Larson, Wendy Asplin, and Ryan R. Garrison at the University of Washington Botanic Gardens; Holly Forbes at the University of California Botanical Gardens at Berkeley; Kristen Hasenstab-Lehman at the Santa Barbara Botanical Garden; Kier Morse, Nina House, and Martin Purdy at the California Botanic Garden; Emily James and Linda Chafin at the State Botanical Garden of Georgia; Steve Oberbauer and Santiago Castañeda at Florida International University; and Kathryn Richardson at the Arnold Arboretum of Harvard University. Many of these same colleagues provided original photographs of bark and leaves for samples that could not be sent by mail. I am especially grateful to Dan Mosheim for the loan of his beautiful wood samples, to Ted Fleming, Andrew Koeser, and Gitta Hasing for their critical photographs, and to John Tweedle, Sandra Knapp, and Stephen Atkinson at the Natural History Museum in London for their help in obtaining images from the UK version of *Leafsnap*. I also thank the collections staff at the US National Herbarium for access to the pressed and dried specimens from which I obtained high-quality photographs. (See if you can find them!) The use of these specimens in this context demonstrates their vital role in documenting the natural world. The efforts by all of these botanists made possible the inclusion of the majority of images of trees in this volume.

Others who made significant contributions of drawings, critical scientific information and reviews, perspectives, and data analyses were Helena and Katherine Hawksby, William Baker at the Royal Botanic Gardens, Kew, Andy Howard, Stinger Guala, Aaron Ellison, Daniel Janzen, Charles J. Hagner for his meticulous copyediting, Erin Greb for her accurate and engaging species maps, and four anonymous external reviewers. I especially thank Margaret D. Lowman for her thoughtful and energetic foreword.

The production team at Yale University Press—guided by Senior Executive Editor Jean E. Thomson Black with the help of Jenya Weinreb, Director of Editorial, Design, and Production, and Elizabeth Sylvia—could not have been more helpful, critical, and honest in all of our interactions. To them I am most grateful. The design and production talents of Scott & Nix, Inc. are much appreciated.

Finally, my companion in this exploration and discovery of the trees of North America was my lifelong partner and wife, Lindsay L. Clarkson, MD. She could not have been more encouraging, more thoughtful, more analytical, more forthright, more supportive, and more loving throughout the entire effort. Along with the 326 species of trees featured here, she is nature's wonder that allowed it all to happen. Now back to the tropics!

—W. John Kress

Credits

This Credits section constitutes a continuation of the copyright page. Unless otherwise noted below, all photographs and illustrations in *Smithsonian Trees of North America* are by W. John Kress and/or Finding Species (© Smithsonian Institution).

PAGE 3 Fig.1.1 Katherine Hawksby, Helena Hawksby. **PAGE 4** Fig.1.2 Mary Parrish. **PAGE 5** Fig.1.3 NPS photo/Monica Larcom. **PAGES 6–7** Fig.1.4 boreal forest, NPS Photo/Claire Abendroth; tropical forest, Marcos Guerra. **PAGE 10** Fig.2.1 Michael S. Dosmann. **PAGE 11** Fig.2.2 Robin Chazdon. **PAGE 12** Fig.2.3 advertisement, Library of Congress; Goss Lumber Mill, Henniker, NH, Andrew F. Howard, Ph.D. **PAGE 13** Fig.2.4 Library of Congress. **PAGE 13** Fig.2.5 Peter Del Tredici. **PAGE 15** Fig.3.1 *Picea glauca*, Reni J. Driskill ©2007 President and Fellows of Harvard College; *Calocedrus decurrens, Ginkgo biloba, Acer saccharum, Gymnocladus dioicus, Ulmus pumila, Carya illinoinensis,* William (Ned) Friedman ©2020 President and Fellows of Harvard College. **PAGE 19** Fig.3.5 *Washingtonia filifera* Nina House. **PAGE 26** Fig.3.10 beetle, NPS Photo/Rebecca Loncosky; fly, NPS Photo/M. Gorman; hawkmoth, NPS photo/Erin Anfinson; butterfly, NPS photo; bee, NPS photo; Anna's hummingbird, Brian E. Small. **PAGE 27** Fig.3.11, rose-breasted grosbeak, Brian E. Small; squirrel, NPS photo/Jane Gamble; fox, NPS photo/Tim Rains; racoon, NPS photo. **PAGE 28** Fig.4.1 NPS photo/Ron Karpilo. **PAGE 29** Fig.4.2 NPS. **PAGE 29** Fig.4.3 NPS photo/Diane Renkin. **PAGE 30** Fig.4.4 NPS photo; Fig.4.5 NPS photo. **PAGE 31** Fig.4.6 NPS photo; Fig.4.7 NPS photo/© Patrick L. Christman. **PAGE 33** Fig.4.9 NPS photo/A. Armstrong; Fig.4.10 NPS photo/Brittni Connell. **PAGE 34** Fig.4.11 NPS photo. **PAGE 35** Fig.4.12 NPS photo; Fig.4.13, NPS photo. **PAGE 44** Fig.6.1 Reproduced by kind permission of the Syndics of Cambridge University Library. **PAGE 46** Fig.6.2, Kew Science Plant Tree of Life figure (2019 version), © Copyright The Board of Trustees of the Royal Botanic Gardens, Kew. **PAGE 57** *Abies amabilis*, mature cone, Alfio Scisetti/Alamy Stock Photo. **PAGE 64** *Abies lasiocarpa*, mature cones, Christopher Price/Alamy Stock Photo. **PAGE 66** *Abies magnifica*, bark, Kier Morse. **PAGE 78** *Picea engelmannii*, bark, Kathryn Richardson, Arnold Arboretum. **PAGE 80** *Picea glauca*, bark, George Scott, Scott & Nix, Inc. **PAGE 89** *Picea sitchensis*, needle above, needle below, male cone, female cone, © The Trustees of the Natural History Museum, London. **PAGE 92** *Pinus albicaulis*, bark, Kier Morse. **PAGE 106** *Pinus elliottii*, bark, Santiago Castaneda. **PAGE 112** *Pinus halepensis*, bark, Martin Purdy. **PAGE 116** *Pinus lambertiana*, bark, Kathryn Richardson, Arnold Arboretum. **PAGE 118** *Pinus monophylla*, bark, Nina House. **PAGE 120** *Pinus monticola*, bark, Kathryn Richardson, Arnold Arboretum. **PAGES 126–127** *Pinus pinea*, bark, branch, cones, seeds, © The Trustees of the Natural History Museum, London. **PAGE 136** *Pinus sabiniana*, bark, Kristen Hasenstab-Lehman. **PAGE 149** *Pseudotsuga macrocarpa*, bark, Kristen Hasenstab-Lehman. **PAGE 155** *Tsuga heterophylla*, needles with male cone, needles with mature cone, mature cone, © The Trustees of the Natural History Museum, London. **PAGE 156** *Tsuga mertensiana*, bark, Kathryn Richardson, Arnold Arboretum. **PAGE 161** *Calocedrus decurrens*, needle above, needle below, fruit, © The Trustees of the Natural History Museum, London. **PAGE 168** *Juniperus californica*, bark, Kier Morse. **PAGE 172** *Juniperus deppeana*, bark, Susan E. Degginger/Alamy Stock Photo; *Juniperus deppeana*, branch above, Dorling Kindersley Ltd/Alamy Stock Photo; *Juniperus deppeana*, mature cones, Ana Iacob/Alamy Stock Photo. **PAGE 173** *Juniperus monosperma*, bark, Bill Gorum/Alamy Stock Photo; *Juniperus monosperma*, male cones, Bill Gorum/Alamy Stock Photo. **PAGE 176** *Juniperus osteosperma*, bark, Nina House. **PAGE 187** *Sequoiadendron giganteum*, needles 1, needles 2, needles with male cone, male cone, seeds, © The Trustees of the Natural History Museum, London. **PAGE 195** *Xanthocyparis nootkatensis*, male cones on branchlet, male cone, female cone, mature cone, mature cone and seed,© The Trustees of the Natural History Museum, London. **PAGE 197** *Taxus brevifolia*, bark, Kier Morse. **PAGE 199** *Torreya californica*, bark, Kier Morse. **PAGE 205** *Cinnamomum camphora*, bark, Nina House. **PAGE 213** *Umbellularia californica*, bark, Kier Morse. **PAGE 231** *Phoenix canariensis*, bark, crown, leaves, Martin Purdy. **PAGE 233** *Sabal palmetto*, leaf, Steven F. Oberbauer. **PAGE 234** *Syagrus romanzoffiana*, bark, Martin Purdy. **PAGE 235** *Syagrus romanzoffiana*, leaf, Kier Morse. **PAGE 237** *Washingtonia filifera*, bark, Nina House. **PAGE 238** *Washingtonia robusta*, entire leaf above, Kier Morse. **PAGES 240–241** *Yucca brevifolia*, George Scott, Scott & Nix, Inc. **PAGE 243** *Yucca brevifolia*, bark, crown, Nina House; inflorescence, Kier Morse. **PAGES 245–246** *Yucca elata*, inflorescence, leaf crown, Ted Fleming. **PAGE 246** *Yucca schidigera*, bark, Nina House. **PAGE 247** *Yucca schidigera*, crown, Nina House. **PAGE 252** *Platanus racemosa*, bark, Nina House. **PAGE 261** *Lagerstroemia indica*, flowers, Stephanie Jackson–Gardens and flowers collection/Alamy Stock Photo. **PAGE 264** *Eucalyptus sideroxylon*, bark, Martin Purdy. **PAGE 267** *Melaleuca quinquenervia*, bark, Sunshower Shots/Alamy

Stock Photo; *Melaleuca quinquenervia*, flowers, Stephanie Jackson-Aust wildflower collection/Alamy Stock Photo. **PAGE 276** *Rhus integrifolia*, bark, Kier Morse. **PAGE 278** *Rhus ovata*, bark, Kier Morse. **PAGE 282** *Schinus molle*, bark, Kier Morse. **PAGE 284** *Schinus terebinthifolius*, bark, Martin Purdy. **PAGE 292** *Acer macrophyllum*, bark, Holly C. Forbes. **PAGE 313** *Aesculus californica*, bark, Nina House. **PAGE 325** *Melia azedarach*, leaf, flower, fruit, bark, Gitta Hasing, IFAS, University of Florida. **PAGE 340** *Ricinus communis*, bark, Kier Morse. **PAGE 347** *Populus alba*, branch 1, branch 2, leaf above, leaf below, ©The Trustees of the Natural History Museum, London. **PAGE 354** *Populus fremontii*, bark, Nina House. **PAGE 361** *Salix alba*, bark, fruits on branch, fruit, ©The Trustees of the Natural History Museum, London. **PAGE 372** *Salix gooddingii*, bark, Nina House. **PAGE 376** *Salix lasiolepis*, bark, Kier Morse. **PAGE 382** *Salix scouleriana*, bark, Holly C. Forbes. **PAGE 399** *Olneya tesota*, bark, Kier Morse. **PAGE 401** *Parkinsonia aculeata*, bark, Kier Morse. **PAGE 402** *Parkinsonia florida*, bark, Kier Morse. **PAGE 404** *Parkinsonia microphylla*, bark, Kier Morse. **PAGE 407** *Prosopis glandulosa*, bark, Kier Morse. **PAGE 408** *Prosopis velutina*, bark, MacAlaska/Stockimo/Alamy Stock Photo. **PAGE 422** *Amelanchier utahensis*, bark, Kier Morse. **PAGE 426** *Cercocarpous montanus*, bark, courtesy Castle Stalker/iNaturalist/CC0. **PAGE 434** *Heteromeles arbutifolia*, bark, Kier Morse. **PAGE 446** *Prunus ilicifolia*, bark, Kier Morse. **PAGE 468** *Frangula californica*, bark, Nina House. **PAGE 474** *Rhamnus crocea*, bark, Holly C. Forbes. **PAGE 499** *Ficus benjamina*, bark, Roberto Nistri/Alamy Stock Photo. **PAGE 519** *Quercus agrifolia*, bark, Kier Morse. **PAGE 522** *Quercus arizonica*, bark, Norma Jean Gargasz/Alamy Stock Photo. **PAGE 526** *Quercus chrysolepis*, bark, Nina House. **PAGE 530** *Quercus douglasii*, bark, Kier Morse. **PAGE 540** *Quercus garryana*, bark, Kristen Hasenstab-Lehman. **PAGE 542** *Quercus geminata*, bark, George Scott, Scott & Nix, Inc. **PAGE 552** *Quercus kelloggii*, bark, Kier Morse. **PAGE 554** *Quercus laevis*, bark, blickwinkel/Alamy Stock Photo. **PAGE 556** *Quercus laurifolia*, bark, George Scott, Scott & Nix, Inc. **PAGE 558** *Quercus lobata*, bark, Kier Morse. **PAGE 596** *Quercus wislizeni*, bark, Nina House. **PAGE 600** *Alnus rhombifolia*, bark, Kier Morse. **PAGE 612** *Betula occidentalis*, bark, Holly C. Forbes. **PAGE 645** *Carnegiea gigantea*, trunk, branches, flowers, barks, Ted Fleming. **PAGE 662** *Nyssa biflora*, bark, courtesy Austin Pursley/iNaturalist/CC0. **PAGE 682** *Arctostaphylos glauca*, bark, Kier Morse. **PAGE 693** *Garrya elliptica*, bark, Kier Morse. **PAGE 702** *Fraxinus dipetala*, bark, Nina House. **PAGE 710** *Fraxinus velutina*, bark, Nina House. **PAGE 713** *Olea europaea*, bark, Kier Morse. **PAGE 717** *Chilopsis linearis*, bark, Kier Morse.

Quotations from other works appear with the permission of the following copyright holders.

PAGES x, 72, 91, 152, 162, 210, 216, 218, 220, 248, 256, 258, 272, 287, 312, 326, 328, 334, 345, 360, 390, 394, 396, 410, 418, 428, 436, 438, 460, 480, 494, 504, 510, 516, 518, 606, 618, 622, 625, 638, 648, 660, 670, 674, 684, 686, 698, 728, 738 From *A Natural History of Trees of Eastern and Central North America* by Donald Culross Peattie. Copyright © 1948, 1949, 1950, 1964 by Donald Culross Peattie. Copyright © renewed 1976, 1977 by Noel Peattie. Copyright © 1966 by Houghton Mifflin Company. Used by permission of HarperCollins Publishers. Copyright © 1966 by Donald Culross Peattie. Reprinted by permission of Curtis Brown, Ltd.

PAGE 2 *State of the World's Trees* reprinted with permission of BGCI, Descanso House, 199 Kew Road, Richmond, Surrey, UK.

PAGE 2 *The Tree Book* by Michael A. Dirr, copyright © 2019. Reprinted by permission of Timber, an imprint of Hachette Book Group, Inc.

PAGES 54, 70, 206, 268, 318, 324, 342, 388, 414, 458, 466, 472, 476, 492, 498, 690, 694 From *Dirr's Encyclopedia of Trees and Shrubs* by Michael A. Dirr, copyright © 2011. Reprinted by permission of Timber, an imprint of Hachette Book Group, Inc.

PAGES 56, 76, 148, 160, 166, 184, 186, 190, 194, 212, 236, 242, 398, 406, 502, 598, 644, 680, 682, 716 From *A Natural History of North American Trees* by Donald Culross Peattie. Compilation and revisions copyright © 2007, 2013 by the Estate of Donald Culross Peattie. Copyright © 1948, 1949, 1950, 1951,1952, 1953, and 1964 by Donald Culross Peattie. Copyright © renewed 1976, 1977, 1978, 1979, 1980, and 1981 by Noel Peattie. Used by permission of HarperCollins Publishers. 2013 edition used with permission of Trinity University Press; permission conveyed through Copyright Clearance Center, Inc.

PAGE 322 From *Wild Urban Plants of the Northeast: A Field Guide*, Second Edition, by Peter Del Tredici, a Comstock book published by Cornell University Press. Copyright © 2010, 2020 by Cornell University.

Species Index

Boldface entries indicate a main species account.

A

Abies
 amabilis, 57
 balsamea, 58
 concolor, 60
 grandis, 62
 lasiocarpa, 64
 magnifica, 66
 procera, 68
Acer
 glabrum, 288
 grandidentatum, 290
 macrophyllum, 292
 negundo, 294
 nigrum, 296
 pensylvanicum, 298
 platanoides, 300
 pseudoplatanus, 302
 rubrum, 304
 saccharinum, 306
 saccharum, 308
 spicatum, 310
Aesculus
 californica, 312
 flava, 314
 glabra, 316
Ailanthus altissima, 322
Albizia julibrissin, 388
Alder
 California, 600
 Gray, 598
 Green, 604
 Red, 602
 Sitka, 604
 Speckled, 598
 Thinleaf, 598
 White, 600
Alnus
 incana, 598
 rhombifolia, 600
 rubra, 602
 viridis, 604
Amelanchier
 alnifolia, 418
 arborea, 420
 utahensis, 422
Apple, Paradise, 436
Aralia
 elata, 728
 spinosa, 730
Arborvitae, 190
Arbutus menziesii, 680
Arctostaphylos glauca, 682
Ash
 Black, 706
 California, 702
 Carolina, 700
 Green, 708
 Oregon, 704
 Pop, 700
 Two-petal, 702
 Velvet, 710
 White, 698
Asimina triloba, 216
Aspen
 Bigtooth, 356
 Quaking, 358
 Trembling, 358

B

Baldcypress, 188
Basswood, American, 334
Bay
 California, 212
 Loblolly, 672
Beech, American, 516
Betula
 alleghaniensis, 606
 lenta, 608
 nigra, 610
 occidentalis, 612
 papyrifera, 614
 populifolia, 616
Bigtree, 186
Birch
 Black, 608
 Cherry, 608
 Gray, 616
 Paper, 614
 River, 610
 Sweet, 608
 Water, 612
 White, 614
 Yellow, 606
Blackgum, 662, 664
Blackhaw, 738
 Rusty, 740
Bladdernut, American, 268
Blueblossom, 464
Bottle Brush Tree, 266
Boxelder, 294
Buckeye
 California, 312
 Ohio, 316
 Yellow, 314
Buckthorn
 California, 468
 Carolina, 470, 472
 Common, 472
 European, 472
 Glossy, 466
 Hollyleaf, 474
 Redberry, 474
Bully, Gum, 668
Butternut, 638
Buttonbush, 694
 Common, 694

C

Calocedrus decurrens, 160
Camphor-Tree, 204
Carnegiea gigantea, 644
Carpinus caroliniana, 618
Carya
 aquatica, 626
 cordiformis, 628
 glabra, 630
 illinoinensis, 632
 ovata, 634
 tomentosa, 636
Castanea
 dentata, 510
 pumila, 512
Castorbean, 340
Catalpa, Northern, 714
Catalpa
 speciosa, 714
Ceanothus thyrsiflorus, 464
Cedar
 Alaska-, 194
 Atlantic White-, 164
 Canoe-, 192
 Deodar, 70
 Himalayan, 70
 Incense-, 160
 Oregon, 162
 Port-Orford-, 162
 Southern White-, 164
Cedrus deodara, 70
Celtis
 laevigata, 494
 occidentalis, 496
Cephalanthus
 occidentalis, 694
Cercis
 canadensis, 390
 occidentalis, 392

Cercocarpus
 ledifolius, 424
 montanus, 426
Cercocarpus
 Alderleaf, 426
 Curlleaf, 424
Chamaecyparis
 lawsoniana, 162
 thyoides, 164
Cherry
 Bitter, 443
 Black, 454
 Cornelian, 654
 Fire, 450
 Hollyleaf, 446
 Pin, 450
Chestnut, American, 510
Chilopsis linearis, 716
Chinaberry, 324
Chinkapin, 512
 Allegheny, 512
Chinquapin, Giant Golden, 514
Chokecherry, 456
Christmasberry, 284
Chrysolepis chrysophylla, 514
Cinnamomum camphora, 204
Coffeetree, Kentucky, 396
Cornus
 alternifolia, 648
 drummondii, 650
 florida, 652
 mas, 654
 nuttallii, 656
 sericea, 658
Corylus cornuta, 620
Cottonwood
 Eastern, 352
 Fremont, 354
 Narrowleaf, 348
Crapemyrtle, 260
Crataegus
 chrysocarpa, 428
 crus-galli, 430
 viridis, 432
Cucumber-tree, 220

D

Devil's Walking Stick, 730
Diospyros virginiana, 670
Dogwood
 Alternate-leaved, 648
 Flowering, 652
 Pacific, 656
 Pagoda, 648
 Redosier, 658
 Roughleaf, 650
Douglas-Fir, 150
 Bigcone, 148

E

Elaeagnus angustifolia, 476
Elder
 European Black, 734
 European Red, 736
Elderberry
 Common, 734
 Eastern Common, 734
 Red, 736
 Scarlet, 736
Elm
 American, 482
 Asiatic, 488
 Cedar, 484
 Chinese, 486
 Japanese, 492
 Lacebark, 486
 Moose, 490
 Siberian, 488
 Slippery, 490
 Winged, 480
Empresstree, 718
Eucalyptus
 globulus, 262
 sideroxylon, 264
Eucalyptus
 Bluegum, 262
 Red Ironbark, 264

F

Fagus grandifolia, 516
Farkleberry, 690
Ficus
 benjamina, 498
 carica, 500
Fig
 Common, 500
 Weeping, 498
Fir
 Balsam, 58
 California Red, 66
 Cascade, 57
 Giant, 62
 Golden, 66
 Grand, 62
 Lowland White, 62
 Noble, 68
 Pacific Silver, 57
 Red, 57, 68
 Rocky Mountain, 64
 Shasta Red, 66
 Subalpine, 64
 Western Balsam, 64
 White, 60
Flannelbush, California, 332
Frangula
 alnus, 466
 californica, 468
 caroliniana, 470
Fraxinus
 americana, 698
 caroliniana, 700
 dipetala, 702
 latifolia, 704
 nigra, 706
 pennsylvanica, 708
 velutina, 710
Fremontodendron californicum, 332

G

Garrya elliptica, 692
Ginkgo biloba, 54
Ginkgo, 54
Gleditsia triacanthos, 394
Goldenrain Tree, 318
Gordonia
 lasianthus, 672
Gordonia, Loblollybay, 672
Gum, Tasmanian Blue, 262
Gymnocladus dioicus, 396

H

Hackberry, Common, 496
Halesia tetraptera, 674
Hamamelis virginiana, 256
Hawthorn
 Cockspur, 430
 Fireberry, 428
 Green, 432
 Southern, 432
Hazel, Western, 620
Hazelnut, Beaked, 620
Hemlock
 Canadian, 152
 Eastern, 152
 Mountain, 156
 Pacific, 154
 Western, 154
Heteromeles arbutifolia, 434
Hickory
 Bitter, 626
 Bitternut, 628
 Mockernut, 636
 Pignut, 630
 Shagbark, 634
 Swamp, 626
 Water, 626
Holly, American, 724
Honeylocust, 394
Hophornbeam
 American, 622
 Eastern, 622
Hoptree, Common, 326
Hornbeam, American, 618
Horse-Apple, 502

I

Ilex
 decidua, 722
 opaca, 724
 vomitoria, 726
Ironwood, Desert, 398

J

Japanese Angelica Tree, 728
Joshua Tree, 242
Juglans
 cinerea, 638
 nigra, 640
Juniper
 Alligator, 172
 Ashe, 166
 California, 168
 Common, 170
 Desert, 176
 Eastern, 182
 Oneseed, 173
 Pinchot, 178
 Rocky Mountain, 180
 Utah, 176
 Western, 174
Juniperus
 ashei, 166
 californica, 168
 communis, 170
 deppeana, 172
 monosperma, 173
 occidentalis, 174
 osteosperma, 176
 pinchotii, 178
 scopulorum, 180
 virginiana, 182

K

Kalmia latifolia, 684
Koelreuteria paniculata, 318

L

Lagerstroemia indica, 260
Larch
 American, 72
 Eastern, 72
 Mountain, 74
 Western, 74
Larix
 laricina, 72
 occidentalis, 74
Laurel
 California, 212
 Camphor, 204
 Mountain, 684
Laurelcherry, Carolina, 442
Lilac, Indian, 324
Linden, 334
 Littleleaf, 336
Lindera benzoin, 206
Liquidambar styraciflua, 258
Liriodendron tulipifera, 218
Locust
 Black, 412
 New Mexico, 410
 Rose, 410

M

Maclura pomifera, 502
Madrone, Pacific, 680
Magnolia
 acuminata, 220
 fraseri, 222
 grandiflora, 224
 macrophylla, 226
 virginiana, 228
Magnolia
 Bigleaf, 226
 Cucumber, 220
 Fraser, 222
 Mountain, 222
 Southern, 224
Mahogany
 Alderleaf Mountain-, 426
 Birchleaf Mountain-, 426
 Curlleaf Mountain-, 424
Maidenhair Tree, 54
Malus pumila, 436
Manzanita, Bigberry, 682
Maple
 Bigleaf, 292
 Bigtooth, 290
 Black Sugar, 296
 Black, 296
 Canyon, 290
 Dwarf, 288
 Hard, 296
 Moose, 310
 Mountain, 288
 Mountain, 310
 Norway, 300
 Oregon, 292
 Red, 304
 Rock, 296
 Rocky Mountain, 288
 Sierra, 288
 Silver, 306
 Soft, 304
 Striped, 298
 Sugar, 308
 Sycamore, 302
Melaleuca
 quinquenervia, 266
Melia azedarach, 324
Mesquite
 Honey, 406
 Velvet, 408
Mimosa, 388
Moosewood, 298
Morus
 alba, 504
 rubra, 506
Mountain-ash
 American, 460
 European, 462
Mulberry
 Red, 506
 White, 504

N

Nutmeg, California-, 198
Nyssa
 aquatica, 660
 biflora, 662
 sylvatica, 664

O

Oak
 Arizona White, 522
 Basket, 568
 Black, 592
 Blackjack, 566
 Blue, 530
 Bluejack, 550
 Bur, 562
 California Black, 552
 California Live, 518
 California White, 558
 Canyon Live, 526
 Cherrybark, 576
 Chestnut, 570
 Chinkapin, 572
 Coast Live, 518
 Emory, 534
 Gambel, 538
 Gray, 544
 Interior Live, 596
 Laurel, 556
 Live, 594
 Mossy-Cup, 562
 Netleaf, 584
 Northern Pin, 532
 Northern Red, 582
 Nuttall's, 590
 Oregon White, 540
 Overcup, 560
 Pagoda, 576
 Pin, 578
 Post, 588
 Red, 582
 Runner, 564
 Sand Live, 542
 Sand Post, 564
 Scarlet, 528
 Shingle, 548

Shumard, 586
Silverleaf, 546
Southern Red, 536
Spanish, 536
Spotted, 586
Swamp Chestnut, 568
Swamp White, 524
Texas Red, 590
Turkey, 554
Valley, 558
Water, 574
White, 520
Olea europaea, 712
Olive, 712
 Russian-, 476
Olneya tesota, 398
Osage-Orange, 502
Ostrya virginiana, 622
Oxydendrum arboreum, 686

P

Pagoda Tree, Japanese, 414
Palm
 Cabbage, 232
 California Fan, 236
 Canary Island Date, 231
 Desert, 236
 Mexican Fan, 238
 Petticoat, 236
 Queen, 234
Palmetto
 Cabbage, 232
 Sabal, 232
Paloverde
 Blue, 402
 Mexican, 400
 Yellow, 404
Paperbark, 266
Parkinsonia
 aculeata, 400
 florida, 402
 microphylla, 404
Paulownia tomentosa, 718
Pawpaw, 216

Peach, 452
Pear
 Bradford, 458
 Callery, 458
Pecan, 632
Peppertree, 282
 Brazilian, 284
 Peruvian, 282
Persea borbonia, 208
Persimmon, Common, 670
Phoenix canariensis, 231
Picea
 abies, 76
 engelmannii, 78
 glauca, 80
 mariana, 82
 pungens, 84
 rubens, 86
 sitchensis, 88
Pine
 Aleppo, 112
 Austrian, 122
 Black, 114
 Bristlecone, 94
 California Foothill, 136
 Cedar, 110
 Colorado Bristlecone, 94
 Eastern White, 140
 European Black, 122
 Foxtail, 94
 Gray, 136
 Hickory, 130
 Hudson Bay, 98
 Italian Stone, 126
 Jack, 98
 Jeffrey, 114
 Jersey, 146
 Knobcone, 96
 Limber, 108
 Loblolly, 144
 Lodgepole, 100
 Longleaf, 124
 Marsh, 137
 Mexican White, 138
 Mountain White, 120

Nut, 104
Pitch, 134
Pond, 137
Ponderosa, 128
Red, 132
Sand, 93
Scotch, 142
Scots, 142
Scrub, 98
Shore, 100
Shortleaf, 102
Slash, 106
Soft, 140
Southwestern White, 138
Spruce, 110
Stone, 126
Sugar, 116
Table Mountain, 130
Umbrella, 126
Virginia, 146
Western White, 120
Western Yellow, 128
Whitebark, 92
Yellow, 102
Pinus
 albicaulis, 92
 aristata, 94
 attenuata, 96
 banksiana, 98
 clausa, 93
 contorta, 100
 echinata, 102
 edulis, 104
 elliottii, 106
 flexilis, 108
 glabra, 110
 halepensis, 112
 jeffreyi, 114
 lambertiana, 116
 monophylla, 118
 monticola, 120
 nigra, 122
 palustris, 124
 pinea, 126
 ponderosa, 128
 pungens, 130

resinosa, 132
rigida, 134
sabiniana, 136
serotina, 137
strobiformis, 138
strobus, 140
sylvestris, 142
taeda, 144
Pinyon, 104
 Singleleaf, 118
 Two-needle, 104
Pistachio, Chinese, 270
Pistacia chinensis, 270
Planera aquatica, 478
Planertree, 478
Platanus
 occidentalis, 250
 racemosa, 252
Plum
 American, 438
 Cherry, 444
 Chickasaw, 440
 Mexican, 448
Poplar
 Balsam, 350
 White, 346
 Yellow, 218
Populus
 alba, 346
 angustifolia, 348
 balsamifera, 350
 deltoides, 352
 fremontii, 354
 grandidentata, 356
 tremuloides, 358
Possumhaw, 722
Pricklyash, Common, 328
Princesstree, 718
Prosopis
 glandulosa, 406
 velutina, 408
Prunus
 americana, 438
 angustifolia, 440
 caroliniana, 442
 cerasifera, 444

emarginata, 443
ilicifolia, 446
mexicana, 448
pensylvanica, 450
persica, 452
serotina, 454
virginiana, 456
Pseudotsuga
 macrocarpa, 148
 menziesii, 150
Ptelea trifoliata, 326
Punktree, 266
Pyrus calleryana, 458

Q

Quercus
 agrifolia, 518
 alba, 520
 arizonica, 522
 bicolor, 524
 chrysolepis, 526
 coccinea, 528
 douglasii, 530
 ellipsoidalis, 532
 emoryi, 534
 falcata, 536
 gambelii, 538
 garryana, 540
 geminata, 542
 grisea, 544
 hypoleucoides, 546
 imbricaria, 548
 incana, 550
 kelloggii, 552
 laevis, 554
 laurifolia, 556
 lobata, 558
 lyrata, 560
 macrocarpa, 562
 margarettae, 564
 marilandica, 566
 michauxii, 568
 montana, 570
 muehlenbergii, 572
 nigra, 574
 pagoda, 576
 palustris, 578
 phellos, 580
 rubra, 582
 rugosa, 584
 shumardii, 586
 stellata, 588
 texana, 590
 velutina, 592
 virginiana, 594
 wislizeni, 596

R

Redbay, 208
Redbud
 California, 392
 Eastern, 390
 Western, 392
Redcedar
 Eastern, 182
 Western, 192
Redosier, 658
Redwood, 184
 California, 184
 Coast, 184
Rhamnus
 cathartica, 472
 crocea, 474
Rhododendron
 macrophyllum, 688
 California, 688
 Pacific, 688
Rhus
 copallinum, 272
 glabra, 274
 integrifolia, 276
 ovata, 278
 typhina, 280
Ricinus communis, 340
Robinia
 neomexicana, 410
 pseudoacacia, 412
Rowan, 462

S

Saguaro, 644
Salix
 alba, 360
 amygdaloides, 362
 bebbiana, 364
 caroliniana, 366
 discolor, 368
 exigua, 370
 gooddingii, 372
 hookeriana, 374
 lasiolepis, 376
 lucida, 378
 nigra, 380
 scouleriana, 382
 sitchensis, 384
Sambucus
 nigra, 734
 racemosa, 736
Sapindus
 saponaria, 320
 albidum, 210
Sassafras, 210
Schinus
 molle, 282
 terebinthifolius, 284
Sequoia, Giant, 186
Sequoia sempervirens, 184
Sequoiadendron
 giganteum, 186
Serviceberry
 Downy, 420
 Saskatoon, 418
 Utah, 422
 Western, 418
Shadbush, 420
Sideroxylon lanuginosum, 668
Silktassel, Wavyleaf, 692
Silktree, 388
Silverbell
 Carolina, 674
 Mountain, 674
Snowbell
 American, 676
 Bigleaf, 678
Soapberry, 320
 Western, 320
 Wingleaf, 320
Sorbus
 americana, 460
 aucuparia, 462
Sourgum, 664
Sourwood, 686
Spicebush, 206
Spruce
 Black, 82
 Blue, 84
 Coast, 88
 Colorado blue, 84
 Columbian, 78
 Eastern, 86
 Engelmann, 78
 Mountain, 78
 Norway, 76
 Red, 86
 Sitka, 88
 White, 80
 Yellow, 86
Staphylea trifolia, 268
Styphnolobium
 japonicum, 414
Styrax
 americanus, 676
 grandifolius, 678
Sumac
 Flameleaf, 272
 Lemonade, 276
 Shining, 272
 Smooth, 274
 Staghorn, 280
 Sugar, 278
 Winged, 272
Sweetbay, 228
Sweetgum, 258
Syagrus romanzoffiana, 234
Sycamore
 American, 250
 California, 252

T

Tallow, Chinese, 342
Tallowtree, 342
Tamarack, 72
Taxodium distichum, 188
Taxus brevifolia, 196
Tesota, 398
Thorn
 Hart's, 472
 Jerusalem, 400
Thuja
 occidentalis, 190
 plicata, 192
Tilia
 americana, 334
 cordata, 336
Toothache Tree, 328
Torreya californica, 198
Torreya, California, 198
Toyon, 434
Tree Huckleberry, 690
Tree of Heaven, 322
Tree Sparkleberry, 690
Triadica sebifera, 342
Tsuga
 canadensis, 152
 heterophylla, 154
 mertensiana, 156
Tuliptree, 218
Tupelo
 Black, 664
 Swamp, 662
 Water, 660

U

Ulmus
 alata, 480
 americana, 482
 crassifolia, 484
 parviflora, 486
 pumila, 488
 rubra, 490
Umbellularia californica, 212

V

Vaccinium
 arboreum, 690
 prunifolium, 738
 rufidulum, 740
Viburnum, Rusty, 740

W

Walnut
 Black, 640
 White, 638
Washingtonia
 filifera, 236
 robusta, 238
Water-Elm, 478
Willow
 Arroyo, 376
 Bebb, 364
 Black, 380
 Coastal Plain, 366
 Desert-, 716
 Dune, 374
 European White, 360
 Goodding's, 372
 Gray, 364
 Hooker, 374
 Narrowleaf, 370
 Peachleaf, 362
 Pussy, 368
 Sandbar, 370
 Scouler's, 382
 Shining, 378
 Sitka, 384
 White, 360
Witch-Hazel, 256

X

Xanthocyparis
 nootkatensis, 194

Y

Yaupon, 726
Yellow-Cedar, 194
Yew
 Pacific, 196
 Western, 196
Yucca
 brevifolia, 242
 elata, 244
 schidigera, 246
Yucca
 Mojave, 246
 Soaptree, 244

Z

Zanthoxylum
 americanum, 328
Zelkova, Japanese, 492
Zelkova serrata, 492

About the Author

W. JOHN KRESS is Distinguished Scientist and Curator Emeritus at the Smithsonian's National Museum of Natural History. He is also an Affiliate Faculty at George Mason University and a Visiting Scholar at Dartmouth College. He formerly served as the Interim Under Secretary for Science at the Smithsonian and Director of Science in the Grand Challenges Consortia. Kress received his B.A. from Harvard University and his Ph.D. from Duke University, where he studied tropical biology, ethnobotany, evolution, and ecology. His current research is focused on plant evolution, conservation, and biodiversity genomics. Supplementing his 300 scientific and popular papers are his books *Plant Conservation: A Natural History Approach*; *The Weeping Goldsmith*; *The Ornaments of Life: Coevolution and Conservation in the Tropics*; and *Living in the Anthropocene: Earth in the Age of Humans*. He has been a recipient of the Parker-Gentry Award for Biodiversity and Conservation from the Field Museum of Natural History and the Edward O. Wilson Biodiversity Technology Pioneer Award. Kress lives in rural Vermont with his wife, Lindsay L. Clarkson, M.D.

Other Contributors

LONNIE G. BUNCH III is the 14th Secretary of the Smithsonian Institution and oversees 21 museums, 21 libraries, the National Zoo, numerous research centers, and several education units and centers. He was the founding director of the Smithsonian's National Museum of African American History and Culture and is the first historian to be Secretary of the Institution.

MARGARET (MEG) D. LOWMAN is an explorer and conservation biologist who pioneered research in forest canopies. She has climbed trees for over 40 years in over 40 countries and is Executive Director of TREE Foundation and a National Geographic Explorer. Her books include *Life in the Treetops: Adventures of a Woman in Field Biology* and *The Arbornaut: Discovering the Eighth Continent in the Trees above Us*.

Colophon

The heads of this book are set in Waldbaum MT, designed by Charles Nix,
Carl Crossgrove, and Juan Villanueva. The running text is set in Alfon
and the captions are set in Tangent, both designed
by James Montalbano, Terminal Design.

This book was printed and bound in China by World Print, Ltd.

Maps were prepared by Erin Greb, Erin Greb Cartography.

The text was copyedited by Charles J. Hagner.

The book was designed and edited by George Scott, Scott & Nix, Inc.